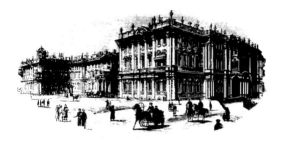

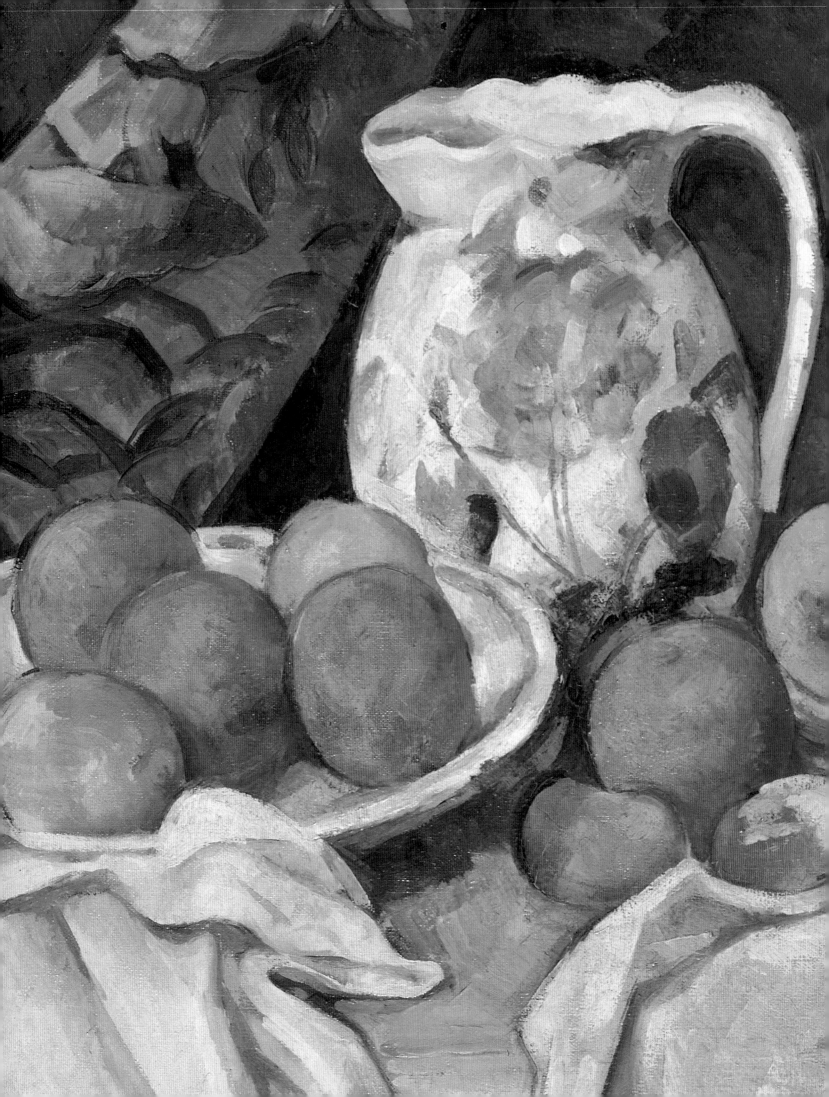

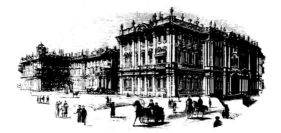

PAINTINGS IN THE
HERMITAGE

COLIN EISLER

❧ ❦

INTRODUCTION BY
B. B. PIOTROVSKY AND V. A. SUSLOV

STEWART, TABORI & CHANG
NEW YORK

For my brother Michael—
ever generous and understanding.

Contents

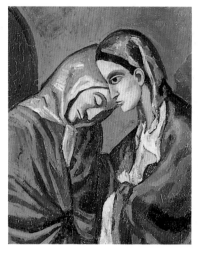
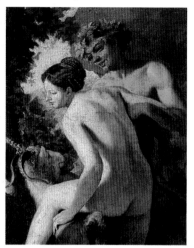
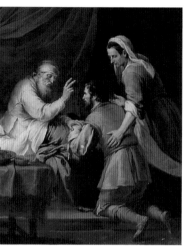

Contents

Preface

❦ ❧

In 1764, two years into the reign of Catherine II, a collection of paintings bought from the Berlin merchant J. E. Gotzkowski, through the mediation of the Russian ambassador Dolgoruky, was delivered to Saint Petersburg's Winter Palace. From then on, Russian diplomats continued to enrich the court museum by purchasing outstanding works of art at auctions in Western Europe.

Gotzkowski's collection of 225 pictures, made up chiefly of the works of Dutch and Flemish painters, included the *Portrait of a Young Man with a Glove* (page 494) by Frans Hals, and Jordaens's *Family Portrait* (486).

Catherine the Great's acquisition of paintings abroad was motivated as much by politics as by a desire for the beautiful. To the European countries, Russia was then a "young" state—one that had to consolidate the prestige gained through the efforts of Peter I. This explains the Empress Catherine's patronage of the arts by which she strove for recognition as an enlightened monarch, succeeding with the help of advisers at home and abroad. Men like Voltaire, Diderot, and Frederick Grimm of France, and the Russian counts Betskoy, I. Shuvalov, and A. Stroganov were among her friends.

Catherine II is known to have said that she had been an "avid" collector of paintings since 1765. Commissioning foreign artists to paint pictures for the Winter Palace, as well as purchasing whole collections at auction, devel-

JEAN-ANTOINE WATTEAU *Landscape* (detail)
(See pages 336–37)

oped into a system. The leading role in this cultural activity, which lasted for fifteen years, belongs to the eminent Russian diplomat, Prince Dmitry Golitsyn, a close friend of Diderot's. No one could compete with him at auctions; the most valuable works of Western European painting that came up for sale flowed to the Winter Palace, quickly making it necessary to build new annexes to house them.

Prior to the purchase of Gotzkowski's collection, the empress had kept a gallery in the mezzanine of her private apartments, which she called her "hermitage"—her place of seclusion—to which only the chosen few gained admittance. However, as early as 1763 she gave orders to build at the eastern end of the palace a second storey–level hanging garden closed in by two pavilions to the north and south. In the northern pavilion, called the Greenhouse, she planned to set up a Hermitage—this one a room for intimate receptions outside her private apartments in the palace.

Many eighteenth-century Western European palaces had pavilions, built in nearby parks, called "hermitages." Since the Winter Palace was surrounded by parade grounds instead of gardens, Catherine II commissioned Vallin de la Mothe to turn the pavilion in the northern extremity of the hanging garden into a hermitage. Two lift tables, serving twelve persons each, were built in the comparatively small chamber so that the empress and her guests could enjoy complete privacy in a room whose walls were hung from top to bottom with paintings bought abroad. In time, the entire picture gallery came to be called the Hermitage.

As the collection grew, which it did quite rapidly, two galleries were built on either side of the hanging garden. These constituted Catherine's entire picture gallery. Corberon and Bernoulli, who were among her guests, noted the lack of space and the low windows, undoubtedly referring to these galleries.

Meanwhile, purchase of pictures from abroad was in full swing. In 1769, six hundred Flemish, Dutch, and French paintings were bought from Count Heinrich von Brühl, chancellor to Augustus III of Dresden, the elector of Saxony. Among these magnificent works were Rembrandt's *Portrait of a Scholar* (499) and *Portrait of an Old Man in Red* (498), Rubens's *Perseus and Andromeda* (37), four landscapes by Jacob van Ruysdael, the

Descent from the Cross of Poussin (242), and Watteau's *An Embarrassing Proposal* (582).

The following year, one hundred pictures were bought from François Tronchin, and, in 1772, Catherine caused a great sensation by purchasing the entire superb collection of Pierre Crozat, a transaction carried out by Golitsyn, who was greatly assisted by Diderot and Tronchin. Among the four hundred works were masterpieces such as Raphael's *Holy Family* (now in the National Gallery, Washington, D.C.), the *Judith* of Giorgione (148), two paintings treating the subject of Danaë—those of Titian (36) and Rembrandt, the latter of whom was also represented by his *Holy Family* (193). The Rubens *Bacchus* (73) and *Portrait of a Maid in Waiting* (475) were also in this collection that included many other canvases by such masters as Van Dyck, Poussin, Watteau, Boucher, and Chardin. In addition, Golitsyn also purchased numerous individual works, including Rembrandt's *Return of the Prodigal Son* (223).

Another major acquisition during Catherine II's reign was that of the famous collection of Houghton Hall, home of Sir Robert Walpole, ex-prime minister of Great Britain. The purchase was effected in 1779 through the offices of the Russian ambassador to Britain, Musin-Pushkin. The export of so many works by such artists as Rubens, Jordaens, Guido Reni, Rembrandt, Claude, and Poussin aroused great protest in England and the collection had to be shipped to Saint Petersburg with great haste.

Dmitry Golitsyn's last purchase was made in Paris in 1784, just prior to his retirement. This was the 119-painting collection of Count Baudouin, which not only increased Catherine's Dutch and Flemish holdings, but also added several works from seventeenth-century France and Italy.

The Winter Palace picture gallery grew so quickly that ten years after the Gotzkowski purchase there were over two thousand canvases to house. Such a large collection called for more room, so it was decided to erect a new building in line with the Winter

Top
The Winter Palace, viewed from Palace Square.

Bottom
The Portico with Atlantes, the New Hermitage.

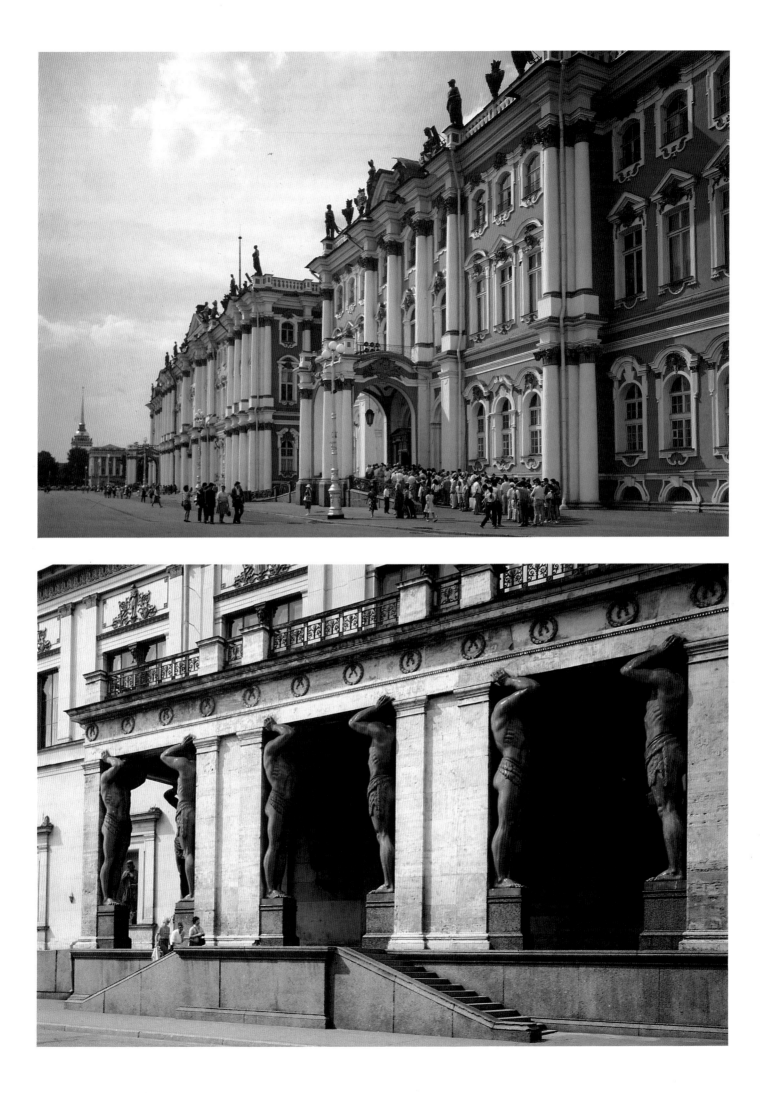

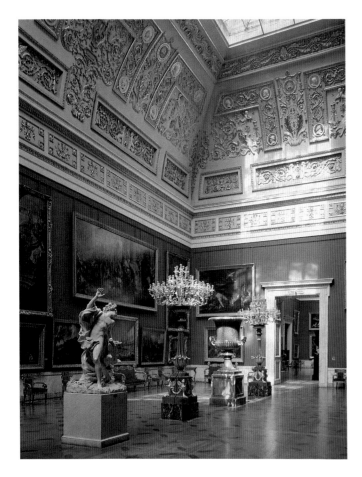

The Grand Italian Skylight in the New Hermitage.

Palace along the Neva embankment, up to the Zimny Canal, demolishing many mansions of Saint Petersburg's nobility that stood in the area.

The new building, designed by Yuri Veldten and called the Large Hermitage, was built in two stages. First there was the three-storey building with ten windows, completed in 1776; then a new annex with seventeen windows was added to it in 1784. The two structures were later joined by a common façade.

After Golitsyn's retirement, Catherine's ardor for painting cooled and she grew interested in theater. While the architect Giacomo Quarenghi was still working on the annex designed by Veldten, construction of a theater was launched on the site of the old palaces that had belonged to Peter I and Elizabeth I. Catherine signed the ukase for the construction of the theater in 1783 and the building was completed in 1785. Quarenghi was rushed with his work for the theater and he was obliged to preserve part of the old palaces—not only foundations, but walls as well. Due

to this haste, the hall of the theater was built into the "shell" of Peter's palace, and in her letters Catherine referred to the palace as if it still existed. Quarenghi's work on the Neva façade was not completed until 1802. Meanwhile, the picture gallery in Veldten's building was turned into drawing rooms where guests came to admire the pictures or to amuse themselves with a game of billiards.

In *A Description of Saint Petersburg* (1793), I. Georgi gives us a picture of the Hermitage as it looked in the closing years of Catherine's reign. He describes in detail the thirty-two halls and points out that the pictures were placed "not so much in keeping with the schools and authors, but the impression they created." Coming out of the Veldten building, guests found themselves in "a glassed-in winter garden with different kinds of trees and species of birds." Catherine II loved to come to the winter garden to play with the little monkeys and to look at the doves, parrots, and other brightly colored birds.

The room Georgi mentions was in the northeastern section of the Pavilion Hall. A spacious room in the gallery was turned over to the painters so they could copy pictures. In this way, Russian artists—Rokotov, Levitsky, and Borovikovsky among them—became acquainted with masterpieces of Western European painting and were able to study the masters without going abroad.

By the close of the eighteenth century, the Hermitage had become one of Europe's most important museums. Its catalogues listed 2,658 pictures, and within its walls were vast collections of other items of no less value and interest than the canvases. In a letter dated September 18, 1790, Catherine informed Frederick Grimm that "My museum in the Hermitage—not counting the paintings and the Raphael loggias—consists of 3,800 books, four rooms filled with books and prints, 10,000 carved stones, approximately 10,000 drawings and natural science collections that fill two large halls."

When Catherine's son, Paul I, ascended the throne, he chose to take up residence at the Engineer Castle, spend his summers in Pavlovsk and Gatchina, and thereby break the direct link between the Hermitage

and the Winter Palace. Separation from the palace led to financial difficulties and new purchases became few and far between.

When Napoleon's army entered Moscow in 1812, the Hermitage received orders to pack all the valuables and take them to a secret hiding place immediately. After that, the museum made only two large purchases: the Coesvelt Collection, bought in Amsterdam in 1814, and, ironically, the picture gallery of Malmaison—the collection of the Empress Josephine of France—also in 1814.

Under Nicholas I, the picture gallery became the property of the imperial family and an integral part of the Winter Palace. The emperor interfered constantly with the affairs of the museum, taking down pictures that did not appeal to him and selling several at auction.

In December 1837, a huge fire raged for two days, destroying the entire Winter Palace, which was rebuilt within two years. The imperial treasury proved to be so rich after the restoration of the palace that the major German architect, Leo von Klenze, was commissioned to design a new building, separate from the palace, to house the Hermitage's collections. The New Hermitage, as it was called in the imperial ukase, opened in 1852; its first floor was given over to the antiquities department while the painting collection occupied the second floor.

Little by little the Hermitage gained independence, its first director taking office in 1863. This man, S. Gedeonov, had a high court rank conferred on him on the occasion, and from this point the museum came within reach of the general public. During Gedeonov's directorship, the Hermitage purchased two great paintings: the *Madonna Litta* (179) of Leonardo da Vinci, and Raphael's *Conestabile Madonna* (180). Later, in 1882, it obtained a fresco by Fra Angelico, imported from the ruins of the San Domenico Monastery in Fiesole, Italy.

The Hermitage came to play an important role in the life of all Russia, not just in that of Saint Petersburg. More than a treasure house, it developed a large research center in which the history of art, a science new to Russia, began to be studied. Purchases of paintings and art objects continued to bring such chefs

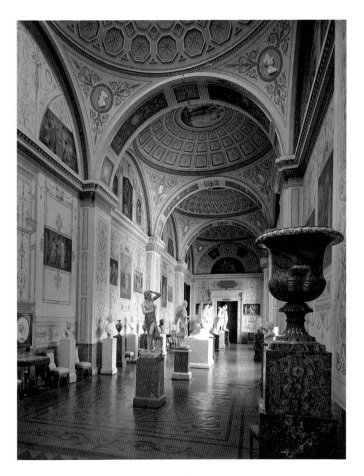

The Hall of Italian Art in the Old Hermitage.

d'oeuvre as Leonardo's *Benois Madonna* (178), Simone Martini's *Virgin Annunciata*, and a reliquary painted by Fra Angelico (170), all of which were bought in Astrakhan, situated in the lower reaches of the Volga.

But the peaceful life of the Hermitage was to be interrupted in 1914 by Russia's entry into World War I. The museum was evacuated in August 1917 and several hundred crates of art treasures were sent to Moscow. Two months later, the victory of the Great Socialist Revolution made the Hermitage the property of the people and the influx of large, recently nationalized private collections enlarged the museum's scope. The paintings and objets d'art evacuated to Moscow were returned in 1920 and the Hermitage staff began to reorganize exhibitions, conduct research and educational work, and provide guided tours through the halls of the museum. The picture gallery grew considerably and now occupied part of the Winter Palace as well, since it now included the masterpieces that had adorned the palaces and mansions of the rich.

The young Soviet state developed under difficult conditions and the blockade of Soviet trade imposed a heavy burden on the country's economy. This obliged the Soviet government to sell some of its museums' treasures in order to obtain currency. Masterpieces were bought by Calouste Gulbenkian, the oil king, and Andrew Mellon, the American secretary of the Treasury. Still more works became the property of other private collectors and of foreign museums.

When Hitler attacked the Soviet Union on June 21, 1941, large parts of the Hermitage collections were evacuated once again, this time to faraway Sverdlovsk, but a considerable portion of the museum's treasures remained in Leningrad. During the siege of the city, the museum staff continued to work stoically, guarding the remaining artworks while they carried on educational work and research. Although the repair of halls damaged by shelling and the restoration and enlargement of the separate expositions required great effort by the staff after the war was over, the Hermitage was restored in a very short time, opening sixty-nine halls of its picture gallery to the public on November 5, 1945.

In that same year, the museum received 316 major pictures by Western European turn-of-the-century artists from the Museum of New Western Art in Moscow. The contribution helped fill gaps and make the Hermitage the possessor of a still more valuable collection.

Membership in UNESCO's International Council of Museums (ICOM) did much to expand the museum's international connections. Cooperation with museums in other countries has promoted exchange of excellent temporary exhibitions. Friendly contacts with artists have prompted many of them to present their pictures to the museum. For instance, Rockwell Kent gave more than ten of his works to the Hermitage.

In the past quarter of a century, the Hermitage has acquired superb paintings such as *The Penitent Magdalene* by Giampetrino, Stanzione's *Cleopatra* (89), *The Lamentation of Christ* of Bellange (248), and a sketch by Kandinsky as well as his *Composition No. 5* (637). The Hermitage receives many gifts from Soviet collectors, artists, and private citizens. Armand Hammer presented the museum with Goya's portrait of the actress An-

tonia Zarate (520) in 1972. Such gifts demonstrate the increasing popularity of the Hermitage, which, besides its collections now displayed in 353 halls, conducts a wide range of lectures, classes, and consultations on art.

To complete our brief history of the Hermitage Museum, we offer a classification of the collection by country of origin. Today, practically all the major European masters are represented by one or another outstanding work. The French collection stands first in order, not only for its paintings but also for its fine drawings and examples of the decorative arts. The Hermitage possesses no fewer than ten canvases each by the great masters of seventeenth-century Classicism: Poussin and Claude Lorrain. Side by side we find the genre pictures of Louis Le Nain and the historical compositions of Simon Vouet and Charles Le Brun rendered in academic style.

About three hundred examples of the works of the outstanding French painters of the eighteenth century are found in the collection. Six of these works illustrate the most important stages of Watteau's creativity, and Boucher and Lancret are represented by groups just as large. The art of Chardin and Fragonard is represented by some their most characteristic works. Several halls are occupied by genre scenes painted by Greuze, landscapes by Hubert Robert, and portraits by Jean-Marc Nattier and Louis Tocqué.

The museum was not as fortunate in acquiring works of the first half of the nineteenth century, but it has a superb collection of works of that century's second half and into the beginning of the twentieth century. Ten canvases by Monet, ranging from his early *Lady in the Garden* (370–71) to his later *London Fog* series, show his artistic quests at different periods of life. Together with the works of Renoir, Pissarro, and Degas, they help us understand the tasks that the Impressionists set for themselves and that they so successfully solved.

The quantity and quality of works belonging to the subsequent trends in French art are equally impressive. While the four paintings by Van Gogh all come from his later work, those of Cézanne—eleven in number—speak of the artist's endeavors at various periods

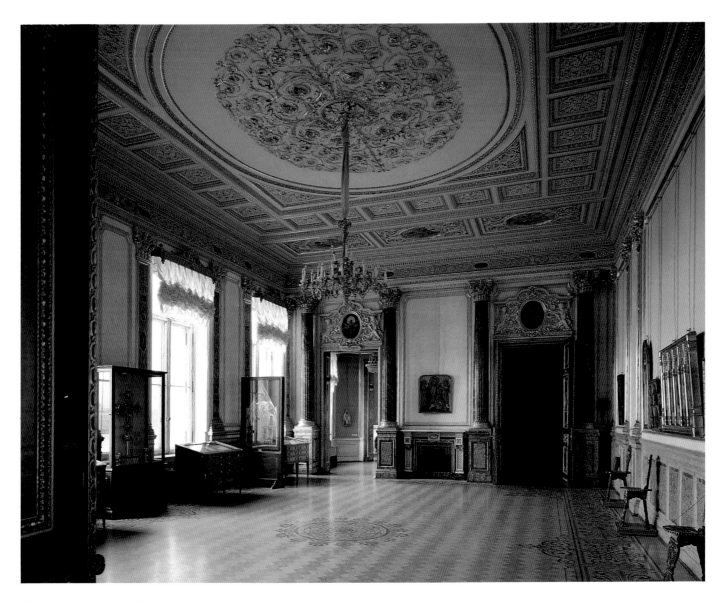

The New Hermitage's Gallery of Ancient Painting.

of his life. The collection of works of masters like Gauguin, Matisse, and Picasso are truly outstanding. The fifteen Gauguin canvases were painted in the artist's mature Tahitian period. Matisse's thirty-seven compositions include *The Dance* (112–13), *Music* (111), *Harmony in Red* (453), and *Family Portrait* (451), and were painted principally during the period between 1900 and 1913. The thirty-one pictures by Picasso were painted about the same time and give a very good idea of his "Blue" and "Pink" periods, and especially his fascination with Cubism. It must be mentioned that the Hermitage has a number of pictures by Derain, Vlaminck, Bonnard, Vuillard, Marquet, van Dongen, and Denis.

The first canvases by Italian painters came to the Hermitage in 1772 in the Crozat Collection. Today, Italian art occupies thirty-seven halls of the museum. The early stages of the development of Italian painting are not too strongly represented except for the *Crucifix* of Ugolino di Tedice (236) and Simone's *Virgin Annunciata* (165). The fifteenth century, however, includes an entire gallery filled with illustrious names: the Florentines, Filippo Lippi, Fra Angelico, Botticelli, and Filippino Lippi; the Venetian Cima da Conegliano; the Ferrarese Lorenzo Costa; and Perugino of Umbria.

The collection of paintings belonging to the High Renaissance is of an exceptionally high quality, beginning with the works of Leonardo mentioned earlier

along with numerous works by his pupils: Andrea del Sarto, Cesare da Sesto, Bernardino Luini, and Francesco Melzi. Correggio, a painter from Parma, may also be mentioned among these. Raphael's *Conestabile Madonna* is an early composition that is aptly complemented by his *Holy Family* of a more mature style. Both of these masterpieces are works of which the Hermitage is especially proud.

As for the variety of the schools of Italian painting, the Venetian undoubtedly holds the palm. There is Giorgione's *Judith*, eight canvases by Titian, seven by Veronese, and ten large panels and pictures by Giovanni Battista Tiepolo.

The Hermitage also has a very representative collection of Italian Baroque art as well as of that of the different local schools of the seventeenth and eighteenth centuries. Among these works are those by the Genoese Bernardo Strozzi and Alessandro Magnasco, Neapolitans Salvator Rosa and Luca Giordano, and Giuseppe Crespi of Bologna. Caravaggio's *Lute Player* (415) also belongs with the masterpieces of this group.

The collection of Flemish and Dutch painting that includes about fifteen hundred items is world-famous. There are thirty-eight works by Rubens, including compositions based on mythological subjects, landscapes, portraits, six landscape sketches for the decoration of Antwerp on the occasion of the arrival of the Spanish vice-regent in that city, and five pictures from the *Life of Marie de' Medici* cycle. The collection of Van Dyck's works is just as rich, with twenty-four canvases included. The panorama of Flemish seventeenth-century art is supplemented by the works of such outstanding artists as Jacob Jordaens, Frans Snyders, Adriaen Brouwer, and David Teniers the Younger.

Dutch painting has been fortunate in Russia from the very start, several works by the Dutch masters being among the first foreign acquisitions that Peter I made in his time. This large and unique collection makes it possible to trace the development of all Dutch genres: Landscape is represented by Jan van Goyen, Salomon van Ruysdael, Aert van der Neer, and the romantic Jacob van Ruysdael; animal pictures include great works by Paulus Potter and Albert Cuyp. It

is no surprise that still life paintings abound, such as examples of the well-known "Breakfast" and "Dessert" pictures by Willem Claesz Heda, Pieter Claesz, and Willem Kalf. Two brilliant portraits by Hals stand out in this genre, while genre painting itself, so popular among the Dutch masters, is amply represented by the works of Adriaen van Ostade, Jan Steen, Pieter de Hooch, and Gerard Terborch.

But the twenty-four canvases by Rembrandt, which characterize all the stages of his career, constitute the cream of the Dutch collection. Along with *Danaë, Portrait of an Old Man in Red, The Holy Family*, and *The Return of the Prodigal Son* mentioned earlier, these include *Saskia as Flora* (69) and *David and Uriah* (147).

Spanish painting in the Hermitage, a group of some two hundred paintings, is distinguished for its exceptionally high quality. The works of Luis de Morales, Juan Pantoja de la Cruz, and the great El Greco are sufficiently illustrative of the specific features of Spain's artistic culture of the sixteenth century, and they reflect the ideals and sentiments of Spanish society. But the greater and the best part of the collection consists of works from the seventeenth century—the golden age of Spanish art—where we find a brilliant galaxy of names: Velázquez, Ribera, Zurbarán, and Murillo. The works of the pupils of Velázquez, Pareja Antonio Puga and Antonio Pareda, hang side-by-side with two of the master's works. There are twelve paintings on religious and everyday themes by Murillo, and Zurbarán and Ribera are represented by some of their most characteristic canvases.

The collections of German and English paintings, while fewer in number, merit high praise. There are five compositions by Lucas Cranach the Elder that may be classed as the best specimens of German Renaissance painting, whereas the achievements of sixteenth-century portraiture are sufficiently well demonstrated by the works of Ambrosius Holbein, Nicolas Neuchatel, and others.

A few canvases of various genres from the seventeenth century are found, such as works by Johann Heinrich Schönfeldt, Daniel Schultz, and Christopher Paudiss. As for the eighteenth century, the era of Classicism in Germany, we can name the works of Anton

Raphael Mengs and Angelica Kauffmann, who were among the most popular artists of the time.

The collection of English paintings was started with commissions to London painters by the Russian imperial court in the eighteenth century. It is this epoch, when English painting was at its zenith, that is most fully represented in the Hermitage, with works by Sir Joshua Reynolds, then head of Britain's Royal Academy, his follower George Romney, the painter of charming landscapes and portraits Thomas Gainsborough, portraitists Henry Raeburn and John Hoppner, and landscape painter George Morland. The Hermitage completes its acquaintance with English painting with works of three artists well known in the first half of the nineteenth century: Sir Thomas Lawrence, George Dawe, and Richard Parkes Bonington.

Naturally, a preface such as this can't begin to give a complete description of a collection as large and multifaceted as that of the Hermitage. Not mentioned are works from a number of other national schools in the Socialist countries of Europe as well as various types of painting from the Americas and individual works representative of various European art trends of the second half of the current century. What follows is a visual tour of the galleries of the Hermitage, selecting for the reader many of the museum's best-known pictures while also presenting many of its perhaps more obscure but equally fascinating paintings.

Professor B. B. Piotrovsky
Professor V. A. Suslov

The Hermitage: Paradox and Dinosaur

A sked where any mineral or gemstone was to be found, Russian children were told they might safely reply, "In the Urals." If pressed for the location of fine examples of most European painting, they could, with equal security, reply, "In the Hermitage." Unquestionably this museum has one of the richest, largest, and most varied collections of Dutch and Flemish Baroque paintings in the world. With forty-one works of Rubens, twenty-six by Van Dyck, and many pictures by Rembrandt and his circle, this is a collection of gargantuan proportions and staggeringly high quality.

In addition, its gathering of French art of the seventeenth and eighteenth centuries and the early modern period is certainly the finest housed under one roof. Along with a few remarkably telling, rare French early sixteenth-century portraits, both Claude and Poussin as well as many other masters of French Classicism are represented in the Hermitage by their most powerful canvases. But the collection also includes very personal works from the same period, such as the moving scenes of rustic life by the Le Nain brothers (pages 407, 559), seventeenth-century artists much admired by Catherine's correspondent Denis Diderot. French paintings of the eighteenth century are numerous and scintillating—with six Watteaus, twelve by Boucher at his best, many Fragonards and Lancrets, along with canvases

HENRI MATISSE *The Dance*, 1910 (detail)
(See pages 112–13)

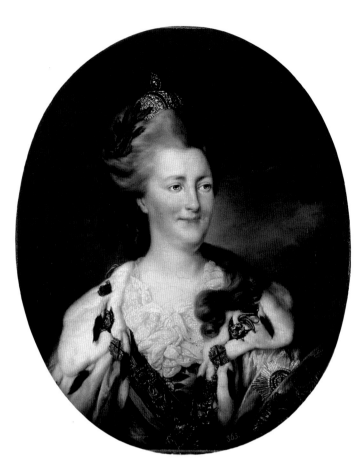

RICHARD BROMPTON England 1734–Tsarskoye Selo 1783
Catherine II, 1782
(Inv. No. 1318) Oil on canvas
32½ × 27" (83 × 69 cm)
(Ex coll. Winter Palace, 1918)

by Pater and others. Here also is the world's largest collection of Hubert Roberts, forty-eight in all. The artist was invited at least twice to come to Russia, even after the Revolution, in which he had participated with enthusiasm. Catherine wrote Frederick Grimm in 1791: "If this Robert were not such a demagogue, or quite so wild, he would find plenty to paint here. . . . However, since he likes painting ruins best of all and has so many of them in front of him, he's quite right not to leave his land of ruins."

Greuze, long admired in Russia before becoming one of Catherine's favorite painters, is wonderfully well represented in the Hermitage, many of his paintings having been picked out by his great admirer, Diderot. Catherine's son, Grand Prince Pavel Petrovich, visited the artist's studio and chose some of the many great Greuze drawings now in the Hermitage.

This museum also boasts an unusually extensive collection of Italian Baroque pictures and brilliant examples of German art of the seventeenth and earlier nineteenth centuries, with Elsheimer and Friedrich represented by exceptionally fine works. Further surprises include fine examples of eighteenth- and early nineteenth-century English art.

Most of the collection's relatively few early Italian paintings—those dating before 1500—were bought by eighteenth- and nineteenth-century Russian nobility resident in Florence or Rome, such as the Grand Duchess Maria Nikolaevna, whose great Lippi *Vision of Saint Augustine* (262–263) went to her daughter in Russia and was then "nationalized" in 1917. The collection of the Stroganovs, mostly gathered in Italy and partially bequeathed to the Hermitage in 1912, was taken over in 1922. It also included major paintings from the Lowlands.

Additional splendid private picture galleries were included in the Hermitage. Prince Dmitri Alekseievitch Golitsyn, a Russian diplomat in Paris and The Hague in the late eighteenth century, bought the distinguished collections of Aved (a painter and a friend of Chardin), along with that of Watteau's friend Jean de Jullienne; both were presented to the Hermitage by the prince's descendants in 1886. Prince Yusopov too assembled a most important gathering, commissioning David's *Sappho and Phaon* (91), which today is numbered among that artist's major works. The collections of Russia's wealthiest *amateurs* were given to the Hermitage or taken over in part or in their entirety after 1917, including those of the Anichokovs, V. Argutinsky-Dolgorukov, the Chremetieffs, Naryshkins, Repnins, and Shuvalovs. The Botkines' Italian paintings came in 1936.

Like another great revolutionary state's national gallery—that of the United States—the Soviet museum is housed in the most conservative of settings. Where Washington's is an imperial fantasy, combining the neo-Roman with the High-Tech Dynastic, its architects appropriately named Pope and Pei, Russia's remains in the palace complex of the czars. What makes the Hermitage so remarkable is the extreme conservatism of the bulk of its paintings and their setting in

contrast with the sudden infusion of turn-of-the century Modernism from the matchless Parisian purchases of Shchukin and Morozov, two captains of the industrialization of Russia near 1900.

Each man lived with his family in a palatial Moscow residence filled with the most brilliantly selected modern masterpieces, many bought from the stock, or with the advice, of Ambroise Vollard, Paul Durand-Ruel, and Daniel Kahnweiler. Shchukin was more inclined to a romantic, decorative vision, and could love the exotic, escapist vision of Gauguin as well as the rigor of Cézanne and Picasso's demanding intellectuality. Both Muscovites were the world's greatest collectors of Matisse's early works. Where Shchukin owned that artist's most daunting masterpiece, the great *Conversation* (452), given the place of honor in his neo-Rococo, Venetian drawing room, Morozov brought Matisse to Moscow in 1911 to install the painter's major pendants, the fundamental *Music* (111) and *The Dance* (112–113). Massive statuary by Rodin and Maillol adorned his hallway and salons.

These two exemplars were by no means solitary in their interests, however. By 1910 Russia already had a flourishing avant-garde, with gifted followers of both Picasso and Matisse, and public exhibition space for artists of the School of Paris. Lavish local periodicals reproduced these advanced works along with those of Kandinsky, Russia's leading modern master. Young artists at home and abroad responded to new and old Russian influences: to vibrant peasant crafts and folk dances just as much as to the sophisticated, innovative choreography, music, costumes, and sets of Diaghilev's internationally celebrated Ballets Russes. The vibrant, novel coloring and haunting motion found in Russia's folk and medieval arts, her glowing Byzantine icons and enamels, made this exotic culture vastly popular with Western Europe before the first world war. Conversely, Russia's heritage made turn-of-the-century collectors unusually responsive to Parisian innovations. Included were men like Ostroukhov who was in close touch with Matisse in 1912, when the artist presented him with a nude now in the Hermitage, a study for *Nude Woman (Black and Gold)* (109), which was exhibited in the collector's Museum of Painting and Icon-Painting in Moscow.

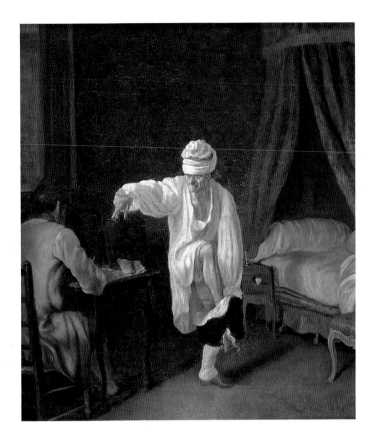

JEAN HUBER Geneva 1721–1786
Voltaire's Morning
(Inv. No. 6724) Oil on canvas
20½ × 17″ (52 × 43 cm)

With its twenty-seven Picassos of the early Cubist period—once again from the Morozov and Shchukin collections—the Hermitage is almost as well furnished with the Catalan's art as with that of Matisse. Where the latter was close to the spirit of Russian music and art, Picasso actually married a ballerina from Diaghilev's company at the time of his first commercial success. He was perhaps the leading artist to be a member of the Communist Party, having joined in the 1950s, but Picasso's painting of that phase was his least effective and is seemingly absent from the Hermitage. He prospered during the German occupation, when the painter abandoned his Jewish dealer to the Nazis, and his styles changed with the seasonal predictability of a couturier.

Metaphysical paintings from Italy were acquired in the early 1930s by exchange for contemporary Russian art with Milan. And the collection is still expanding: Kandinsky's *Composition No. 5* (637) and a vast Bel-

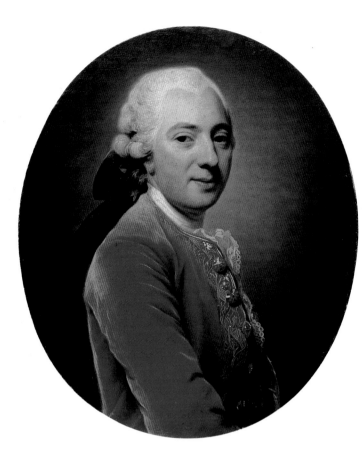

ALEXANDER ROSLIN Malmö 1718–Paris 1793
Portrait of I.I. Betskoy, 1777
(Inv. No. 5826) Oil on canvas
26 × 21″ (66 × 53 cm)
(Ex coll. Winter Palace, 1924)

lange *Lamentation* (248) are among its recent acquisitions. Long without a Goya in its otherwise comprehensive Spanish collection, this gap was filled by Armand Hammer's 1972 gift of the unusually pretty portrait of an actress, *Antonia Zarate* (520).

Russia's prime collection represents a mystical marriage of czarist, noble, and bourgeois collections in a productive mixture of fascinating opposites—Northern Baroque and School of Paris; Flemish abundance and the austerity of the Italian metaphysical vision. As vast in scope as its nation, the Hermitage—although located in Russia's greatest seaport city, which was developed by Peter the Great on isles in the Gulf of Finland to bring his nation close to Europe—seems so near and yet so far from the West. While it abounds with the very best of almost all later European art, the Hermitage fascinates for odd omissions: Why no portraits by Fragonard (that artist so close to Catherine's taste), or no examples of the admittedly very rare

works by Vermeer? Why no better Courbets? Can the presence of so few nudes be explained by Peter III's prejudice or by Russian Orthodox prudery?

There is no official founding date for the Hermitage, yet Catherine II's purchase of 225 canvases from a Berlin merchant, J. E. Gotzkowski, in 1764 is often regarded as the initial acquisition even though Peter the Great had bought some important pictures earlier in the eighteenth century.

With a long line of gifted, scholarly curators from princely and middle class Russian and German families, the Hermitage's first catalogue, including 2,080 works, was printed in 1774 in French for the *Galeries du Palais Impérial.* This magnificent assemblage is essentially a tribute to, and reflection of, Russia's need to capture the images of Western faith and commerce as well as creativity.

The collection's first major contributor, Peter the Great, was most responsive to art of the Lowlands. Reassuring by its careful rendering, often conservative and moralizing in content, this was by far the most popular, "collectible" painting of the time, suitable for the czar's Frenchified castle of Monplaisir at Peterhof. Dutch and Flemish pictures were bought for the same reasons that Impressionism would flourish two centuries later—the images often seemed cheerfully atmospheric and/or materialistic, they were not too religious in content, and projected a reassuring sense of "All's right with this World and not to worry about the Next" (if such there was).

Dutch art, even more than Flemish, presented an orderly, carefully regulated, highly profitable society, one where the upper class looks middle class, and the peasants look rightly pleased by their unusually prosperous fate. Nothing could have been further from Mother Russia's children—very few were of the professional class, and here the peasant's lot was distinctly not a happy one. Peter must have seen these paintings not only as pleasant prospects, but also as exemplary of a different, distinctly commendable style—in life as well as in art.

His ambassadors bought pictures in Amsterdam, Brussels, and The Hague but the czar was disappointed by their purchases. Among his finest acquisitions was Rembrandt's *David and Jonathan* (141), purchased

in Amsterdam upon Peter's orders in 1716, following the year of his second Western journey. Three years later, when he went West once again, further canvases were acquired.

With an eye to foreign cultural institutions, Peter III established in Saint Petersburg the Academy of Fine Arts in 1757, twelve years after his marriage to Catherine. The academy's founding and the marriage were both planned by his adoptive mother, the Czarina Elizabeth. The academy was built as an extension of Rastrelli's Winter Palace, part of the imperial residence on the Neva.

By bringing a brilliant Western woman and a Western cultural institution into Russian fabric, Elizabeth must be credited with continuing the ambitions of Peter the Great for an advanced Russia, incorporating new European ideas, and providing a model for Catherine's future plans.

Impressed by the new academy at Saint Petersburg, sister to their own Académie Royale, French painters began to present it with their own works of art such as Boucher's magnificent *Pygmalion and Galatea* (75), which was brought to Russia by the artist's friend Falconet, who was then engaged upon a massive equestrian monument to Peter the Great. Long a separate institution from the Hermitage (which housed the czars' palace collection), the academy had its own important pictures, mostly bequeathed by major connoisseurs. In 1922 this institution was amalgamated with the great museum and many of its pictures were transferred to the Hermitage.

Art and nature, illusion and reality, are the two fields for conquest by wealth. Czarina Catherine II (1729–1796) won both, and these along with many other victories were to earn her the sobriquet of "the Great." Her palace was given the fashionable name of Hermitage, suggesting monastic retreat, neither inclination being remotely true for the resident. Under Catherine's guidance the palace came to enclose thousands of the finest paintings rubles could buy, as well as special greenhouses filled with exotic birds, monkeys, flowers, and trees, all defying the seasons.

While the Pompadour had to content herself with interiors where thousands of porcelain flowers blossomed upon gilt-bronze stems, the czarina reveled in the real—whether in art or nature—housed separately but equally, all under her Teutonic thumb. Fascinated by the wonders of nature as well as culture, Catherine also kept a *Wunderkammer*, two large halls filled with her natural science collections, so that these could be studied just as closely as the splendors of art.

Through a correspondence with Frederick Grimm, Diderot, and other of the Encyclopaedists (her own best letters were ghost written for the czarina), Catherine accumulated a vast panorama of art. Though her earlier sympathy for the Encyclopaedists might suggest that the bulk of the Hermitage's massive collection of eighteenth-century French paintings were bought by the czarina, such is not the case. She was far more concerned with buying razzle-dazzle, blockbuster, *bona fide* accumulations of Old Masters, and she did so with great success. Nonetheless, that amusingly intimate view of Voltaire dictating early morning insights while pulling on his breeches (21) may reflect her affection and regard for the *philosophe*. Catherine had thought of building an exact copy of his Swiss retreat in order to lure Voltaire into Russian residence, but the closest she came to having him nearby was through the posthumous purchase of his library. This was housed in the Hermitage along with that of Diderot, which was sold to provide his daughter Angélique with a dowry.

Unwanted and neglected by her parents, Catherine's brilliant, forceful personality (unusually well known from her frank *Mémoires*) was etched along strikingly deliberate, often painfully and cruelly self-aware lines. Catherine's father was a military man, and both parents had hoped for a son, seldom forgiving what they considered to be her unfortunate sex.

Like most prosperous Europeans of the time, the future czarina was educated by a French governess and had been on familiar ground with Gallic culture from her girlhood in Stettin, Pomerania. Catherine's lifelong interest in France may also have been influenced by that of Frederick the Great (rumored—wrongly—to have been her father), whose collection of recent Parisian painting was of remarkable quality. The king of Prussia was instrumental in seeing that Catherine—then the unprepossessing fifteen-year-old daughter of his field marshal, Prince Christian Augustus of Anhalt-

Zerbst—came to wed her second cousin, one of the world's least appealing, although potentially most powerful, future leaders.

The Grand Duke Peter was the grandson of Peter the Great, his mother the latter's eldest surviving daughter and his father duke of Holstein-Gottorp. Little Peter was adopted by his mother's sister, the amiable, childless, highly capable Czarina Elizabeth Petrovna (daughter of Peter the Great), who had seized control of Russia's government in 1741. It was she who arranged his marriage to Catherine. Homely, probably brutal, ignorant, politically inept, impotent, homosexual, and epileptic (the last two characteristics shared by his famous grandfather), Peter was also subject to tics, hallucinations, and a persecution mania, and was soon to be pockmarked.

The unfortunate seventeen-year-old's major passion—toying with real as well as tin soldiers—was one of the very few that he and his intellectually venturesome wife (sneering, he called her Madame Quick Wit) came to share. Poor Peter's persecution complex proved all too justified when, in 1762, the year of his mother's death and his accession as Peter III, Catherine staged a palace revolution. She placed him under house arrest and he died under suspiciously convenient circumstances nine days later, doubtless dispatched by the princes Orlov at Catherine's behest.

For the next thirty-four years the czarina proved herself to be an effective, often innovative, if increasingly despotic, ruler. Catherine spent about three billion dollars upon her innumerable lovers, many, many times more than the considerable, yet thriftily selective, sums that went into art. Catherine held her own in an erratic reign that swerved between the enlightened and the tyrannical, increasingly inclining toward the latter as she became ever more frightened by the violent excesses of the French Revolution. Many of these atrocities she came to believe originated with the *philosophes* she had patronized, and who, in turn, had supported her.

Like most motives, those for Catherine's art collecting were mixed. She began buying paintings for the Winter Palace two years before Peter's death. Soon, as czarina, she needed to see herself in the great line of the world's major rulers, so, following the splendid examples of Alexander the Great and Louis XIV, Catherine used the arts to reflect and enhance the imperial power that was hers alone. The new czarina's personal device, a column, which is included in her portrait by Lampi (515), suggested the strength of Hercules (that hero had two of them), a suitable emblem for the duration of her rule and fortitude, but also an unconscious echoing of her phallic compulsions.

Élisabeth Vigée-Lebrun, the Parisian portraitist who fled the French Revolution and found Russian sanctuary, garnered many commissions at Saint Petersburg. Recalling Catherine in her memoirs, she noted how she "had imagined her to be prodigiously tall, as high as her reputation." But by 1789, the sixty-year-old Catherine "was very fat (and toothless). . . . She still had a handsome face [the diplomatic painter found almost all those in power handsome and/or charming]. . . . Genius was stamped upon her brow, which was broad and very high. . . . I have said that she was short, [yet] on days when she appeared in state, everything about her—the head held high, the eagle eyes, the assured bearing that comes with the habit of command—was so majestic that she seemed to rule the world."

At the Russian court in 1773, Diderot described the czarina in franker, alarmingly bisexual terms, hers "the soul of Brutus combined with the charms of Cleopatra." He ordered statues, furniture, and medals as well as paintings and sculpture for her. Frederick Grimm, who first went to Russia in 1773-1774, succeeded Diderot in this role and maintained a massive correspondence with Catherine on all cultural matters. The hardy empress' equilibrium was shattered when told by Baron Grimm how revolutionaries had broken into his Parisian apartment and torn "all Her Majesty's portraits to shreds with their sacrilegious hands."

Critic of all the Paris salons from 1759 to 1771, Diderot had unique access to the latest developments in French art and didn't miss the opportunity to incline his patroness toward his favorites, such as the exquisitely anecdotal Greuze. She commissioned canvases from Chardin—another of Diderot's favorites—and many by Vernet, whose views she particularly ad-

mired. Paintings were brought to the Hermitage from other czarist palaces at Oranienboom and Tsarkoeselo during the mid-eighteenth century making for an ever more monumental collection. These pictures, with many others, were housed in an addition to the Winter Palace, a great gallery begun in 1760, which suggests another possible date marking the "beginning" of the Hermitage.

By 1765 the major agent in expanding the collection was the brilliant Prince Golitsyn. He, almost as much as Catherine, was in contact with advanced intellectual French currents, close to Diderot and Voltaire. Where Diderot did not do too well as a bidder for the czarina at major auctions, Golitsyn bought splendidly, most notably at the sale of works from the collection of the prince de Ligne, in Brussels.

The czarina may have identified herself with three Medici women, all of them, like herself, shifted from one culture to another in which they became leading collectors and patrons of the arts. Catherine and Marie de' Medici both wed kings of France. Upon baptism into the Russian Orthodox church (incurring great parental wrath), the German princess changed her name from Sophie to Catherine whereupon she could have seen herself as one of the French queens reborn as she took on a new language and, in Sophie-Catherine's case, faith.

The young czarina may also have linked herself with the "last of the royal race of the Medici," Anna Maria Ludovica de' Medici, who, like Catherine the Great, had been a grand duchess. After marrying the Elector Palatine, Anna Maria Ludovica went to live in Germany for twenty-six years where she acquired Flemish and German works. Returning to Florence, she generously bequeathed the ancestral collections throughout Italy "to the state of Tuscany forever, in the person of the new grand duke, and his successors."

However, few of Catherine's measures were quite so altruistic or public-spirited as those of the last of the Medici. The Hermitage was only occasionally opened to the public, and that practice began during the reign of her son Paul. Forthright yet wily, the czarina saw her own character as "frank and original as any Englishman." Claiming no taste whatever for painting,

sculpture, or music, this confession rivaled that of her Hanoverian peer, George III of England, with his self-proclaimed hatred of all "boetry and bainting." Used to life-long neglect as a daughter and wife, Catherine was good at getting what she wanted. She was blessed with what used to be called "the common touch," endearing herself to many, often with *faux-naïf* remarks, such as the flattering one she made to the French sculptor Falconet, claiming that "the least schoolchild knows more about sculpture than I!" In truth she was shrewd about using all the arts and many of the sciences not only to flatter her reign but more than occasionally to benefit Russia, the land she so loved that she asked her doctor to drain her of German blood and replace it with that of her new nation.

With relentless honesty Catherine said of her collecting, "It is not love of art, it is voracity. I am not an *amateur* [art lover], I am a glutton." In truth she was more of a gourmet than a gourmand, seldom buying anything but the best, and often at reasonable prices. The czarina must have been especially pleased by the chance to buy all the works of her great enemy, Count E.F. Choiseul et Amboise. That good deal, combining humiliation and acquisition, was made with Diderot's help and bought at a low price in 1772.

"God grant us our desires, and grant them speedily" was the toast closest to Catherine's heart, typifying her lusty appetite for men and masterpieces. Generally a shrewd purchaser of both, she did better with pictures, where the quality and quantity held up better over time. Often she bought well-known collections in their entirety, thereby cutting out the costly middleman. By dealing out the dealer and benefiting from the proven connoisseurship of such renowned collectors as Crozat or Walpole, whose pictures she purchased on a wholesale basis, the czarina amassed a splendid gathering of paintings over a relatively short time. Occasionally her agents sneaked out whole collections just before they came up at auction, or arranged for some of the best canvases to come her way prior to going under the hammer.

Catherine loved striding along the lengthy passages between her isolated chambers and the more public halls of the palace, relating how "my little retreat is so situated that to go back and forth from my room takes

three thousand steps. There I walk amid quantities of things that I love and delight in, and it is these winter walks that keep me in good health and on my feet."

With the assistance of her astute ambassadors, Catherine saw to it that many major collections came her way, such as that of Gaignat, secretary to Louis XV, consisting of forty-six remarkably fine pictures, including five by Rubens. Among the czarina's first purchases was Rembrandt's *Return of the Prodigal Son* (223), a daring acquisition—far from a typical or "safe" work of that master—which she bought from its Russian owner. She relished buying the collection of 225 mostly Netherlandish paintings that Frederick II of Prussia decided he could not afford in 1768, which was also the year she acquired six thousand drawings and many excellent paintings from the Count Coblentz sale in Amsterdam.

A year later she bought more than six hundred paintings from Count Brühl of Dresden, a great connoisseur of independent, discerning judgment, a man of vast wealth who had been minister of the king of Poland. This purchase included outstanding works by Rembrandt, Rubens, and Cranach as well as splendid Bellottos and Giovanni Battista Tiepolos. Brühl liked to be known as the "Saxon Richelieu," and enjoyed the deserved, flattering comparison with Maecenas, a great Roman art patron. When Tiepolo painted *Maecenas Presenting the Liberal Arts to the Emperor Augustus* (93), he added the Palladian façade of Brühl's palace on the banks of the Elbe, making Dresden, then a great center of the arts, into a new Rome. Blind Homer is led before Augustus by his young guide who holds Fame's trumpet. Painting, Sculpture, and Architecture kneel in the foreground. Young Augustus's throne is flanked by the deities of Art and Wisdom, Apollo and Athena, to guide him in his imperial conduct. Catherine, too, identified herself with ancient wisdom, with Maecenas and the arts, gathering her own collection close to her in her new palace, making it a center for the most effective, best-informed of governments.

Buying the paintings left by Chardin's friend, the painter Aved, in 1766, Catherine benefitted from the intimate, discerning taste of an unusually subtle connoisseur. Two years later a most unusual collection went on the block, that of Count Karl Cobenzl, in Brussels, with its distinguished group of Spanish and Northern paintings. Thanks to this and purchases from two other sales, the Hermitage owns about two hundred Spanish paintings, including twelve Murillos.

In 1771 the czarina purchased the vast Dutch collection of Braamkamp, which sank en route to Saint Petersburg. That same year, Catherine bought the fine assemblage of paintings owned by the Swiss jurist, François Tronchin, including great Dutch pictures such as the De Witte (396) and van de Velde (330) sold in Geneva in 1771. Here, once again, Golitsyn's contacts with the *philosophes* helped make the purchase possible, just before the pictures were to go on public sale. With the 1781 Parisian auction of the comte de Baudouin's collection, Catherine bought 119 paintings, including Rembrandts, Van Dycks, and Claude Lorrain's magnificent *The Harbor of Baiae with Apollo and the Cumaean Sibyl* (42).

Also interested in English art, Catherine paid Sir Joshua Reynolds for three paintings—the subject of at least one of which to be of the artist's choosing. This turned out to be *The Infant Hercules Strangling Serpents in His Cradle* (27), "in allusion," so the painter claimed, "to the great difficulties which the Empress of Russia had to encounter in the civilization of her empire." Her lover, Grigory Aleksandrovich Potemkin, received Reynolds's *Cupid Untying Venus' Belt* (61). Unfortunately for Catherine, the recipient—unlike that of the girdle in Greek mythology—proved an inconstant lover. A third canvas was of a subject distinctly alien to the czarina—continence—that of Scipio.

Spectacular paintings came from the sale of the holding of Sir Robert Walpole, that celebrated collection bought from Houghton Hall in its entirety in 1779. Many of these masterpieces had come to England from the Mantuan sale of the d'Este collection, purchased for Charles I by Rubens, at the extraordinary sale following the ducal family's bankruptcy. So distressed was Samuel Johnson at the prospect of England losing these magnificent pictures that he petitioned Parliament to block their export.

SIR JOSHUA REYNOLDS Plimpton 1723–London 1792
The Infant Hercules Strangling Serpents in His Cradle, ca.1786/88
(Inv. No. 1348) Oil on canvas 119 × 117" (303 × 297 cm)
(Commissioned by Catherine II)

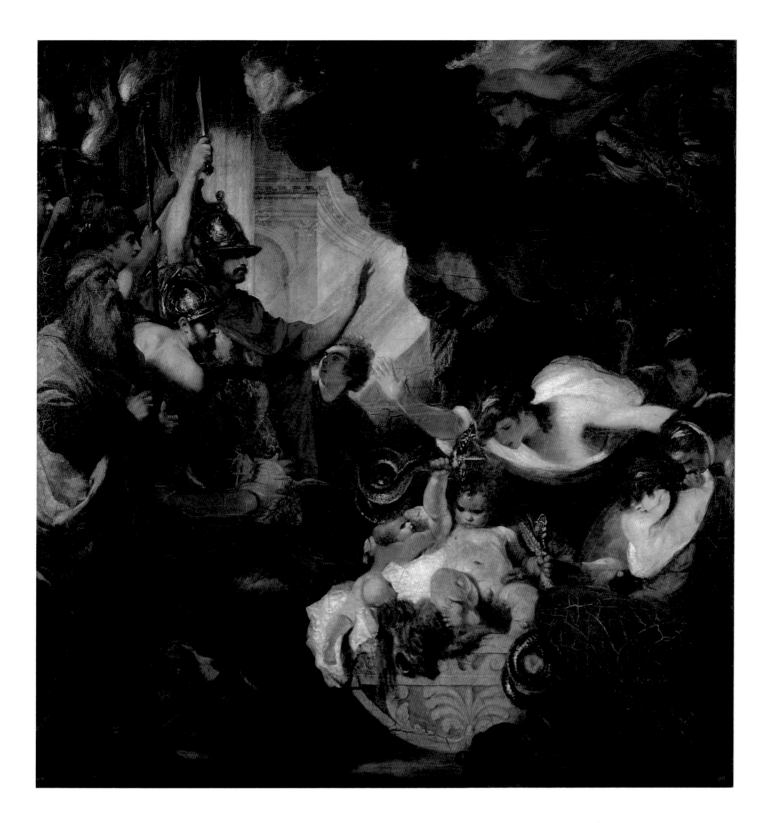

Qualitatively, Catherine's two major scoops were the acquisition of the Houghton Hall Collection and the Crozat Collection, purchased in 1772 from Louis-Antoine Crozat, baron de Thiers and marquis de Mois, who had inherited his uncle Pierre's fabulous paintings and added fine purchases of his own. Pierre Crozat was popularly referred to as "Crozat le Pauvre" because he was only slightly less wealthy than his brother. Both of them were among the richest men in France, their fortunes having been founded by their father's trade with Louisiana. Pierre Crozat's was one of the world's finest assemblages of paintings. He owned a vast collection of sculpture, drawings, and gems, but was best known for the magnificent group of 556 Dutch and Flemish, Italian, and Spanish paintings of the sixteenth, seventeenth, and eighteenth centuries, including the Giorgione *Judith* (148), then ascribed to Raphael, and the Titian *Danaë* (36). Not surprisingly, his holdings of contemporary French paintings were equally impressive, Pierre having been friend and patron to Watteau, the painter having lived in the banker's museumlike home.

The combined forces of Tronchin and the Russian ambassadors Prince Golitsyn and General Betsky (director of imperial buildings and president of Saint Petersburg's Academy of Fine Arts) were called for to make the Crozat purchase possible since many voices were raised against its paintings leaving France. However, money talks, and such eloquence is enhanced when from an imperial source. Soon Crozat's four hundred best canvases were shipped from Paris to Saint Petersburg in seventeen packing cases.

Though he had helped get them out of France, Diderot regretted the departure of Crozat's pictures, writing Falconet, who was still a fellow recipient of Catherine's largesse, "Ah! my friend . . . how we have changed! We sell our paintings and statues in peacetime. Catherine buys them in the middle of a war [against the Turks]. The sciences, arts, taste and wisdom are moving North, and barbarism, with all that accompanies it, is descending upon the south!"

In the 1780s Catherine's acquisitive instincts flagged. She wrote her advisers that space and funds for more pictures were lacking. With the czarina's death in 1796 the most magnificent phase of the Hermitage's expansion came to a close. By then the collection numbered 3,996 paintings. Her son Pavel Petrovich (511), later to be Paul I, transferred seven hundred of these to his favorite palaces—Gatchina, Pavlovsk, Tsarkoeselo, and Peterhof—but did not continue Catherine's magnificent purchases or penchant for concentrating such pictorial riches in a single setting. These were revived by her grandson Alexander I whose occasional passion for art was shared by his equally occasional passion for the owner: With his victorious troops in Paris after Napoleon's Russian defeat, the czar proved a great admirer of Josephine's, buying thirty-eight of her paintings at the important Malmaison sale of 1814 and acquiring more owned by her daughter Hortense, another of his flames. A third Napoleonic collection, that of the Bonaparte king, William II of Holland, was purchased in 1850, providing many important Early Netherlandish paintings including the very early, superb Eyckian diptych now in the Metropolitan Museum of Art, the fine Goesian triptych (202, 203), as well as the great Lucas van Leyden triptych of the *Healing of the Blind Man of Jericho* (224, 225).

A great gallery, known since 1805 as Le Musée Impérial, was established at the Hermitage, all the paintings of which were devoted to the Napoleonic wars, many of them by an English artist. Baron Vivant-Denon, Napoleon's major museum adviser and the genius behind the Louvre's organization, was also a consultant for the Hermitage. His sophisticated taste led to the acquisition of such distinguished works as Caravaggio's *Lute Player* (415) and the violent Heemskerck *Golgotha* triptych (234, 235), both works distinguished by a sense of drama far beyond the narrow confines of Neoclassical taste even if their eccentric virility was close to that period's concerns.

In the early 1800s, just when *Kunstgeschichte* (art history) emerged from Romantic vaporings, the Russian imperial collection underwent a period of self-evaluation under its new director, the bibliophile D. P. Boutourline. He noted how lopsided the holdings were: Triumphant in the Northern areas (now including

about fifteen thousand paintings from the Lowlands), it was far less representative of Italy. This realization led to one of Russia's most fortunate purchases—the cream of the Barbarigo collection, sold in Venice in 1850. Many of the pictures had been owned by this old local ducal family since the sixteenth century. Five of their Titians, all acquired by the Hermitage, were purchased at Titian's estate sale when they bought his house and all that was left in it from the painter's son. Canvases by Veronese and other of the Venetian masters also came to Saint Petersburg from this extraordinary auction.

The Hermitage also abounds in paintings that revive the art of sixteenth-century Venice—the canvases of Rubens and Van Dyck, those of Watteau and his circle, and, most strikingly, the incomparable gathering of masterpieces by Matisse. His vibrant color and authoritative use of antique themes, so close to the Serenissima's, may make him the last truly classical painter. Trained as a lawyer, the French painter's work shows a special harmony, a balance between opposites, a sense of the passionate and dispassionate scrutiny that bring his works so close to the present yet leave them to eternity.

By the early nineteenth century, almost four thousand paintings hung on the Hermitage's walls or were kept in its cellars and attics. In 1837 the entire Winter Palace burned down; fortunately the bulk of the collection was saved from the flames and the building reconstructed within two years. But these were the years when so many of the great national galleries were built up, their housing under construction, and it was decided to separate the paintings and other collections from the imperial residence and to house them in a new building (designed between 1840 and 1849 by the architect of the Munich museums, Franz Karl Leo von Klenze). They were reinstalled in 1852.

Under Nicholas I, who meddled with every aspect of the museum's management right down to the guards' uniforms, radical de-accessioning took place. Many pictures were deemed worthless or poorly preserved. Similarly drastic weeding out, as noted by the Hermitage's erudite director of the 1950s and 1960s, W. F. Levinson-Lessing, was also going on in Munich.

Happily, by accident and design, some of the best of Nicholas's sales items have found their way back to the Hermitage.

Soon the excellent German scholar G. F. Waagen made two Russian journeys to study and publish the Hermitage's holdings in 1864. Wandering through the estates and churches of darkest England, Scotland, and Ireland, he soon astonished the continent by the great treasures he found to have quietly been accumulated there, hidden away in the most obscure of British manor houses and parish churches. Braving the most unwelcoming of housekeepers and philistine owners, Waagen managed to rediscover many of Europe's greatest works, which had been uprooted in Napoleonic times. His research at the Hermitage was equally productive, resulting in new, much-needed publications in 1864 and 1870.

A historian, Gedeonov, was appointed the museum's director at midcentury, and made two of its major acquisitions, Leonardo's *Madonna Litta* (179) and *The Conestabile Madonna* (180) by Raphael. These would be the last stellar purchases for a long time. More major early Italian pictures entered the collection with the addition of the Golitsyn gallery, which included the tranquil Cima da Conegliano *Annunciation* (164).

A geographer with more brains than means, P. P. Semenov-Tianchansky decided to buy examples of the work of those artists of the Lowlands not yet represented in the Hermitage. His collection of over seven hundred pictures including a strong Stomer (133) and an unusual portrait of an old woman by van Ostade (497), was acquired by the museum in 1910. Fine scholarly endeavors by local and foreign specialists proceeded at an ever-increasing pace. Finally, in 1865, the Hermitage "went public" (previously special tickets and elegant attire had been required for admission).

Though the great gallery's collection has always been looked after with the greatest of care, early paintings suffered from some nineteenth-century Russian conservators' compulsion to transfer them from panel to canvas, whether or not this treatment was called for. Thus such key works as the van Eyck diptych (now in New York's Metropolitan Museum of Art) and many early Italian and other Northern paintings were subjected to drastic therapy that sometimes

deadened the paint surface by pressing it upon new canvas backing.

Spanish art was the sleeping giant of nineteenth-century European painting. But for the ever-popular Murillo, Spain's painters were little known outside that nation's borders. Only with the Napoleonic invasions did many fine pictures from the Iberian peninsula come north of the Pyrenees. The Hermitage obtained outstanding examples of the works of Carducho, Collantes, Maino, Pereda, and Zurbarán through purchases from the collection of the Russian consul to Cadiz, General Gessler, in 1834. The Spanish ambassador to Saint Petersburg, Paez de la Cadeña, sold the museum fifty-one Spanish pictures. Fifteen more came from the V. G. Coesvelt sale in 1836. Having been sold in Paris in 1831, pictures owned by the Spanish queen's lover Manuel Godoy also passed into the czar's collection, including the great Cortona *Martyrdom of Saint Stephen* (306) and Zurbarán's *Saint Laurence* (289). Canvases from almost every aspect of Murillo's career are found in Leningrad, as is an austere yet magnificent still life by Pereda (607), one of the Hermitage's most beautiful pictures.

As tribal or ethnic arts acted as inspiration for novel early twentieth-century creativity, the Spanish Baroque masters' emotional intensity, concentration upon material, and lightening brushwork were a source of fascination for painters of the mid-nineteenth century. At that time, a whole museum of Iberian art was briefly established in Paris under Emperor Napoleon III, whose beautiful bride Eugénie was a Spanish Bourbon. Soon Velázquez, Murillo, Zurbarán, and Goya provided focal points for artists such as Manet, Bonnat, and many others.

Need for food and farm equipment led to the sale of major paintings from the Hermitage in the early 1930s. Andrew Mellon bought thirty-three works for the National Gallery founded by him in Washington, D.C., including Raphael's *Saint George and the Dragon* and *Alba Madonna*, the Veronese *Finding of Moses*, and Botticelli's *Adoration of the Magi*. The van Eyck diptych (Metropolitan Museum of Art) was the museum's major early Northern painting, and the Cézanne *Bathers* (Philadelphia Museum of Art) was an equally painful loss as it represented an aspect of that artist's oeuvre

not otherwise seen in Russia's extraordinarily comprehensive collection of his work.

Another kind of damage—that to the Hermitage's buildings—during World War II, together with the need to evacuate the vast collection in order to reduce the threat of German appropriation, called for enormous labor before, during, and after the dreadful Siege of Leningrad. Thanks to massive curatorial efforts, however, the museum was already partially open to the public near the end of 1945.

With more than eight thousand paintings, forty thousand drawings, and many prints—to say nothing of its classical antiquities, sculpture, Scythian gold, and art from the ancient Near East and the Orient—the Hermitage remains a massive collection, combining rare variety and strength.

What makes this great museum both dinosaur and paradox is its resolute, productive conservatism in a revolutionary nation, where it remains a palatial picture gallery in the most traditional sense. With endless grand salons still in the magnificent manner of French or Italian absolutism, the Hermitage rejoices in the opulent swagger that only endless lashings of ormolu and malachite can lend. Where earlier revolutionary nations like America and France have recently recast their national palace museums in terms of the novel or the fashionably accessible, Russia's remains within the protective shadow of regal splendor, clinging to a conservative installation of her magnificent heritage.

The richest expression of this museum's paradox, so old and yet so new, is its vast collection of School of Paris paintings. Not even that terrible-tempered American, Dr. Albert Barnes, could outdo those two Moscow industrialists, Shchukin and Morozov, in buying the very best works by Cézanne, Renoir, early Matisse and Picasso, and their generation. Like Morozov, Barnes, too, succeeded in luring the reluctant Matisse to come to his home (in Merion, Pennsylvania) in 1933 to supervise the installation of painted lunettes designed for his gallery. But where the doctor's decorative canvases look like panels from some French luxury liner of the 1920s or 1930s, Morozov's *Music* and *The Dance* are sublime statements of the origin and power of art.

A major revelation for admirers of the School of Paris will be the strength of the art of the young Derain, whose best early works are found in Russia in every genre—portraiture (542), landscape (626), and still life (389). The museum's recent holdings were further enriched after World War II by the addition of 316 works from the Museum of New Western Art in Moscow, which still has 700 French paintings.

This book is meant to be an hors d'oeuvre to the chefs-d'oeuvres found in such abundance in the palace of the Neva, where they may fill as many as 353 galleries. That massive collection's contents are not only magnificent in themselves, but also provide such telling documents for the history of taste.

Unlike previous publications of the Hermitage's paintings, this one breaks away from national boundaries to present the works thematically, thereby stressing their artists' challenges in terms of style through subject, and going beyond the ghettoes of regionalism toward a glasnost of mutual interest and common understanding. This approach also allows the highly distinguished, yet numerically far fewer, examples of German, English, and Spanish paintings to be seen with their peers, not viewed in far-less- splendid, inappropriate isolation.

By presenting the museum's pictures according to theme, these chapters allow for a novel stroll through new galleries, rehung on paper, to yield those insights that can only come by juxtaposition, in a fresh context. This recalls Catherine's own installations, as recorded by I. Giorgi in his *Description of Saint Petersburg* (1793): Her thirty-two galleries were still hung "not so much in keeping with Schools or Artists, but for the impression they created."

Many lavish Soviet communal centers are known as People's Palaces. Hopefully this publication, too, will prove a "People's Book," bringing to many readers fresh, colorful access to a faraway collection, a book that was designed to share Leningrad's matchless constellation of masterpieces.

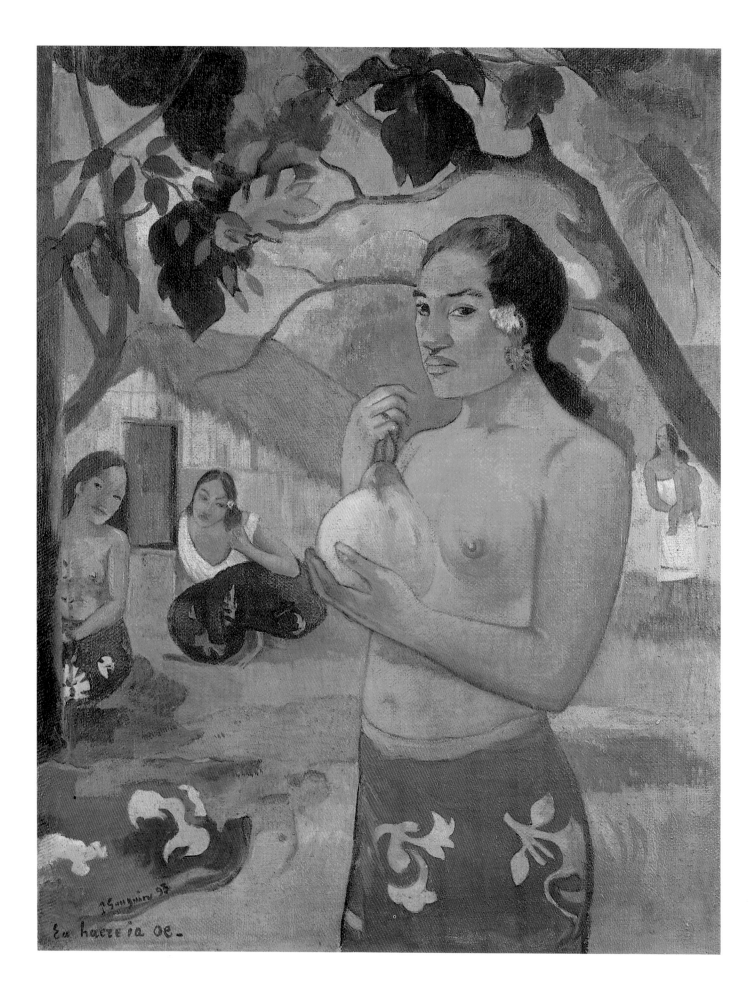

Golden Ages: Picturing Paradise Lost

❦ ❧

While faith may free us from original sin, only art can show us paradise now. Illusion revives Eden's delights, restores Utopia, re-creates the divinities of Parnassus, relives Arcadia's bliss. Pictures are the stuff of romantic yearning—for a pagan paradise regained or never lost, for primal purity before the Fall, and carnal joys beyond all Judeo-Christian prohibition.

Paintings' savages are the most noble. Even those brutish bad old days Before History have been painted with relish, necessary to the genesis of the human family, as in Franz von Stuck's Men Battle for a Woman (page 102). The Munich artist identified so closely with his archetypal subject that he used photographs of himself as model caveman. Here the roughest passages in Sir James George Frazer's ponderous Golden Bough—that massively popular turn-of-the-century literary ramification of the ways and means of tribal life and literature—were painted as a barbarian's Bildungsroman. Admired for the purity of their primitive sentiments, scenes of primordial life went back to the Stone Age when Men were Men, fighting for their Women and their Turf (or vice versa), returning to a time before faith and hope (let alone charity), depicted when heady Nietzschean and Bergsonian absolutes were in the air. Such episodes went over best near times of war or industrial revolution, as if to justify the "inevitable": cruelty

PAUL GAUGUIN Paris 1848–Atuana 1903 *Woman Holding a Fruit (Ea Haere Ia Oe)*, 1893
(Inv. No. 6510) Oil on canvas 36 × 29″ (92 × 73 cm) (Ex coll. I.A. Morozov, Moscow)

and competition; unrestrained violence seen as innate to the human condition, making the asocial acceptable.

So art brings back those halcyon days when it wasn't rude—only truthful—to be nude; when clothes conveyed falsehood, not modesty, and gardens were kept for love, not women's clubs. Illusion alone allows the spirit and the flesh eternal and unchanging union, together Happily Ever After on canvas if not in life. Similarly, canvases of classical, tribal, or pre-Christian subjects, from cultures innocent of Original Sin, radiate a sense of confident freedom, of pure pleasure, and unselfconscious corporeality seldom found in images of biblical or contemporary inspiration. *Woman Holding a Fruit* (32) shows how shrewdly Gauguin assembled and exploited our hopes for innocence and youth. This New Eve's fruit must stem from a tree that is all to the good.

While Gauguin went far East to find surviving ancient culture, most painters turned to the classics for similar inspiration, reading Ovid above all other texts. The Latin poet recalled glad days—long lost golden times when heaven and earth neared one another for mutual bliss— in which the gods descended, falling generously or jealously in love with nature's nymphs or with mere mortals. Such interplanetary passions often merged the best of both worlds, uniting divine and human strengths and beauties. If frustrated, the gods punished their nay-saying loves, so those lesser deities, spirits of stream or forest, fair maidens, shepherds, or hunters suddenly found themselves becoming streams or stars, flowers or gemstones. Such transformations are described by Ovid's ever-popular verses of that title: his *Metamorphoses*. These amorous, adventurous lines survived medieval censorship—carefully. "Moralized" conclusions were added at the behest of a French princess, thereby legitimizing their spicy contents by appending a Christian gloss to each episode. Ovid's accounts of coupling and changing, with lively legends of the loves of gods and humans, soon became as central to the genesis of art as they were to explaining that of nature. Venus and Apollo, gods of love, beauty, and art; Bacchus, the drunken, bisexual deity of inspiration; lame Vulcan, Venus's most unlikely mate, close to war and metalworking, along with a host of greater and lesser divinities, all presented a wide spectrum of fantasy and experience, grace and grotesquerie, wisdom and folly, envy and virtue.

Where Genesis's creator cast us in his own daunting image, Parnassian deities seem no more than ourselves, elevated to the dubious heights of the eternally human, condemned to the endless freedom of the flesh. Antiquity's divinities suggest that there, *with* the grace of gods, go you and I—our gods, ourselves— readiest of reasons for the endless popularity of classical mythology in all the arts.

Those gods, along with their human playmates, provide a raison d'être for the plethora of nudes painted in and after the Renaissance. But for Adam and Eve, a bathing Susanna or Bathsheba, along with a few youthful, obligingly bared martyrdoms or Last Judgments, very little else allowed for quite such time-hallowed scrutiny of the body beautiful and the form divine as the heritage of Greece and Rome.

Painters, their advisers, and their historians spent many an hour devising or unraveling intricate programs to justify series of nudes seen from a variety of vantage points. Titian's *Danaë* (36) is a major example of just such artful calculation. The painter wrote his Spanish patron, "Because the *Danaë*, which I have already sent to Your Majesty, was visible entirely from the front I have wanted to introduce a variation in the other composition, and make the figure show her other side." So, for erotic fun and games, as well as to compete with the sculptor's many-sided plastic powers, the painter brought mythology to life by presenting its nudes from multiple viewpoints.

A celestial explosion of gold links heaven and earth as Jupiter joins Danaë, long locked away in a tower, impregnating her in the form of a shower of glittering coins, Perseus being the fruit of their union. Ecstatic saints, close to divinity, share Danaë's pose, one derived from antiquity and revived for Michelangelo's *Night* on the tomb of Giuliano de' Medici. Titian followed this marble right down to her braided coiffure. Here he achieves that fusion of Florentine *disegno* and Venetian *colore* soon to prove the ideal combination for so many painters.

Rubens takes up the same legend, along with much of Titian's art, for his rendering of *Perseus Liberating Andromeda* (37). Here the daughter of the king of Ethiopia is freed from the bonds that chained her to a rock

where she was guarded by a fearsome dragon. Perseus was able to slay the monster, shown in its death throes in the foreground, because he came equipped with Hermes' winged sandals and the helmet that makes him invisible to his enemies. Perseus's shield is emblazoned with Medusa's petrifying stare. He was spared this Gorgon's fatal gaze as he slew her while she lay sleeping, the reward being Pegasus, the winged horse, who arose from her blood.

Few artists, among them Leonardo and Caravaggio, could paint horses as well as Rubens. The last, more upper class than most painters, was trained as a page in the costly practices of *chevalerie*. Here Perseus's steed is a piebald draft or war horse yet there is nothing incongruous about the great wings sprouting from his body. Like Bacchus, Pegasus was a symbol of artistic inspiration. Andromeda's liberation was a theme that was close to Rubens, painted once again (Berlin Museum) and repeated in a fresco on the garden façade of his own small Antwerp palace.

Rape, abduction, seduction, disguise, and deception are among the seamy yet central acts of classical mythology, mostly committed in the name of love or duty. Inevitably, the mortal object of a divinity's passion must be carried off to a suitably higher or lower sphere, linking this world to those above or below, or an attempt is made to do so.

Whether in the Trojans' abduction of screaming Sabine women for Rome's founding (87); Pluto's seizing Ceres's daughter Proserpina (40) and taking her to the underworld; or Apollo's crude grab for Daphne (41), rampant lust, in art if not in life, has a choreography all its own, pursuer and pursued often being caught in a torrid, sinuous *pas de deux*.

Thwarted or fulfilled, gods' passions for mortals explained the changing seasons, the genesis of plants and gems, rare birds and flowers. Love's unhappiest objects, according to Ovid, were often saved from a fate worse than death by answered prayers, the price of their sudden rescue that of permanent change of fair maiden or youth into constellation, laurel, heifer, or river. Strangely, such rescues, along with their infrequent failures, shown in painting or sculpture, were found suitable for wedding presents, singular harbingers of connubial bliss. These subjects were seen as triumphs of love—either that of the enamored ravisher, or of the victim's protective deity—in the days when women had little if any choice as to their marital fate.

Jean-François de Troy, somewhat Flemish in his abundant approach, takes on the movemented aspects of Bernini's statuary for his *Abduction of Proserpina* (40). Here Pluto, king of the underworld, suitably in red, with black steeds, carries off the personification of Spring, daughter of Ceres, the earth goddess. He makes her his queen with the consent of Zeus, Proserpina's father. De Troy's brother Jean, painting *Apollo and Daphne* (41), has the former capture the latter just as laurel leaves sprout from her fingers and toes. As Daphne is about to be embraced by the radiant sun god, she prays for delivery, and is turned into a tree.

Zeus, a fine figure of a naked god, makes a grab for the equally beauteous Io (38). Soon she, too, changes form, becoming a gleaming white heifer to hide her from the wrath of his jealous wife (this switch seen in the middle distance). All this takes place in a typically Venetian ideal landscape, invented by Giorgione near the year 1500, and here repeated by a capable Flemish assistant of Titian's, Lambert Sustris.

Forever randy, on another occasion Jupiter disguises himself as a lovely maiden, all the better to seduce one of Diana's nymphs, the fair Callisto (39). Jacopo Amigoni gives the viewer a clue to the true identity of the dark-haired beauty in his pretty Venetian picture by placing Jupiter's fierce eagle at her side.

The classical survived in Europe's mind and art because antiquity stayed so much in view. Most urban centers had Greek or Roman temples and roads, squares, walls, and gates along with large-scale statuary. Ceramics, glass, and tombs were found almost everywhere. Many a well-preserved temple became a church just by the addition of a cross; ancient public baths remained in use (46), fed by their original medicinal springs. Excavating for new buildings and roads, or plowing the fields, still brings to light ancient treasure, works in marble or bronze, carved gems, silver and gold.

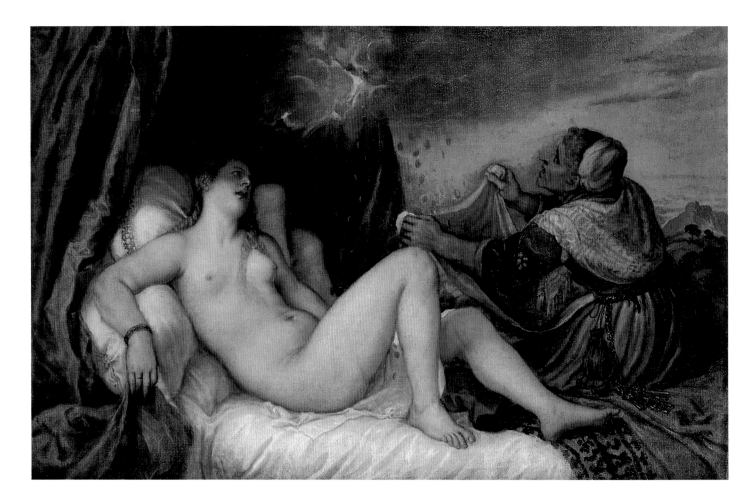

Alessandro Magnasco's *Bandits' Stopping-place* (47) resembles a setting for a raffish comic opera, painted with that Genoese's usual brisk sense of adventure. Here the noble ruins lend scant shelter to a roving band of thieves.

Claude's *Harbor of Baiae with Apollo and the Cumaean Sibyl* (42) is a pendant to his *Landscape with Argus Guarding Io* (Holkham Hall, Earl of Leicester), and linked, too, with *A Procession at Delphi* (Chicago Art Institute). All three canvases, like most of this painter's works, present glowing re-creations of antiquity, persuasive despite their flat, theatrical presentation, effulgent with magical light from the golden past. Incapable of painting man or

beast, Claude often called upon other artists to help him out. Despite his oddly limited skills and restricted imagination, Claude's is a compelling mastery of the mystery of light, illuminating succeeding centuries of landscapists' art.

Baiae was an imperial Roman resort on the Gulf of Naples, made famous because it was believed to be the harbor of Cumae, home of the oldest sibyl. Claude took his subject from Ovid, where Apollo, in love with a Cumaean maiden, promised her any gift. Pointing to a heap of sand, she requested as many years as it had grains, neglecting to ask for eternal youth as well. Oddly, the French painter added bits and pieces of ancient ru-

TITIAN
Pieve di Cadore 1488/90–Venice 1576
Danaë, 1546/53
(Inv. No. 121) Oil on canvas
47 × 73½″ (120 × 187 cm)
(Ex coll. Crozat, Paris, 1772)

Opposite
PIETER PAUL RUBENS
Siegen 1577–Antwerp 1640
Perseus Liberating Andromeda, early 1620s
(Inv. No. 461) Oil on canvas, transferred from panel
39 × 55½″ (99.5 × 139 cm)
(Ex coll. Brühl, Dresden, 1769)

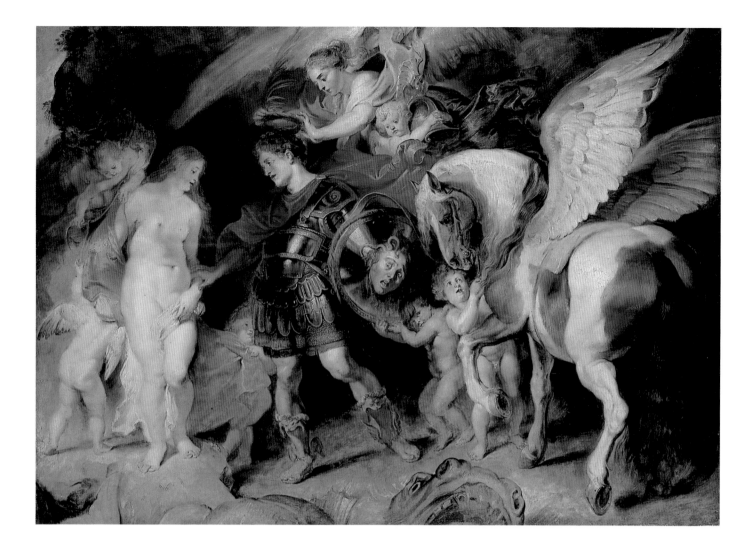

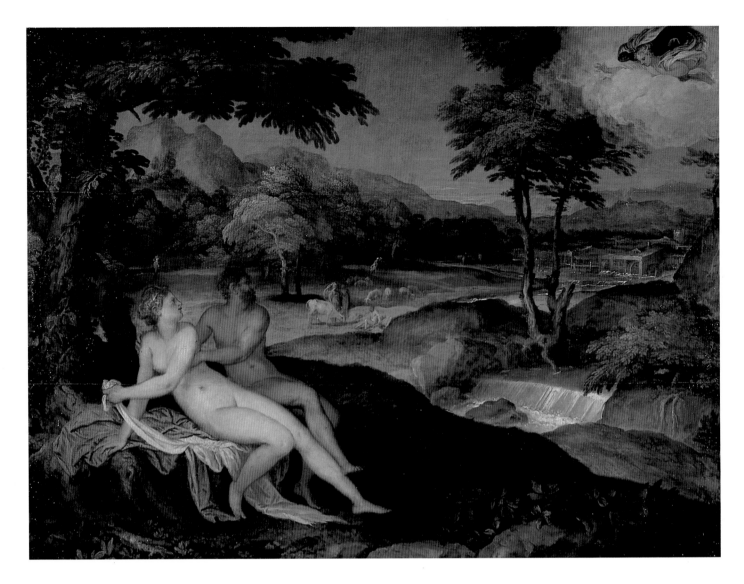

ins whose presence denies the logic of his tale, but adds prophetic authenticity to his radiant artifice.

A contemporary of Claude's, Jean Lemaire, exercised almost archaeological gifts for his *Square in an Ancient City* (43, 44-45), yet this reconstruction is more imaginative than rigorous, as it combines ancient and Baroque buildings in picturesque fashion. Washerwomen in the foreground soften the classical austerity of Lemaire's perspective.

Veronese's small sketch of a *Diana* (43), almost eighteenth-century in its delicacy, was probably meant to guide his studio in the painting of a large-scale fresco for Palladio's Villa Barbaro, now Villa Volpi. (The Venetian painter's silvery light proved to be one of Claude's many sources of inspiration.) The moon goddess, Diana, sister of Apollo, is shown here as a fair hunter; restraining one of her dogs who is raring to go.

With knowledge equaling his talent, Rubens achieved an effortless combination of the heritage of antiquity—the vocabulary of the pastoral—with that of the Bible. A great rainbow (48), symbolizing God's covenant with Noah after

LAMBERT FREDERIC SUSTRIS Amsterdam
1515/20–Padua after 1568
Jupiter and Io
(Inv. No. 60) Oil on canvas
81 × 108½″ (205.5 × 275.5 cm)
(Ex coll. Crozat, Paris, 1772)

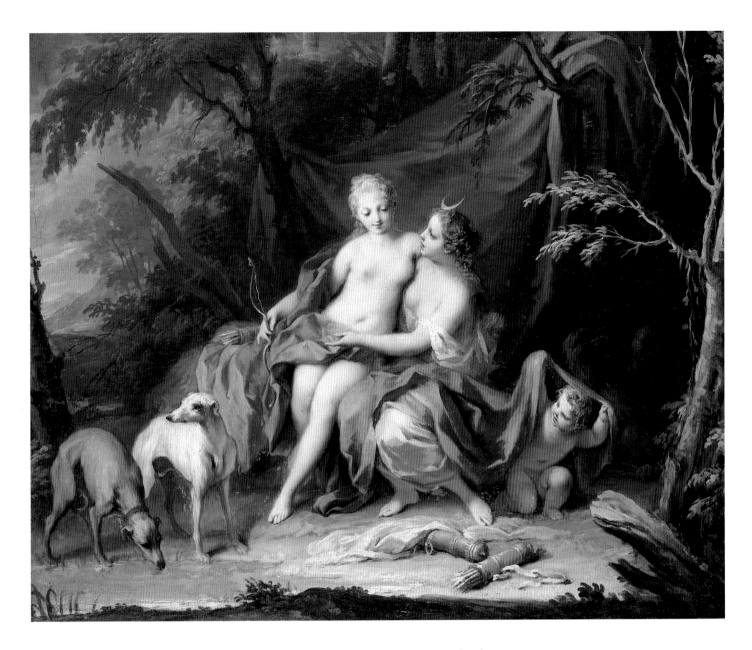

the Flood, sheds its luster over an ideal Flemish landcape, one long-rescued from the waters. Shepherd folk are seen alongside couples in contemporary rich attire, all sharing an earthly paradise with the promise and intimacy of love on every level. This idyllic land—Arcadia—one of rustic peace and plenty, is among the happiest of conceits, first found in the classical pastoral, later re-created in the sounds and sights of the Venetian Renaissance.

Even Rubens's colors, which echo those of the rainbow, suggest a universality, a saturation, a quality of all-inclusiveness, a feeling of All's right in the Heavens, All's right on Earth. Bridged by the Fleming's rainbow, or Titian's shower of golden coins, the celestial and terrestrial are united, if only briefly, with eternal consequences. Such ties, realized in a golden, heroic age when the gods descended, are the stuff of some of painting's happiest subjects, themes of promise

JACOPO AMIGONI
Venice 1675–Madrid 1752
Jupiter and Callisto
(Inv. No. 251) Oil on canvas
24½ × 30" (62 × 76 cm)
(Ex coll. V. Ovseenko, St. Petersburg, 1872)

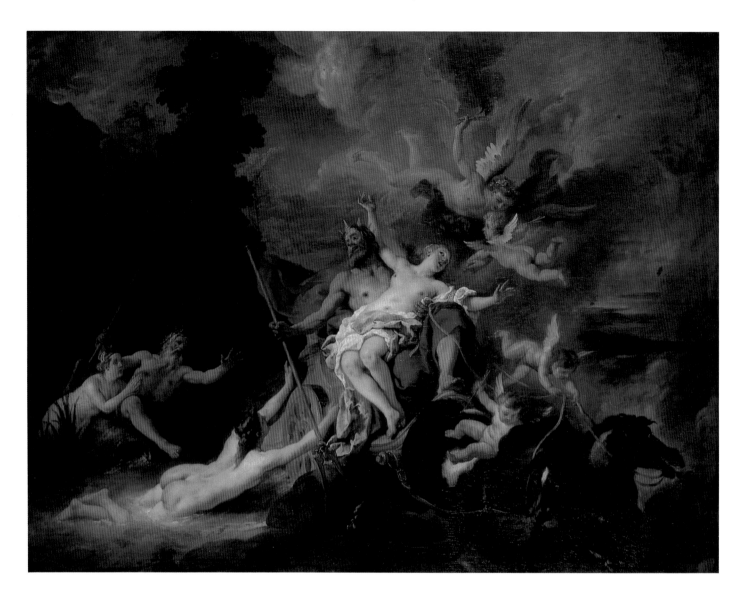

and nurture as well as jealousy and metamorphosis. What they say is that this world matters so much, its people are so beautiful and beloved, that even the gods come down to share, to pursue, to endow our life and its setting.

Not finding paradise on earth, the search was on for ways of life close to that unspoiled state. Peasants' supposedly innocent pleasures were credited with a freedom and purity far from the corruptions of court and capitalism, their hard life seized upon as a happy one.

Based upon classical literature, with its medieval and Renaissance equivalents, were hundreds of thousands of illuminated manuscripts, tapestries and paintings, drawings and prints, all devoted to the rustic genre. Marie Antoinette loved milking her cow into a Sèvres bucket in a little Rococo farm, carefully built into a state of picturesque disarray, tucked into the woods by Versailles. Such basic pursuits had already been taken on by Burgundian nobility four centuries before.

Boucher's and Pater's amorous peasants were meant to suggest pure passion, free in its naïve immediacy from the calculation, arti-

JEAN-FRANÇOIS DE TROY
Paris 1679– 1752
The Abduction of Proserpina, 1735
(Inv. No. 7526) Oil on canvas
48 × 63″ (122.5 × 161 cm)

Opposite
FRANÇOIS DE TROY
Toulouse 1645–Paris 1730
Apollo and Daphne
(Inv. No. 3739) Oil on canvas
80 × 53″ (204 × 135.5 cm)

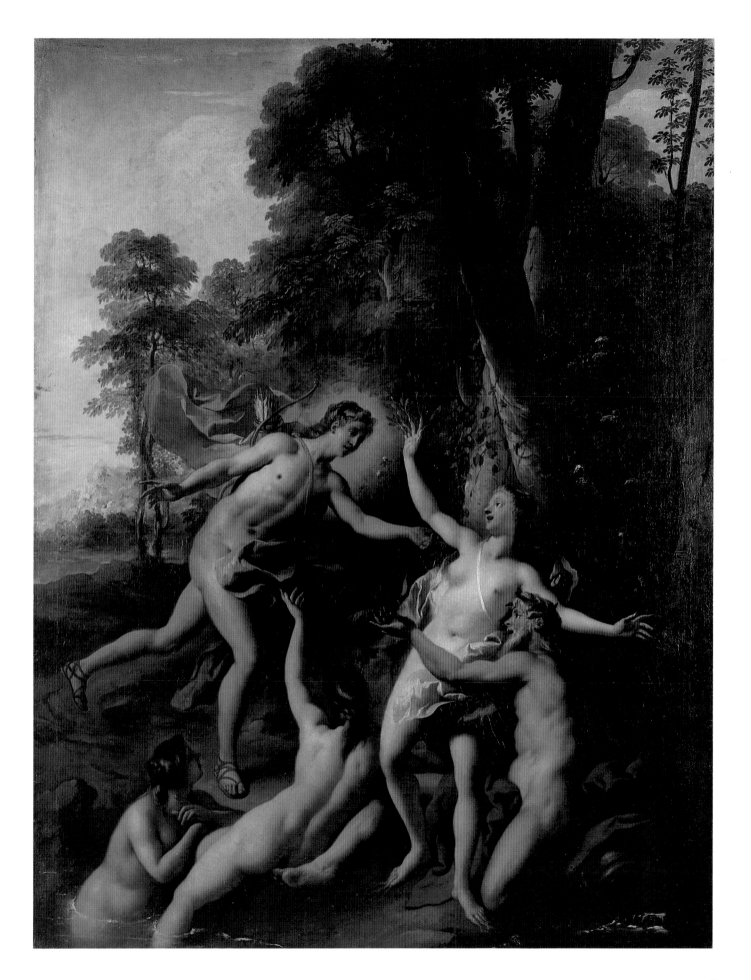

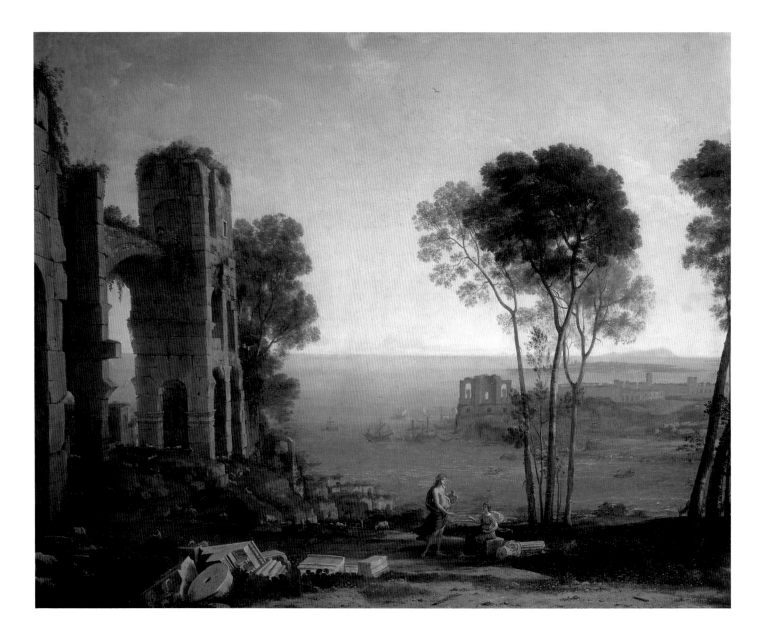

ficiality, and cynicism of life at court, where everyone's price was an all-too-well-known commodity. Outdoors, safely away from perfidious palaces, these rustics, in their remarkably silken robes and lace-edged collars, were the ultimate fantasy. Ladies-in-waiting (along with laundresses and hairdressers) lurked hidden behind every bush to restore the pristine disarray of their eternally youthful, nonchalant masters and mistresses with only love in view, piping a tune, or clipping or finding an errant sheep once in a long, long while.

Drinking to one another with more than their eyes, Boucher's shepherd and shepherdess (48), arms interlaced, are raising wine cups whose lavish style is in keeping with the hothouse peaches and grapes that will prove their humble repast. Pater's *Flute Recital* (49) suggests how that more sophisticated instrument may take longer in the winning of a lady's heart. This lady's friend has already been swept away by the urgent, basic importuning of the bagpipe that has fallen to the ground at the right corner.

Even Paradise was long found marked on early maps, staked out with surprising specificity. Baths in Eden's garden or other faraway places not only provided earthly delights but reversed time's inexorable tide. Such restoration of eternal youth was somewhere between a side effect and a prerequisite for endless wine, women, and song. These, in turn, were aspects of that most wondrous of drugs—love. Ever on the search for just such rejuvenation (as well as for gold), explorers often found Venus's diseases instead.

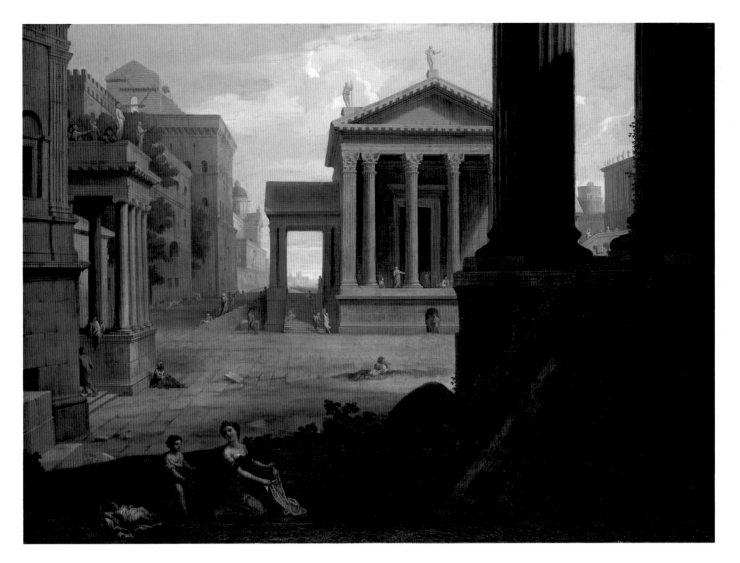

Above
JEAN LEMAIRE (LEMAIRE-POUSSIN)
Dammartin 1597–Gaillon 1659
Square in an Ancient City, 1763/74
(Inv. No. 1181) Oil on canvas
38 × 53″ (97 × 134 cm)

Left
PAOLO VERONESE (PAOLO CALIARI)
Verona 1528–1588
Diana, ca. 1560
(Inv. No. 167) Oil on canvas
11 × 6″ (28 × 16 cm)
(Ex coll. Crozat, Paris, 1772)

Opposite
CLAUDE LORRAIN (CLAUDE GELLÉE) Charmes 1600–Rome 1682
The Harbor of Baiae with Apollo and the Cumaean Sibyl, 1650s
(Inv. No. 1228) Oil on canvas
39 × 49″ (99.5 × 125 cm)
(Ex coll. Walpole, Houghton Hall, 1779)

Overleaf
JEAN LEMAIRE *Square in an Ancient City* (detail)

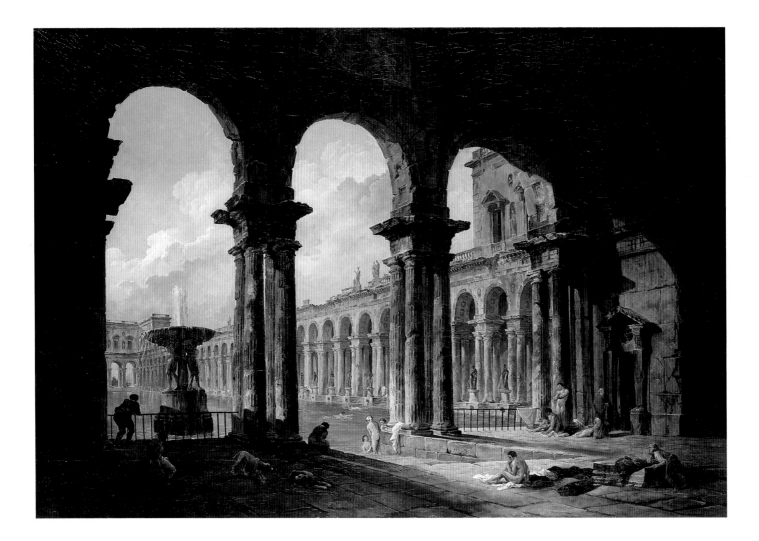

By accentuating the supposed difference in flesh tints between men and women, first described in ancient art, Karel van Mander heightens the eroticism of his *Garden of Love* (51). That effect was also increased by presenting figures in various stages of undress, the men in or out of the *lansquenet*'s attire worn by northern European mercenaries. One of the implicit messages of this jolly scene may be that war is best disarmed by the artful joys of love.

Perfect love, a popular concern in the age of chivalry, gained classical cachet with the recovery of Platonic thought in the Early Renaissance. Purest passions' pursuit required a stately ambience, that of

the ideal court. Here music, terraced gardens, and fountains provided romantic promenades and hideaways where lover and beloved could find and cherish one another. Near the fantasy of the stage Hendrik van Steenwyck's endless pleasure palace (50) echoes its residents' infinite bliss.

Karel van Mander's sinuous nudes recall those painted by his nearby contemporaries Hendrik van Balen the Elder (53) and Hans von Aachen (52). All three were popular at Rudolph II's court at Prague, which was noted for its mannered mixture of mystical, alchemical practices and a revival of late medieval art set in an elegant, intensely sexual ambience. In Aa-

HUBERT ROBERT Paris 1733–1808
Ancient Ruins Serving as a Public Bath
(Inv. No. 1262) Oil on canvas
52 × 76" (133 × 194 cm)

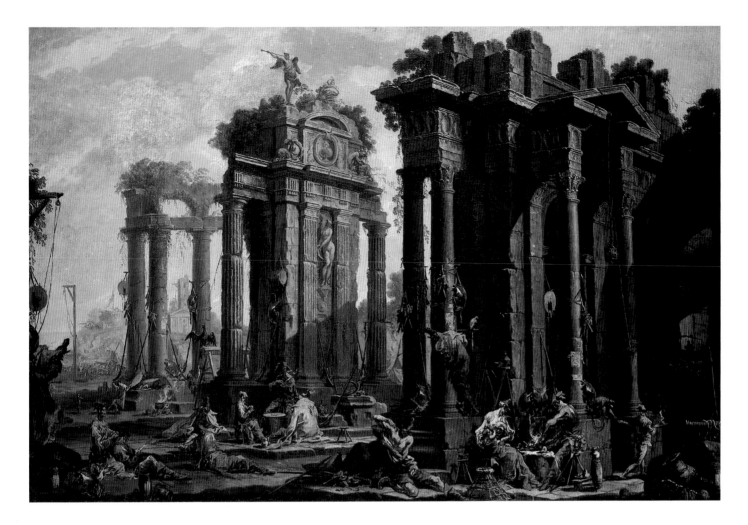

chen's *Allegory of Peace, Art, and Abundance*, Peace is a languid nude grasping an olive branch, holding the sleek pose of a Giambologna bronze. She is the central figure of an allegory whose message is that only when Peace reigns supreme—that is, under the enlightened rule of Rudolph II—may the Arts and Sciences flourish. The latter are merged into a single figure holding a palette (bearing the painter's signature), a figurine, and an armillary sphere. Abundance, with the usual cornucopia and a fancy-footed cup of wine, is seen from the back. All three women are placed among war's scattered trappings, those dangerous toys happily if temporarily hors de combat while the arts

flourish. (That ghostly sword behind the sphere is a *pentimento*, a survival from an earlier pictorial program. Though at one time painted over, with the increasing transparency of the uppermost paint layer it has become visible once again.) As van Balen's *Venus* is surrounded by rapidly breeding animals (guinea pigs), fruits, and flowers (the latter linked with Flora, goddess of courtesans), she shares some of the attributes of a fertility goddess, her nudity accentuated by a crimson silken tent. At the far left, Venus's husband, Vulcan, forges armor for Aeneas, her son by Anchises, the Trojan noble. This vignette adds a subtle little subtext on the elusive links between sexuality and conflict.

ALESSANDRO MAGNASCO
Genoa 1667– 1749
Bandits' Stopping-place, 1710s
(Inv. No. 4036) Oil on canvas
44 × 64″ (112 × 162 cm)
(Ex coll. I.I. Shuvalov)

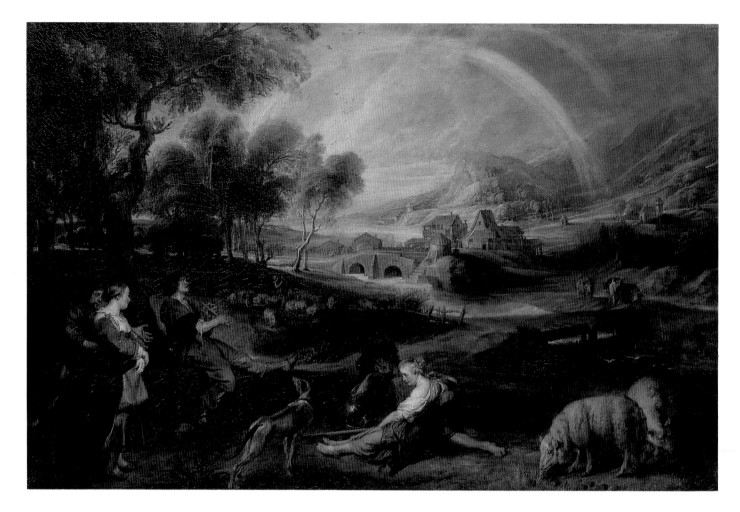

Above
PIETER PAUL RUBENS
Landscape with a Rainbow, early 1630s
(Inv. No. 482) Oil on canvas, transferred
from panel
34 × 51″ (86 × 130 cm)
(Ex coll. Brühl, Dresden, 1769)

Right
FRANÇOIS BOUCHER Paris 1703–1770
Pastoral Scene (Inv. No. 1275) Oil on canvas
24 × 29½″ (61 × 75 cm)

Venus, shown with her infant Cupid, was restored to nudity by Lucas Cranach the Elder when the medieval was stripped away from Northern art in the early sixteenth century (54). Cupid, the son of Mars, is notoriously careless with his arrows. Here the personification of divine love and beauty is seen with her arbitrary, infant-agent. That love should be symbolized by its fruit has a logic singularly absent from most passions' course. Cranach presents the two as a somewhat sneaky duo, adding a Latin warning: "Strive to drive away Cupid's pleasures/ Lest Venus seize your soul bewitched." Dated 1509, this is early for a Northern image of the Roman deity in the nude (according to Wernher Schade, she is based on Italian print sources). Significantly, the goddess's gains by such exposure are lost by her monitory text. Such ambivalence is common to erotic subjects, their self-censorship meant to disarm the opposition.

Cupid seems to have the stage to himself in a horizontal panel by the Sienese High Renaissance artist Il Sodoma (55), yet this is probably part of a larger decorative ensemble with amorous activities carried on to the left, the direction of Cupid's gaze, part of a painted frieze or a *cassone*, an Italian hope chest, both suited to amorous themes.

Mysterious and romantic, like love itself, is *The Repose of Venus*, a canvas ascribed to Domenichino (56, 58–59). The goddess's chariot is backed by a scallop shell referring to Venus's maritime birth, also alluded to by the wavelike blue vel-

vet on which she reclines close to turtledoves and putti. Two old men peer down at her from behind a rock, their pose recalling Susanna's lecherous elders'.

For all his later rigor, the young Poussin was a master of *amor*; his cherubs, aloft or temporarily grounded, are the ultimate messengers of love, all baby yet wise beyond their years (57). Whether Cupid sharpens his arrows of love, a cunning gleam in his eyes, or suffers for his pains, he was a favorite subject because pretty babies are both love's promise and its fulfillment. Nicolas Vleughels, a friend of Watteau's, shows *Cupid Punished* (60) with Venus witnessing his flagellation, a temple of love in the background. Charles Joseph Natoire depicts Cupid sharpening his arrows on a Rococo grindstone (60), with the assistance of little Amors.

JEAN BAPTISTE JOSEPH PATER
Valenciennes 1695–Paris 1736
Flute Recital (Inv. No. 2044)
Oil on panel 6 × 8″ (15.5 × 20 cm)
(Ex coll. Crozat, Paris, 1772)

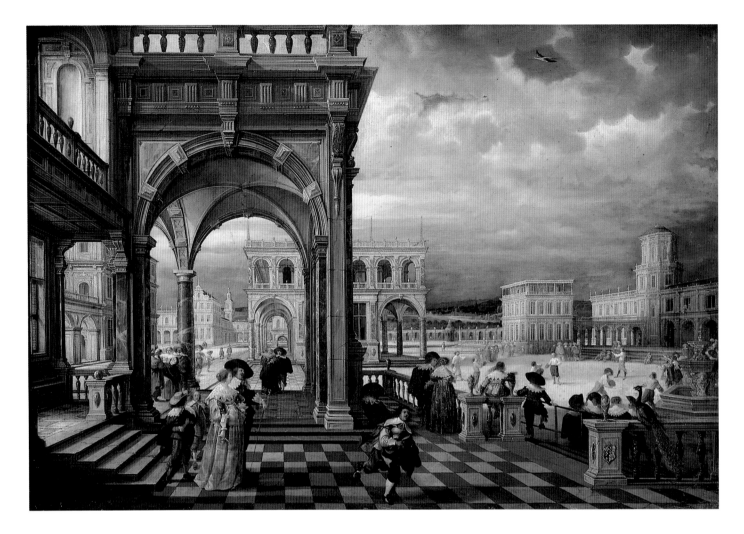

Most winsome of the Hermitage's scenes of Cupid at work is one in which he unfastens Venus' belt (61), that girdle guaranteed to make any wearer irresistible. This is one of the two canvases commissioned by Catherine from Sir Joshua Reynolds, letting him choose his own subjects. Evidently that wise knight knew of the czarina's love for love. His other painting showed the *Infant Hercules Strangling Serpents* (27), the reptiles having been sent by his jealous stepmother, Hera, to slay her ever-straying spouse's son in the cradle, a theme suggesting Reynolds may have known too of the violence endemic to the Russian court, though the al-

ways-diplomatic artist's explanation differs.

Joseph Marie Vien's *Mars and Venus* (63), but for their nakedness, resemble a young married couple, out for a stroll, rejoicing in a rare moment of freedom. Their architectural setting is like those of Madame de Pompadour, the artist's major patron. The highly influential Vien was both Neoclassical and somewhat naturalistic (Jacques-Louis David his ever-grateful pupil).

Honoré Daumier, born a year before Vien died, caricatured classical divinities as reborn in the guise of Parisian lower-middle-class pretension. He took images like this pedestrian *Mars and Venus*

down a few pegs, turning the Pompadour's polite snigger into belly laughter.

Dutch seventeenth-century nudes tend to the literal—yet Gerrit Dou's plump *Bather* (64) is done with greater than usual delicacy. She is one of three: A second shows the same model from another side, in the Titian tradition, and the third is male (64). The male of the trio is especially interesting, in his pose of a river god or Paris. He leans against a tree like the bathers in a print of still-startling frankness by Dou's great teacher, Rembrandt. But Dou plays it safe by invoking biblical as well as antique images—Adam, or John

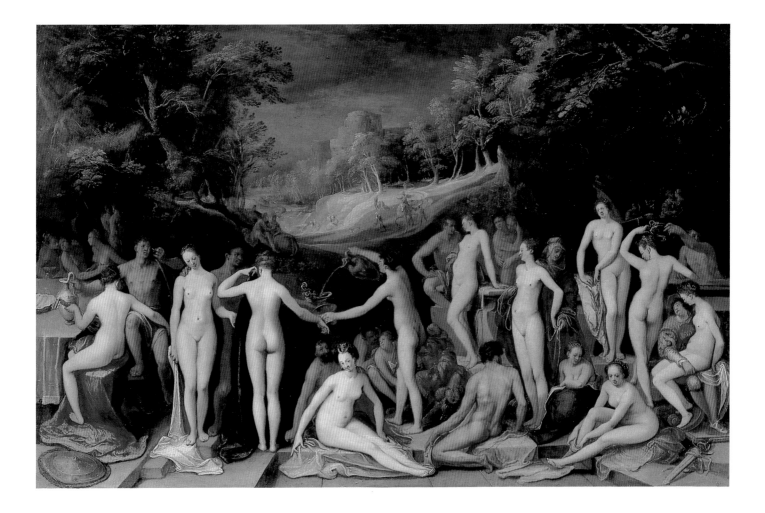

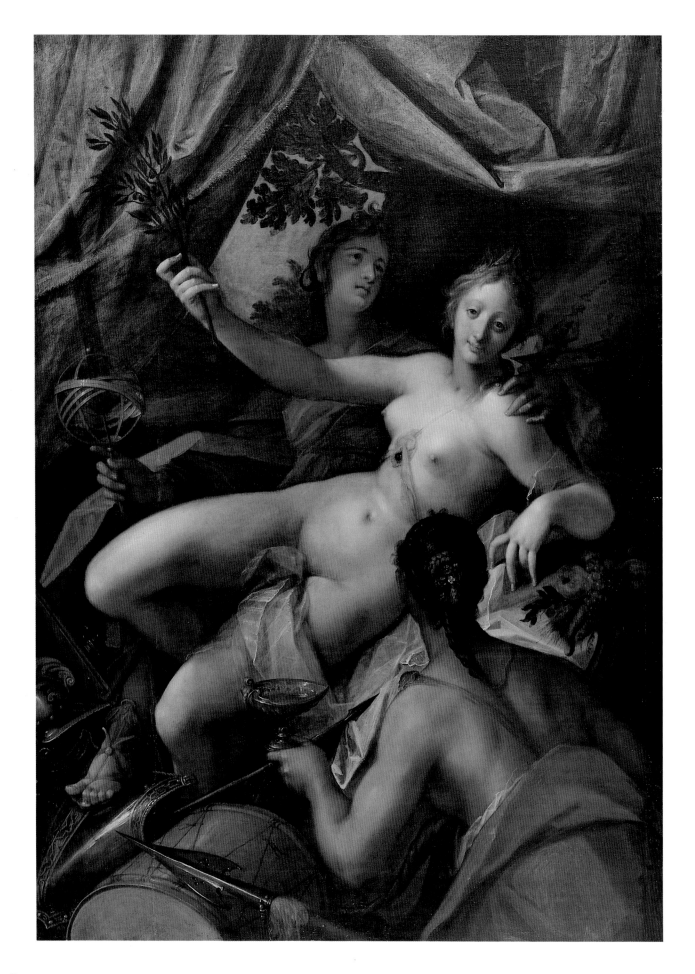

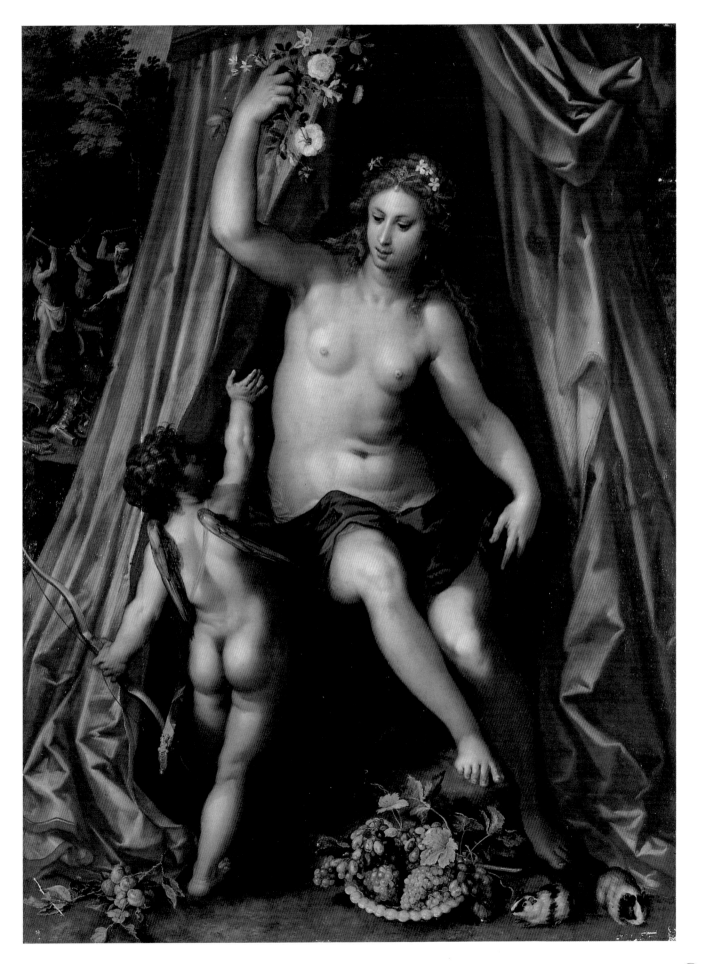

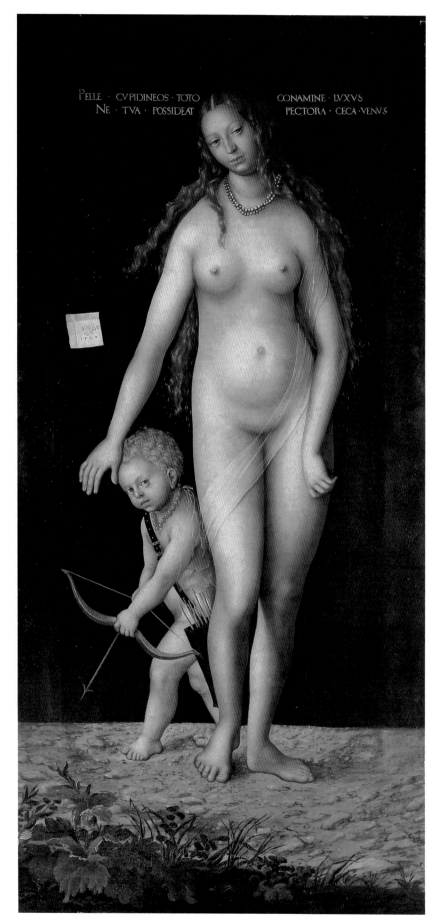

PELLE · CVPIDINEOS · TOTO CONAMINE · LVXVS
NE · TVA · POSSIDEAT PECTORA · CECA · VENVS

the Baptist in the wilderness. The trio of bathers were procured by Diderot for Catherine II. Possibly she had them hung together as a mural *ménage à trois*. François Lemoyne's *Bather* (65) is pensive. Wearing pearls in her hair, she tests the stream's temperature with her foot, helped into the water by an attendant. The sculpturelike group suggests a certain ritual solemnity, that of a Bathsheba or other figure whose loveliness would lead to more serious consequences than mere admiration—just looking at her image makes the viewer into a new David.

Only the greatest artists can reveal the extraordinary in the ordinary and the ordinary in the extraordinary. Edgar Degas excelled in the former, nowhere more so than in his innumerable images of bathers and women at their toilette, which he produced in every medium. Here ablution takes on mythic implications—a goddess rising from what is only a zinc tub; a Venus wringing her hair before striding ashore. Both of the studies included here (66, 67) are in pastel, an unusually fugitive medium sharing the precision of drawing and the color of painting, ideally suited to Degas's art as its broad strokes seem to hold and radiate light while defining form. Disguise turns the everyday into the unexpected, accessories often effect the magic of transformation. Props allow subjects a certain distance from artist and viewer alike. At best, such basic trimmings (oxymorons *can* make sense) lend authority and independence, letting us become

who or what we need. Such wishes often reveal the real person far more clearly than a more clinical, reductively "truthful" presentation. When stripped of our fantasies, what's left?

By painting his beloved Hendrikje Stoffels as she holds a magnificent pearl drop to her ear (68) Rembrandt may be suggesting that this servant girl, now in lavish dress, is to be seen as no less than a regal Cleopatra. At one of her banquets the queen dissolved a priceless pearl in vinegar and drank it down to prove the extent of her wealth. With her lover Mark Antony dead and the prospect of Roman slavery before her, the thirty-nine-year-old Egyptian queen ended her life by applying an asp to her breast. A popular subject as it tempered nudity, history and undying love, Cleopatra's suicide was depicted by the Neapolitan painter Massimo Stanzione (89).

Rembrandt's wife, Saskia van Uylenborch, appears as the goddess *Flora* (69), her hair lavishly dressed with blossoms, holding a flowery staff. The artist celebrates his bride, too, being in bloom, pregnant with their son, Titus, whose birth in 1641 would soon result in Saskia's death.

One of Dosso Dossi's loveliest works is a *Sibyl* (70), far removed from his usual, more slapdash productions. The picture is supposedly from the Este dukes, native to Ferrara as was their court artist. As recorded in classical literature, the sibyls were antiquity's female equivalent to the biblical wise women; their lines read as prophet-

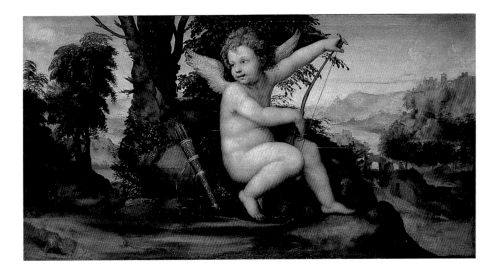

ic pronouncements and the later ones, especially those found in Virgil's *Fourth Eclogue*, were often thought to foretell Christ's coming. Just such a message is probably inscribed on this sibyl's tablet.

Satyrs and bacchantes are the wild folk of ancient literature, creatures of fields and woods who escorted Bacchus from the East. Rejoicing in their freedom, satyrs combine much of the best of man and beast. That Poussin's creatures (71) are close to Bacchus is made clear by the vine wreaths in their hair and the prominence of goats, sacrificed to the fertility god. Son of Zeus, Bacchus was raised by nymphs at Mercury's direction, and this is the subject of Laurent de La Hyre's canvas (72).

Bacchus is about to carry off his bride Ariadne in a painting by Natoire (72). Abandoned by Theseus, Ariadne slept in gloom on the isle of Naxos until Bacchus carried her off to be his bride. This painting's warm tones suggest those of Versailles in the fall. The god's adventures are among antiquity's most rough and tumble—his appetites,

IL SODOMA Vercelli 1477–Siena 1549
Cupid in a Landscape, ca. 1530
(Inv. No. 4163) Oil on canvas
27 × 51″ (68 × 129 cm)
(Ex coll. S.G. Stroganov, 1926)

Opposite
LUCAS CRANACH THE ELDER
Kronach 1472–Weimar 1555
Venus and Cupid (Inv. No. 680)
Oil on canvas, transferred from panel
84 × 40″ (213 × 102 cm)

with all else about him, more abundant than those of his peers.

A symphony in cellulite, Rubens's *Bacchus* (73) is a difficult image for an age whose Beautiful People can't be "too thin or too rich." Here the god of *furor poeticus* has the head of a young man, his body lost in the raddled adiposity of a *Venus of Willendorf*, taking on the proportions of that small stone prehistoric fertility goddess, now seen via Rubens's work in massively enlarged travesty. Kept in the artist's own home, this late, Falstaffian image

came very close to the old painter's needs (and to those of successive owners and artists) as the canvas is a ravishing presentation of inexhaustible creative abundance. Bacchus—drunken, wanton, obsessed by insane wanderlust—is the loose cannon of classical mythology. Seated upon a barrel, source of the god's wine, he frees men's minds, hearts, and hands, liberating creative passion on every level. Everyone pours, drinks, eats, or relieves themselves of the inspiring fruit of the vine. That magical potion was the agent of poetic fury credited

Above
IL DOMENICHINO (?)
Bologna 1581–Naples 1641
The Repose of Venus
(Inv. No. 127) Oil on canvas
23 × 30" (58 × 76.5 cm)
(Ex coll. Walpole, Houghton Hall, 1779)

Opposite
NICOLAS POUSSIN
Les Andelys 1593–Rome 1665
Cupids and Genii, 1630s
(Inv. No. 1187) Oil on canvas
37½ × 28" (95 × 71.5 cm)
(Ex coll. Crozat, Paris, 1772)

Overleaf
IL DOMENICHINO (?)
The Repose of Venus (detail)

NICOLAS VLEUGHELS Paris 1668/69–Rome 1737
Cupid Punished, 1720
(Inv. No. 2520) Oil on copper
19½ × 15″ (50 × 39 cm)
(Ex coll. Crozat, Paris, 1772)

CHARLES JOSEPH NATOIRE Nîmes 1700–Castel 1777
Cupid Sharpening His Arrow, 1750s
(Inv. No. 7653) Oil on canvas
22 × 17″ (55.5 × 42.5 cm)
(Ex coll. Crozat, Paris, 1772)

Opposite
SIR JOSHUA REYNOLDS Plimpton 1723–London 1792
Cupid Undoing Venus's Belt (Inv. No. 1320) Oil on canvas
50 × 40″ (127.5 × 101 cm) Completed 1788
(Ex coll. G.A. Potemkin, St. Petersburg, 1792)

with the initiation of all the arts. Even the tiger (symbol of Bacchus's return from India), lying catlike at the god's feet, gnaws upon a bunch of grapes. Here Cupid is the *puer mingens*, a Roman emblem of good fortune still popular in Rubens's homeland as Brussels's beloved little bronze fountain *Mannekin Piss*, his a relieving arc and shower of gold. So far from gentility and decorum, distant from our post-Freudian decades of deconstructive analysis, of Derridan agendas and decodings, this gargantuan painting may appall. Yet Rubens's *Bacchus* is actually a canvas of daring beauty, a September Song conveyed by the most subtle, caressing touch and moving, shimmering Titian-like colorism, doubtless much admired by Watteau when he lived with it in Crozat's collection (earlier *chez* Richelieu). The canvas was brought to Catherine II with the best of Crozat's treasures. The czarina—stout, earthy, and intelligently greedy—must have been especially appreciative of Bacchus's radiantly lusty message.

Nude beauty seldom looks better than when shown as more than itself—in the guise of the nymph Galatea or that of a Venus or an Apollo—their divine roles and props proclaiming them to be never changing, ever themselves, eternally clothed in the once and future glory of their flesh. Until the later nineteenth century much of art's industry went to the fabrication of just such images: human loveliness cast in the radiance of classical reference, made safe for official morality by the requisite

distance only antiquity or allegory could confer with such authority. So art turned to the literature of the Golden Age for so much of its safest, most profitable subjects.

Among the Hermitage's finest Bouchers is one that he painted as a gift to the newly established Saint Petersburg Academy of Fine Arts, his picture brought there by the painter's friend Falconet (75). Showing Pygmalion at work on a statue of the beautiful nymph Galatea, the canvas was actually a pictorial tribute to Falconet's genius. Soon in love with his statue, the young sculptor, the king of Cyprus, prayed to Venus that the sculpture come to life. His wish, soon answered, is every artist's prayer for their work, the fervent hope that their image will live in the viewer's mind, if not in actuality. Boucher's pale marblelike coloring suits that of Galatea's name, meaning "the milk-white." *The Triumph of Galatea* (74) by Jean-Baptiste Van Loo uses a much richer palette. In her native habitat, a sea nymph's, Galatea is shown rejoicing in the ocean breezes. They fill her sails as dolphins speed her away from Polyphemus, playing his panpipes at the upper right. That jealous, ugly creature has killed Galatea's lover, Acis, whom she then turns into the Sicilian river of the same name.

The Beautiful Woman—call her Venus, Muse, or what you will—usually personifies artistic inspiration as well as peace and creativity, in contrast with Man's favorite game (and essay in futility), the art of war. With Cupid at her side, nude, vulnerable Venus walks from

JOSEPH MARIE VIEN
Montpellier 1716–Paris 1809
Mars and Venus, 1768
(Inv. No. 2249) Oil on canvas
89 × 59½" (225.5 151 cm)
(Commissioned by Prince Golitsyn for Catherine II)

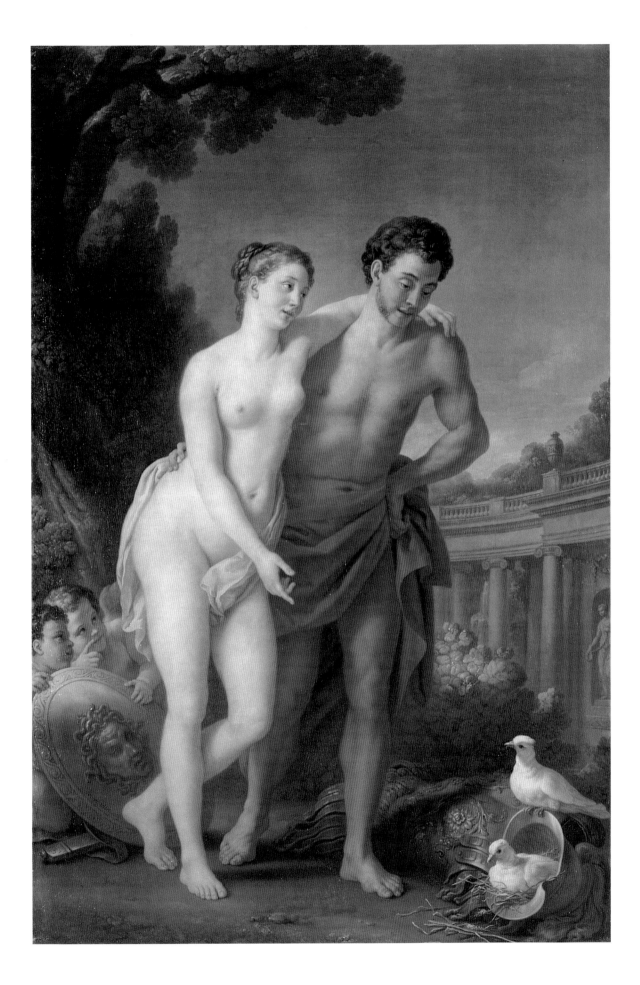

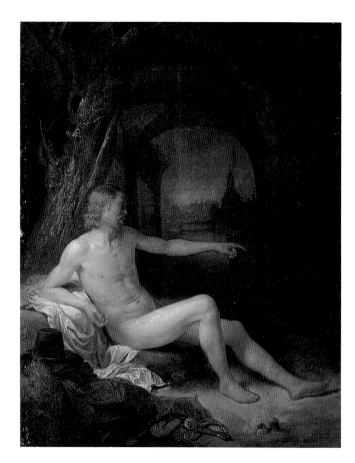

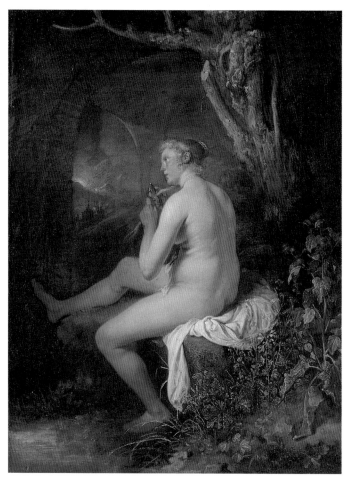

GERRIT DOU Leyden 1613–1675
Bather, ca. 1660/65
(Inv. No. 893) Oil on panel
10 × 7½″ (25.5 × 19 cm)
(Ex coll. N. Genier, Paris, 1768)

GERRIT DOU *Bather,* ca. 1660/65
(Inv. No. 894) Oil on panel
10 × 7½″ (25 × 19 cm)
(Ex coll. N. Genier, Paris, 1768)

Opposite
FRANÇOIS LEMOINE Paris 1688–1737
Bather, ca. 1724
(Inv. No. 1222) Oil on canvas
54 × 41½″ (136.5 × 105 cm)

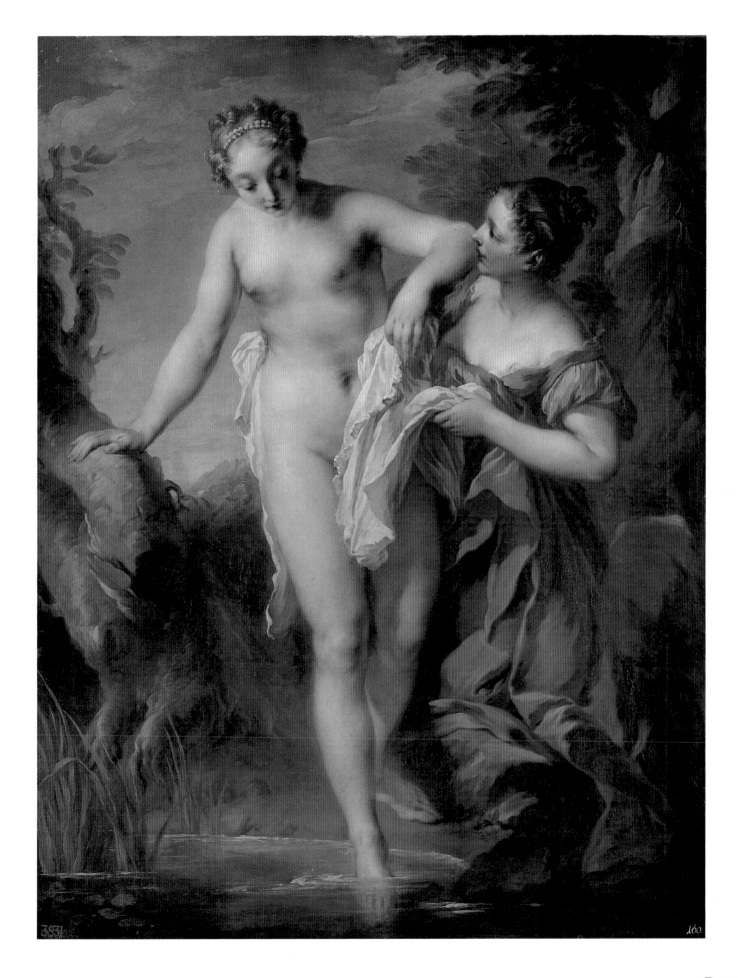

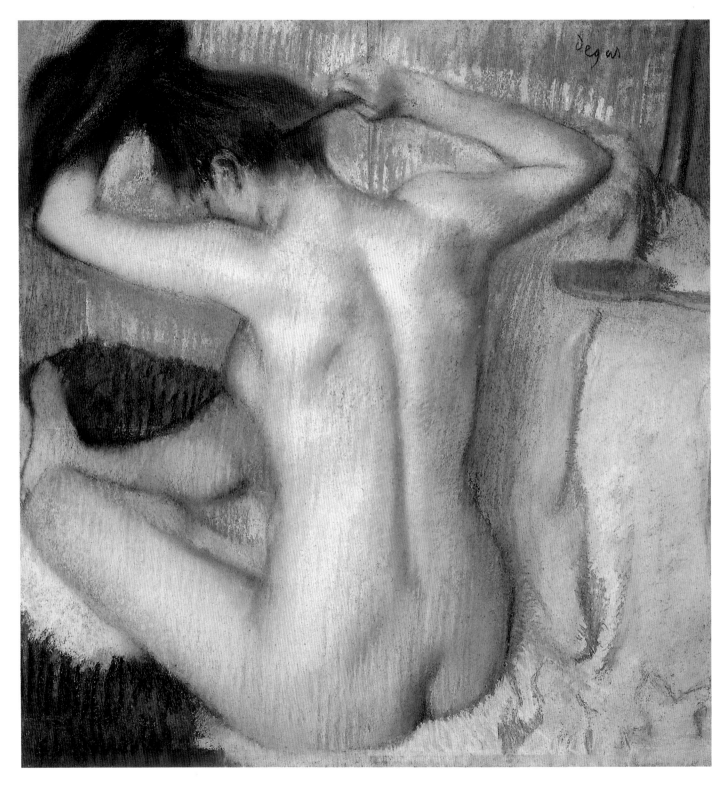

EDGAR DEGAS Paris 1834–1917
Woman Combing Her Hair, ca. 1886
(Inv. No. 4254) Pastel on cardboard
21 × 20½″ (53 × 52 cm)
(Ex coll. S. Shchukin, Moscow)

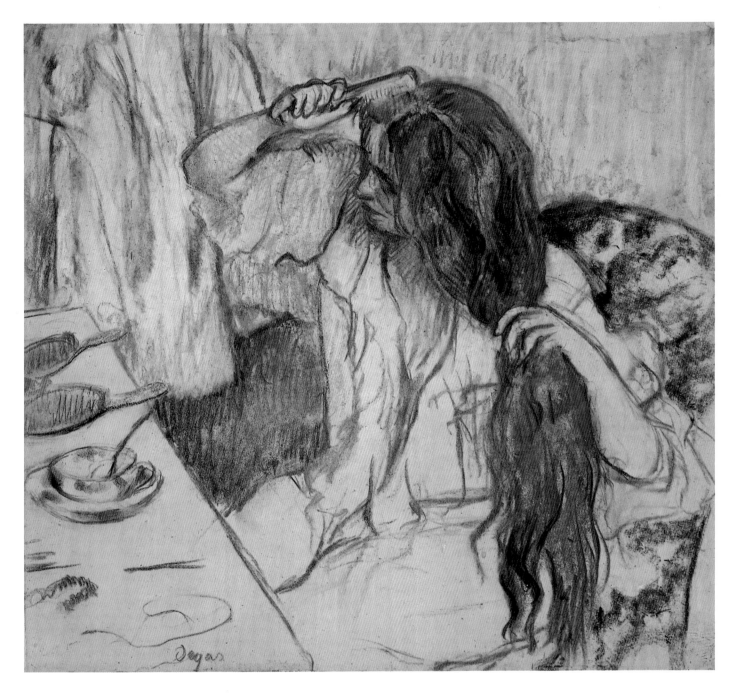

EDGAR DEGAS
Woman at Her Toilette, ca. 1885
Pastel on cardboard

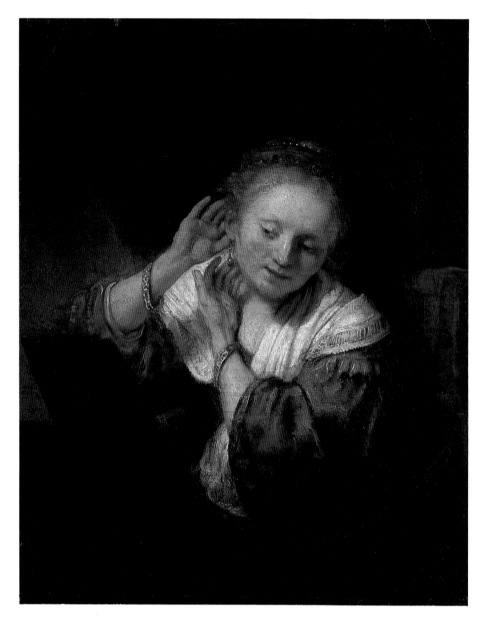

REMBRANDT HARMENSZ VAN RIJN
Leyden 1606–Amsterdam 1669
A Young Woman Trying on Earrings, 1657
(Inv. No. 784) Oil on panel
15½ × 13" (39.5 × 32.5 cm)
(Ex coll. Baudouin, Paris, 1781)

Opposite
REMBRANDT *Saskia as Flora,* 1634
(Inv. No. 732) Oil on canvas
49 × 40" (125 × 101 cm)

a massive pile of trophies standing for the wonders of pillage, painted with miniaturist's care by Jan van Kessel I (76, 78–79). Fortresses in the background and the newly invented cannon make it clear that this is a warrior's world. Venus visits her husband's forge where Vulcan will make arms at her request for her son, Aeneas.

Bernardo Strozzi's muses in his *Allegory of the Arts* (77), each with their attribute, are a harmonious trio, their state of concord a necessary prelude to creativity. *Vulcan's Forge* (77) by Luca Giordano stresses the earth-born mineral world, his scene set in a somewhat cave-like environment, illuminated by the forge's flickering light.

The mechanical arts, with their world of motion and invention, are traditionally a male domain, initially that of the Cretan magician Daedalus, discoverer of flight. His son, Icarus, flew too close to the sun; the sun melted his waxen wings, and he plummeted to a watery death in the Aegean Sea. Charles Lebrun shows Daedalus attaching his son's wings (77) with a sense of tragedy that recalls an Abraham and Isaac group. Icarus's body is in an almost sacrificial pose, as if to stress the divine significance of the arts, a theme dear to the heart of this painter, who was founder of the Académie Royale.

Art's dullest images are often allegories, because these seldom come close to painters' real concerns. Imposed by patrons who personalize the abstract, allegories use people to represent issues or symbolize places, factors, or qualities, thus

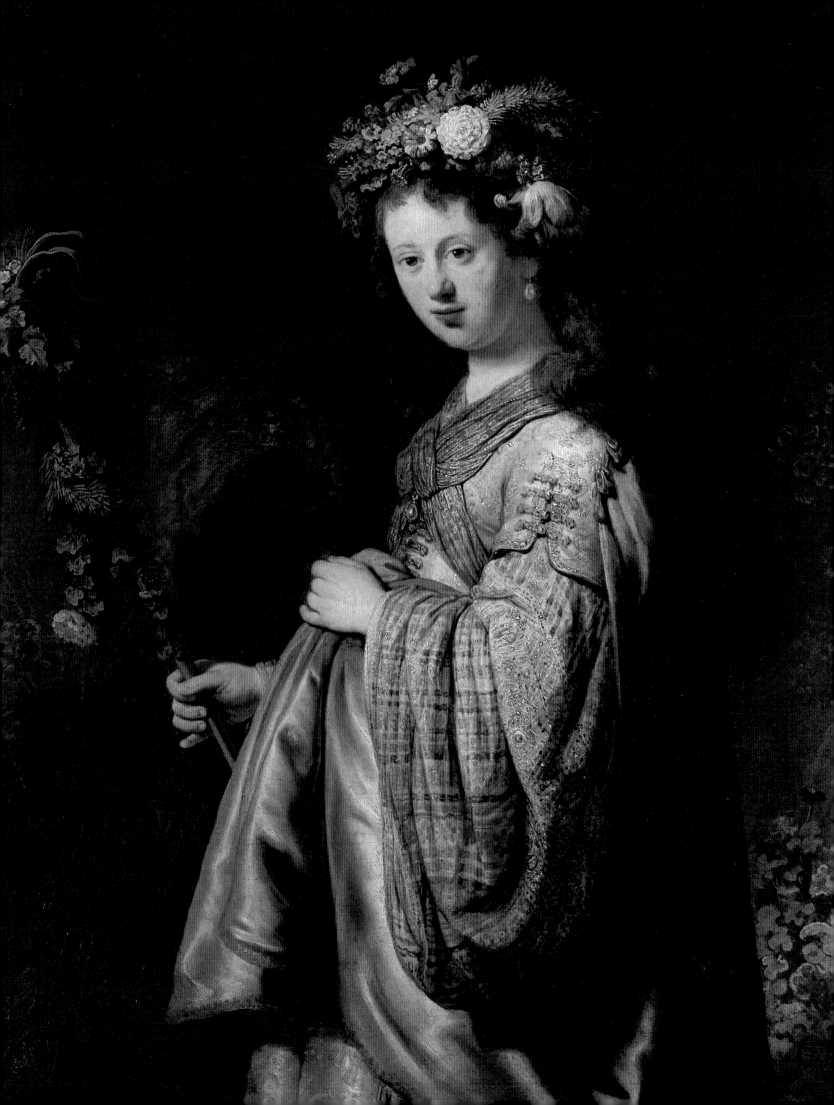

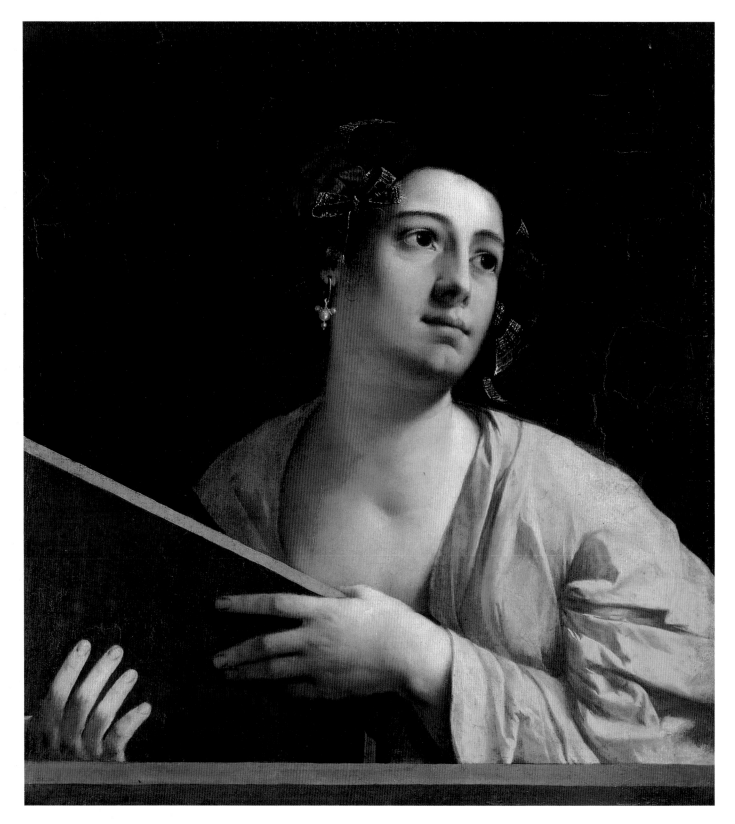

DOSSO DOSSI Trent ca. 1490–Ferrara 1542
Sibyl, 1516/20
(Inv. No. 7) Oil on canvas 27 × 33″ (68.5 × 84 cm)
(Ex coll. Coesvelt, Amsterdam, 1814)

adding human interest to abstract contrivance.

Some great artists, by the force of their fantasy, erudition, and illusionism, overcame allegory's aridity. Pieter Paul Rubens, adapting antique prototypes—a Roman statue of Cybele, the maternal earth goddess, along with that of a Neptune or river god—brought an allegory of the *Union of Earth and Water* (80) to radiant life. Their hands joined upon a pouring vessel, symbolizing Antwerp's Scheldt River, Earth—Antwerp and her environs—marries Water (that city's profitable river, harbor, and sea). Water god and earth goddess gaze into one another's eyes as their union is celebrated by a Victory who places marital garlands upon their brows.

The Judgment of Paris, where that prince must decide an awesome beauty contest between Athena, Hera, and Aphrodite, along with any number of themes in which gods or mortals have to make up their minds, boil down to one of life's thorniest, most readily identifiable torments: the agony of choice. These decisions lend themselves readily to representation, to compositions of three or four figures, each laden with symbolic or narrative import, with all the implicit joys and sorrows native to the nuclear family.

Innocence Choosing Love over Wealth (81) was designed by Pierre-Paul Prud'hon, yet signed solely by his beloved associate Constance Mayer-Lamartinière in 1804, when it was exhibited at the Salon. For all its overt moralizing, the picture has

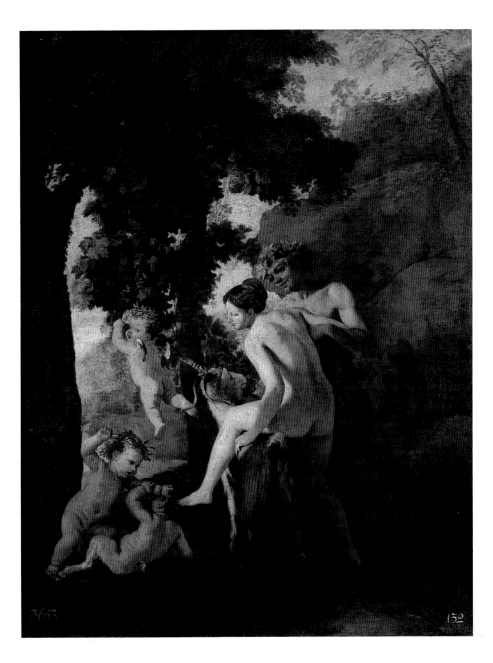

a complex substructure, offering loaded choices and subversive agendas. As Wealth, like Innocence, is shown as a beautiful woman, the latter's decision may involve more than money. She embraces Love, an enormously winged male, nude but for a prominent loincloth, who has his hand upon her breast. Equally titillating is Batoni's *Hercules Between Love and Wisdom* (81), where a naked hero glowers at wise Athena as she points to the rough highroad of

NICOLAS POUSSIN
Satyr and Bacchante, 1630s
(Inv. No. 1178) Oil on canvas
28 × 22″ (72 × 56 cm)
(Ex coll. Crozat, Paris, 1772)

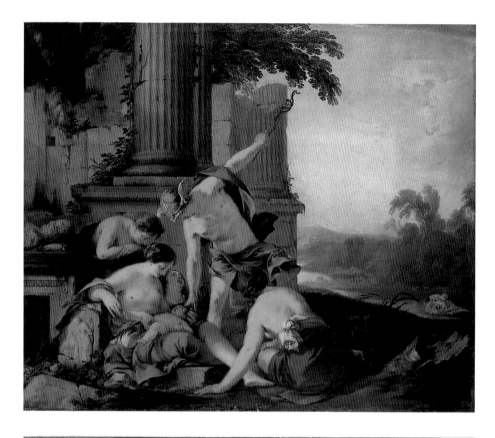

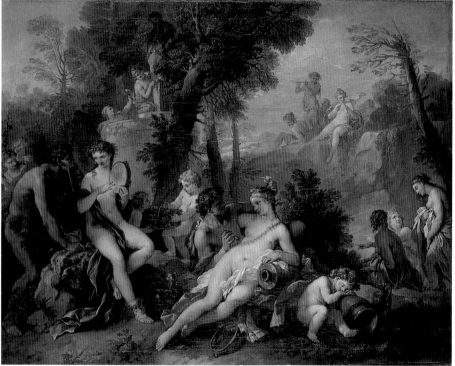

Left
LAURENT DE LA HYRE Paris 1606–1656
Mercury Giving Bacchus to Nymphs to Raise, 1638
(Inv. No. 1173) Oil on canvas
49 × 52" (125 × 133 cm)
(Ex coll. Crozat, Paris, 1772)

Below, left
CHARLES JOSEPH NATOIRE
Bacchus and Ariadne
(Inv. No. 1220) Oil on canvas
36 × 47" (91 × 120 cm)

Opposite
PIETER PAUL RUBENS
Bacchus, 1638/40 (Inv. No. 467)
Oil on canvas, transferred from panel
75 × 63½" (191 × 161.3 cm)
(Ex coll. Crozat, Paris, 1772)

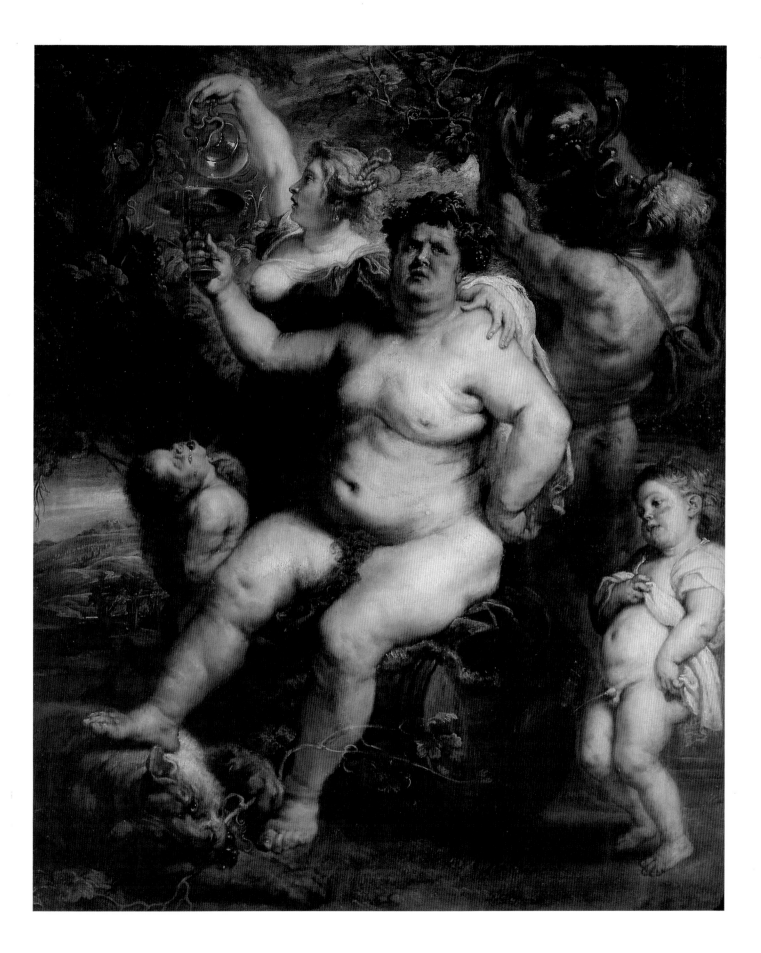

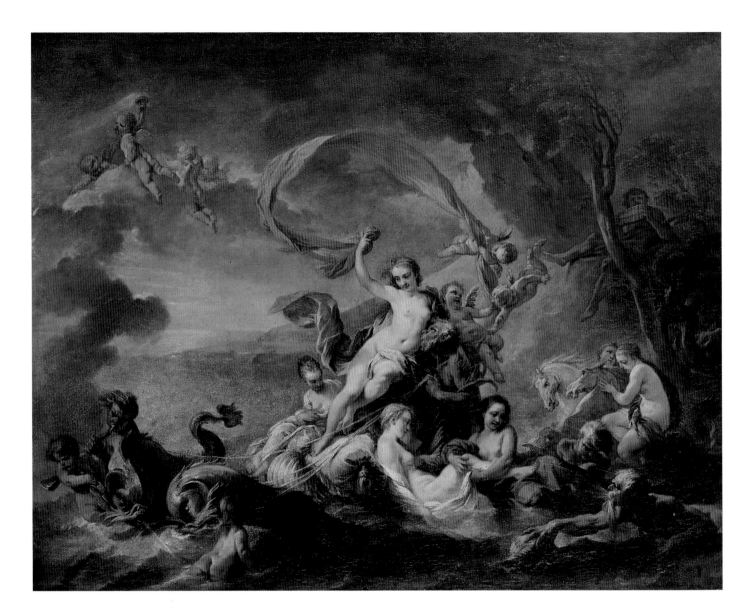

virtue. A deliciously décolleté Venus waves a rose in Hercules's face, promising accessible joys of love if he takes the lowroad of earthly pleasures. Whom will he choose? That's for you to guess. Or know.

Triumph, that celebration of victory, cannot be conveyed without returning to those who invented its performance, the crafty propagandists of ancient Greece and Rome. Working with poets, playwrights, composers, leaders of choruses, and dancers, those pageant-masters of the past just knew what winning

was all about. Great arches with narrative and symbolic reliefs, piles of trophies, prisoners in chains, timely acts of mercy, parades of the victors and the vanquished, these many exultant or tragic images addressed the central issue: "We won—you lost!"

Rubens took over the barrage of metaphors connected with these victories in classical art and literature and applied them to his Catholic patrons' needs. He helped establish the Habsburgs in the Lowlands by designing temporary architecture to celebrate their vic-

JEAN BAPTISTE VAN LOO
Aix-en-Provence 1705–1765
The Triumph of Galatea
(Inv. No. 1219) Oil on canvas
35 × 45½" (89.5 × 116 cm)

Opposite
FRANÇOIS BOUCHER
Pygmalion and Galatea
(Inv. No. 3683) Oil on canvas
90½ × 129½" (230 × 329 cm)

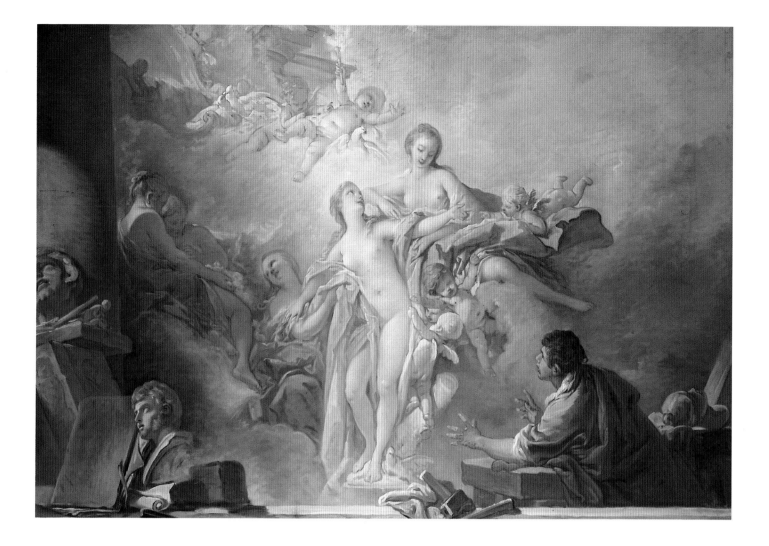

tories. The grandest of these festivities took place in 1635, when the city of Antwerp planned a triumphal entry—an *Entrée joyeuse*—for the new governor of the Spanish Netherlands, the Cardinal Infante Ferdinand of Austria. He had already proven his military mettle, blessed with the double-barreled clout of two hats—those of cardinal and general. Two of Rubens's great archway projects, along with six figure studies for the same lavish Joyful Entry are in the Hermitage. All this temporary splendor was to celebrate a victory which would never take place, one over Dutch mercantile competition, toward the revival of Antwerp as a great center for trade and industry.

The Temple of Janus (82), sketched for an arch nineteen meters high and fifteen meters wide, was still more complex in execution (as is known from prints) than in this initial design. Its central theme is War's forcing the doors of the temple of the two-faced god, Janus, whose bust is on the central pediment. The arch contrasts Tranquility and Security, on the right, with the Ferocity of War, at left.

Like so many of Rubens's projects, this one is steeped in classical sources, most motifs being based upon ancient numismatics. A roundel of Honor and Virtue (on the side of Peace) is encircled by a pacific wreath of laurel, itself ringed by the arts' attributes—palette,

JAN VAN KESSEL I Antwerp 1626–1679
Venus at Vulcan's Forge
(Inv. No. 709) Oil on canvas
23½ × 33″ (59.5 × 84 cm)

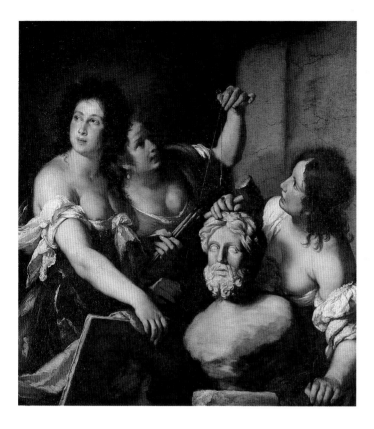

Above, left
BERNARDO STROZZI Genoa 1581–Venice 1644
Allegory of the Arts, ca. 1640
(Inv. No. 6547) Oil on canvas
60 × 55″ (152 × 140 cm)

Above, right
LUCA GIORDANO Naples 1634–1705
Vulcan's Forge (Inv. No. 188)
Oil on canvas, transferred from panel
76 × 59½″ (192.5 × 151.5 cm)
(Ex coll. Walpole, Houghton Hall, 1779)

Right
CHARLES LEBRUN Paris 1619–1690
Daedalus and Icarus
(Inv. No. 40) Oil on canvas
75 × 49″ (190 × 124 cm)

Overleaf
JAN VAN KESSEL I *Venus at Vulcan's Forge* (detail)

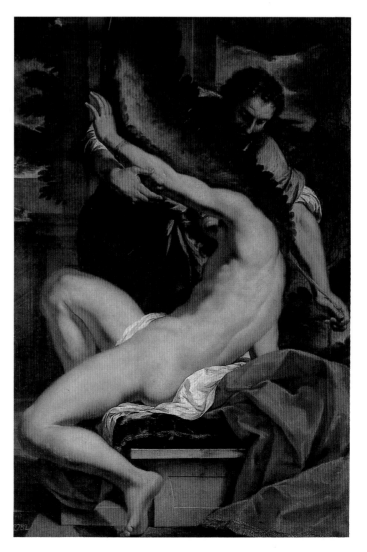

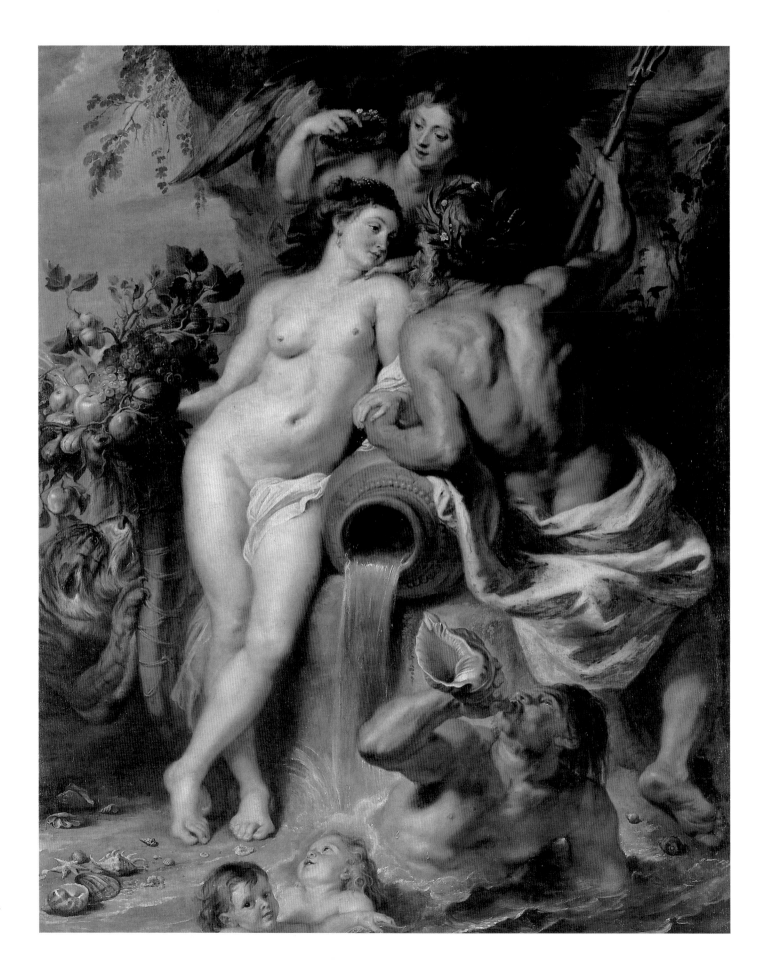

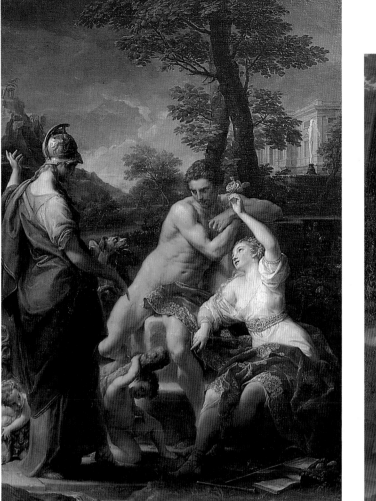

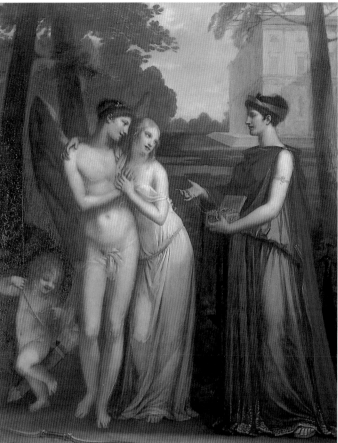

brushes, lyre, square, and compasses—all flourishing without war. In nun's garb, the widowed Archduchess Isabella holds a torch; she tries to keep War from charging through the gates. Appropriately, this arch, where women fight for peace, was placed in Antwerp's milk market, center of the kindest of trades.

The same fictive architecture that took on such strength in the *Arch of Janus* extends to Rubens's *Statue of Ceres* (83), a character whose nurturing nature, essential to a harvest goddess, is accentuated by the sterile power of her rusticated masonry setting. She, too, is based upon a Roman statue.

Gifted with an unusually dramatic view of everything—portraiture, history painting, or satire—Salvator Rosa's *Democritus and Protagoras* (84) presents the key moment in which the Greek philosopher selects his disciple on the basis of Protagoras's systematic binding of brushwood. Once again the episode is taken from ancient literature, invested with profundity and moral seriousness, almost as if these qualities were precluded by the present, going back to the Golden Age with its plenitude of great minds beyond return.

Rosa's passion for drama led him to choose the passage in the *Odyssey* where a shipwrecked Odysseus

Above
PIERRE-PAUL PRUD'HON Cluny 1758–
Paris 1823
(in collaboration with Marie François
Constance Mayer-Lamartinière)
Innocence Choosing Love over Wealth, 1804
(Inv. No. 5673) Oil on canvas
95½ × 76″ (243 × 194 cm)

Above, left
POMPEO GIROLANO BATONI Lucca
1702–Rome 1787
Hercules Between Love and Wisdom, 1765
(Inv. No. 4793) Oil on canvas
96½ × 68″ (245 × 172 cm)

Opposite
PIETER PAUL RUBENS
The Union of Earth and Water, ca. 1618
(Inv. No. 464)
87½ × 71″ (222.5 × 180.5 cm)
(Ex coll. Kijé, Rome, 1798/1800)

PIETER PAUL RUBENS
The Temple of Janus, ca. 1635
(Inv. No. 500) Oil on panel
27½ × 26″ (70 × 65.5 cm)
(Ex coll. Walpole, Houghton Hall, 1779)

Opposite
PIETER PAUL RUBENS
Statue of Ceres, ca. 1615
(Inv. No. 504) Oil on panel
35½ × 26″ (90.3 × 65.5 cm)
(Ex coll. Cobentzl, Brussels, 1768)

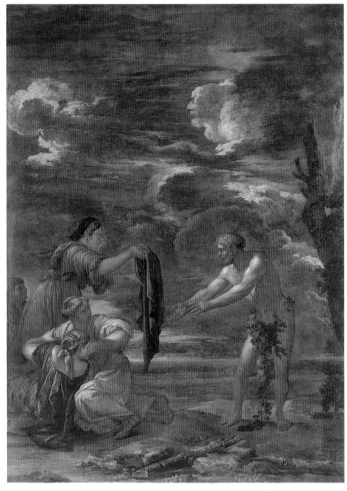

Above
SALVATOR ROSA Naples 1615–Rome 1673
Democritus and Protagoras, 1650s
(Inv. No. 31) Oil on canvas, transferred from panel
73 × 50" (185 × 128 cm)
(Ex coll. Walpole, Houghton Hall, 1779)

Above, right
SALVATOR ROSA
Odysseus and Nausicaa, 1650s
(Inv. No. 35) Oil on canvas, transferred from panel
76½ × 56½" (194.5 × 144 cm)
(Ex coll. Walpole, Houghton Hall, 1779)

Opposite
EUSTACHE LE SUEUR Paris 1616/17–1655
King Darius Visiting the Tomb of His Father Hystaspes
(Inv. No. 1242) Oil on canvas
64 × 44" (163 × 112 cm)
(Ex coll. Crozat, Paris, 1772)

Page 86
SÉBASTIEN BOURDON Montpellier 1616–Paris 1671
The Death of Dido
(Inv. No. 1247) Oil on canvas
62½ × 54" (158.5 × 136.5 cm)
(Ex coll. Crozat, Paris, 1772)

Page 87, top
JOHANN HEINRICH SCHÖNFELDT
Biberach 1609–Augsburg 1682/83
The Rape of the Sabine Women
(Inv. No. 2513) Oil on canvas 39 × 53" (98.5 × 134 cm)

Page 87, bottom
THOMAS HAMPSON JONES Readonshire, Wales 1743–1803 (?)
Landscape with Dido and Aeneas, 1769
(Inv. No. 1343) Oil on canvas
54 × 76" (137.5 × 193.5 cm)
(Ex coll. G.A. Potemkin, St. Petersburg, 1792)

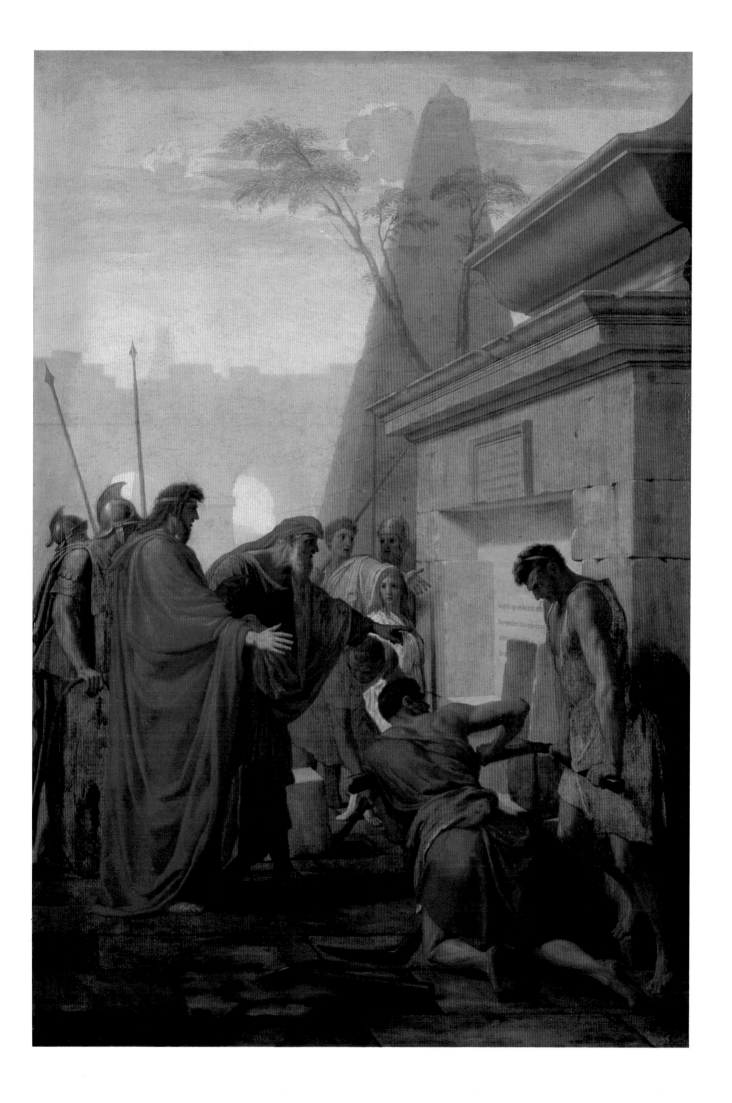

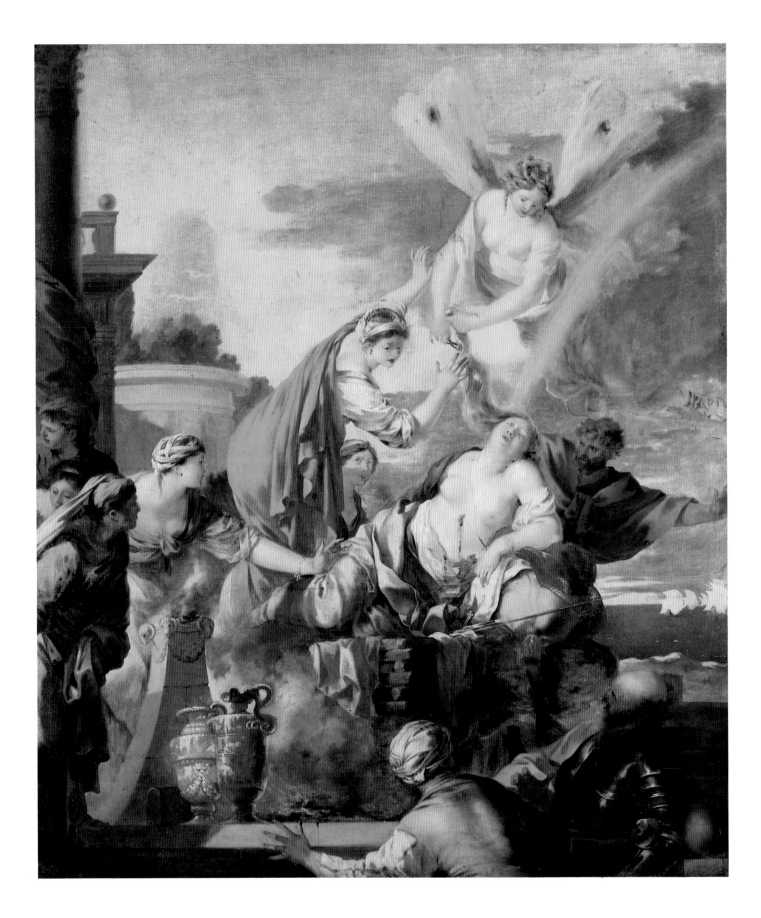

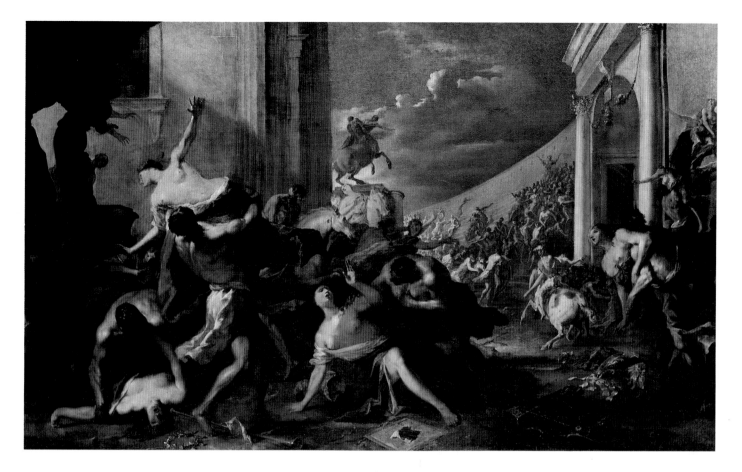

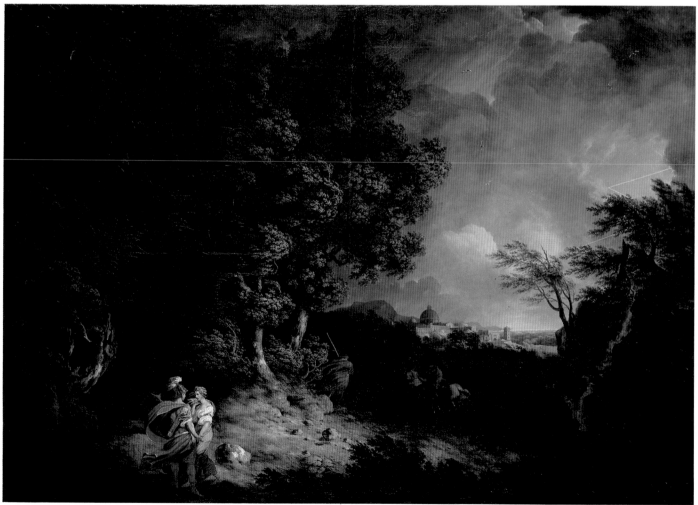

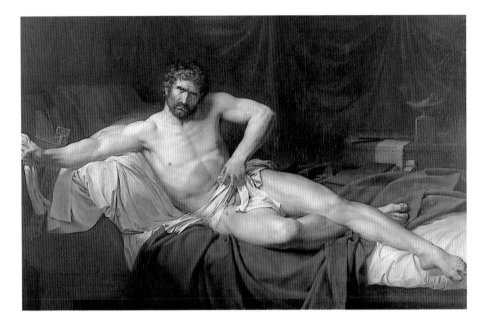

Left
GUILLAUME GUILLON LETHIÈRE
St-Anne 1760–Paris 1832
Death of Cato of Utica, ca. 1795
(Inv. No. 1302) Oil on canvas
59 × 89″ (149.5 × 226 cm)
(Ex coll. K.A. and E.P. Vlasov, 1899)

Below
PIETER PAUL RUBENS
A Roman Woman's Love for Her Father
(Roman Charity), ca. 1612
(Inv. No. 470) Oil on canvas,
transferred from panel
55 × 71″ (140.5 × 180.3 cm)
(Ex coll. Cobentzl, Brussels, 1768)

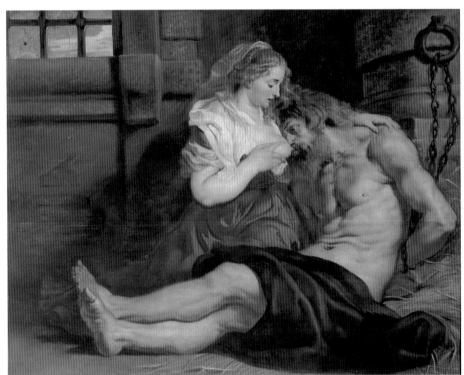

Opposite
MASSIMO STANZIONE
Naples 1585/86–1656
Cleopatra
(Inv. No. 10030) Oil on canvas
66½ × 39″ (169 × 99.5 cm)

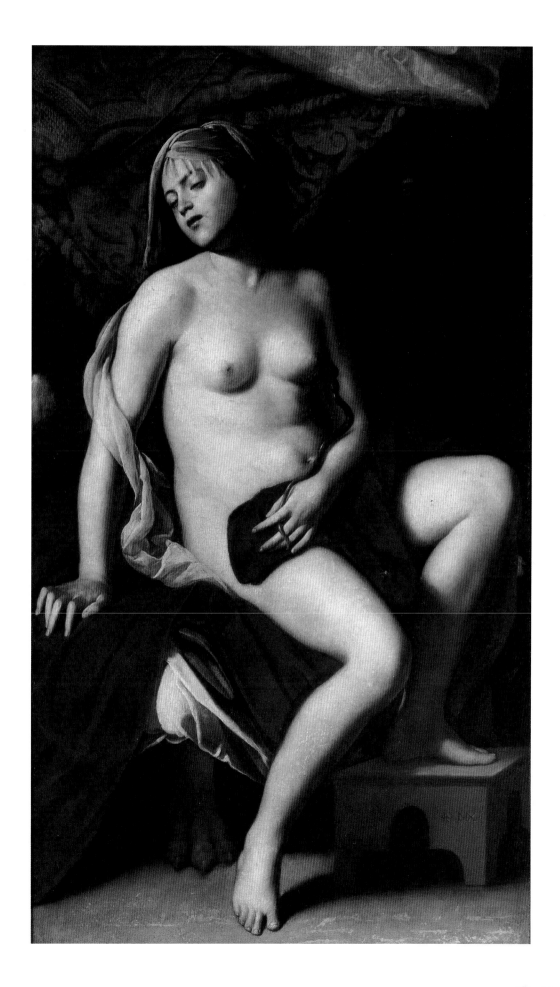

is washed up on the shores of Nausicaa's island as middle-aged jetsam (84). The gods, sporadically caring for their hero's welfare, now see to it that the sailor attracts Nausicaa by restoring his youthful luster, gilding his hair, tanning and invigorating his body. All three women facing Odysseus exhibit varying degrees of interest, handing him a much-needed towel as he emerges from the waters. Like so many classical themes, this is one of change, of altering physical and psychological states, a challenge to the painter restricted to one pose and moment to convey many.

History painting was long considered art's highest form, far from the pandering of portraiture or the supposed sordid triviality of still life or everyday scenes. Eustache Le Sueur's large *King Darius Visiting the Tomb of His Father Hystaspes* (85) was the sort of imperial subject that offered special appeal to an age of absolutism, when Louis XIV saw himself as the spirit of enlightened rule. Darius's vast military campaigns, his sponsorship of studies, and his reorganization of religion and state made him a model for Louis.

Of all classical literature, the *Aeneid* was dearest to the West since almost every ruling house claimed direct descent from its eponymous hero, Aeneas, son of the Trojan nobleman Anchises and Venus. The poor Trojans, their city totally destroyed by "Greeks bearing gifts"— the great wooden horse having smuggled enemy soldiers into their midst—wandered around the Mediterranean until they resettled themselves with the foundation of

Rome. They led lives of adventure, looked after jealously and benignly from above.

Thomas Jones, a Welsh eighteenth-century painter, showed Aeneas cavorting with his beloved Dido (87), queen of Carthage, the happy couple in a tame woodland setting. This naïve scene is very different from Sébastien Bourdon's magnificent tableau of the *Death of Dido* (86). Upon her funerary pyre, about to die, Dido prefers death to life without Aeneas, who, following Zeus's orders, sails away at the far right. Iris, with butterfly wings, rides down a rainbow, dispatched by a compassionate Hera to release Dido's soul.

A scene of extreme sexual violence and historical significance, *The Rape of the Sabine Women* (87) was always popular. Johann Heinrich Schönfeldt's version brings together many sculptural representations of the subject, almost as if it were an assemblage of statuary by the great Giambologna.

Biographies of philosophers and more arcane events from the remote past were grist for the same pictorial mill. These subjects often flattered their recipients, enhancing their virtue and wisdom. New knowledge of ancient literature, recovered since the later Middle Ages, made much of examples of Stoical virtue, of filial love such as that of Pero for her aged, imprisoned father, Cimon, who was condemned to death by starvation. She saved his life by nursing him at her breast. Rubens's plausible depiction of that strange subject (88) brought it a massive dignity, elevating what lesser hands and minds might have

JACQUES-LOUIS DAVID
Paris 1748–Brussels 1825
Sappho and Phaon, 1809
(Inv. No. 5668) Oil on canvas
89 × 103" (225.3 × 262 cm)

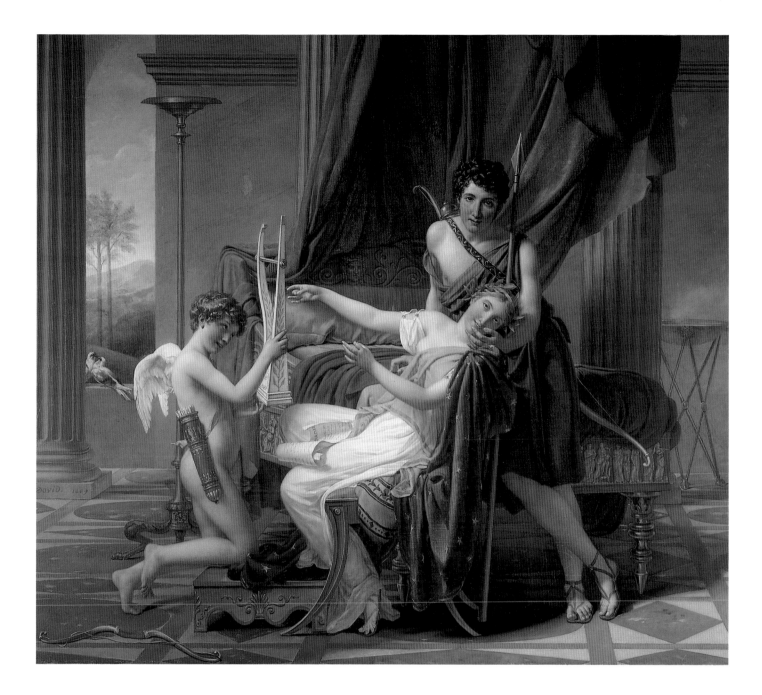

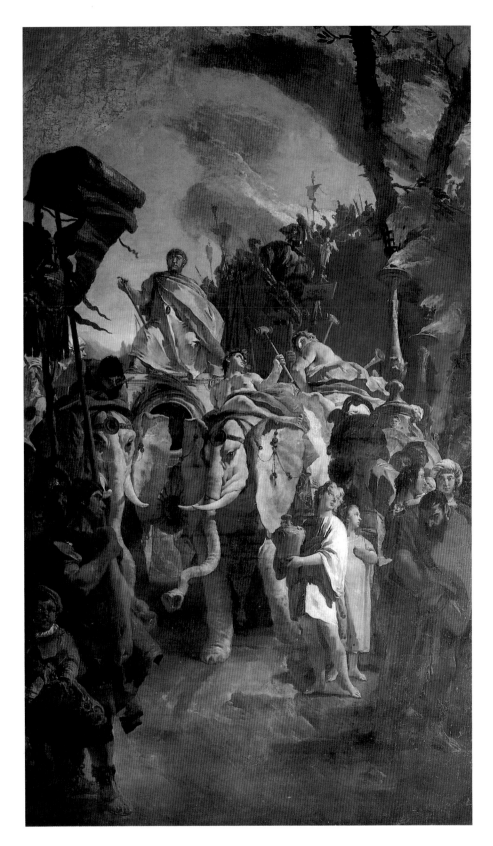

GIOVANNI BATTISTA TIEPOLO
Venice 1693–Madrid 1770
The Triumph of Aurelian
(Inv. No. 7475) Oil on canvas
215 × 127″ (546 × 322 cm)

Opposite, top
BERNARDINO FUNGAI Siena 1460–1516
The Magnanimity of Scipio Africanus
(Inv. No. 267) Tempera and oil on panel
24½ × 65″ (62 × 166 cm)

Opposite, bottom
GIOVANNI BATTISTA TIEPOLO
*Maecenas Presenting the Liberal Arts to the Emperor
Augustus*, ca. 1745
(Inv. No. 4) Oil on canvas
27 × 35″ (69.5 × 89 cm)
(Ex coll. Brühl, Dresden, 1769)

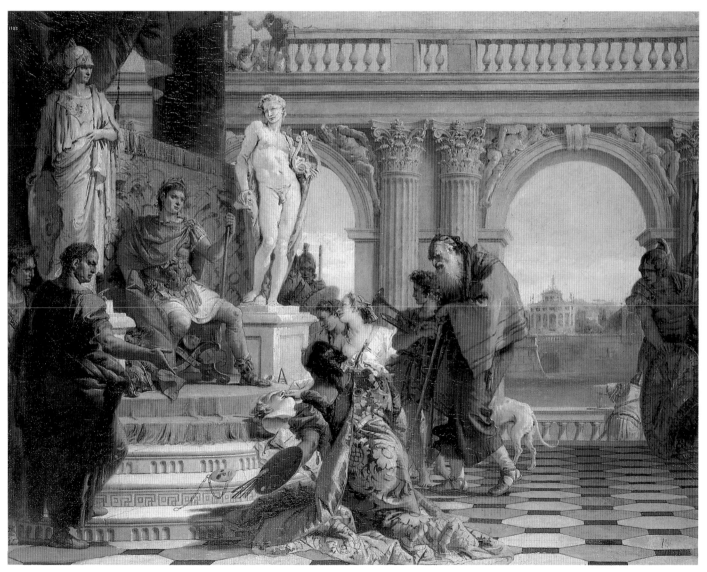

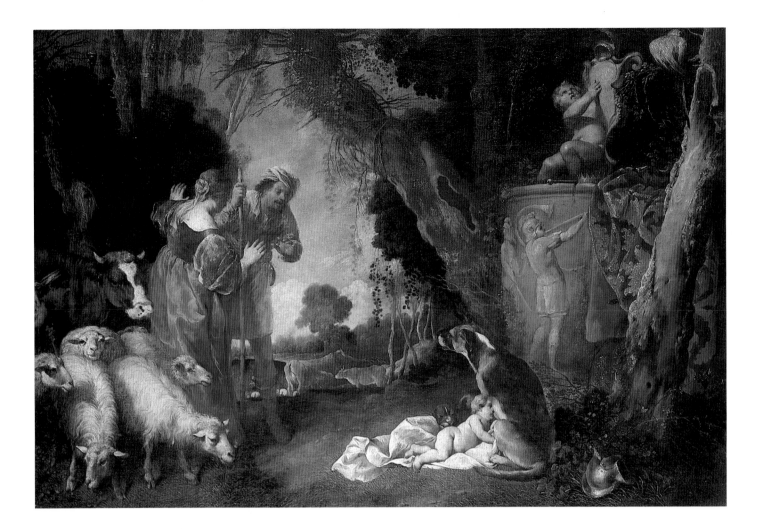

reduced to a risible incest fantasy to a moving image of rare solemnity.

Another example of Stoical virtue is the *Death of Cato of Utica* (88), depicting the suicide of a staunchly republican Roman who chose death over Caesar's dictatorship. This painful scene provides the viewer with a vivid lesson in classical *hari kiri*, along with an equally close study of the anatomy of the unfair sex. Exhibited by its painter, Guillaume Lethière, at the Salon of 1795, this subject reflects the politics of the period, and was taken, like so many similarly tough-minded and bodied topics, from Plutarch's *Lives*.

David's determinedly heterosexual *Sappho and Phaon* (91) presents that ecstatic poet in the arms of her putative lover, her words, "He appears to me as god's equal" (Ode II,1), inscribed on a scroll in Greek as if to document Phaon's existence. A very large Cupid has his work cut out for him as he holds out a harp for Sappho's languorous plucking. Her somewhat stunned gaze is shared by the sheepish, reluctant suitor, both shown at that critical moment when, in David's description, "Cupid has at last kindled the passion of love."

Where the French artist had previously cultivated a severely Roman "Republican" style, suitable to his role of pageant-master to the French Revolution, and then a more opulent, Napoleonic manner,

ANTONIO MARIA VASSALLO
The Birth of King Cyrus
(Inv. No. 221) Oil on canvas
29 × 43″ (74.5 × 110 cm)
(Ex coll. Walpole, Houghton Hall, 1779)

Opposite
ANTONIO MARIA VASSALLO
The Birth of King Cyrus (detail)

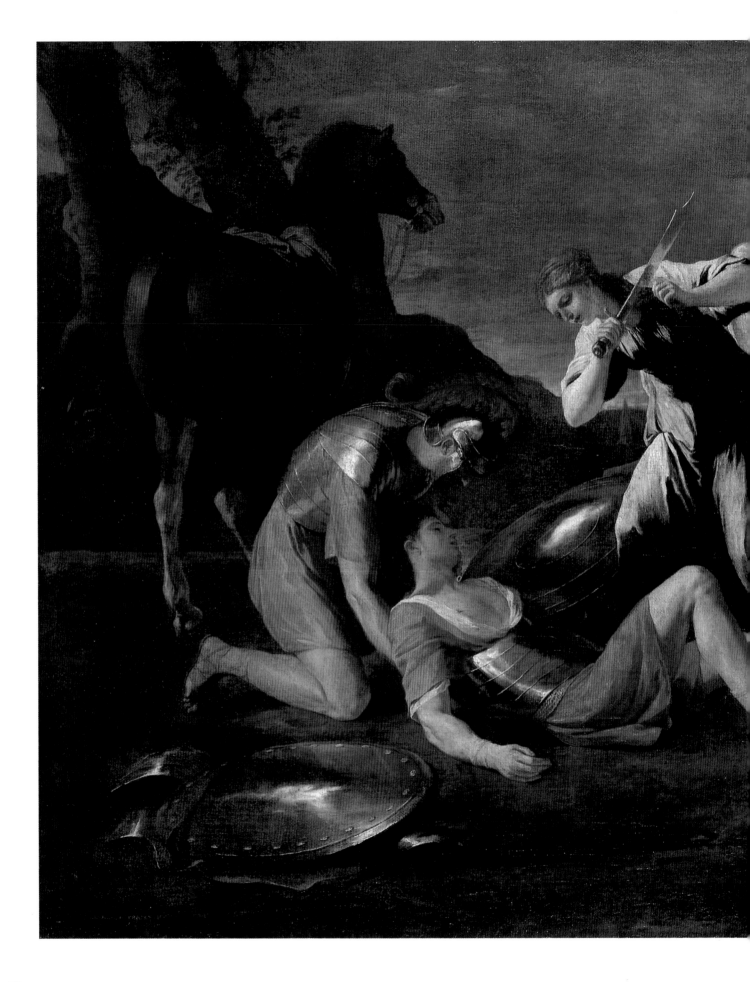

his style is now softened by an almost Correggiesque sensuality and a new stress on the decorative, as seen in this vast picture-postcard romance. Some may find *Sappho and Phaon* too contrived or just plain silly—the last gasp of a played-out, post-Napoleonic, high-campain—yet exquisite passages, such as Sappho's chryselephantine arm, linger in the mind long after they ravish the eye. Scholars at the Hermitage have noted how the recently cleaned canvas shows a new, bold use of color that comes as a surprising foreshadowing of Matisse.

Personifying kindness, tolerance, and generosity in the midst of victory, Scipio Africanus's character came as a welcome reminder that no matter how unlikely it might seem, one and the same person could be a great military leader and a man of magnanimous spirit. Combining the best of both worlds, this Roman general-emperor, from modest origins, was a popular figure in ever-combative Europe. Two long panels by the Sienese Early Renaissance painter Bernardino Fungai are in the Hermitage. One shows Scipio's celebrated magnanimity (93) and the other the general with his partisans. In the first, the reward for such an enlightened military policy

NICOLAS POUSSIN
Tancred and Erminia, 1630s
(Inv. No. 1189) Oil on canvas
39 × 57½" (98.5 × 146.5 cm)
(Ex coll. J.A. Aved, Paris, 1766)

is indicated by the general's throne with its horns of plenty, suggesting that plenty comes with kindness.

Another scene of benevolence is Giovanni Battista Tiepolo's tableau of Maecenas, the magnificent Roman patron of the arts, as he introduces female personifications of Painting, Sculpture, and Architecture, along with Poetry—blind Homer—to the young emperor, Augustus (93). Here the message is that all achievements are soon forgotten; greatness needs perpetuation by the genius of the arts.

Less lyrical and about thirty years earlier in date is Tiepolo's *Triumph of Aurelian* (92) one of a large series of classical victories painted for the Venetian palace of the Dolfin, a family of soldier-patriots close to antiquity's military values and doubtless claiming descent from Roman emperors. Aurelian's African victories are symbolized by great elephants—he is almost overshadowed by their massive presence—along with the banners and prisoners passing before him.

Best known for his skills as an animalier and flower painter, Andrea Vassalo put both to good effect in painting such subjects as *The Nurture of Cyrus* (94, 95). The future king of Persia was abandoned at birth because his grandfather had dreamed that his daughter would give birth to a deluge that would flood Asia. The infant was found by shepherds and nursed by their bitch (whose puppy glares resentfully at the two-legged interloper). Cyrus went on to conquer Babylon and released the Jews from captivity, freeing them to return to Israel. Merciful to the Babylonians, he

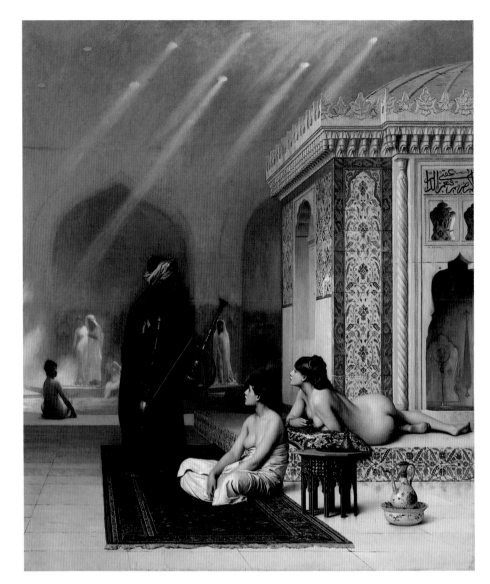

proved less so to his grandfather: Cyrus killed him. This little picture may be a pendant to another at the Hermitage of *Orpheus*, another good subject for an animalier.

Nostalgia came with the Gothic-revisited in sixteenth-century romances by Ariosto and Tasso. These leading Italian poets of the Late Renaissance revived a knightly world of derring-do, of days when knights were bold, when crusades were won for love of God and fair maiden alike. But they recast Gothic chivalry in terms of the antique. Only a Poussin could

JEAN-LÉON GÉRÔME
Vesoul 1824–Paris 1904
Harem Pool
(Inv. No. 6221) Oil on canvas
29 × 24″ (73.5 × 62 cm)

Opposite
JEAN-LÉON GÉRÔME
Slave Auction
(Inv. No. 6294) Oil on canvas
36 × 29″ (92 × 74 cm)

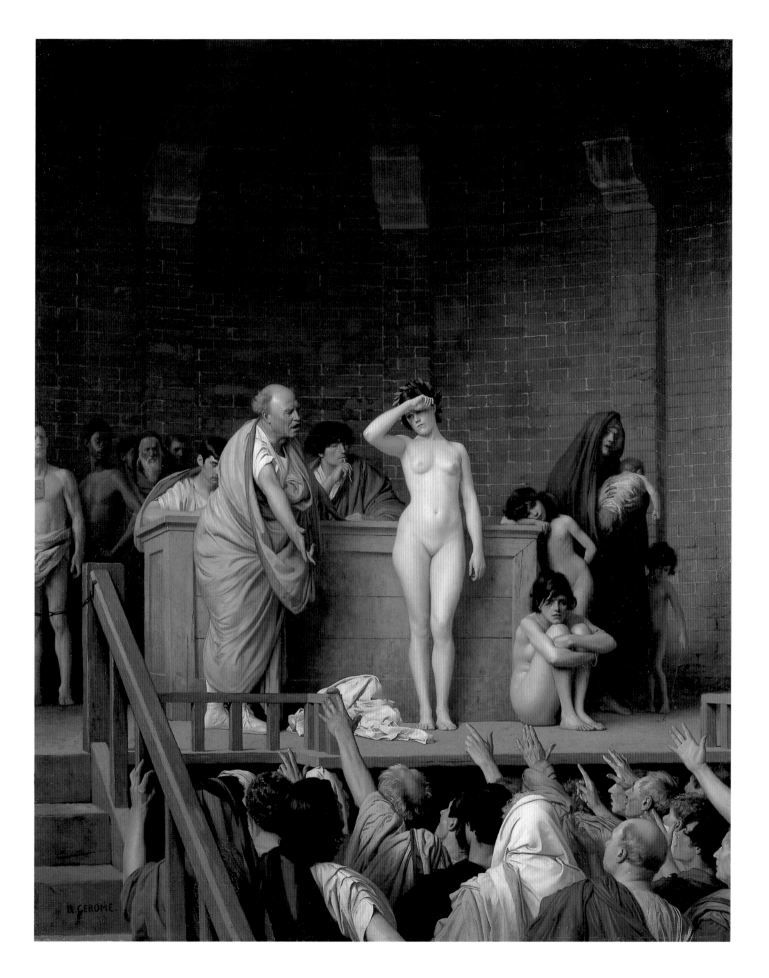

Above

HENRI MATISSE Le Cateau-Cambrésis 1869–Cimiez 1954
Arab Coffeehouse, 1913
(Inv. No. 9661) Oil on canvas
69 × 82½″ (176 × 210 cm)
(Ex coll. S.I. Shchukin, Moscow)

Opposite, top
EUGÈNE FROMENTIN La Rochelle 1820–Paris 1876
Desert Scene, 1868
(Inv. No. 6104) Oil on canvas
40 x 65″ (102.5 × 166 cm)

Opposite, bottom left
MARIANO JOSÉ MARIA BERNARDO FORTUNY Y CARBO
Catalonia 1838–Rome 1874
Moroccan Soldier (Inv. No. 7313) Oil on canvas
10½ × 6½″ (26.5 × 17)

Opposite, bottom right
FERDINAND-VICTOR-EUGÈNE DELACROIX
Charenton-St-Maurice 1798–Paris 1863
Moroccan Saddling a Horse, 1855
(Inv. No. 3852) Oil on canvas 22 × 18½″ (56 × 47 cm)

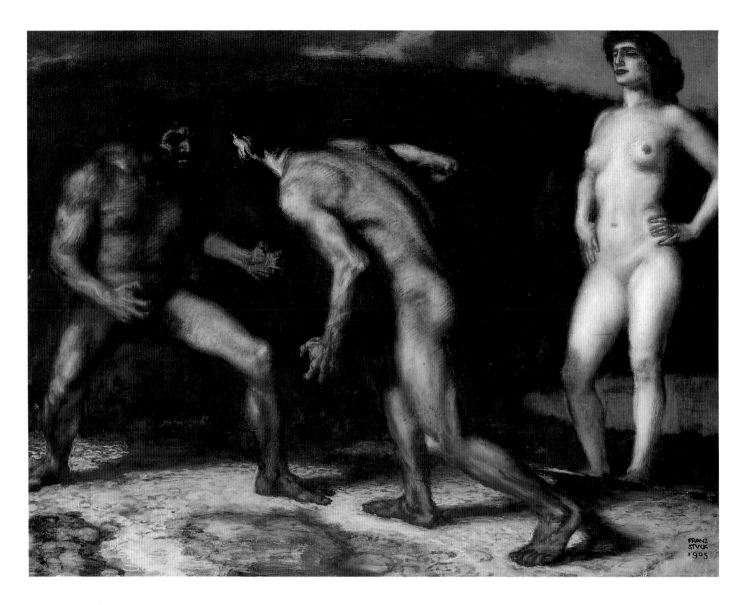

make these keening, vastly elabo-
rate, "cast of thousands" sagas, with
their clanking imagery of magic
steeds and swords, come across in
such dignified yet deeply human
fashion. The French artist saw his
overwrought libretto in terms of a
haunting, stripped-down vision
without losing a sense of noble ro-
mance in his second version of
Tancred and Erminia (96–97) from
Tasso's *Gerusalemme Liberata* (1581).
Upon viewing her victim for the
first time, Erminia, mistress of East-
ern magic, whose spells have led to
Tancred's death, realizes that she
has killed the man she loves. Com-

pared with the artist's earlier ver-
sion (Barber Institute of Arts, Bir-
mingham), the Hermitage's
painting is radically simplified.
Now the flourishes and sensuality
of the first are gone, the new image
nearing the basic classicism of a
Piero della Francesca.

Combining cherished values—the
biblical and the imperial—North
Africa was a fertile crescent for
French pictorial exploration.
Scenes of Egypt and Morocco had
been particularly popular ever
since Napoleon conquered the for-
mer, and Delacroix explored Jew-

FRANZ RITTER VON STUCK
Tettenweise 1863–Munich 1928
Battle for a Woman, 1905
(Inv. No. 9175) Oil on panel
35½ × 46" (90 × 117 cm)

Opposite
PIERRE CECILE PUVIS DE CHAVANNES
Lyons 1824–Paris 1898
Mad Woman at the Edge of the Sea, 1857
(Inv. No. 6564) Oil on canvas
29 × 29" (74.5 × 74 cm)

ish and Arab (100) life in Morocco. Slavery, a practice sanctioned by the Good Book (and none too far from Russian serfdom), was painted with luminous, fanciful eroticism by Jean-Léon Gérôme. The first of his Hermitage canvases (99) was bought for Czar Alexander III from the Salon of 1876, and the second (98) for his sister-in-law, the Grand Duchess Aleksandrovich.

Artists often designed their pictures' frames and Gérôme (who received unusually high prices for his grown-up peek-a-boos) provided them with ornate borders that both echoed the Orientalizing architectural motifs within and increased

the sense of perspective and sensation of voyeurism.

Painters traveled to the new French empire in North Africa as part of their military service or in search of exotic, Byronic adventures in the Wild Near East, looking for subjects that conveyed an intensity of passion, or simplicity of feeling, free from the constraint and corruption of the bourgeoisie, haute and petite alike.

Fortuny, a Spanish master of rare dash and realism, went to North Africa as an officer, where he made many studies like the *Moroccan Soldier* (100). Equally successful as art historian and as a painter, Eugène

Above
VINCENT VAN GOGH
Groot-Zudert 1853–Auvers-sur-Oise 1890
Ladies of Arles (Memory of the Garden at Etten), 1888
(Inv. No. 9116) Oil on canvas
29 × 36½″ (73.5 × 92.5 cm)
(Ex coll. S.I. Shchukin, Moscow)

Opposite, top
PAUL GAUGUIN
Scene from Tahitian Life, 1896
(Inv. No. 6517) Oil on canvas
35 × 49″ (89 × 124 cm)
(Ex coll. S.I. Shchukin, Moscow)

Opposite, bottom
PAUL GAUGUIN
The Miraculous Source (Sweet Dreams), 1894
(Inv. No. 6510) Oil on canvas
29 × 38½″ (73 × 98 cm)
(Ex coll. I.A. Morozov, Moscow, 1931)

Overleaf
PAUL GAUGUIN *The Miraculous Source* (detail)

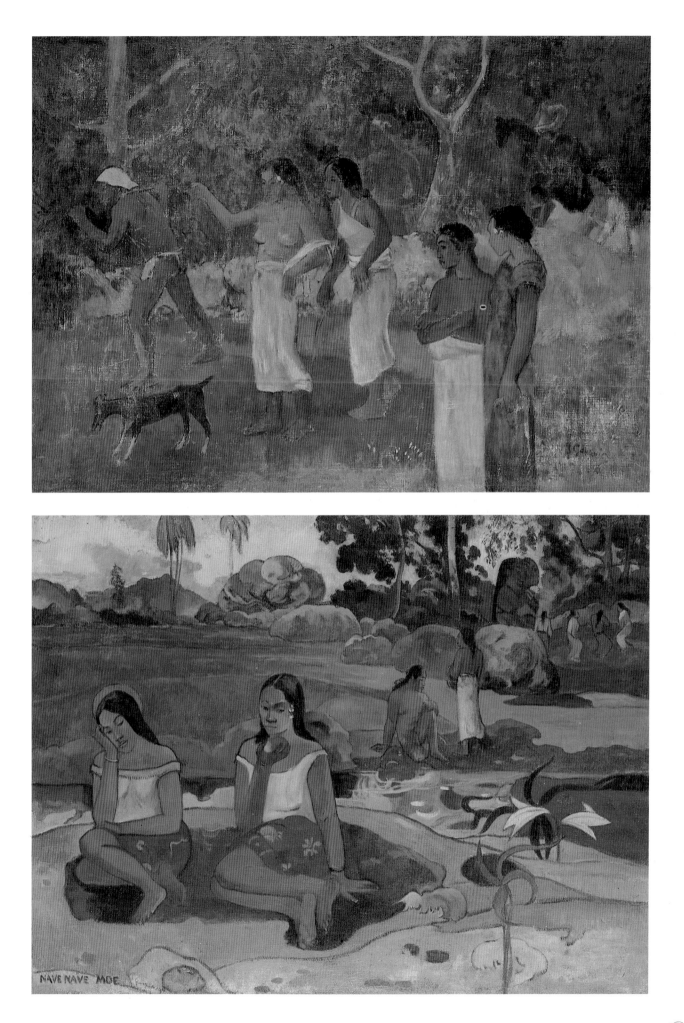

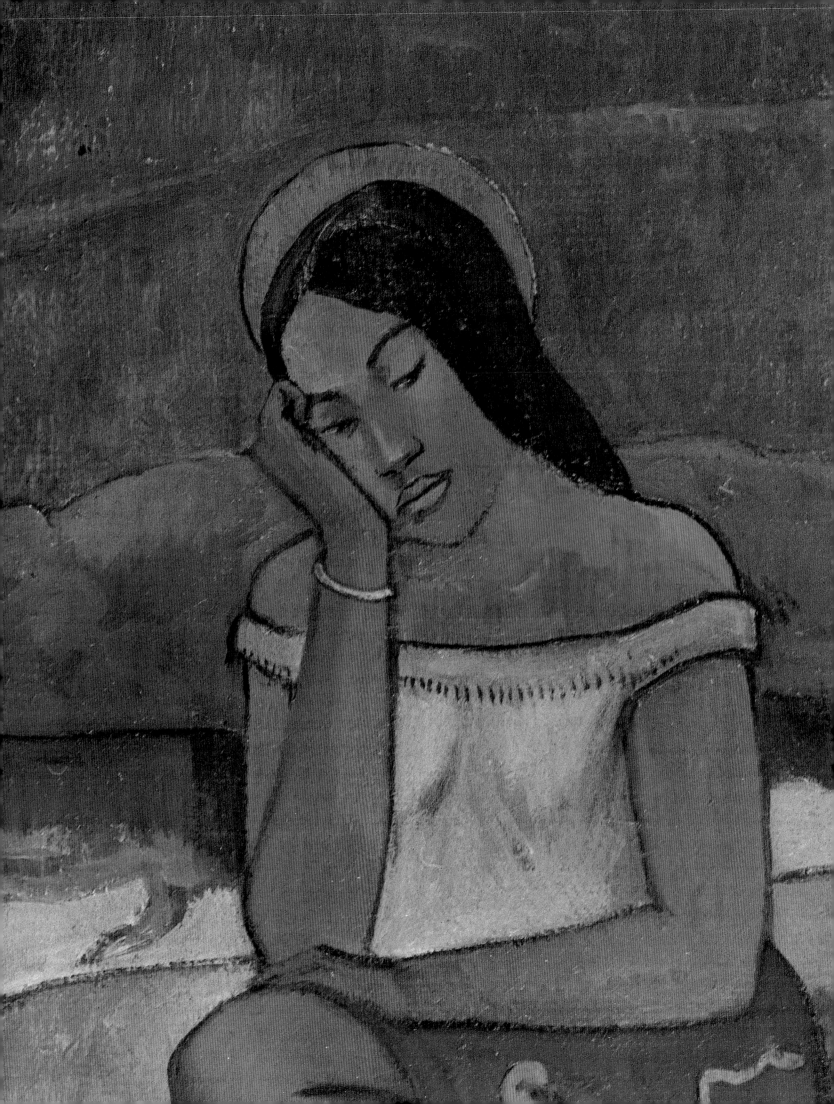

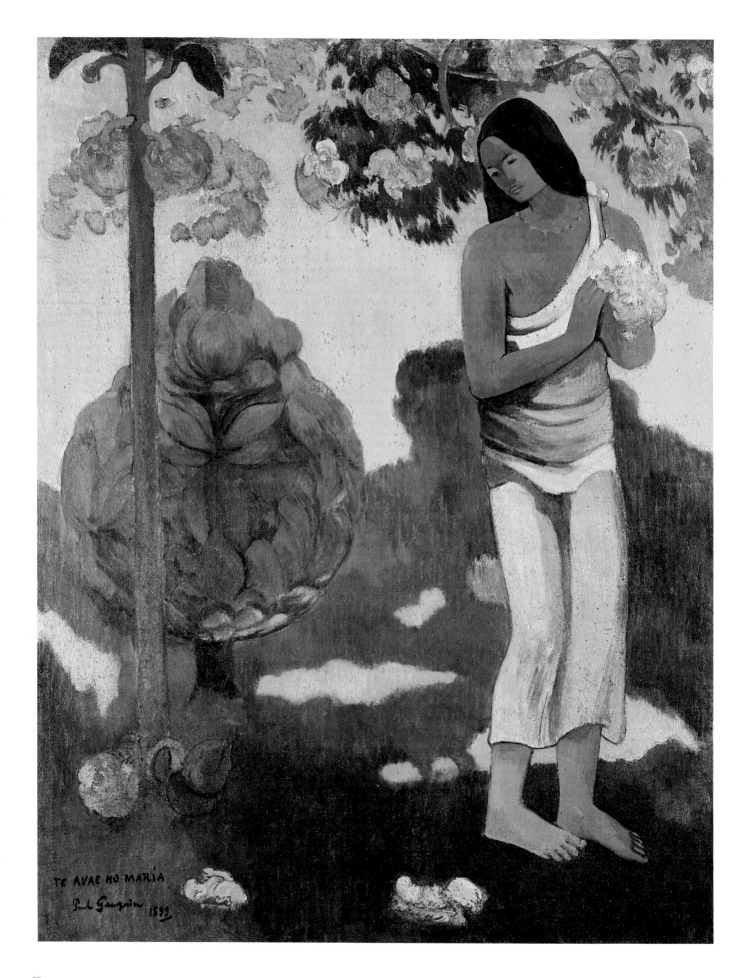

TE AVAE NO MARIA

Paul Gauguin 1899

Fromentin found scenes of romantic excitement in North Africa (100)—the capture of wild horses under a starry sky, with Géricault-like blacks pitting their force and craft against those of beasts.

Matisse's ample tapestry of Moroccan leisure (101) continues the exotic North African genre initiated almost a century before. Here his pleasure in architectural patterns, extended to that painted frame within a frame, anticipates the fresh quality of the découpages dating from the painter's old age. With its abundant sense of decorative delight, this Moroccan siesta is amusingly all-male in its *luxe*; almost suspiciously *calme* in the absence of *volupté*.

In the same spirit of moving away from the known, to the exploration of new emotions in new locations, Puvis de Chavannes showed a woman running on a beach (103), painted with a simplicity and authority that are both classical and revolutionary, breaking with the fussy refinements of contemporary taste. Using a novel economy of means, a daringly economical palette, and a bold confrontation and redefinition of tragedy, this too little-known French master manifests the qualities that made him so seminal a figure for Gauguin, Picasso, and many other early modernists.

Nineteenth-century painters deep in the woods of Fontainebleau saw this as a forest primeval, recalling the ancient *Urwald*. Further south, in the Provence, with its haunting fusion of rusticity and antiquity, peasant life took on even more

evocative qualities. There Van Gogh found Arles imbued with a purity and intensity far from urban sins. His flamelike forms wedded the ritual and the rustic in mysterious ways, beyond the needs and works of the everyday. *Ladies of Arles (Memory of the Garden at Etten)* (104) includes portraits of Van Gogh's relatives, strolling under the shade of a parasol. Their leisure is contrasted with the labor of a gardening woman whose back is bent in the agonizing maintainence of formal flower beds.

Gauguin also went to Arles to share a brief, disastrous residence with Van Gogh in 1888, but was soon traveling far further afield to find his rural paradise, sailing to Tahiti in 1891. Merging Christian and primitivistic themes, the Frenchman painted panoramas of native life limited to implausibly beautiful people. His prettified versions of the ceremonial and quotidian unfold in a Pacific Paradise Regained, realized through an eclectic art. Gauguin combined the decorative, abstract art of Puvis de Chavannes, whose talent he described as overwhelming him, along with vivid memories of Egyptian and many another ancient culture's line and color, closely studied in Paris long before leaving for Polynesia. That the painter never forgot his academic heritage is also felt in his titles, one of these Pacific panoramas called *Scene from Tahitian Life* (105) has figures close to the British Museum's Panathenaic Frieze from the Acropolis.

Another of his works that combines biblical and antique references is *The Miraculous Source*, or

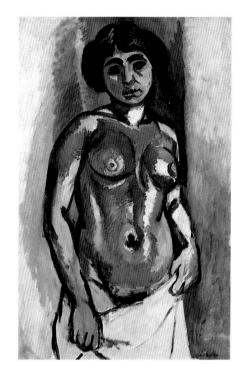

HENRI MATISSE
Nude Woman (Black and Gold), 1908
(Inv. No. 9057) Oil on canvas
39 × 25½″ (100 × 65 cm)
(Ex coll. S.I. Shchukin, Moscow)

Opposite
PAUL GAUGUIN
Woman with Flowers in Her Hands, 1893
(Inv. No. 6515) Oil on canvas
36 × 29″ (92 × 73 cm)
(Ex coll. I.A. Morozov, Moscow, 1931)

Sweet Dreams (105, 106–107), painted in France following the artist's first two-year residence in Tahiti. That island is seen once again as a promised land or paradise, the lily a virginal attribute, a religious symbol like the sleeping maiden's halo. Madonnalike, native mothers gather in the background while a spring bubbles near the artist's inscription—as if the latter rose from Pacific waters. Golden-hued and bare-breasted, Gauguin's Tahitian maid sustains dreams of maternal nurture as well as arousing fears for its loss. That's why the painter's inscription reads *"Nave nave moe"* ("Where are you going?").

Woman with Flowers in Her Hands (108) of 1893 is inscribed *Te avae no Maria* (In the Month of Mary), once again blending East and West, Christian and tribal. Its emphasis on abstract yet botanical forms is in keeping with the contemporary Art Nouveau movement so fashionable in Europe. Paradoxically, Gauguin, a brave advocate of natives' rights in an exploitative colonial system, conquered the people he loved by casting them in so classical a light, painting the Polynesians less as they were than as they might have been.

A similar yet more powerful fusion of classical and alien cultural elements prevails in Matisse's early *Nude Woman (Black and Gold)* (109) whose musical, abstract title recalls those of Whistler's paintings and Gautier's poems. While the figure still adheres to the conventional confines of an antique torso, it betrays a new boldness of form and color far beyond the academy's confines. Now, in 1908, Matisse

finds novel ways to convey one of the most ancient of subjects, with a radical simplification of chiaroscuro that recalls the sculptor's art, one in which he also excelled.

Only before the first of two world wars could this century's most persuasive modern images of a primal paradise have been painted: those by Matisse. Never again has an artist brought together belief in the possibility of initial harmony with so absolute a command of the body, one requiring the academy's rigorous familiarity with antiquity.

His two awesome, lyrical canvases of *Music* (111) and *The Dance* (112-113) are seamless in Matisse's merging of a totally novel colorism—a tricolor of red, blue, and green. Their confident lines are still close to those found on a Grecian or Etrurian pot, drawn with classical discipline and restraint. Matisse's sense of the nude in motion recalls those sculpted by Carpeaux in their vital, daring dance, cut in stone for the façade of Paris's Belle Époque temple of the arts— Garnier's opulent Opéra.

Each vast canvas returns to the mythology of a golden age; here the sexes separate to dance or make music on their own terms and hilltops. These sacred, elevated sites are meeting places of bright blue sky and bright green land for the genesis of new harmonies. By joining hands in their magical, ritual circle dance, five short-haired women, their skins an elemental red between clay and fire, bring together heaven and earth.

Five men, their egos in single unblessedness, even on this first

HENRI MATISSE
Music, 1910
(Inv. No. 9674) Oil on canvas
102 × 153" (260 × 389 cm)
(Ex coll. S.I. Shchukin, Moscow)

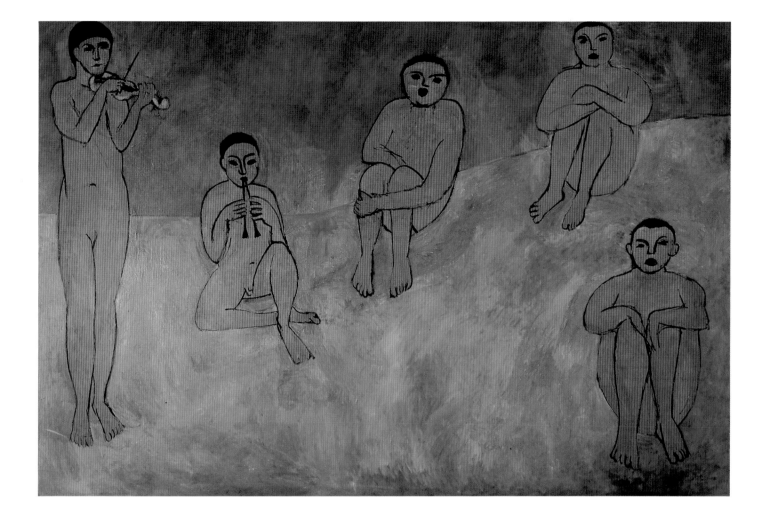

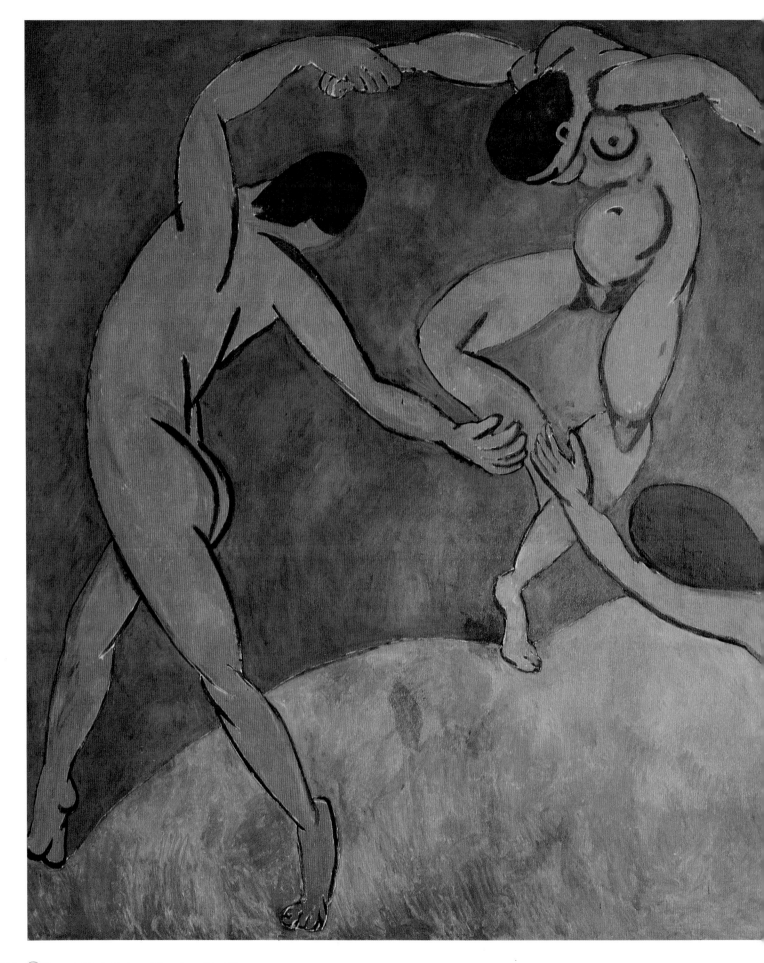

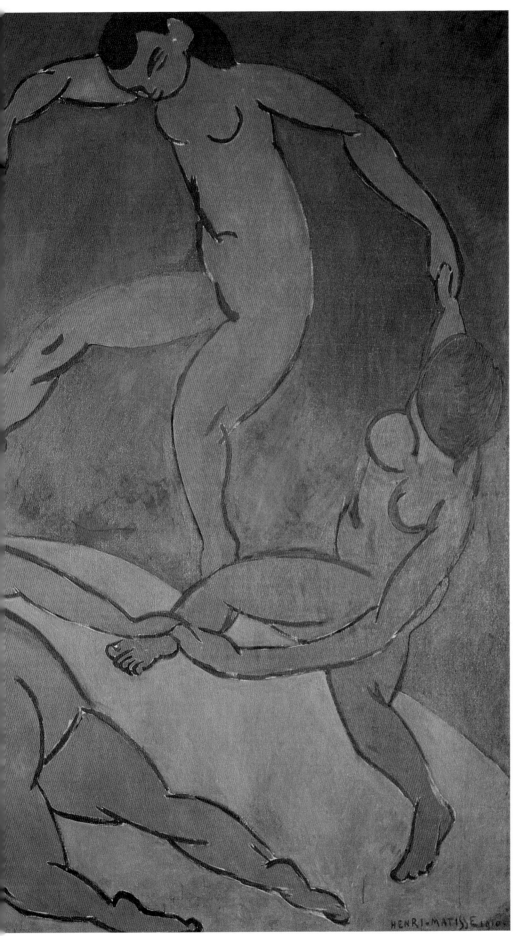

HENRI MATISSE
The Dance, 1910
(Inv. No. 9673) Oil on canvas
102 × 154″ (260 × 391 cm)
(Ex coll. S.I. Shchukin, Moscow)

Page 114
PABLO RUIZ Y PICASSO
Malaga 1881– Mougins 1974
Dance with Veils, 1907
(Inv. No. 9089) Oil on canvas
59 × 39″ (150 × 100 cm)
(Ex coll. S.I. Shchukin, Moscow)

Page 115
PABLO PICASSO
Three Women
(Inv. No. 9658) Oil on canvas
79 × 73″ (200 × 185 cm)
(Ex coll. S.I. Shchukin, Moscow)

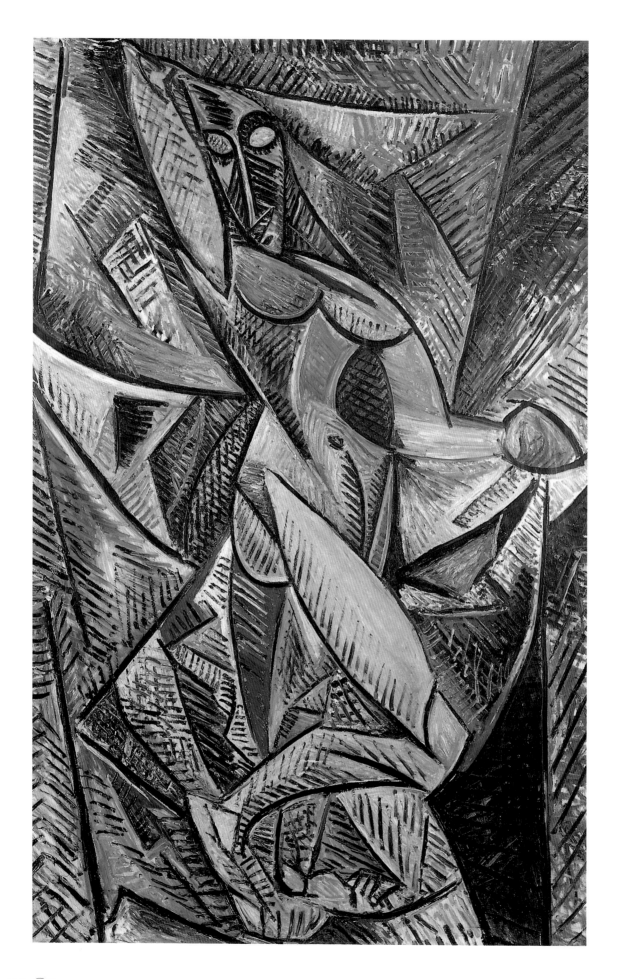

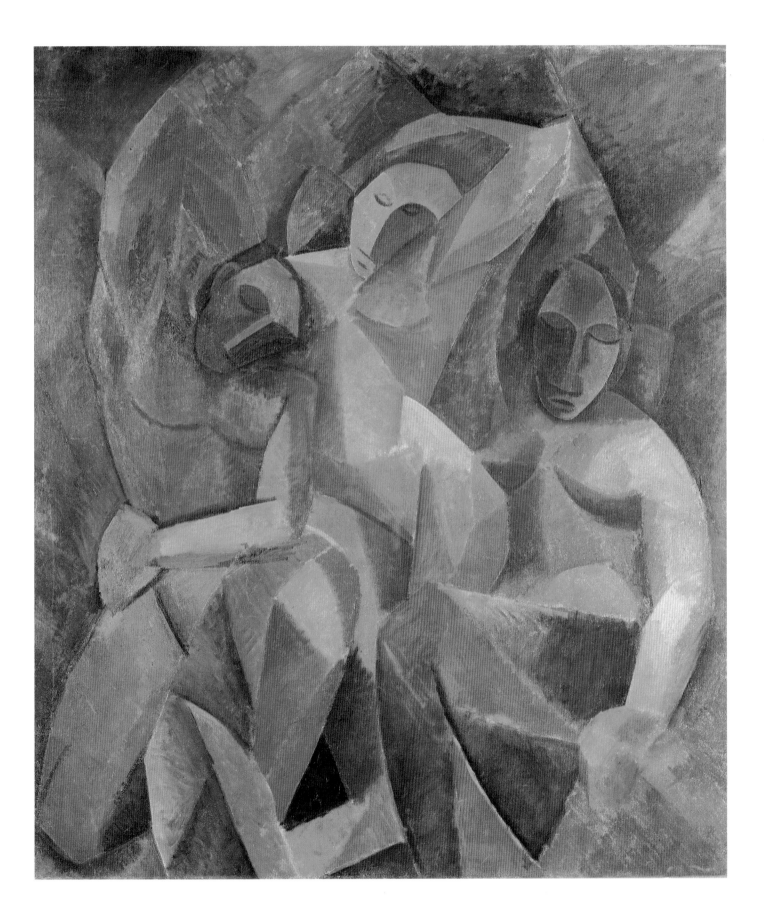

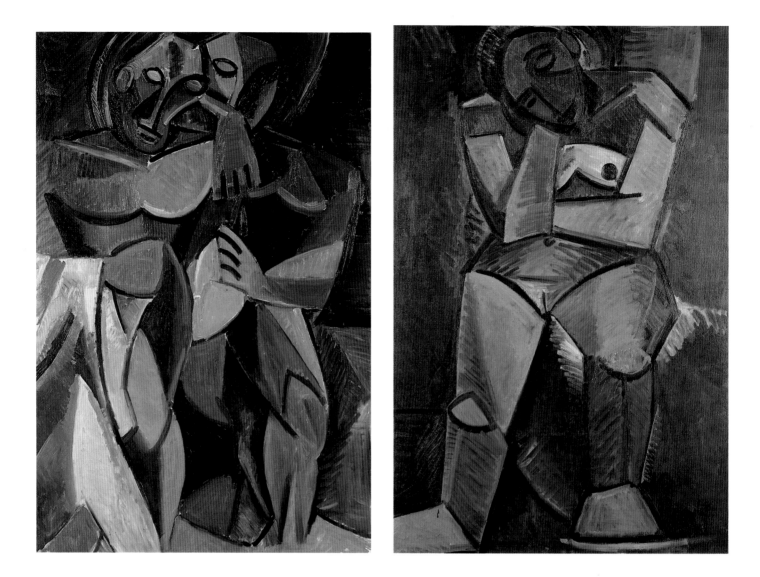

day, each make their own Apollonian or Dionysiac music as others crouch in difficult poses, some so daring that Shchukin petitioned Matisse for a cover up. Happily, he soon saw the folly of his shame.

Picasso, too, returned to the antique, each of his many styles almost definable in terms of their differing attitudes toward the distant past. Poised between adulation and burlesque, his *Three Women* (115) follows an ancient trinitarian formula, that of the Three Graces. A pioneering work in the Cubist idiom, this canvas of 1908 came from the Catalan's important early pa-

tron Gertrude Stein. She sold it back to Picasso's dealer Daniel Kahnweiler from whom Shchukin then bought it around 1913 or 1914.

While Stein described the *Three Women* as terrifying in her *Autobiography of Alice B. Toklas*, the same painter's *Dance with Veils* (114) is far more so. Her swirling, seductively movemented veils are negated by the dancer's crudely carved wooden head, its features clock-stoppingly close to the many tribal sculptures soon to be de rigueur in advanced Parisian artists' studios. Now austere ethnic objects replaced the studio's equally exotic

claptrap of moth-eaten tapestry, bogus medieval armor, and other neo-Gothic bric-a-brac and yellowed plaster casts after the antique.

Much of Picasso's art (even that of his extreme old age) remains that of a young man—audacious, aggressive, analytic, critical, independent, inventive—his way hard, bold, uncompromising, and, quite often, extraordinarily unkind.

Four studies of nude or partially exposed women (116, 117) combine the Catalan's distance from, and proximity to, the heritage of antiquity. Still reveling in the solidity and implacability of ancient

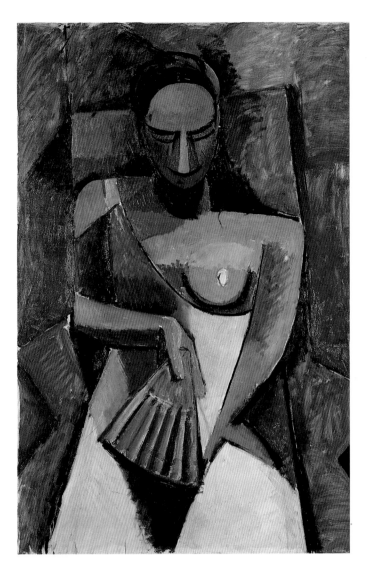

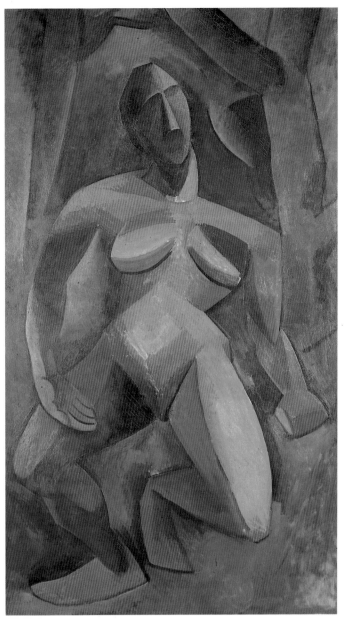

Opposite, left
PABLO PICASSO
Friendship, 1908
(Inv. No. 6576) Oil on canvas
60 × 40″ (152 × 101 cm)
(Ex coll. S.I. Shchukin, Moscow)

Opposite, right
PABLO PICASSO
Seated Woman, 1908
(Inv. No. 9163) Oil on canvas
59 × 39″ (150 × 99 cm)
(Ex coll. S.I. Shchukin, Moscow)

Above, left
PABLO PICASSO
Woman with a Fan (After the Ball), 1908
(Inv. No. 7705) Oil on canvas
59 × 39″ (150 × 100 cm)
(Ex coll. S.I. Shchukin, Moscow)

Above, right
PABLO PICASSO
Dryad, 1908
(Inv. No. 7704) Oil on canvas
73 × 42½″ (185 × 108 cm)
(Ex coll. S.I. Shchukin, Moscow)

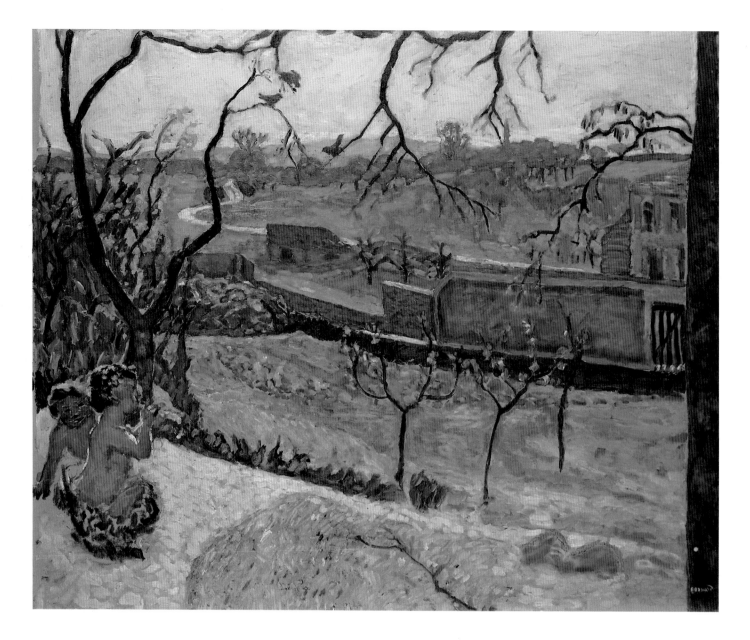

statuary, Picasso exploits its weighty stripped state as a fait accompli for his own prismatic figures, while rejecting classicism's then-clichéd harmonies and bland beauty. Himself woman-loving and woman-hating, Picasso's nudes fluctuate between the Virgin and the Whore, sometimes blending both to suit his macho Catalan mood. Variously analytical or sentimental, with a long sense of success followed by one of impotent wrath, many moods modify this one-man Fury, routing and exalting his subjects. Picasso's variable virtuosity is the masculine equivalent to a periodic table.

Twelve years younger than Matisse and self-admittedly his inferior, the Catalan's ingenuity, fertility, and ambition, determining so much of the art of this century, led to ever speedier innovation. At his most conventionally grand—when married to a star of the Ballets Russe—Picasso's flair for self-promotion, as much as his talent, kept him the star of the century until his death in 1973 at the age of 92.

PIERRE BONNARD
Fontenay-aux-Roses 1867–Le Cannet 1947
Advent of Spring (Small Fauns), 1909
(Inv. No. 9106) Oil on canvas
40 × 49″ (102.5 × 125 cm)
(Ex coll. I.A. Morozov, Moscow, 1931)

Ever aware of antiquity, herself once a minor Greek and major Roman colony, France could not quite believe in that dismal blackout, the Dark Ages, following upon the twilight of the gods. Nymphs and satyrs never left her land and culture, faithful to the pagan spirits of the past, so Pierre Bonnard (118) and Ker Xavier Roussel (119) knew the woods and fields still sheltered these classical creatures. Their painters' patience was rewarded by hearing the songs and witnessing the dances of those Bacchic pied pipers, seeing Amalthea, the goat who nurtured the infant Bacchus.

So Bonnard equated the coming of spring with little fauns' arrival. Crossing the borders of reality, he understood the passing of the seasons by the changing presence of nature's gods. Harmonies from the golden dawn of time may still await the artist willing to listen and to watch, ready to hide in order to seek musical sounds, sights, and steps.

KER XAVIER ROUSSEL
Lorry-les-Metz 1867–L'Étang-la-Ville 1944
Mythological Scene
(Inv. No. 9065) Oil on cardboard
18½ × 24½" (47 × 62 cm)

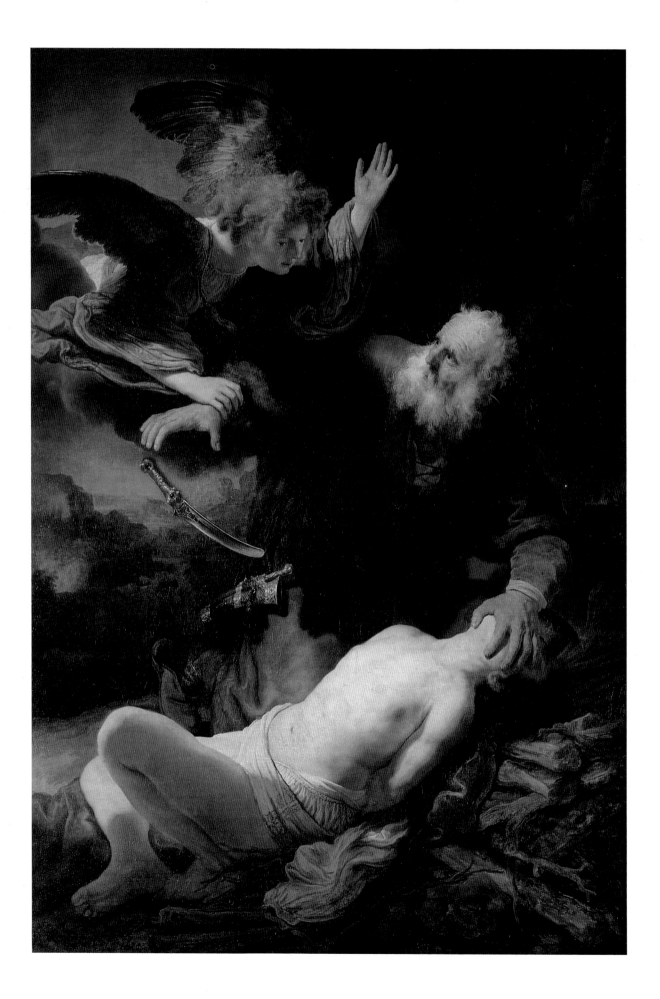

The Art of Faith: The Bible and Saints

❧ ❧

Both the Old and the New Testament has its own, uniquely compelling narrative appeal. The first teems with cosmic drama encompassing all passion and sin, rocking back and forth between the extremes of emotion, from the confidence of the Chosen Ones to their depths of abandonment and despair. This saga of a people begins with the multiple blessings of their Genesis and ends in their destruction as a nation.

Only a faith so richly endowed with vivid verbal images as that of the Jews—for so many reasons the People of the Book—could afford to reject those same aspects in the visual arts lest they lead to idolatry, to those graven images forbidden by the second commandment. Surprisingly, recent scholarship and archaeology show that early synagogues abounded with frescoes. These, with the copious illuminations of ancient Hebrew manuscripts, were the foundation for the first Christian figurative arts.

Filled with injunctions to see or to look, to examine the physical evidence for God's presence in his works and deeds, the Bible is the most stirring of narratives, the basis of many faiths, lending itself to profuse illustration, to translation into mystery play, oratorio, opera, and film.

The adventures of the children of Israel, from slavery to victory, receiving and breaking God's commandments, their wars and sacrifices, temple

REMBRANDT HARMENSZ VAN RIJN Leyden 1606–Amsterdam 1669 *Abraham and Isaac*, 1634
(Inv. No. 727) Oil on canvas 62 × 46″ (158 × 117 cm) (Ex coll. Empress Josephine, Malmaison, 1814)

JOHANN FRIEDRICH OVERBECK Lübeck 1789–Rome 1869
The Triumph of Religion in the Arts (Inv. No. 7597)
Oil on canvas 57 × 57½″ (145 × 146 cm)

building and destruction, encompass almost every sentiment and deed, merging faith and history, meeting the extremes of legality and violence, of the tangible and the mystical.

Focused primarily upon the lives of a single man, his mother, and his first followers, the New Testament is radically different in form and feeling from the Old. Four relatively brief recitations of good tidings (the meaning of "gospel") recall Christ's life and work, as given in the sparing reportage of Matthew, Mark, Luke, and John. Each gospel, retracing the same holy ground, gives the effect of critical corroboration. The evangelists' collective variations upon a single sacred biographical theme lend their texts a compelling resonance and reciprocity.

Much of the Bible is designed to explain, console, guide, reassure, sustain, and, most important of all, to give hope and buttress faith. Many biblical subjects originate with, and lend themselves to, domestic settings, Christ's first miracle taking place at an ordinary wedding at Cana, where there just wasn't enough wine. Their powerful human interest and narrative appeal, often set in everyday, domestic settings, close to familial values, make so many biblical subjects accessible to the reader and the artist.

Only Luke provides those critical moments from the life of Mary that mark the very beginning of Jesus' life. He alone tells of the Annunciation, along with many other aspects of the Virgin's days, years, and emotions. Such intimacy led early Christians to speculate that Luke must have been both Mary's confidant and painter, so vivid and immediate was his knowledge of her life. So, soon this apostle came to be seen as patron saint of artists, frequently shown holding a portrait of the Virgin (page 257).

Each Testament also has an unauthorized supplement or Apocrypha. The first includes the books of Tobit and Judith, along with others. Far longer, the Christian Apocrypha adds information about the Holy Family and the Apocalypse, as if in answer to those many questions of the faithful that were not addressed by the four gospels and Paul's texts. Theologians prepared correlations of almost every aspect of both testaments so Christians could find corroboration and continuity in each word and line from the first testament in the second, making both equally their own.

Images from sacred sources could be explored (and often enjoyed), not only for what they were, but because of what came before and after, for their sources and promises, each a tessera in the mosaic of divine providence, sacrifice, and redemption. Often these scenes reinforced the solidarity and authority of life at home or at court, where parents and rulers were meant to guide the lives of their children or their subjects according to religious example and event.

Large altarpieces were necessarily for church settings, while smaller ones often suited the family chapels of the rich, destined for domestic use, hanging above or resting upon a prie-dieu. Small circular panels were painted with religious subjects for placement above the head of a bed, while romantic encounters like the meeting of Solomon and Sheba (or that of Jacob and Rachel) were often depicted on hope chests, over mantels, as friezes, or on sweetmeat trays brought to mothers in childbed. Martial biblical themes were also popular, combining the active with contemplative spiritual values.

Jewish heroes, heroines, and strongmen—an Esther or David, Judith or Samson—entered everyday life, placed on banners, shields, and city monuments as models for modern behavior and sound government: brave, independent, confident in the justice of their cause, in their people, and in God's support.

Literally and figuratively, no text can come closer to home than the Bible. Families often kept the good book in a special protective box, together with dates of birth, wedding, and death, all bound in with the Bible or in the same container. While its words may mostly have been read or recited in church or at home in the mornings and evenings or before mealtimes, biblical images were always part of everyday life. For the rich, these were the subjects of paintings, enamel plaques, and silver, jeweled brooches, cut into mother of pearl, found in tapestries or embroideries as well as carved marble, ivory, wood, alabaster, or bronze statuary. Even the poorest of the faithful could afford a woodcut or a linen banner stenciled with a sacred subject, designed to keep trouble away, or, if need be, help see one through the worst of it.

Because of the universality of their messages, biblical themes seldom lost impact, even in times of official doubt, of Encyclopaedism and Enlightenment, during decades when political, philosophical, and scientific issues dwarfed those of "superstition." Topics from both testaments remained central to instruction at the Académie Royale, selected for illustration in competition for the Prix de Rome as the most ancient of themes for history painting.

Most Western nations have seen themselves as Chosen, as new Israels, their kings and queens long anointed like David, enthroned upon chairs designed along the lines of Solomon's. Even presidential inaugurations of those nations where church and state are divorced often depend upon biblical oath. Venice or Amsterdam, with many other centers, viewed themselves as new Jerusalems, their people like the Children of Israel, saved from the surrounding waters by dikes and windmills or controlled by canal.

Churches and cathedrals are still dedicated as new Temples of Solomon. Devout families strive to follow the simplicity, harmony, and modesty of Jesus, Joseph, and Mary. All Christians belong to an extended family, with Mary, in Augustine's words, the Mother of Us All, and the Trinity the ultimate in tripartite Paternity.

Europe's Gothic (and often religious) Revival, in the late eighteenth and early nineteenth centuries, included the primitivistic Christian images of the Nazarenes in Germany and the English Pre-Raphaelites. Devotional art came to be increasingly restricted to the church. Parliament, worried about unrest among Britain's "working classes," subsidized a church-building act in 1818 to bring Christianity to the slums, so saving the blue-collared class from turning red. The popular arts—cheap reproductions in plaster or print, whether crude French woodcut *images d'Épinal*, or tinted American lithographs by Currier and Ives—kept the tradition of domestic religious art alive.

Need for showing as well as telling was felt for the later life of Christ. Just exactly how did he look on the way to Calvary? The absence of authentic images led to the urge for inventing an eyewitness—Veronica, who, in a sense, was also a painter. Her name is a conflation of the Latin for "true image"—*vera icon*. Her canvas for Christ's tormented visage (257) was a fine cloth with which she supposedly wiped his face—his features miraculously recorded upon it.

Recently drummed out of the saintly band by Vatican decree, Veronica and her putative deed remain an allegory of Christian art. Along with Luke's legendary portrait of the Virgin or Turin's discredited *Volto Santo* (supposedly the winding sheet upon which Christ's face and body are imprinted), all these images fulfill the need to see, that injunction so powerfully felt throughout the literature of faith.

After a massive setback during the eighteenth century's years of revolution and enlightenment, Catholic Europe emerged once again in the early nineteenth century with the religious revival that followed the excesses of the Revolutionary and Napoleonic reforms. Many Protestant or atheistic artists, weary of the Lutheran or the rational, yearning for a more mystical spirituality, converted to Catholicism.

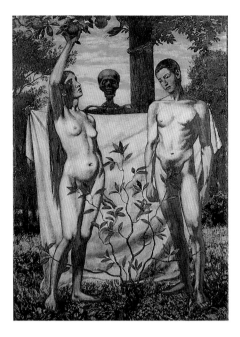

HANS THOMA
Bernau (Schwarzwald) 1839–Karlsruhe 1924
Adam and Eve, 1897
(Inv. No. 5757) Oil on canvas
43 × 31″ (110 × 78.5 cm)

Opposite
GUIDO RENI Bologna 1575–1642
The Building of Noah's Ark, ca. 1608
(Inv. No. 51) Oil on canvas
76 × 61″ (193.5 × 154.5 cm)
(Ex coll. Brühl, 1769)

The brutality of the Industrial Revolution and intolerance of Neoclassicism led to nostalgia for the good old days of art before archaeology, to the supposedly simple sweetness and higher morality of Raphael and his predecessors. In Paris, London, Rome, Munich, and Vienna, painters turned to Jan van Eyck and Botticelli, to artists whose religious images suggested greater conviction and verisimilitude than those in the Classical manner.

Johann Friedrich Overbeck shows David and Luke as personifications of religious music and painting (Solomon with the molten sea stands for Sculpture, and Saint John the Divine, with a plan of the heavenly Jerusalem, is Architecture) in a replica of his huge work *The Triumph of Religion in the Arts* (122) painted for Frankfurt's Staedel Art Institute. Great artists and writers are shown below, including, with a happy sense of his own worth, none other than Overbeck.

Many Russians, visiting his Roman studio, were deeply impressed by this encyclopaedic allegory of the Christian arts. In 1833 Turgenev found it "a historical poem, wrought with incomparable perfection." Six years later the Grand Duke Aleksander Nikolaevich went to Overbeck's studio with his tutor, and ordered this costly replica for the Winter Palace, which arrived in 1843. The Raphaelesque Mother and Child at the top (Mary represents Poetry as she recites the "Magnificat") are very like those found in a little Raphael tondo (180) bought by the same patron.

Few noteworthy artists have concerned themselves with overtly religious issues in this century or at the end of the last. (Those who did include Kaethe Kollwitz, Eric Gill, Jacob Epstein, Ernst Barlach, James Ensor, Vincent van Gogh, Stanley Spencer, Matisse in his later works, and Francis Bacon.) Gauguin and the Nabis (the Hebrew word for prophet) delved into Christian symbolism, as did the Croix Rouge and the arcane, exquisite painters of Bruges. Yet, until very recently, when abstraction's politic lack of specificity precluded most effective devotion, not many canvases concerned themselves with faith or conscience.

The major monuments of the Northern and the Italian Renaissance may in both cases be best known for their depictions of the Fall—Jan and Hubert van Eyck's *Ghent Altar*, and Masaccio's Brancacci Chapel. Of all biblical subjects, this comes closest to all of us. A beginning and an end, it presents us as we might have been and as we became, caught in an act whose consequences call for sacrifice, suffering, and salvation.

The Old Testament

A man and a woman, still unaware of their nakedness, stand sadly by the Tree of Knowledge in Hans Thoma's archaizing picture (124), a subject that he painted ten times, even designing and decorating the frames for each. By including Death as well as the snake, Thoma

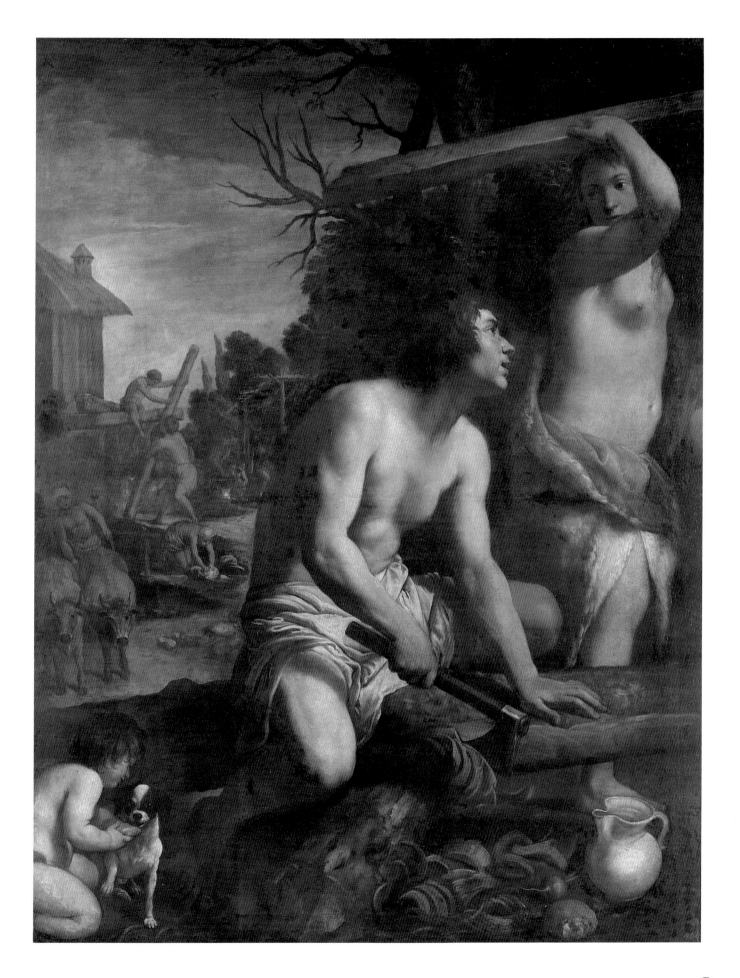

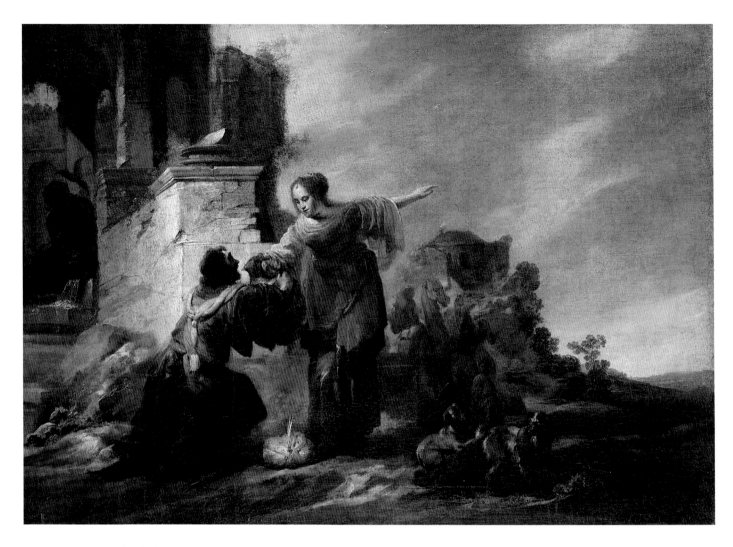

JACOB HOGERS probably Deventer 1614–Amsterdam after 1660
Abraham's Servant and Rebecca
(Inv. No. 3378) Oil on canvas
37 × 38½″ (69.5 × 98 cm)
(Ex coll. P.P. Semyonov-Tian-Shanskii, 1915)

was attuned to late medieval sources, but the idea of Death as a Wardrobe Master, holding out a corpse's winding sheet as the beginning of mortality, is all his own. A shrub is artfully espaliered, lending strategic coverage to the naked couple, a device taken over from Dürer, the father of German art.

The Building of Noah's Ark (125), that almost contradictory episode of partial salvation and mass destruction, is the subject of Guido Reni's Baroque scene. Here Noah mobilizes his family's forces to complete the Ark and his mission in the face of impending deluge. The artist's attention may be more on the beauty of his nudes and the rich still life treatment than upon their moral significance. While the canvas's silvery luminosity is Reni's hallmark, its highly specific approach to the demands of narrative is atypical.

Overtly or covertly, sacrifice is always the central theme of the Bible and its art—in the events that make it necessary and the ways in which it is fulfilled. The ghastly scene and subject of Abraham's sacrifice of Isaac establish the awesome extreme of obedience to divine dictate. Rembrandt, more than any other artist, captured the horror of that event (120). Abraham covers his son's face with his own swollen, butcher's hand so Isaac cannot see the paternal source of doom. Dramatic illumination picks out Isaac's body, the agonized face of his father, as well as the head and hands of the angel of deliverance and the falling knife, highlighting the action in near-cinematic fashion.

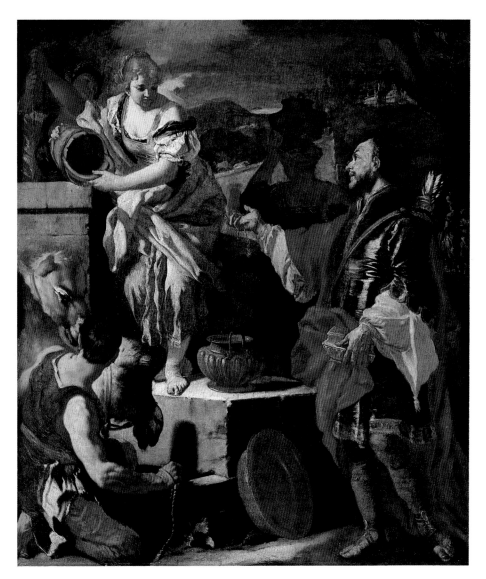

FRANCESCO SOLIMENA Canale di Senno 1657–Barra 1747
Rebecca at the Well
(Inv. No. 2) Oil on canvas
28 × 25″ (72 × 63 cm)

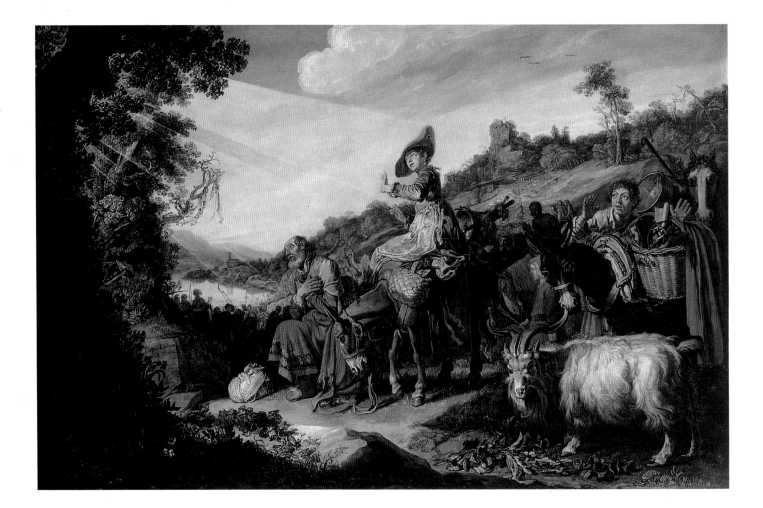

Rembrandt added a surprising, almost incongruous refinement of detail, of *Feinmalerei*, which only serves to underscore the tension, brutality, and relief of this moment.

In another event affecting Isaac's life, Abraham's servant Eliezer is given water by the beautiful Rebecca, and decides that she is the right bride for his master's son. Where the Dutch seventeenth-century Jacob Hogers places the scene in a ruined, serious setting (126), the Neapolitan Francesco Solimena gives the subject a festive, Tiepolesque feeling (127).

A major chapter in Abraham's life is his leaving his people, in obedience to God's will, to settle in the Promised Land of Canaan, where Abraham's family separates from Lot's. Peter Lastman expresses divine support and direction abstractly, by the light streaming from the left (128, 129). His pupil Rembrandt learned a lot about composition, Italian sources, and the many uses of illumination and specificity from this sophisticated Amsterdam teacher.

Lot and his daughters were a favorite theme, one that allowed the smug to contemplate the almost unmentionable. Jean-François de Troy did justice to all requirements (130), painting a strikingly appetizing incestuous orgy, with Lot looking remarkably like Rembrandt's Abraham, as if all patri-

PIETER PIETERSZ LASTMAN
Amsterdam 1583–1633
Abraham on the Way to Canaan, 1614
(Inv. No. 8306)
Oil on canvas, transferred from panel
28 × 48″ (72 × 122 cm)

Opposite
PIETER PIETERSZ LASTMAN
Abraham on the Way to Canaan (detail)

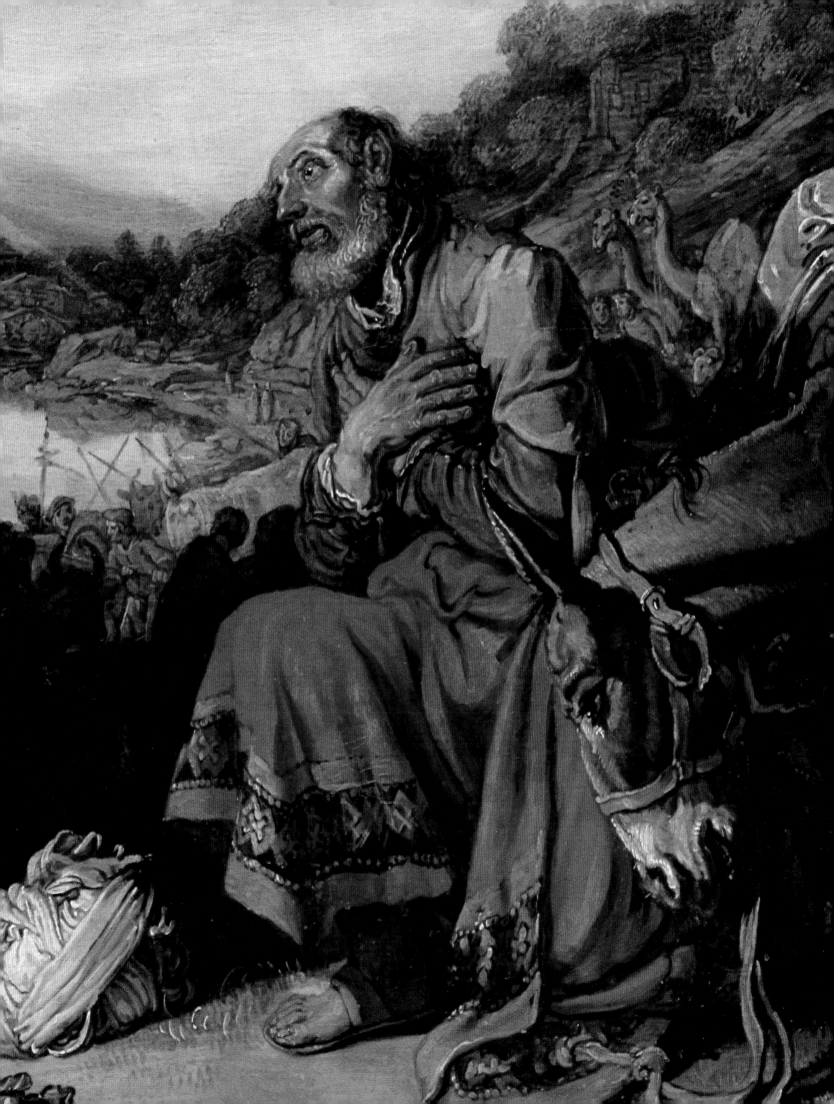

archs came from the same heavily bearded mold. Active almost a century before the French artist, Joachim Wtewael treated the drunken Lot in a far more decorous way (131), relatively speaking. His daughters keep their distance and are rendered with the same degree of elegant Mannerism as nudes by Hans von Aachen (52). A magnificent repast at the center is in striking contrast with the modest picnic, readied for the flight from Sodom, in the lower right corner.

Of the many beautiful Bartolomé Murillos in the Hermitage, the most unusual may be *Isaac Blessing Jacob* (132), surprising for the fresh, inventive presentation of its theme, so different from the condescending aspects of many of the Sevillean's lesser works. This composition suggests a split screen, evenly divided between the exploration of nature and of humanity. Seldom thought of as a leading landscapist, Murillo devised a setting for this mistaken benediction that recalls those of contemporary Genoese painters and the Le Nain brothers. Here the smooth-skinned Jacob, with his mother, Rebecca's, connivance, receives the blessing blind Isaac believes he is giving his favorite, Jacob's hairy twin, Esau.

Esau Selling His Birthright (133) is presented by Matthias Stomer in the intimacy of a nocturne, their mother glancing approvingly toward her beardless favorite, the plump, plumed, white-skinned Jacob, as Esau, the hunter, brandishes his bag, and sells his patrimony.

Having twice deceived Esau, Jacob met his match in chicanery when he had to deal with his uncle

Laban, father of the desirable Rachel. Pier Francesco Mola shows a powerful Jacob (134), in shepherd's garb, facing a queenly Rachel, for whom he is willing to take on the many years of agricultural servitude laid upon him by Laban. What happier, more agreeable subject for familial contemplation in an ever dowry-conscious Europe!

Eventually the young couple flees with Laban's household gods, taken in the hope that Laban will make Jacob his rightful heir. (Actually Jacob buried these idols and those of their servants before departure.) Sébastien Bourdon painted this episode (134) as if it came from Roman history—only the camels make its Near Eastern origin discernible.

Jacob finally realized the error of his ways in a long dark night of the soul. Wrestling with an angel, he came to understand how his meanness was as much against God as against his fellows, and vowed to change for the better. This revelation is the subject of Claude's dramatic nocturne (135), where the winding phalanx led by Esau (out for fraternal blood) suggests, far from coincidentally, the Roman soldiers coming to arrest Christ after his agony in the Garden (227). Entitled *Night*, Claude's canvas is one of three named for times of day, all devoted to biblical subjects, and all in the Hermitage. *Noon* (210, 211) depicts the Rest on the Flight into Egypt, and *Evening* shows Tobias and the Angel.

As the central figure of the Old Testament, Moses' role as savior and law-giver is analogous to that

JEAN-FRANÇOIS DE TROY
Paris 1679–Rome 1752
Lot and His Daughters, 1721
(Inv. No. 1232) Oil on canvas
92 × 70" (234 × 178 cm)

Opposite
JOACHIM ANTHONISZ WTEWAEL
Utrecht ca. 1566–1638
Lot and His Daughters
(Inv. No. 1443) Oil on copper
6 × 8" (15.5 × 20.5 cm)
(Ex coll. Tronchin, Geneva, 1770)

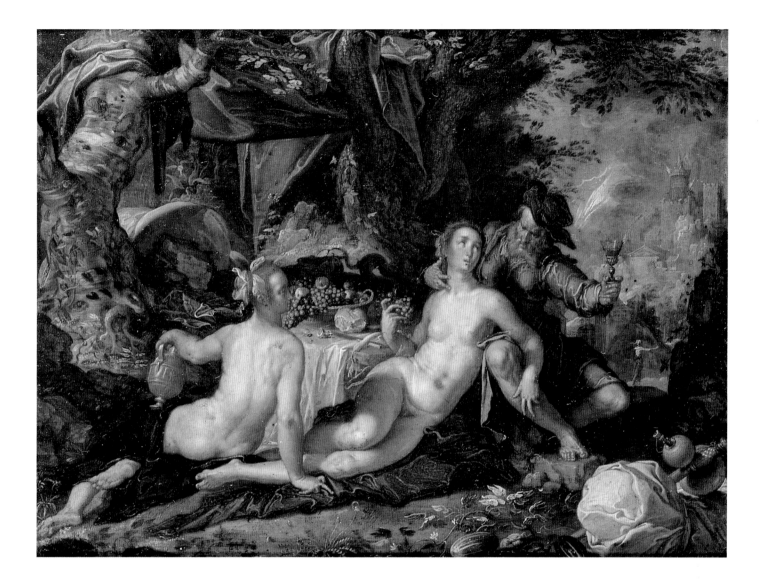

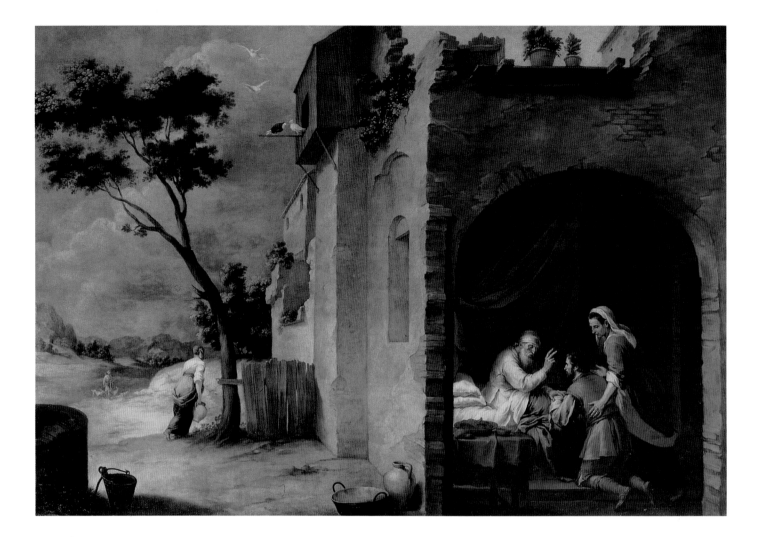

of Christ. These functions are stressed in a stately half-length image (138), a pictorial format commonly given to prophets. By Philippe de Champaigne, this might have been painted for a judiciary, just as well as for an ecclesiastical, setting. The commandments, carved in French, use Latinate lettering to give them classical authority. Moses was also a highly effective general and statesman—these qualities made him a popular subject for secular as well as religious art, as the personification of greatness on every level. From early abandonment in the bulrushes, from whence he was saved by pharaoh's daughter as shown by Étienne Allegrain (136–37), to his

death just in sight of the Promised Land, Moses' life makes for a biography of epic proportions. A French Baroque academician, Allegrain shows the Egyptian princess and her maids-in-waiting playing with the baby Moses in almost Seurat-like dots and dashes as well as stitches of color, giving the canvas an unusually richly textured, decorative quality. The river landscape is close to the Classical ideal, suggesting a theatrical flat, generalized but for the little pyramid and lone palm.

Moses' striking the rock (139), and thus saving the children of Israel from dying of thirst in the desert, was also a popular subject, not only in itself but because this, too,

BARTOLOMÉ ESTÉBAN MURILLO
Seville 1617–1682
Isaac Blessing Jacob, 1665/70
(Inv. No. 332) Oil on canvas
96½ × 141" (245 × 357.5 cm)
(Ex coll. Marquis of Villamanrique, 1811)

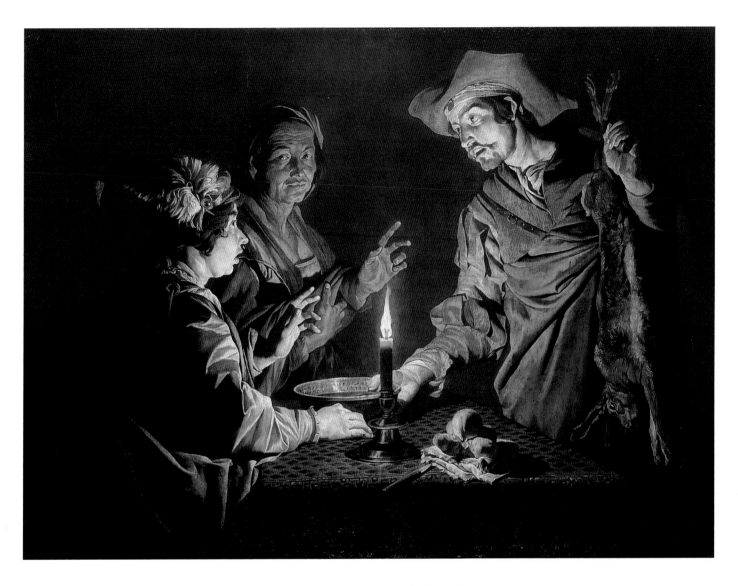

was seen as a forerunner of the saving waters streaming from Christ's pierced side at the Crucifixion. This late Poussin has a certain stiffness in pose and in its contrived coloring that may make it hard to admire, but these qualities have a rigor and forceful originality beyond facile illusion or ready sympathy, conveying a deeply felt experience as if reflected upon a smoke-tinted mirror.

Poussin's early depiction of *Joshua's Victory over the Amalekites* (139) was inspired by a section of relief from a Roman triumphal column. Long the enemies of Israel, living on adjacent territory, the Amale-

kites are here shown defeated in battle, as the prayers of old Moses, his arms sustained by Aaron, kneeling in the distance, were answered by victory.

Young David may be the Old Testament's most beloved figure, with everything on his side—bravery, youth, resourcefulness, and, most important of all, triumph. But for the inevitable decline and bitterness of old age, his sins as a lover, and sadness as a parent, David's is the ultimate success story. Every major aspect of his life, from shepherd to victor and king, lends itself to pictorial celebration.

MATTHIAS STOMER
Amersfoort ca. 1600–after 1651 Sicily (?)
Esau Selling His Birthright
(Inv. No. 2913) Oil on canvas
46½ × 64½" (118 × 164 cm)
(Ex coll. P.P. Semyonov-Tian-Shanskii, 1915)

Jacob van Oost I painted a young, matter-of-fact David, his trophy—Goliath's gigantic severed head, with its fatal slingshot wound—suspended from a sword (140). The Dutch painter employed a long-haired, fresh-faced model whose assured look fills the bill for today's shepherd and tomorrow's king.

Among the earliest and finest of the Hermitage's many Baroque Netherlandish acquisitions is Rembrandt's *David and Jonathan* (141), a subject well suited to the painter's psychological penetration. Here David, in regal turban and lavish attire, seems already to be heir to King Saul as he embraces his dearest friend, Saul's son Jonathan. That brave and faithful general may be leaving for his final, fatal battle. Without jealousy or rivalry, Jonathan and David share the Bible's best friendship. Learning of Jonathan's death, his stricken survivor could only lament: "Your love to me was wonderful, passing the love of women."

David was almost as beloved for being bad as he was for being good, making him the most plausible of biblical heroes. His passion for Bathsheba led the young king to send her husband off to death in the battlefield. First seeing the bathing beauty from his palace tower, David is a small figure in the background of Florentine Giovanni Battista Naldini's elegant bathing scene (142). She has the enticing pose and seductive, vacuous gaze found earlier in Michelangelo's nude youths strutting their stuff on the Sistine Ceiling.

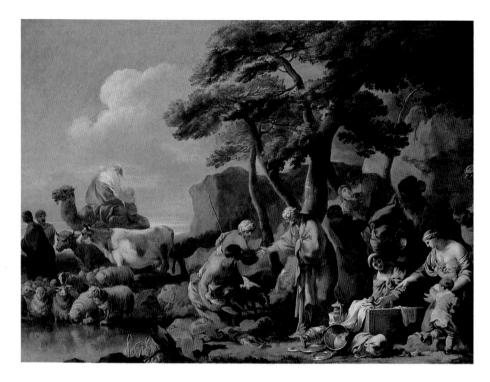

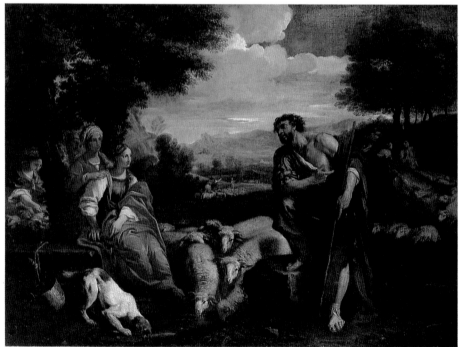

Top
SÉBASTIEN BOURDON Montpellier 1616–Paris 1671
Jacob Hiding the Strange Gods Under the Oak at Shechem
(Inv. No. 7481) Oil on canvas
37½ × 51″ (95 × 129 cm)

Bottom
PIER FRANCESCO MOLA Coldrerio 1612–Rome 1666/68
Jacob's Meeting with Rachel
(Inv. No. 141) Oil on canvas 28 × 38½″ (72 × 98 cm)
(Ex coll. Crozat, 1772)

CLAUDE LORRAIN (CLAUDE GELLÉE) Charmes 1600–Rome 1682
Night, 1672
(Inv. No. 1237) Oil on canvas
45½ × 63″ (116 × 160 cm)

ÉTIENNE ALLEGRAIN Paris 1644–1736
Landscape with Moses Saved from the River Nile
(Inv. No. 1133) Oil on canvas
34½ × 45″ (88 × 114 cm)

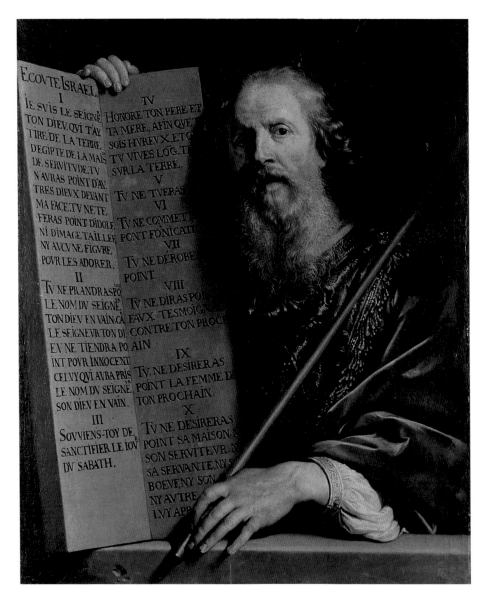

Above
PHILIPPE DE CHAMPAIGNE
Brussels 1602–Paris 1674
Moses with the Ten Commandments
(Inv. No. 625) Oil on canvas
36 × 28" (92 × 72 cm)
(Ex coll. Choiseul-Praslin, 1808)

Opposite, top
NICOLAS POUSSIN
Les Andelys 1594–Rome 1665
Moses Striking the Rock, 1649
(Inv. No. 1177) Oil on canvas
48½ × 76" (123.5 × 193 cm)
(Ex coll. Walpole, Houghton Hall, 1779)

Opposite, bottom
NICOLAS POUSSIN
Joshua's Victory over the Amalekites, ca. 1625
(Inv. No. 1195) Oil on canvas
38 × 53" (97.5 × 134 cm)
(Probably acquired at François Defresne Sale,
Amsterdam, 1770)

Page 140
JACOB VAN OOST I Bruges 1601–1671
David with the Head of Goliath, 1648
(Inv. No. 676) Oil on canvas
40 × 32" (102 × 81 cm)
(Ex coll. V.P. Rostromitihovoya,
St. Petersburg, 1895)

Page 141
REMBRANDT
David and Jonathan, 1642
(Inv. No. 713) Oil on panel
29 × 24" (73 × 61.5 cm)
(Ex coll. Jan van Beyningen,
Amsterdam, 1716)

Healing, the meaning of "salvation," is a biblical *Leitmotif*, interwoven with that of sacrifice. Naaman, a Syrian general afflicted with leprosy, came to be healed by the prophet Elisha and was cured after following the latter's directive to bathe in the Jordan seven times. When the prophet refused the converted general's gifts, which is the subject of Lambert Jacobsz' panel (144), Naaman asked for two mule-loads of earth from the land of Israel so that he could take this home with him, to pray upon its soil. Jacobsz combines a friezelike composition with sudden views into the distance. At the far right is the sick man's chariot; just above the prophet a servant opens a door—a Rembrandtesque theme also used by Hoogstraten.

Zarephath was the town to which the prophet Elijah came during a famine. Bartholomeus Breenbergh shows the encounter between the prophet and a poor widow, whose kindness to the stranger will result in her own nurture and the healing of her son (145). Though the figures are clumsy, they are placed in a typically classicizing, romantically lit landscape that Breenbergh and his Dutch contemporaries active in the environs of Rome painted so well. These scenes from prophets' lives are rare subjects, but are typical of Lowlands artists' passion for depicting almost everything biblical, partly because they and their patrons identified themselves with the People of the Book.

That the Hermitage is so very well supplied with fine German art is

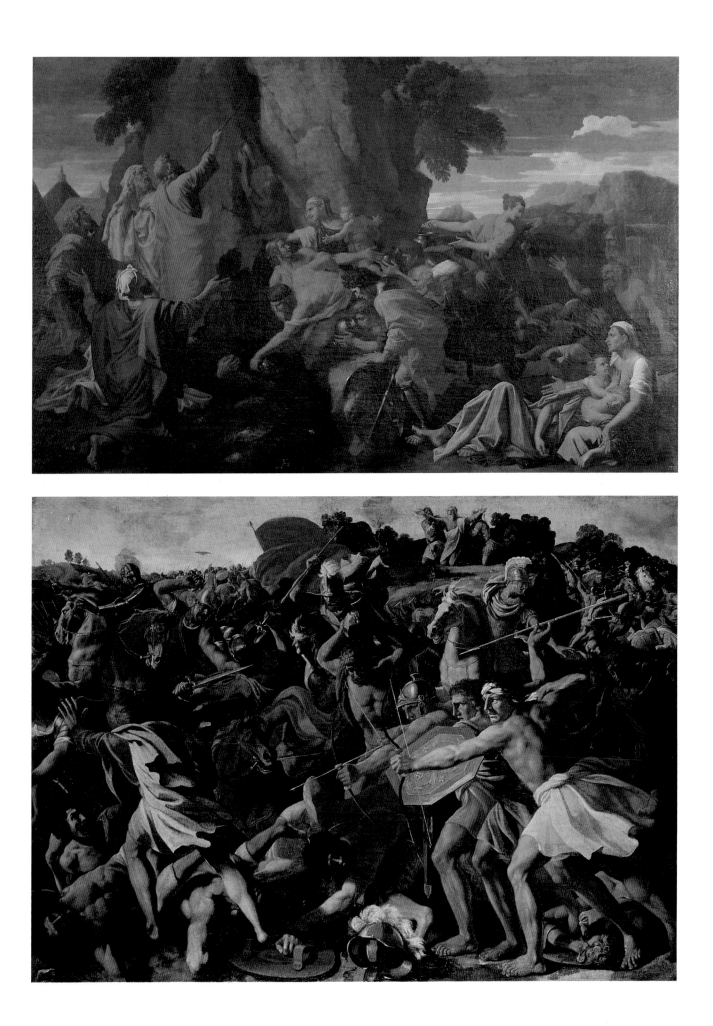

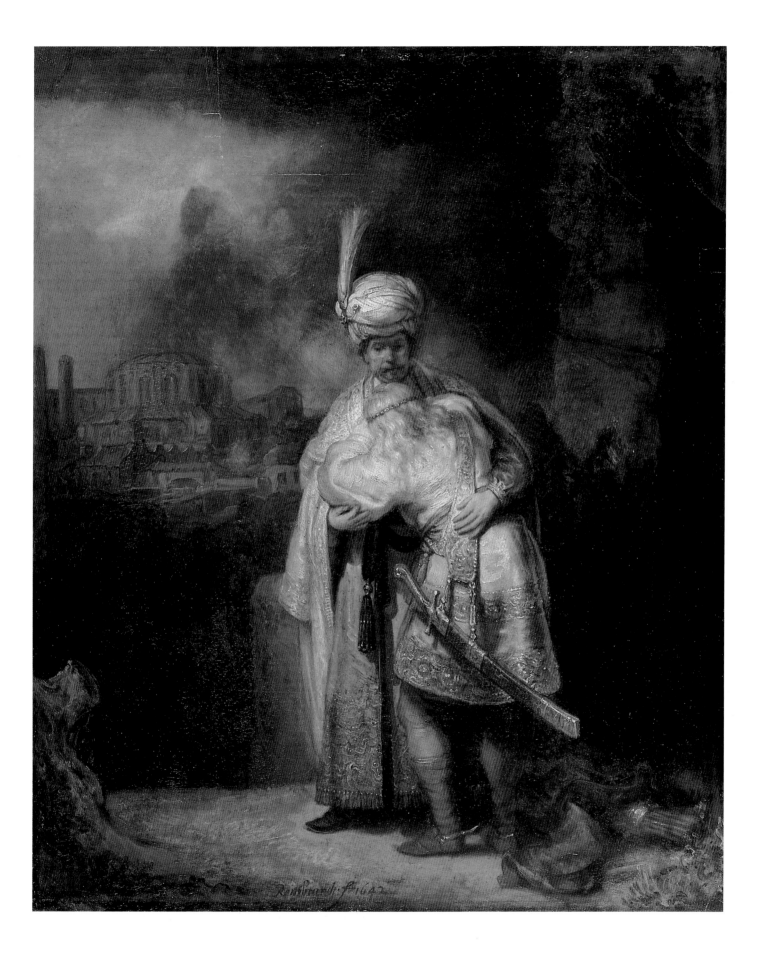

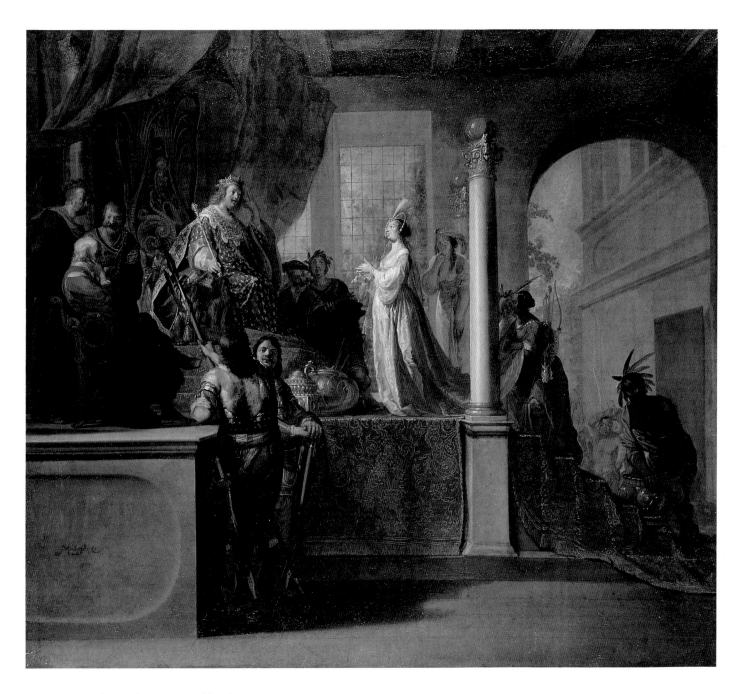

NICOLAUS KNÜPFER Leipzig 1603–Utrecht 1655
The Queen of Sheba Before Solomon
(Inv. No. 699) Oil on canvas 29 × 32″ (73.5 × 81 cm)

Opposite
GIOVANNI BATTISTA NALDINI Fiesole ca. 1537–Florence 1591
Bathsheba Bathing
(Inv. No. 47) Oil on canvas, transferred from panel
71½ × 59″ (182 × 150 cm)
(Ex coll. Carlo del Caro, 1825)

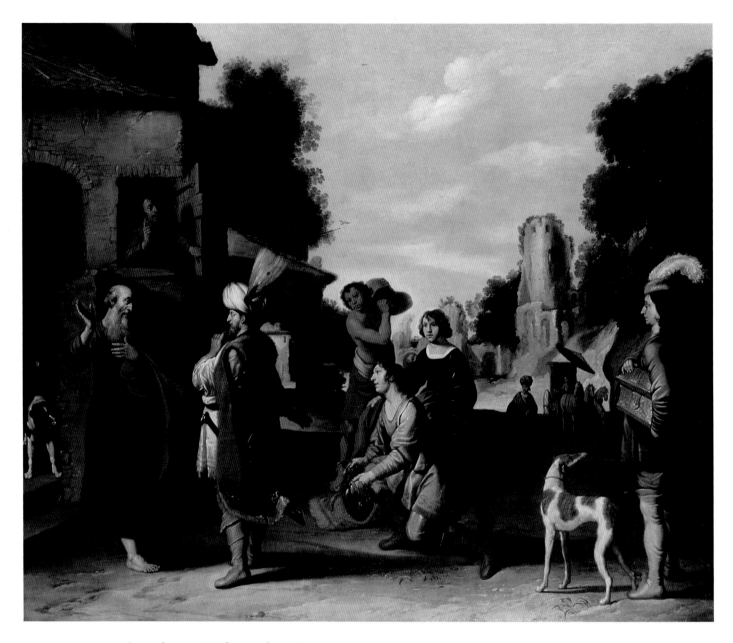

LAMBERT JACOBSZ Amsterdam ca. 1598–Leeuwarden 1636
The Prophet Elisha and Naaman
(Inv. No. 8677) Oil on canvas
52 × 63" (133 × 160 cm)
(Ex coll. J.E. Gotzkowski, Berlin, 1764)

explained by a czarist penchant for choosing German mates for their progeny. Nicolaus Knüpfer's *The Queen of Sheba Before Solomon* (143) recalls Rembrandt in its delicacy, the style of the German's early eighteenth-century canvas also close to the art of Rubens and Italy. Sheba's exotic origin is indicated by the American or Far Eastern Indians the artist furnished for her train; her other slaves' armor comes from the Dutch East Indies. The wise king, looking a little like Rembrandt himself, is clad in the lavish attire of a French monarch. Because there was no unified Germany, France represented the continent's greatest power. A happily interlocking directorate of love and money, Sheba and Solomon present a pacific, romantic, lasting merger of Eastern and Western powers, a theme long employed for political and religious, as well as personal, reasons.

Where Solomon and Sheba's love is the Bible's major "official romance," its formality (excepting the king's amorous Song) makes the other royal love story, told both in the Old Testament and in the apocryphal Book of Esther, far the more winning. This is the tale of a Jewish orphan who becomes the beloved of Persia's King Ahasuerus. The Book of Esther, when inscribed upon a scroll, known as a *megilloth*, is the traditional present for pious Jewish brides.

Poussin's canvas (146) shows Esther's heroic stand, just after she had revealed herself as a Jew in order to save her people from death—the policy of mass murder inspired by her husband's evil

counselor, Haman. In a wondrous fusion of love and valor, Esther, having summoned all her resources for the crucial revelation, faints into the arms of her handmaidens. She suggests the grand style of some diva in a swoon as much induced by realizing her own bravery as by the still inscrutable face of her Zeus-like spouse.

A School of Rembrandt work shifted the same story's dramatic key from major to minor, turning attention away from the more obvious encounter between Esther and the king to the moment of Haman's awareness of his guilt (147). After learning that Haman planned his death, too, Ahasuerus condemned him to death. Some scholars have viewed the subject as that of *David and Uriah*, where the king sends Bathsheba's husband to death in battle. Whomever the three figures may prove to be, they suggest an inner dialogue, a silent trio.

BARTHOLOMEUS BREENBERGH
Deventer 1598/1600–Amsterdam 1657
The Prophet Elijah and the Widow of Zarephath
(Inv. No. 6158) Oil on panel
27 × 36" (69.5 × 92 cm)
(Ex coll. L.A. Musina-Pushkina,
St. Petersburg, 1919)

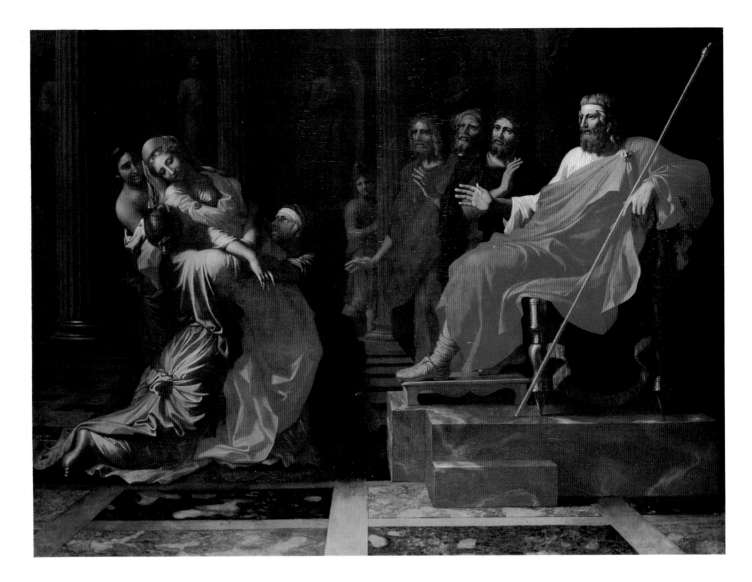

Apart yet together, they share the sort of tragic communion that only a Verdi could project into sound. Rembrandt's influence, as revolutionary as that of the composer, caused the painter or painters to make wonderful use of light, gesture, and physiognomy to manifest this trio. By cutting the figures off at the knees and concentrating upon them alone, a bold route to the heart of the matter has been found.

Where Esther's beauty won a Persian king, and her courage the salvation of her people, the same attributes enabled Judith to seduce and slay the Jews' enemy, the Assyrian commander, Holofernes, whom she murdered in his tent after getting him drunk. In Giorgione's painting (148), whose verticality follows Judith's standing figure, she looks down at the severed head of Holofernes under her foot (150–51). Her exquisitely bared leg is revealed as the weapon leading to the Assyrian's fall.

Venice, one of Europe's most militant and romantic centers, found Judith's apocryphal book appealing, as did Florence. Both states were republics, and saw in

NICOLAS POUSSIN
Esther Before Ahasuerus, 1640s
(Inv. No. 1755) Oil on canvas
47 × 61″ (119 × 155 cm)
(Ex coll. Philippe, duc d'Orleans)

Opposite
SCHOOL OF REMBRANDT
The Condemnation of Haman
(or *David and Uriah*), ca. 1665
(Inv. No. 752) Oil on canvas
50 × 45½″ (127 × 116 cm)
(Ex coll. John Blackwood, London, 1773)

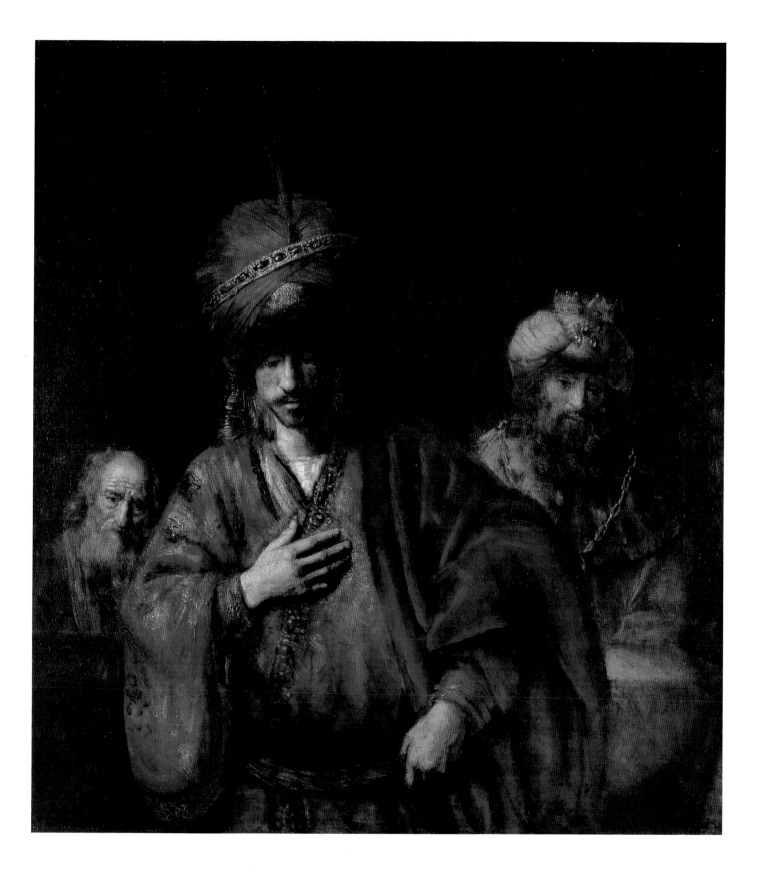

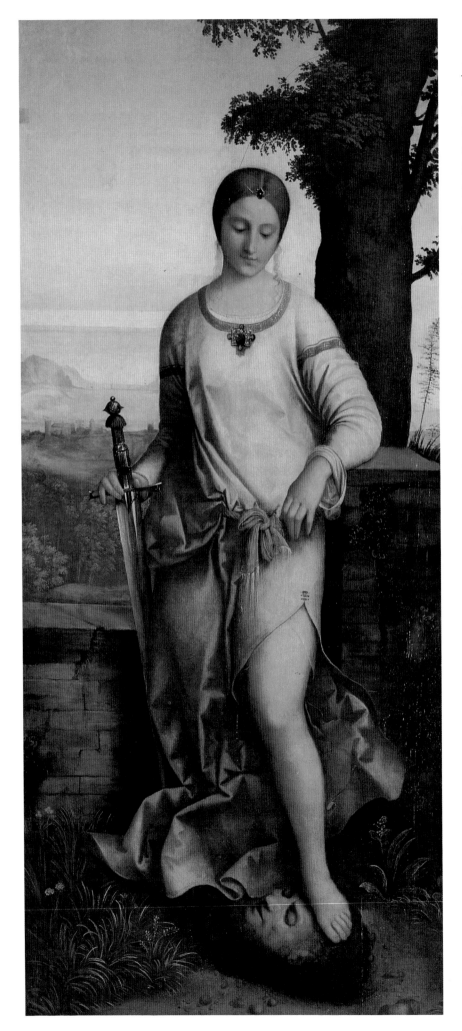

Judith their equivalent to a statue of Liberty. Bought with Crozat's collection as a Raphael, this *Judith* may be the Hermitage's greatest rarity, one of the handful of paintings that even the crustiest of experts agrees to be by the leading artist of the Early High Renaissance in Venice, Giorgione.

More than any other apocryphal book, that of Tobit came close to the lives of patrons. Once again love and salvation are the central themes. Here that love is between parent and child, and the healing is of a father's blindness. Among the most dreaded of afflictions, blindness is especially terrifying from a painter's viewpoint, equated, too, with spiritual opacity and with the need for revelation, all closely concerned with faith and art.

Another reason Tobias's tale came to mean so much was its theme of a boy sent on the road to collect his father's debt. Such commercial travel was a common source of parental anxiety in the first stage of modern economic development between the fifteenth and later seventeenth centuries. At that time, Tobias's journey was identified with those undertaken by so many youths working in trade as apprentices in faraway places; travels made when they were hazardous in every way, and countless sons were never heard from again. That's why few images were dearer to anxious parental hearts than that of Tobias's guardian angel Raphael, shielding their faraway child from harm, as so beautifully told in *The Book of Tobit.*

SAMUEL DIRCKSZ VAN HOOGSTRATEN Dordrecht 1627–1678
Tobias's Farewell to His Parents
(Inv. No. 2274) Oil on canvas, transferred to new canvas
25½ × 29″ (65 × 73 cm)

Opposite
GIORGIONE (GIORGIO DA CASTELFRANCO)
Castelfranco ca. 1477–probably Venice 1510
Judith
(Inv. No. 95) Oil on canvas 56½ × 26″ (144 × 66.5 cm)
(Ex coll. Crozat, Paris, 1772)

Overleaf
GIORGIONE *Judith* (detail)

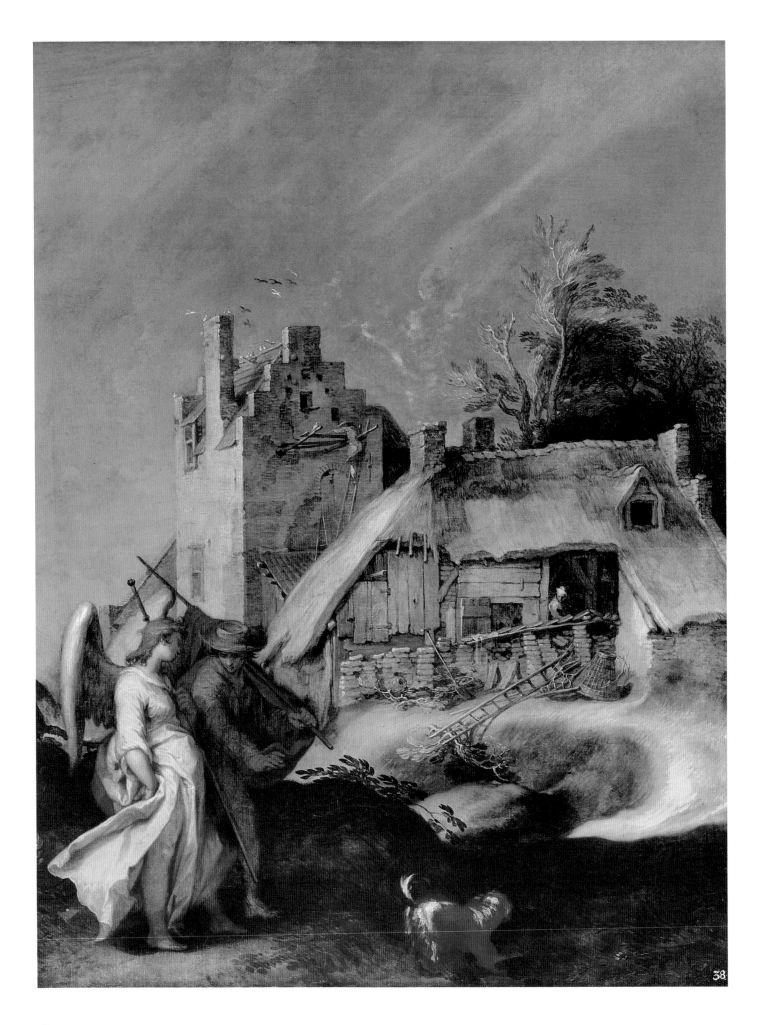

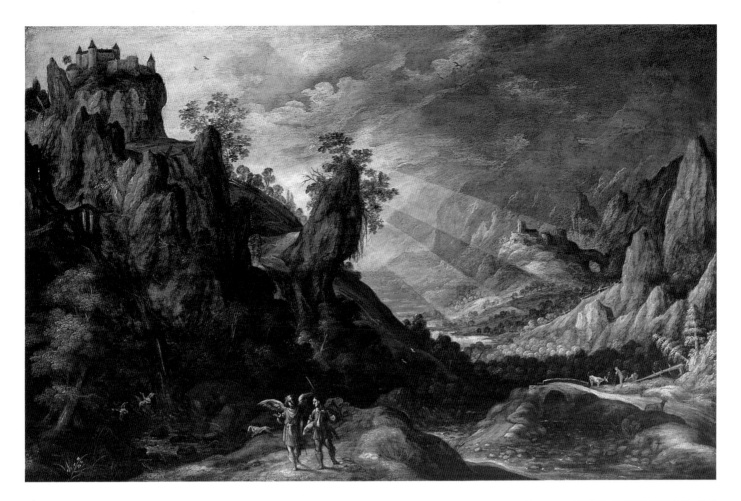

Above
KERSTIAEN DE KEUNINCK
Kortrijk ca. 1560–Antwerp 1632/35
Landscape with Tobias and the Angel
(Inv. No. 6188) Oil on panel 16 × 25″ (40 × 63 cm)
(Ex coll. N.K. Roerich, St. Petersburg, 1921)

Right
JEAN BILEVELT (GIOVANNI BILIVERTI)
Maestricht 1576–Florence 1644
The Angel's Parting from Tobias
(Inv. No. 41) Oil on canvas 74 × 57″ (188.5 × 144.5 cm)
(Ex coll. Empress Josephine, Malmaison, 1814)

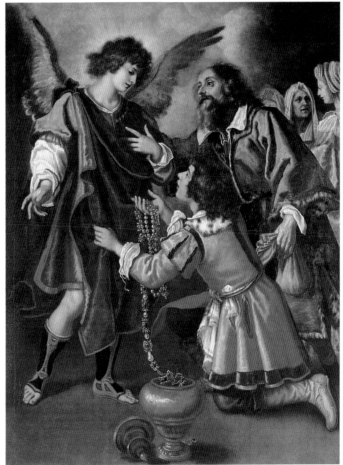

Opposite
ABRAHAM BLOEMAERT
Gorinchen 1564–Utrecht 1651
Landscape with Tobias and the Angel
(Inv. No. 3545) Oil on canvas
55 × 42″ (139 × 107.5 cm)

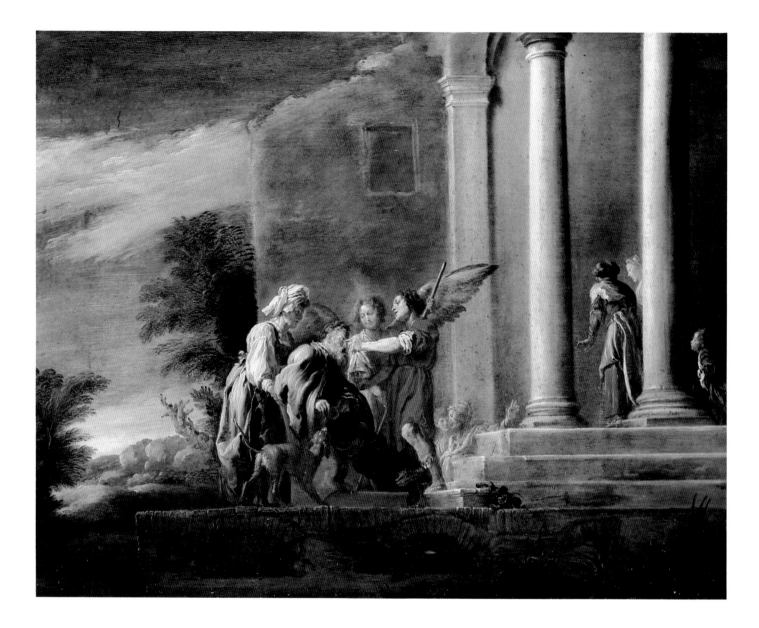

Still close to the art of his teacher, Rembrandt, Samuel van Hoogstraten's dark, evocative interior for *Tobias Taking Leave of His Parents* (149) has a few light areas such as the white table top, which provides a focal point for the scene of departure. The guardian angel stands at the right; the simplicity of the scene is in keeping with the painter's Mennonite faith.

Abraham Bloemaert's paintings are unusually prophetic in style. Though dating from the later sixteenth century, they are done with a rare freedom and dash that anticipate the art of such disparate masters as Rembrandt and Boucher. With an odd, infectious fusion of the decorative and the realistic, Bloemaert infuses his canvases with a brisk, closely observed approach, one refreshingly lacking in the extremes of sentimentality or realism. Here (152), guided by his Victory-like angel and led by his little dog, Tobias leaves his parent's tumble-down cottage to catch the fish whose gall will heal his father's blindness. A gloomy panorama, de-

DOMENICO FETI
Rome ca. 1589–Venice 1624
The Healing of Tobit, early 1620s
(Inv. No. 136) Oil on panel
26 × 33½″ (66.7 × 85 cm)

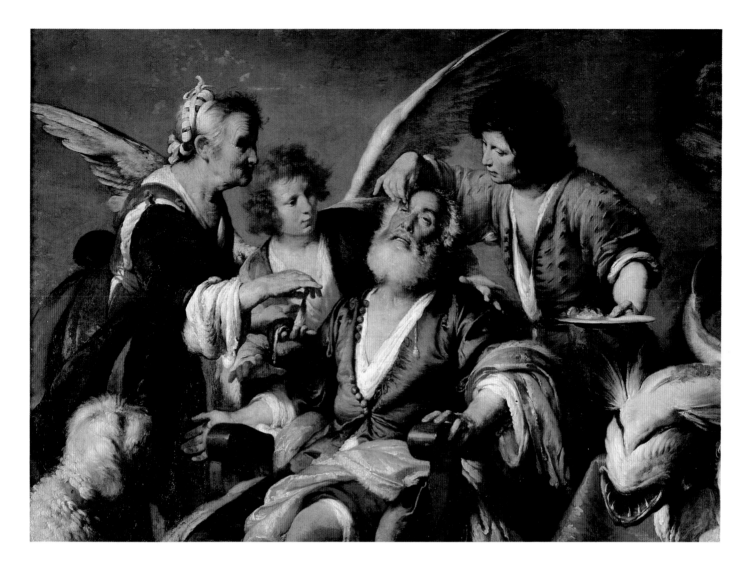

signed to strike terror in any parent, is the setting for Tobias's travels as shown by Kerstiaen de Keuninck (153).

Concentrating on the figures alone, Giovanni Antonio Biliverti (his real name was Bilivelt) shows Raphael taking leave of Tobias and his family who offer jeweled chains, which are of course refused with angelic good grace (153). The artist painted at least four other versions of this popular composition, along with canvases depicting scenes from Tobias's later life, including his marriage to Sarah.

Observed from a safe distance, Domenico Feti's *The Healing of Tobit* (154) is in keeping with the artist's delicate, suave manner, shaped more by his Venetian residence than his Roman birth. Young Tobias, with his pilgrim's staff, applies the fish gall to his father's blind eyes as Raphael beams. This almost reticent, decorative presentation of restored sight is in striking contrast with Bernardo Strozzi's treatment of the same subject (155, 156–57) where even the fish is terrifying. Now the special surgery is watched by the whole family, including Tobias's dog, in a composition whose power is increased by moving the figures very close together and cutting them off at the knee.

BERNARDO STROZZI
Genoa 1581–Venice 1644
The Healing of Tobit, ca. 1635
(Inv. No. 16) Oil on canvas
62 × 88" (158 × 223.5 cm)

Overleaf
BERNARDO STROZZI *The Healing of Tobit* (detail)

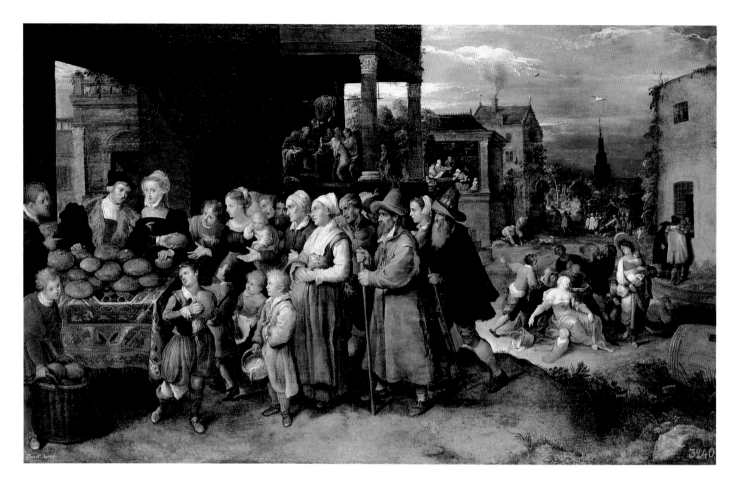

The New Testament

Where the Old Testament is largely the history of a people, the New Testament deals with the growth of a new faith through the life of Christ and his followers. Moretto da Brescia's *Allegory of Christian Faith* (159) has a beautiful woman, the Church, holding the cross in one hand, as she elevates the chalice and the host with the other, the sacrifice of the Crucifixion making possible the miraculous efficacy of the Eucharist. Frans Francken the Younger artfully unites all *Seven Acts of Charity* (158). Those good works, equal in number to the sacraments, are the doing of God's will on earth. Charity is the highest of the three theological virtues, and its

administration is often identified with Christ's presence as the giver or recipient.

Mary is one of the chief links between Christians and divinity, as she is the mortal chosen to be Jesus' mother. Her girlhood, marriage, maternity, with all their joys and sorrows, though unique for their proximity to Christ, offer parallels to the lives of many women, her cult partly founded upon the great strength of that bond.

Eustache Le Sueur shows the young virgin's Presentation in the Temple with all the Classical elegance and decorum of French seventeenth-century culture (160). Here Mary's mother, Saint Anne, reaches across in pathetic farewell as her docile little girl is taken away

Above
FRANS FRANCKEN THE YOUNGER
Antwerp 1581–1642
The Seven Acts of Charity (Allegory)
(Inv. No. 395) Oil on canvas,
transferred from panel
27 × 43½" (68.5 × 110.5 cm)

Opposite
MORETTO DA BRESCIA
Brescia ca. 1498–1554/5
Allegory of Faith, 1520s
(Inv. No. 20) Oil on panel
40 × 31" (102 × 78 cm)
(Ex coll. Crozat, Paris, 1772)

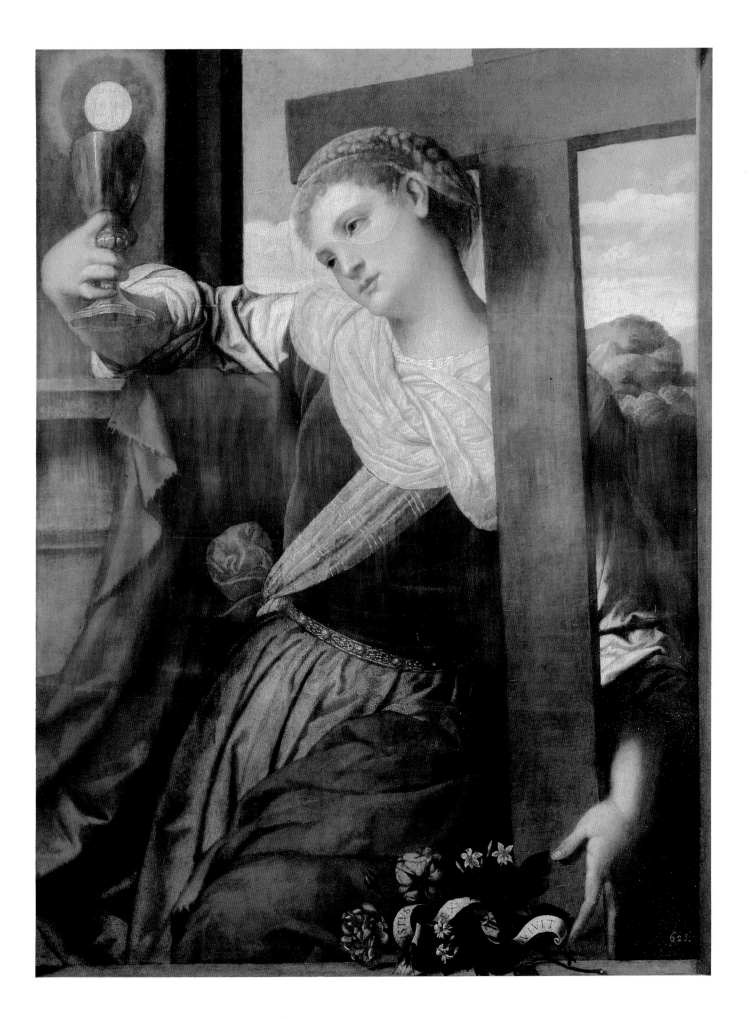

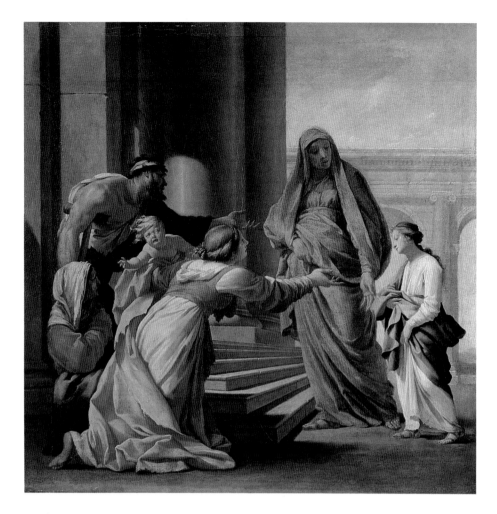

EUSTACHE LE SUEUR Paris 1616/17–1655
The Presentation of the Virgin in the Temple, 1640/45
(Inv. No. 1777) Oil on canvas
39½ × 39½″ (100.5 × 100.6 cm)

Opposite
PIETRO TESTA Lucca 1607/11–Rome 1650
The Presentation of the Virgin in the Temple (Inv. No. 48)
Oil on canvas 127 × 89″ (322.5 × 226 cm)
(Ex coll. Triebel, Berlin, 1771)

by a holy woman who is clearly modeled upon a Roman vestal. A related episode, that of Mary received by the high priest, her parents kneeling proudly yet sadly at the lower right (163), is painted by Pietro Testa, who is rightly best known for his etchings. This *Presentation* may be Testa's finest canvas, with its light flickering over white drapery that unites the composition.

Spanish art, with its gut instinct for the moment of truth, is typified by the telling austerity of Francisco Zurbarán's works. He shows Mary as a little girl, interrupting her sewing to pray (162), possibly following a mystical account where she pricks her finger, that initial bloodshed a prefiguring of a life of sacrifice. One of Mary's girlhood labors in the temple was the sewing of its great curtain, which will tear at the moment of Christ's death. Placement of the white cloth on her lap intimates that project as well as the Pietà (245, 247), when, with a winding sheet across her knees, she will cradle Christ's dead body in her arms.

Mary is shown among the temple's virgins by Guido Reni (163) in matter-of-fact fashion, his Baroque canvas's handsome complacency far from Spain's tragic mysticism. These plump, modish girls resemble local debutantes sewing for San Petronio's altar guild.

Mary's angelic *Annunciation* is followed by the moment when Christ is made flesh, the Incarnation, the beginning of Jesus' earthly life. This key mystical event is given a comfortably day-to-day, documentary credence by Cima da Coneg-

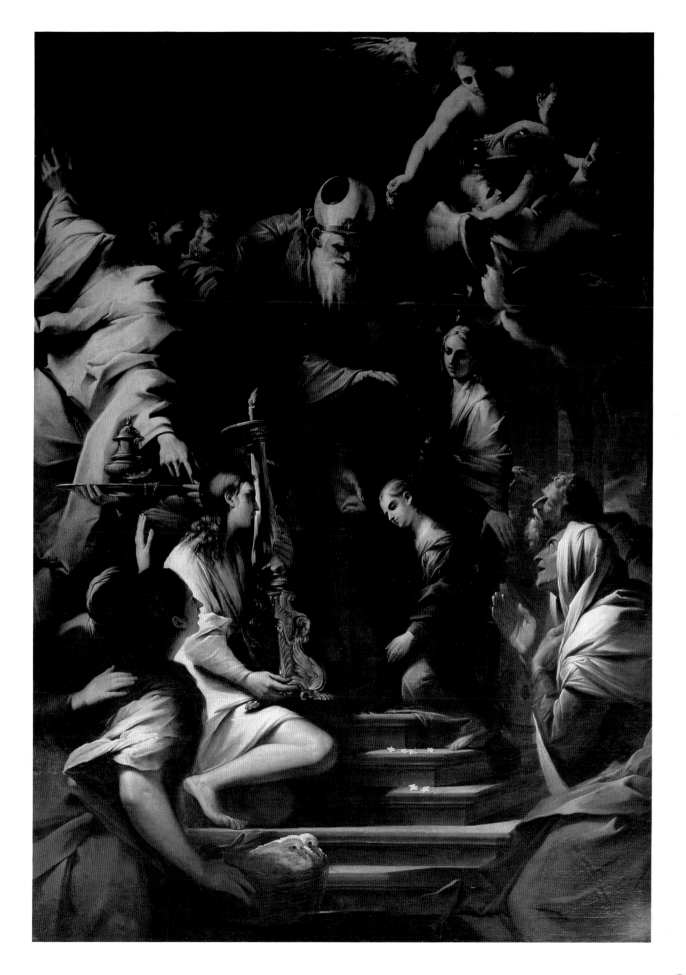

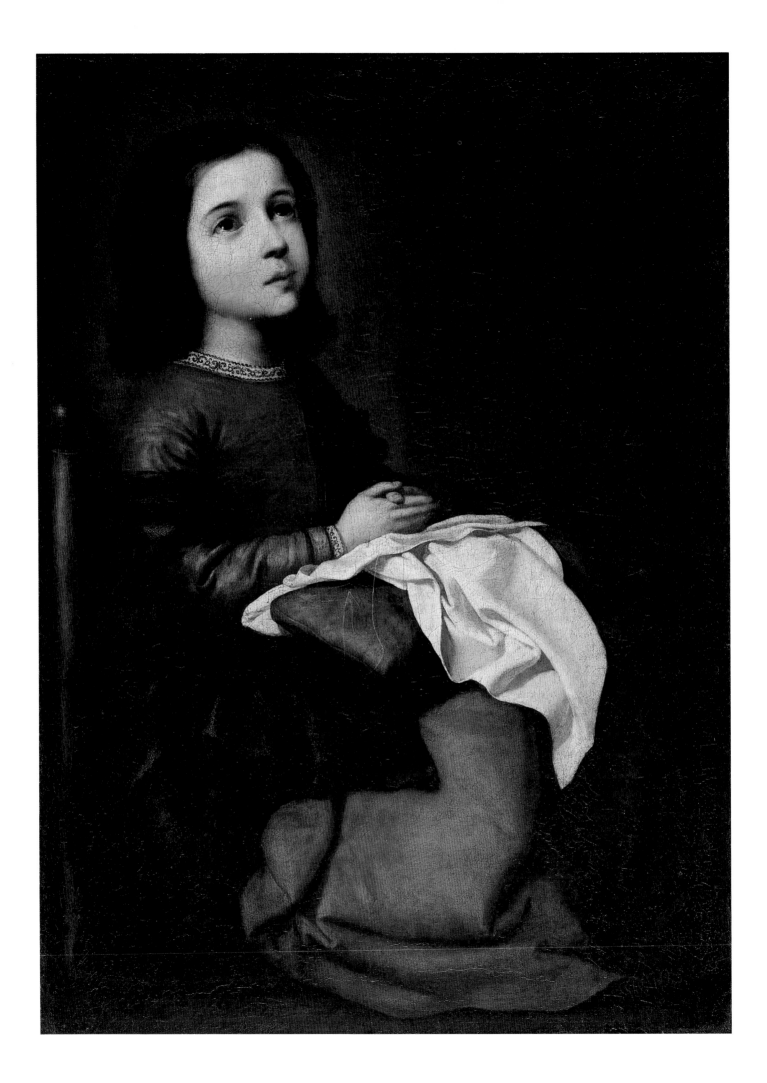

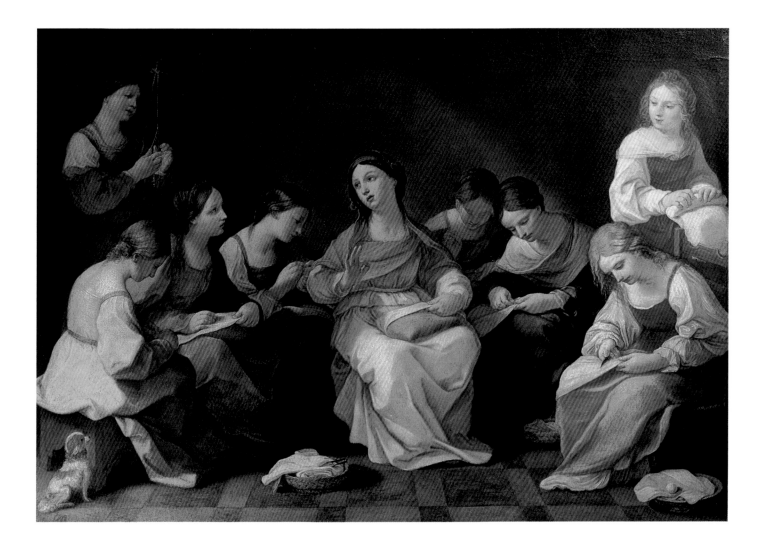

liano (164). Gabriel comes to Mary in a lavish Venetian domestic setting. The artist turned to the Veneto's large Jewish community for the lengthy Hebrew inscription over the Virgin's bed. Proud of his work, linking it to the magical illusionism of Apelles, Cima refers to a legendary episode from the Greek artist's life—when Apelles painted a fly on a picture, his rival tried to brush it away. Cima, too, painted one (on a little paper, or *cartellino*) where his name is also inscribed.

Among the Hermitage's earliest works is a little *Virgin Annunciate* (165) by Simone Martini. (The left pendant is in the National Gallery, Washington, D.C.) The Sienese

painter may have invented this sort of modest yet courtly Mary, who, seated close to the earth, is known as a Madonna of Humility, so very different in pose from Cima's prosperous maiden.

Among the few Florentine fifteenth-century pictures in the Hermitage, Filippino Lippi's *Annunciation* (165) may be one of the most complex. Humbly kneeling, Gabriel's manner reflects the gravity of his message, acknowledging and announcing Mary as future queen of Heaven. The Holy Ghost, third member of the Trinity, flies in from the left, about to enter Mary's ear for the Incarnation. A beautiful still life shows the scattered prophetic

GUIDO RENI
The Girlhood of the Virgin Mary, 1610s
(Inv. No. 198) Oil on canvas
57½ × 81″ (146 × 205.5 cm)
(Ex coll. Crozat, Paris, 1772)

Opposite
FRANCISCO DE ZURBARÁN
Fuente de Cantos, 1598–Madrid 1664
The Girlhood of the Virgin, ca. 1660
(Inv. No. 306) Oil on canvas
29 × 21″ (73.5 × 53.5 cm)
(Ex coll. Coesvelt, Amsterdam, 1814)

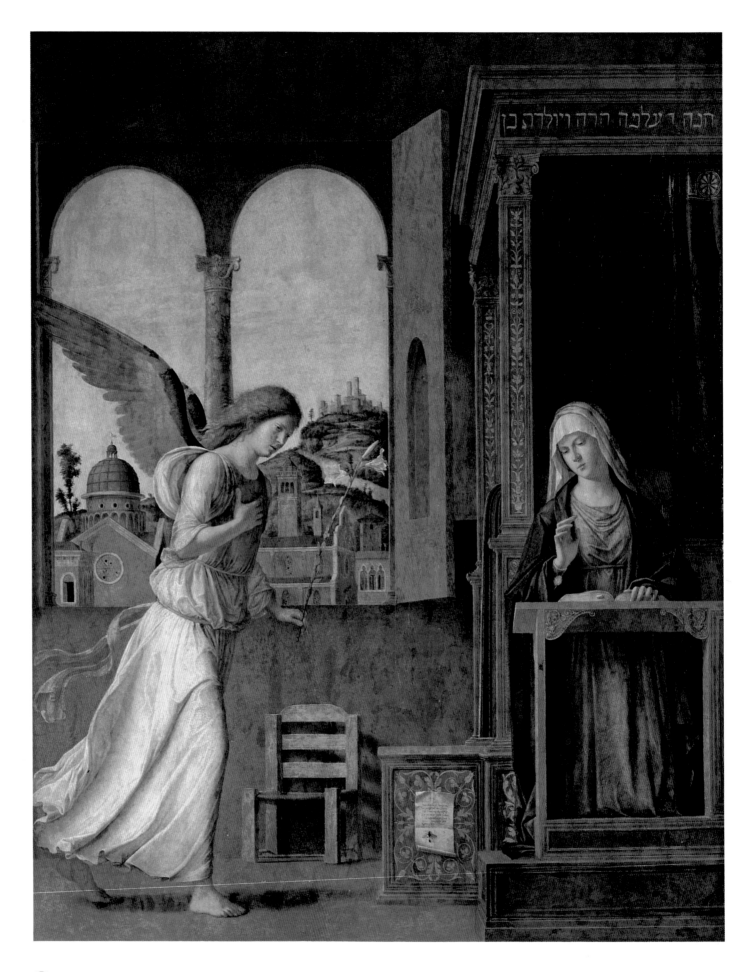

Left
SIMONE MARTINI Siena ca. 1280/85–Avignon 1344
Virgin Annunciate
(Inv. No. 284) Tempera on panel
12 × 8½″ (30.5 × 21.5 cm)

Below
FILIPPINO LIPPI Prato 1457/58–Florence 1504/5
Annunciation
(Inv. No. 4079) Tempera on panel
14 × 20″ (35 × 50.5 cm)

Opposite
CIMA DA CONEGLIANO Friuli 1459–Conegliano 1517/18
Annunciation, 1495
(Inv. No. 256) Tempera and oil on canvas, transferred from panel
54 × 42″ (136.5 × 107 cm)

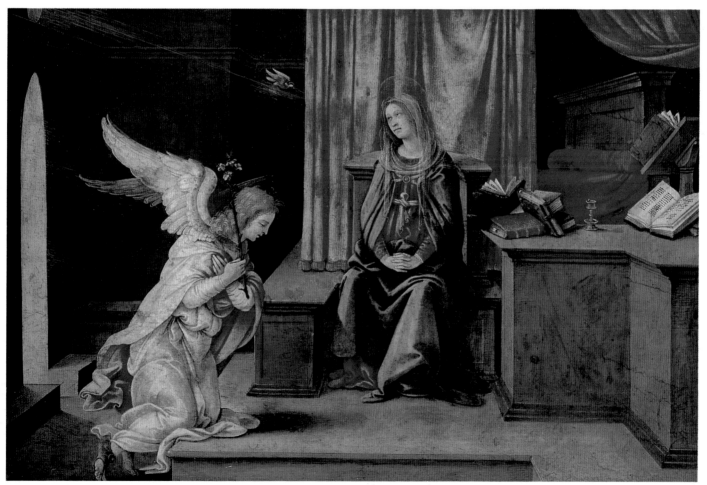

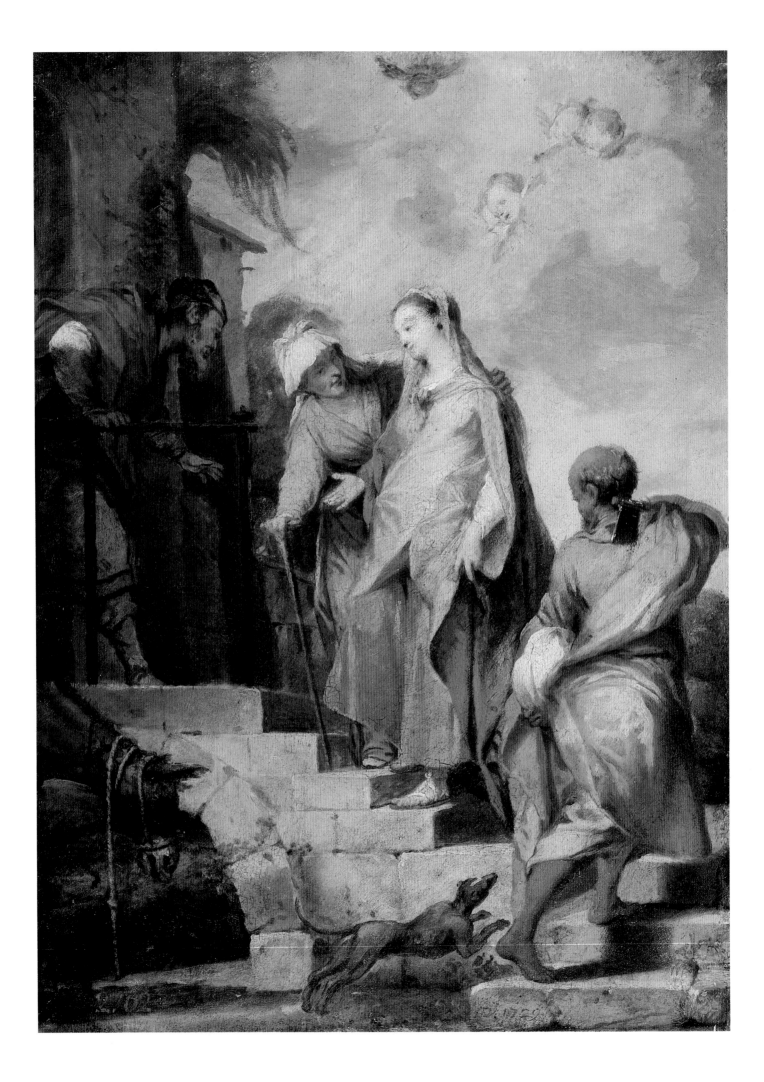

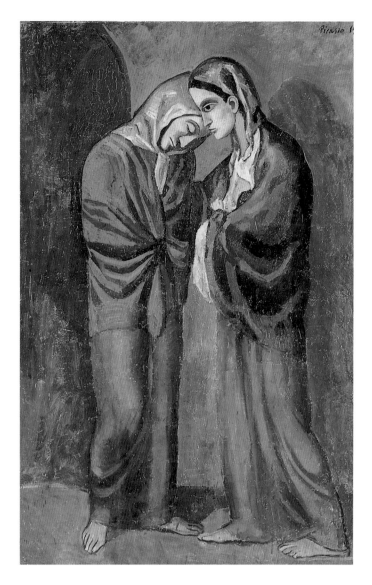

MAURICE DENIS Granville 1870–Paris 1943
Mary Visits Elizabeth, 1894
(Inv. No. 6575) Oil on canvas
40½ × 36½" (103 × 93 cm)
(Ex coll. Shchukin, Moscow)

PABLO RUIZ Y PICASSO Málaga 1881–Mougins 1974
The Visit (Two Sisters), 1902
(Inv. No. 9071) Oil on canvas, glued to panel
60 × 39" (152 × 100 cm)
(Ex coll. Shchukin, Moscow)

Opposite
NICOLAS VLEUGHELS Paris 1668/69–Rome 1737
The Visitation, ca. 1729
(Inv. No. 1888) Oil on panel
14 × 10½" (35.5 × 26.5 cm)

ALESSANDRO ALLORI Florence 1535–1607
Madonna and Child (Inv. No. 8430) Oil on canvas
51 × 45″ (129 × 114 cm)
(Ex coll. Paez de la Cadena, St. Petersburg, 1834)

JACOB JORDAENS Antwerp 1593–Putte 1678
Madonna and Child Wreathed with Flowers, ca. 1618
(flowers painted by Andris Daniels, 19th century)
(Inv. No. 2041) Oil on canvas
41 × 29″ (104 × 73.5 cm)
(Ex coll. Crozat, Paris, 1772)

Opposite
VALERIO CASTELLO Genoa 1625–1659
The Miracle of the Roses (Inv. No. 235) Oil on canvas
19 × 15″ (47.5 × 37.5 cm)
(Ex coll. Crozat, Paris, 1772)

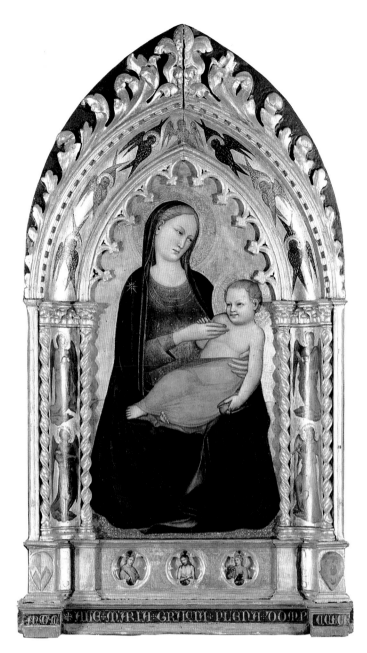

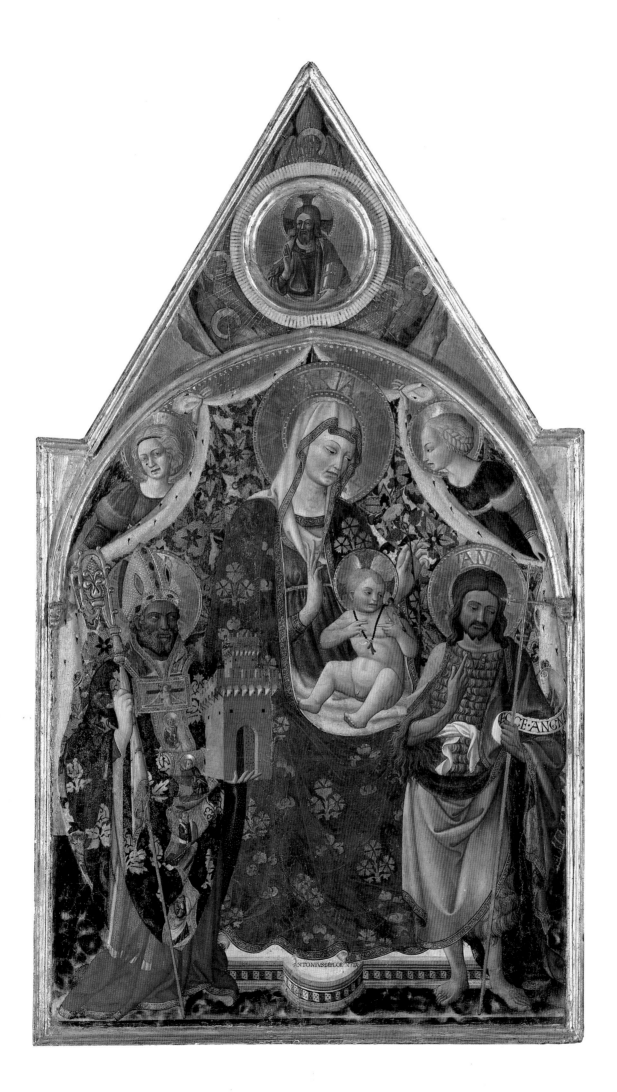

books Mary was reading just before this moment of fruition. Her gesture, fingers humbly laced in her lap, refers to the line where Mary describes herself as the handmaiden of the Lord—*Ancilla Domini*.

The Visitation is given a contemporary presentation by the early-eighteenth-century Parisian artist Nicolas Vleughels (166). Pastel colors used here revive those of Barocci and presage the decorative, lighthearted approach so typical of much French art to come. Here both women are aware of their pregnancy, as are the cherubs above, whose presence stresses the miraculous cause of the blessed events. Old Elizabeth will give birth to Saint John the Baptist, the baby in each woman's womb stirring as their mothers meet. This theme is updated by Maurice Denis (167), who staged the episode as if it were the encounter of two rather arty, middle-class French housewives, self-consciously posed on a terrace. Picasso kept the Visitation in mind as a prototype for his Blue Period painting, *The Visit* (167), yet here the intent is far different—this encounter is between ailing Catalan prostitutes.

Flowers abound in religious observance, and many of them flourish in the cult of the Virgin, representing her qualities and those of Heaven. A rich oval border (by Andris Daniels) surrounds Jacob Jordaens's iconic image of Mother and Child (168). Here, the Infant's gestures anticipate his role at the Last Judgment, blessing the Saved and pointing down to the Damned. Holding a wreath of flowers over

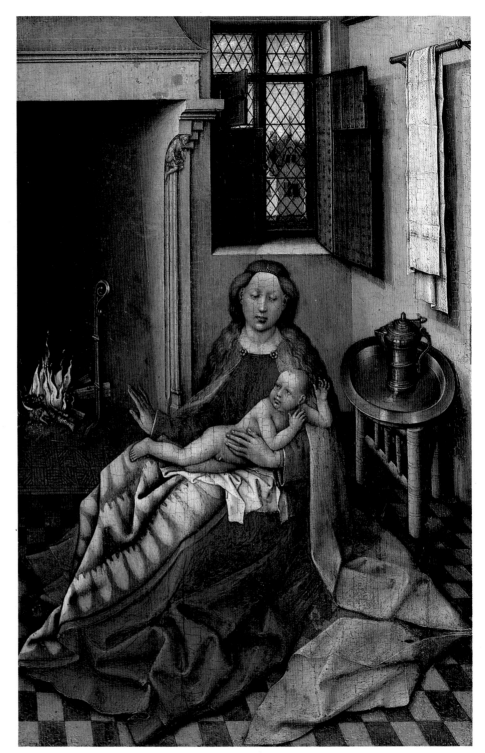

Above
ROBERT CAMPIN
(MASTER OF FLÉMALLE)
Valenciennes 1380–Tournai 1444
Madonna and Child Before a Fireplace
(Inv. No. 442) Oil on panel
13 × 9½" (34 × 24.5 cm)
(Ex coll. D.P. Tatishchev, St. Petersburg, 1845)

Opposite
JAN PROVOST Mons 1460–Bruges 1529
The Virgin in Majesty, 1524 (Inv. No. 417)
Oil on canvas, transferred from panel
80 × 59½" (203 × 151 cm)
(Ex coll. King William II, The Hague, 1850)

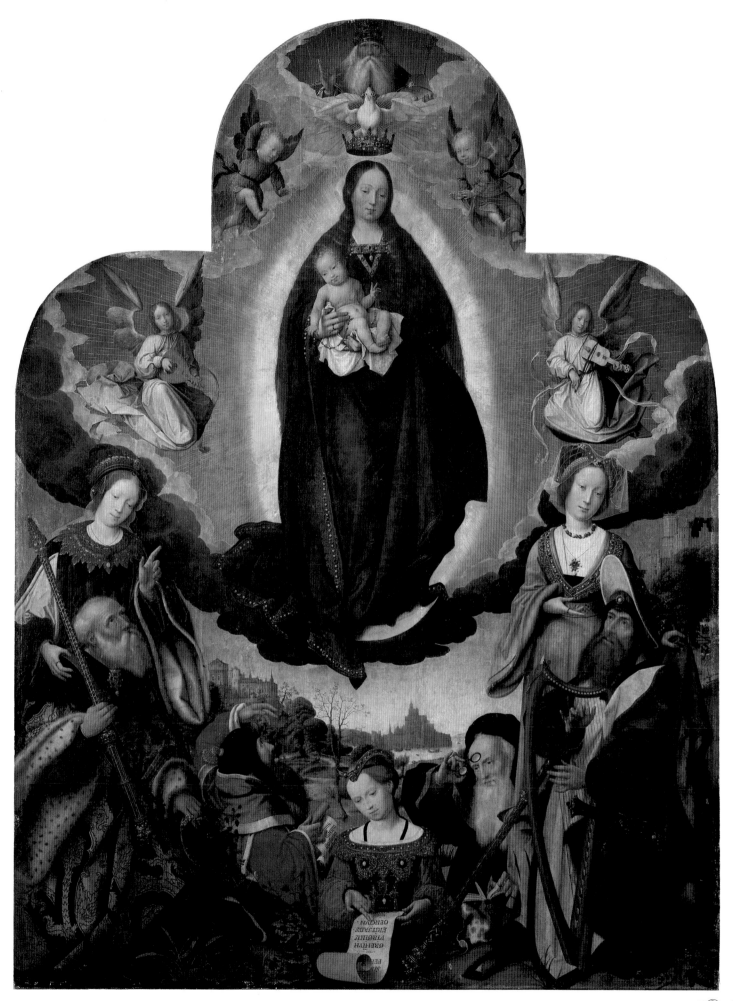

his mother's head, in a rustic *Madonna and Child* (168) by Alessandro Allori, the Infant anticipates his Coronation of the Virgin in Heaven. Another canvas, a freely brushed oil sketch by the Genoese Valerio Castelli, is devoted to *The Miracle of the Roses* (169).

Often Madonnas are independent panels, as seems true for the early Florentine one by Niccolò di Pietro Gerini (170). Judging by the paired coats of arms on the frame this may commemorate a recent wedding and express the couple's hope for children.

Far more delicate is a *Madonna and Child with Angels* (170) by Fra Angelico, dating from early-fifteenth-century Florence. For once, a baby looks like a baby, and his mother's blonde, girlish courtliness, along with a richly tooled, lavish brocade floor-covering, contradict her humble pose.

Frequently subordinate to the sculptor's and goldsmith's skills, painters often worked on close terms with those more immediately

Above, left
LUIS DE MORÁLES
Badajoz (?) ca. 1510–Badajoz 1586
Madonna and Child with Yarn Winder
(Inv. No. 364) Oil on canvas,
 transferred from panel
28 × 20½" (71.5 × 52 cm)
(Ex coll. D.P. Tatishchev, St. Petersburg, 1845)

Above
LUCAS CRANACH THE ELDER
Kronach 1472–Weimar 1553
Madonna and Child Under an Apple Tree
(Inv. No. 684)
Oil on canvas, transferred from panel
34 × 23" (87 × 59 cm)

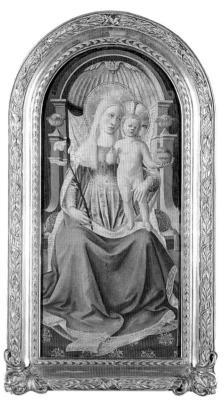

Above
JACOPO DEL POLLAIUOLO
Florence ca. 1441–Rome 1494/6
Madonna and Child, 1469/70
(Inv. No. 5520) Tempera and oil on canvas,
transferred from panel
29 × 21″ (73 × 54 cm)
(Ex coll. A.K. Rudanovsky, St. Petersburg,
1919)

Above, right
BENOZZO GOZZOLI
(**BENOZZO DI LESE**)
Florence ca. 1420–Pistoia 1497
Madonna and Child, ca. 1447
(Inv. No. 135) Tempera on panel
35 × 16½″ (89 × 42 cm)

arresting, glittering arts. This co-operation can be seen in a gilded reliquary enclosure adorned by Fra Angelico with a painted Christ and six angels (170).

Jesus' nurture and sacrifice are the two major images of Christian art. The first depends upon the Virgin, the second on the cross. Contrasting love and death, the beginning and the end, many small altarpieces were divided into diptychs, juxtaposing images of mother love with those of paternal sacrifice, the initial milk of maternal kindness compared with terminal torture.

The Hermitage's most powerful Italian twinned image is by the little-known Antonio Fiorentino. One side of the panel shows the Madonna and Child with John the Baptist and another, unidentified, male saint (171); on the other is an exceptionally gruesome *Crucifixion*

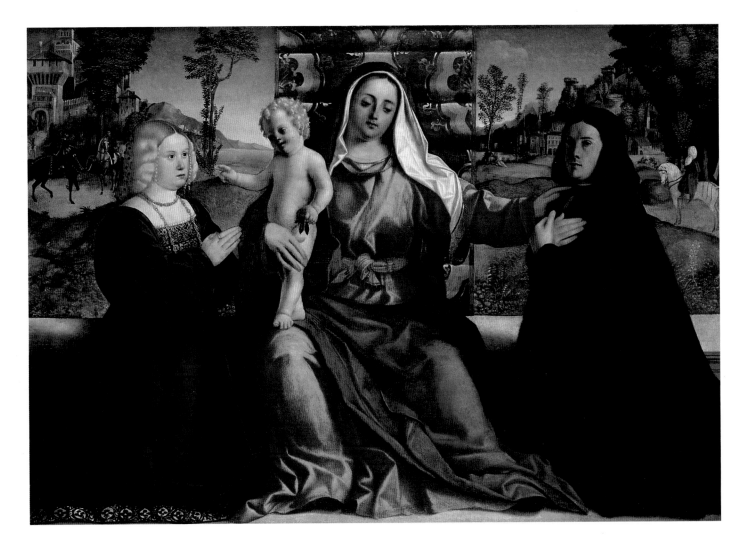

PALMA VECCHIO (JACOPO D'ANTONIO NIGRETTI)
Bergamo 1480–Venice 1528
Madonna and Child with [painting's] Commissioners (Inv. No. 116)
Oil on canvas, transferred from panel 47 × 68″ (120 × 173 cm)
(Ex coll. Barbarigo, Venice, 1850)

with Two Flagellants (231, 232–33). In the former, sadness is in the air though Mary is in regal attire. Mary's rose is a symbol of Heaven; the finch, perched on Jesus' wrist, is a messenger of suffering, death, and resurrection.

Finest of the collection's Early Netherlandish paintings is a diptych by Robert Campin, who was a contemporary of Jan van Eyck and the teacher of Rogier van der Weyden. Where the left half shows a brooding mother and baby seated before a fireplace in a startlingly realistic domestic setting (172), the right presents a *Mourning Trinity*, known also as the *Throne of Grace* (252, 254–55).

Among the largest of the Hermitage's early Northern paintings is one by Jan Provost of Bruges that encompasses many different moments (173). It features three prophets and three sibyls for their announcement of Mary's and Christ's coming. The panel also suggests the Virgin's Immaculate Conception, Assumption, role as Woman of the Apocalypse, and future Coronation.

A Spanish painter, Luis de Moráles, stressed Jesus' self-sacrifice as already manifested in infancy (174); he grasps a yarn winder that resembles a miniature crucifix, and holds a bobbin. Both objects pertain to the miraculous robe that tradition holds was made for him as a baby by the Virgin and that grew along with its wearer and was worn to Calvary. Lucas Cranach conveyed a similarly sacrificial sentiment by showing the baby as the New Adam, also willing to redeem humanity, making a gesture of benediction with his right hand (174).

Unfortunately cut down to an oval format, Piero Pollaiuolo's *Madonna and Child* (175) presents the pair enthroned high over the valley of the winding Arno, as if Heaven had to be just above Florence. A more conservative, slightly earlier indication of Florentine art is found in a *Madonna and Child* (175) by Benozzo Gozzoli, a follower of Fra Angelico, who, like the latter, enjoyed extensive Medici patronage.

Venice, so close to Northern Europe, has a more realistic and more intimate approach to devotional subjects than is often true for the rest of Italy. This is seen in an Adoration attributed to Palma Vecchio (176), not far in color from the works of Giorgione. Here the blonde, somber donatrix is blessed by the Infant, while the Virgin has her hand resting reassuringly on the donor's shoulder.

Signed by Bartolommeo Vivarini and dated 1490, an unusually sculptural *Madonna and Child* (177) continues Donatello's Paduan presence; he was established there in the mid-fifteenth century. The Vivarini brothers moved to Padua from their native Murano in 1447, and their painting soon combined Tuscan plastic values with Venetian luminosity.

The Hermitage boasts two Madonnas by Leonardo. Earlier and far the more graceful of the two is the *Benois Madonna* (178), which still reflects the Florentine concern with goldsmiths' work, and has all the hallmarks of da Vinci at his delicate, youthful best, as seen in

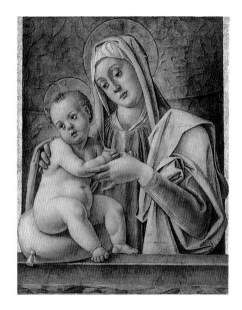

BARTOLOMMEO DA MURANO VIVARINI
Murano, Venice 1450 (?)–1499
Madonna and Child, 1490
(Inv. No. 4116) Oil and tempera on canvas, transferred from panel
22½ × 18½" (57.5 × 46.5 cm)
(Ex coll. P.S. Stroganov)

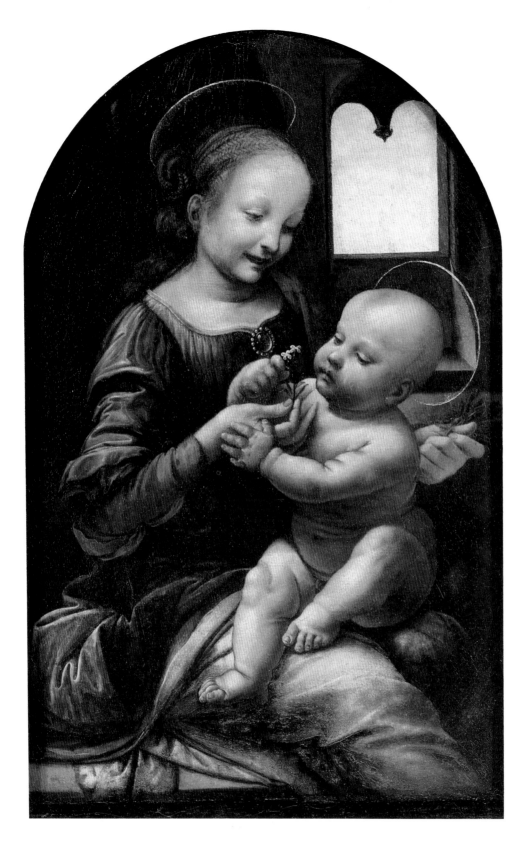

Above

LEONARDO DA VINCI
Vinci 1452–Cloux, Amboise 1519
The Benois Madonna, begun 1478 (Inv. No. 2773)
Oil on canvas, transferred from panel
19½ × 12½" (49.5 × 31.5 cm)
(Ex coll. M.A. Benois, St. Petersburg, 1914)

Opposite

LEONARDO DA VINCI
Madonna Litta, ca. 1490–91 (Inv. No. 249)
Tempera on canvas, transferred from panel
16½ × 13" (42 × 33 cm)
(Ex coll. Litta, Milan, 1865)

the girlish Mary's spiraling hair; her delicately movemented drapery; the sense of sudden, spontaneous gesture and fugitive expression; and a mysterious dynamic of light over form.

Later and less lovely, the *Madonna Litta* (179) has a waxy, marbled, heavy-lidded, erotic look only too easily copied by Leonardo's unappealing Lombard followers with whom this painting is sometimes associated. Nursing greedily, the baby clutches a finch, the symbol of his suffering, death, and resurrection. Two compelling arched apertures, like eyes, are the windows to the *Madonna Litta's* soul.

Raphael placed his exquisite, minute *Conestabile Madonna* (180) within the confines of a circle, symbolizing perfection and infinity. The format and small size probably refer to those of contemporary convex mirrors, which were also symbols of the Immaculate Conception of the Virgin, an increasingly popular cult at the time of this Madonna's painting.

Originally, as is known from a preparatory drawing in Berlin, Raphael wanted the child to hold an apple. This would have repeated the circularity of the painting's format. But he then changed that motif to the present book. Mother and Child are now united, not only as New Adam and New Eve, but also in looking at the sacred text, one that prophesies those events that they will live and die to share. Happily the panel is in its original frame, of the artist's devising.

Among the loveliest of the Hermitage's Madonnas is a magnificently playful one painted by the

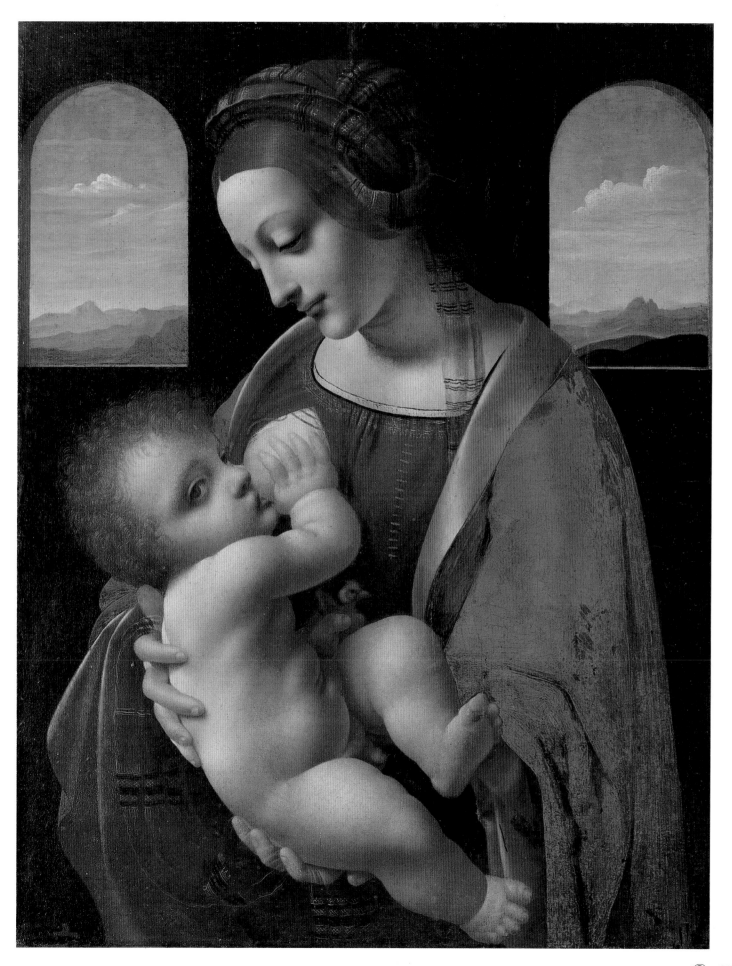

RAPHAEL *Holy Family (The Virgin with Beardless Joseph)*, 1506
(Inv. No. 91) Tempera and oil on canvas, transferred from panel
28½ × 22½″ (72.5 × 57 cm)
(Ex coll. Crozat, Paris, 1772)

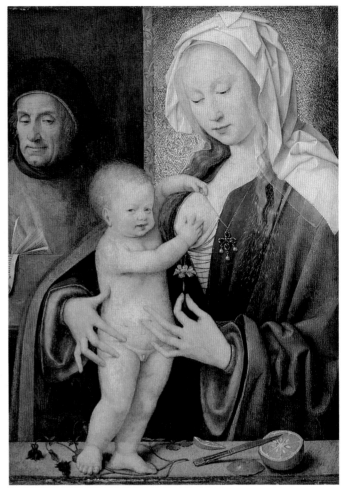

JOOS VAN CLÈVES THE ELDER Clèves 1485 (?)–Antwerp 1540/41
Holy Family (Inv. No. 411) Oil on canvas, transferred from panel
17 × 12½″ (42.5 × 31.5 cm)

Page 180
RAPHAEL (RAFFAELLO SANZIO) Urbino 1483–Rome 1520
The Conestabile Madonna, 1502/3
(Inv. No. 252) Tempera on canvas, transferred from panel
7 × 7″ (17.5 × 18 cm)
(Ex coll. Conestabile, Perugia, 1870)

Page 181
SIMON VOUET Paris 1590–1649
Madonna and Child (Inv. No. 1216) Oil on canvas
39 × 30″ (99.1 × 75.5)
(Ex coll. Crozat, Paris, 1772)

Opposite
CESARE DA SESTO Sesto 1480–Milan 1521/23
Sacra Conversazione (Inv. No. 80)
Oil on canvas, transferred from panel
35 × 28″ (89 × 71 cm)

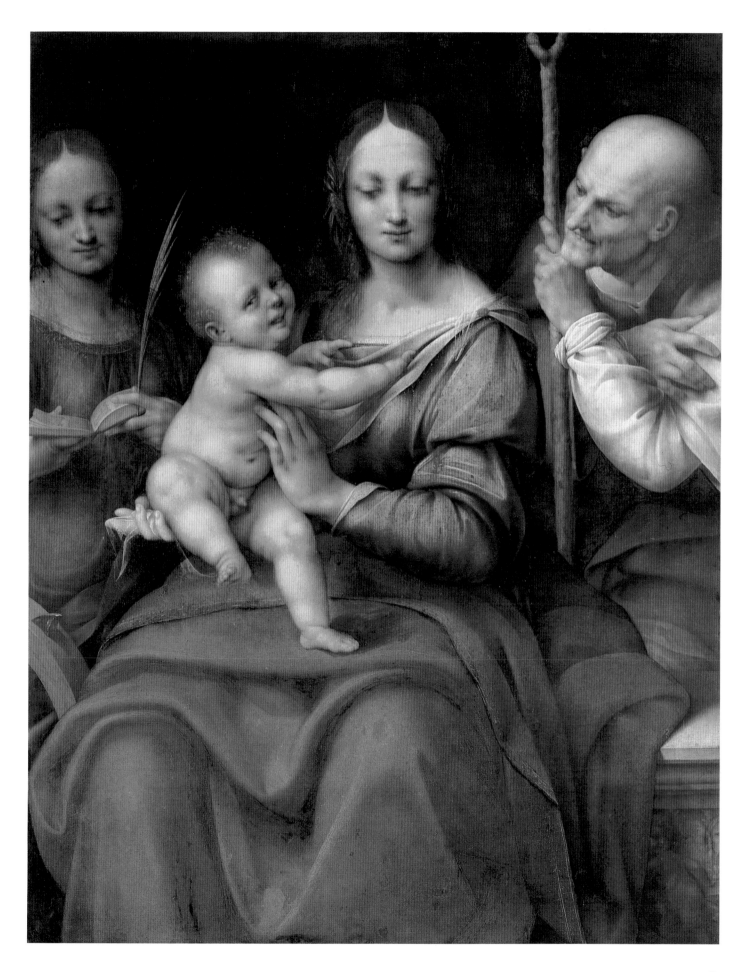

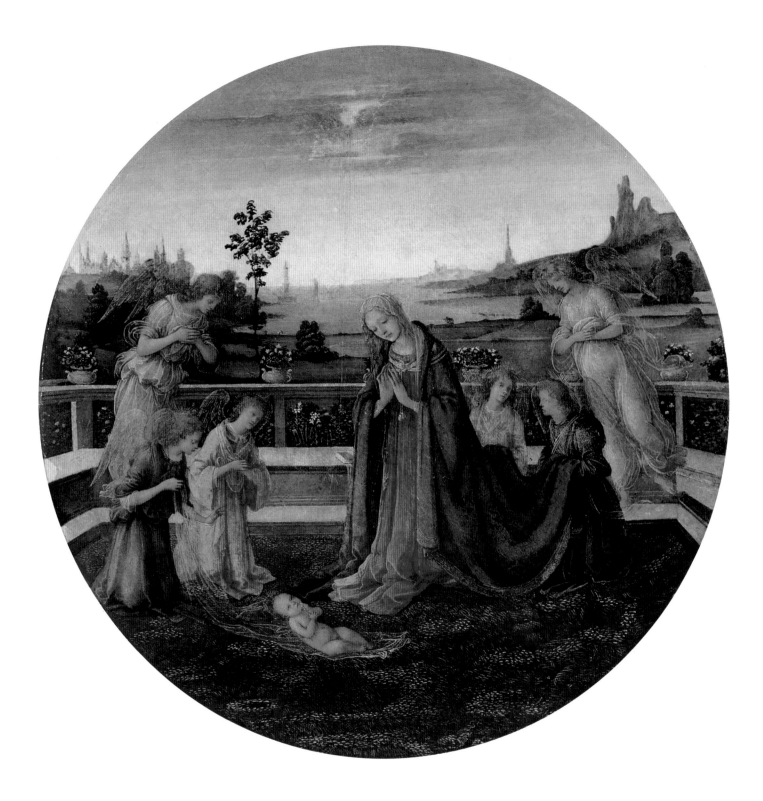

FILIPPINO LIPPI *Adoration of the Christ Child*, mid-1480s
(Inv. No. 287) Oil on copper, transferred from panel
35″ (69 cm) diameter
(Ex coll. P.S. Stroganov, St. Petersburg, 1911)

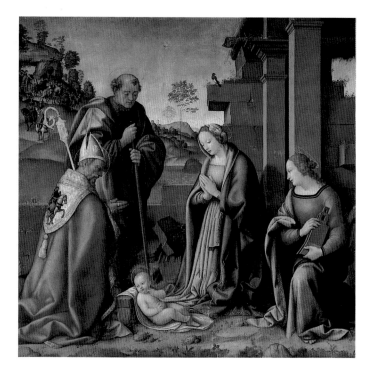

RAFFAELLO BOTTICINI Florence 1477–1520 (?)
Adoration of the Christ Child with St. Barbara and St. Martin, 1512
(Inv. No. 79) Tempera and oil on canvas, transferred from panel
68 × 69" (172 × 175 cm)

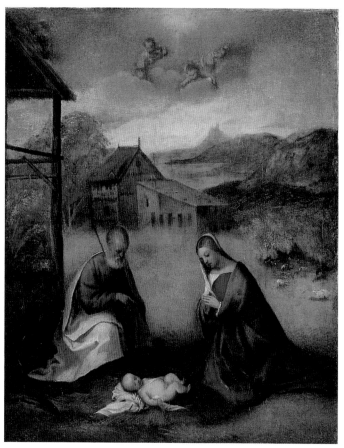

GIROLAMO ROMANINO Brescia ca. 1484–ca. 1566
Adoration of the Christ Child, 1510/15
(Inv. No. 230) Oil on canvas
19 × 15½" (49 × 39.5 cm)
(Ex coll. Crozat, Paris, 1772)

French seventeenth-century artist Simon Vouet (181). It must have been very well received as there are several versions of this composition, which unites the formal and the spontaneous in assured yet novel fashion. Like many of his compatriots, Vouet spent early years in Rome where he absorbed the force of Italian art, so much in evidence in this picture. What distinguishes his forms from those of the South is a love for simplicity and abstraction, with an elegance of line and light all his own.

One of the ways in which the Renaissance changed from the late Middle Ages lies in the new reverence for Joseph. No longer a figure of fun, a risible old cuckold, he now becomes the Good Provider, revered as the third member of the terrestrial Trinity. Ever provident and prescient, Joseph is a perfect role model of a father, worthy of the young Jesus, his surrogate son.

New images of the nuclear family were popular all over Europe, whether in Raphael's painting (182), with its poorly preserved, beardless Joseph, or in a work contemporary with it, by Joos van Cleves the Elder (182). Among Leonardo's most accomplished followers, Cesare da Sesto presents a *Sacra Conversazione* (183)—a spiritual dialogue between the Madonna and Child, Joseph, and Saint Catherine of Alexandria. Mary's lap and knees seem swollen to enormous proportions, contrasting oddly with her very small head, in Cesare's highly mannered, foxy-faced continuation of Leonardo's art, brought up to date with a tincture of Michelangelo's.

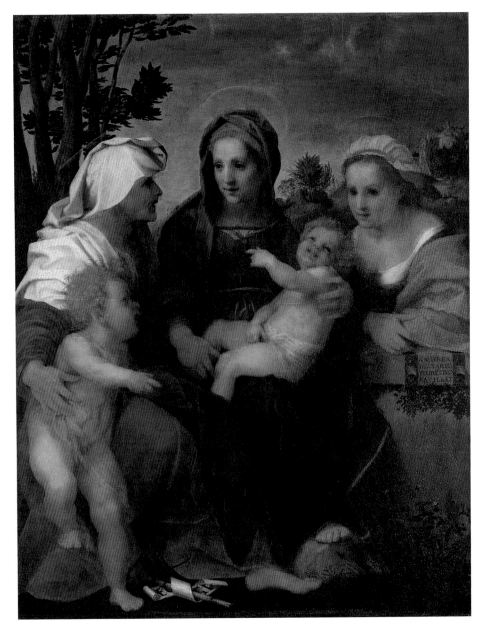

Above
ANDREA DEL SARTO Florence 1486–1530
*Madonna and Child with St. Catherine,
St. Elizabeth, and John the Baptist,* 1519
(Inv. No. 62) Oil on canvas, transferred from panel 40 × 31½" (102 × 80 cm)
(Ex coll. Empress Josephine, Malmaison, 1814)

Opposite
ANDREA DEL SARTO
Holy Family with John the Baptist
(Inv. No. 6680) Oil on panel 51 × 38½"
(129 × 98 cm)
(Ex coll. Musina-Pushkina, 1919)

Page 188
ROSSO FIORENTINO (GIOVANNI BATTISTA ROSSO)
Florence 1495–Fontainebleau 1540
Madonna and Child, ca. 1517 (Inv. No. 111)
Oil on canvas, transferred from panel
44 × 30" (111 × 75.5 cm)

Page 189
FRANCESCO PRIMATICCIO
Bologna 1504–Paris 1570
Holy Family with St. Elizabeth and John the Baptist
(Inv. No. 128) Oil on slate
17 × 12" (43.5 × 31 cm)
(Ex coll. Crozat, Paris, 1772)

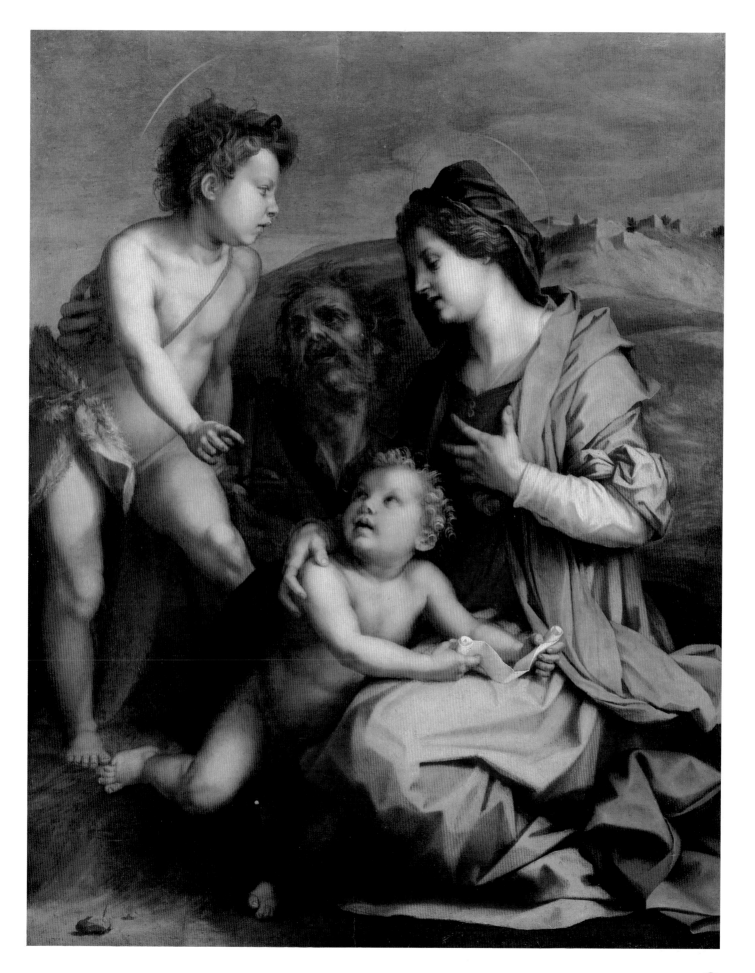

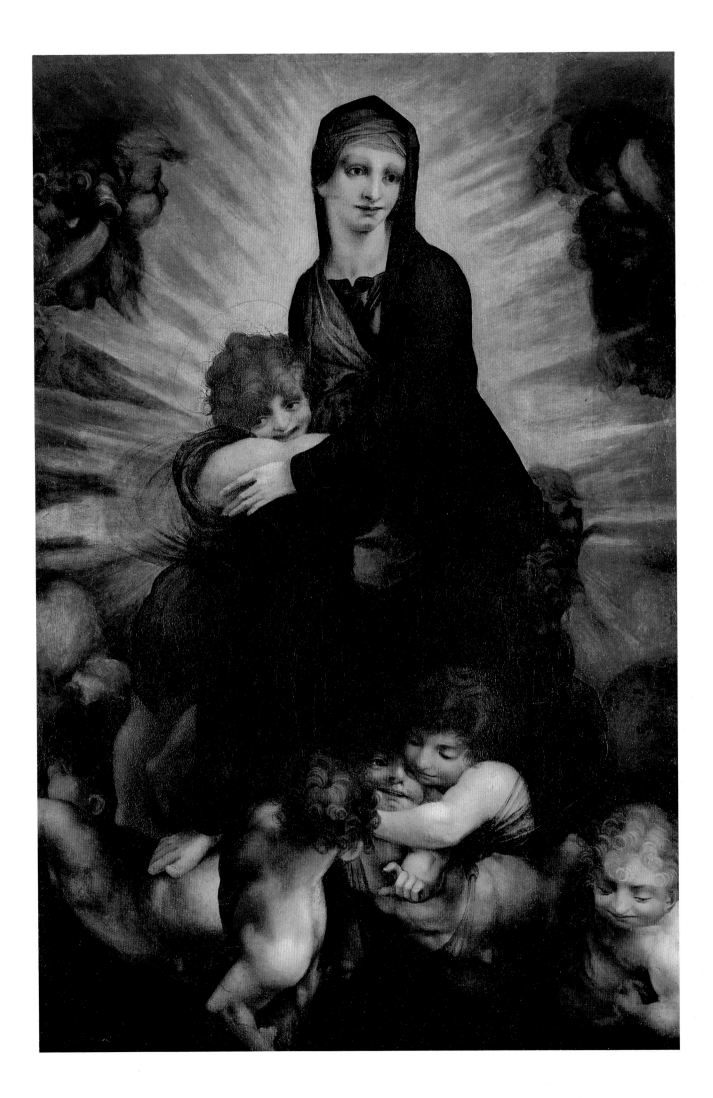

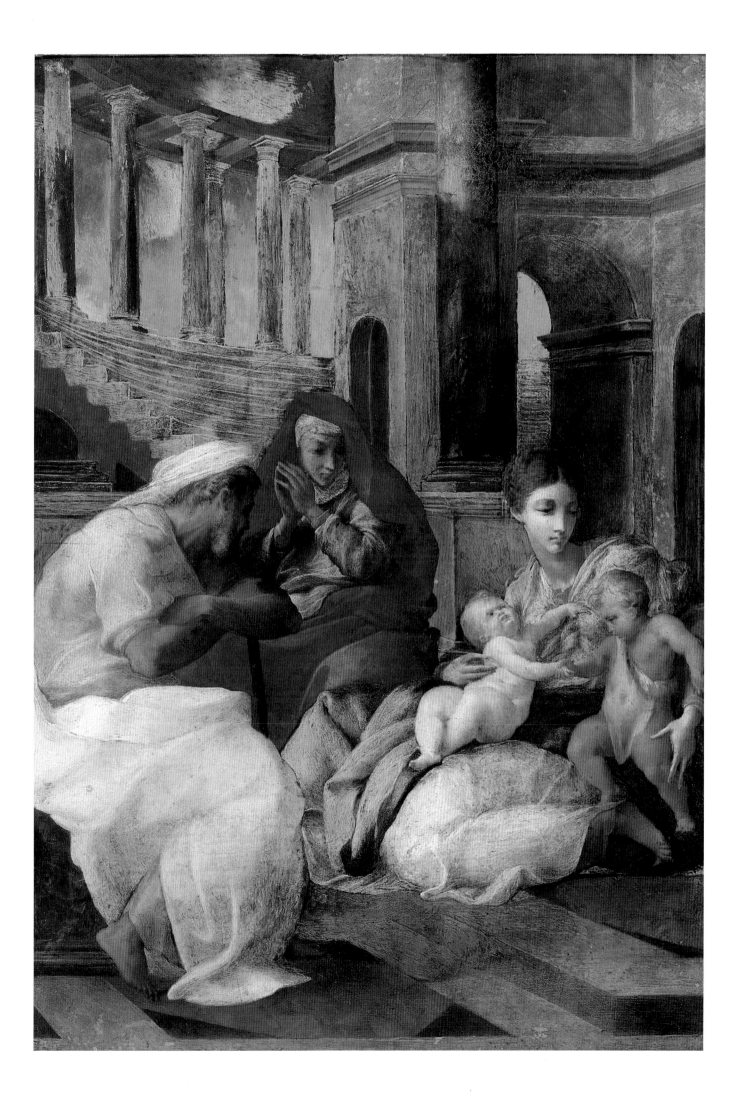

Adoration of the newborn Child is one of the happiest of Christian themes, whether this is by the mother alone, or includes Joseph, angels, shepherds, magi, donors, or any combination of the above. All allow viewers a special sense of engagement, adding their adoration to the painted participants'. Shown in a circle with a deep, cosmic landscape background, Filippino Lippi's tondo (184) stresses Mary's future role as Queen of Heaven. Joseph joins her in a Giorgionesque panel (185) by Girolamo Romanino. Saints Barbara and Martin accompany the Holy Family in a painting of Raffaello Botticini (185).

Neither his chic *changeant* coloring nor imposing, courtly gesture restrains Andrea del Sarto's mastery of emotion. His *Virgin and Child with Saint Catherine, Saint Elizabeth, and John the Baptist* (186) and his *Holy Family with John the Baptist* (187) both show a keen Florentine sense of interaction as well as introspection, exploring the dynamics of relationships in a new, convincing fashion. Each painting exploits the circular and triangular compositions dear to the High Renaissance, beginning with works by Leonardo and Raphael.

Where Sarto moved from the conventions of late-fifteenth-century art, his way one of elegant, emotionally nuanced monumentality, a far more audacious rupture was made by Rosso Fiorentino and Primaticcio. The first, a follower of Michelangelo, added eccentric, intense elements: wildly original color and equally idiosyncratic facial types. These led to unpredictable emotional responses, shaking up the

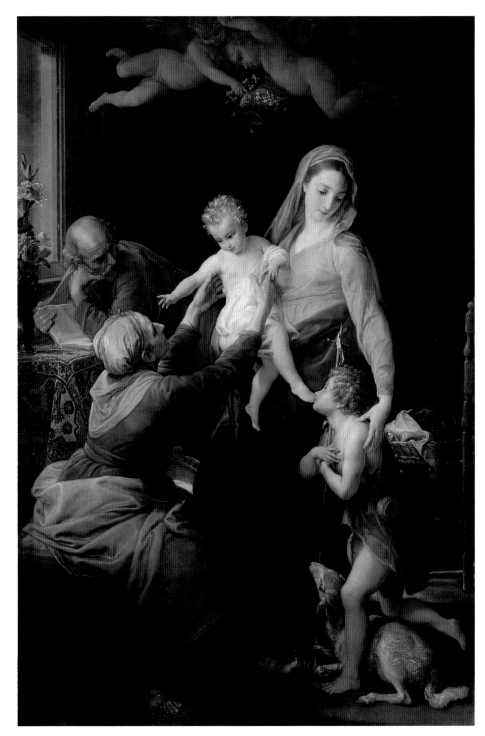

Above
POMPEO GIROLANO BATONI
Lucca 1708–Rome 1787
Holy Family, 1777
(Inv. No. 12) Oil on canvas
89 × 59″ (226 × 149.5 cm)

Opposite
NICOLAS POUSSIN *Holy Family with John the Baptist and St. Elizabeth,* 1644/55
(Inv. No. 1213) Oil on canvas
68 × 52 ½″ (172 × 133.5 cm)
(Ex coll. Walpole, Houghton Hall, 1779)

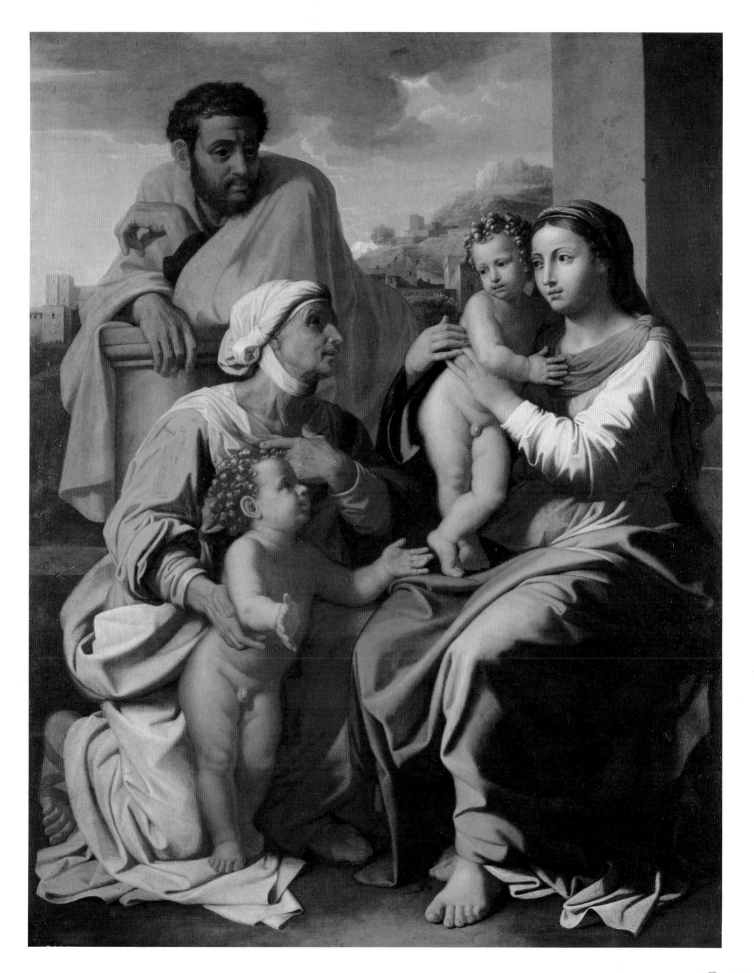

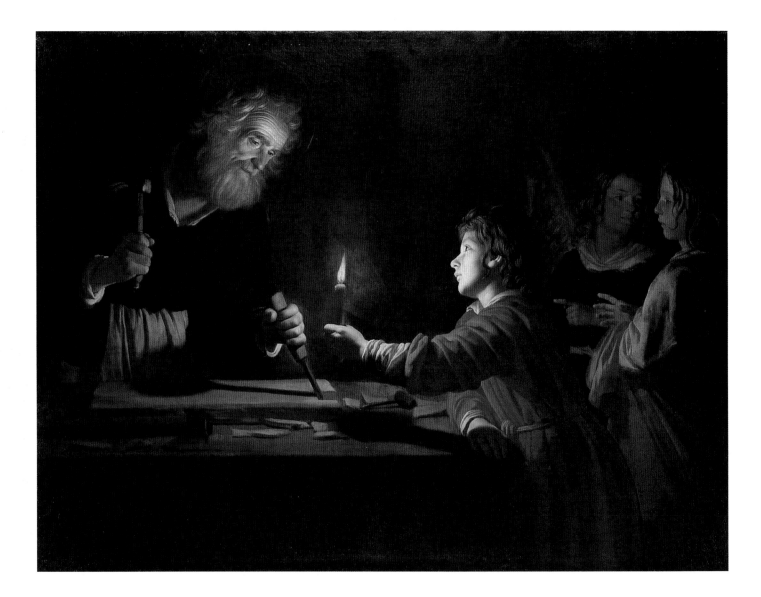

tried and too true. More logical and beautiful is the precociously Hellenizing art of Primaticcio. Both painters worked together at the Fontainebleau court of Francis I.

Rosso's painting seems to send the Madonna and large Child (this group almost a satire of Michelangelo's *Bruges Madonna*) into outer space, adding weird, sinister cherubs below (188). Primaticcio's small *Holy Family* (189) with Saint Anne and the infant Baptist, is Classical in feeling, set in a beautiful combination of theater and triumphal arch. It is painted on slate to prevent reflections. This is a

scene of profound refinement, its originality equal to but very different from Rosso's.

No one since Raphael brought as much frankly Classical authority to his art as Poussin. Where High Renaissance artists—even the favorite of the French, Raphael—had to disguise their borrowings from antiquity, Poussin reveled in the doubled intensity of images frankly combining Classical and Christian authority. His *Holy Family with John the Baptist and Saint Elizabeth* (191) has a daringly abstract, Neo-Etruscan impact, making Picasso's most classicizing works pale in compari-

GERRIT VAN HONTHORST
Utrecht 1590–1656
Christ in the Carpenter's Shop, ca. 1620
(Inv. No. 5276) Oil on canvas
54 × 73″ (137 × 185 cm)
(Ex coll. P.P. Durnoi, Leningrad, 1925)

Opposite
REMBRANDT *Holy Family*, 1645
(Inv. No. 741) Oil on canvas
46 × 36″ (117 × 91 cm)
(Ex coll. Crozat, Paris, 1772)

Overleaf
REMBRANDT *Holy Family* (detail)

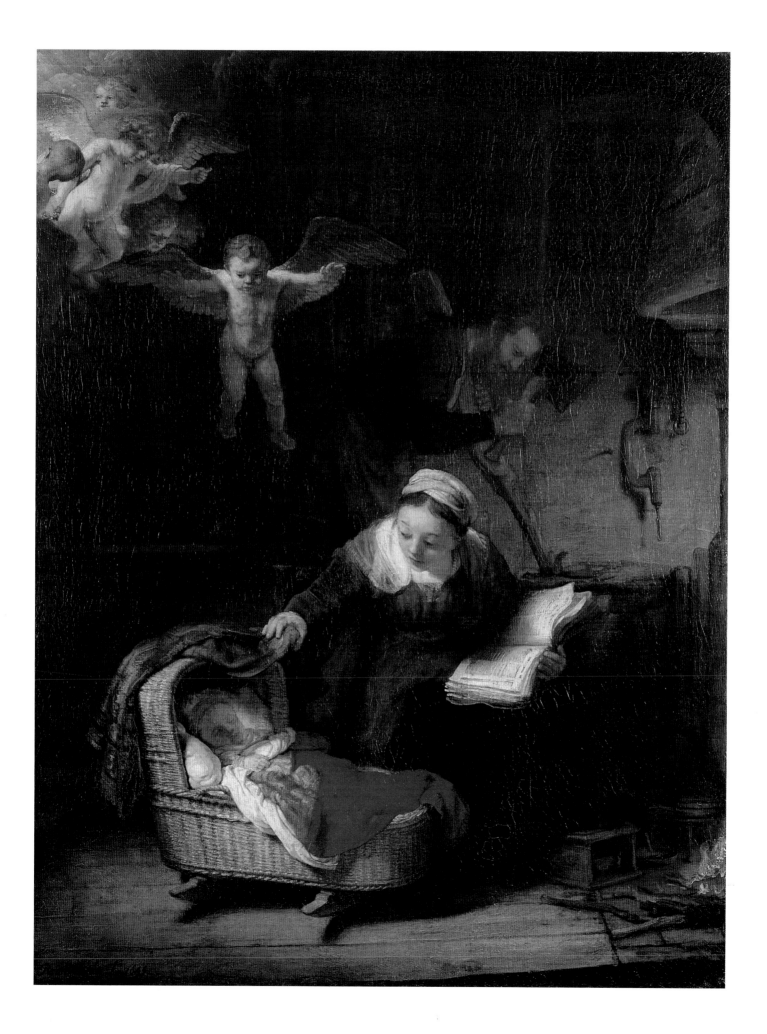

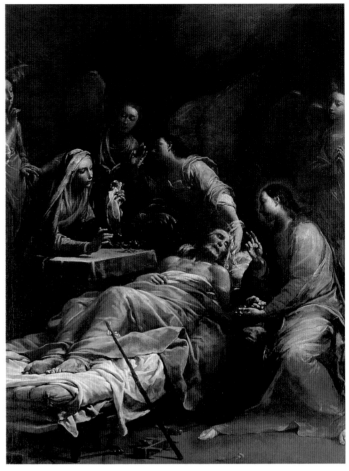

GUIDO RENI
Joseph with the Christ Child in His Arms, 1620s
(Inv. No. 58) Oil on canvas
49½ × 40″ (126 × 101 cm)
(Ex coll. King William II, The Hague, 1850)

GIUSEPPE MARIA CRESPI Bologna 1664–1747
The Death of St. Joseph, ca. 1712 (Inv. No. 25) Oil on canvas
92 × 73½″ (234.5 × 187 cm)
(Ex coll. Brühl, Dresden, 1769)

Opposite
JUAN BAUTISTA DEL MAINO
Pastrano, near Toledo 1569–Madrid 1649
Adoration of the Shepherds (Inv. No. 315) Oil on canvas
56½ × 39½″ (143.5 × 100.5 cm)
(Ex coll. Coesvelt, Amsterdam, 1814)

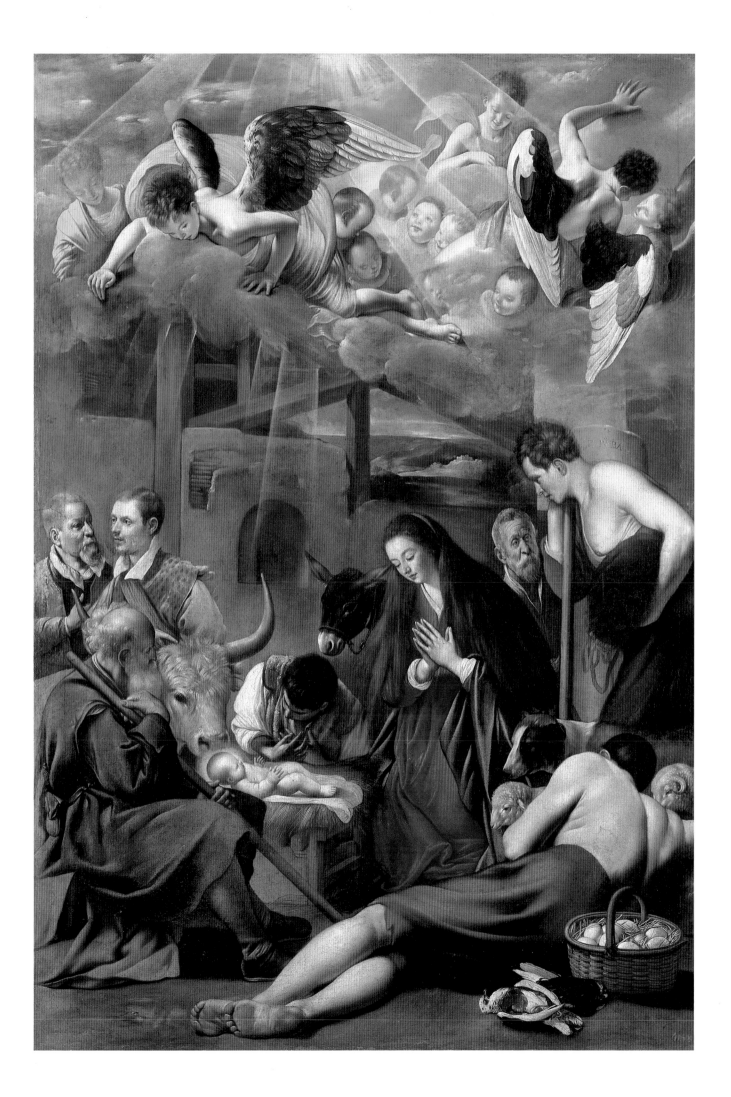

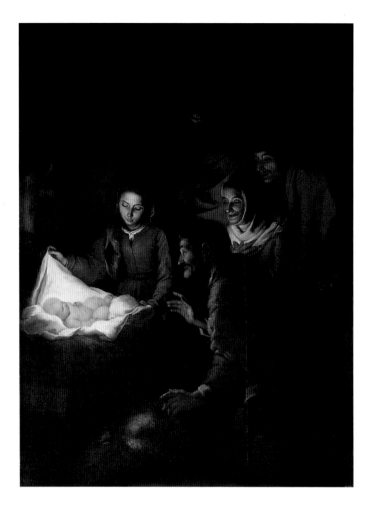

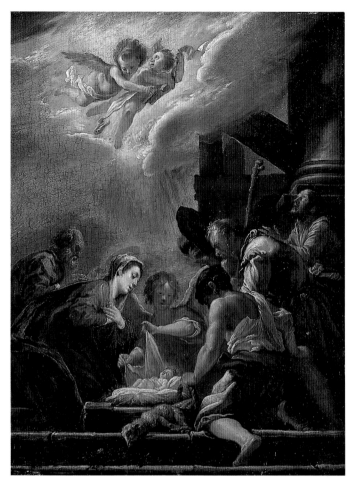

son. Here the big, barefoot Madonna and the looming masculinity of a young Joseph add an exciting sense of physicality.

Dealing with the same cast of sacred characters, Pompeo Batoni choreographs a composition paying tribute to the High Renaissance, though he painted more than two centuries later. His porcelain-like smoothness of paint surface suggests a virtuoso, "Look, no hands" approach and contributed to the Roman's immense popularity. The Hermitage has the world's largest collection of Batoni's works.

Following the Franciscan values of poverty, humility, and labor, many seventeenth-century painters, Protestant and Catholic alike,

stressed the role of Joseph as carpenter, or that of Mary as a hard-working, middle-class mother, rocking her baby in a wicker cradle, as shown by Rembrandt (193, 194–95). Laboring in the background, Joseph uses carpenter's tools, others hang on the wall. In Gerrit Honthorst's *Christ in the Carpenter's Shop* (192), shadows cast on Joseph's workbench suggest the sign of the cross.

By the seventeenth century, Joseph was often shown with the Infant Jesus all to himself, as in the classically harmonious art of Guido Reni (196). With his emphasis upon dignity, grace, and order, the Bolognese painter was well suited to painting a highly idealized old man taking patient care of the baby

Above
DOMENICO FETI *Adoration of the Shepherds*
(Inv. No. 149) Oil on panel
19 × 14½" (49 × 37 cm)

Above, left
BARTOLOMÉ ESTÉBAN MURILLO
Adoration of the Shepherds
(Inv. No. 316) Oil on canvas
77½ × 58" (197 × 147 cm)
(Ex coll. Walpole, Houghton Hall, 1779)

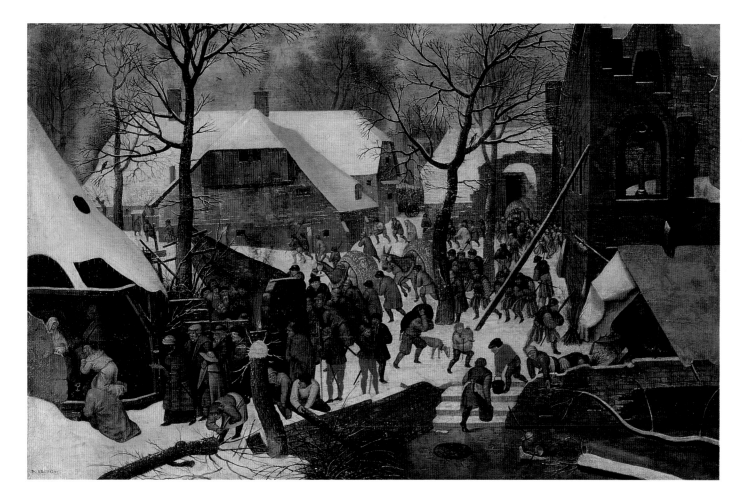

Jesus. The patriarch's last days on earth are shown by the Milanese Giuseppe Maria Crespi (196) with an almost Rococo agitation of surface. Here the young Christ gives extreme unction to his earthly father in an entirely apocryphal scene.

Without the pomp and circumstance of the Adoration of the Magi, that of the shepherds comes closer to most viewers. The three kings symbolize the Gentile world recognizing Christ as the king of kings. The shepherds are Jews, and as such have their own special significance. Murillo comes close to caricature in his broad presentation of the ignorant shepherds (198). Divine light, emanating from the Child, illuminates the nocturne, following a Northern fifteenth-

century innovation. More refinement is brought to the same subject by Domenico Feti (198). Now the light source is the angels just above.

One of the Hermitage's major paintings of Spanish origin is the *Adoration of the Shepherds* by a Milanese friar, Juan Bautista Maino (197). Established in Toledo in 1611 as a Dominican, he later became drawing master to the future Philip IV. Here the rustics are painted with such specificity that they suggest disguised donor portraits. Much of the picture, especially the faces and still life elements, anticipates the adroit realism of Velázquez.

A wintery *Adoration of the Magi* (199, 200–201), all too appropriate to the Northern climate at Epiphany, was painted by Pieter Brueghel the Younger along the famil-

PIETER BRUEGHEL THE YOUNGER
Brussels 1564–Antwerp 1638
Adoration of the Magi (Inv. No. 3737)
Oil on canvas, transferred from panel
14 × 22″ (36 × 56 cm)

Overleaf
PIETER BRUEGHEL THE YOUNGER
Adoration of the Magi (detail)

Page 202
CIRCLE OF HUGO VAN DER GOES
Adoration of the Magi (center panel) (Inv. No. 403)
Oil on canvas, transferred from panel
38 × 30½″ (96.3 × 77.5 cm)

Page 203
CIRCLE OF HUGO VAN DER GOES
Adoration of the Magi (wings)
38 × 12½″ (96.2 × 31.7 cm)

Pages 204–205
CIRCLE OF HUGO VAN DER GOES
Adoration of the Magi (detail)

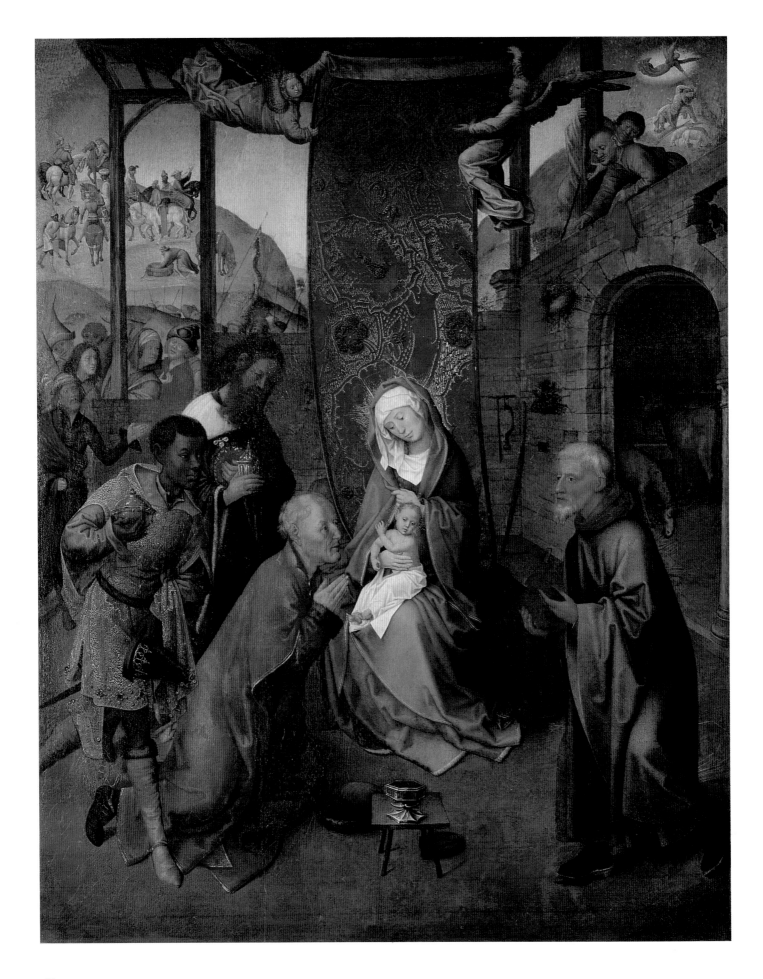

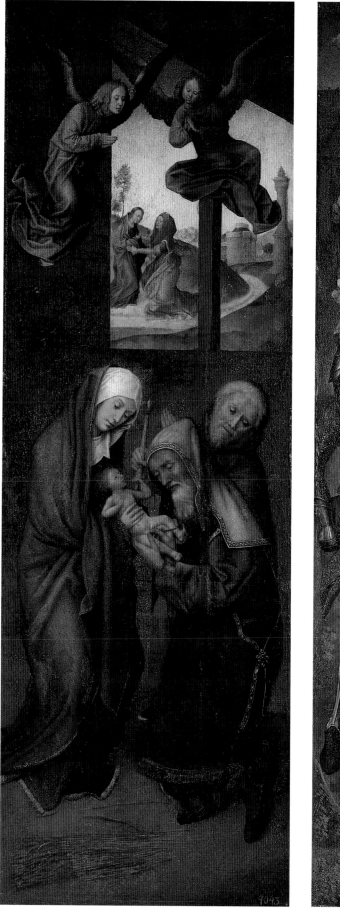
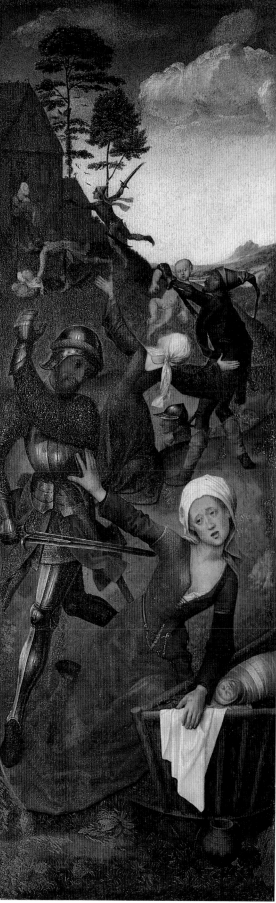

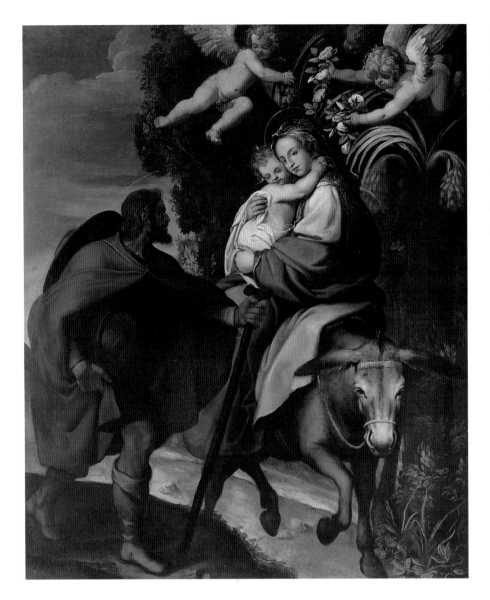

BARTOLOMMEO CARDUCCI Florence 1560–Madrid 1608/10
The Flight into Egypt (Inv. No. 376) Oil on canvas
50 × 41½″ (126.5 × 105.3 cm)
(Ex coll. Coesvelt, Amsterdam, 1814)

iar lines of his illustrious father. Copying the latter's magical realism, with its myriad compelling details, this is as much a portrait of a season as of an event, giving the spectator a bird's-eye view.

By a gifted follower of Hugo van der Goes, a triptych in the Hermitage is freely modeled upon lost works of that great Ghent artist. An *Adoration of the Magi* (202) is the central subject, painted with much of the psychological penetration and innovational color found in Hugo's art. The Magi meet at Golgotha, shown to the upper left, and the Annunciation to the Shepherds takes place at the upper right (204–205). On the inner left wing is the highly original *Circumcision*, with the Visitation in the background (203). The inner right wing shows the Massacre of the Innocents (203), a subject seldom given such prominent treatment in Early Netherlandish art. With its serpentine figural composition, this follows Hugo's tragic sense of invention, as if the Massacre were a hideous, fatal twist on children's games like "Follow the Leader."

Linking a major religious theme with the exploration of landscape, the Flight into Egypt is a subject that did not lose its pictorial popularity until most devotional art came to an end. Thanks to date palms that bend at will and Joseph's country-wise ways, even the desert proves a friendly environment. So the Flight turns into the opposite of what it might have been. From a poor refugee's horror story—a narrow escape of their baby son's slaughter in the Massacre of the In-

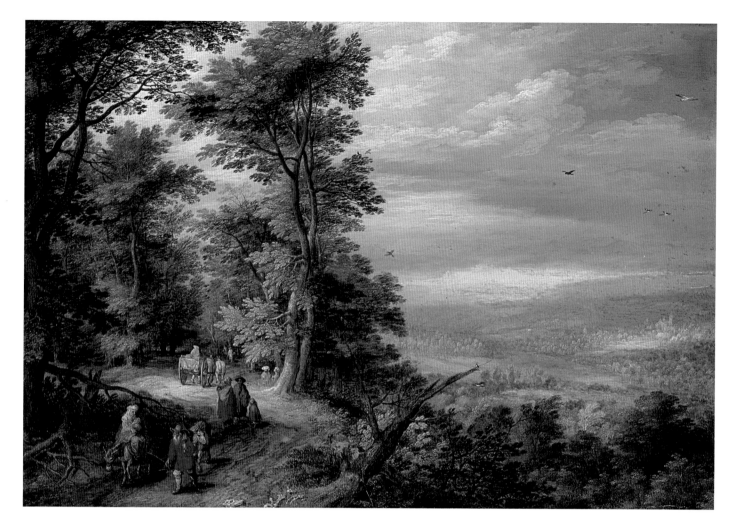

JAN BRUEGHEL THE ELDER Brussels 1568–Antwerp 1610
Forest's Edge (Flight into Egypt), 1610
(Inv. No. 429) Oil on copper 10 × 14″ (25 × 36 cm)
(Ex coll. Crozat, Paris, 1772)

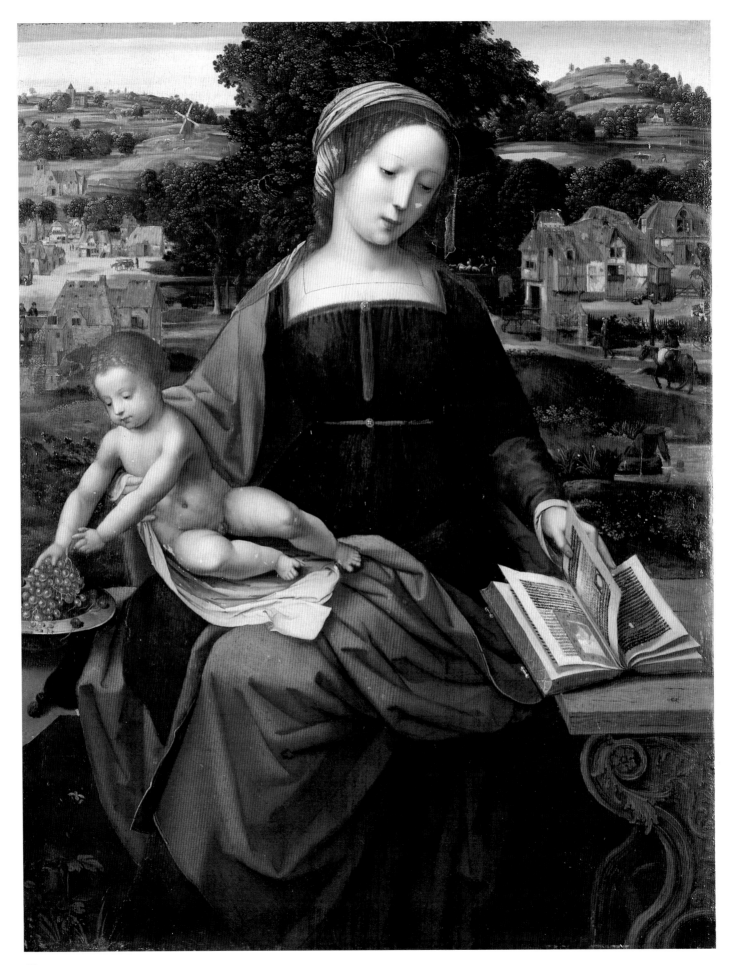

nocents—the Flight became an idyllic, Arcadian delight.

Bartolommeo Carducci contrived a Correggiesque *Flight* (206). Little angels cheer the family on its way as a date palm bends, these motifs taken from an early engraving by Schongauer. To find the sacred fugitives you must look really closely at Jan Brueghel the Elder's *Forest's Edge* (207); they are tucked away in the left foreground. This painting is on the borderline between religious art and pure landscape, as if the Holy Family were working overtime to legitimize what, in essence, was Art for Art's sake.

Many paintings of the Mother and Child have elements that suggest a Rest on the Flight into Egypt, an enormously popular apocryphal subject. This may be the subject of an elegant *Virgin and Child* by the Antwerp artist known as the Master of the Female Half-Figures (208). Here Jesus' grapes pertain to the Eucharist, and Mary's prayer book echoes a prophetic theme. In a painting from the same time by Bernard van Orley (209), Mary, seated on the earth as a Madonna of Humility, nurses her baby as Joseph comes back with a pear, a fruit equated with the apple of the Fall.

Noon (210), from Claude's series of the Three Times of Day, is represented by the Rest on the Flight, with an angel coming to the Holy Family's rescue by providing much-needed food (211). The way to Egypt is turned into a typically Classical landscape, closer to a lush interpretation of the Arno or Tiber than the valleys of the Nile or Jor-

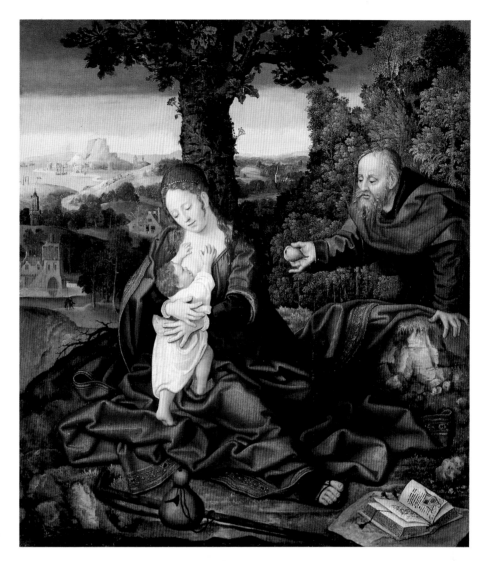

dan. In Annibale Carracci's *Rest* (210), two angels attend to the Mother and Child as Joseph hitches their mule to a tree.

By far the grandest of the Hermitage's depictions of this theme is the one by Van Dyck (212–13), who painted relatively few scenes from Christ's infancy. Though partridges usually symbolize Evil, they can also represent Truth and the Church—the latter being the meanings conveyed in this painting, where the survival of the Church is dependent upon the Flight's success. For Van Dyke, the sunflower, so prominent in this canvas, represents the royal ap-

BERNARD VAN ORLEY
Brussels ca. 1492–1542
Rest on the Flight into Egypt (Inv. No. 453)
Oil on canvas, transferred from panel
31½ × 28″ (80 × 72 cm)
(Ex coll. E.V. Vsevolozhskaya,
St. Petersburg, 1905)

Opposite
MASTER OF FEMALE HALF-FIGURES
active Antwerp 1530–1540s
Madonna and Child (Inv. No. 4090) Oil on panel
21 × 17″ (53 × 42.5 cm)
(Ex coll. Stroganov Palace Museum, 1922)

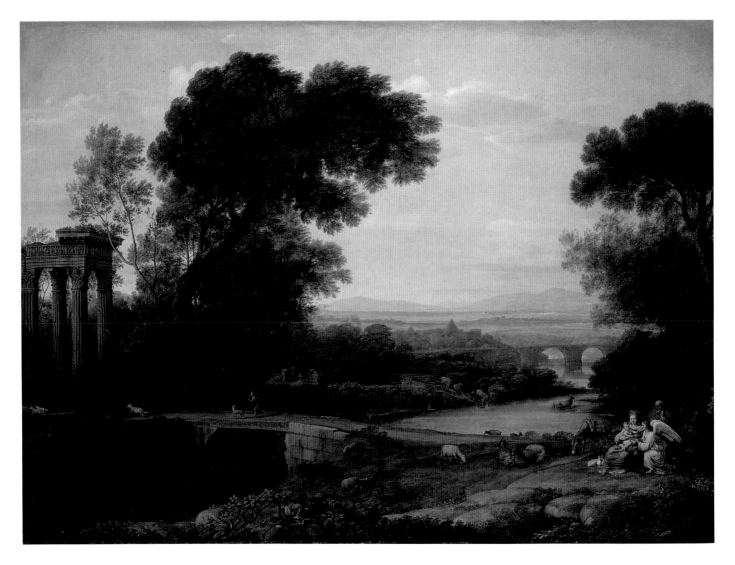

Above
CLAUDE LORRAIN
Noon, 1651 or 1661
(Inv. No. 1235) Oil on canvas
44½ × 62″ (113 × 157 cm)
(Ex coll. Empress Josephine, Malmaison, 1815)

Opposite
CLAUDE LORRAIN *Noon* (detail)

Left
ANNIBALE CARRACCI
Bologna 1560–Rome 1609
The Holy Family Rests on the Flight into Egypt
ca. 1600
(Inv. No. 138) Oil on canvas
32½″ (82.5 cm) diameter
(Ex coll. Crozat, Paris, 1772)

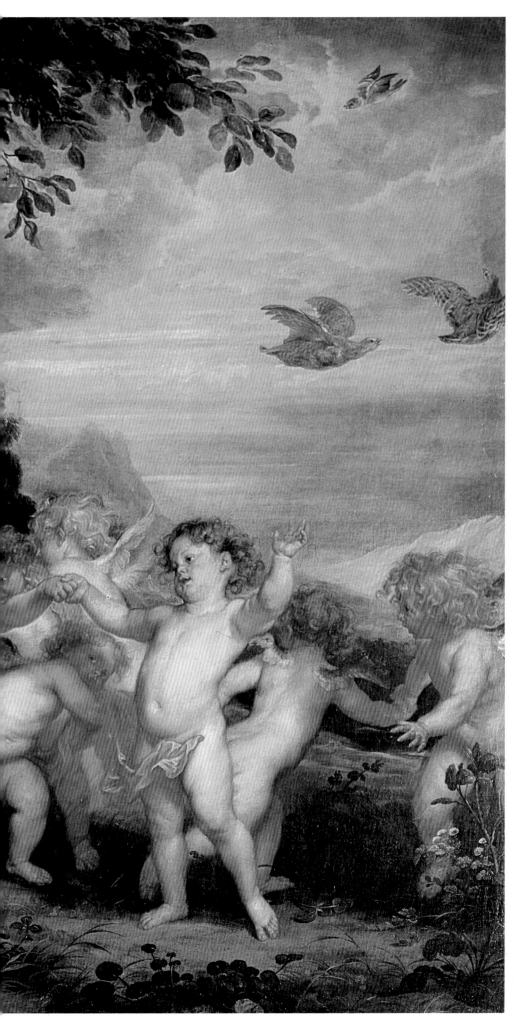

proval of Charles I, who conferred a knighthood and extensive patronage upon the painter.

Boucher and Watteau, concerned above all with terrestrial love, are seldom associated with the art of faith. The infant Baptist has run away from home to join the Holy Family in Boucher's highly unorthodox, predictably decorative version of the Flight (214). Watteau's example is equally novel (215, 216–17), its seriousness conveyed solely by Joseph's grave expression. Murillo's treatment of the Rest (219) is unusually broad, with a highly individualized Joseph looking down at the sleeping baby as Mary makes a gesture that might be read as reproachful.

Poussin, with his passion for archaeological accuracy, was ideally suited to the theme of the Flight (218). He was one of the very few painters who showed the family safely arrived in Egypt, reveling in a plethora of ibis, pylons, and other correct examples of local color. His contemporary and compatriot Sébastien Bourdon was equally at home with the same exotic setting, placing the *Massacre of the Innocents* (218) in an Egyptian ambience.

Known as Jesus' "public life," the acts and words in Christ's last few years that led to controversy and crucifixion are the subjects of innu-

ANTHONIS VAN DYCK
Antwerp 1599–London 1641
Rest on the Flight into Egypt (Virgin with Partridges), 1630s
(Inv. No. 539) Oil on canvas
84½ × 112½" (215 × 285.5 cm)
(Ex coll. Walpole, Houghton Hall, 1779)

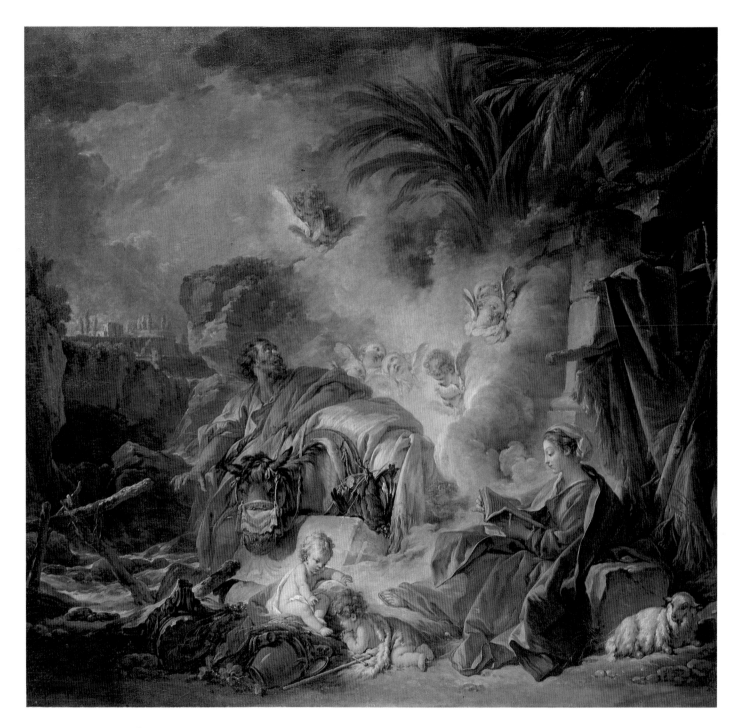

FRANÇOIS BOUCHER Paris 1703–1770
Rest on the Flight into Egypt, 1757
(Inv. No. 1139) Oil on canvas
55 × 58½" (139.5 × 148.5 cm)

Opposite
JEAN-ANTOINE WATTEAU
Valenciennes 1684–Nogent-sur-Marne 1721
Rest on the Flight into Egypt, 1719
(Inv. No. 1288) Oil on canvas
46 × 38½" (117 × 98 cm)
(Ex coll. Brühl, Dresden, 1769)

Overleaf
JEAN-ANTOINE WATTEAU
Rest on the Flight into Egypt (detail)

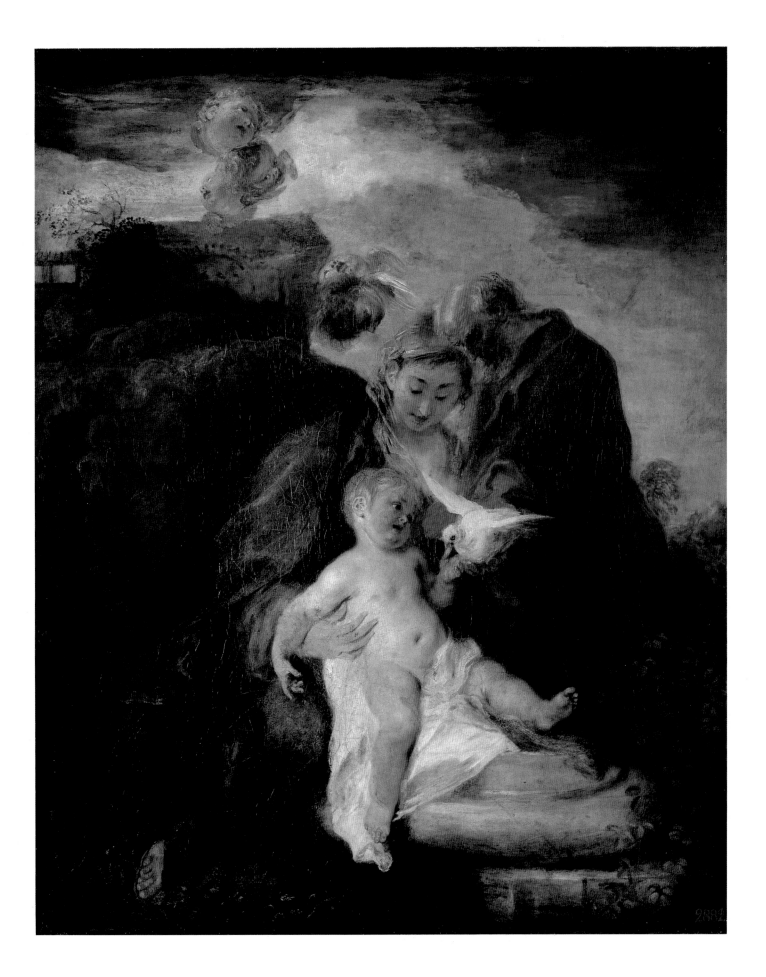

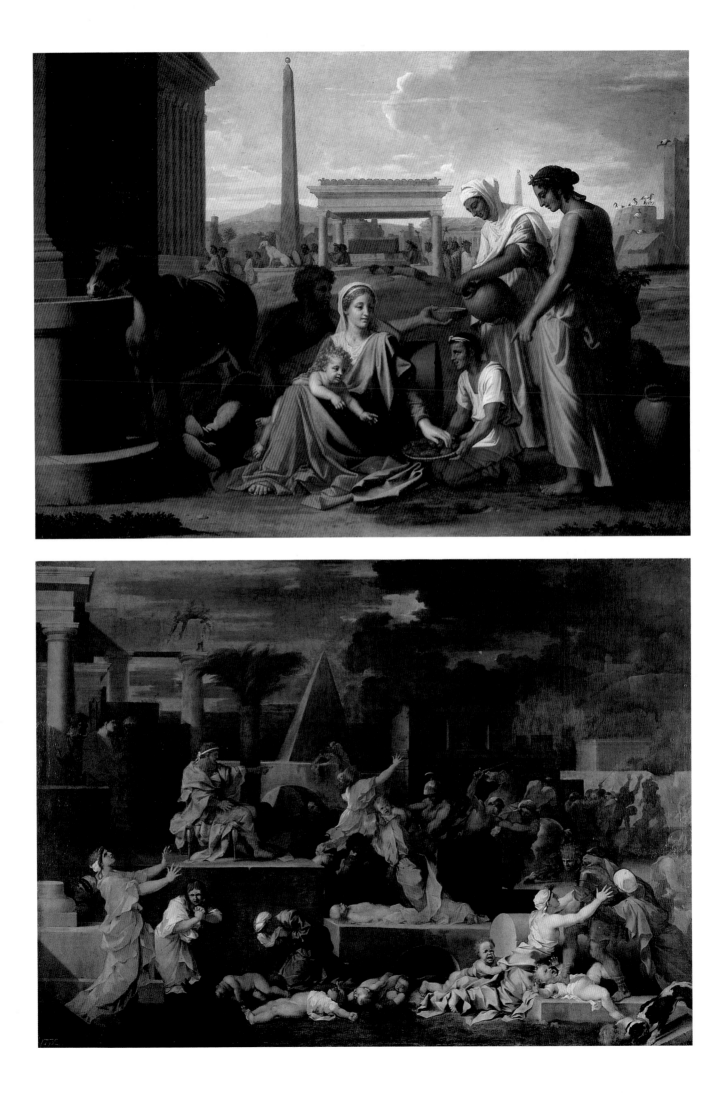

BARTOLOMÉ ESTÉBAN MURILLO *Rest on the Flight into Egypt*
(Inv. No. 340) Oil on canvas 54 × 79½″ (136.5 × 179.5 cm)
(Ex coll. N. Genier, Paris)

Opposite, top
NICOLAS POUSSIN *Rest on the Flight into Egypt*
(Inv. No. 6741) Oil on canvas 41 × 56″ (105 × 142 cm)
(Ex coll. Stroganov Palace Museum, 1932)

Opposite, bottom
SÉBASTIEN BOURDON *Slaughter of the Innocents*
(Inv. No. 1223) Oil on canvas
49½ × 70″ (126 × 177.5 cm)
(Ex coll. Walpole, Houghton Hall, 1779)

merable paintings. Allowing access and witness, they made Jesus as a very young man a famous or infamous figure, calling attention to all his special qualities.

A massive panorama of the Sea of Galilee presents the setting for the *Miraculous Draught of Fishes* (220), and shows the new exploration of landscape found in the art of the sixteenth century. This subject was beloved in the Lowlands and Venice, with their links to the sea. Ludovico Pozzoserrato, painter of this wide-angled scene, was actually a Fleming—Lodewyck Toeput by name—his style far more Northern than Italian in feeling. Jesus, at the lower left, tells Simon to go fishing once again, though his nets are empty from a futile mission just before. Just as the fishermen will fill their nets, so

will Christ catch new apostles—Simon and Simon Peter, the brothers James and John, all boatmen. In the middle is the subject of Christ walking on the waters, with Peter sinking as he comes toward him.

A related theme, once again of divine providence, was painted with rare force by the Spanish landscape artist Pedro Orrente. Here the *Miracle of the Loaves and Fishes* (221) is rendered in a style near that of Tintoretto and the Carracci in its rich color and vigorous modeling. This miracle comes just before the events on the Sea of Galilee and is especially important, as Christ's words now proclaim his mission.

The Parables, or comparisons, help to understand complex articles of faith by bringing them down to

LODEWYCK TOEPUT
(LUDOVICO POZZOSERRATO)
Mechlin ca. 1545–Treviso 1610
The Miraculous Draught of Fishes
(Inv. No. 445) Oil on canvas
33 × 61½" (84 × 156 cm)
(Ex coll. Tronchin, Geneva, 1770)

Opposite
PEDRO ORRENTE
Montealegre ca. 1570–Valencia 1645
The Miracle of the Loaves and Fishes (Inv. No. 349)
Oil on canvas 42 × 53½" (106 × 135.7 cm)
(Ex coll. Coesvelt, Amsterdam, 1814)

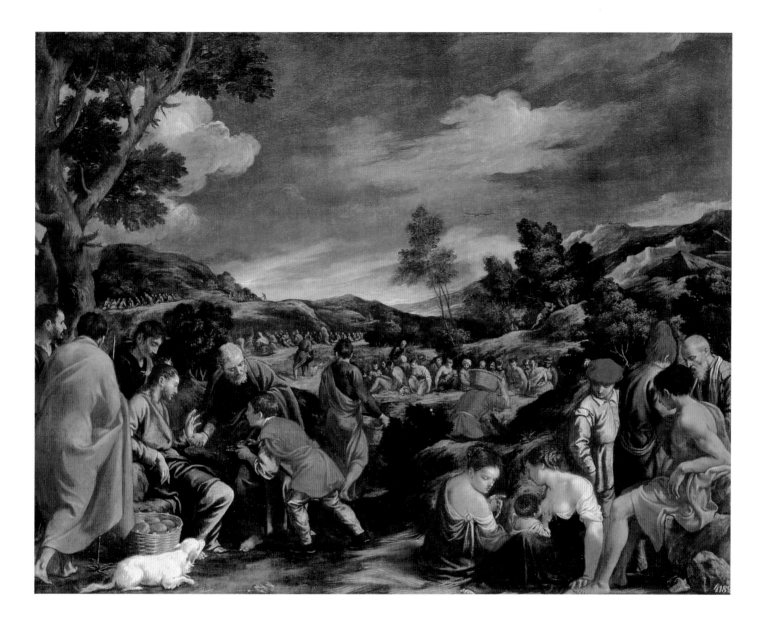

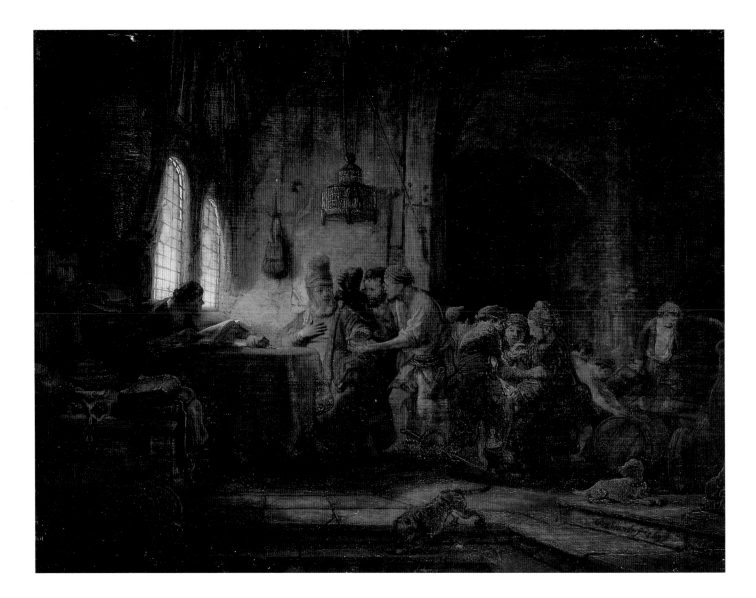

earth. Among Christ's hardest messages is that one is rewarded for essence, not effort, for being, not striving. Grace is always freely given, never "deserved"; you can't work your way to Heaven.

Rembrandt's gloomy interior (222), where laborers complain of being paid the same for a full day's work as those who were hired later and only put in an hour or so, illustrates Christ's parable of the Workers in the Vineyard, of the mysterious ways to Heaven's entry.

Closest to home, and the most stirring of all parables, is the one of the Prodigal Son (223). Having left

home and squandered his birthright, the wastrel son, returning in rags, is welcomed back by his father with a joy and devotion that the dutiful son who stayed home cannot comprehend. Only a parent may fully appreciate this parable, painted by Rembrandt after all his children were dead. Answering the perplexed stay-at-home's question as to why he celebrates, the father replies with two of the Bible's most moving lines: "Son thou art ever with me, and all that I have is thine. It was meet that we should make merry, and be glad: for this thy brother was dead, and is alive

REMBRANDT
The Parable of the Laborers in the Vineyard, 1637
(Inv. No. 757) Oil on panel
12 × 16½" (31 × 42 cm)
(Ex coll. Crozat, Paris, 1772)

Opposite
REMBRANDT
The Return of the Prodigal Son ca. 1668/69
(Inv. No. 742) Oil on canvas
103 × 81" (262 × 205 cm)

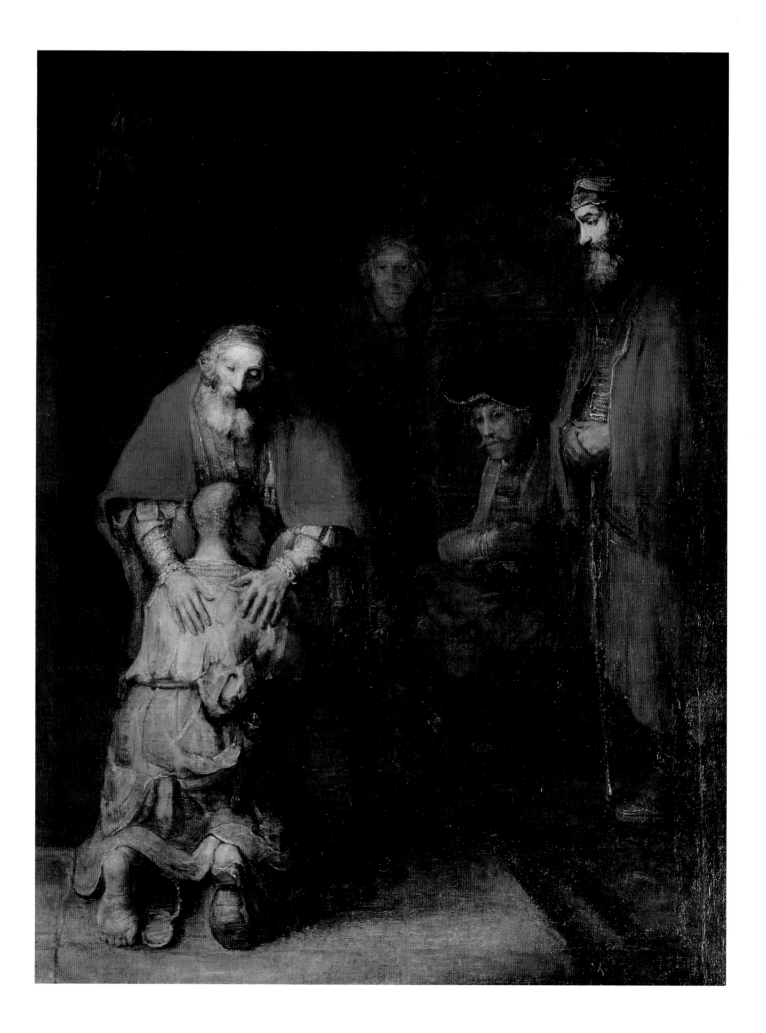

again; and was lost, and is found." Rembrandt brings a sense of the absolute to this scene of reconciliation. By showing the Prodigal from the back, so hiding his features, Rembrandt leaves his expression to that most powerful of media—the viewer's imagination.

Stiffly painted, using strangely metallic, awkward poses, Lucas van Leyden's *Healing of the Blind Man of Jericho* (225) attempts the fusion of two radically different stylistic worlds. One of the very few prodigies in the history of art, Lucas tried to blend the Florentine Mannerism of Rosso Fiorentino and the late style of Giovanni Bellini.

Here Christ restores the sight of Bartimaeus, who, though blind, had recognized his special presence by addressing him as "Son of David," an attribute of the Messiah. This is one of three of Christ's healings of the blind, a theme suitable to the Leyden hospital chapel for which the triptych was probably painted. The wings (224), discovered and purchased for the Hermitage eighty-two years after the central panel came there, flaunt two armorial figures that provide a visual fanfare celebrating the donors' affluence and aristocracy.

In an exquisite reprise of the art of Veronese, Charles de LaFosse painted *The Temptation of Christ* (226) more than a century after the great Venetian's death. Seldom represented in art, the subject of this canvas took place following Christ's baptism, when he went into the desert for forty days, was tempted by Satan, and then comforted by angels.

LUCAS VAN LEYDEN Leyden 1489/94–1533
The Healing of the Blind Man of Jericho (wings), 1531
(Inv. No. 407) Oil on canvas, transferred
from panel 35 × 13" (89 × 33.5 cm)
(Ex coll. Crozat, Paris, 1772)

Opposite
LUCAS VAN LEYDEN
The Healing of the Blind Man of Jericho (center panel)
45½ × 59" (115.5 × 150.5 cm)

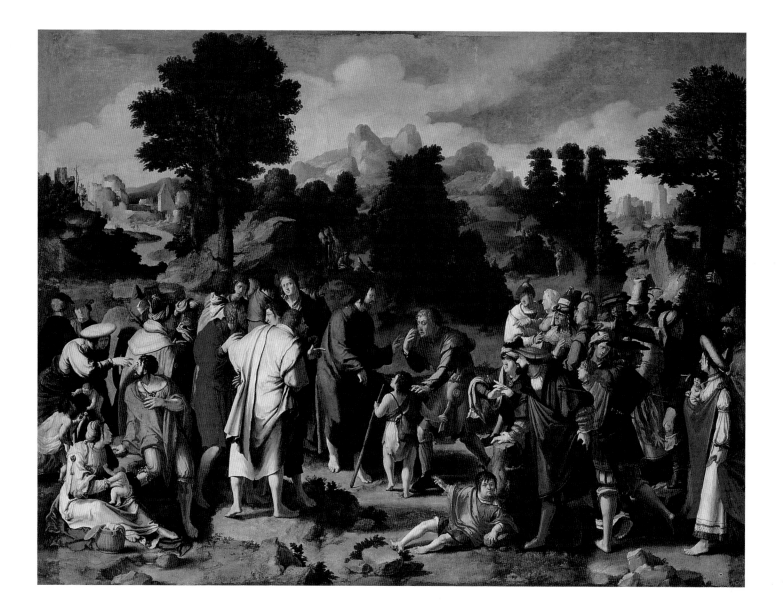

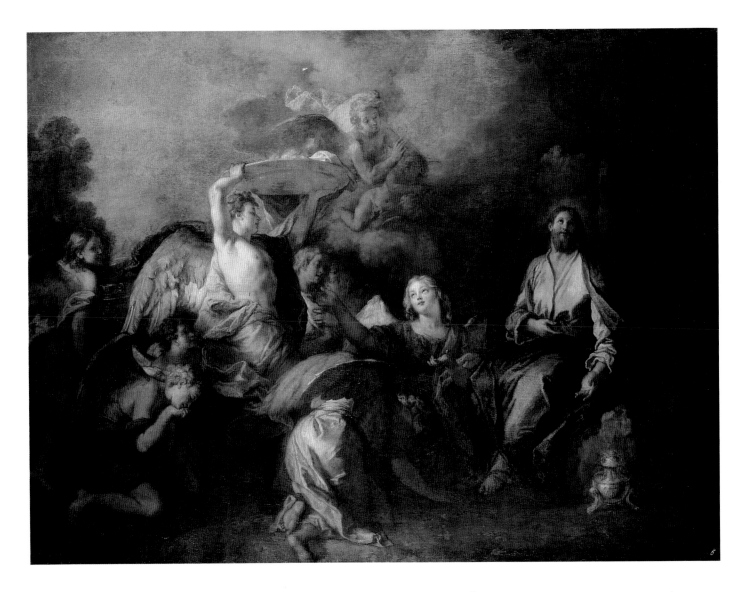

CHARLES DE LAFOSSE Paris 1636/40–1716
The Temptation of Christ
(Inv. No. 4427)
Oil on canvas 56 × 76″ (143 × 193 cm)

A little-known French painting of the last third of the fifteenth century presents the *Entry of Christ into Jerusalem* (227), probably the left wing of a lost Passion polyptych. With this entry on Palm Sunday the events of Holy Week begin.

After the Last Supper, Christ, with Peter, James, and John, went to the Mount of Olives. The apostles sleep as Christ seeks guidance during a night of spiritual torment, doubt, and prayer known as *The Agony in the Garden* (227), painted by Pieter Coeck van Aelst. While his mission is made clear by the chalice atop the altarlike rock, the Be-

trayal has taken effect: Roman soldiers (led by Judas grasping his bag of silver) approach from the left.

Tragic close-ups of the extremes of Christ's suffering and abuse, painted to inspire pity—*pietà*—have long been focal points for devotion. Savagely crowned with thorns; bound with ropes; whipped; dragged on the way to Calvary; or nailed to the cross—all these gruesome images of Christ's suffering helped devout viewers share his burden, to follow Thomas à Kempis's instructions to prepare their own spiritual Imitation of

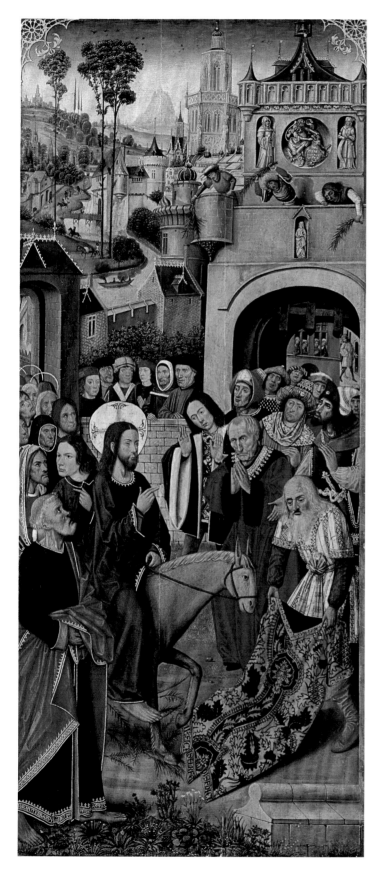

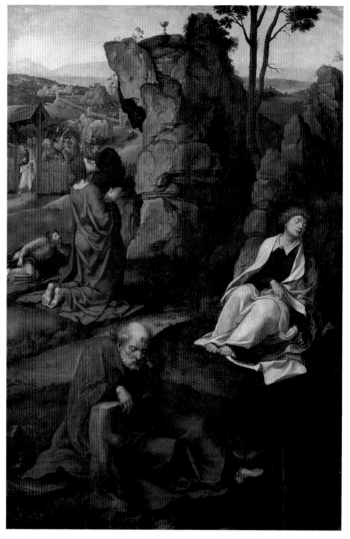

Above
PIETER COECKE VAN AELST Aelst 1502–Brussels 1550
The Agony in the Garden (Inv. No. 406) Oil on panel
32½ × 22″ (83 × 56.5 cm)
(Ex coll. N.K. Roerich, St. Petersburg, 1921)

Left
UNKNOWN French 15th century
The Entry of Christ into Jerusalem
(Inv. No. 5699) Oil on panel
46 × 20″ (116.5 × 51.5 cm)
(Ex coll. A.G. Gagarin, St. Petersburg, 1919)

Christ, following the *Via Crucis*, taking on torture borne in the name of their salvation. Sixteenth- and seventeenth-century painting, with its dramatic plays of light and shade and new, obsessive concern with the corporeal, was ideally suited to bring suffering close to home.

Martyrdom simply means "bearing witness," and never were its horrors seen by so many as through the novel immediacy of the pictorial journalism that evolved in Naples, Rome, and Spain. You can almost smell the suffering in the *Christ Before Caiaphas* (228) by the Neapolitan Giovanni Battista Caracciolo. Bearing his humiliating attributes of mock coronation—the crown of thorns and reed scepter—Christ gives visual meaning to the question "How long, O Lord?" in Jusepe de Ribera's Neapolitan canvas (228). Luis de Moráles often painted pendants of the *Mater Dolorosa* (229) juxtaposed with that of the Man of Sorrows. These pictures were so effective that their artist was called "Il Divino."

Titian's *Christ Bearing the Cross* (229) is one of the Venetian's most moving religious images. Taking an agonized, if rapid, glance at the spectator as he makes his way to Calvary, Jesus is assisted by Simon, a Jew from Cyrene who had come to Jerusalem for Passover and who helped Christ bear the heavy cross. An important subtext to this image of suffering is that of physical wealth as a metaphor for spiritual riches. Christ still wears the mockingly regal purple robe along with the crown of thorns. His beautiful white forearm and exquisite hand are clearly innocent of labor. Such

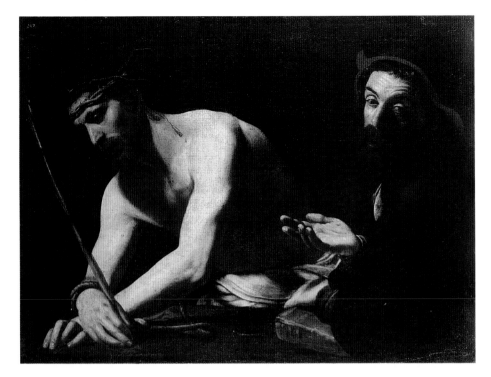

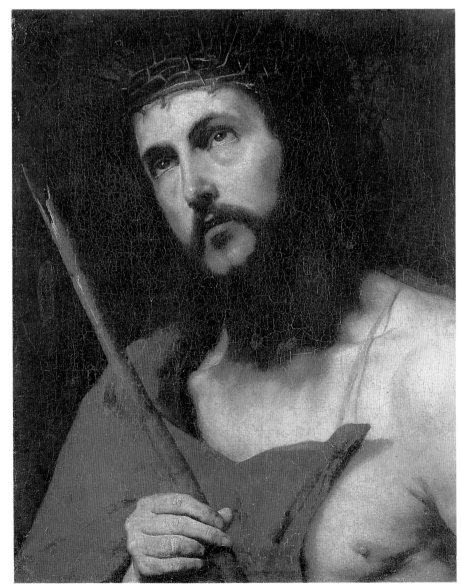

LUIS DE MORÁLES *Mater Dolorosa*
(Inv. No. 358) Oil on panel
32½ × 23″ (82.5 × 58 cm)
(Ex coll. Coesvelt, Amsterdam, 1814)

TITIAN Pieve di Cadore 1488/89–Venice 1576
Christ Bearing the Cross, 1560s
(Inv. No. 115) Oil on canvas
35 × 30″ (89.5 × 77)
(Ex coll. Barbarigo, Venice, 1850)

Opposite, top
GIOVANNI BATTISTA CARACCIOLO Naples 1570–1637
Christ Before Caiaphas (Inv. No. 2123) Oil on canvas
29 × 40½″ (73 × 103 cm)
(Ex coll. Brühl, Dresden, 1769)

Opposite, bottom
JUSEPE DE RIBERA Játiba, near Valencia 1591–Naples 1652
Christ in the Crown of Thorns (Inv. No. 7760) Oil on canvas
22½ × 18″ (57 × 46 cm)
(Ex coll. M. Solovyov, St. Petersburg, 1894)

I.N.R.I

FRAN^{co} RIBA. T CAT_a A
LO PIN TOEN M^oDD
AN^o D M DLXXXII

Opposite
FRANCISCO RIBALTA Solsona ca. 1555–Valencia 1628
Christ Nailed to the Cross, 1582 (Inv. No. 303)
Oil on canvas 57 × 41″ (144.5 × 103.5 cm)
(Ex coll. Coesvelt, Amsterdam, 1814)

Right
ANTONIO FIORENTINO *Crucifixion with Madonna and St. John*
(Inv. No. 8280) Tempera on panel
59½ × 33″ (151.5 × 84.5 cm)
(Ex coll. M.P. Botkine, Leningrad, 1936)

Overleaf
ANTONIO FIORENTINO
Crucifixion with Madonna and St. John (detail)

Page 234
MAERTEN JACOBSZ VAN HEEMSKERCK
Heemskerck 1498–Haarlem 1574
Golgotha (wings) (Inv. No. 415)
Oil on canvas, transferred from panel
40 × 11″ (101 × 28 cm)

Page 235
MAERTEN JACOBSZ VAN HEEMSKERCK
Golgotha (center panel)
40 × 23″ (101 × 58.5 cm)

Page 236
UGOLINO DI TEDICE flourished 1273–77
Cross, with Depiction of the Crucifixion, ca. 1270
(Inv. No. 4167) Tempera on panel
35½ × 24½″ (90 × 62 cm)
(Ex coll. Stroganov Palace Museum, 1926)

Page 237
FRANCISCO DE ZURBARÁN *Crucifixion*, 1650s
(Inv. No. 5572) Oil on canvas
104 × 68″ (265 × 173 cm)

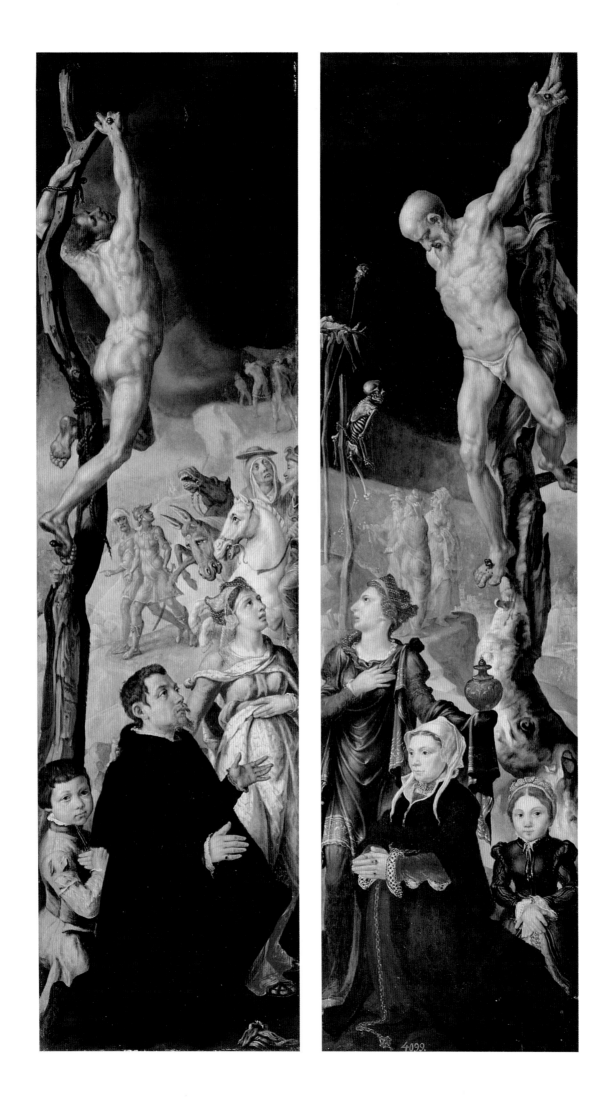

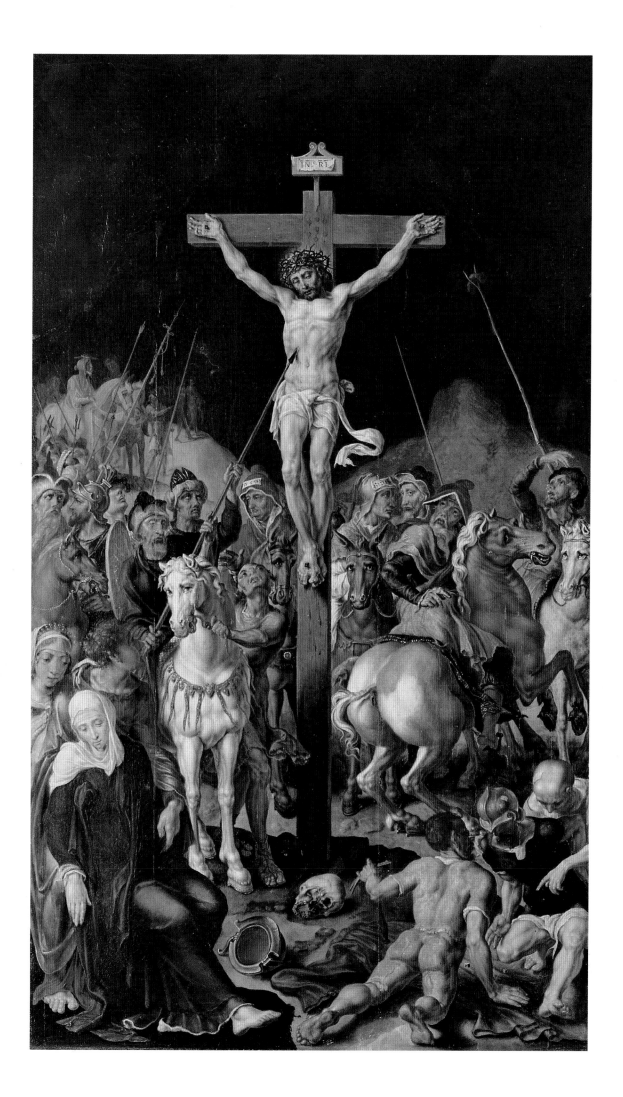

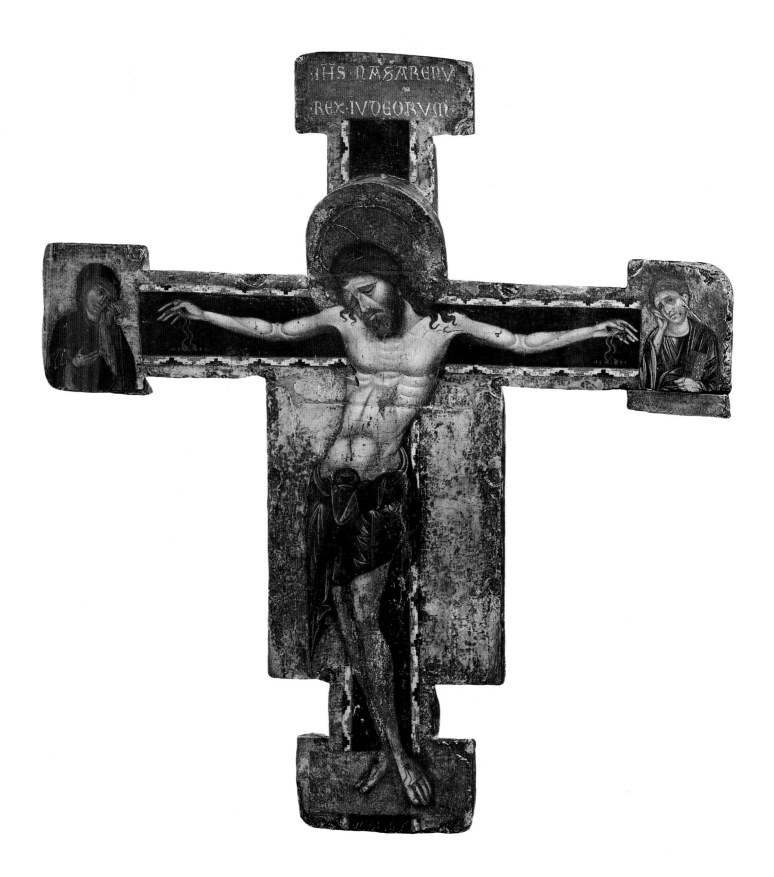

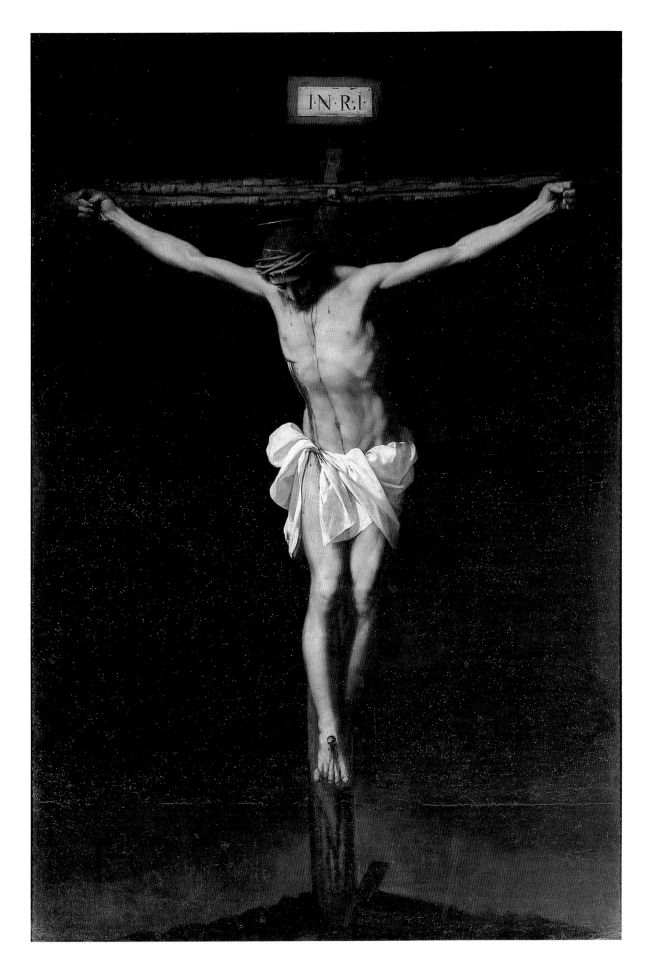

a typically Venetian view is extended to Simon who wears a costly ruby ring.

Lavish in color, with opulent brushwork, this image is nonetheless close to Northern fifteenth-century spirituality and to the asceticism of Thomas à Kempis. This late medieval votive association is reinforced by Titian's cutting the figure so radically on three sides to bring the image close to the viewer.

The sheer physicality of Christ's suffering, long realized through polychromed sculpture, was now found in the horrible sights of his kneeling in agony or close to flagellation in a perpetual *Ecce Homo* almost too awful to contemplate. Concentrating upon the nailing to, and elevation of the cross, Francisco Ribalta's canvas (230) has an almost voyeuristic quality, as if the viewer were intruding upon the obscene intimacy of torture.

Two centuries earlier in date, Antonio Fiorentino's *Crucifixion* (231, 232–33) lets the kneeling members of a local flagellant society share the bloodshed by adding their own, beating themselves bloody in penitence and homage. This small panel unites the beginning and the end of Christ's life on earth—the Annunciation tucked into the pediment; he and his mother young and happy on the other side (171).

Christ's death on the cross is the subject of Maerten van Heemskerck's powerful *Golgotha* triptych (234, 235), set against the darkened skies of the eclipse. Mary swoons into the arms of Saint John at the lower left of the central pan-

el (235), while three soldiers in the opposite corner cast dice for the robe she wove for Christ. Stolid donors kneel in the wings (234), just below the crucified thieves. Van Heemskerck may have included the legend of the blind centurion, Longinus, who will be healed and converted by Christ's blood, which runs down the lance. (Longinus may be the soldier who requires the assistance of the man above to guide the lance.)

Turning back from narrative, an iconic presentation of the same subject is found in the earliest of the Hermitage's Western paintings, a *Crucifixion* (236) by Ugolino di Tedice. Here the theme is brought down to its most basic limitations; even the panel's shape is that of the cross, with busts of a mourning Mary and Saint John, at the left and right respectively.

Equally back-to-basics, though painted nearly four centuries later, Zurbarán's *Crucifixion* (237) may offer the ultimate in devotional concentration. Without escape, this relentless image is in the spirit of the Counter-Reformation. Zurbarán follows the dictates of the Council of Trent designed to keep the pious in Catholicism's fold by allowing for a new level of emotional experience and spiritual excitement. At once monumental yet shatteringly intimate, this *Crucifixion* is of such power that only two people can exist in the viewer's consciousness—the watcher and the one watched.

The Descent from the Cross (239) is pretzeled into an elaborate inter-

JAN GOSSAERT (MABUSE)
Hainaut 1462/70–Antwerp 1533/41
Descent from the Cross, 1521 (Inv. No. 413)
Oil on canvas, transferred from panel
55½ × 42″ (141 × 106.5 cm)
(Ex coll. King William II, The Hague, 1850)

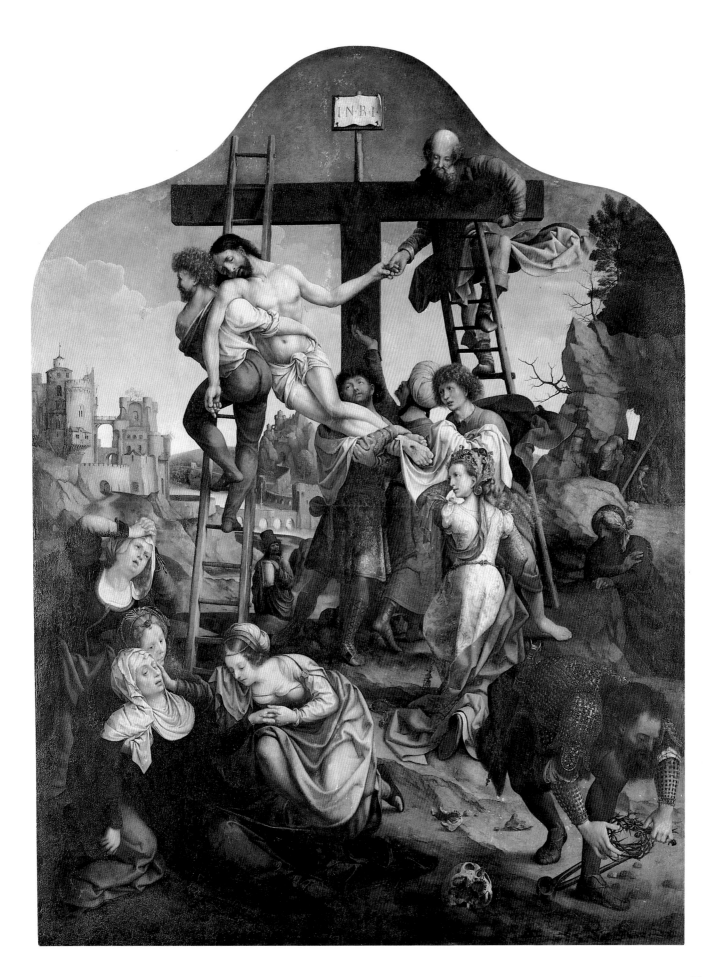

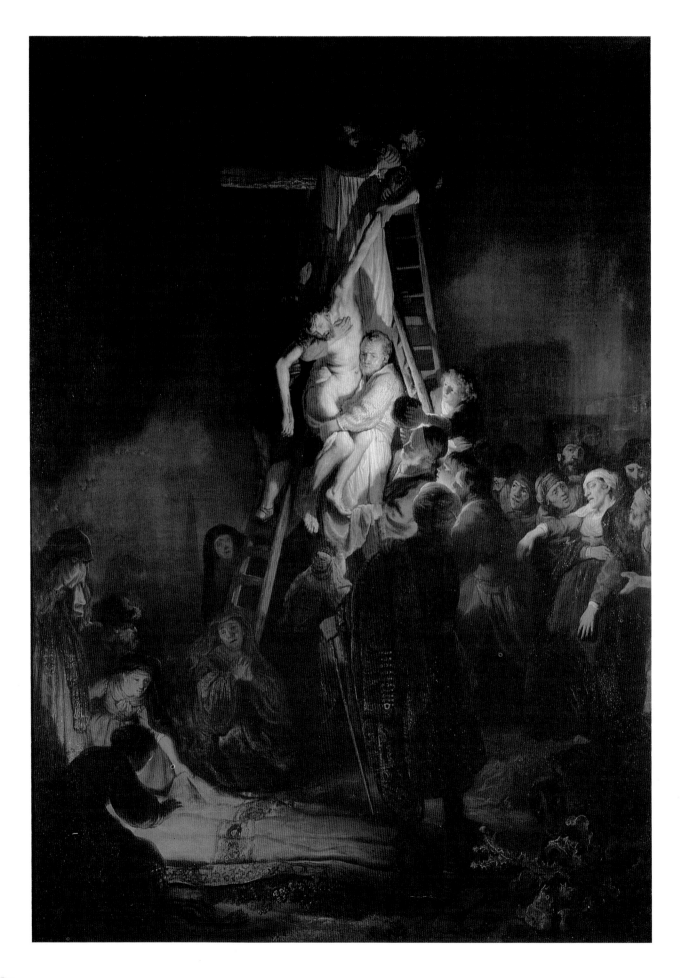

lace by a Flemish Mannerist painter of rare virtuosity—Jan Gossaert. Like Lucas and van Heemskerck, Gossaert turned to Italy for some of his figures: The three mourning Maries at the lower left are taken from an engraving after Raphael, and other figures are from the same artist's designs for tapestries, the cartoons for which were sent to Brussels for weaving. The Deposition itself comes from a Mantegna engraving. This shrewd fusion of Northern finesse and Southern force loses the distinctive features of each source; the result, while compelling, is nearer artifice than art.

Rembrandt's *Descent* (240) of 1634 is an enlarged version of one in Munich. Highly finished, the painting comes close to the intricate, intensely felt qualities of Rembrandt's etchings of the same period. Opposed in every way to Gossaert's aesthetic of the preceding century, Rembrandt works above all for simplicity and unity of light, space, and emotion. The Deposition takes place at night; Christ and his followers share a homely presence that brings the holy within the realm of the everyday—or does the artist mean that the everyday is within the realm of the holy?

Taken down from the cross, Christ is seen just before the Pietà in the penultimate phase of the Deposition by two French Baroque painters: Nicolas Poussin (242) and Jean Jouvenet (243). As usual, the first artist finds the simplest solution. Jouvenet uses at least twice as many full-size figures, and thereby dilutes the intensity of the tragedy. Unlike Rembrandt, whose Protes-

tant perspective was often far from the beauty of antiquity, both these artists learned by copying casts of ancient statuary, and drawing after models holding Classical poses. Their dead Christs resemble some Adonis or Leander, as ready for Venus's lamentation as for Mary's.

In his presentation of the readying of Christ's body for burial (244), Annibale Carracci's pioneering art shows that sort of full-bodied, richly movemented sense of drama followed by Jouvenet and so many other painters (particularly Rubens) in the seventeenth century. Though Veronese is best known for ingratiating by decorative frescoes and secular canvases, his religious paintings are at least as fine. Resonant color sense enhances the poignance of biblical subjects, clearly the case in the Venetian's *Lamentation* (245).

Probably painted in Castile, a later-fifteenth-century Entombment (246) is crude in comparison with the art of more sophisticated patronage centers. Here an enormously long Christ is laid to rest by seven holy mourners as a minute donor kneels in the foreground. Lilies and roses, growing along the tomb's edge, symbolize Heaven, while the carnation and iris are flowers of sorrow.

Miniature close-ups of the *Virgin Embracing the Dead Christ* (247), designed by Geraerd David and usually executed by his studio, were very popular; about seven survive, including the Hermitage's. Their intense proximity to the sacred subject achieves an emotional immediacy much sought-after in the anxious concluding years of the fif-

Opposite
REMBRANDT *Descent from the Cross*, 1634
(Inv. No. 753) Oil on canvas
62 × 46" (158 × 117 cm)
(Ex coll. Empress Josephine, Malmaison, 1814)

Page 242
NICOLAS POUSSIN
Descent from the Cross, ca. 1530
(Inv. No. 1200) Oil on canvas
47 × 39" (119.5 × 99 cm)
(Ex coll. Brühl, Dresden, 1769)

Page 243
JEAN-BAPTISTE JOUVENET
Rouen 1644–Paris 1717
Descent from the Cross
(Inv. No. 5717) Oil on canvas
38½ × 24½" (98 × 62 cm)
(Ex coll. A.A. Voeykov, St. Petersburg, 1919)

Page 244
ANNIBALE CARRACCI
Lamentation of Christ, mid-1580s
(Inv. No. 1489) Oil on canvas
75 × 61½" (191 × 156 cm)
(Ex coll. Walpole, Houghton Hall, 1779)

Page 245
VERONESE Verona 1528–Venice 1588
Lamentation of Christ, 1576/82 (Inv. No. 49)
Oil on canvas 58 × 44" (147 × 111.5 cm)
(Ex coll. Crozat, Paris, 1772)

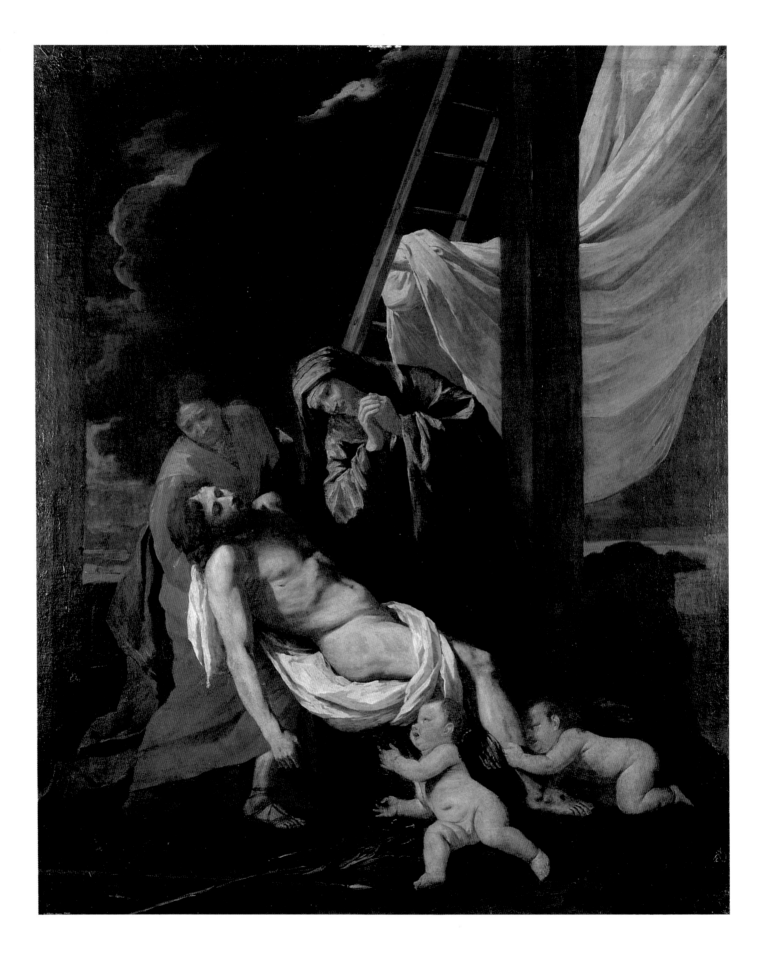

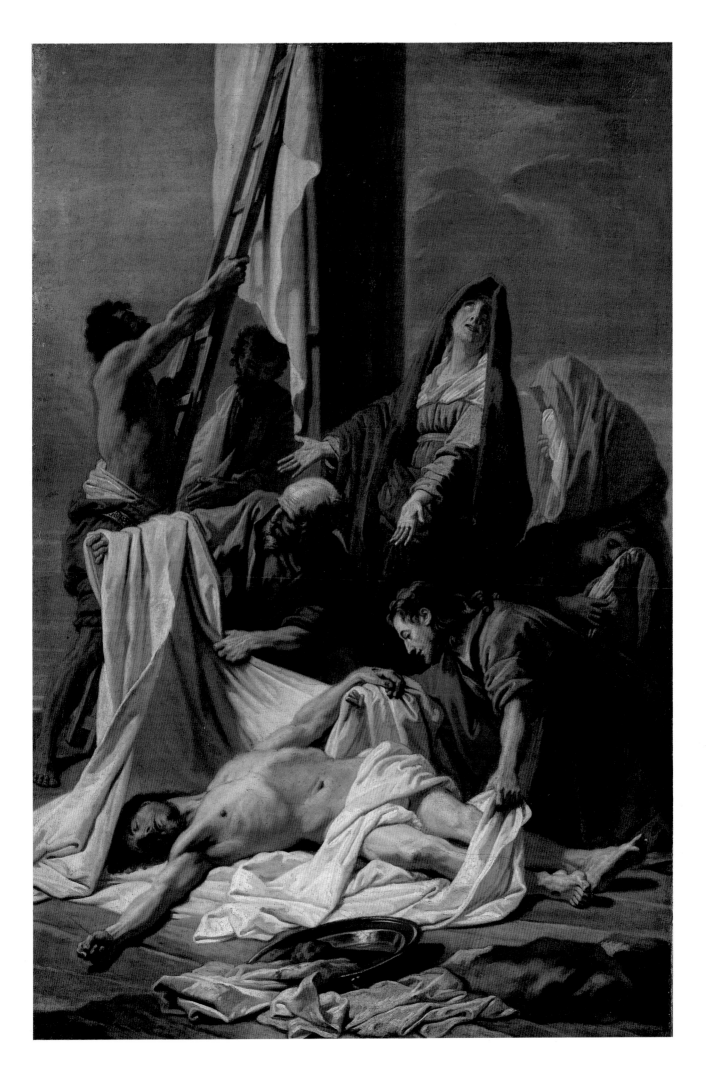

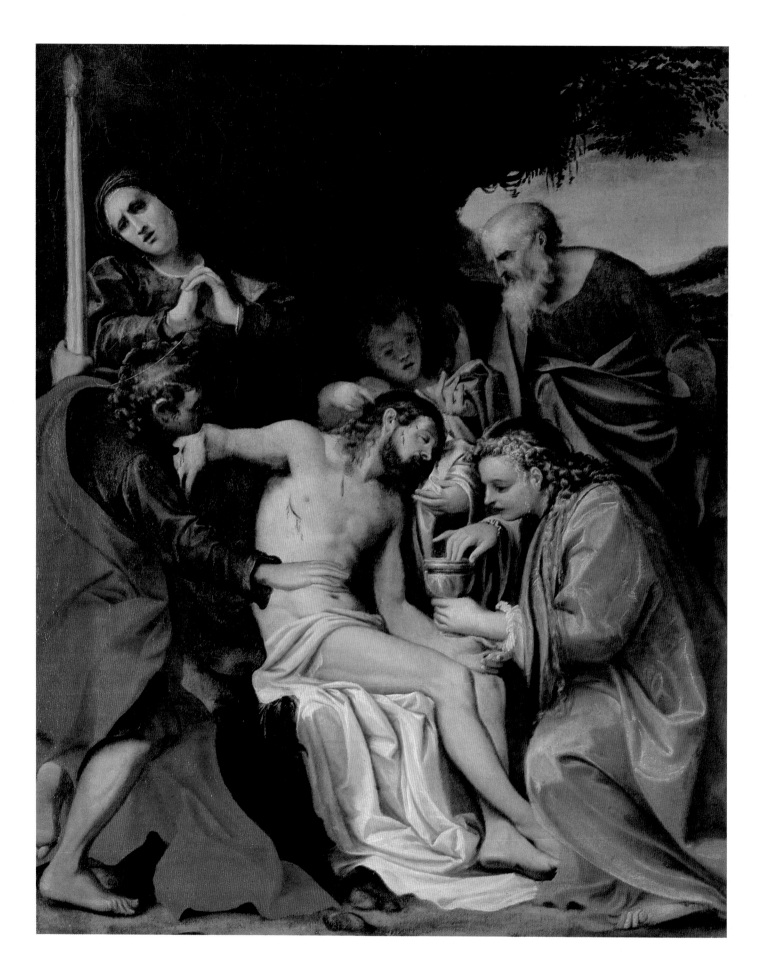

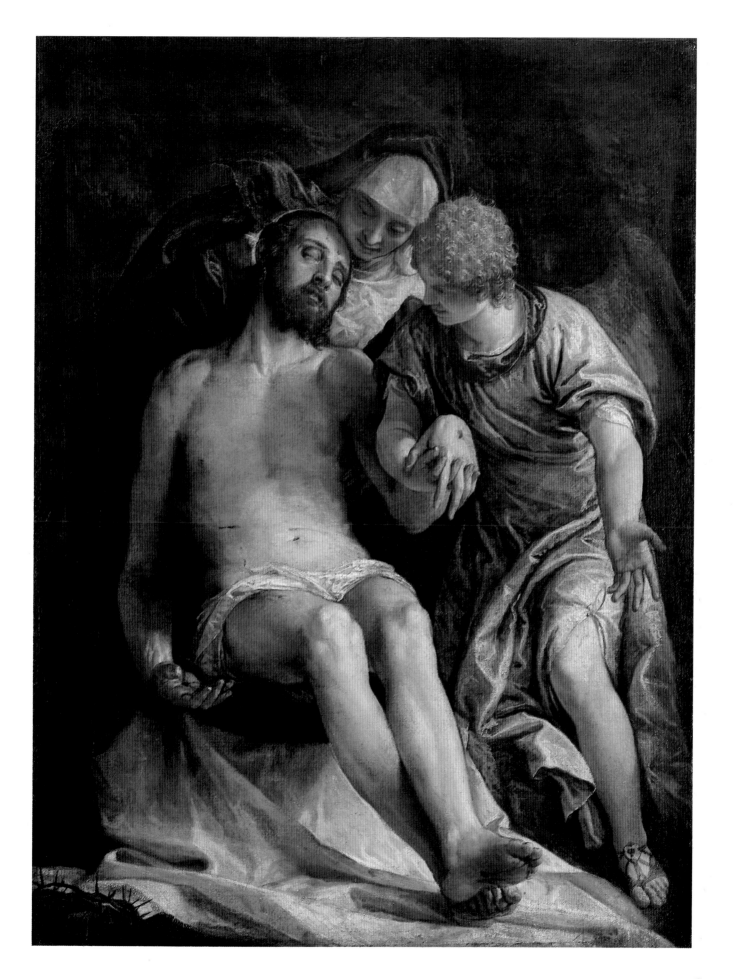

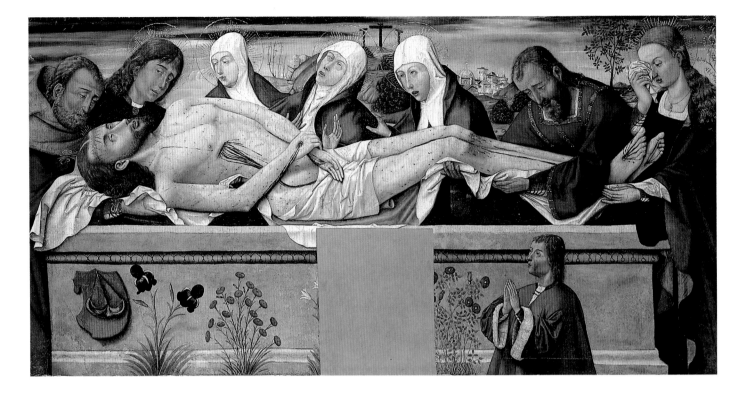

teenth century, during a decade of chiliasm when it was feared that the world would end in 1500.

A bizarre *Lamentation* (248) by Jacques Bellange, presents the subject as a nocturne, including a prominent, worldly donor, seemingly in cardinal's attire, at the right. This canvas's long, narrow outermost limits are those of the Holy Sepulcher, so it was worshipped as such, set into an altar for veneration like a pilgrimage site.

Coming to the tomb after the Resurrection, the three Maries are shown the empty grave by a Tintorettoesque angel in Annibale Carracci's handsome *Holy Women at Christ's Sepulcher* (249). Its color points to that of Rubens, while the noble forms anticipate French Classical art of the next century. A painter's painter, Annibale is almost always full of surprises, equally inspired as an inventor, an adapt-

er, and as a dramaturge of full-bodied, richly movemented scenes.

Andrea Vanni's *Ascension of Christ* (250) is an unusually persuasive rendering of that subject, celestial in its typically Sienese pale coloring. Extensive punchwork lets the gold leaf on the panel come shimmering through the textiles, adding to the panel's festive luminosity. Mary, flanked by the apostles, looks up at her son, who rises seemingly weightlessly, defying the laws of gravity by his divinity.

Two of Andrea's brothers were also painters. His art is close to Simone Martini's, and Vanni was Siena's envoy to Avignon, where Simone's last years where spent. As a friend of Saint Catherine of Siena, Andrea may have benefited from her vivid approach to devotional subjects in the unusual vitality of this panel.

UNKNOWN, CASTILE SCHOOL
2d half of 15th century
Christ Laid in the Tomb
(Inv. No. 7646) Tempera and oil on panel
37 × 71½" (94 × 182 cm)

Opposite
GERAERD DAVID
Oudewater 1450/60–Bruges 1523
The Virgin Embracing the Dead Christ (Inv. No. 402)
Oil on panel 14 × 17" (36 × 44.5 cm)

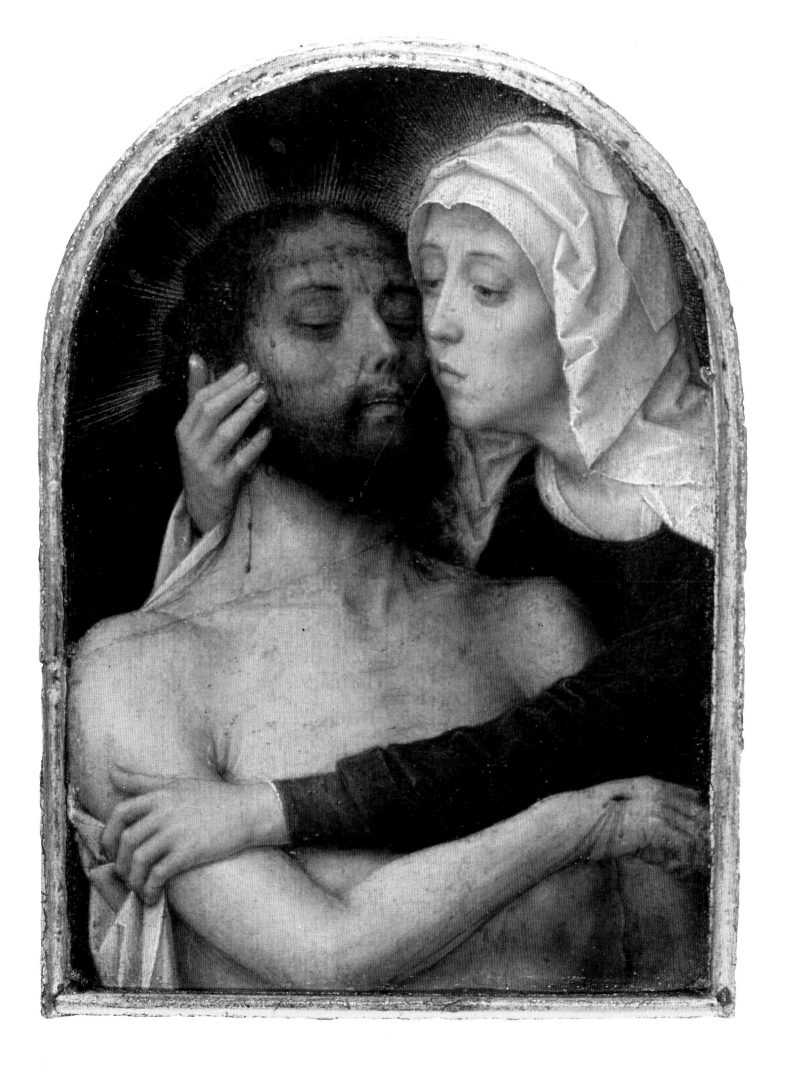

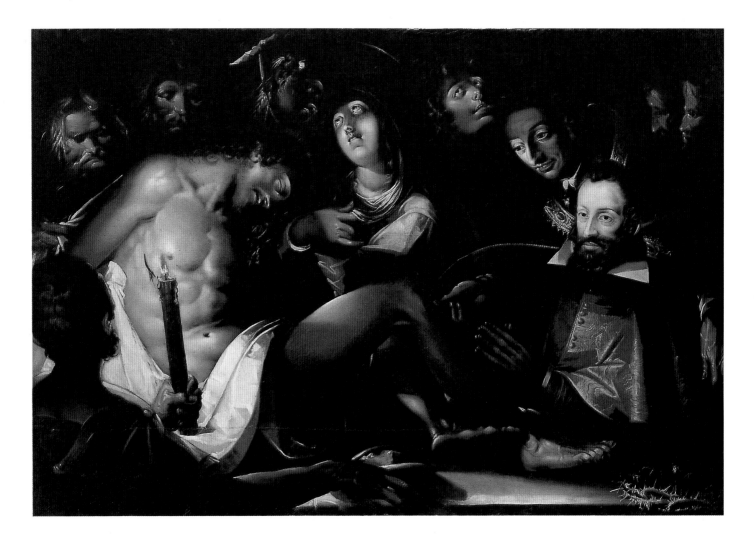

A similar ascent is that of the Virgin in Murillo's *Assumption* (251). Mary's girlish appearance is ascribed to the purity of her life. Along with the Immaculate Conception, the Assumption was especially popular in Spain, where Murillo and his studio painted many versions of both.

As a perpetuation of divine sacrifice, Robert Campin's *Mourning Trinity*, or *Throne of Grace* (252, 254–55) presents the most tragic image of the Trinity, in which God the Father holds his dead son, and the Holy Ghost mediates between the two. Symbols of the Resurrection are on the Lord's throne. Pendant to this panel is the domestic vista of Mother and Baby (172), so

that the owner might address prayers to both the beginning of Christ's life on earth and to the Trinity in Heaven, each bearing its special meaning for the possessor's present and future lives.

Usually in a triumphal mode, the Last Judgment takes place at the end of time. As the dead are raised, Mary intercedes before God on their behalf, for the mercy of the lily rather than the sword's swift justice. A very early German panel of this subject, dating to about 1425 (252), from Elblong, was presented to Catherine I, wife of Peter the Great, by that little town near Hamburg in 1712.

This terminal subject was a pop-

JACQUES BELLANGE
active Nancy 1600–1617
Lamentation of Christ (Inv. No. 10032)
Oil on canvas 45 × 69" (115 × 175 cm)

Opposite
ANNIBALE CARRACCI
The Holy Women at Christ's Sepulchre, late 1590s
(Inv. No. 92) Oil on canvas
47½ × 57" (121 × 145.5 cm)
(Ex coll. Coesvelt, London, 1836)

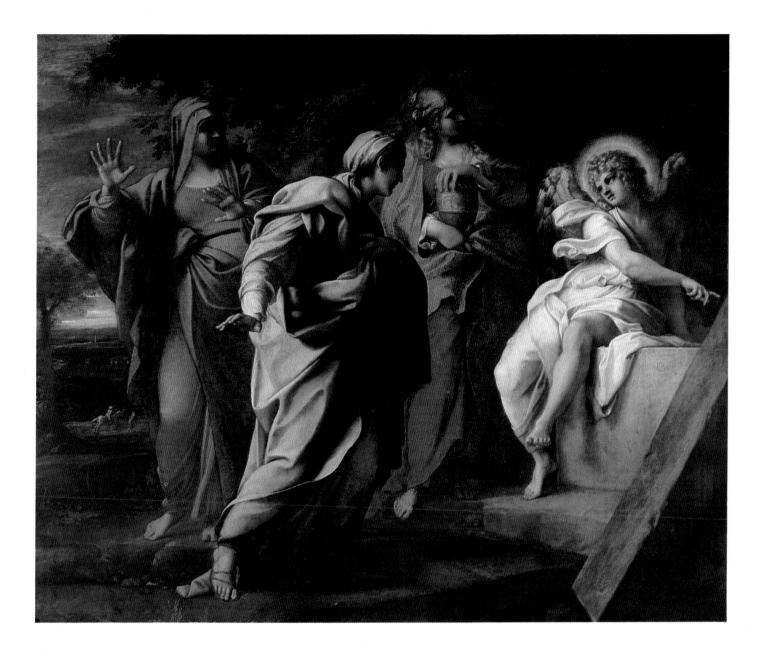

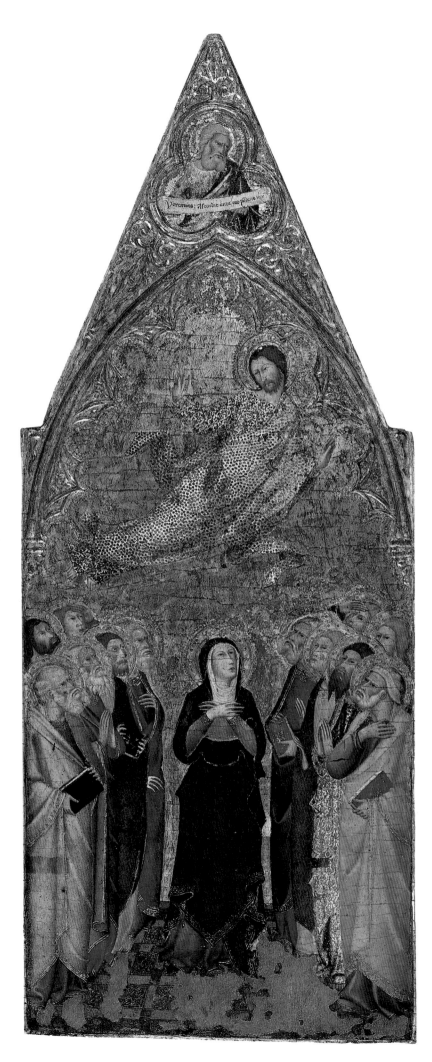

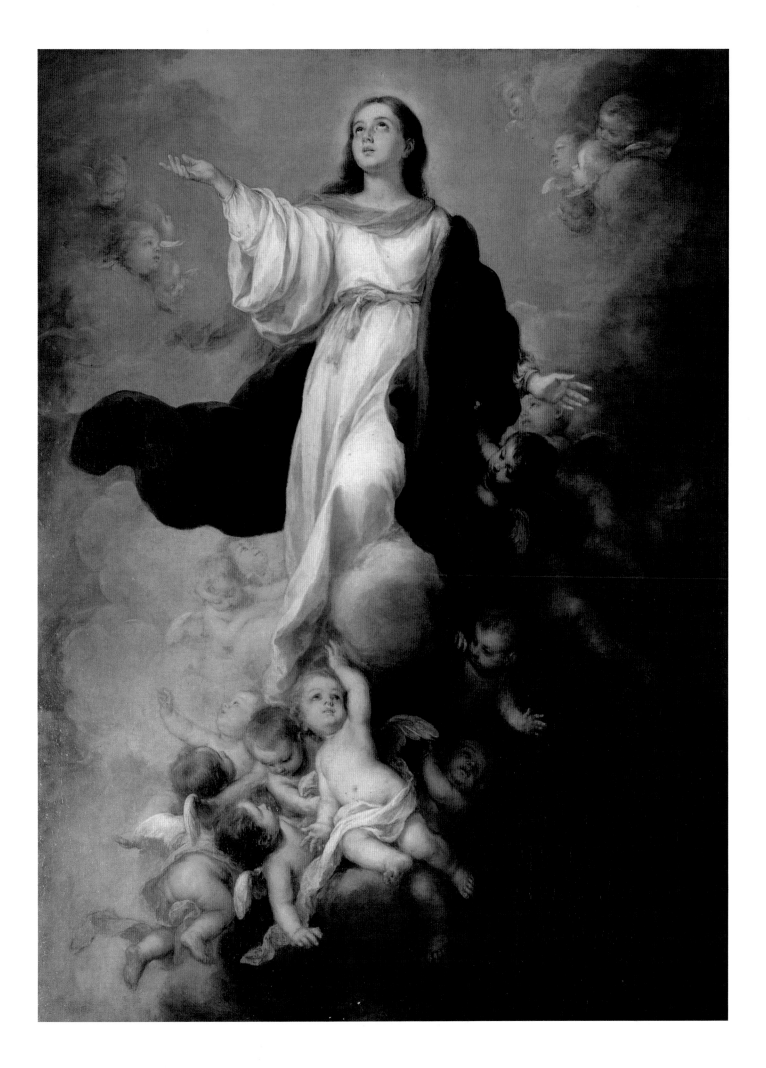

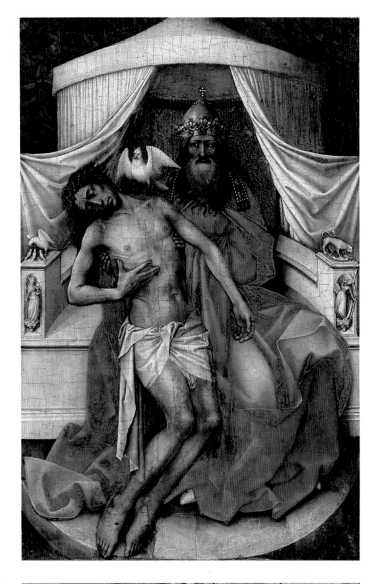

ular one for justice chambers, reminding magistrates of the importance of their duties, and how they should temper judgment with the quality of mercy, remembering that one day all would stand in trial before God. That this painting also filled such a role is stated by the German inscription on its frame: "The man elected to the Council should be careful not to lose his soul, to let everyone be his equal, rich or poor, friend and stranger [alike,] for [only] then will he judge without sin."

The same subject is shown in a remarkably detailed painting ascribed to Hans Süss von Kulmbach. Christ holds the cross and reveals his wounds, surrounded by angels with the Instruments of the Passion (253). Mary, with angels holding the seven swords of her sorrows, bares her breast. Thus reminding God of her nurturing of Christ, she begs for his merciful judgment of humanity.

Kneeling at the lower right is an abbot, with open book and crozier, his coat of arms at the far left. Combining the pious formulae of the later Middle Ages with the new decorative vocabulary of the Renaissance, this painting shows an uneasy duality between Northern Gothic and Classical traditions, but neither side wins in this stylistic stalemate of Transalpine specificity and the antique ideal. Let's hope the abbot made out better in the next world than is suggested by his significant, if unpersuasive, donation to the one he left behind.

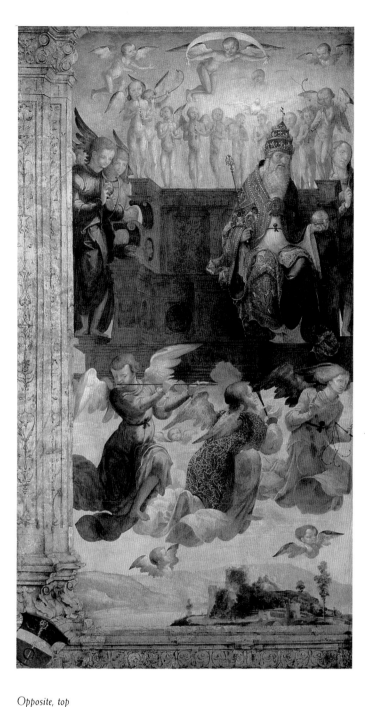

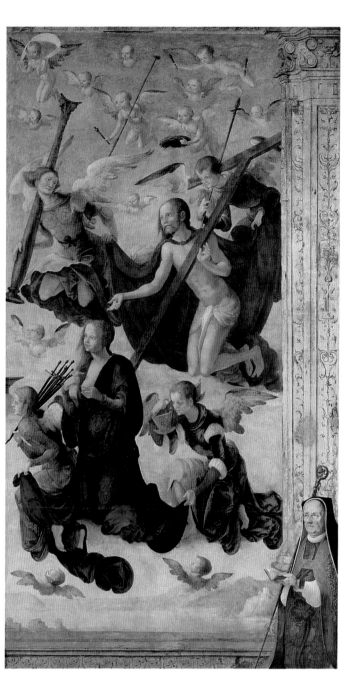

Opposite, top
ROBERT CAMPIN (MASTER OF FLÉMALLE)
Mourning Trinity (Throne of God)
(Inv. No. 443) Oil on panel 13 × 9″ (34 × 24.5 cm)
(Ex coll. D.P. Tatishchev, St. Petersburg, 1845)

Opposite, bottom
UNKNOWN, German Early 15th century
The Last Judgment (Inv. No. 691)
Tempera on panel 18 × 27½″ (46.5 × 70 cm)
(Gift to Peter I from Elblong Town Council, 1712)

Above
HANS SÜSS VON KULMBACH Kulmbach 1476/80–Nürnberg 1522
Christ and the Virgin Before God the Father (Inv. No. 696)
Oil on panel 56 × 61½″ (142 × 156 cm)
(Ex coll. P.V. Zhukovskii, 1907)

Overleaf
ROBERT CAMPIN (MASTER OF FLÉMALLE)
Mourning Trinity (detail)

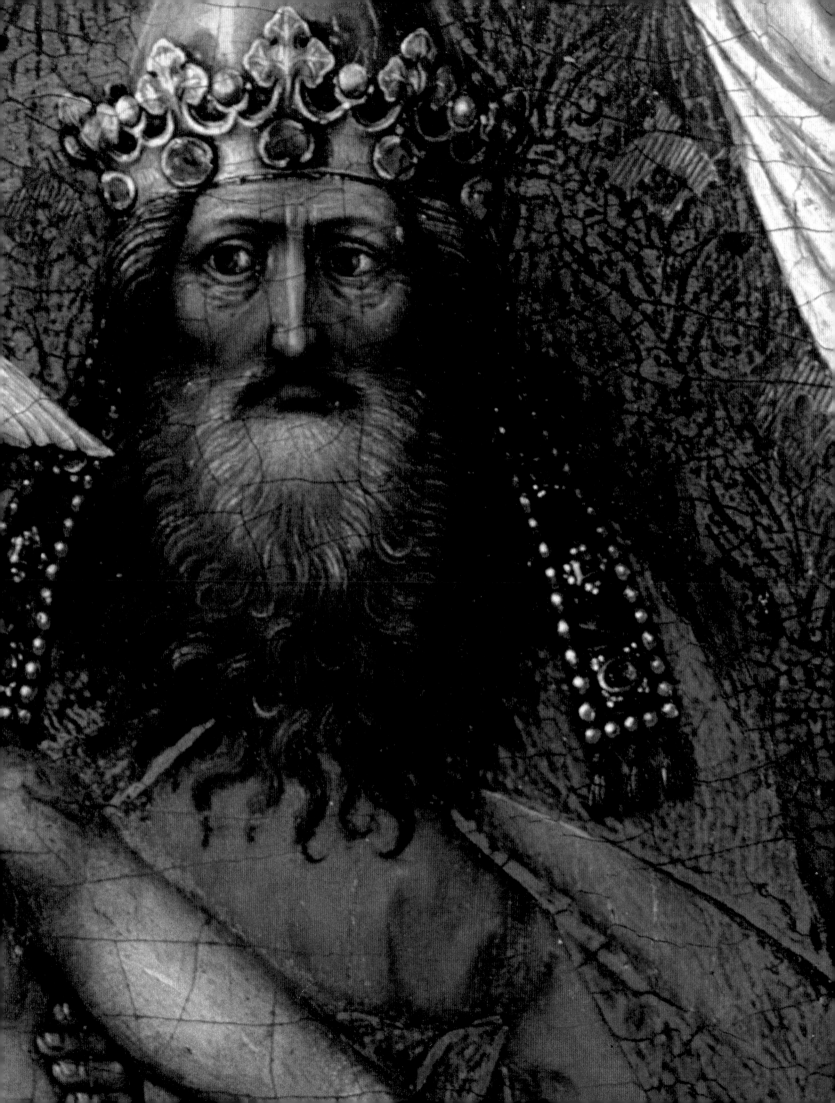

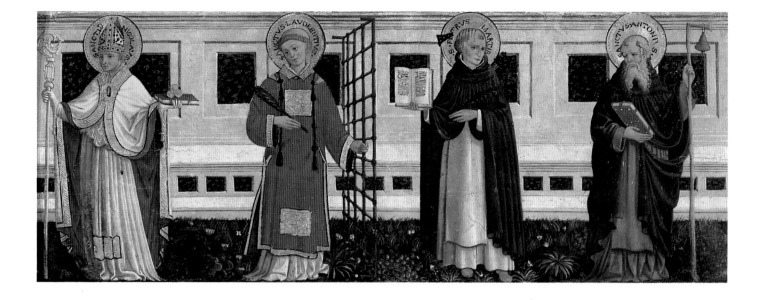

Sharing Saintly Vision

Saints keep many Christians going, close to hope and protection on an intimate, everyday level. While Jesus, his mother and Heavenly father inspire the faithful by example, their promise is on the very grandest scale, part and parcel of the cycle of redemption. Such divinity remains dauntingly absolute. No matter how much Mary, the Trinity, and the rest of the Heavenly Host may love humanity, others must fill the breach between the way-down-here and those-on-high. Starting as sinners like ourselves, saints are those essential others.

Touched by divinity, glorified by the fortitude and grace of faith, the saints are an ever-growing band, as ongoing canonization keeps the making or acknowledgment of sanctity rolling along. Events from the biographies of these men, women, and children of unusually good faith and exemplary fortitude, often brave in life and valiant in death, are frequently the stuff of Christian art as well as life,

yielding many of our finest, most stirring images. Stephen (306) and Laurence (289), deacons in a still-pagan Rome, are known as the first, or proto-, martyrs, keeping the faith in the face of the cruelest of fates. They are designated as martyrs by the palm branches they hold, pagan symbols of victory that now celebrate faith triumphant. What killed Stephen and Laurence are called the Instruments of their Passion and are included for the ready identification of the saints.

Sometimes saints bear far happier signs, souvenirs of good deeds, not cruel ends, emblems such as Nicholas's three golden orbs (256). He threw these into a bedchamber window, having seen and heard three poverty-stricken young sisters lamenting their lack of dowries. Well timed, his precious gifts saved each girl from a life of prostitution. These three gilded orbs were taken over by pawnbrokers in the pious hope that their loans might fulfill a similar service.

But those heroes and heroines of the faith subjected to cruel and un-

usual punishment were often depicted in paintings for triple reassurance: to demonstrate how superhuman strength may be summoned by belief; to show how those who so succeeded (with God's help) may come to our aid in times of need; and to inspire by example that we, too, might so behave, displaying similar fortitude.

Many of us are named for the saints on whose days we are born according to the Church's calendar. So the births, the lives, and the deaths of these spiritual godfathers and godmothers may come very close to our own, because we now share that most intimate of gifts— their identity.

Saints' lives unfold in a far more immediate historical context than that of the Bible, close to the modern calls of nationalism and militarism, private charity or public service. Recently some of the Blessed most beloved by artist and patron have been disqualified due to falsified papers or lack of documentation. The Catholic Church no longer accepts Veronica (257).

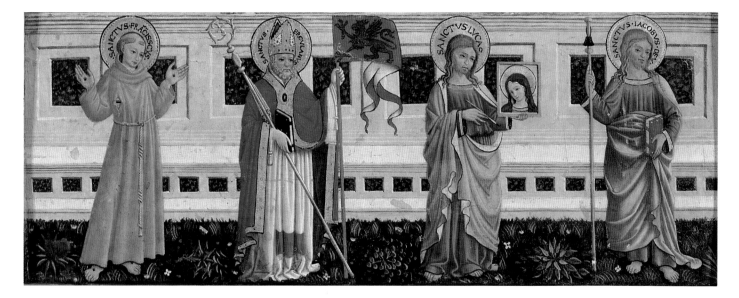

Opposite
BARTOLOMMEO CAPORALI active 1442–Perugia 1509 (?)
St. Nicholas, St. Laurence, St. Peter the Martyr, and St. Anthony of Padua
(Inv. No. 4159) Tempera and oil on panel
9 × 24½″ (23 × 62 cm)
(Ex coll. G.S. Stroganov, Rome, 1926)

Above
BAROTOLOMMEO CAPORALI *St. Francis of Assisi, St. Herculan,*
St. Luke, and the Apostle Jacob the Elder
(Inv. No. 4157) Tempera and oil on panel
9 × 24½″ (23 × 62 cm)
(Ex coll. G.S. Stroganov, Rome, 1926)

Right
JACQUES BLANCHARD Paris 1600–1638
St. Veronica (Inv. No. 2557) Oil on canvas
50 × 38½″ (127 × 98 cm)
(Ex coll. Brühl, Dresden, 1769)

Page 258
SCHOOL OF RIBALTA *St. Vincent in a Dungeon*
(Inv. No. 374) Oil on canvas
104 × 70″ (264 × 178 cm)
(Ex coll. Manuel Godoy, Paris, 1831)

Page 259
FRAY JUAN BAUTISTA MAINO
The Virgin, with St. Mary Magdalen and St. Catherine,
Appears to a Dominican Monk in Seriano
(Inv. No. 321) Oil on canvas
80 × 53″ (203 × 134 cm)
(Ex coll. Baroness d'Este, Paris, 1852)

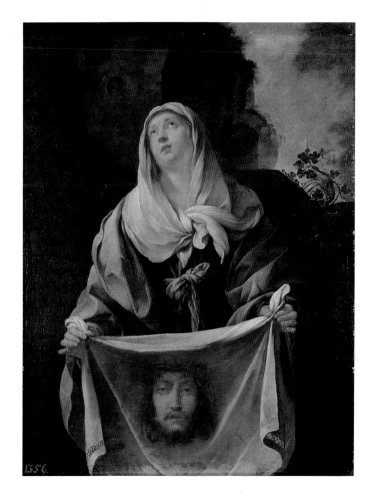

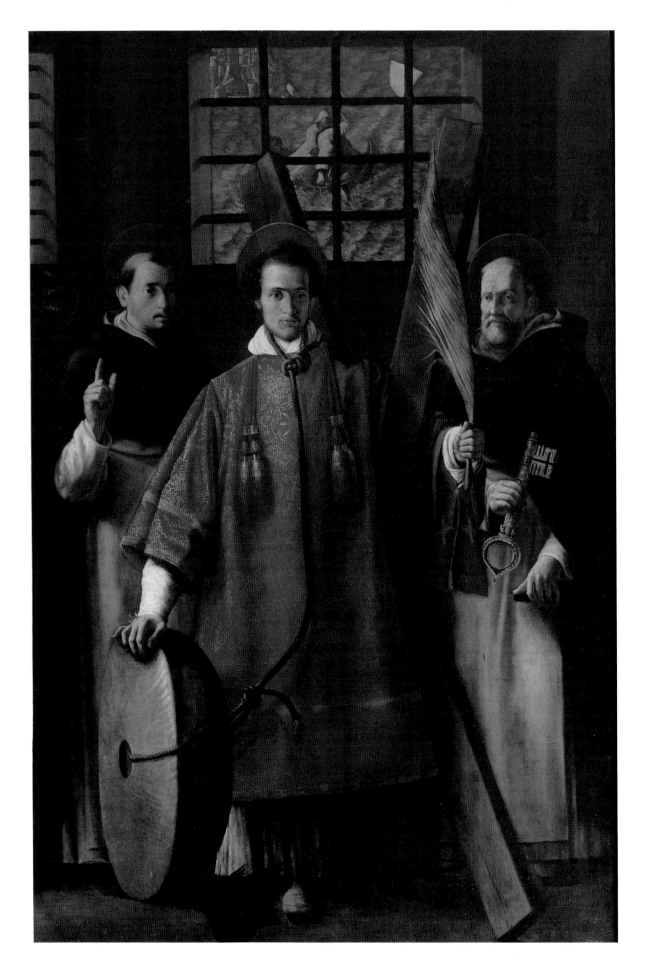

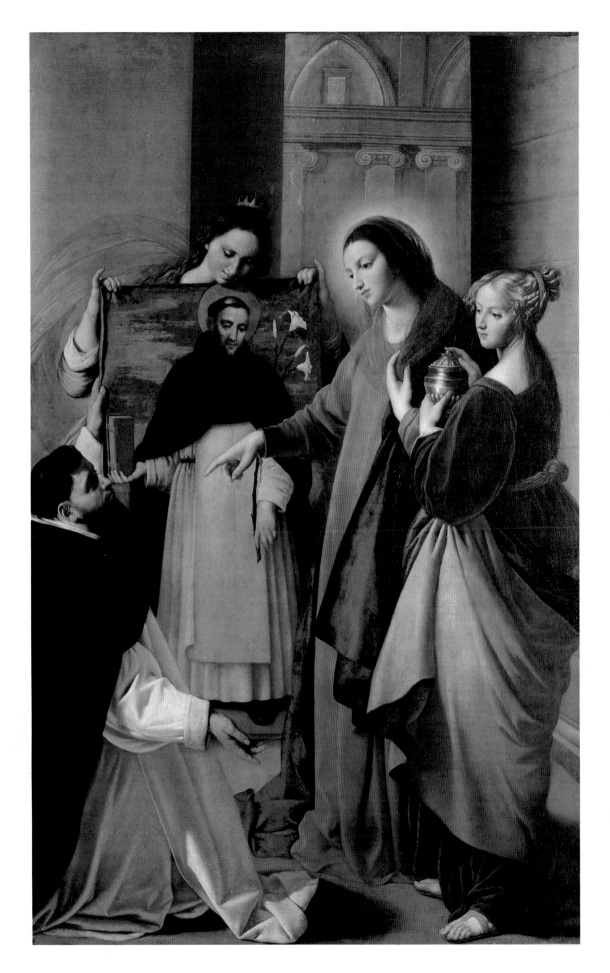

Even Christopher (273, 275), meaning "bearer of Christ"—the venerable patron saint of travelers having been a giant long credited with carrying the Infant across a river—is now removed from the roster of saints, if not from our dashboards. All these fabrications bear witness to the need for images of divinity, for visual news of Jesus' infancy and of his last days on Earth.

No one saint can hope to cover all the contingencies arising between, before, and after the birth and death of society's millions of different members. Any number may be needed, ever ready to encourage romance, induce fertility, assist in childbirth, protect or help cure each and every disease, supervise or assist in all crafts and professions, guard against fire and flood, war, pestilence, and famine. So saints are there for the asking, to lend an eye or ear, a hand or heart, to those sordid, relentlessly everyday problems beneath the troubling of Heaven's higher-ups though they, like the saints, are also ready for the praying, prepared for intimate communion. Even if unusually touched by divine grace, endowed with rare spiritual fortitude, the saints remember the day-to-day problems of every class and calling, of harried cook, cold soldier, poor shoemaker, impatient schoolteacher, soft-hearted moneylender, unsuccessful whore or thief. There's a saint for everyone—even lawyers.

Their images and visual biographies, almost as much as those of the Holy Family and Trinity, are central to Christian art. Saints are

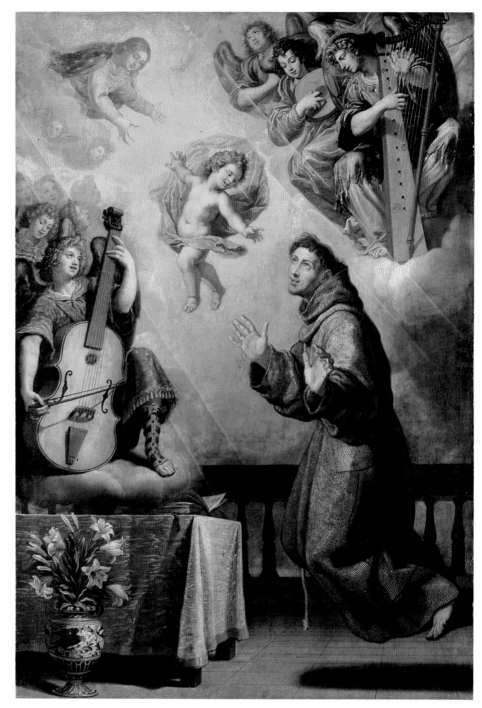

VINCENZO CARDUCCI Florence 1578–Madrid 1638
The Vision of St. Anthony of Padua, 1631
(Inv. No. 352) Oil on canvas
109 × 42" (277 × 107 cm)
(Ex coll. Coesvelt, Amsterdam, 1814)

ourselves at our very best. They represent all we can hope to be, role models from birth to death for our working and loving, believing, fighting, giving, and dying.

More revered than any posthumous image was the saint's body. The cult of relics, those tragic bits of bone, hair, and skin, long-treasured scraps of corporeality all convey the most vital, immediate of sentiments: "Nearer my needed, blessed One to Thee." So we should see pictures of saints' lives as relics, enduring shared visions of moments of sacred experience, service, and sacrifice.

Many paintings were commissioned for installation above altars dedicated to saints and their relics. Such images vivify sacred deeds, as if resurrecting the dead by the power of visual suggestion. So many pictures that are biographies of the Blessed are often "working images" as well. Seldom meant as static embellishments for a museum's walls, these paintings were usually paid for and designed to inspire prayer and reinforce faith.

Great Baroque canvases dramatizing the ways in which holy men, women, and children were touched by divinity, blessed with courage and special gifts of spiritual and physical strength, were painted to propagate the faith; inspiring examples of the way to go and the way to be. Many of these scenes may now seem theatrical or operatic, harbingers of Hollywood at its least inhibited. And so they are — passion plays in the truest sense, continuing the lavish scenography of the medieval mystery plays staged within or near the churches.

No spiritual holds are barred in the saints' battles for our souls, in the endless fight against the collective, devilishly ingenious powers of evil. Domestic interiors and those of churches often had friezes or furnishings covered with many images of the Blessed whose special presence was particularly needed. Two sections from one such fifteenth-century architectural embellishment present an odd contrast between that Old Time Religion — quintessentially the highly personalized cult of the saints — and the new classically oriented taste of the Renaissance. This duality is indicated by the Umbrian Bartolommeo Caporali (256, 257). While his architectural setting and some of the saints' drapery is in the newly antique style, other figures still look medieval. The saints' gathering is a festive one, celebrated by the pink wall coloring and the *mille fleurs*-tapestried foliage at their feet.

DAVID TENIERS THE YOUNGER
Antwerp 1610–Brussels 1690
The Temptation of St. Anthony
(Inv. No. 3789) Oil on canvas
39 × 52" (99 × 132 cm)

Overleaf
FRA FILIPPO LIPPI
Florence ca. 1406–1469
The Vision of St. Augustine, late 1450s–early 1460s
(Inv. No. 5511) Tempera and oil on panel
11½ × 20" (29 × 51.5 cm)
(Ex coll. Grand Princess Maria Nikolaevna, Florence, 1917)

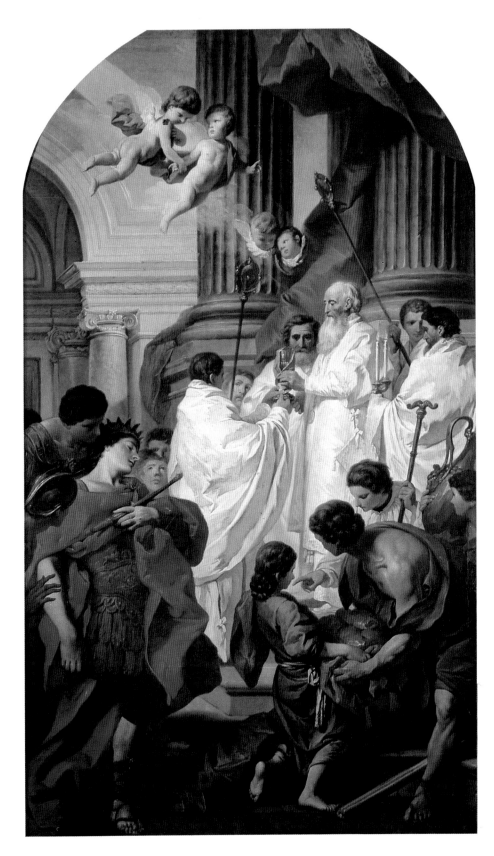

Two especially complex Spanish Baroque canvases each combine several saints to suit special monastic devotions. In a painting ascribed to Maino, Mary points to a kneeling Dominican from Soriano as he is shown an image of Saint Dominic holding a lily and a red book (259). This picture within a picture is held by Saint Catherine as Mary Magdalen stands to the right. All three holy women have appeared in order to demonstrate to the Dominican just how the founder of his order ought to be painted.

Saint Vincent is in the foreground of a Ribalta schoolpiece (258). He holds the palm of martyrdom and the millstone that is his attribute as if these were a knight's sword and shield. Vincent's vibrant presence makes the figures at his side pale by contrast. Waves are seen through the dungeon's barred windows, with the ship that carried his body out to sea.

Saint Anthony of Padua actually came from Lisbon, but is named for his burial place. Using those strange tints of beige and pink that were so popular in the seventeenth century, Vincente Carducho shows the miraculous appearance of Mary and the infant Jesus to the monk, as an angelic orchestra stresses this moment of harmony between Heaven and Earth (260). In a fine majolica vessel at the lower left, lilies symbolize the purity of one and all, showing Carducho's great skills as a painter of still life.

By retreating to the desert in the valley of Thebes, far from the sins of the cities, another, far-earlier,

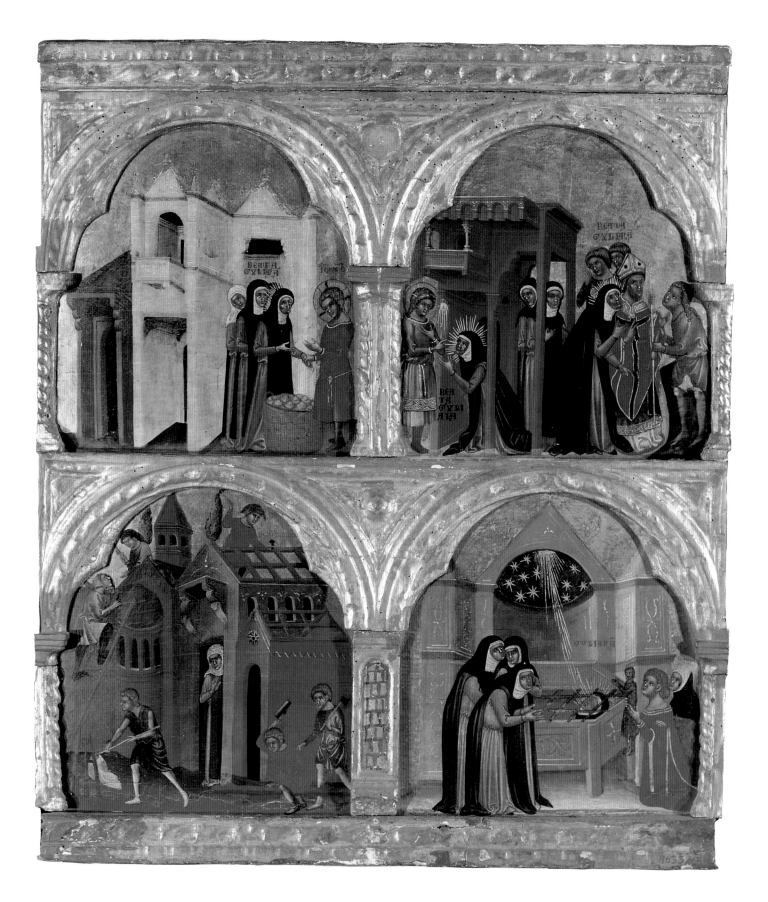

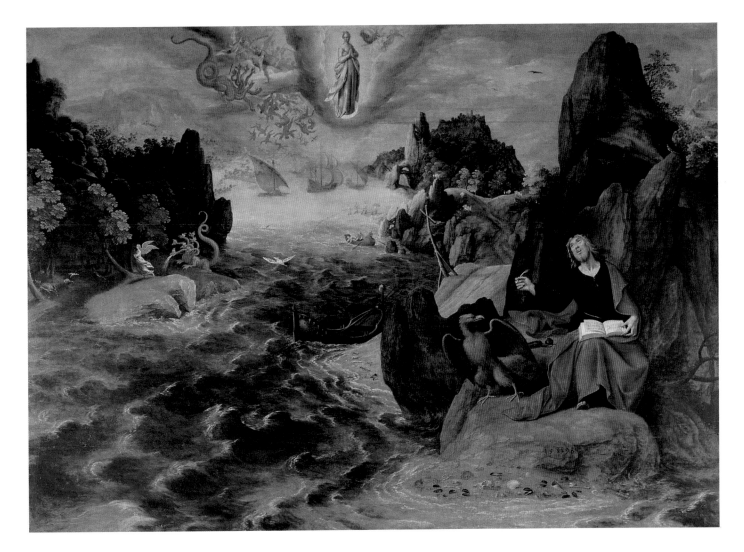

Of the four Fathers of the Church, Jerome may be the best loved because his story appealed equally to the most conservative of believers, to humanists, and to those who just liked the legend of the lion. The aged, penitent saint, suffering in the wilderness, is one of the best-known images of him, Ribera making the ravages of time and conscience equally painfully apparent (276). Sometimes Jerome is painted with an angel blowing a trumpet overhead, that event taken from an apocryphal letter in which he wrote: "Night or day, whether I sleep or wake, I always believe I hear the trumpet of the Last Judg-

ment." Ribera lovingly illuminated aged or tormented flesh and specialized in scenes of penitence, especially popular in Spain.

Jerome, with his faithful guardian lion on one side and skull of contemplation on the other, records his biblical studies and translations as he hears the Last Trumpet sounding overhead. The bedeviling, omnipresent sense of sin, that brassy sound perpetually ringing in his ears, is a moral equivalent to tinnitus, the awful, endless sound that often proves one more cross of old age. (Very like Ribera's *Jerome* is his typical canvas of another ascetic early Christian her-

TOBIAS VERHAEGHT Antwerp 1561–1631
Landscape with John the Evangelist Writing the Book of Revelation on the Island of Patmos, 1598
(Inv. No. 8694) Oil on panel
52 × 75" (133 × 191.5 cm)

Opposite
UNKNOWN
VENETIAN SCHOOL 14th century
Scenes from the Life of Beata Juliana of Collalto
(Inv. No. 6366) Tempera on panel
29 × 25" (73 × 64.5 cm)

Overleaf
TOBIAS VERHAEGHT
Landscape with John the Evangelist (detail)

them all over again on poor Christopher in a pastiche produced to meet the insatiable market for the wonderfully weird (275). Active long after Bosch's death in 1516, his Flemish follower reused the grotesque diablerie that the older master first trotted out with such seductive skill.

Saint Francesca Romana founded the Olivetan Oblates, deeply concerned with the hospitals of her native city. Il Guercino presents a vision of Francesca's in which she embraces the Christ Child as Mary and Joseph look on, and angels celebrate this moment of concord so beautifully echoed by Guercino's rich coloring (272).

Among the finest small paintings Tintoretto ever painted is a *Saint George and the Dragon* (274), reflecting all his powers *in nucleo*. These include a flair for drama, exciting chiaroscuro, and a sense of motion. Tintoretto was familiar with Near Eastern topography and used the walls of Jerusalem or other Islamic strongholds for the Cappadocian city. The princess kneels in gratitude for her deliverance by the knight who has converted the region to Christianity and freed her from the dragon's jealous clutches.

PIETER BRUEGHEL THE YOUNGER
Brussels 1564–Antwerp 1638
The Testimony of John the Baptist (Inv. No. 3519)
Oil on canvas, transferred from panel
42 × 66" (107.5 × 167 cm)
(Ex coll. Baron Pritvits, St. Petersburg, 1889)

JACOPO TINTORETTO
The Birth of St. John the Baptist
(Inv. No. 17) Oil on canvas
71 × 105″ (181 × 266 cm)
(Ex coll. Crozat, Paris, 1772)

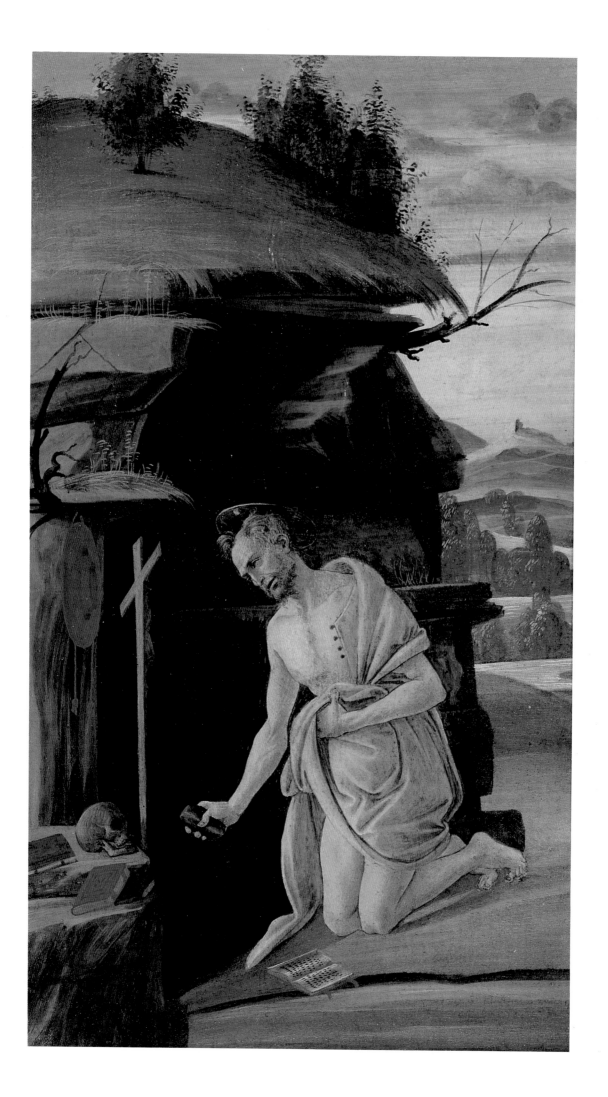

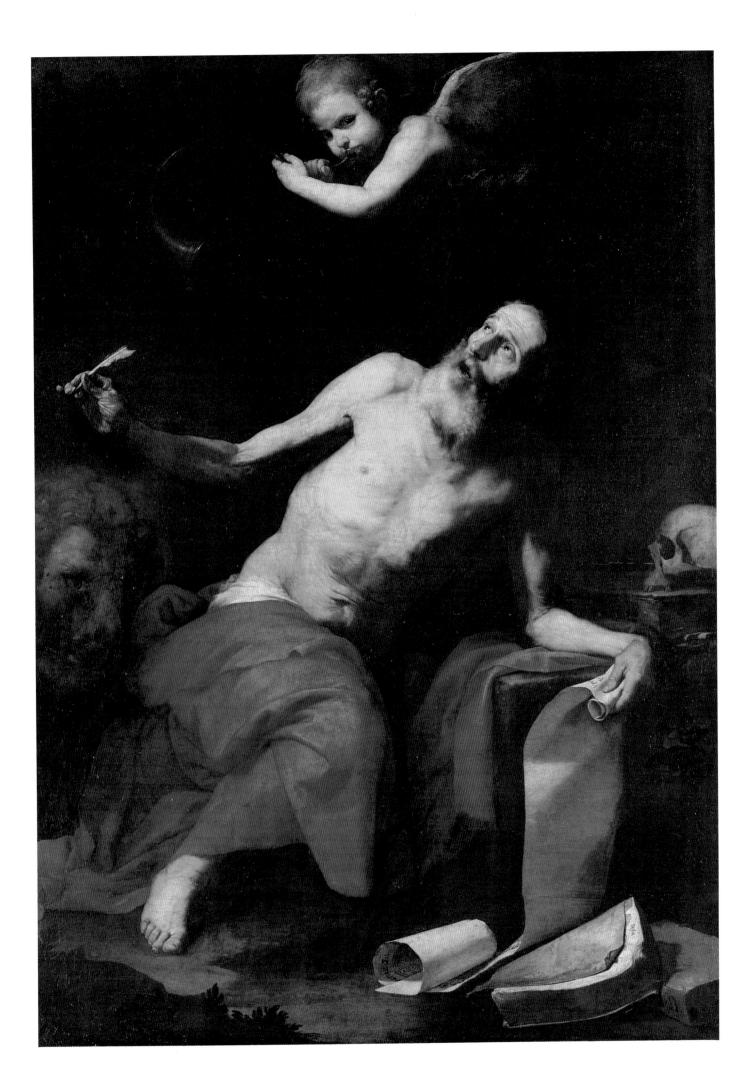

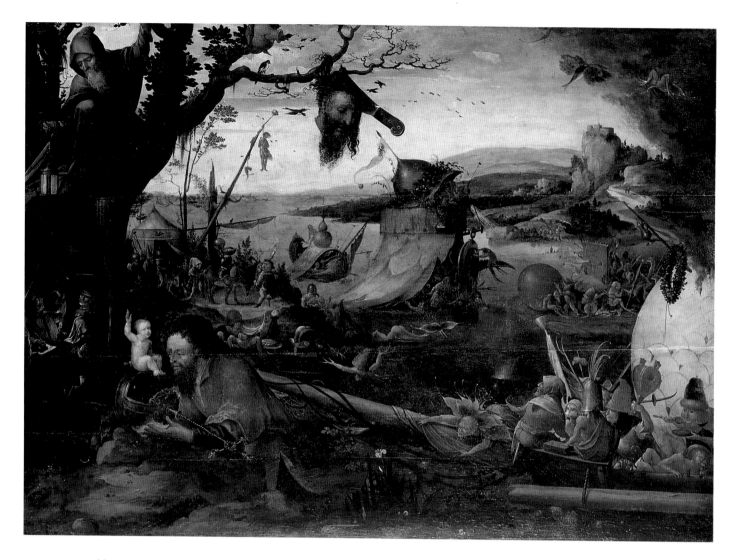

JAN MANDYN Haarlem 1500–1560
Landscape with the Legend of St. Christopher
(Inv. No. 4780) Oil on panel
28 × 39″ (71 × 98.5 cm)

Opposite
JACOPO TINTORETTO Venice 1518–1594
St. George and the Dragon
(Inv. No. 194) Oil on canvas
48 × 36″ (122 × 92 cm)
(Ex coll. D.A. Naryshkin, St. Petersburg, 1806)

Page 276
JUSEPE DE RIBERA
St. Jerome Hears the Trumpet, 1626
(Inv. No. 311) Oil on canvas
73 × 52″ (185 × 133 cm)
(Ex coll. Manuel Godoy, Paris, 1831)

Page 277
ALESSANDRO BOTTICELLI
St. Jerome, early 1490s (Inv. No. 4077)
Tempera and oil on canvas, transferred from panel
17½ × 10″ (44.5 × 26 cm)
(Ex coll. Stroganov Palace Museum, 1922)

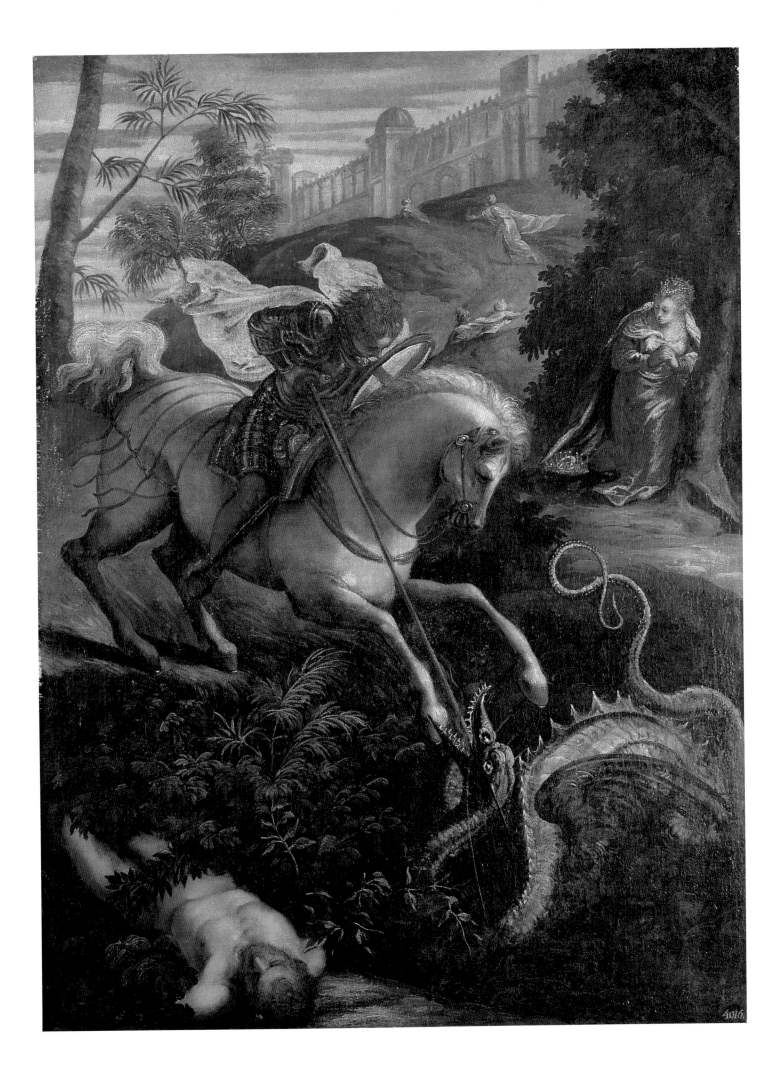

ALESSANDRO BOTTICELLI
Florence ca. 1445–1510
St. Dominic, (Inv. No. 4076)
Tempera and oil on canvas,
transferred from panel
17½ × 10″ (44.5 × 26 cm)
(Ex coll. Stroganov Palace Museum, 1922)

ADAM ELSHEIMER Frankfurt-am-Main 1574/78–Rome 1610
St. Christopher
(Inv. No. 694) Oil on copper
9 × 7″ (22.5 × 17.5 cm)

CARLO DOLCI (after)
St. Cecilia, ca. 1670
(Inv. No. 44) Oil on canvas
49½ × 39″ (126 × 99.5 cm)

GIOVANNI FRANCESCO BARBIERI GUERCINO
Cento, Emilia 1591–Bologna 1666
The Vision of St. Francesca Romana
(Inv. No. 156) Oil on canvas
19½ × 15″ (50 × 37.5 cm)
(Ex coll. Crozat, Paris, 1772)

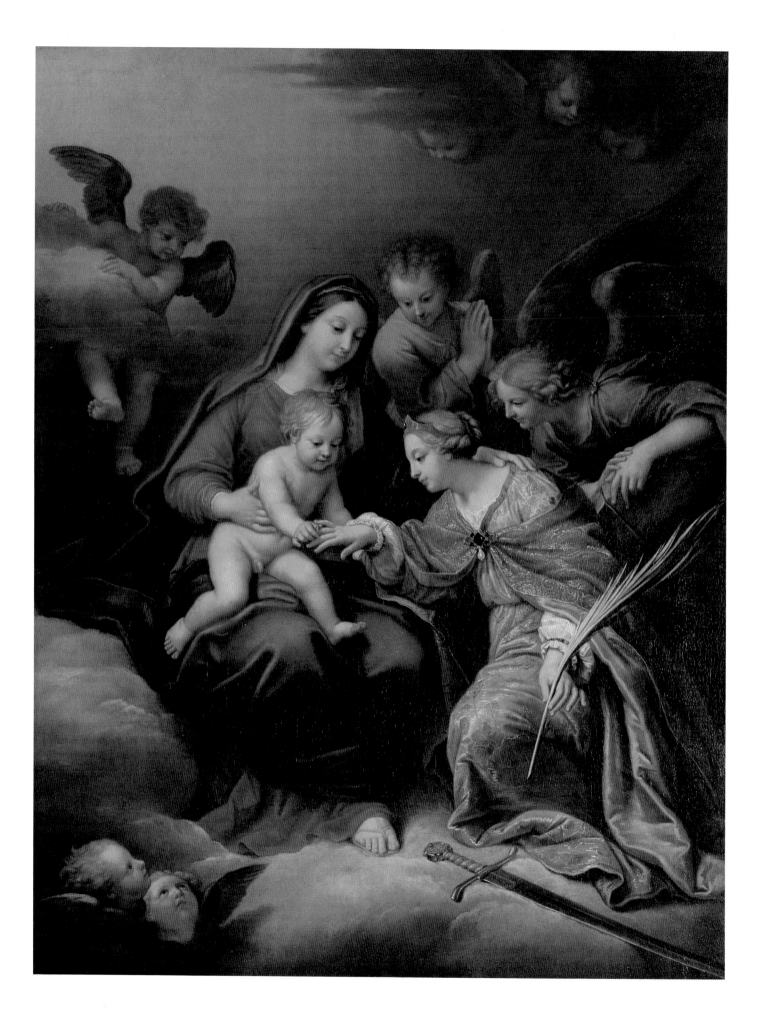

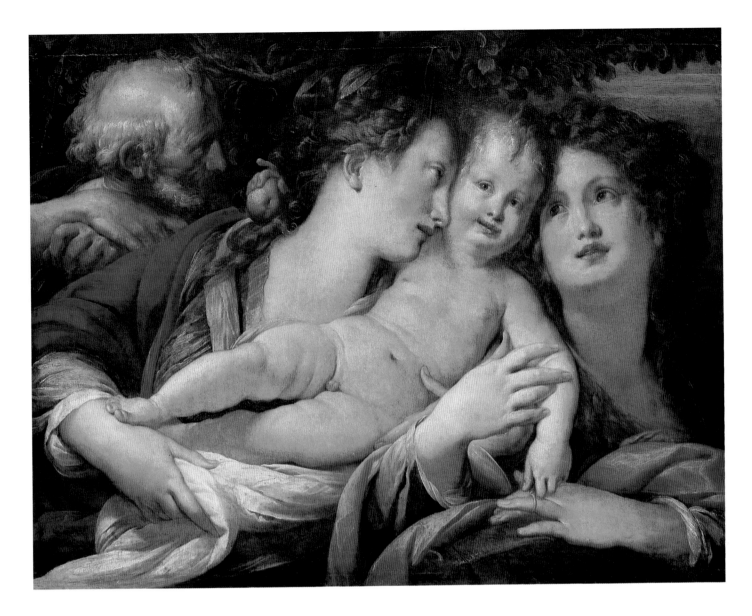

tire and costly instrument illustrate the early Christian martyr's wealthy Roman circumstances.

Two small early paintings by Botticelli, of Saints Dominic (273) and Jerome (277), show some of his austere, almost mannered approach. They probably belonged to a little portable altar. Born in Spain, most of Dominic's life was spent in France and Italy countering heretical movements and founding his monastic order. Here he answers the wrath of Christ, a small figure seen in the clouds holding three arrows intended to punish Pride, Avarice, and Lust.

Painting in the sixteenth century, Adam Elsheimer came from Germany to Rome, where his small yet powerful paintings gained ready popularity and influence. He took over some of the forceful figures of Tintoretto and other Northern Italian artists, adding the compelling magic of miniature scale. His Saint Christopher (273) carrying the infant Christ across the river—light from the opposite bank provided by a hermit's lantern—continues an Early Netherlandish theme, now reinforced by a novel breadth only Italy could provide.

Jan Mandyn reopens Hieronymus Bosch's bag of tricks, playing

GIULIO CESARE PROCACCINI
Bologna 1570/74–Milan 1625
The Mystical Marriage of St. Catherine
(Inv. No. 94) Oil on panel
22 × 29″ (56 × 73 cm)
(Ex coll. Walpole, Houghton Hall, 1779)

Opposite
PIERRE-FRANÇOIS MIGNARD
Troyes 1612–Paris 1695
The Mystical Marriage of St. Catherine, 1669
(Inv. No. 5709) Oil on canvas
53 × 41″ (134 × 105 cm)
(Ex coll. Vorontsov-Dashkov, St. Petersburg, 1920)

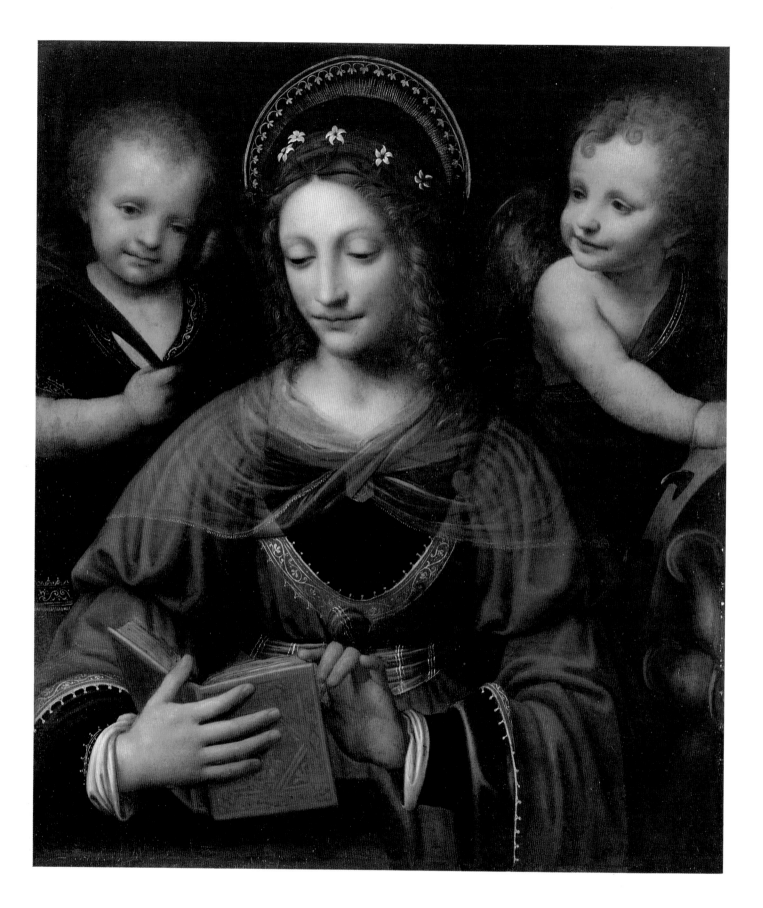

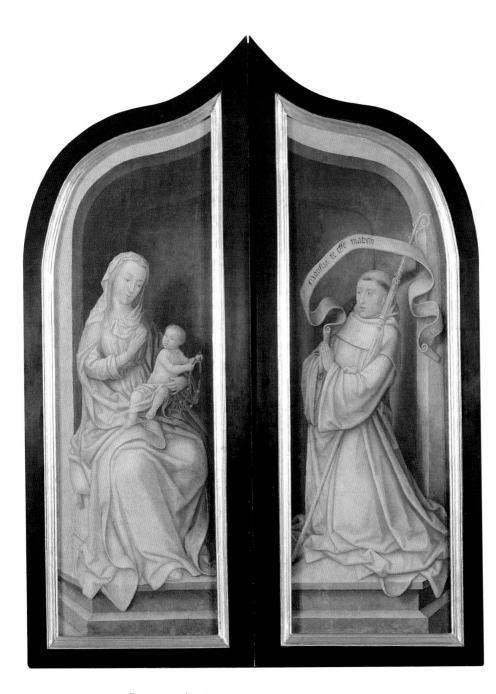

JEAN BELLEGAMBE Douai 1470/80–1535
The Miracle of Lactation
(Inv. No. 5526/7) Oil on canvas, transferred from panel
40½ × 13″ (103 × 33 cm)

Opposite
BERNARDINO LUINI Luini ca. 1480/82–1532
St. Catherine, 1527/31
(Inv. No. 109) Oil on canvas, transferred from panel
27 × 23″ (68 × 59 cm)
(Ex coll. Empress Josephine, Malmaison, 1814)

tury, often painted for monastic orders. Here, in the *Miracle of Lactation*, shown on the outer wings of an Annunciation triptych (268), Bernard prays to a statue of the nursing Virgin, asking her to show him that she was a mother. The statue comes to life and lets her spiritual son, Bernard, share milk from her breast with Jesus.

Where Bernard received Mary's maternal care, Catherine of Alexandria became the mystical bride of the Virgin's infant Son. One of Leonardo's finest followers, Bernardino Luini, depicts the martyred princess with two little angels (269). One holds her palm of martyrdom, the other the wheel on which she was tortured. The marriage takes place in the bosom of the Holy Family, in Giulio Cesare Procaccini's depiction (270), where old Joseph looks away while Jesus puts the wedding ring on Catherine's finger. As she rests one hand on the martyr's wheel, he holds the fruit of Redemption.

A far more elaborate ceremony is staged in heaven by Pierre-François Mignard (271), a formality entirely in keeping with his role as painter to the court of Louis XIV. As is true for so many paintings of the later seventeenth and early eighteenth centuries, Mignard's is painted with great smoothness, partly in imitation of Carlo Dolci, whose Madonna-type is followed by Mignard's Virgin.

Patron saint of devotional music, Cecilia is presented in a sadly cutdown work by Carlo Dolci (272) as a richly dressed, poised maiden playing a portative organ. Such at-

Saint Anthony was a founder of monasticism. Little did he know that temptation would follow him to the remote, isolated hermit's life. While this subject was one of high moral seriousness for a long time, by the seventeenth century it usually dwindled into genre (261), with an almost incidental view of the devil in female guise (demonic clawed feet give that maiden's show away) tempting Anthony, as in the scene by David Teniers the Younger.

Among the finest of the few early Florentine paintings in the Hermitage is a predella panel by Fra Filippo Lippi showing a vision of Saint Augustine (262–63). Here the church father is seen in a Tuscan landscape where he resembles a grandfather wearied by his infant charge, the little one poised dangerously near a stream. The subject of this panel is Augustine's desire to explain the nature of the Trinity. The Christ Child appears to him; while pointing to a vision of the Trinity, he holds a spoon toward the brook, telling Augustine that it is as futile to try to empty the stream with a spoon as it is to attempt an explanation of the nature of the Trinity!

Pierre Hubert Subleyras shows one of the patriarchs, Saint Basil the Great of Caesarea, who left retirement to follow the call of his bishop to go to court to defend orthodoxy against the Aryanism of Valentinian I, the magnificent figure at the lower right (264).

One of two saints in the Hermitage from a polyptych by Spinello Aretino, Benedict of Nursia, the patriarch of Western monasticism

(265), wears the white habit of one of the three reformed branches of his order.

Early Netherlandish art is in very short supply at the Hermitage. Its finest (and almost only) example is a *Saint Bavo* (265) painted by the Utrecht lay brother of the Order of Saint John, Geertgen tot Sint Jans. His little panel shows Bavo, patron saint of Ghent and of Haarlem. A knight of the first city, Bavo converted to Christianity after the death of his wife and entered the local monastery of Saint Peter's, where he lived as a hermit until the end of his life. Here he wears the armor of the mid-fifteenth century, a hooded falcon perched on his wrist as the final touch of knightly leisure—before Bavo saw the light.

A stirring realization of the ideals of the Counter-Reformation, Orazio Borgianni's dynamic portrait of Saint Carlo Borromeo (266) presents the cardinal in a moment of spiritual communion. From one of Lombardy's wealthiest noble families, Borromeo was archbishop of Milan at twenty-three. He soon became cardinal, heroically serving the sick in the great plague of 1575. Strikingly ugly, the cardinal is shown with Caravaggiesque realism in this uncompromising image, in which he seems to be instructing Heaven rather than the other way around.

The Burgundian Bernard of Clairvaux established the Cistercian order. Active in the cult of the Virgin, he was known as her faithful chaplain, and all his order's churches were designated as *Nôtre-Dame*. Jean Bellegambe, active near the end of the fifteenth cen-

ORAZIO BORGIANNI Rome 1578–1616
St. Carlo Borromeo, 1610/16
(Inv. No. 2357) Oil on canvas
60 × 48½″ (152.5 × 123 cm)

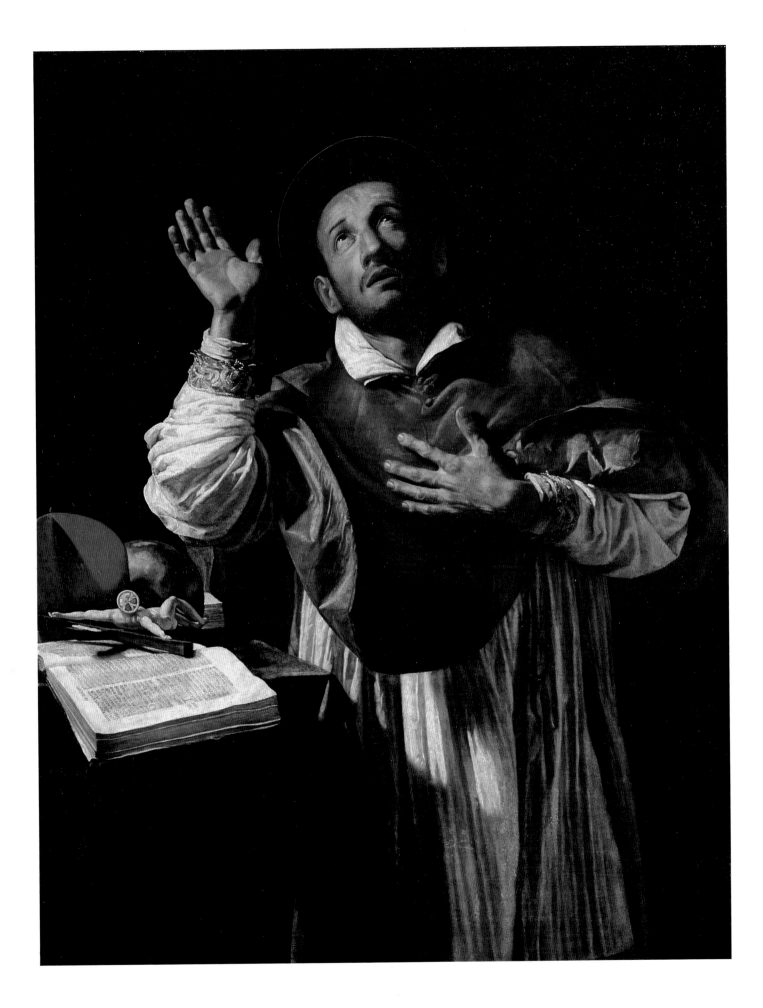

GEERTGEN TOT SINT JANS
Leyden active 1465–1493
St. Bavo (Inv. No. 5174) Oil on canvas,
transferred from panel
14 × 12″ (36.5 × 30 cm)
(Ex coll. Prince Repnin Estate, 1923)

Above
SPINELLO ARETINO Arezzo
active 1373–1410
St. Benedict, ca. 1385
(Inv. No. 272) Tempera on panel
50 × 17½″ (127.5 × 44.5 cm)

Opposite
PIERRE HUBERT SUBLEYRAS
Saint-Gilles du Gard 1699–Rome 1749
Emperor Valentinian Before Bishop Basil
(Inv. No. 1169) Oil on canvas
52½ × 31½″ (133.5 × 80 cm)
(Ex coll. Crozat, Paris, 1772)

mit, probably Onuphrius (288), a penitent in the desert of Thebes, so hairy that one of his fellow hermits supposedly mistook him for a chimpanzee.)

Botticelli portrays Jerome beating his breast with a stone (277), punishing himself for fantasies of beautiful women. Jerome wrote: "All alone, under the burning sun, with only scorpions and wild beasts for company, in my imagining I join in the dances of young Roman girls"; he then describes his cruel mortification of the flesh, and the rocky landscape of his Syrian desert retreat. Botticelli probably read the saint's vivid words before painting this little panel. By placing the cross at an angle, in the cave opening, he gives it a mystical power almost as strong as the far larger figure of the penitent saint.

Known as the Forerunner, John the Baptist was so close to Christ's teachings and their sources that he was uniquely prepared to preach the Gospel. The great, unusually well preserved Tintoretto canvas of the *Birth of Saint John the Baptist* (278–79) stages that event in a patrician Venetian setting. His aged father, literally dumbstruck by the miraculous event, stands at the far right. Because Elizabeth, in childbed, is far too old to nurse her baby, a wetnurse in the foreground is about to do so, near the Virgin Mary, who will give the newborn baby a bath. Mary takes on a role that John will assume in turn when baptizing her Son many years later.

Though painted well into the sixteenth century, Pieter Brueghel the Younger's *Testimony of John the Baptist* (280–81) is still close to the pictorial conventions of the early fifteenth century, to the cosmic crowds and views of the van Eycks. By showing many figures from the back, dwarfing the main character, and introducing a large tree as a *repoussoir*, Brueghel makes the viewer feel like a participant, as if he or she has also followed the Baptist to hear his incendiary words.

Accused of sorcery, Saint John the Divine was exiled to the island of Patmos by Emperor Domitian. It was there that he wrote his turbulent Revelations. This most confusing mystical text owes its constant currency to the fact that John's visions lend themselves to multiple interpretations.

A Flemish painter, Tobias Verhaeght, shows John writing his Revelations at the right, an eagle, symbol of divine inspiration, alongside (282, 284–85). Events of John's mystical text unfold at the left. The Woman of the Apocalypse, escaping the dragon by rising Heavenward, was an especially significant aspect of Revelations, for she became the focal point of a new doctrine—that of the Immaculate Conception. The vitality with which land and sea are both brought close to the viewer are not far from Rubens's skills, not surprisingly, for Verhaeght influenced Rubens and his generation.

Strictly speaking, Juliana di Collalto of Venice is not a saint, having only reached the less-exalted status of Blessedness. One would not expect that romantic yet materialistic place to spawn saints, and

GABRIEL CORNELIUS VON MAX Prague 1840–Munich 1915
A Christian Martyr on the Cross (St. Julia)
(Inv. No. 8372) Oil on canvas 49 × 36"
(124 × 92)

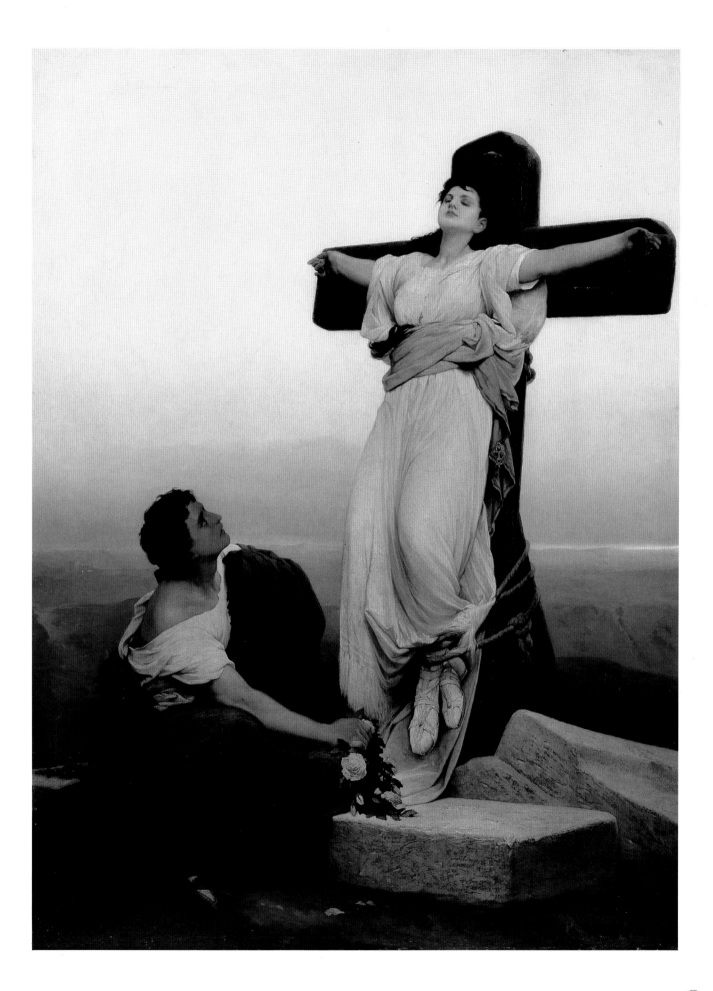

Venice does not disappoint: There are none. Four scenes from the Beata Juliana di Collalto's life (283) are represented in a partially preserved Byzantinizing altar that must originally have had more than twice as many panels. Here the strong, clear, beautiful coloring recalls that of the Eastern enamels of San Marco's Pala d'Oro, that great golden covering of the high altar in the Doge's Chapel.

Concerned with the clairvoyant, drawn to the occult, the devout, and the hysterical, a Czech painter, doubtless self-named Gabriel Cornelius von Max, was inspired by images in Prague's Church of Loreto to paint the crucifixion of an ecstatic early Christian martyr, Julia (287). This is one of von Max's many pictures in the Hermitage—they must have struck a responsive chord in the fervently orthodox breast of Russian art collectors.

Laurence, the Protomartyr, is given an unusually monumental portrayal by Zurbarán, with a rich landscape background (289). That bright parting of the skies overhead is a common pictorial device to indicate divine blessing or other communion. Laurence grabs the massive gridiron of his martyrdom; the saint's other hand is laid upon his breast in a rhetorical gesture. A great embroidered panel of Saint Paul (294) is on Laurence's dalmatic.

Mary Magdalen is among the most cherished of saints, largely because her sort of sinner is not beloved by God alone. Especially close to Christ, Mary was the first mortal to

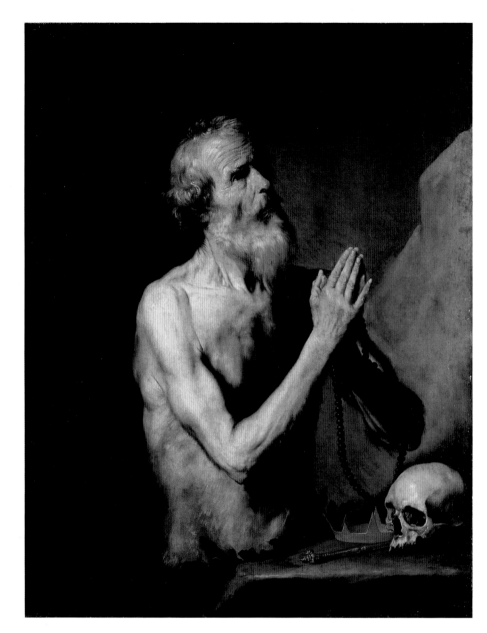

JUSEPE DE RIBERA *Saint Onuphrius,* 1637
(Inv. No. 375) Oil on canvas
51 × 41″ (130 × 104 cm)

Opposite
FRANCISCO DE ZURBARÁN *St. Laurence,* 1636
(Inv. No. 362) Oil on canvas
115 × 88½″ (292 × 225 cm)
(Ex coll. Marshal Soult, Paris, 1852)

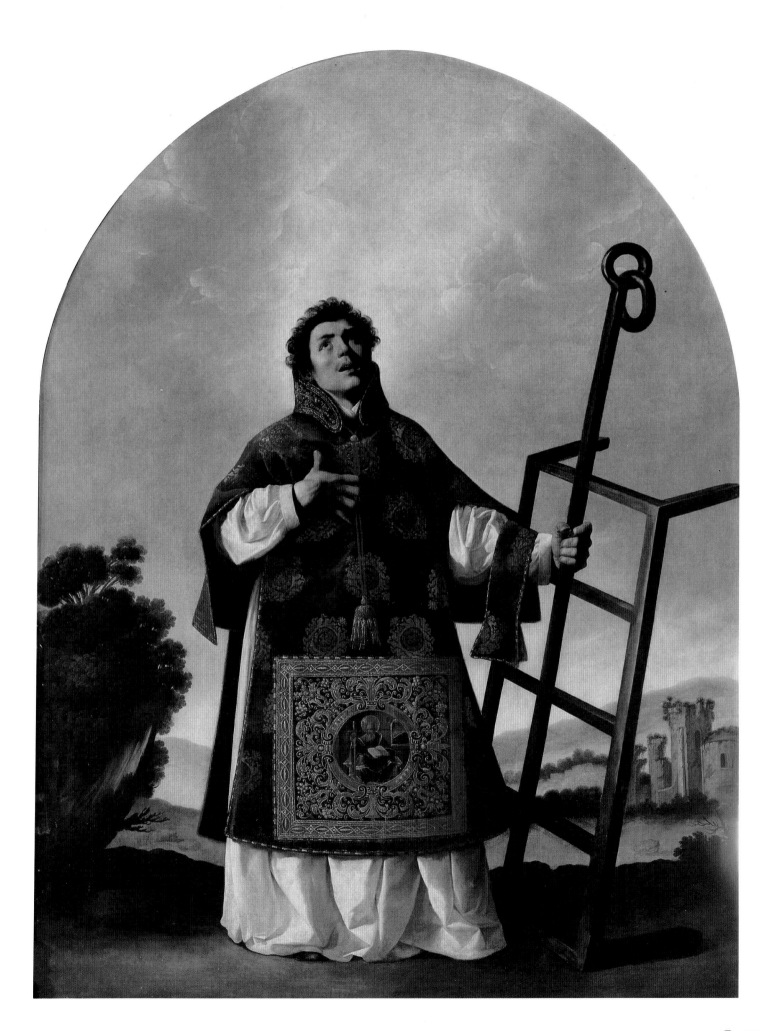

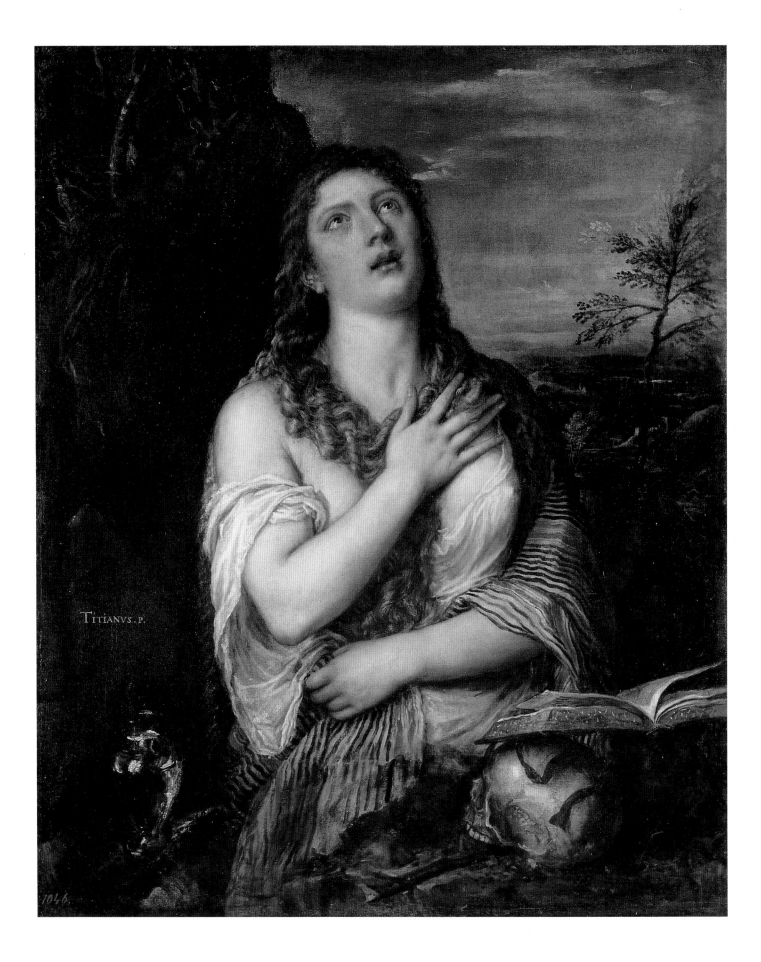

TITIANVS . P.

1046.

whom he appeared after the Resurrection. She was the sibling of the industrious Martha and of Lazarus, whose dead body was the first to be raised by Christ. She and Martha argued before Christ about the two ways of life—the contemplative versus the active. He agreed with Mary in speaking for the superiority of the first.

Mary Magdalen affords the faithful, lustful, or both a legitimate occasion to see a beautiful penitent wearing little but her long tresses, looking very well indeed as she does good by renouncing the bad. Titian's half-length *Penitent Mary Magdalen* (290) in the Hermitage, one of several of the same composition, is among the finest. Andrea Vaccaro shows the popularity of the same theme in the next century (291), where Mary Magdalen looks more strapless than topless, her well-worn prayer book and skull strangely out of place.

Apocryphal sources have the Magdalen ending her days in Provence, where she sailed from the Near East with her brother Julian, settling in the cliffs of the Riviera at La Baume. There she lived a life of hermetic retreat, including hair shirt, flagellation, and daily levitation, with Heaven providing her daily bread. The Magdalen's final heavenly ascent (292) is shown in unusually rich narrative detail by the seventeenth-century Bolognese, Domenichino.

Both she and her rustic residence are reduced to barest essentials in a belle époque example of mustache-twirling hagiography by Jules-Joseph Lefèbvre (293). His canvas was bought by Alexandre Dumas

fils. After the writer's death it was sent to Saint Petersburg for the French Art Exhibition of 1896. Nikolas II was the happy purchaser, buying it for his Winter Palace.

Almost as erotic as the Magdalen's life is that of Petronilla, whom legend made the daughter of Saint Peter. As the "first daughter of the church," she was made a patron saint of France. Poor Petronilla was so beautiful that Peter, fearing for her virtue—and that of his disciples—prayed that she fall ill every time they came to his house. A Roman threatened to have her condemned to death as a Christian if she failed to marry him. Presumably this is the scene Simone Pignoni (301) shows, with Peter's putative daughter swooning as Flaccus brandishes his knife. Pignoni's crafty wedding of Venus and violence explains why he was among the very best-paid painters in seventeenth-century Florence.

Veronese is linked with harmony more than conflict, yet when he had to deal with violence, he did so with surprising skill, and nowhere more so than in the *Conversion of Saul* (294) with all its requisite turbulence. Though some critics have seen a certain mannered approach alien to Veronese in this picture, the grandeur of the canvas's equestrian groups, coupled with the audacity of the composition, make it hard to take this thrilling painting away from the Venetian and assign it to a lesser light in his circle.

Saul, on the road to Damascus, falls from his horse, blinded by heavenly light. He almost rolls out of the picture as he hears the voice

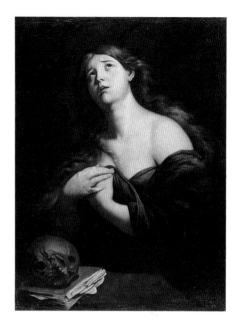

ANDREA VACCARO Naples 1604–1670
Penitent Mary Magdalen
(Inv. No. 1460) Oil on canvas
40 × 30″ (102 × 76 cm)
(Ex coll. D.P. Tatishchev, St. Petersburg, 1845)

Opposite
TITIAN *Penitent Mary Magdalen*, 1560s
(Inv. No. 117) Oil on canvas
46½ × 38″ (118 × 97 cm)
(Ex coll. Barbarigo, Venice, 1850)

of Christ asking him in Hebrew, "Saul, Saul why persecutest thou me?" Here the protagonist, soon to convert to Christianity and be renamed Paul, is almost overshadowed by the staggering array of horseflesh and fleeing warriors, yet the saint-to-be just barely manages to hold his own within a magnificent friezelike composition.

Peter, key in hand, is seen to the right of the bald Paul in a double portrait by El Greco (295). Peter and Paul may have been paired by El Greco because they came to Rome together and both were sentenced to death by Nero at the same time. Paul has his hand on a book, probably his Epistles.

Preaching alone, Paul is seen among classical ruins in a painting by the Venetian painter Giovanni Paolo Pannini (300), most of whose career was spent in Rome. The Eternal City's classical ruins inspired the setting the painter used for Paul's preaching at the ancient Greek altar on a rocky knoll—the hill of Ares, near the Acropolis, where there was an altar dedicated "to the unknown God."

Close to the delicacy of Elsheimer and Tobias Verhaeght's art, David Teniers the Younger's *Miracle of Saint Paul on the Island of Malta* (296–97) shows the shipwrecked apostles gathering around a campfire as Paul shakes a viper from his arm. A halo rings the bald apostle's head, just one of many light sources used by the artist to produce a variety of illumination—natural, artificial, and sacred.

An Amsterdam painter, Pieter Aertsen, presents various scenes of Peter and John healing the sick

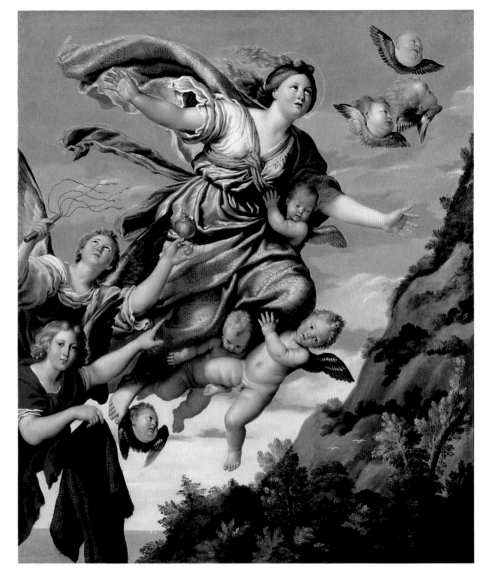

(298–99). Peter heals by his shadow at the center. Another cure, of the paralytic of Lydda, may be part of the same panel. This expansive view draws upon the traditions of the van Eycks and Bruegel, but is painted with a new sense of freedom that comes from Italy.

Bored by the grand, heroic approach of the Baroque, eighteenth-century artists and patrons welcomed a new mode—the Rococo —one that managed to be intimate and decorative at the same time. Franz Anton Maulbertsch used a similarly decorative vignette for his

DOMENICHINO (DOMENICO ZAMPIERI)
Bologna 1581–Naples 1641
The Assumption of Mary Magdalen into Heaven,
ca. 1620 (Inv. No. 113) Oil on canvas
51 × 43″ (129 × 110 cm)
(Ex coll. Crozat, Paris, 1772)

Opposite
JULES JOSEPH LEFÈBVRE
Tournan 1834/36–Paris 1912
Mary Magdalen in the Grotto
(Inv. No. 4841) Oil on canvas
28 × 44½″ (71.5 × 113.5 cm)
(Ex coll. Nicholas II, Winter Palace, 1926)

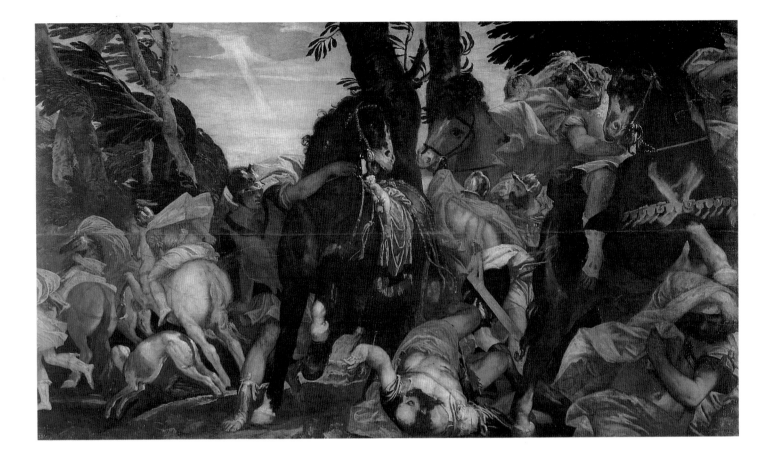

Above
VERONESE *The Conversion of Saul,* ca. 1570
(Inv. No. 68) Oil on canvas
75 × 129½″ (191 × 329 cm)

Right
FRANCISCO DE ZURBARÁN *St. Paul,*
from *St. Laurence* (detail)

Opposite
EL GRECO (DOMENIKOS THEOTOKOPOULOS)
Candia, Crete ca. 1547–Toledo 1614
The Apostles Peter and Paul, 1587/92
(Inv. No. 390) Oil on canvas
48 × 41″ (121.5 × 105 cm)
(Ex coll. P.P. Durnovo, St. Petersburg, 1911)

Overleaf
DAVID TENIERS THE YOUNGER
Miracle of St. Paul on the Island of Malta
(Inv. No. 692) Oil on panel
21½ × 32½″ (54.5 × 83 cm)

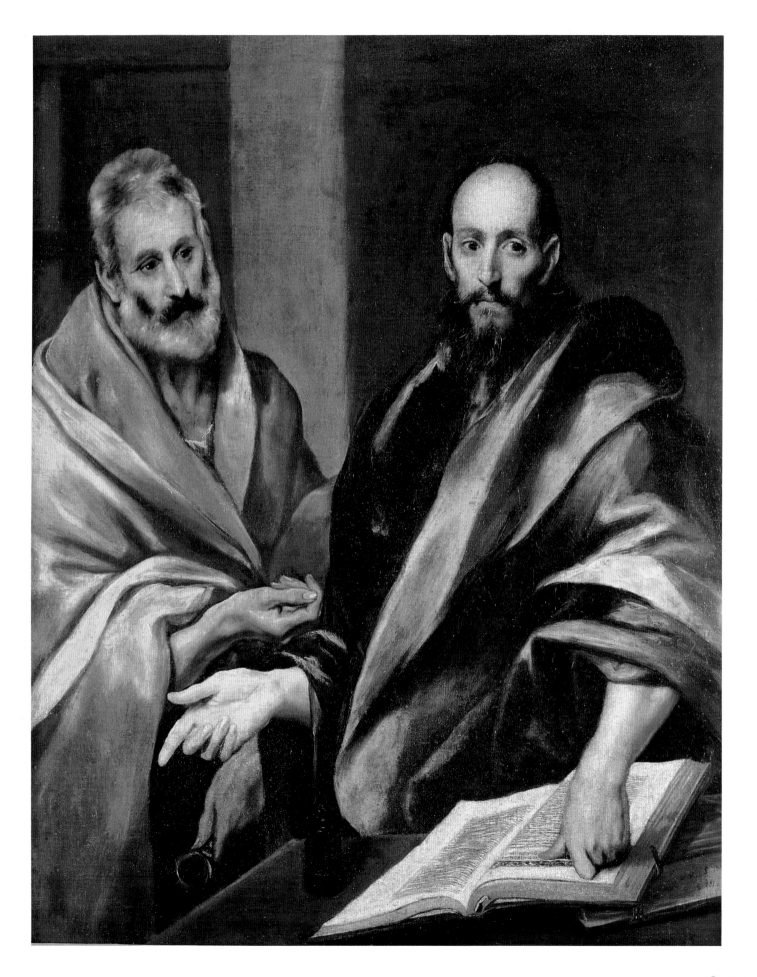

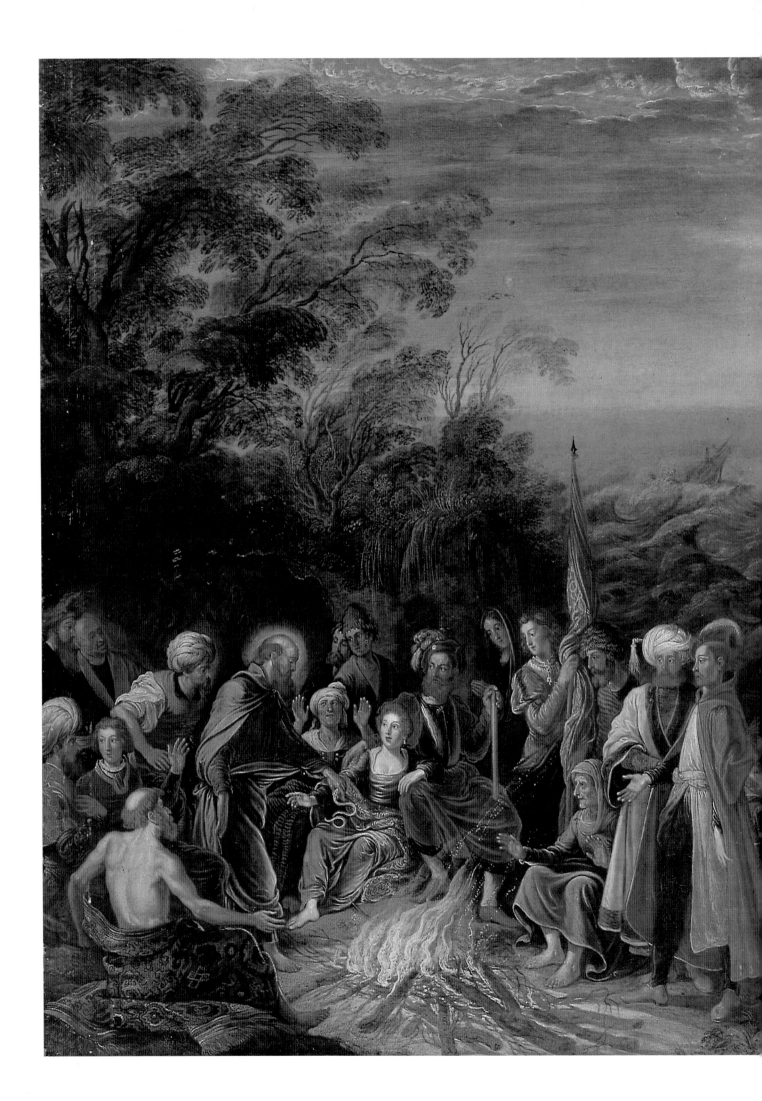

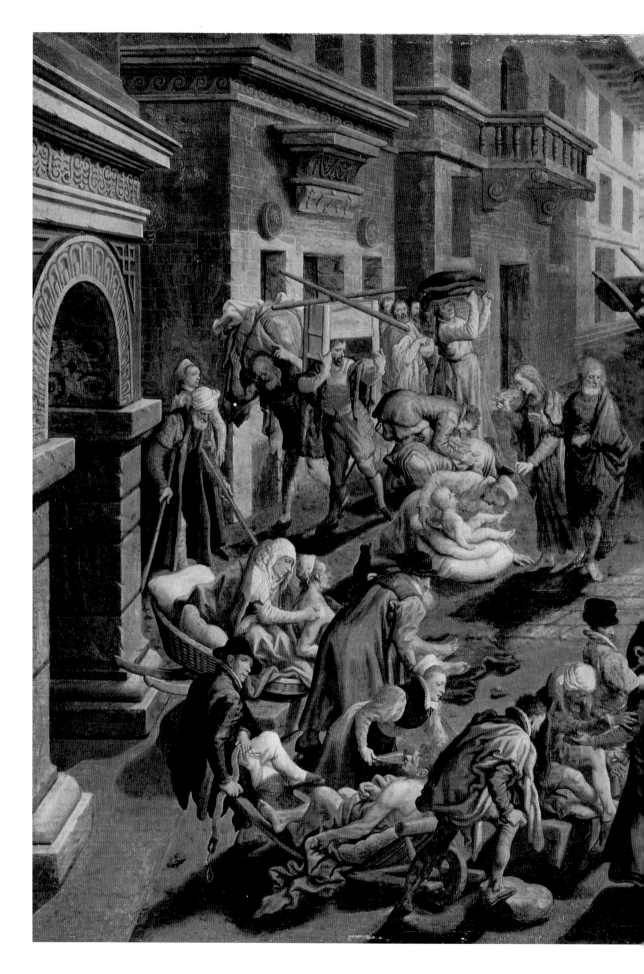

Baptism of the Eunuch (300). The Ethiopian official of the title had been reading aloud from Isaiah, and Philip, hearing his voice, converted and baptized him. Here the novel pictorialism of a Tiepolo is seen in Austrian translation, with a little extra *Schlag*.

Sebastian was a young Roman soldier twice subjected to martyrdom. The Hermitage's first painting of a scene in the cycle of the martyr's life and death is the saint's trial before Diocletian and Maximus, a panel that is the museum's finest early French painting (302). At this trial, Sebastian was condemned to death by archery. He survived the first shower of arrows, these removed by Saints Irene and Lucila (305), whose loving care cured him, making him a holy healer. Pagans caught on that beheading was the best way to kill a martyr, and ultimately subjected Sebastian to that fate.

Though as many arrows as the quills of a hedgehog supposedly pierced Sebastian, thanks to the Renaissance cult of the body beautiful fewer and fewer of them were allowed to penetrate the splendor of his skin. Perugino runs the lethal dart through the ecstatic saint's neck, lovingly inscribing his own name upon it (304), as if that sharp point were the source of the soldier-saint's terminal bliss.

PIETER AERTSEN Amsterdam 1508/9–1575
The Apostles Peter and John Healing the Sick
(Inv. No. 404) Oil on panel
22 × 30″ (55.5 × 76 cm)
(Ex coll. Tronchin, Geneva, 1770)

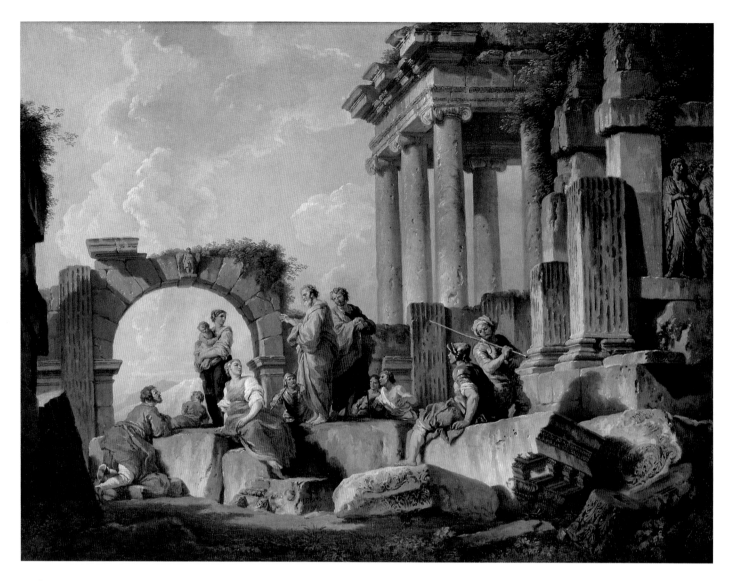

Disturbed by such erotic images in the service of the Church, there was a Counter-Reformation rumble against paintings like this. That Perugino's picture had a particularly personal association is suggested by the painter's condemnation by the Florentine Council of the Ten in 1487 for what seem to have been homosexual practices. This exquisite picture (sometimes thought to have been cut down) dates from the following decade.

Playing it safest, two or even three saints close to the same area of concern were sometimes grouped together to insure the best possible results. This is found in a sketch by the Venetian Late Renaissance painter Giacomo Bassano

Above
GIOVANNI PAOLO PANINI
Piacenza 1691/92–Rome 1778
Ruins with Scene of the Apostle Paul Preaching, 1744
(Inv. No. 5569) Oil on canvas
25 × 33″ (64 × 83.5 cm)

Left
FRANZ ANTON MAULBERTSCH
Langenargen 1724–Vienna 1796
The Baptism of the Eunuch
(Inv. No. 5758) Oil on canvas
20 × 13½″ (50.5 × 34.5 cm)

Opposite
SIMONE PIGNONI *The Death of St. Petronilla*
(Inv. No. 4797) Oil on canvas
55½ × 45″ (141 × 114 cm)

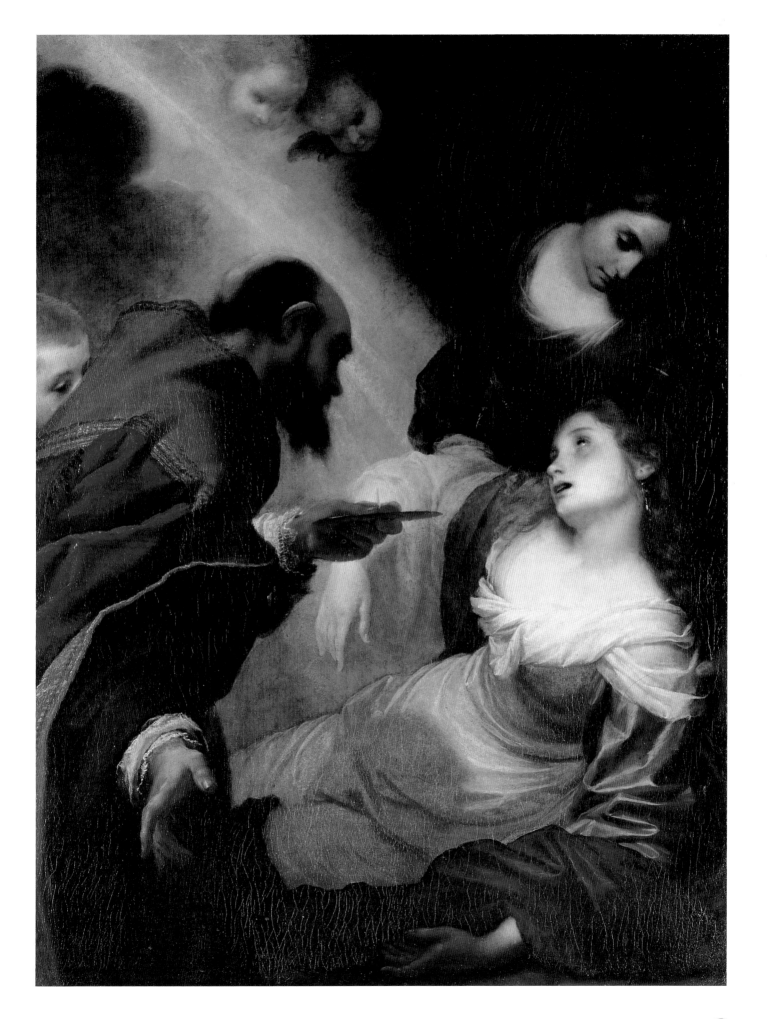

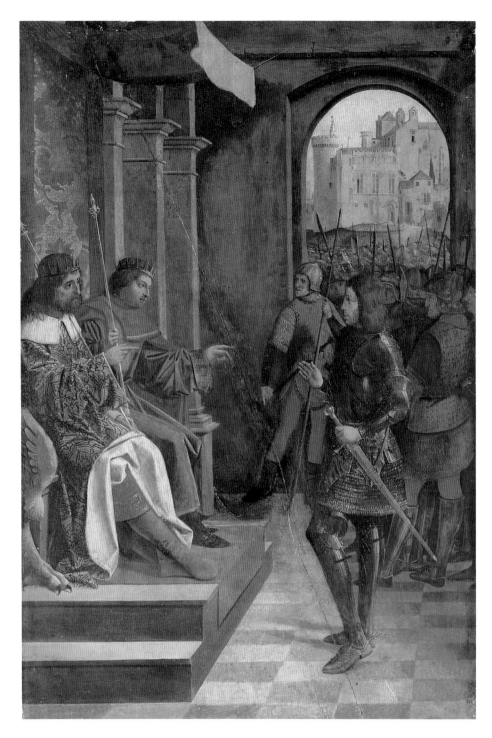

Above

**GIACOMO BASSANO
(GIACOMO DAL PONTE)**
Bassano 1517/18–1592
St. Fabian, St. Rocco, and St. Sebastian
(Inv. No. 2590) Oil on paper
22½ × 18″ (57.5 × 45 cm)
(Ex coll. Crozat, Paris, 1772)

Left

MASTER OF SAINT SEBASTIAN, France
St. Sebastian Before the Emperors Diocletian and Maximus
(Inv. No. 6745) Oil on panel
31½ × 22″ (80.5 × 56 cm)
(Ex coll. V.A. Volkonskaya, Leningrad)

Opposite

TITIAN *St. Sebastian*, ca. 1570
(Inv. No. 191) Oil on canvas
82½ × 45″ (210 × 115 cm)
(Ex coll. Barbarigo, Venice, 1850)

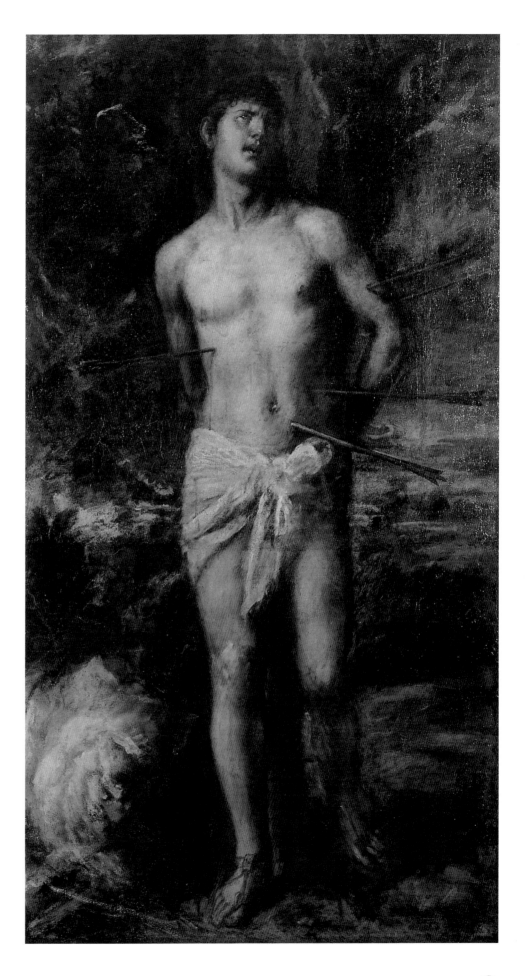

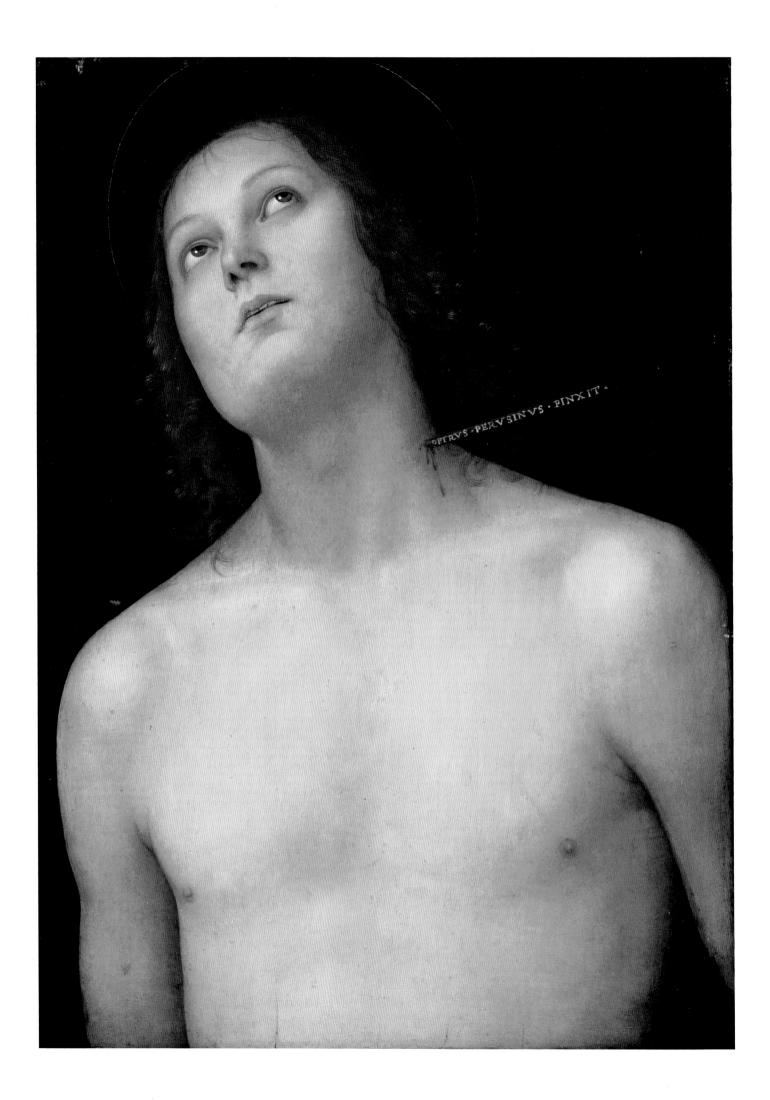

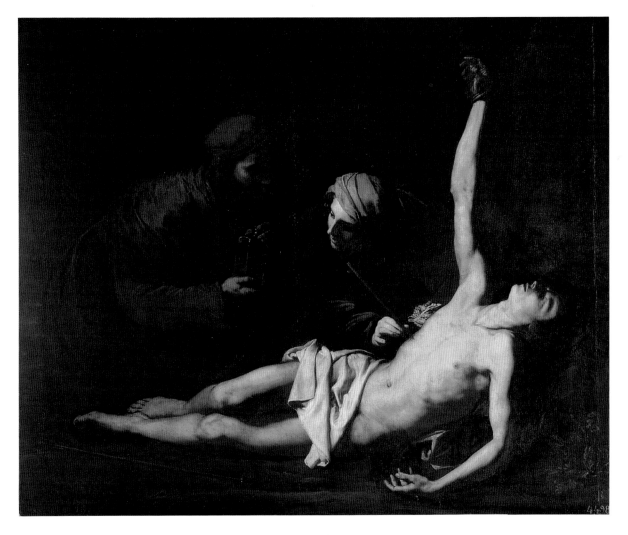

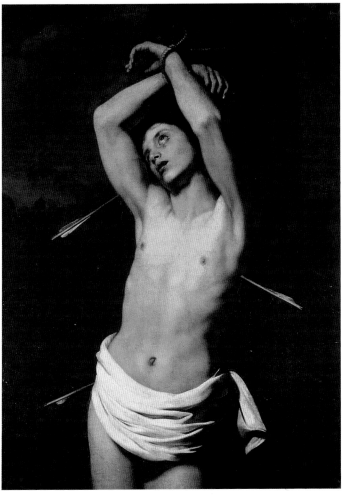

Above
JUSEPE DE RIBERA
St. Sebastian, St. Irene, and St. Lucila, 1628
(Inv. No. 325) Oil on canvas
61½ × 74″ (156 × 188 cm)
(Ex coll. Duchesse de St. Leu, Malmaison, 1829)

Left
NICOLAS RÉGNIER Maubeuge ca. 1590–Venice 1667
St. Sebastian, 1610s
(Inv. No. 5564) Oil on canvas
51 × 39″ (130 × 100 cm)
(Ex coll. Leichtenbergsky, St. Petersburg, 1923)

Opposite
PERUGINO Citta della Pieve ca. 1448–Fontignano 1523
St. Sebastian, ca. 1495
(Inv. No. 281) Tempera and oil on panel
21 × 15½″ (53.5 × 39.5 cm)
(Ex coll. Princess Z.A. Volkonskaya)

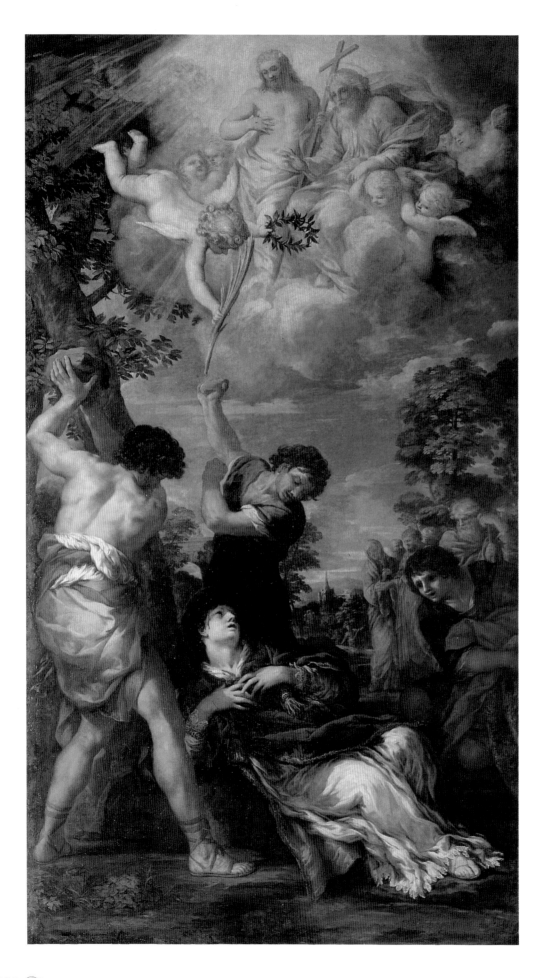

(302), who groups Sebastian with Rocco—another saint of healing—and Pope Fabian (who shares the same saint's day as Sebastian). Here Rocco is cured by a little angel; the old pope and the tormented soldier-saint are to the left. All is painted in a thick, almost Rembrandtesque impasto that gives this sixteenth-century sketch a surprising modernity and spontaneity.

Those qualities of speed and immediacy are also seen in a very late Titian *Sebastian* (303). Whom old Titian may have painted this image for is an open question, as it remained in his own home until after his death. The artist may very well have worked his canvas for purely personal purposes—a painted prayer for health and fortitude as the slings and arrows of extreme old age assailed him, demanding to be dealt with on every level—physical, spiritual, and artistic.

Each generation sees a major artist in its own way. This canvas did not suit the nineteenth century's vision of Titian, so it remained in storage until the century's end. Now the Stoical image, with its extraordinarily contrasting Venetian sunset, has become a canonical example of the grand old man's art at its very best. For all its physical beauty, this is an image beyond easy seduction, returning to the lapidary yet painterly skills of Mantegna at the dawn of the Venetian Renaissance for some of its firmness of purpose.

A Flemish artist, Nicolas Régnier selected the erotic pose of a Michelangelo *Slave* for his *Sebastian* (305). As the two most highly fin-

ished of those statues were in France, the painter may have studied them at first hand.

Among the Hermitage's grand canvases is a *Lapidation of Saint Stephen* (306), probably a replica by Pietro da Cortona of about 1660, after his painting for the Roman monastic church of Sant'Ambrogio in Massima. Like his contemporary, Gianlorenzo Bernini, Cortona was a leader of the Roman Baroque style. Both were great architects as well as artists, sharing the magnificent patronage of the Barberini family. Cortona's sweeping orchestration of this handsome composition makes his mastery of space in another medium unsurprising. Here the protomartyr sees an angel descend with crown and palm branch as God the Father blesses the saint-to-be. Christ points to his own lance wound as if to share in the agony below. Two torturers at the left suggest the same figure seen from the front and back, a traditional Italian academic device.

With deconstruction, saints' lives and works are not what they used to be—or mean. A psychoanalytic age has reduced martyrdom to a complex. Witness is seen as a compulsion, and self-denial and retreat are denigrated to sublimation or escape. Even the Catholic Church has come to question some of the lives and works of the Blessed, embarrassed by the depth, the intimacy, the immediacy of the emotions that their works and days may still arouse in art and life alike.

PIETRO DA CORTONA
Cortona 1596–Rome 1669
The Lapidation of St. Stephen, 1660
(Inv. No. 184) Oil on canvas
102½ × 58½" (260.5 × 149 cm)
(Ex coll. Manuel Godoy, Paris, 1831)

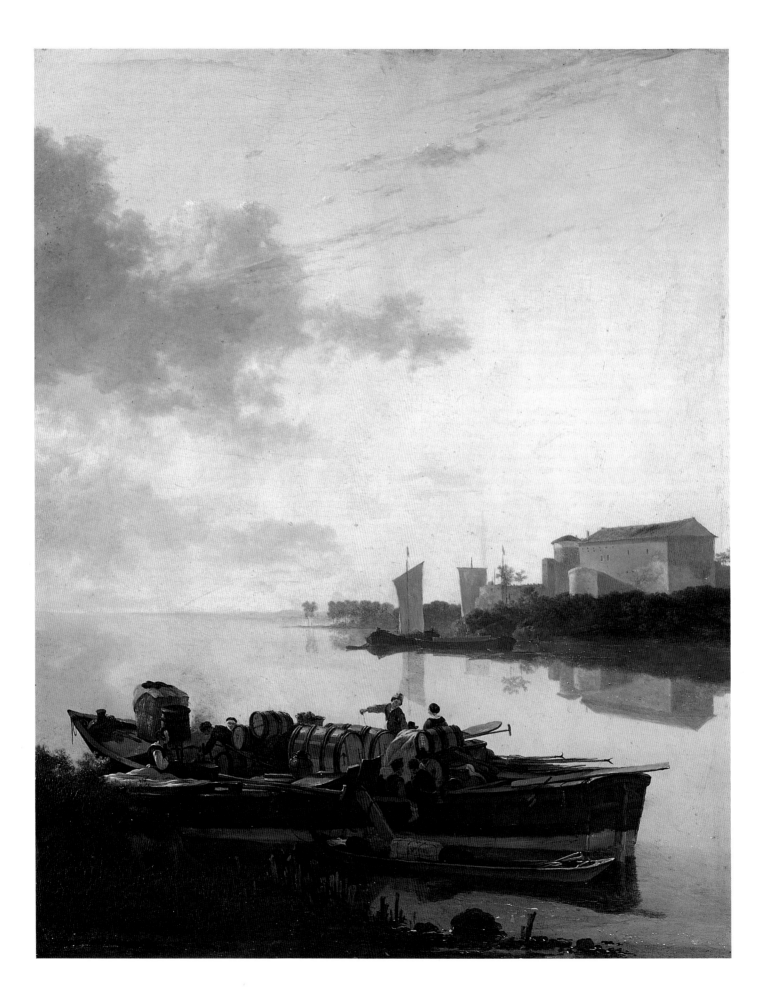

Land is life, fought over far more passionately and extravagantly than love or money because it encompasses yet transcends them. A piece of turf brushed by Dürer, trees in the fog breathed upon Chinese silk, an arrangement of stones cut into a Japanese woodblock—these bespeak the beginning and the end, as if addressing all that ever was or will be. Picturing sea or sky, those most visible manifestations of the infinite, affirms what we can (or wish we could) believe in—that sense of eternal, immutable values beyond human understanding or penetration, no matter how much we may pollute the cosmos.

Almost every society's or faith's creation account describes genesis in terms of a divinity or savior—whether the ancient Chinese giant Pan Ku, from whose flesh and bones the earth and mountains sprang, or Christ, the shedding of whose blood, with that of the martyrs, alone can save this world. In Ovid's *Metamorphoses*, like the earlier literature of faith, Nature is never neutral, her flowers and streams, gems and trees so often generated by the perpetuation of divine passion and frustration, nymphs and mortals changed—metamorphosed—into stars and streams, as well as gems, trees, and flowers, embellishing land, sea, and sky.

ADAM PYNACKER Pijnacker, near Delft 1621–Amsterdam 1673
Barge on a River at Sunset (Inv. No. 1093) Oil on panel 17 × 14" (43.5 × 35.5 cm) (Ex coll. Crozat, Paris, 1772)

Homer's songs and Virgil's lines have led ancient and later painters to many pictorial adventures, as has the Bible, all of these often set in a landscape whose special features played an almost personal role in the communication of the event. Only in the later Middle Ages, with the new lyrical Christianity of Saint Francis of Assisi, Dante, and Petrarch, could nature be seen once again, restored and freed from a guilt-ridden denial of "pagan" values, her beauty now experienced independently, without reference to the Classical vision. This fresh view of creation is found in Francis's hymns to Brother Sun or his still more touching Sermon to the Birds, and in Petrarch's Provençal mountain climbing (or his wish to do so). In addition, the fresh personalization of nature by troubadors like Charles d'Orléans's legitimized and secularized landscape, a trend long moving at a glacial pace, from the marginal to, quite literally, the center field. One of Charles's songs even saw the changing beauties of this earth in terms of human rather than divine fashioning.

An ancient Roman painter is described by Pliny as having "introduced the most attractive fashion of painting walls with pictures of country houses and porticoes and landscape gardens, groves, woods, hills, fish ponds, canals, rivers, coasts, and whatever anybody could desire, together with various sketches of people going for a stroll or sailing or in carriages, fishing, fowling, hunting, or even gathering the vintage riding to country houses on asses " Many of these subjects are found in tapestries and probably were frescoed in the later Middle Ages.

Other art forms of the time—the horizontal vista provided by the *bas-de-page* (the strip at the bottom of the illuminated page), the front of the hope chest or *cassone,* or the painted wooden friezes known as *spalliere*—allowed for a quality of visual exploration, a bird's-eye or panoramic view of ancient narrative or romantic Gothic adventure, both in landscape settings, of whatever subjects might best be in keeping with the happy and/or virtuous expectations of bride and groom.

Sienese Trecento vistas by Ambrogio Lorenzetti, along with the same school's later landscapes by Sassetta, and Florentine scenes by the Lippi, father (262–63) and son (184), and by two pairs of brothers, the

Ghirlandaio and the Pollaiuolo, are all great essays in the same genre, as are those of the Arno Valley so often painted by the latter and drawn by Leonardo.

Such Baroque masters as the Carracci and Domenichino working in Bologna, Saraceni in Rome and Venice, the matchless vistas provided by Giovanni Bellini, Titian, or Giorgione (148), the romantic approach of Dosso Dossi, Salvator Rosa, Giovanni Battista Castiglione, or Alessandro Magnasco (342), all these must be remembered along with the best-known, ever-fashionable later masters of eighteenth-century Venice.

Earlier, Jan van Eyck and Leonardo explored perception and distance, both mastering the science of art and art's science as they examined the mysterious ways of aerial perspective. Windows in the latter's *Benois Madonna* (178) evidence the skyborn level of his consummate search, above and beyond his peers' earthbound endeavors, the artist's vision as seemingly unrestricted as the flight of birds, which he analyzed with such unprecedented insight. Though Raphael later left large stretches of landscape to studio assistants' execution, the Hermitage's early tondo (180) shows how accomplished a painter of that genre he could be, the trees' pale leaves an arboreal parallel to the tender age of his sacred central subject.

Linguistically, landscape is quite a new word, first found in the sixteenth century, "landskip" its Old English spelling. In Dutch or German, the same term, *Landschaft,* pertains to the making of a view, and so the artists must have seen themselves, or been understood, as inventors or recorders of landscapes ranging from the ideal to the real, from the perfect or frightening fantasy to a painstaking recording of the souvenir or re-creation of the remembered.

An outdoor scene with satyrs was part of a perspectival peep show devised by the great architect Brunelleschi, recently recognized as illustrating Satire in the Classical sense, following Vitruvius's ancient text. That rustic genre, along with the Arcadian landscape, provided two of the leading literary references to ways of seeing, and showing, life in nature, whether of satyrs and other wildfolk living in the woods, with their precipitous encounters with humanity, or those of shepherds and shepherdesses perfected in the Veneto and in the fantasies of Danubian painting.

Those Italian centers with the least land to take for granted were most appreciative of nature in art. In the late fifteenth century, the Veneto first revived the Classical vision of Arcady, the art and literature of Virgil, who was buried in nearby Mantua. Theocritus's romances of shepherd and shepherdess were first reprinted, in Greek, on the Serenissima's Aldine press. Not only Venice, but such neighboring cities as Ferrara were criss-crossed by canals, water by far the most effective means of transportation within Italy and for the rest of Europe.

Saved from the seas, like Venice, the Low Countries, too, were the great discoverers of landscape, beginning with the van Eycks but reaching popular heights in the seventeenth century. It was then that this region—as had Northern Italy so much earlier—rediscovered the art of the classicizing pastoral, even writing new literature in the same mood.

Ancient Roman villas' lavish decor included extensive landscapes in fresco, an integral part of the architectural interior. This theme lost its popularity, long part of late medieval surroundings in vast tapestries of romantic adventures and of *bergerie*. There shepherds and shepherdesses cavorted in the greensward, minding each other far more than their sheep. These pictorial woven hangings kept drafty halls warm, their romantic subjects soon to be painted on canvas. The revival of such continuous panoramas, comparable to those of antiquity or the Renaissance, is found in the large canvases of Vuillard or Bonnard (394–95), described as frescoes.

Landscape renderings met the most basic demands, recording real estate, the needs of local pride, and for the souvenir. So they were brought into service, their painters filling in battle scenes and other areas with topographical data, providing requisite documentation of what's Mine, All Mine. The latter found its transcendent image in the pages of the duc de Berry's *Très Riches Heures* (Chantilly, Musée Condé), where the constellation for each month appears above an illuminated portrait of one of the duke's twelve major residences. Reflecting the passage of the seasons, paintings of the months were also indicative of Providence, with the labors of the months and the changes in weather and color all proclaiming divine design.

The seasons are the art of the calendar, whether wintery white making way for spring's tentative tints, or summer's reckless abundance anticipating the golden haze of autumn. Landscape painting follows nature's, taking over and repeating the changes that bespeak reassuring cycles of continuity. Though spring, summer, and fall are painted with abundant skills throughout Europe, the winter landscape came to be a speciality of the Low Countries, beginning with the snow-covered landscape of the duc de Berry's *Très Riches Heures*. Diminutive brush strokes of the early fifteenth century first captured the falling snowflake, expanded in the great cycle of the months by Pieter Bruegel, seen also in his son Pieter's *Adoration of the Magi* (199).

Painted landscapes work for a living, lending any room a view, suggesting light and air, space and change, often offering a sense of adventure and romance, laying out regions ready for the roaming, allowing for more free association and fantasy than those pictures that are overpopulated: all ego and no trips. Open seas, precipitous cliffs, tropical rain forests, and mountain ranges, these dwarf our troubles as we sail or climb to the sublime, exulting in our enemies' exile to sultry or frozen climes.

Landscapes could also be part of a cure, so Leone Battista Alberti observed, because "such as are tormented with a Fever are not a little refreshed by the Sight of Pictures of Springs, Cascades, and Streams of Water, which anyone may easily experience." Less than a century later, Italian art became relentlessly high-minded: "Pedestrian" landscapes were found unworthy of the academic mind behind the hand behind the brush. Michelangelo, so responsive in his youth to Netherlandish art (long admired in Florence), complained in old age how "They paint in Flanders only to deceive the external eye, things that gladden you and of which you cannot speak ill. Their painting is of stuffs, bricks and mortar, the grass of the fields, the shadows of trees, and bridges and rivers, which they call landscapes, and little figures here and there. And this, though it may appear good to some eyes, is in truth done without reason, without symmetry or proportion, without care in selection and rejection."

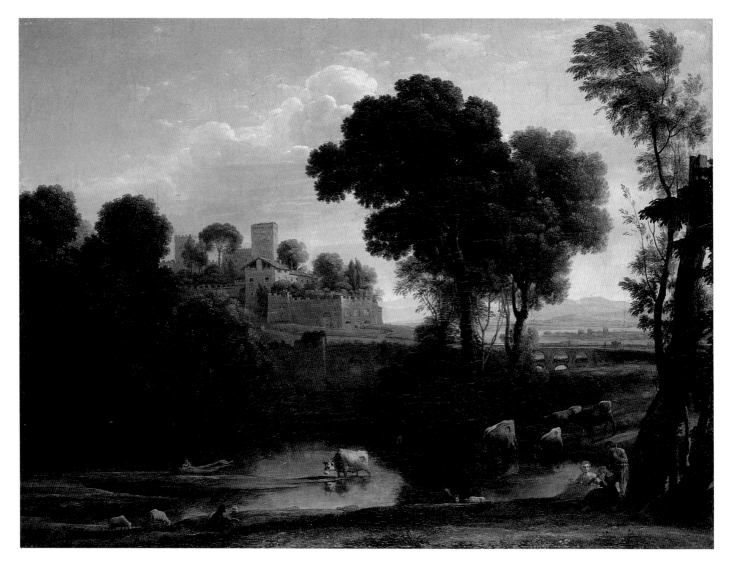

CLAUDE LORRAIN (CLAUDE GELLÉE)
Charmes 1600–Rome 1682
Italian Landscape (Inv. No. 1225) Oil on canvas
29½ × 39″ (75 × 100 cm)
(Ex coll. Crozat, Paris, 1772)

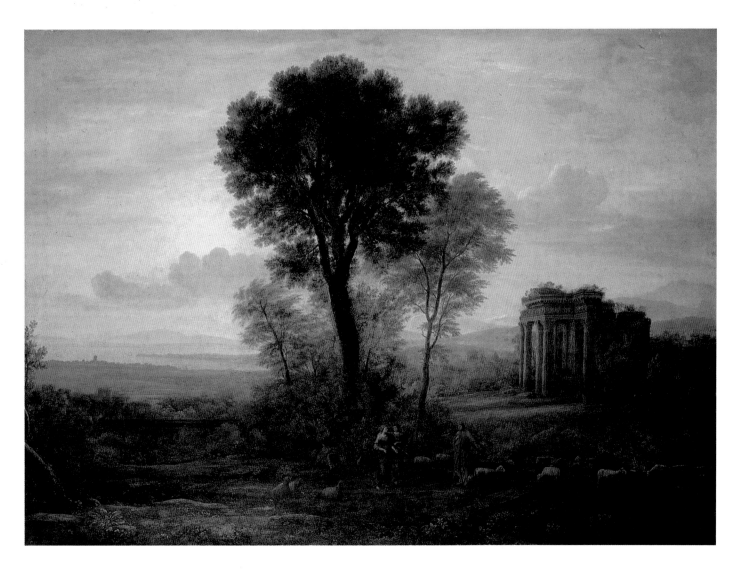

CLAUDE LORRAIN *Morning,* 1666
(Inv. No. 1234) Oil on canvas
44½ × 62″ (113 × 157 cm)
(Ex coll. Empress Josephine, Malmaison, 1815)

His diatribe against Northern art for its mindlessly literal character, its vulgar "ocularity," is strikingly like Cézanne's denigration of Monet's painting as "nothing but an eye" and, by extension, of the deceptively easy, seemingly mindless prospects and perspectives of Impressionism.

Landscapes by the thousand, beginning in the sixteenth century, were exported to Italy, where that art, though popular among collectors, was far less so with her painters, who found such a "simple," descriptive genre unworthy of their historically oriented, ever-more-academic training.

One of the marvels of so much of this art in the seventeenth century is that it must have been painted remarkably speedily, the surviving oeuvre of several of the leading Dutch landscapists still nearing the thousand mark. Talent meant relatively little, as there were so incredibly many gifted artists in such a small area—some forced to give up painting in midcareer, others financing their habit by inn-keeping, or running a barge-service or brewery, relegating their Muse to the odd free hours.

Nothing looks more removed from the worlds of words, of messages, and of morals, than an unpeopled landscape, and many paintings in that genre are indeed purely what meets the eye, devised solely with the spectator's pleasure in mind. But trees and flowers, animals and stones have long been invested with religious and mythological meaning—mountains reaching toward the empyrean—Parnassus or

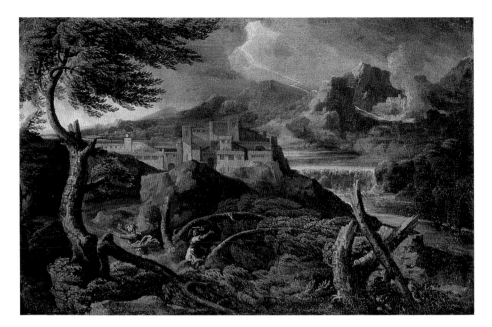

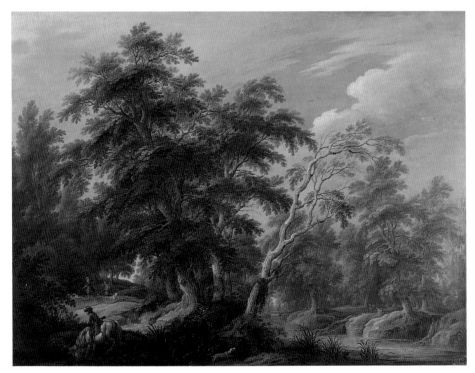

Above, top
GASPARD POUSSIN (GASPARD DUGHET)
Rome 1615–1675
Landscape with Lightning, 1665
(Inv. No. 2372) Oil on canvas
16 × 24½" (40 × 62.5 cm)

Above, bottom
ALEXANDER KEIRINCKX
Antwerp 1600–Amsterdam 1652
Hunters in a Forest
(Inv. No. 455) Oil on panel
27 × 36" (69 × 92 cm)
(Ex coll. Baudouin, Paris, 1781)

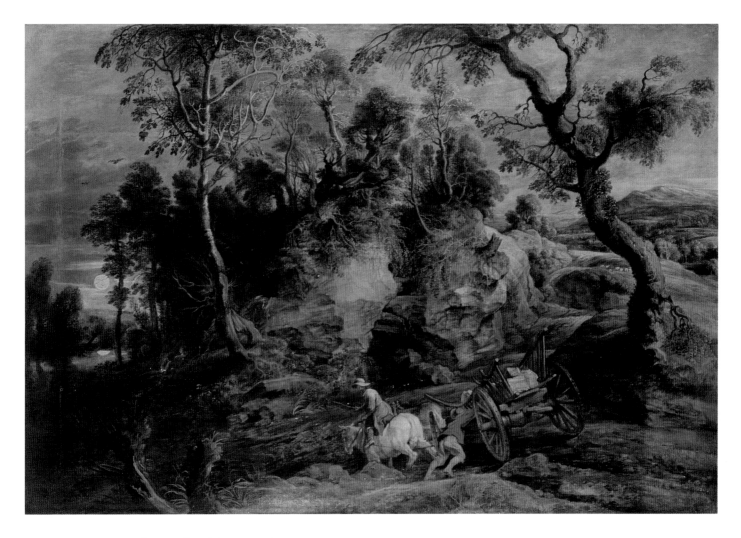

PIETER PAUL RUBENS Siegen (Westphalia) 1577–Antwerp 1640
The Stone Carters, ca. 1620
(Inv. No. 480) Oil on canvas, transferred from panel
34 × 50″ (86 × 126.5 cm)
(Ex coll. Walpole, Houghton Hall, 1779)

Overleaf
GASPARD POUSSIN *Landscape with Lightning* (detail)

Monte Alban, gardens of Eden or of Marian purity. The land of Israel, the Valley of the Kings, the Bay of Naples, the Strait of Gibraltar, Mount Sinai, the Garden of Gethsemane—all are permeated by sacred presence or promise, by Classical or biblical character. So their representation or reference releases a symbolic chain reaction, a reassuring sense of proximity to sanctity, to eternity, to divinity.

An emotional response to landscape, in art or reality, becomes ever more keenly felt with time. Age sensitizes the eye to the pace of nature's change, to the pathos of the blighted tree, to the heedless damage of the rushing torrent, to what Germans call "the tooth of time." But there's also a compensatory heightened sense of nature's beauty despite time's bite, of the miracle of light from sun, moon, or stars, reflected by water or filtered by clouds' passage. These, with the changing colors of the leaves, come to be metaphors for fate, which, in the immortal words of Lorelei Lee, "keeps on happening," and for age, which, if we're lucky, arrives with inner illumination, to help face Father Time with acceptance, if not grace.

So the art of landscape is also the art of time, to be seen at a distance, admired for its references toward and away from the infirmities of self, making these seem irrelevant, undiminished by the grand design of days and years.

What Russians used to call "the Cult of Personality," with the Youth Quake (where that first wrinkle is a touch of leprosy), the sterility of the city, the cruelties of

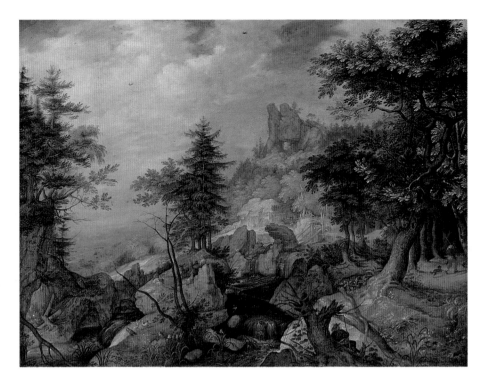

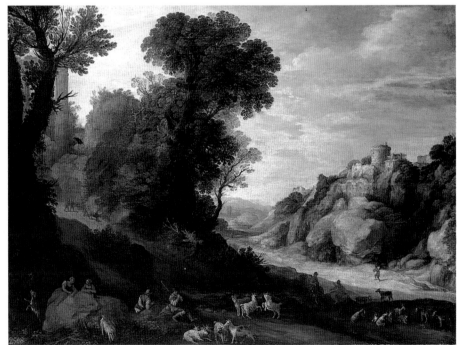

Above, top
ROELANDT JACOBSZ. SAVERY
Courtrai 1576–Utrecht 1639
Tyrolean Landscape, 1606
(Inv. No. 2807) Oil on copper
21 × 28″ (54 × 72 cm)
(Ex coll. P.P. Semyonov-Tian-Shanskii, 1915)

Above, bottom
PAUL BRILL Antwerp 1554–Rome 1626
Mountain Landscape, 1626
(Inv. No. 1955) Oil on canvas
29½ × 40½″ (75 × 103 cm)
(Ex coll. Bruhl, Dresden, 1779)

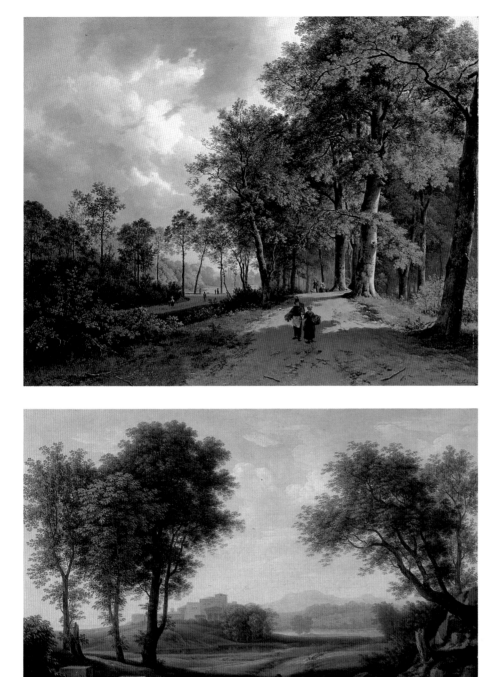

Above, top
BAREND CORNELIS KOEKKOEK
Middelburg 1803–Clève 1862
View of a Park, 1835
(Inv. No. 6033) Oil on panel
27 × 34″ (68 × 86 cm)

Above, bottom
JOHANN CHRISTIAN REINHART
Hof (Bavaria) 1761–Rome 1847
An Ideal Landscape, 1810
(Inv. No. 5498) Oil on canvas
22 × 29½″ (56 × 75 cm)
(Ex coll. Novo-Mikhailovskii Palace,
Leningrad, 1928)

power—all these abuses, leading to a miasma of meaninglessness, may be relieved by a fresh view of nature, in art or reality. For rivulets and reflections, birdflight, cow, cat, horse, or dog, all come as essential reminders of a something else, a somewhere else, or a someone else. Landscape *is* the art of the else.

Until the last three decades, with the great Joseph Mallord William Turner revival, and those of Caspar David Friedrich (356–58) and Frederick Church, landscape, long largely so tame and tedious, has come into bloom once again. Some artists returned to the massive canvases of Albert Bierstadt, or availed themselves of similar passages to the sublime in the art of another German, Anselm Kiefer, with his ambivalent romancing of the devastated glories of totalitarianism.

Other recent painters, working on the small scale of a Rembrandt etching, have re-created the intimacy that went with the landscapes of the distant past, giving a surreal sense of having "the whole world in one's hands," or of viewing it through an Eyckian eyeball. The reverse, from diminutive to huge, found in Abstract Expressionism, also led to a return to nature, those big messy canvases often alluding to the larger-than-life experience of cloud, river, and mountain, best expressed by Jackson Pollock's succinct self-definition: "I am nature." That movement cleared the air for a less circuitous approach to the "real thing," allowing painters to go back to landscape with a long-lost spontaneity and confidence.

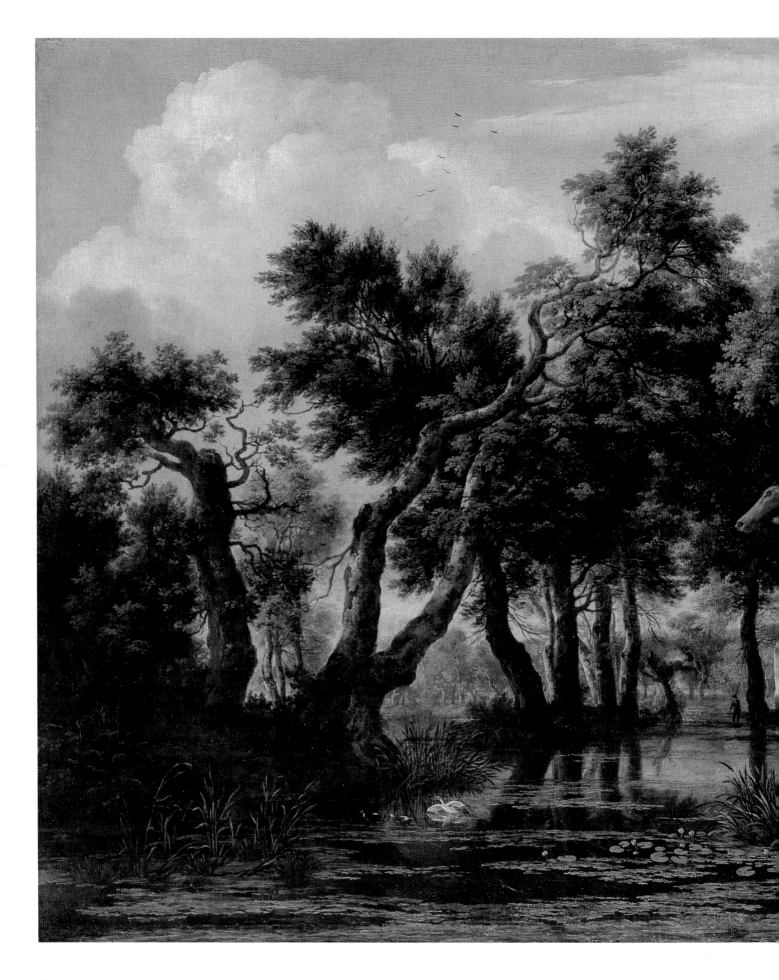

JACOB ISAACKSZ. VAN RUISDAEL
Haarlem 1628/29–Amsterdam 1682
The Marsh, 1660s
(Inv. No. 934) Oil on canvas
28½ × 39″ (72.5 × 99 cm)

FRANS DE MOMPER Antwerp 1603–1660
Environs of Antwerp
(Inv. No. 6236) Oil on canvas
23 × 32″ (58 × 81 cm)

Opposite, top
ISAACK JANSZ. VAN OSTADE
Haarlem 1621–1649
Winter View, ca. 1648
(Inv. No. 906) Oil on panel
28 × 44½″ (71.5 × 113.5 cm)
(Ex coll. Cobentzl, Brussels, 1768)

Opposite, bottom
AERT VAN DER NEER
Gorinchem 1603/4–Amsterdam 1677
A River in Winter
(Inv. No. 923) Oil on panel
14 × 24½″ (35.5 × 62 cm)
(Ex coll. Cardinal Valenti, Amsterdam, 1763)

Landscapes of all sorts do often share an implicit anti-intellectuality, inviting the eye to wander, sending the mind to oblivion. Without overt goal or intrinsic meaning, artists may paint mountains (or other views) for the same reasons Alpinists climb them—because they're there.

The recent renaissance in collecting Dutch pictures by New York parvenu real estaters is appropriate, since that "nouvelle society" doesn't differ too much from the speculative one for which these pictures were made, the Netherlands in the seventeenth century enjoying unprecedented prosperity, with lots of freshly minted wealth and local stock exchanges booming. Having profited so handsomely from the real thing, recent collectors found what they perceived as similarly materialistic images in Dutch painting (art ever a passport to the gilded shores of Mobility), these carefully tendered pictures validating their new owners' values, theirs a sense of property and technical finesse anyone in business could admire.

While contemporary landlords snatch real estate from the skies, moving ever upward, those of the Low Countries wrested theirs from marsh and sea; dikes and windmills—not elevators or landfill—added acreage to their domain. Their pictures of earth and sea and sky fulfilled many a Netherlander's vicarious territorial imperative: essential, if unreal, estate, painted and purchased to manifest the new owners' needs, sharing their dreams and lining their walls, if not always their pockets.

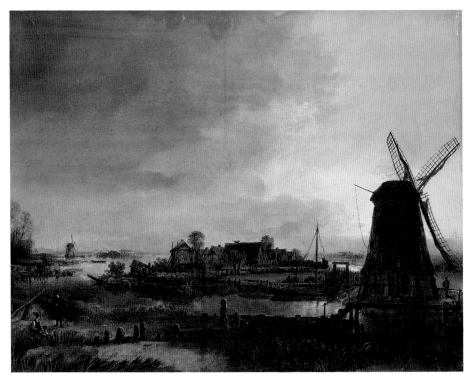

Above, top
AERT VAN DER NEER
Moonlit River
(Inv. No. 929) Oil on panel
13 × 18" (33.5 × 46 cm)
(Ex coll. Cobentzl, Brussels, 1768)

Above, bottom
AERT VAN DER NEER
Landscape with a Mill
(Inv. No. 927) Oil on panel
27 × 36" (69 × 92 cm)
(Ex coll. Duval, St. Petersburg, 1805)

Opposite
AERT VAN DER NEER
Landscape with a Mill (detail)

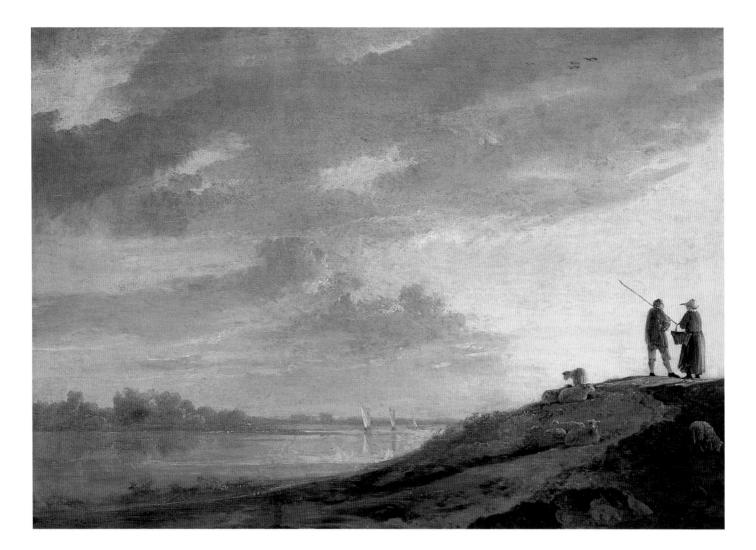

What the Low Countries lost to the seas, they regained in the skies — nowhere can such abundant clouds be seen — their painters masters in re-creating the abstract sense of light and space that only such celestial spectacles provide. Affording spiritual breathing space, these exalted land-and-skyscapes, with their welcome disregard for the tedious *minutiae* of daily life, freed the spectator from the nagging, irrefutable demands of Good Example, now open to a loftier, transcendental experience, with every viewer a visionary, privy to the unchartable, unreal state of the skies.

The seas offered a source of wealth and of "getting away from it all." Best of both worlds, the waters provided a rare instance where the call of the wild and the need for regular pay could be requited simultaneously. That fine line where land or sea meet sky remains among the greatest spectacles. Far more than an intimation of infinity, the horizon is a mysterious zone just beyond the beyond, its quality primal, its viewers witness to the dawn of creation, to the separation of day from night, earth from water.

Protestant more than Catholic culture may have been closer to the challenge of landscape and its painting, that genre possibly retaining a haunting, disguised intimation of pantheism, one long

ALBERT CUYP Dordrecht 1620–1691
River Sunset
(Inv. No. 7595) Oil on panel
15 × 21" (38.5 × 53 cm)

Opposite
JACOB ISAACKSZ. VAN RUISDAEL
Coastline, late 1660s/early 1670s
(Inv. No. 5616) Oil on canvas
20½ × 27" (52 × 68 cm)

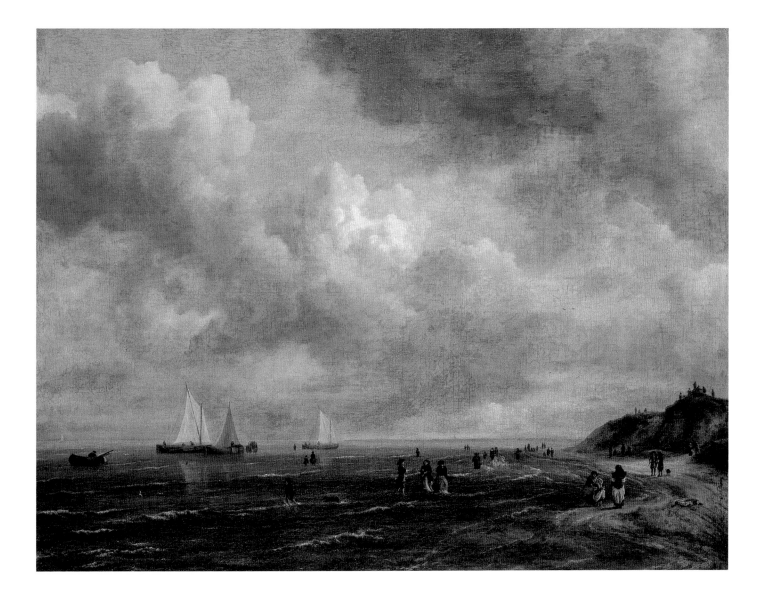

SALOMON VAN RUISDAEL Naarden 1600/3–Haarlem 1670
Ferry Crossing in the Environs of Arnhem, 1651
(Inv. No. 3649) Oil on panel 35 × 45½" (89 × 116 cm)
(Ex coll. Count G.V. Orlov)

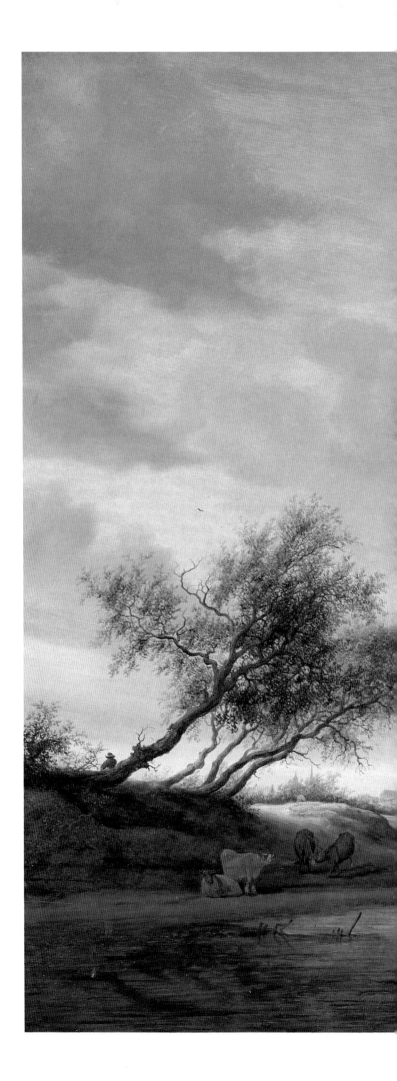

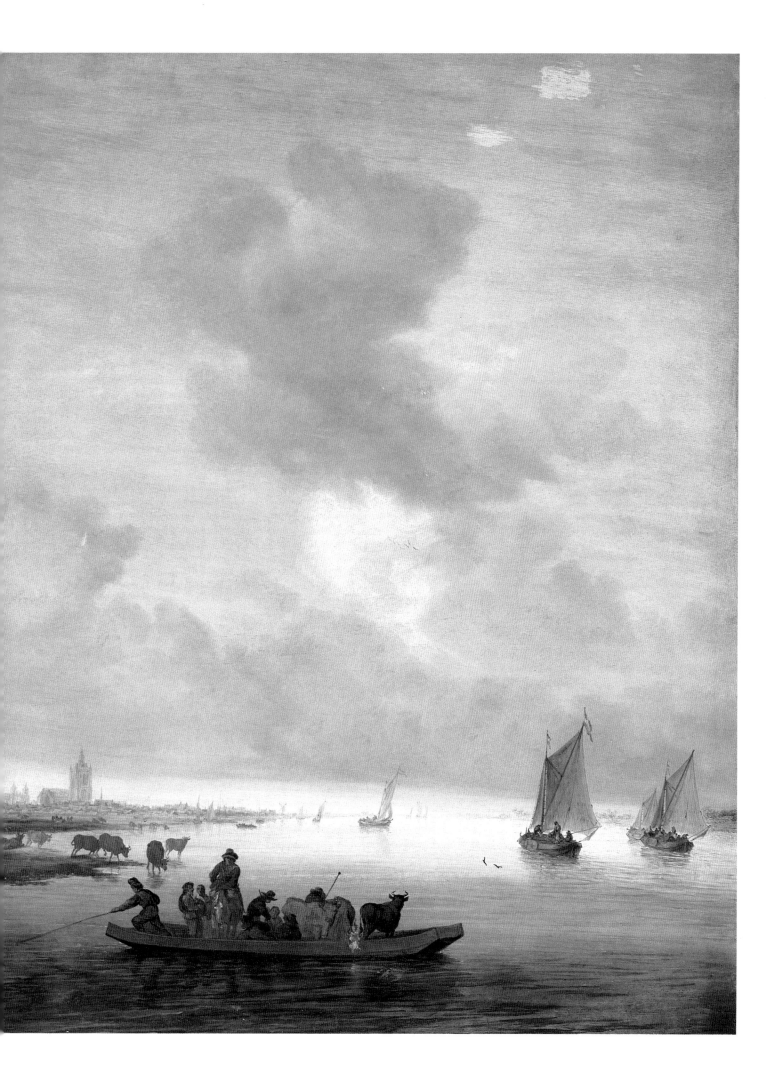

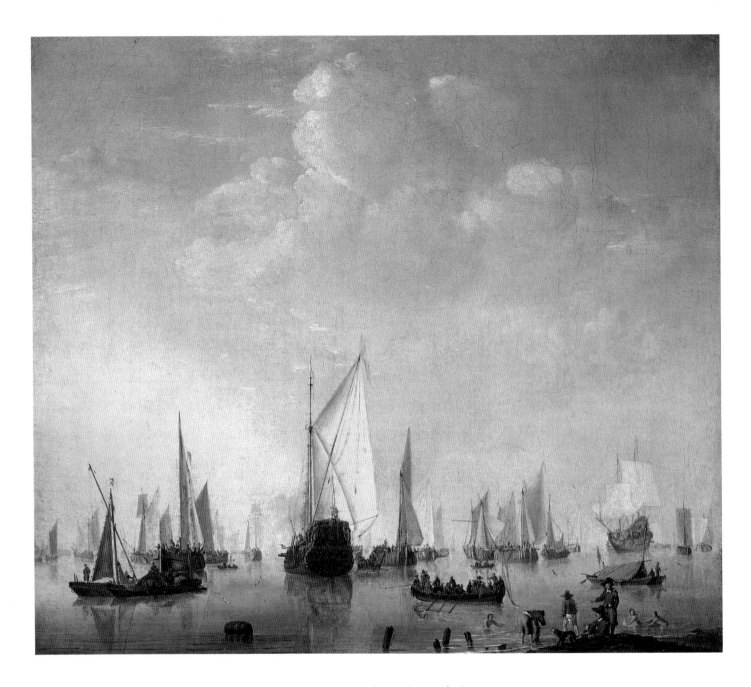

since stamped out in Italy but more resistant north of the Alps. A few great French and Flemish Catholic seventeenth-century masters of landscape, Claude, Poussin, and Rubens, give the lie to such sweeping generalization, often taking shelter in antiquity for the *justification* of their fertile pictorial *tirage*.

Those Northern painters who went to seventeenth-century Italy, while they enjoyed a bohemian, raffish life in Rome's rowdy taverns and artists' clubs, often adopted a blander, more conventional land-scape manner than that of their peers who never left home. Bathed in the golden light of the Campag-na, scenes that these men painted, inspired by the Tiber Valley, were so close to the roots of antiquity that they took on Classical quali-ties, infused by the spirit of the dis-tant past. Artists like Claude Lor-rain often added some fresh touch of specificity to their clichéd vistas of times past, so preserving their work from the too-predictable.

Rubens's several late views of his chateau of Het Steen, with other

WILLEM VAN DE VELDE THE YOUNGER
Leyden 1633–London 1707
Ships in the Roads, 1653
(Inv. No. 1021) Oil on canvas
42 × 48″ (106.7 × 121.9 cm)
(Ex coll. Tronchin, Geneva, 1770)

Opposite
WILLEM VAN DE VELDE THE YOUNGER
Ships in the Roads (detail)

Above
ABRAHAM JANSZ. BEGEYN Leyden 1637/38–Berlin 1697
Seacoast, 1662
(Inv. No. 3469) Oil on canvas
35½ × 46½" (90 × 118.5 cm)
(Ex coll. V.P. Zurov)

Left
JAN JOSEPHSZ. VAN GOYEN Leyden 1596–The Hague 1656
The Coast at Egmond an Zee, 1645
(Inv. No. 993) Oil on panel
21 × 28" (53 × 71.5 cm)

Opposite
FRANS POST Leyden 1612–Haarlem 1680
Sugar Plantation, Brazil, 1659
(Inv. No. 3433) Oil on panel
16 × 24" (40 × 61 cm)
(Ex coll. P. P. Semyonov-Tian-Shanskii, 1915)

Arcadian vistas (48), are remarkably free in their spirit and sketchlike technique. What the Flemish painter is really showing is a state of grace—the miracle of fertility still his in old age. That same sense informs *The Stone Carters* (315), painted for the artist's delectation, seminal for the arts of John Constable, Eugène Delacroix, and Gustave Courbet. But for its borrowings from Adam Elsheimer (273), whose works Rubens had collected in Italy, seen in the reflected moon and in the Venetian, Arcadian aspects of this scene, it is essentially a fantasy, a landscape of the mind, where the central image of the quarry could have a Classical source, or prove an emblematic reference to the chateau, meaning

"the Stone." A more mannered essay in a similar style is the forest scene by another Fleming, Alexander Keirinckx (314).

The French gave travel awards, the Prix de Rome, through their Royal Academy. Many young Northerners had long gone informally, enjoying a rowdy student life, learning as much about nature from bohemian adventures as they did from sketching trips into the Campagna. These artists may have lost as much as they won from their exposure to the topographical grandeur that was Rome, for all too soon this contributed to a certain formulaic approach, perfected by Claude Lorrain. Just as excessive study of ancient statuary blinded

artists to the individual qualities of the model, so could the predictable perfection of the Southern landscape lead to a monotonous, often ludicrous attempt to impose the same sense of order upon that of the North.

One of the artists benefiting from this Italian exposure was Adam Pynacker, who, with Jan Asselijn, Nicolaes Berchem, and Karel Dujardin, belonged to the same generation of southbound painters. They took over some of the dramatic grandeur of Roman vistas without losing their local heritage: the response to the particular. Houbraken, historian for so many Dutch painters of the seventeenth century, recalled how Pynacker often painted series of canvases for

interiors, covering each wall with a different view, in much the way that far-earlier tapestries had done, or, for that matter, the so-called "fresco cycles" of decorative canvases that Vuillard (446) and Bonnard (392–95) would provide. Pynacker's lustrous views brought light and air into the rather cramped, dark townhouses of the period. Like looking glasses, these paintings added a sense of space and visual adventure, exemplified by the Hermitage's superb *Barge on a River at Sunset* (308).

The dramatic, authoritatively Classical landscape in an Italianate setting, first perfected by Nicolas Poussin, was repeated many a time by Gaspard Dughet (also known as Gaspard Poussin). His *Landscape with Lightning* (314, 316–17) is probably based partially upon ancient descriptions of long-lost works by Greek or Roman painters. Here lightning has set afire the upper right area as terror-stricken travelers take flight, in opposing directions, from the falling trees, a medieval building in the background. Subjects like these were first revived in the late fifteenth century, found in Giorgione's still enigmatic *Tempest* (Venice, Accademia).

Most influential of all landscapists is a painter from the Lorraine, known as Claude (312, 313). The very rich have always been drawn to Claude's art, beginning with the Roman aristocracy; soon Pope Urban VIII and the king of Spain followed suit. They all bought, and bought, and bought, because Claude tapped into an archetypal motherlode of Neoclassical land-

scape. His polite, lyrical art is as predictable as death and taxes: The sun rises or sets; shepherds leave at dawn or return at dusk; boats come and go; the subject is indicated by figures, never too distressing or distressed. These characters, sometimes added by other painters, identify the scene as biblical or mythological or taken from some suitably impressive historical episode, painted so slowly and methodically that the artist never completed more than twelve or so major pictures a year. Surprisingly, he is said to have actually painted out-of-doors on some of his works, so adding a certain verisimilitude that drawing alone could not provide.

Verging upon boredom and repetition, these pictures are usually saved from tedium by a magical quality of light falling over land or water; this illumination comes as close to poetry as paint ever can. So the best of Claude is a vague yet haunting sense of epiphany found in all the Hermitage's canvases.

Above
JAN JANSZ. VAN DER HEYDEN
Gorinchem 1637–Amsterdam 1712
A Fortified Castle on a Riverbank
(Inv. No. 1008) Oil on panel
18 × 25½" (45.5 × 64.5 cm)

Opposite, top
JAN WEISSENBRUCH
The Hague 1822-1880
A Street in a Dutch Town
(Inv. No. 3824) Oil on canvas
30 × 36" (76 × 92 cm)

Opposite, bottom left
GERRIT ADRIAENSZ. BERCKHEYDE
Haarlem 1638-1698
The Great Market Square in Haarlem, 1673
(Inv. No. 812) Oil on panel
17 × 24" (44 × 60.5 cm)
(Ex coll. duc de Choiseul, Paris, 1772)

Opposite, bottom right
GERRIT ADRIAENSZ. BERCKHEYDE
View of the Canal and City Hall in Amsterdam
(Inv. No. 958) Oil on canvas
21 × 25" (53 × 63 cm)
(Ex coll. Tronchin, Geneva, 1770)

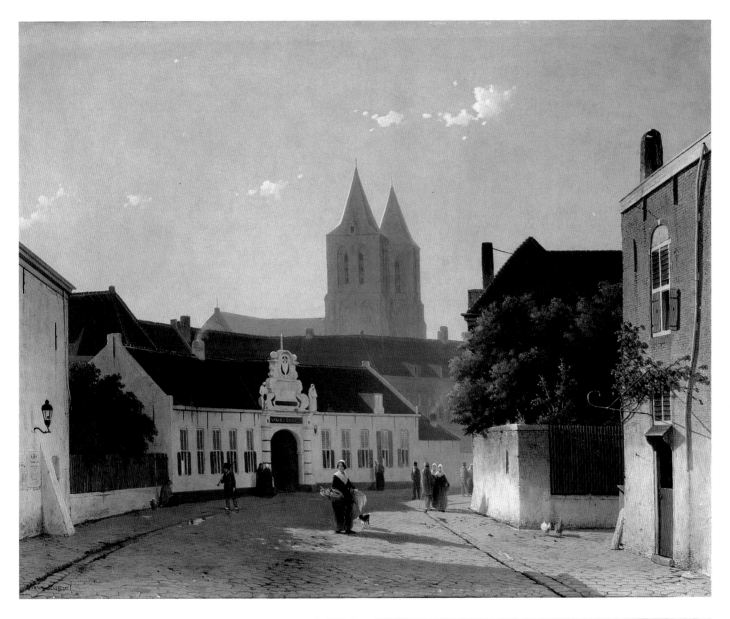

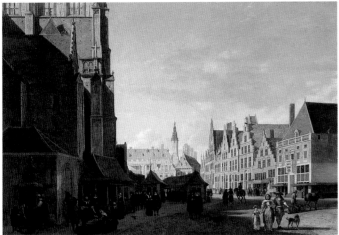

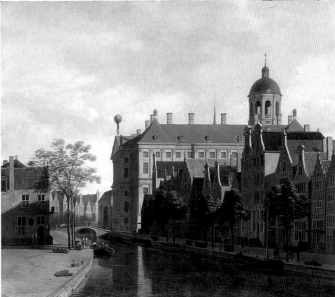

Claude proved to be a painter's and poet's painter for more than two centuries, neither Turner nor Corot imaginable without his radiant classicism, so engrained in the European aesthetic that dark-tinted mirrors known as Claude Glasses were popular paraphernalia for painters, who would hold them up against a landscape for reflection as an instant Claude. His enduring art is still seen in Barend Koekkoek's *View of a Park* (319) and Johann Reinhart's *An Ideal Landscape* (319).

Largely independent of figures, scenes were painted from the mid-sixteenth century on, often the works of Flemings active in Italy, such as Paul Brill, who frescoed hundreds of Roman walls with formulaic little vistas, his *Mountain Landscape* (318) anticipating the canvases of Claude. Members of the so-called Mannerist generation like Frans de Momper enjoyed a new freedom, partly Italian and partly Northern in origin, seen also in the *Tyrolean Landscape* (318) by Roelandt Savery, with its odd mix of reality and almost Danubian fantasy, half fairy tale, half Leonardesque in its study of sky and leaf.

Marshes might not seem likely subjects for romantic grandeur, but in the hands of Jacob van Ruisdael (320-21), a bog takes on just that quality, with great trees, dead and

JEAN-ANTOINE WATTEAU
Valenciennes 1684–Nogent-sur-Marne 1721
Landscape, ca. 1715
(Inv. No. 7766) Oil on canvas
28 × 42″ (72 × 106 cm)
(Ex coll. N.I. Bulychev, Kaluga)

alive, rising from the water like creatures from another age, struggling against extinction. A *Stag-hunt* by Savery and a *Marsh* etched by Sadeler contributed to the genesis of Ruisdael's magisterial image, but the latter's wild scene, where trees suggest a grotto, went beyond those points of departure.

Three winter scenes, by Frans de Momper (322), of Antwerp's environs, and those by Isaack van Ostade (323) and Aert van der Neer (323) represent one of the most popular of genres, single snowflakes having been shown in Netherlandish art long before in the *Cloisters Triptych* by Robert Campin, from the early fifteenth century.

A windmill seems to teeter gingerly on the banks of van der Neer's icy river. Combining stasis with motion, few buildings are more inherently contradictory than mills, and few provide more arresting examples of the power of vernacular architecture, enriching landscape by becoming part of it. Distance is established in a dialogue between two mills in another of this artist's landscapes (324, 325), with a very large one in the foreground and a small one far away.

Skyscapes more than landscapes, many of the loveliest paintings from the Low Countries let the land form little more than a repoussoir, using that theatrical prop as a strip in the foreground, bordering the sky, to keep all that celestial splendor from falling out of the picture. A *River Sunset* by Albert Cuyp (326) has an almost obligatory bit of staffage—the peasant

couple at the far right. Jacob van Ruisdael's *Coastline* (327) includes many elegantly dressed couples on the beach for his unusual scene. Somewhat intrusive, the figures may be by van de Velde.

Ruisdael's uncle, Salomon, painted a *Ferry Crossing in the Environs of Arnhem* (328–29). The best of Netherlandish landscape art, it shows what's there and suggests far more, with a rare combination of fidelity and imagination, in a constant crossing over between the visionary and the realistic.

When Turner was not looking at Claude, he went to the Dutch masters, particularly Willem van de Velde the Younger. That artist's works—so well represented in British collections (due to his activity there under the Stuart kings, Charles II and James II)—canvases like *Ships in the Roads* (330, 331), were the models for Turner's own seascapes. In this early work Van

JACQUES DE LA JOUE II Paris 1687–1761
Park Scene, 1730s
(Inv. No. 5625) Oil on canvas
37½ × 49½" (95 × 126 cm)
(Ex coll. E.P. and M.S. Oliv,
St. Petersburg, 1923)

Above
FRANÇOIS BOUCHER Paris 1703–1770
Landscape near Beauvais, early 1740s
(Inv. No. 5734) Oil on canvas
19 × 23″ (49 × 58 cm)
(Ex coll. E.P. and M.S. Oliv, St. Petersburg, 1925)

Right
FRANÇOIS BOUCHER
Landscape with a Pond, 1746
(Inv. No. 1137) Oil on canvas
20 × 25½″ (51 × 65 cm)
(Ex coll. Crozat, Paris, 1772)

Overleaf
FRANÇOIS BOUCHER *Landscape with a Pond* (detail)

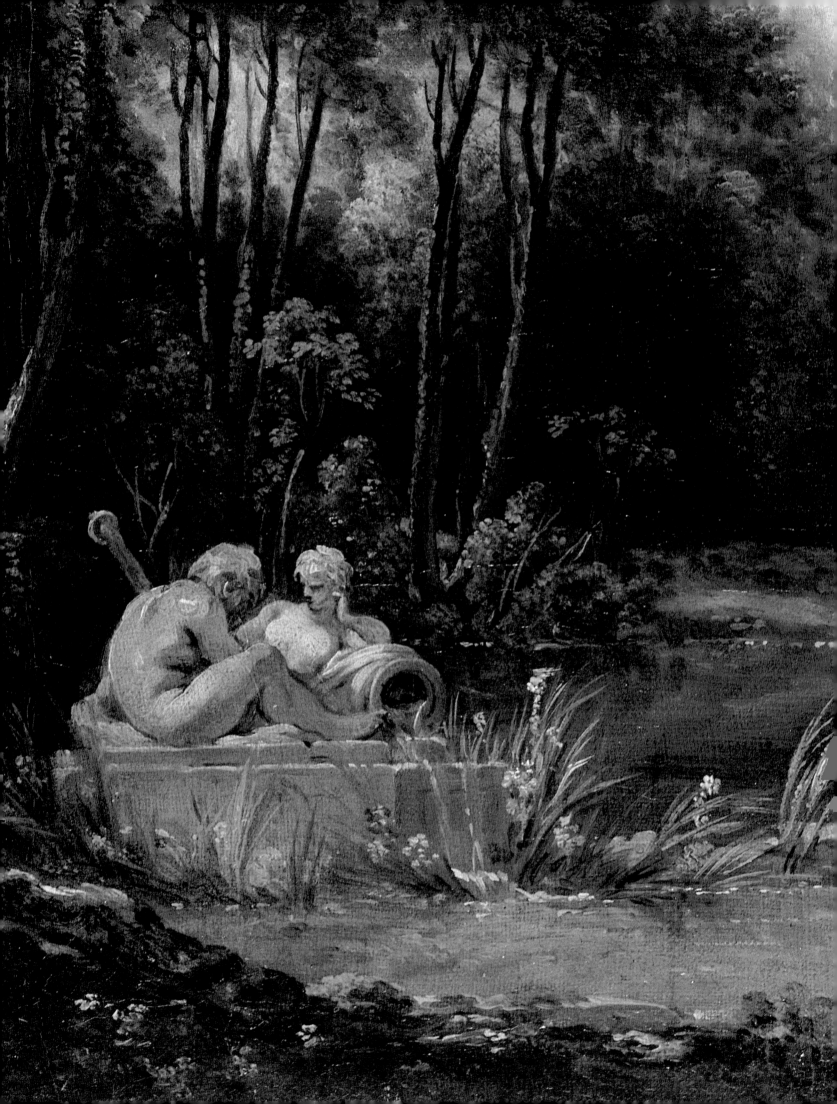

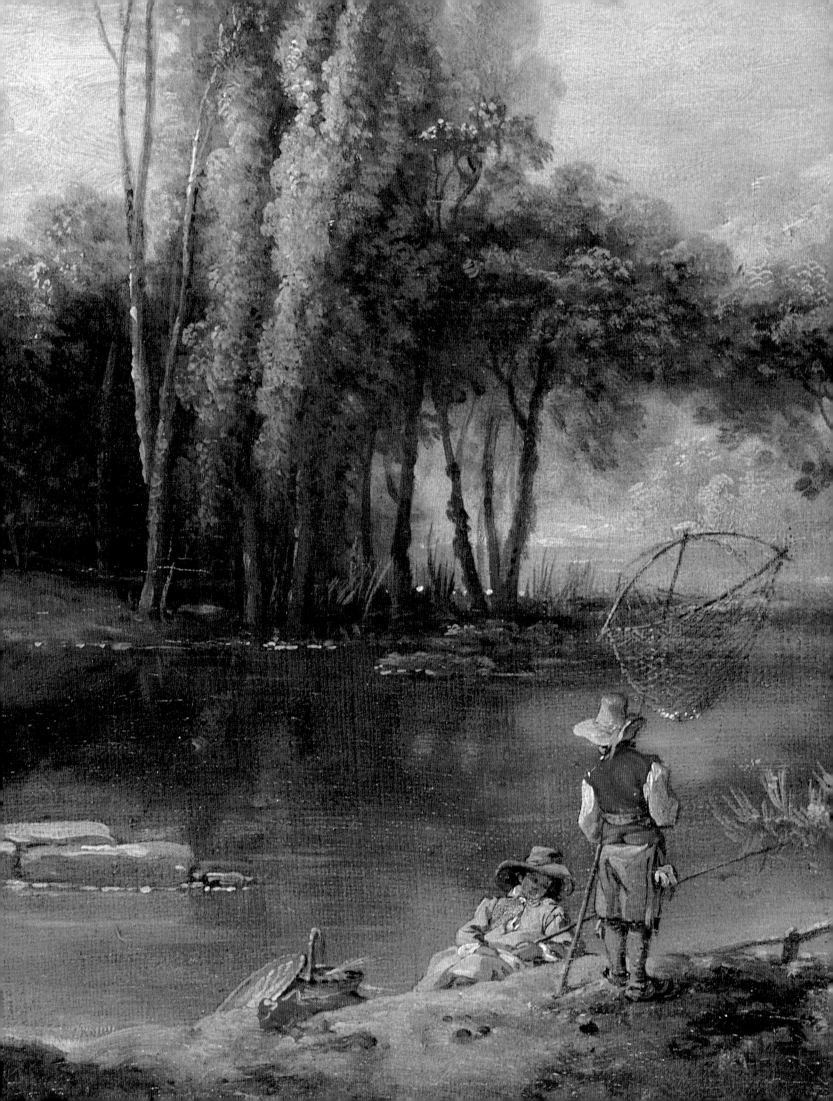

de Velde depicts a royal yacht bearing the arms of the House of Orange, surrounded by the large sailing vessels upon which the Netherlands' new fortunes were founded. These ships are exalted by the golden light caught in their sails, rather than by the precious cargoes in their holds, attended to by the becalmed crew.

A particularly colorful harbor view by Abraham Begeyn (332) is probably of Neapolitan inspiration. Though the artist is not known to have gone to Italy, he did work in Paris and London, and may have used others' notebooks and paintings as points of departure for his brilliant scene. A much more subdued palette is typical of Jan van Goyen, found in his *Coast at Egmond an Zee* (332), its earth colors felt even in the sea.

Frans Post is the only painter of any distinction to have gone to the New World before Degas's visit to New Orleans. He sailed for Brazil in the seventeenth century, where he painted many pictures (333), producing replicas of these upon his return to Haarlem.

Urban views, whether seen from beyond the city walls, like Jan van der Heyden's *Fortified Castle on a Riverbank* (334), or viewed from safely inside, as in two cityscapes by Gerrit Berckheyde (335), often have a doll's-house fascination, letting the viewer assume Gulliver-like size, taking in everything at once.

Active at just the time of the nineteenth-century rediscovery of Vermeer's genius, Jan Weissenbruch painted *A Street in a Dutch Town* (334) with a brilliant lumi-

Above, top
ALESSANDRO MAGNASCO
Genoa 1667–1749
Seashore, 1720s
(Inv. No. 3527) Oil on canvas
62 × 83″ (158 × 211 cm)
(Ex coll. V.N. Argutinsky-Dolgoruky,
St. Petersburg, 1919)

Above, bottom
ALESSANDRO MAGNASCO
Mountainous Landscape, 1720s
(Inv. No. 3528) Oil on canvas
62 × 83″ (158 × 211 cm)
(Ex coll. V.N. Argutinsky-Dolgoruky,
St. Petersburg, 1919)

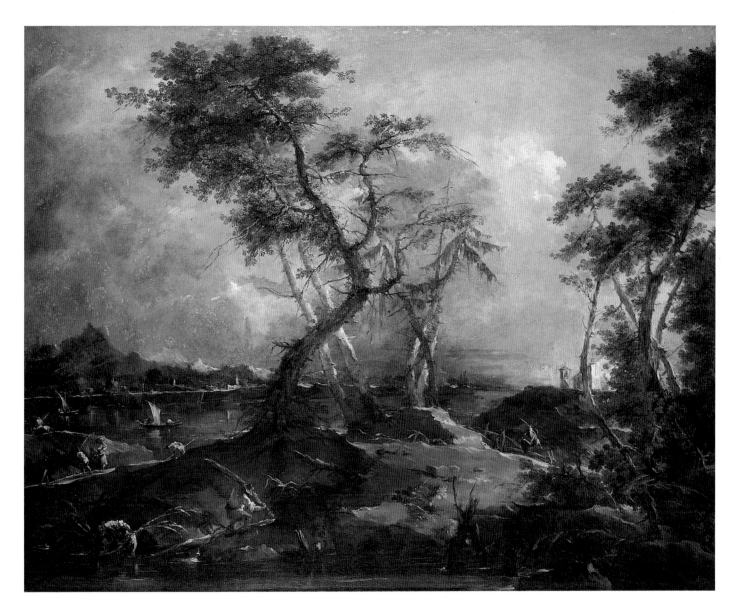

FRANCESCO GUARDI Venice 1712–1793
Landscape, ca. 1790
(Inv. No. 4305) Oil on canvas
47 × 60″ (120 × 152 cm)

nosity reminiscent of the Delft master's, his view appearing so real that it may well prove a fantasy.

Doubling as a fireman, Gerrit Berckheyde brought to his town views a niggling sense of detail that almost encourages the spectator to share the painter's compulsions, obsessively counting the number of windows in the pride of Amsterdam, her great City Hall (335), or of the clay tiles covering the adjacent rooftops, that same telescopic aperçu found in his *Great Market Square in Haarlem* (335), appropriate sensations for the culture that was just evolving the microscope.

That precise Dutch aesthetic was dumped by Jean-Antoine Watteau, as he went right back to the pastorals of Titian and Campagnola, taking over the hazy background of Venetian Late Renaissance art for his *Landscape* (336–37). Watteau knew Flemish art even better than he did Titian's. For a romantic painting like this he saw the Venetian's achievement through Rubens's eyes. Inna S. Nemilova noted that the couple at the left were added by a Russian restorer at the time of the painting's transfer from panel to canvas in 1883.

Waterfall and birdsong, so dear to the operas of Lully, are found (or meant to be heard) in Jacques de La Joue II's *Scene in a Park* (338). Here a certain scalelessness, often endemic to the art of the Rococo, turns everything into a motif: The garden pavilion could readily double as a model for a pocket-watch stand, and the couple at the right suggest figurines from the Schloss Nymphenburg porcelain works.

Though François Boucher comes out of the same tradition, his feeling for landscape was a major strength, his art not limited to immortalizing rouged cheeks and bottoms. Among the painter's very finest landscapes (339) is one painted near Beauvais, or based upon drawings that he made there when he provided cartoons for the local tapestry works between 1734 and 1755.

Few are allowed to age beyond mid-adolescence in Boucher's *dix-huitième* Disneyland. There, work must seem like play—even his laundresses (like Hubert Robert's) are at their back-breaking labor for the good clean fun of it. Ultimately merciless, such frivolity is in keeping with the artificial, carefully contrived quality of Boucher's stagelike ambience.

Extravagantly feathery, the bluish trees behind Boucher's *Landcape with a Pond* (339, 340–41) of 1746 also recall the theater, like a backdrop for a Tchaikovsky ballet. Once again the stigma of labor (along with its sweat) is gone: The fishermen are little boys who play at their work, while a river god and goddess engage in petrifyingly serious dialogue.

Because they tend toward ambiguity, nearer tragedy than comedy, suggesting banditry (47) and/or wild romance, Italian landscapes, other than the Venetian, embrace dramatic tension seldom found in the North before the mid-nineteenth century. This tormented tincture may have originated with Salvator Rosa. Famous as a poet, playwright, and musician as well as

FRANCESCO GUARDI *City View* (Inv. No. 261) Oil on panel 20½ × 13½" (52 × 34.5 cm)

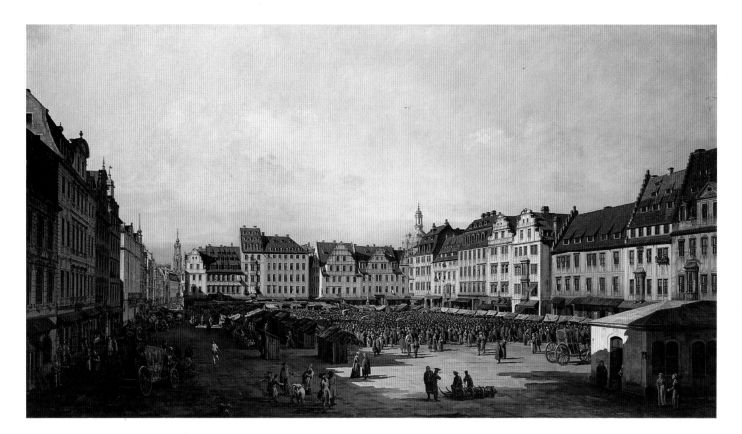

BERNARDO BELLOTTO Venice 1720–Warsaw 1780
The Old Market Square in Dresden, 1747/55
(Inv. No. 211) Oil on canvas 53 × 93″ (135 × 237 cm)
(Ex coll. Brühl, Dresden, 1779)

Opposite, top
BERNARDO BELLOTTO
The New Market Square in Dresden, 1747/55
(Inv. No. 204) Oil on canvas 53 × 93″ (134.5 × 236 cm)
(Ex coll. Brühl, Dresden, 1779)

Opposite, bottom
BERNARDO BELLOTTO
Pirna Seen from the Right Bank of the Elbe, 1747/55
(Inv. No. 208) Oil on canvas 52½ × 93½″ (133.5 × 237.5 cm)
(Ex coll. Brühl, Dresden, 1779)

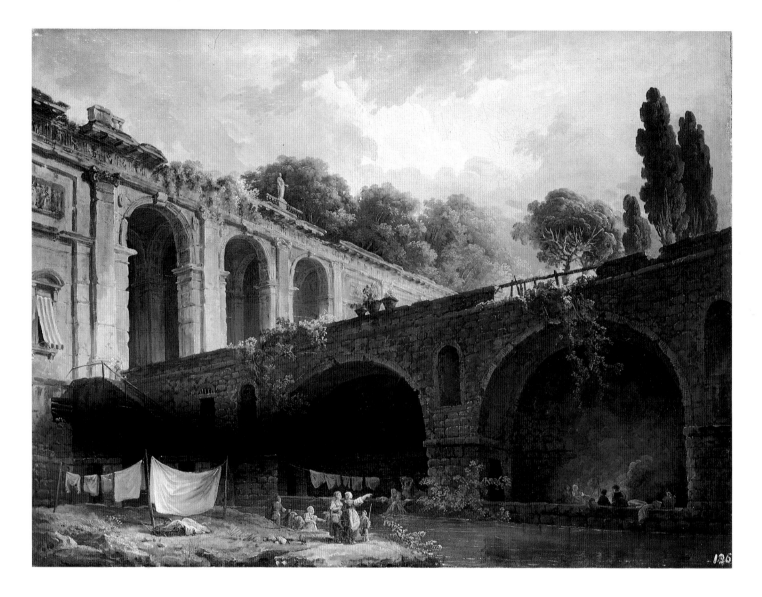

painter, Rosa's activities helped define the new "literary" mood he added to the Western vision of landscape. Similar currents are found in Genoa with Giovanni Battista Castiglione and Alessandro Magnasco whose mountains and shores are equally agitated (342). All these artists liked turbulence, stormy skies, wild seas, and wind-tossed woods. Touched with melancholy, their moody pictorialism anticipates Goethe's *Sorrows of Young Werther*, along with the often rain-soaked, if poetic, wonders of England's Lake District, or the blackened, melancholic marvels of

Piranesi's etched vision of antiquity. Even the Venetian Francesco Guardi, influenced by Magnasco, could paint a surprisingly moody *Landscape* (343), although he was more apt to depict urban confinement (345).

Like Canaletto, Bernardo Bellotto traveled widely throughout Europe in search of commissions. With the purchase of Count Brühl's collection, Catherine the Great bought many of Bellotto's finest topographical works—urban panoramas painted for the ambassador of the king of Poland in Dresden. *The Old Market Square in Dresden* (347),

HUBERT ROBERT Paris 1733–1808
The Villa Madama near Rome, 1760s
(Inv. No. 7593) Oil on canvas
20½ × 27″ (52 × 69.5 cm)
(Ex coll. N.V. Repnin, Yagotin, 1935)

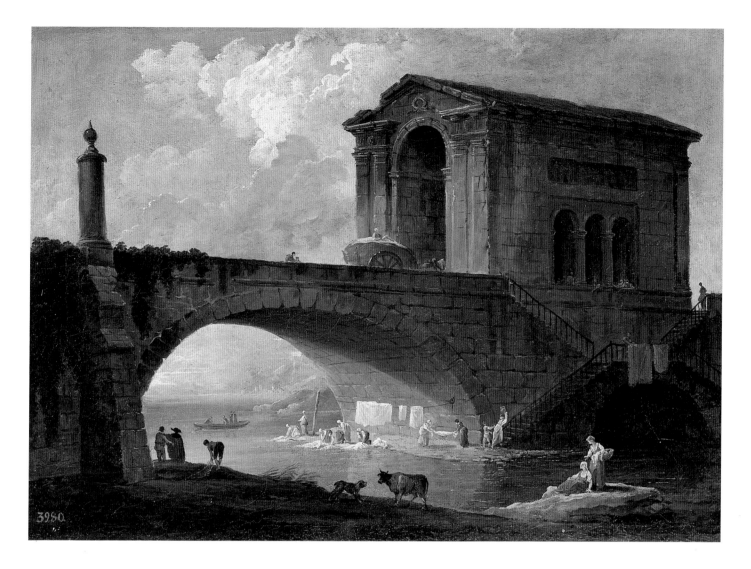

The New Market Square in Dresden (346), *Pirna Seen from the Right Bank of the Elbe* (346) are not only compelling in and for themselves, but also as the most potent reminders of what went when Dresden was bombed to bits in World War II. Bellotto's magical perspectives may have been facilitated by his use of an optical device, the camera obscura, to lay out those complicated urban portraits that the Venetian artist conveyed with such consummate skill.

These vast picture-postcards of the urban scene exercise such peculiar fascination because they, like Canaletto's English views, for all their obsessive fidelity to the uniqueness of their local topography, betray the painters' native Venetian vision. Whatever these men painted was seen through the Serenissima's filters, experienced by way of that floating city's unique chiaroscuro, so that each vista, no matter how far from home, proves a haunting reminder of Venice. Since most of Europe had long agreed that the greatest architect was the Late Renaissance Venetian Antonio Palladio, and Venice by far the most entertaining city on the Grand Tour, no one really minded having their local wonders Venetianized. On the contrary,

HUBERT ROBERT
Landscape with Stone Bridge, 1766
(Inv. No. 1766) Oil on canvas
15 × 22" (38.5 × 55.5 cm)
(Acquired from the artist, 1803)

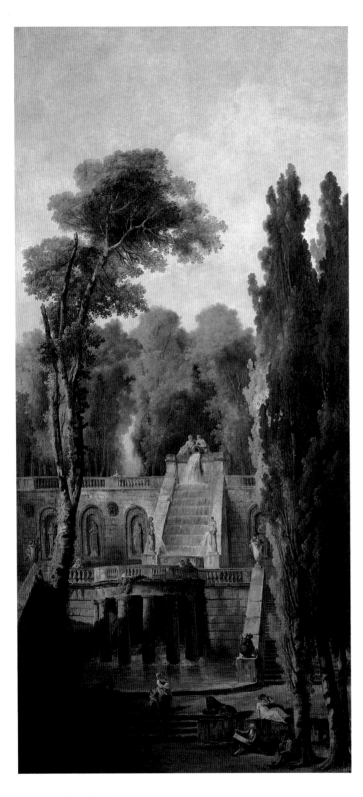

HUBERT ROBERT
Landscape with Terrace and Cascade, 1802
(Inv. No. 5720) Oil on canvas
123 × 58½″ (312 × 148.5 cm)
(Ex coll. Grand Prince S.A. Romanov, St. Petersburg)

HUBERT ROBERT
Landscape with Waterfall
(Inv. No. 5721) Oil on canvas
123 × 57″ (312.5 × 145.5 cm)
(Ex coll. Grand Prince S.A. Romanov, St. Petersburg)

HUBERT ROBERT
Landscape with Obelisk
(Inv. No. 5722) Oil on canvas
122½ × 57½″ (311 × 146 cm)
(Ex coll. Grand Prince S.A. Romanov, St. Petersburg)

HUBERT ROBERT
Landscape with Ruins
(Inv. No. 5723) Oil on canvas
122½ × 58″ (311 × 147 cm)
(Ex coll. Grand Prince S.A. Romanov, St. Petersburg)

just as Good Americans were said to go to Paris when they died, so the rest of Europe often felt about the Serenissima.

"Easy on the eyes," an old-fashioned phrase for pretty people, also applies to the countless canvases by Hubert Robert (348–52). Many of them were painted for the Russian market, these paintings briskly diverting exercises in the art of the picturesque. Almost like decorative wallpapers or tapestries-by-the-yard, what kept Robert's series from the vacuous was their sense of humor, a certain quality of witty intelligence that bubbled through the formulaic. So, no matter how repetitious his paintings might be, there was always a touch here and there to inform the viewer that their maker had a mind of his own, an ironic way with the icons of antiquity, an occasional irreverence that presaged his role in the French Revolution.

Above all, Robert was a decorative artist, thoughtfully producing pictures that went together in twos, threes, and fours—so furnishing a room, adding architectural qualities to indifferent interiors, surrounding the owner with an ambience of youth, safe adventure, and fun. Close to the art of drawing-room comedy, these canvases are often pictorial equivalents to the strategy of polite chatter of people who are sizing each other up, detecting strengths and weaknesses, learning where reality lies, and lies. So, as in all the arts of society, there is a strong, if disguised, element of threat or subversion to Robert's vision, saving it from boredom.

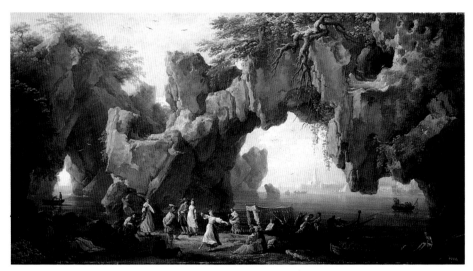

His obelisks, aqueducts, and cascades, those looming bridges that go nowhere, all relate to the new landscape arts, re-dressing Nature, improving her prospects with the ingenuity of the "ha-ha," that road dropped from view to lengthen vistas, so-named after the amused reaction to its discovery. Often it is hard to tell whether Robert's art begins or ends: Is that terrace with the horses (352) under construction or destruction? He loved wrecking real architecture, painting the Louvre subject to various

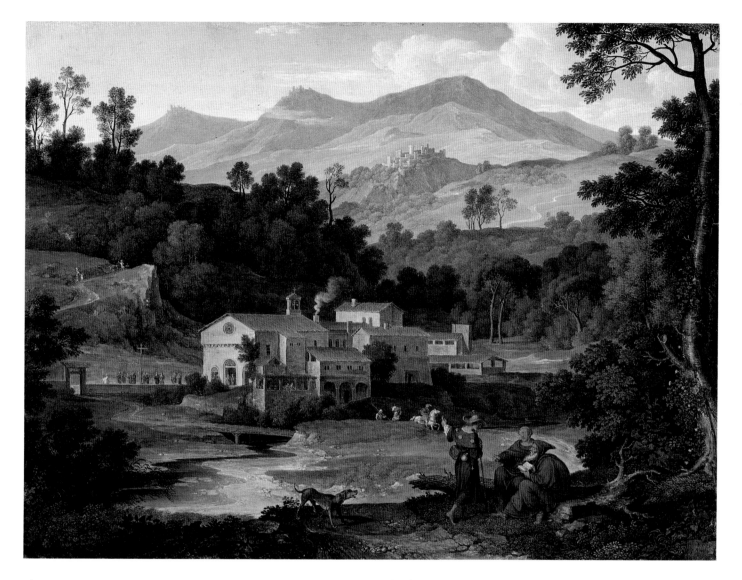

Above

JOSEPH ANTON KOCH

Obergieblen (Tyrol) 1768–Rome 1839

The Monastery of St. Francis in the Sabine Hills, Rome

(Inv. No. 5776) Oil on panel

13 × 18″ (34 × 46 cm)

(Ex coll. Leuchtenberg, St. Petersburg, 1920)

Right

JOHANN NEPOMUK RAUCH

Vienna 1804–Rome 1847

Landscape with Ruins

(Inv. No. 6148) Oil on canvas

6½ × 25½″ (17 × 65 cm)

Overleaf

JOHANN NEPOMUK RAUCH *Landscape with Ruins* (detail)

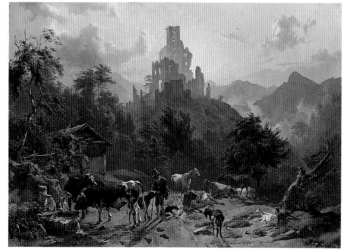

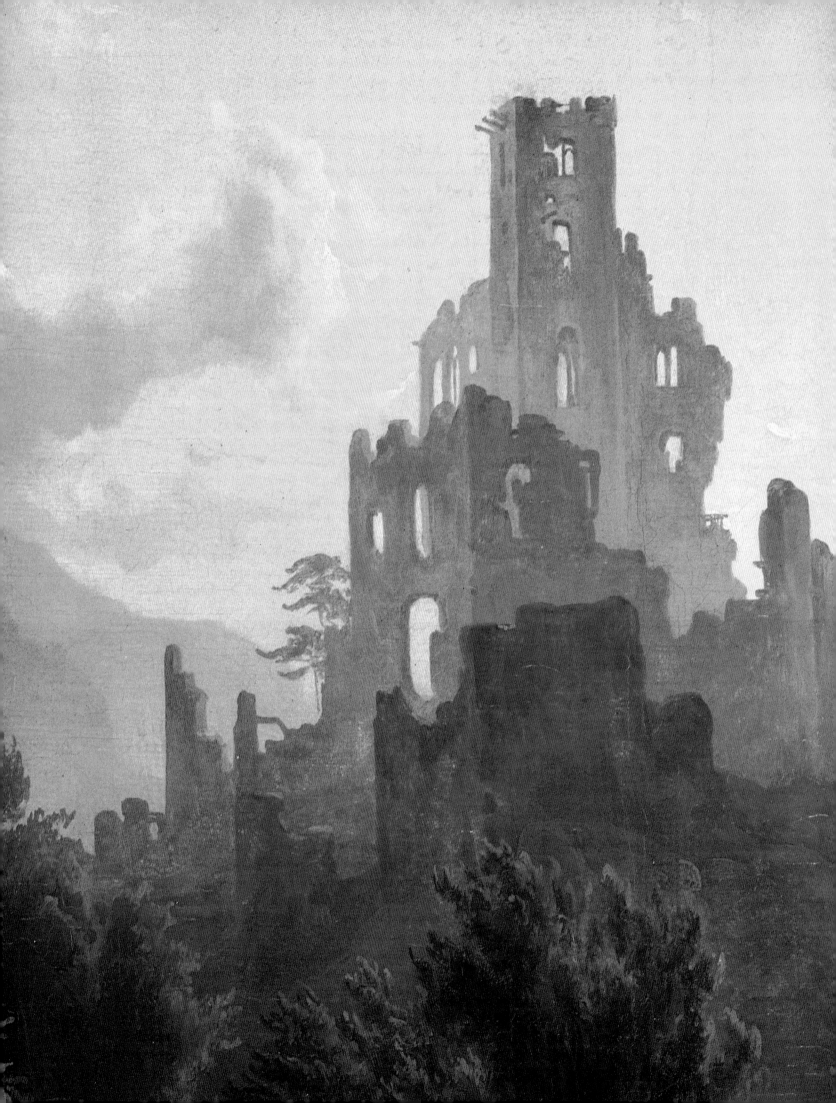

Above
CASPAR DAVID FRIEDRICH
Greifswald 1774–Dresden 1840
Riesengebirge, 1835
(Inv. No. 4751) Oil on canvas
29 × 40″ (73.5 × 102.5 cm)

Left
CASPAR DAVID FRIEDRICH
Harbor at Night (Sisters)
(Inv. No. 9774) Oil on canvas
29 × 20″ (74 × 52 cm)

forms of disaster long before the end of the Ancien Régime. So often a greening of the blackened fantasy etched by Piranesi, Robert at his best is but a banderilla away from Goya.

Claude Joseph Vernet, another of Catherine the Great's favorite painters, showed peasants dancing for tourists in the grottoes of Sorrento (352), far-tamer entertainments than those offered Roman emperors in the same hidden locale. This painting, also known as *La Gondole italienne*, has the hanging rocks and twisted trees that conform to the new decorative conventions of the *rocaille*, a delight in irregularity that is the other side of the strictly Classical coin.

Claude Lorrain's Italian views were kept in mind by a German painter who went south. Joseph Anton Koch used for his *Monastery of Saint Francis in the Sabine Hills, Rome* (353), a repoussoir effect enlivened by a pilgrim with two fairy-tale friars, painted in the sentimental, anecdotal style of Moritz von Schwind.

A clever pastiche of Dutch seventeenth-century rustic realism like that of the bland Nicolaes Berchem is wedded with the new luminous romanticism of Caspar David Friedrich in the art of Johann Nepomuk Rauch (353, 354–55). Painting when photography was born, just as artists were experimenting with transparent pictures, colored slides, and vast illusionistic illuminations, Rauch's spooky command of light enabled him to create a persuasive contrast between

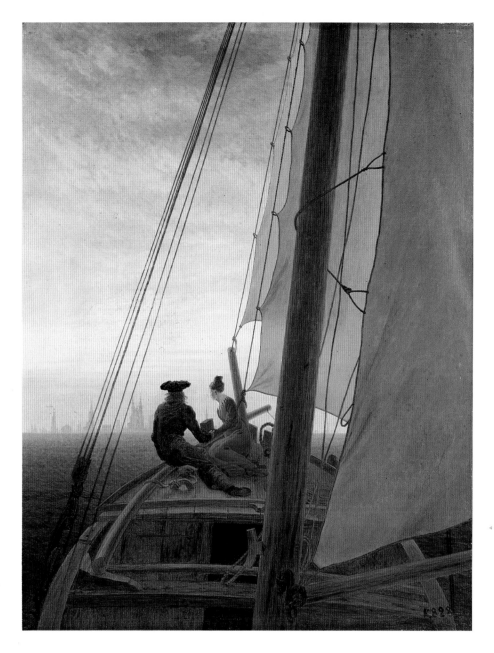

CASPAR DAVID FRIEDRICH
On a Sailing Ship
(Inv. No. 9773) Oil on canvas
28 × 22" (71 × 56 cm)

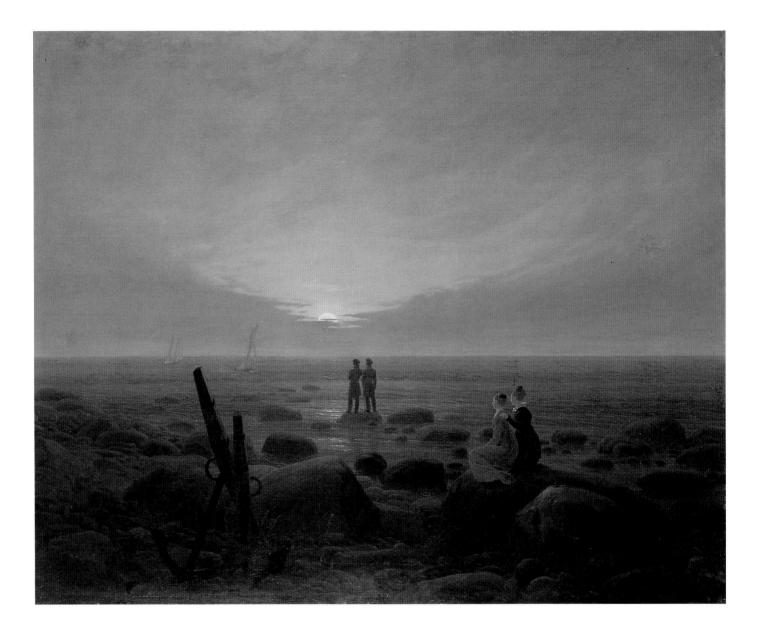

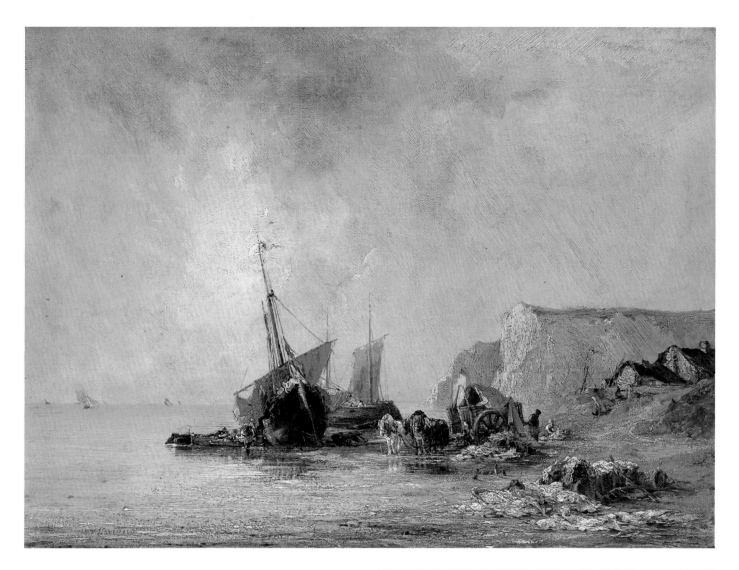

Above
RICHARD PARKES BONINGTON Arnold 1802–London 1828
Boats on the Shore of Normandy, ca. 1825
(Inv. No. 5844) Oil on canvas 13 × 18″ (33.5 × 46 cm)

Right
PIERRE-ÉTIENNE-THÉODORE ROUSSEAU
Paris 1812–Barbizon 1867
A Market in Normandy, 1830s
(Inv. No. 3950) Oil on panel
11½ × 15″ (29.5 × 38 cm)

Opposite
CASPAR DAVID FRIEDRICH
Moon Rising over the Sea, 1821
(Inv. No. 6396) Oil on canvas
53 × 67″ (135 × 170 cm)

Overleaf
RICHARD PARKES BONINGTON
Boats on the Shore of Normandy (detail)

the pedantic realism of the foreground and the Neo-Gothic splendors of the ruined castle rising against the skies.

Illumination is central to the imagery of faith, whether in John's characterization of Christ as "the light of the world," the effulgent mysticism of Neoplatonic reference, or Dante's lyrics. Emerson and Swedenborg employed the language of light, whose implicit spiritual force was stronger than ever in the early nineteenth century.

Nervous about corporeal imagery, Northern art often preferred its transcendental messages sent from or by appropriately nonfigurative means—sun and moon, stars and reflections. The Hermitage is extraordinarily rich in pictures where light alone is the beginning and the end, found in its nine canvases by Caspar David Friedrich, among the world's largest collections of the artist's works. In 1810 the painter went to the Riesengebirge (356), the Alpine source of the Elbe, which flows through Friedrich's working center of Dresden. Many of his most stirring images include spectators, often seen from the back or obscured by drapery, yet this large, unpopulated canvas is almost lunar in its absolute, isolated grandeur. Not based upon a single, "accurate" vista, it is more visionary than topographical, a synthesis of several views, though the mountains can be identified.

An uncharacteristically private canvas (357) presents the artist and his wife holding hands on their honeymoon, seated on deck as they approach a many-spired harbor, a Neo-Gothic Cythera, facing

Above, top
PIERRE-ÉTIENNE-THÉODORE ROUSSEAU
Landscape with a Plowman
(Inv. No. 7269) Oil on panel
15 × 20″ (38 × 51.5 cm)

Above, bottom
OSWALD ACHENBACH
Düsseldorf 1827–1905
Monastery Garden
(Inv. No. 3798) Oil on canvas
21½ × 29″ (55 × 73 cm)

Above

JACOB HENDRIK MARIS
The Hague 1837–Karlsbad 1899
Landscape with Mills
(Inv. No. 6739) Oil on canvas
18 × 29″ (46 × 73 cm)

Right

ANDREAS ACHENBACH
Kassel 1815–Düsseldorf 1910
Landscape with a River, 1866
(Inv. No. 9179) Oil on panel
20 × 24½″ (51 × 62.5 cm)

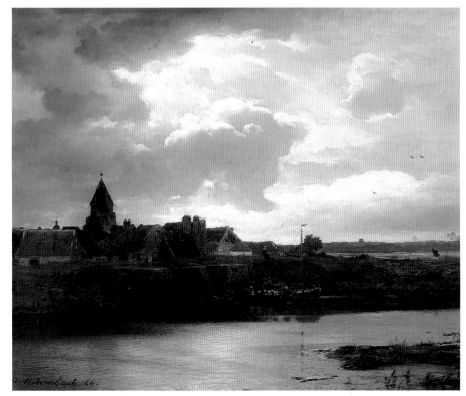

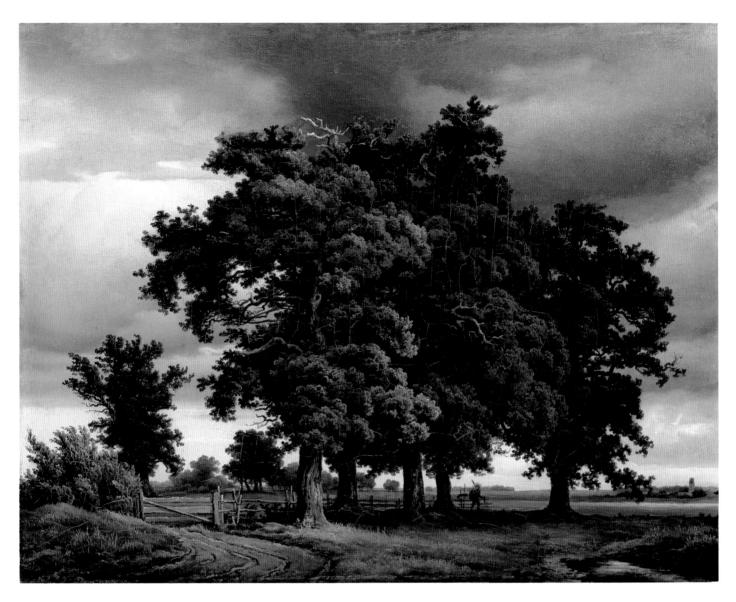

Above
GEORG-HEINRICH CROLA
Dresden 1804–Ilsenbourg 1879
Oak Trees, 1833
(Inv. No. 8665) Oil on panel
9 × 13″ (23 × 32.5 cm)

Left
JULES DUPRÉ Nantes 1811–L'Isle-Adam 1889
Autumn Landscape
(Inv. No. 3868) Oil on canvas
20 × 18″ (51 × 46 cm)

Opposite
ALEXANDER CALAME
Vevay 1810–Mentone 1864
Landscape with Oak Trees, 1859
(Inv. No. 5779) Oil on canvas
68 × 55″ (173 × 140 cm)
(Ex coll. Sausen-Attenburgsky,
St. Petersburg, 1924)

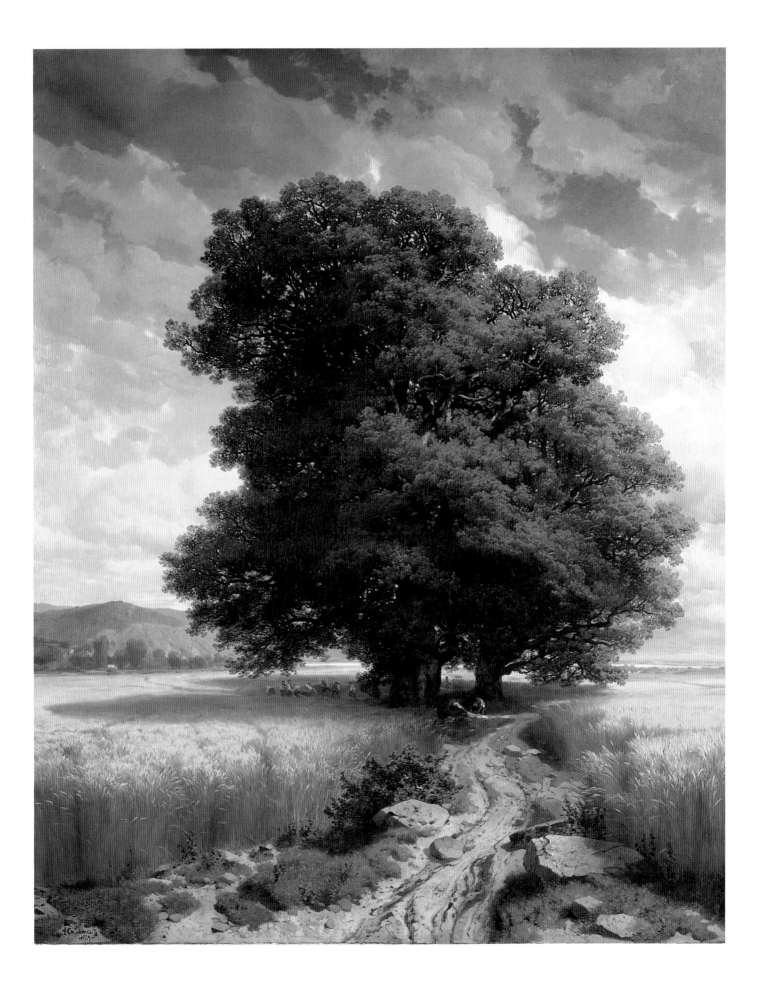

a future of loving Christian promise, billowing sails a traditional symbol of good fortune. Grand Prince Nikolai Pavlovich bought this painting directly from the artist when he visited Friedrich's Dresden studio in 1820. It seems ironic yet perhaps appropriate that this image, fatalistic and visionary at the same time, should have attracted the future czar, so far from the stereotypical ship of state and the role of its leader.

Harbor at Night (Sisters) (356) is in a similar mood. Once again seen from the back, two women on a terrace view a Gothic harbor city. Peter Feist identified the buildings as those of Halle, far from the sea and possibly visited by Friedrich in 1811. The painter added an imaginary monument to lost sailors, a cross with two mourners, seen against the masts of sailing ships, which may themselves be meant to be read as bearing references to crosses in their rigging.

Responsible for the purchase by the Russian aristocracy of so many original, challenging paintings, the poet Vasily Zukhovsky, who saw Friedrich's *Moon Rising over the Sea* (358) in the artist's studio in 1821, considered it the pendant to the czar's *On a Sailing Ship* and, describing it as one of several the painter had just started, advised his royal client to purchase the canvas. To call this a pendant is pure poetic license—it is twice as large as *On a Sailing Ship*, and differs in format. Equally unlikely is Zukhovsky's view that "those who are leaving their native land in your picture now return," but all this nonsense may have been needed to push the

costly goods. Watching the moonrise, paired men and two seated women are seen with twinned anchors and sailing ships. Friedrich's awesome image of a shining orb, rising over the waters, was to be developed as a hieroglyph of obsessive despair by Edvard Munch in the next century.

Though he died at twenty-six in 1828, Richard Parkes Bonington remains among England's greatest painters, described by his friend Eugène Delacroix as unique for "the lightness of execution that makes his work, in a sense, diamonds, enticing and charming the eye no matter the subject and independent of imitative appeal." His *Boats on the Shore of Normandy* (359, 360–61) resembles Turner's work in its brilliant luminosity, partly developed through Bonington's rare mastery of watercolor.

Near Bonington in date, style,

KARL BUCHHOLZ
Schlosswippach 1849–Oberweimar 1889
Autumn Day, 1875
(Inv. No. 6486) Oil on canvas
19 × 23½" (48 × 60 cm)

ALFRED SISLEY
Paris 1839–Moret-sur-Loing 1899
Windy Day in Veno, 1882
(Inv. No. 6508) Oil on canvas
23½ × 32″ (60 × 81 cm)
(Ex coll. I.A. Morozov, Moscow)

and locale is an early sketch by Théodore Rousseau (359). Vastly and deservedly popular in his own day, that original, powerful artist, like Jean Millet, fell out of favor because succeeding generations always turn against whatever their parents adore. Usually very large in size, with massively costly gold frames, Rousseau's pictures were neglected because they looked terrible in an International Bauhaus milieu of dead white walls and sterile chrome tubing. Uncleaned, they appeared to have been painted in alternate layers of tar, bouillon, and syrup. Rousseau's *Landscape with a Plowman* (362), seen against a

flaming sunset sky, presents a direct concern with labor that was followed by Van Gogh.

Though but one year Rousseau's junior, Jules Dupré sentimentalizes his "elder's" formulae in conventional, timid fashion, as if Rousseau's innovations had been around for at least a generation (363).

A German Romantic, Oswald Achenbach softened the Italianate art of his earlier compatriot Joseph Anton Koch for his *Monastery Garden* (362), employing the rich coloring soon to be used with such great profit (in every sense) by the immensely popular Swiss painter Arnold Böcklin. Here the sunset is

reflected in the friars' faces and on the earth and tree trunks. Andreas Achenbach's freshly brushed *Landscape with a River* (363) of 1866 is close to Dutch and English models, his work acquired by the Grand Duke Aleksander Nikolaevich when he attended an exhibition in the artist's honor at Düsseldorf.

Characteristic of the Hague School, Jacob Maris's *Landscape with Mills* (363) is painted in oils with a peculiarly flattened, blurry brush stroke, and that distinctively pastel luminism that won the Dutch center great, if short-lived fame. *Oak Trees* (364), by Georg-Heinrich Crola, a student of Friedrich's, is a late Biedermeier landscape, its decorative cluster of trees still influenced by old-fashioned concepts of the Picturesque, with just a hint of the Ruisdael Renaissance.

Later-nineteenth-century Academic art is seen at its best in Alexander Calame's *Landscape with Oak Trees* (365). Sufficiently highly finished and "realistic" to meet the demands of the monied, it manages to be far more than a catalogue of Mother Nature's wonders, suggesting a reflection upon innate qualities, the intrinsic character of tree and sky, of wheat and shadow, of near and far, a reflection upon growth and change.

Painted in 1875—just when Claude Monet was at Argenteuil— Karl Bucholz's *Autumn Day* (366) shows what European painting was like without that extra push of individuality and spontaneity that made for Impressionism, as seen in Alfred Sisley's *Windy Day in Veno* (367) of 1882.

Superlatives always sound stupid— and usually are, the "most," the "best," the "greatest" at best demanding qualification or modification. Yet meeting all those vulgar words' expectations is Claude Monet's *Pond at Montgeron* (369) of 1876–1877, painted on the estate of the artist's major patron, Ernest Hoschedé, the canvas's first owner. As a woman, perhaps Mme Monet, stands fishing in the background, a symphony of reflections shimmers over the water, painted by the thirty-seven-year-old artist with a vitality and energy that the very best of Abstract Expressionism cannot approximate, a pictorial embodiment of Monet's description by Émile Zola, who, comparing him with his fellow artists, wrote: *"Voilà un homme dans la foule des eunuchs"*— "At last, a man in this crowd of eunuchs." This is a difficult picture, utterly uncompromising, a looking at life as if never seen (let alone painted) before, one of those canvases that must be equated with courage as well as genius.

Monet's *Woman in a Garden (Sainte-Adresse)* (370–71) was completed in 1867, nine years before the far bolder *Pond at Montgeron*. Sainte-Adresse is a suburb of Le Havre, the painter's childhood home, and his model is Margaret Lecadre, a relative of the artist, standing in her family's garden. Here the naturalism of Impressionism comes into play, with its fidelity to the dramatic cast shadows, to the remarkably ugly, pizza-like flower beds filled with short red blossoms, usually begonias, loved by French and Belgian gardeners.

CLAUDE MONET Paris 1840–Giverny 1926
Pond at Montgeron, 1876/77
(Inv. No. 6562) Oil on canvas
68 × 76" (173 × 193 cm)
(Ex coll. I.A. Morozov, Moscow)

CLAUDE MONET
Woman in a Garden (Sainte-Adresse), 1867
(Inv. No. 6505) Oil on canvas
31½ × 39" (80 × 99 cm)
(Ex coll. S.I. Shchukin, Moscow)

Though Impressionism is usually praised in terms of mastery of transience, the fleeting qualities of light and shade, the aesthetic of the momentary, early Monets suggest quite another dimension, a compelling sense of finality, a pictorial equivalent to "This is *It.*" Once again, Zola's praise of Monet comes to mind, because *Woman in a Garden* is a definitive statement, without evasion or compromise.

The Hermitage's landscapes by Alfred Sisley are so fine that were one to judge by these alone, the English artist would be seen as an Impressionist of the first, rather than second, rank. The *Villeneuve-la-Garenne on the Seine* (372) shows one of the several small towns where the poor artist lived for peace, economy, and beauty. Painted twelve years later, *Riverbanks in Saint-Mammés* (373) is done in a far bolder style, its brushwork prophetic of Munch and Ensor.

Possibly because he was born on the small Caribbean island of Saint Thomas, where he first studied painting, Camille Pissarro was especially responsive to the landscape of urban life, to the natural wonders of the city, as if its habitat were not an artifact but had the inevitability and immutability of Creation. Rouen and Dieppe provided him with sites for urban fieldwork—he painted from hotel windows—but of course the City of Light was his favorite setting. Pissarro painted fifteen views of the boulevard Montmartre, some of these from the window of the Hôtel de Russie, one of the Hermitage's views named for the grand

street (374, 376–77), another depicting the *Place du Théâtre-Français* (375).

Impressionists are not usually thought of as History Painters or as View Painters in the traditional sense, but in many ways they should be considered as extreme, obsessive adherents to both pictorial traditions, continuing the genre of Guardi and Bellotto, providing an art for the future, a souvenir of a city that they already knew to have changed radically in their own childhoods and one that could be counted upon to continue that process for better or worse. No art dealt more determinedly

with the Now than Impressionism, but that very process and concern could be counted upon to become an immediate Then. So who could be more aware of *temps perdu*, with all the requirements of fidelity and responsibility for the perpetuation of the moment, than the Impressionists?

Cézanne is the Éminence Grise of Modernism; this is true right up to the present. A major paradox of that movement is the way in which one of the most isolated, hermetic of painters should have had his pictorial weight thrown around with such enduring results. If Harold

ALFRED SISLEY
Villeneuve-la-Garenne on the Seine, 1872
(Inv. No. 9005) Oil on canvas
23 × 31½″ (59 × 80.5 cm)
(Ex coll. S.I. Shchukin, Moscow)

Opposite
ALFRED SISLEY
Riverbank in Saint-Mammés, 1884
(Inv. No. 9167) Oil on canvas
19½ × 25½″ (50 × 65 cm)
(Ex coll. I.A. Morozov, Moscow)

Bloom's concept of the "anxiety of influence" can be applied to the visual arts (and why not?), then the absolute character of Cézanne's achievements can be seen as albatross and inspiration to Western painters for well over a century. This is all the more remarkable as the artist falls into a special category (as does Van Gogh) devised by Max J. Friedländer—that of the genius without talent.

Utterly lacking in facility, terrified by the nude, with Academic drawing, perspective, and anatomy utterly beyond him, Cézanne had to reinvent the painter's wheel, his art all "basics," with no "Back to." The best of Cézanne's paintings suggest an artist whose creative biography was a pictorial equivalent to that of the late Helen Keller's, but with a big difference. She, born deaf, dumb and blind, learned, just barely and almost inaudibly, to speak. Had he been she, Cézanne would have suddenly burst into Brahms's *Alto Rhapsody*, or written *Moby Dick*.

Mont Sainte-Victoire, the Parnassus of Provence, where Cézanne lived, is often encountered in his paintings, one of the many that Morozov bought from Cézanne's great dealer, Ambroise Vollard. Of the two protean collectors of early Modernism, Morozov and Shchukin, the first was the most interested in Cézanne, buying even more of his canvases than his friendly rival. Morozov was the more rigorous and systematic of the two—as the more intellectually challenging, he was also willing to be challenged. So it was he who owned Cézanne's *Mont*

Sainte-Victoire (378). John Rewald dates this painting to 1900, singularly fitting for such a monument to and of Modernism. Now there's no such thing as a detail, and "descriptive" takes on new meaning in its absence—the literary banished from art. The audacity of that achievement may well be why it took a writer to first recognize the artist's genius, Cézanne's boyhood friend Émile Zola the first among his few champions.

The historian Henri Focillon noted how the color blue is the essence of French art, whether in medieval manuscripts, or in the pictorial achievements of Jean Fouquet or Nicolas Poussin. Cézanne belongs to that list. Blue lies at the core of his vision, it *is* his vision. Blue rings the tonal bell releasing the painter's wordless poetry, as seen in *The Banks of the Marne* (378) or *Blue Landscape* (379). Without blue, there's trouble, found in *Young*

CAMILLE PISSARRO
St. Thomas 1830–Paris 1903
Boulevard Montmartre, Paris, 1897
(Inv. No. 9002) Oil on canvas
29 × 36" (73 × 92 cm)
(Ex coll. M.P. Ryabushinsky, Moscow)

Opposite
CAMILLE PISSARRO
Place du Théâtre Français, Paris, 1898
(Inv. No. 6509) Oil on canvas
26 × 32" (65.5 × 81.5 cm)
(Ex coll. S.I. Shchukin, Moscow)

Overleaf
CAMILLE PISSARRO
Boulevard Montmartre, Paris (detail)

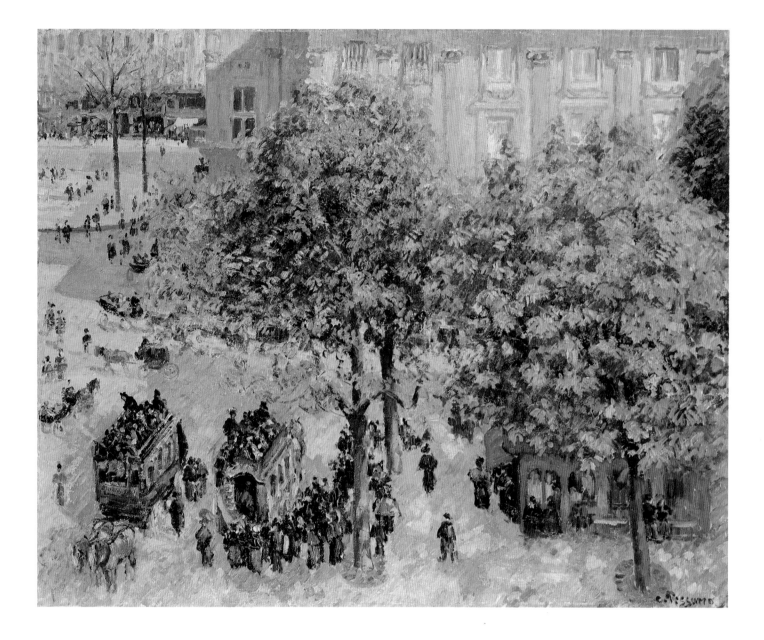

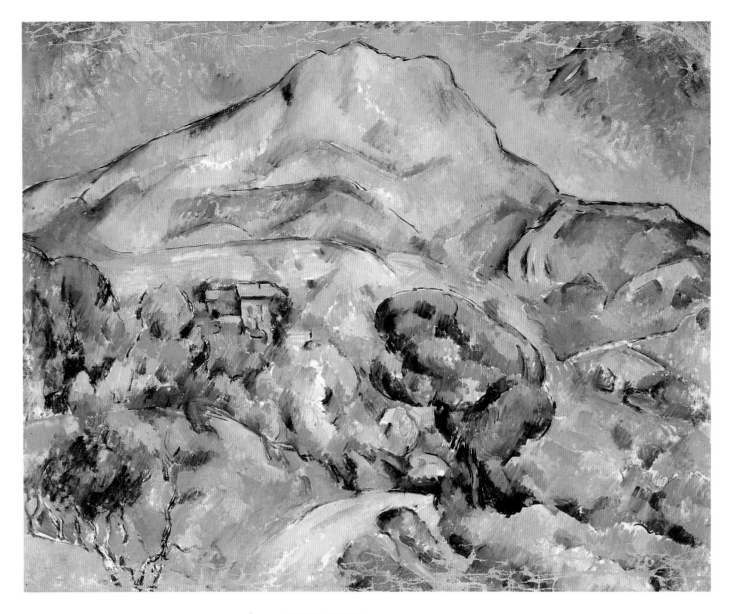

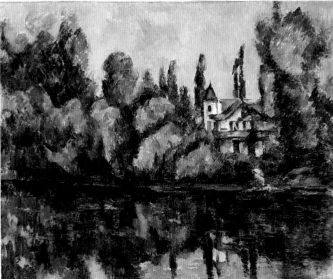

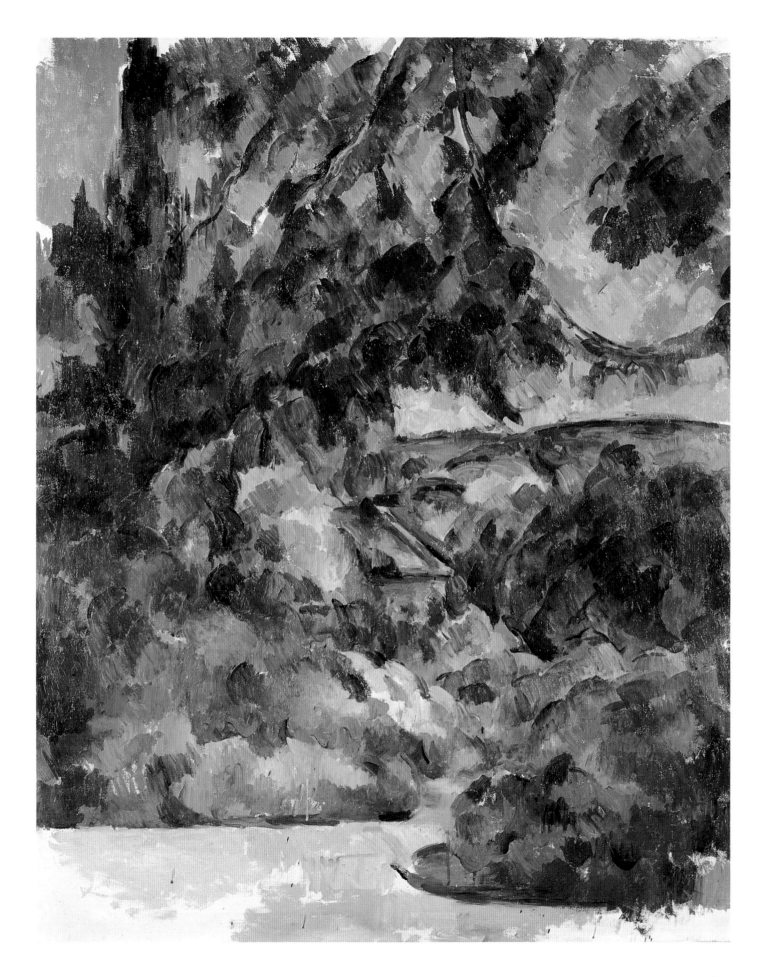

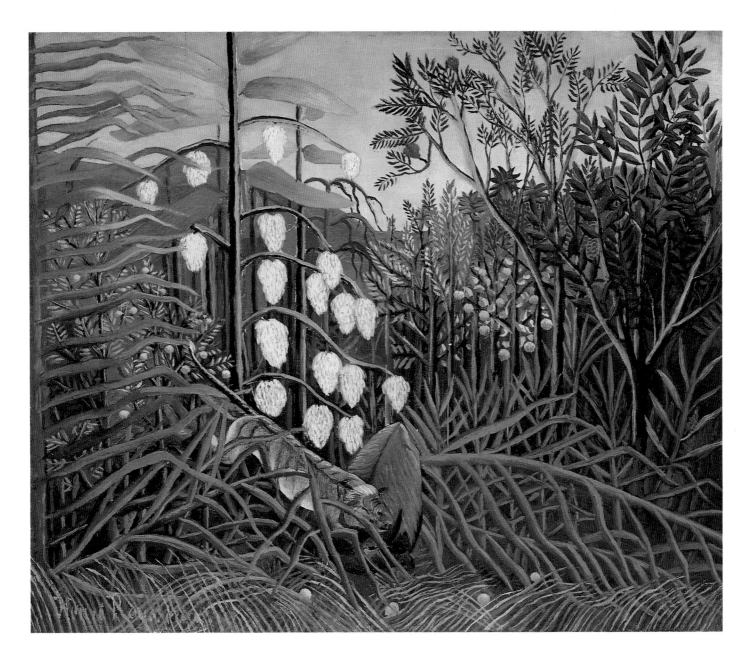

Girl at the Piano (445) where, trapped indoors, deprived of day's light, the only beauty lies in Wagner's unheard sound.

Peasants, treated like supernumeraries in the entertainments of the eighteenth century, came back into serious view in the next. Socialism, with its several political precedents, led to new interest in agrarian, as well as urban, reform. Artists now saw rustic life with the seriousness of Rembrandt, whose many studies of peasant cottages may have been in Van Gogh's mind when he painted his own (380).

Six years Van Gogh's senior, the Norwegian painter Fritz Thaulow was drawn to many of the same subjects (380). Their works are not all that far from one another, but where the elder was a great success, the second proved an abject failure. Today Thaulow is undeservedly forgotten, and Van Gogh equally obscured—by dollar signs.

One of Vincent Van Gogh's very finest nature studies is the Hermitage's *Bushes* (381, 382–83). His knowledge of Dutch seventeenth-century art, as well as that of contemporary Academic and Impressionist painters, is seen to scintillating advantage in this canvas, with its shimmering awareness of blossom, leaf, and light. Had Vincent, who strove for the ministry, thought of the bush that burned yet was not consumed by fire? Here he celebrates the ongoing miracle of nature, one of an-

Right, top
HENRI ROUSSEAU
Fortification: Porte de Vanves, Paris, 1909
(Inv. No. 6535) Oil on canvas
12 × 16″ (31 × 41 cm)
(Ex coll. S.I. Shchukin, Moscow)

Right, bottom
HENRI ROUSSEAU
Luxembourg Gardens: Chopin Monument, 1909
(Inv. No. 7716) Oil on canvas
15 × 18½″ (38 × 47 cm)
(Ex coll. S.I. Shchukin, Moscow)

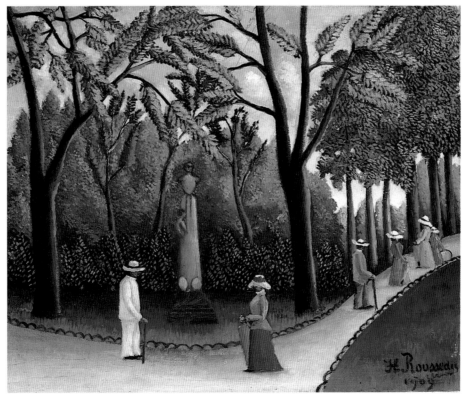

Opposite
HENRI "LE DOUANIER" ROUSSEAU
Laval, Mayenne 1844–Paris 1910
Tropical Forest: Battling Tiger and Bull, 1908
(Inv. No. 6536) Oil on canvas
18 × 21½″ (46 × 55 cm)
(Ex coll. S.I. Shchukin, Moscow)

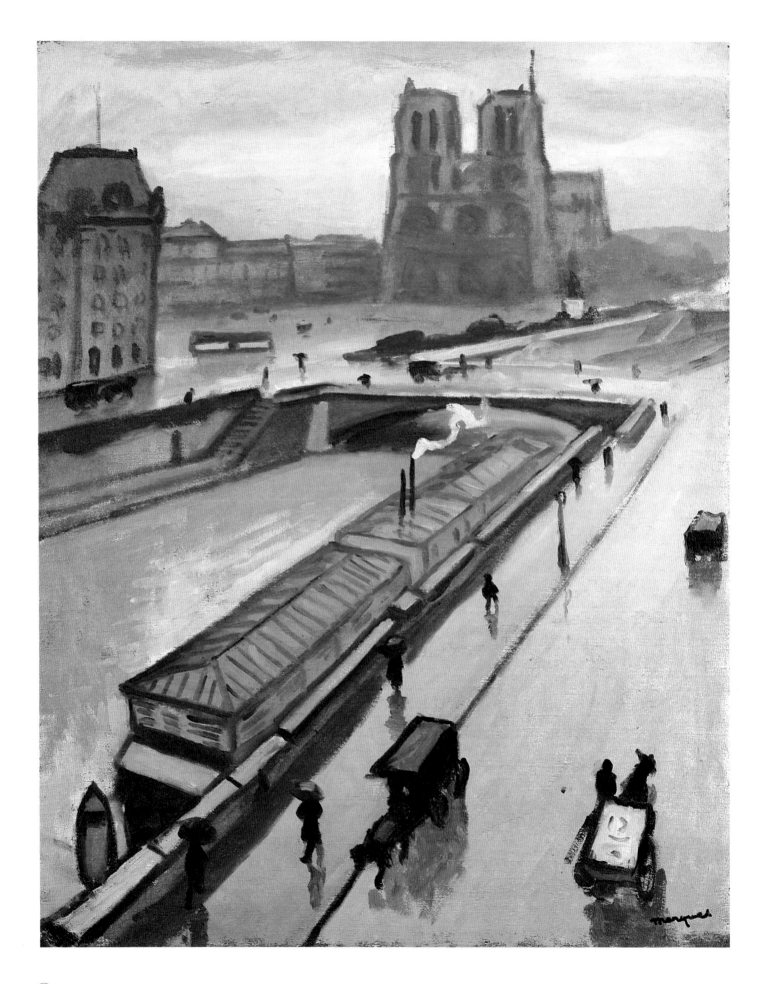

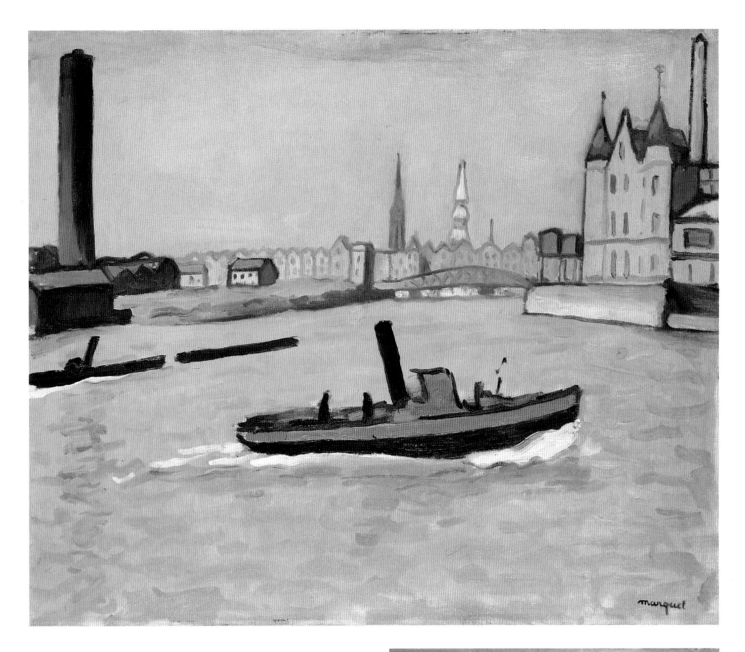

Above
ALBERT MARQUET Bordeaux 1875–Paris 1947
The Port of Hamburg, 1909
(Inv. No. 8907) Oil on canvas
27 × 32″ (68 × 81 cm)
(Ex coll. S.I. Shchukin, Moscow)

Right
ANDRÉ DERAIN Chatou 1880–Chambourcy 1954
Port, ca. 1905/6 (Inv. No. 6540) Oil on canvas
23 × 29″ (59 × 73 cm)
(Ex coll. S.I. Shchukin, Moscow)

Opposite
ALBERT MARQUET
Rainy Day in Paris (Nôtre-Dame), 1910
(Inv. No. 6526) Oil on canvas
32 × 25½″ (81 × 65 cm)
(Ex coll. I.A. Morozov, Moscow)

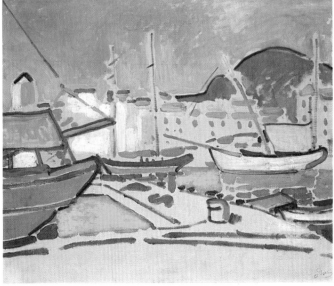

nual death and resurrection, in an image so antithetical to the artist's tragic last months at Arles.

A retired customs collector, "Le Douanier" Henri Rousseau delighted far-more-sophisticated, struggling, younger painters by the naïve force of his fantasy and by his character. When Picasso visited his studio, Rousseau remarked: "We are the two greatest artists of our age—you in the Egyptian manner, I in the modern." Such inspired *chutzpah* is also the hallmark of his art, with an ever-fresh, amusing perspective, sold by Vollard, Cézanne's dealer, from whom Morozov bought so many of his finest canvases. Rousseau was a true Primitive, obviously innocent of the Academy, though he admired it deeply. His pictures (384–85) recall folk art, embroideries, patchwork quilts, and découpage.

A lesser Fauve and Matisse's student, Albert Marquet excelled in landscapes. The Hermitage's *Rainy Day in Paris (Nôtre-Dame)* (386) owes much of its strength to Marquet's following his teacher's composition, yet the student's work is more old-fashioned, less demanding in its concession to diverting detail. His *Port of Hamburg* (387), though of a year earlier, is bolder in its painterly attack. Another Matisse follower, André Derain, cuts his jib along the same master's lines for his *Port* (387) of 1905, close to the works Matisse painted at Collioure, such as the *View* (390) of about 1905 or 1906. Very close to early Cubist landscapes yet more conservative in style, Derain's *Grove*

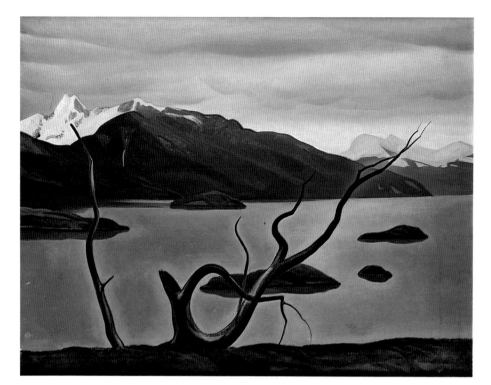

(389) has an elegiac elegance that goes back to seventeenth-century Classical sources.

One of the handful of the Hermitage's paintings to come from the United States—though Cézanne's *Banks of the Marne* was owned briefly by the H. O. Havemeyers—Rockwell Kent's *Admiralty Inlet* (388) was presented by the painter. Long out of fashion, he should be revived: Many of his works, with their hard edged Deco quality, are superior to those of Georgia O'Keeffe.

Too little known outside his native Switzerland and Northern Europe, Ferdinand Hodler is one of this century's most powerful painters. His *Lake* (391) shows the artist in an atypically lyrical mood, far from his more habitually massive, brooding forms of men and mountains. A similar shift in locale and spirit is found in Kees van Dongen's *Spring* (391), painted long be-

ROCKWELL KENT
Tarrytown Heights, NY 1882–
Plattsburgh, NY 1971
Admiralty Inlet, 1922
(Inv. No. 9922) Oil on cardboard
34 × 44" (86 × 112 cm)
(Gift of the artist, 1964)

Opposite
ANDRÉ DERAIN *Grove*, ca. 1912
(Inv. No. 9085) Oil on canvas
45½ × 32" (116 × 81 cm)
(Ex coll. S.I. Shchukin, Moscow)

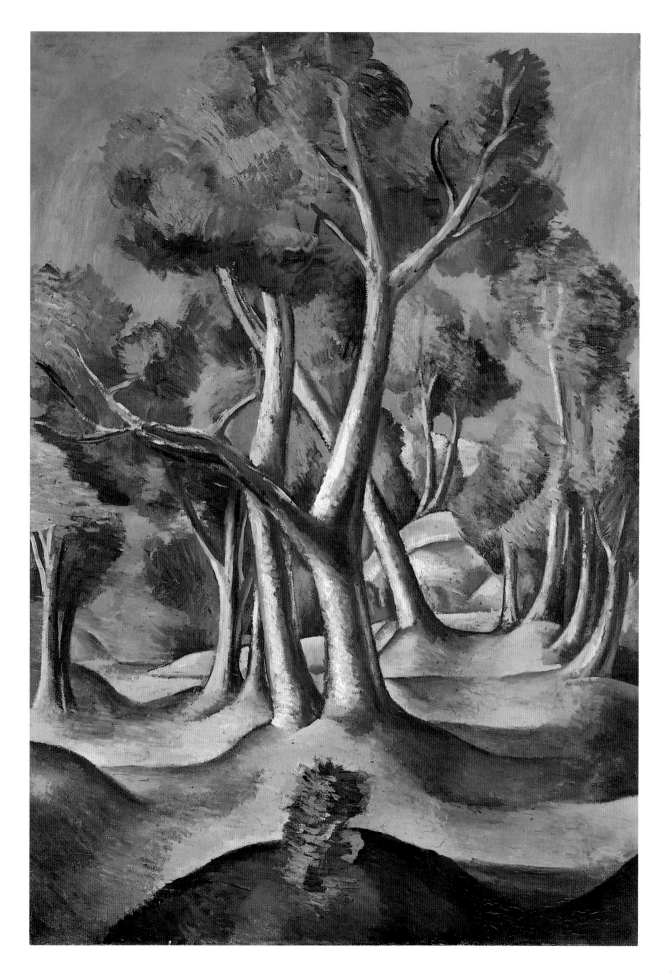

fore that repetitive, slender talent got lost in the lounges of Parisian Deco Society.

Earlier Bonnards seldom disappoint—theirs a witty, indulgent view of the world, with good times the only ones worth remembering. His deceptively easy paintings suggest that he is the very best of all possible Sunday Painters. What could be more delightful than the projection of that sense of pleasure, of painting purely for oneself, forever on pictorial holiday? That popular American children's book *The Little Engine That Could* comes to mind when seeing the *Landscape with Freight Train* (392–93). An ancient little locomotive, right out of Turner's times, puffs through the landscape with the same insouciance as the little girl walking along in the foreground.

Less successful is Bonnard's great triptych (394–95) commissioned to decorate the stairwell of Morozov's palatial Moscow residence. The three panels' informal subjects conflict with the rigidity required for their pompous architectural installation. Equally tripartite, pictorial screens, so popular at the time—on the floor, not up against the wall—allowed for a flexibility better adapted to such casual images.

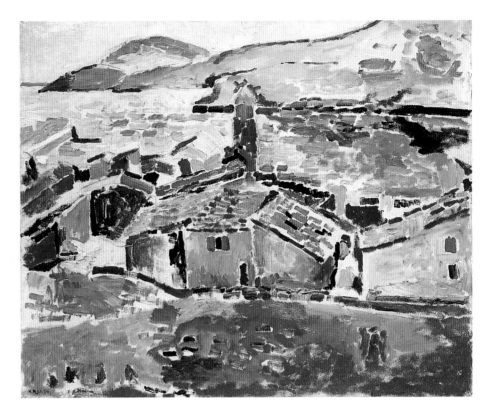

HENRI MATISSE
Le Cateau-Cambrésis 1869–Cimiez 1954
View of Collioure, 1906
(Inv. No. 8997) Oil on canvas
23½ × 29″ (59.5 × 73 cm)
(Ex coll. S.I. Shchukin, Moscow)

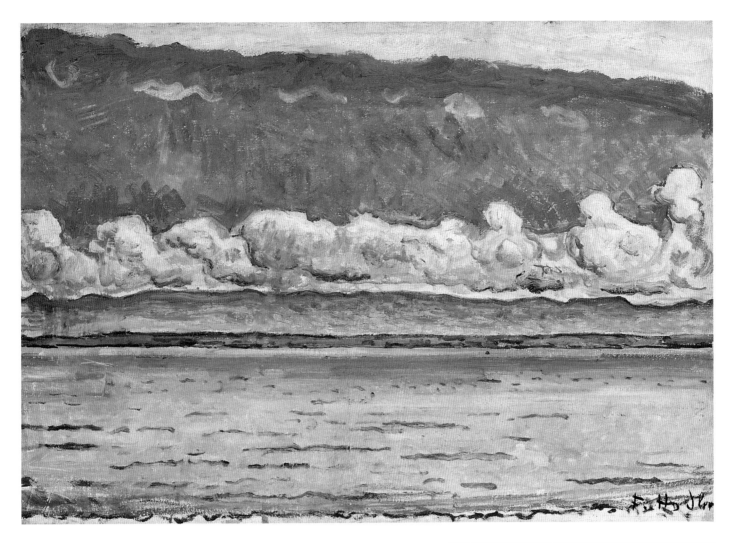

Above

FERDINAND HODLER
Gürzelen 1853–Geneva 1918
Lake (Inv. No. 4857) Oil on canvas
17½ × 25″ (44.5 × 64.5 cm)
(Ex coll. G.E. Haasen, St. Petersburg, 1921)

Right

KEES VAN DONGEN
Delfshaven 1877–Paris 1968
Spring, ca. 1908
(Inv. No. 9130) Oil on canvas
31½ × 39″ (80 × 99 cm)
(Ex coll. S.I. Shchukin, Moscow)

PIERRE BONNARD Fontenay-aux-Roses 1867–Le Cannet 1947
Landscape with Freight Train, 1909
(Inv. No. 6537) Oil on canvas 30 × 42½ (77 × 108 cm)
(Ex coll. I.A. Morozov, Moscow)

PIERRE BONNARD
The Mediterranean Sea, 1911
Oil on canvas
Left panel: (Inv. No. 9664) 160 × 58½″ (407 × 149 cm)
Center panel: (Inv. No. 9665) 160 × 60″ (407 × 152 cm)
Right panel: (Inv. No. 6537) 160 × 58½″ (407 × 149 cm)
(Ex coll. I.A. Morozov, Moscow)

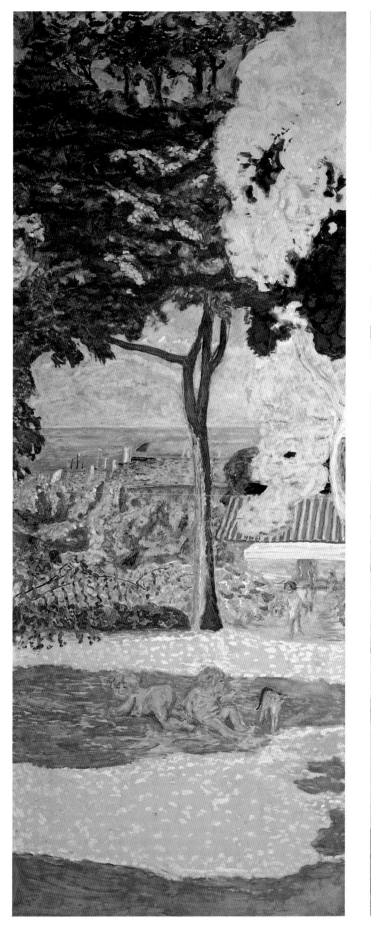

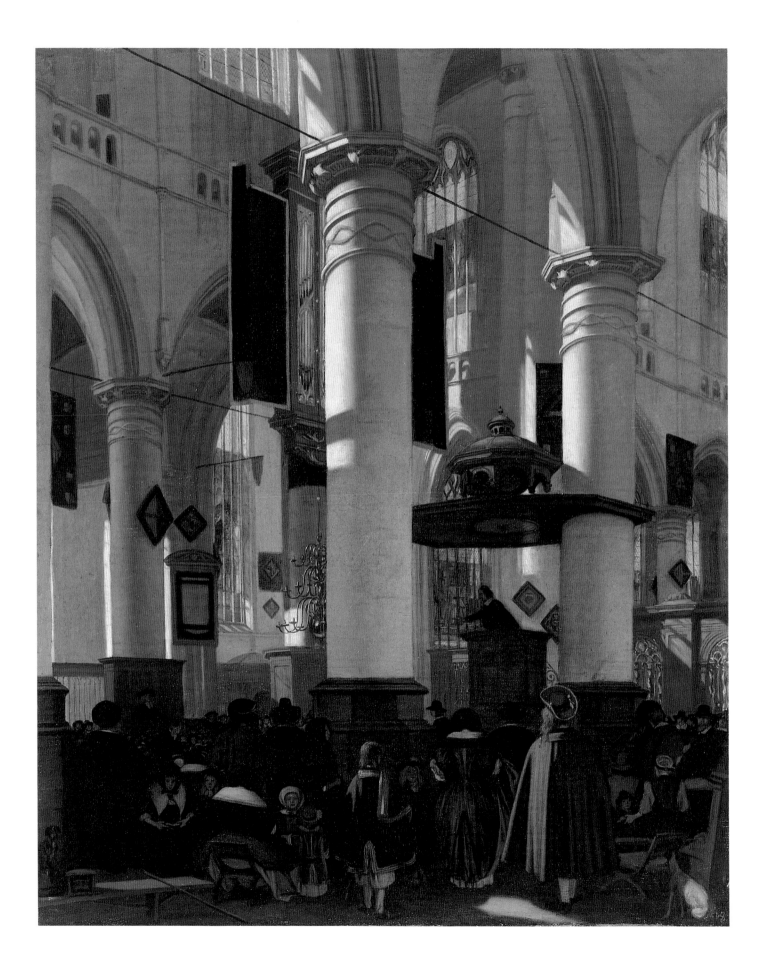

Within Three Walls: Privacy Revealed

⁓⦚ ⦙⁓

Painters' protean strength can smash walls, their demolition conducted with such silent skill that those within remain innocent of their lost façade, blind to exposure, oblivious to an audience now able to see just what takes place in the intimacy of a living room or bedroom, witness to those many exchanges whose varying expressions and degrees of formality tell who and even what we are and how we feel.

The viewer becomes a privileged onlooker, knowing more than the subjects themselves, examining them alone or together, with all their *longeurs* and *frissons*, the veiled anger, jealousy, and busywork, these as much the hallmarks of intimacy as love or friendship. Such interiors can betray the cruel cage of familial living—man, woman, and children all too often confined to a doll's house without escape from the relentless demands of roles and relatives.

Other scenes show just the reverse, the drama of family life richly resolved, so rewarding that the participants are oblivious to all but the pleasurable duties of the ordinary, their only hope that nothing will change. The joys of mother-love, of children's games, the blessings of the faithful servant, the well-ordered house, prove a happy microcosm of how all's right with the world.

EMANUEL DE WITTE Alkmaar ca. 1616/17–Amsterdam 1692 *Protestant Gothic Church*, ca. 1685
(Inv. No. 803) Oil on canvas 31½ × 26" (80 × 66 cm) (Ex coll. Tronchin, Geneva, 1770)

Today, the dwarfed limitations of the nuclear family make many interiors, even those of only two generations ago, take on an almost mythic quality, from a time when a grandmother or maiden aunt could live contentedly, or so seem, with child or sibling; when more than the most modest comforts went along with middle-class living, without the present day's struggle for maintaining the status quo.

Paradoxically, the most real of these painted "lookings-in" are often the most artificial—interiors of a church, palace, or home, devoid of people, or only showing very small ones, allowing viewers to wish themselves into the scene, whether to attend a sermon, waltz at court, or jump into bed. As irresistible to a human viewer as an empty box or bag is to a cat, these artfully vacant pictorial enclosures are catnip to visual Wanderlust, conducive to vicarious projection of presence into another space and time.

Pictures where the space tells the story are close to the origins of perspective, to the invention of those strange mirrored boxes and other Renaissance optical devices that first created the most powerful illusion of depth. Among the largest of these to survive, from seventeenth-century Holland, are the ones known as peepboxes, calling for the spectator to peer with one eye into a closed case where the *dramatis personae* are painted (with their furnishings) around the inside walls.

Most pictures stressing depth use the same mathematical formula for space construction as the peepbox, that of one-point perspective, in which the painting's frame acts like a window and the squared-off flooring allows the viewer a sense of measured distance. This gives the painted interior a stagelike quality, one of vital enclosure, private yet accessible.

These interiors and what they display are the theater of art: They represent what the first Renaissance art theorist, Leone Battista Alberti, referred to as an *istoria*, the staging of a persuasive narrative event in a perspectival setting, in which all those little tiles on the floor (along with all other lines parallel to the picture plane), converge at a central vanishing point. This provides a mensurable sense of the boxlike interior. Alberti specified that one character should always make eye contact with the viewer, so providing a link between the worlds of reality and illusion.

Later painters, less awed by the wonders of perspective, felt no need for such eye-to-eye linkage. By electing the hermetic qualities of enclosure, they offered snoops untold bliss. Dismissing the eternal, immutable moment as literally passé, artists' interiors now provided showcases for the emotions, often variations on the theme of wine, women, and song, differing mostly in the players' number, sex, and alcohol content.

Significantly, the first Early Renaissance peep show to lead to the invention of one-point perspective—the major mathematical shortcut to illusion—was a view of the Florentine Baptistery. All images of churches, inside or out, function as spiritual pilgrimages to the house of the Lord, made without taking a step, as seen in the interiors by Wilhelm van Ehrenberg (400) and Peter Neeffs I (401). Just before the invention of photography, such spaces were still enormously popular, as found in François Granet's operatic re-creation of the choir of a Capuchin monastery (401), which called for many replicas to satisfy collectors' requests.

Ceremonies perpetuated in paint also give a sense of witness, of presence at any number of creations. In Rubens's sketch of Saint-Denis, readied for the coronation of Marie de' Medici (403), the cathedral's then-embarrassingly Gothic gaucheries were cunningly obscured by tapestries, so decorated by the painter himself who often acted as pageant-master. This little scene was to be immensely enlarged as one of the twenty-one key episodes Rubens painted from the life of the Medici queen of France (Louvre). The sacred space, along with its ceremony and regalia, conferred authority upon the person—by recapturing the setting as well as its service Rubens provided the requisite, certifying souvenir of a validating experience.

But there were other interiors, devoted to the magic of silence, to the eloquence of emptiness, cerebral spaces, to be peopled by creatures of the viewers' imagining or left extravagantly empty, as volptuous voids. Rejoicing in the absence of a *horror vacui*, these pictorial equivalents to "nobody's home," far from suggesting deprivation or creative exhaustion, are quite the reverse. Awaiting visual occupation, they allow the viewers to place themselves, alone or with whomever they wish, in the ideal enclosure, ready for prayer, power, or passion.

Few images offered greater appeal to Netherlanders

than that of the church interior, reduced to Protestant austerity, its ancient Gothicism whitewashed and original stained glass long gone. Though these sacred interiors by Jan Saenredam and Emanuel de Witte (396) are as palpable as possible, conceptually they were quite the opposite, often eclectic fantasies whisked together from three or more sources, a nave from here, an altar from there, columns and windows from a third source. In the de Witte, the artist, as detected by Elsa Manke, combines features from Amsterdam's Oude Kerk and Nieuwe Kerk, as if underlining the frequent dependence of the "new" upon the old.

This sort of antihistorical historicism may have been meant as a diversion for a region only a few generations away from the victories and defeats of the Reformation and its iconoclasm. Though characterized as the Art of Describing, there is a subversive element to many an apparently realistic Northern scene, one that lets the artist, if not the viewer, enjoy the last laugh.

Looking "into" rather than "at" domestic interiors has a voyeuristic quality, as if the viewer is invading privacy, violating the sanctuary of the home where the bonds of daily life are forged in unseen intimacy. What makes "interior revelations" work is an elaborate game of Let's Pretend, the models taking on the role of whomever they are told to be. In the case of real people—families, servants, peasants—they must pretend not to be observed, not be recorded, not act as models. This triple denial of the truth is essential if the illusion of the missing wall is to work.

Artists often subject their families to a seemingly endless Open House, painting their mates and progeny because these are both their best-known and cheapest models, most accessible to translation into the second dimension. The result, whether by Cézanne (445), Valloton (444), or Matisse (451), may often prove more a matter of sharing than of exploitation, their models advised and consenting.

Mathieu Le Nain's *Peasants in a Tavern* (404) gives its three primary figures the gravity of apostles, allowing us to witness the daily lives of poor farmers who face their marginal existence with the stoicism of the Suffering Servant. Seated at table, it is almost as if theirs

were a secular Eucharist, celebrating the sanctity of the everyday, no matter how harsh.

A religious subtext may be also be suggested by Diego Velázquez's *Three Men at a Table* (405) because its composition recalls Dürer's print of Christ appearing to the pilgrims at Emmaus—the subject of another of the Spaniard's early works (New York, Metropolitan Museum of Art). But such readings are perilous. Even if his composition were indeed partly inspired by Dürer's well-known woodcut, this ribald image is not steeped in the odor of sanctity.

Realistic scenes of humble Spanish life like Velázquez's—observed in the kitchen, on the farm, in a cheap eating place—are all termed *bodegones*, after the word for low-priced taverns, as if the pictures themselves were to be seen as humble visual fare. Yet the opposite is true: With that radical reversal often found in virtuosity, Spanish painters exploited simple subjects to accentuate the strength of their illusionism.

Velázquez's biographer, Antonio Palomino, recalled how the young artist selected the *bodegone* "to distinguish himself from everyone else and start a new trend, knowing that Titian, Dürer, Raphael, and others had the advantage over him, their fame being greater now that they were dead. He had recourse to the fertility of his invention and took to painting bravura rustic subjects, with strange lighting and colors [so as] to be first in that kind of coarseness [rather] than second in delicacy."

Bought for Catherine II, the *Three Men at a Table* is not among Velázquez's finest *bodegones* because it leans too heavily upon the symmetry and monumentality of the Italian and Northern Renaissance. Soon the equal of any artist, dead or alive, the young painter scrutinized the realistic ways and means of Pieter Aertsen or Caravaggio for his early style. The youths in Velázquez's scene still suggest Alberti's *istoria*, making gestures as well as eye contact, inviting us to join in their dubious revels.

A gentler interior is that for *A Visit to Grandmother* (407, 408–409) by Louis Le Nain. A *Knife Grinder* (406) by Antonio Puga (in a Velázquez-like style) or an aged peasant couple by Jean-Baptiste Pierre (406) present figures so absorbed by their work or in each other that they are oblivious to the outside world, letting the viewer watch them with as good a conscience as theirs.

Monkeys pictured in taverns (421, 422–23) and kitchens (and almost everywhere else) were popular subjects, often done by David Teniers the Younger as satires on human lust and curiosity—of all that "monkey business" that is the human condition. "Monkey see, monkey do" was used as a way to make fun of artists who were slaves to imitation, incapable of independent judgment or action, bound to the "senseless copying of nature or the soulless dependence upon antiquity," as N. Babina observed.

Many seventeenth- and eighteenth-century canvases dwelled upon alchemy or fortune-telling, the latter shown by Jan Cossiers (410) and Jean-Baptiste Le Prince (411), almost as if the act of looking at a palm were the corollary to looking at a picture, and painting the ultimate process of alchemical transmutation in a magical leap from oil to image.

Making music is among the happiest of all subjects—harmony a key to all the arts, to a state of concord and inspiration, that beautiful, Apollonian sound from stringed instruments guiding the artist's head, heart, and hand, liberating creative activity to the highest possible level, from craft to art, attuning labor to the music of the spheres.

Merry musical companies, wine the source of their *furor poeticus*, leading to new flights of art and love, had been a favorite subject since the late Middle Ages. Caravaggio's sultry young castrato, who accompanies himself on a lute (415), has exchanged his virility for an enduringly high voice and,

hopefully, an equally long-lasting and luxurious high life. In Roman Baroque drag, he wears a revealing shirt designed to please Cardinal del Monte, Vincente Giustiniani, or any one of the many other gay and powerful Roman art patrons of the period.

All the beautiful still life elements—along with the singer himself—suggest the sum total of the five senses: sound and sight by the youth's voice and eyes, his lute, viol and music sheets; taste by the fruit; scent by the flowers; touch by the young man's hands upon his instrument. So the cocky *hubris* of Caravaggio's canvas may convey the conceit that his powers of illusion subsume all the senses, now experienced solely by the strength of his painting.

Dutch followers were quick to emulate Caravaggio's dramatic illu-

WILHELM SCHUBERT VAN EHRENBERG
Antwerp 1630–1676
Church Interior, 1665
(Inv. No. 1441) Oil on canvas
41 × 45½" (104.5 × 115.6 cm)

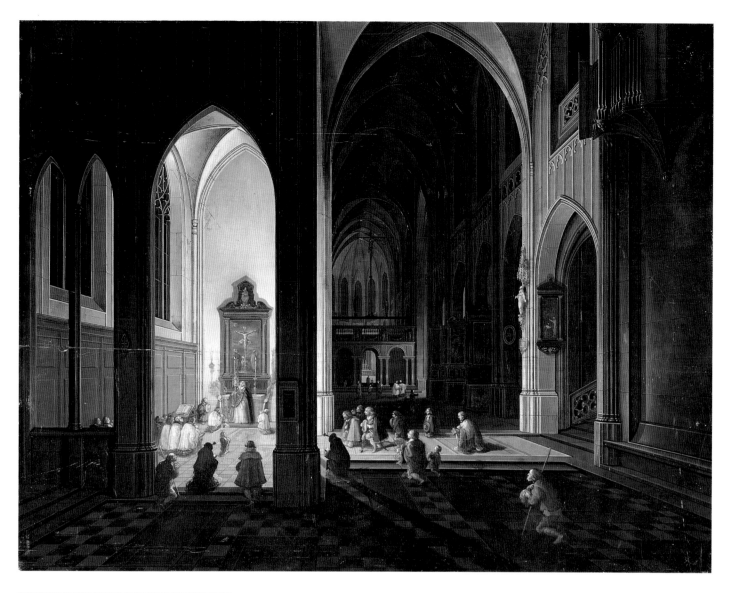

Above
PETER NEEFFS I Antwerp ca. 1578–1656/61
Interior of a Gothic Church
(Inv. No. 645) Oil on panel
16 × 21″ (41 × 53.5 cm)
(Ex coll. Empress Josephine, Malmaison, 1814)

Left
FRANÇOIS MARIUS GRANET Aix-en-Provence 1775–1849
View of the Capuchin Monastery Choir on the Piazza Barberini, Rome, 1818
(Inv. No. 1322) Oil on canvas 69 × 50″ (174.5 × 126.5 cm)
(Gift of the artist to Czar Aleksandr I)

mination and novel sense for the erotic, especially those artists working in Catholic centers like Utrecht, with their close Roman connections. Dirck Baburen, one of the most gifted of these Netherlandish Caravaggisti, enlarges his *Concert* (414) to a merry group of four. Though the Dutch player's garb is far less flattering than the castrato's, its more likeable wearer is concerned with happy harmony rather than seductive appearance, leaving the romancing of the spectator to the Roman lutenist. Finally, Hendrick Ter Brugghen's contemporary version of the subject (413) seems more interested in his countryman's high spirits and the Roman painter's lighting than in anything sexual.

Far more modest in size and scale, a little picture by Dirck Hals (412) places four full-length musicians—three men and a woman—in a comfortable Dutch interior. All looks festive and positive, yet a map in the background and the precious objects to the right suggest that this is a Vanitas: young people enjoying themselves in the ways of the world without a thought or care for the morrow.

In a scene by Adriaen van Ostade (416), three children look in on musicians playing in a rustic tavern, as if they might be witnessing their future. Ostade's paintings were reproduced by the artist in print form, adding to their fame.

A canvas by a Caravaggio follower, Bartolomeo Manfredi, is a tribute to the simultaneity of lovely sound and handsome image (417), as if sight and sound echo or repeat one another's appealing refrain.

This amorous sentiment carries right on into the faraway world of early Cubism, with Picasso's *Woman with a Mandolin* (417), which is remarkably Cézannesque.

Fascination with low life had Classical roots. Being avid readers of Pliny, artists knew that their ancient forerunners specialized in the pictorial equivalent of throwaway chic, painters of detritus. The need for visual slumming, for watching others waste time, life, and fortune, has long been filled by Northern painters. Did their provident, well-organized society harbor a certain envy for the hopeless schlemiel, the drunken maid, lecherous manservant, and sloppy cook?

Dismal subjects by Adriaen Brouwer (418) were highly prized by Pieter Paul Rubens, who collected many of them and encouraged the original young painter as best he could; the gifted artist's brisk, audacious reportage must have come as a welcome change from Rubens's standard repertoire of courtly and Classical pomp and impeccable devotional circumstance. Stunned and stunted by their poverty, Brouwer's denizens of a dive seem incapable of discourse, reduced to crude gesture, muttering or screaming like mutants or retardates. His tavern scene is the end of the line from Pieter Bruegel's peasants of the preceding century, closer to those found in Dürer's mostly mean-spirited engravings of rustics. Could Brouwer be making a broader statement? Are these blunted, coarsened boors all of us, were we without those civilizing comforts only money can buy?

PIETER PAUL RUBENS
Siegen (Westphalia) 1577–Antwerp 1640
The Coronation of Marie de' Medici (oil sketch)
(Inv. No. 516) Oil on panel
19 × 25" (49 × 63 cm)

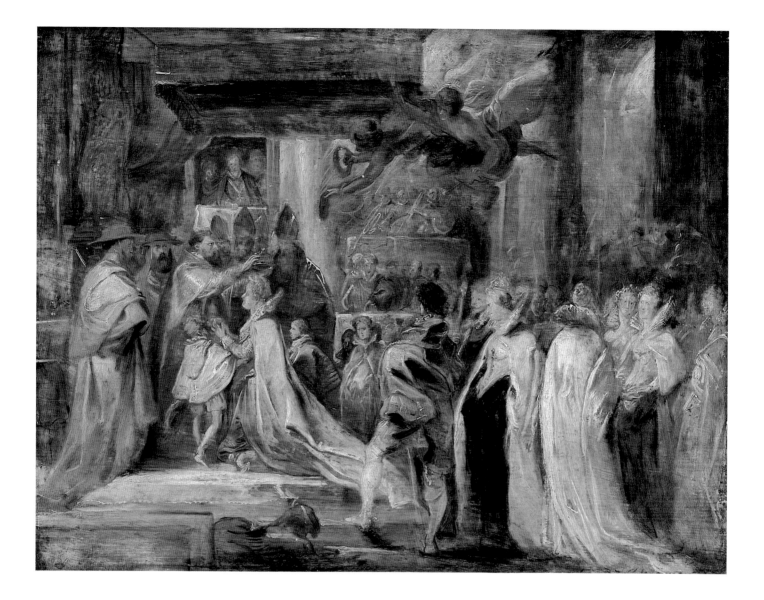

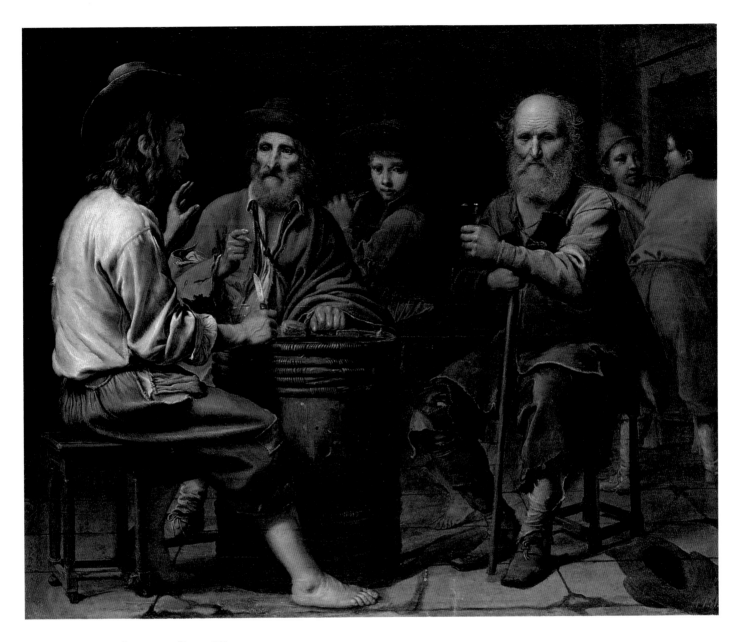

MATHIEU LE NAIN Laon 1607–Paris 1677
Peasants in a Tavern, 1640s (Inv. No. 328)
Oil on canvas 31 × 37″ (78 × 94.5 cm)
(Ex coll. Potocki, 1838)

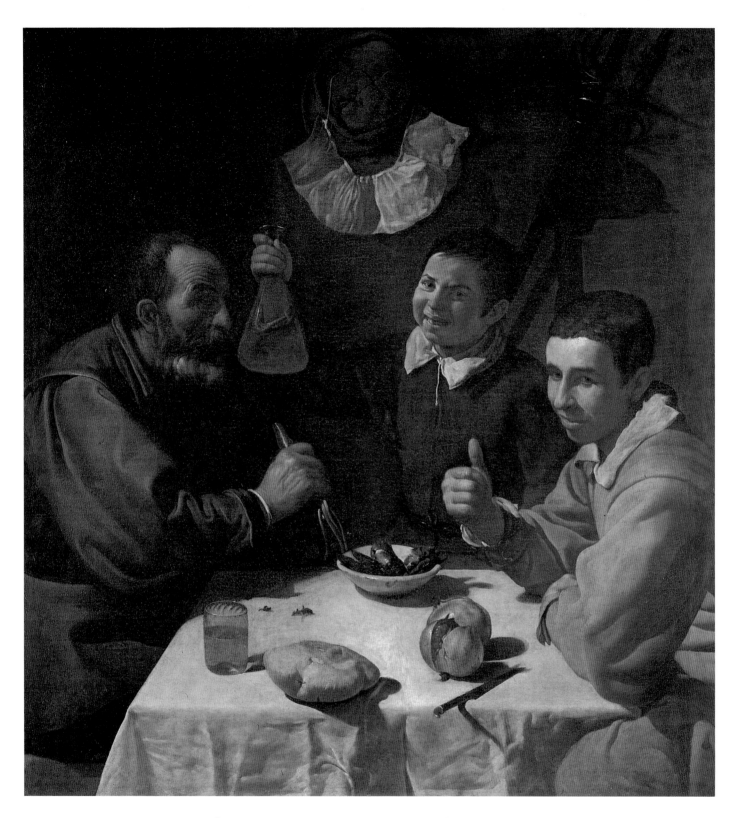

DIEGO RODRIGUEZ DE SILVA Y VELÁZQUEZ
Seville 1599–Madrid 1660
Three Men at a Table, ca. 1617/18
(Inv. No. 389) Oil on canvas
43 × 40" (108.5 × 102 cm)

Dutch and Flemish collectors loved scenes of flea-picking, of mothers or grandmothers going through their little charges' hair to kill vermin. Adriaen van Ostade shows this activity (418) taking place in a tumbledown peasant's cottage, the man possibly crippled, the woman, if the mother, prematurely aged, as a little boy drinks beer. Painted without compassion, images like this are hard to understand, done from the perspective of neither social critic, the poor, or their patron. Its odd title, *Sight*, indicates that the artist saw flea-picking as an allegory of the power of vision. *The Idlers* (419), painted by Jan Steen with his usual consummate skill, includes a pipe as a standard Vanitas symbol; an empty slipper implies sexual abandon.

Alchemists in their messy, foul-smelling studies (419) were symbols of folly, of misplaced hopes that the transmutation of lead into precious metal would line their pockets with gold. Thomas Wyck satirized the waste of time and the ignorance of true values that went into this vain pursuit. Despite all this pictorial tut-tutting, alchemy was actually the beginning of modern science, of chemistry and physics, long a favorite study in Europe's Renaissance courts.

Dutch seventeenth-century interiors often tell a heavily didactic tale, devoted to that formidable guardian of thrift and high priestess of *Gründligkeit*, the Dutch housewife, and to her endless duties as wife, mother, chatelaine, dietitian, house detective, and hostess. Individually or collectively, these domestic qua-

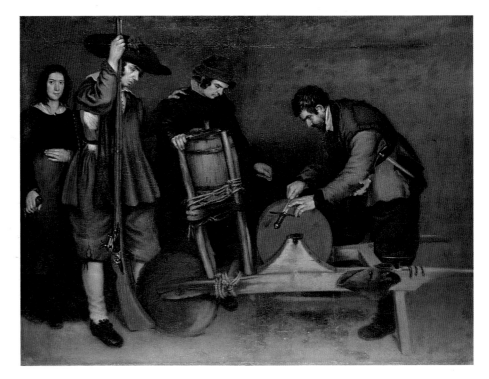

Above
ANTONÍO PUGA Orense 1602–Madrid 1648
The Knife Grinder
(Inv. No. 309) Oil on canvas
46½ × 62½" (118 × 158.5 cm)
(Ex coll. Coesvelt, Amsterdam, 1814)

Left
JEAN-BAPTISTE MARIE PIERRE
Paris 1714–1789
Old Man in a Kitchen
(Inv. No. 7240) Oil on canvas
51 × 38" (130 × 97 cm)
(Ex coll. Crozat, Paris, 1772)

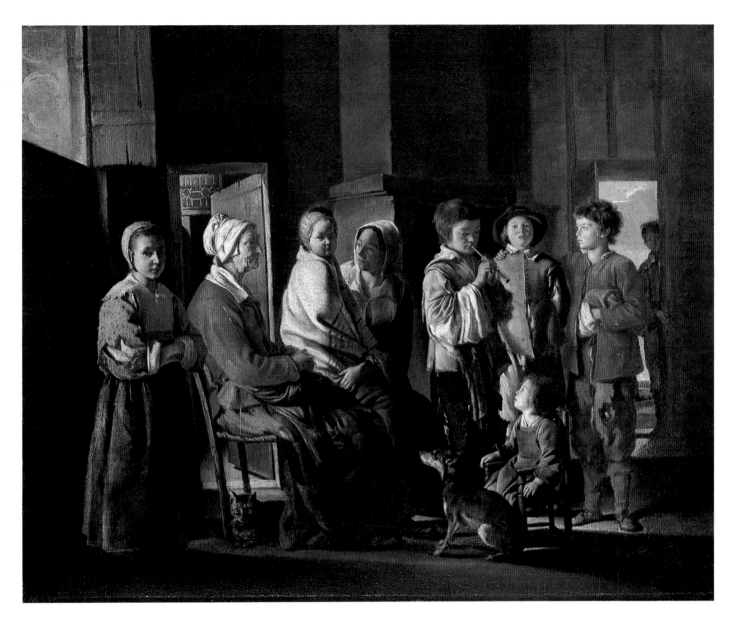

LOUIS LE NAIN Laon 1593 (?)–Paris 1648
A Visit to Grandmother, 1640s (Inv. No. 1172)
Oil on canvas 23 × 29″ (58 × 73 cm)
(Ex coll. Crozat, Paris, 1772)

Overleaf
LOUIS LE NAIN *A Visit to Grandmother* (detail)

lities are exalted in paintings that are often secular sermons on the manifold arts of housewifery and the crafts surrounding maternity.

Pieter de Hooch's magical mastery of light saves his Home Sweet Home scenes from the banal; their clear understanding of life as well as art makes these prismatic vistas Mondrians with a message. Never before (or after) did a rich housewife care to be immortalized by having her maid thrust a large pail right next to her mistress's head (424), as if such an image were meant as a Vanitas, a visual Lest We Forget, a reminder that in the end the First shall be Last. De Hooch's groups are informed by a "contractual focus," a sense that settlements will be arrived at, even in silence, between maid and mistress, husband and wife, mother and child, in a climate of silent agreement that makes for pleasant if serious watching.

Samuel van Hoogstraten's peepshow perspective is still felt in Pieter Janssens's singularly compelling *Dutch Interior* (425). Here, illuminated space is the real subject— the device of showing the woman's face in a mirror is one that Velázquez, too, used for his *Rokeby Venus* (London, National Gallery). A keen appreciation for the figure seen against mathematical forms recalls that of the great Rogier van der Weyden *Crucifixion* diptych (Johnson Collection, Philadelphia Museum of Art). Interestingly, this painting, too, has been thought of as a diptych; the other half, of a woman reading, is in Munich. Clothilde Brière-Misme suggested that the two images were meant to

JAN COSSIERS Antwerp 1600–1671 *Fortune-telling*
(Inv. No. 4717) Oil on canvas 52 × 61″ (132 × 155 cm)
(Ex coll. Crozat, Paris, 1772)

Opposite
JEAN-BAPTISTE LE PRINCE Metz 1734–St-Denis-du-Port 1781
At the Palmist's, ca. 1775 (Inv. No. 5645)
Oil on canvas 31 × 26″ (78 × 66 cm)
(Ex coll. E.P. and M.S. Oliv, St. Petersburg, 1923)

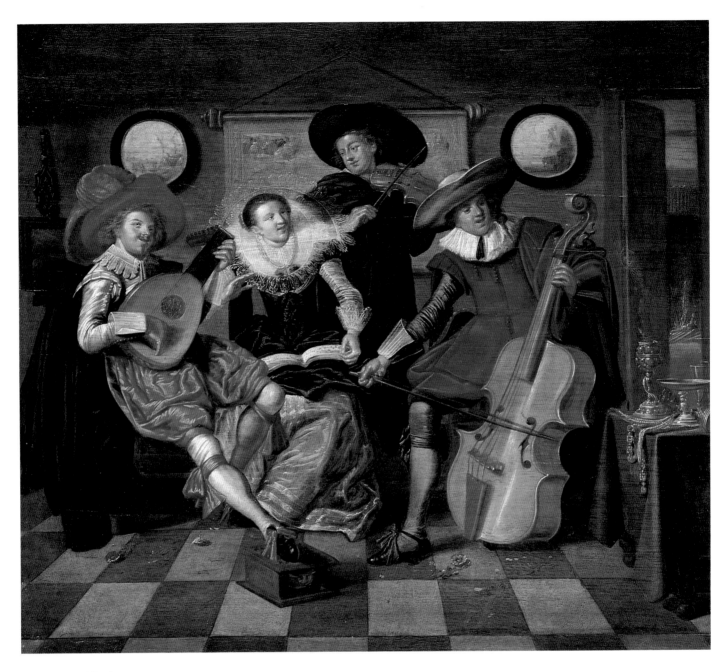

DIRCK HALS Haarlem 1591–1656
Musicale, 1623
(Inv. No. 2814) Oil on panel
17 × 18½″ (43 × 47 cm)

be understood as the Active and Contemplative lives.

Twentieth-century art also comes to mind, with Josef Albers's endlessly repetitious *Homage to the Squares*. Here, far earlier tribute seems paid to the rectangles of glass pane and marble tile. These windows anticipate the disquietingly concentrated domestic visions of René Magritte, whose Belgian sorcery of the suburban image revived the magic realism of the ordinary of two centuries before.

Protestant simplicity, where a spade's a spade and nothing else, can be one of the chief appeals of much Dutch art. Even if it often has recourse to the proverb and the double entendre, these, mercifully, are not always in evidence. Austere pictures take on almost naïve topics that other painters (and patrons) might well shy away from: Few images are more challenging and elusive than the truly unassuming. This modest world is the purlieu of little masters, like Jacobus Vrel, his old men and women, often shown alone (420), all share an austere appeal, particularly keenly felt in eighteenth-century France, followed by painters like Chardin, who sought escape from the formulaic frivolity of the Rococo.

Surprisingly, though far less theatrical than most of Greuze's painting, Chardin's restrained art also elicited Diderot's enthusiasm. *Grace Before a Meal* (435) shows Chardin at his best, direct, with believable people acting as if the artist were unseen by them. Modest domesticity provided him with a highly successful genre. Chardin's reasonable, humane images were fought

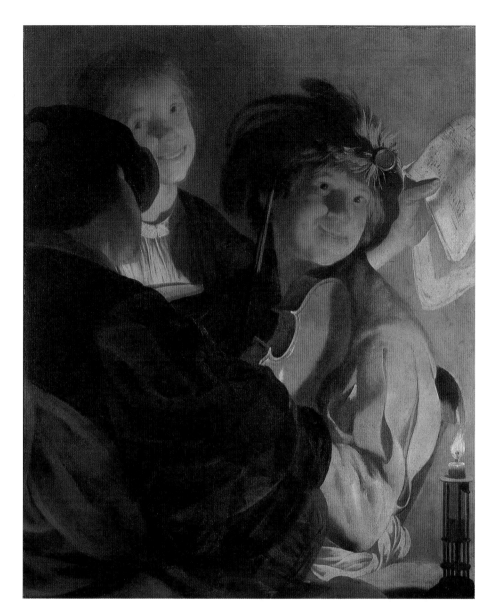

HENDRICK JANSZ. TER BRUGGHEN Deventer ca. 1588–Utrecht 1629
The Concert, 1626 (Inv. No. 5599)
Oil on canvas 40 × 32½″ (102 × 83 cm)

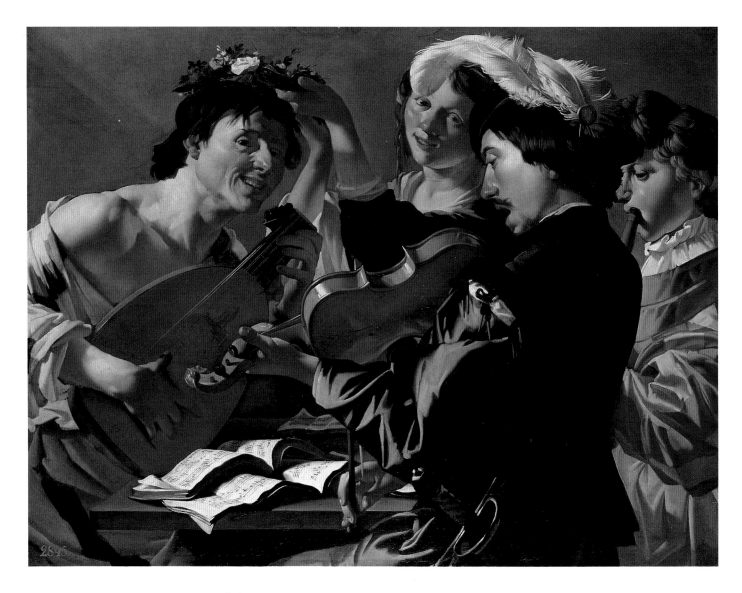

over by Europe's most powerful collectors after Diderot gave these images his imprimatur. Vast wealth and greed were drawn to such exquisitely simple, moral paintings as if money could buy their humble virtues, in much the same way that twentieth-century collectors acquire ethnic, tribal, and folk art along with paintings by the "naïve."

Mothers teaching children how to say grace, servants in the kitchen or at the cistern, boys blowing bubbles or building card houses, a washerwoman taking her little son along on the job (421)—all proved enormously popular themes, soon made famous in reproductive prints. Chardin painted many replicas to satisfy the demand for his art, so often staged within the reasonable world of middle-class mores as would be those by Vuillard and Bonnard.

Witnessing low life can approach the privileging of that in the middle or on high. The wealthy who first bought paintings of the poor found their scrutiny of the have-nots could prove easily as satisfying as the sight of yet another conspicuously opulent canvas. "Downstairs" is always a lively mi-

DIRCK (THEODOR) VAN BABUREN
Utrecht 1590–1624
The Concert, ca. 1623
(Inv. No. 772) Oil on canvas
39 × 51" (99 × 130 cm)
(Ex coll. J.E. Gotzkowski, Berlin, 1764)

Opposite
CARAVAGGIO (MICHELANGELO MERISI)
Caravaggio ca. 1573–Port'Ercole 1610
The Lute Player, ca. 1595
(Inv. No. 45) Oil on canvas
37 × 47" (94 × 119 cm)
(Ex coll. Giustiniani, Rome, 1808)

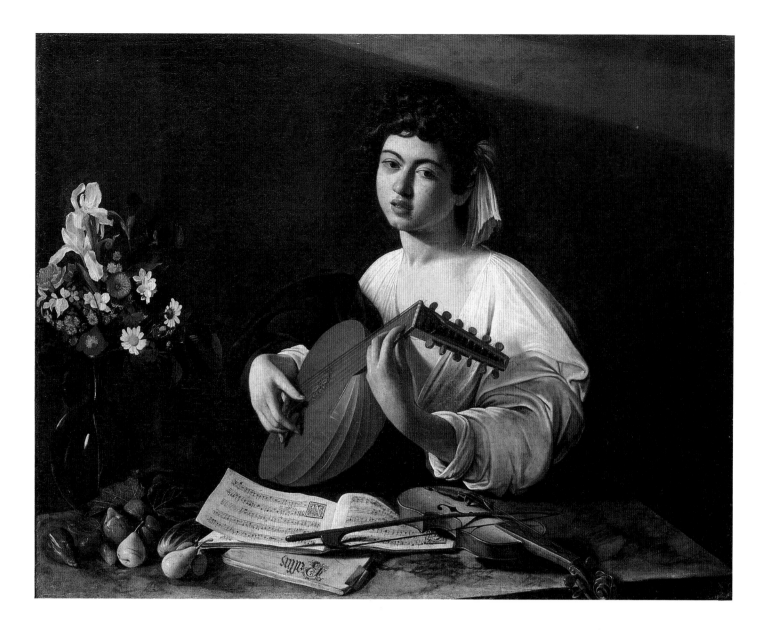

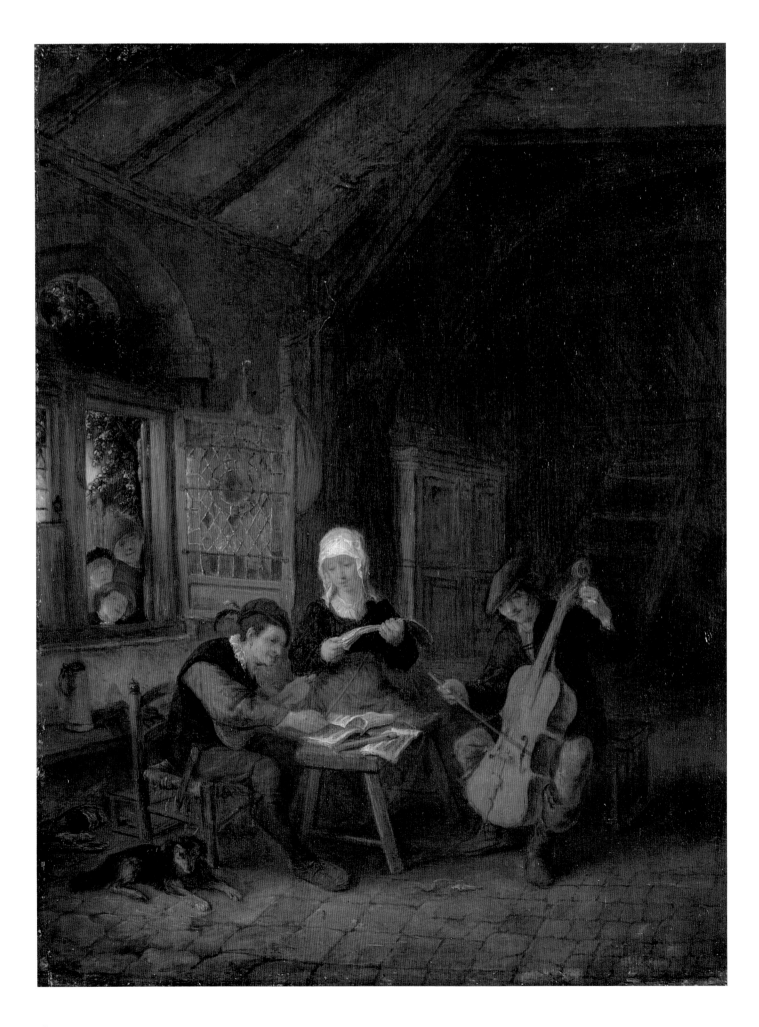

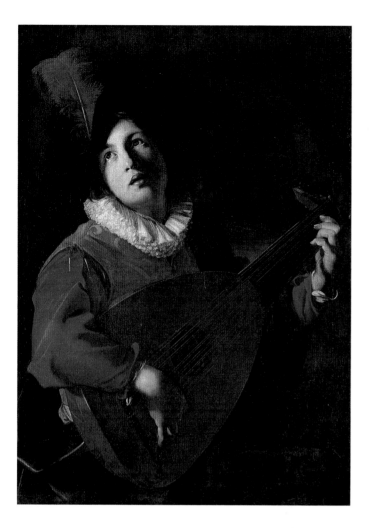

PABLO RUIZ Y PICASSO
Málaga 1881–Mougins 1973
Woman with a Mandolin, 1909
(Inv. No. 6579) Oil on canvas
36 × 28½″ (91 × 72.5 cm)
(Ex coll. S.I. Shchukin, Moscow)

BARTOLOMEO MANFREDI
Ostiano ca. 1580–Rome ca. 1620
The Lute Player, ca. 1610
(Inv. No. 5568) Oil on canvas
41 × 30″ (105 × 77 cm)
(Ex coll. Shuvalov, St. Petersburg)

Opposite
ADRIAEN VAN OSTADE Haarlem 1610–1685
Village Musicians, 1645
(Inv. No. 904) Oil on panel
15 × 12″ (39 × 30.5 cm)

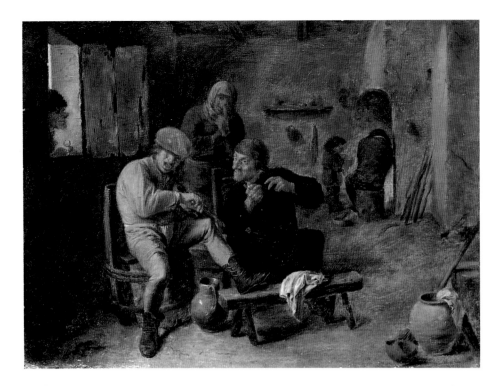

crocosm of "Upstairs," their servants ever a subject of persistent preoccupation to the rich, so often providing them with their closest link to reality, to the immediate challenges of everyday life.

Eighteenth-century kitchen scenes allowed for fun and frolic for servant as well as master. So Nicolas Lancret's restatements of Baroque themes contrasted conventionally industrious behavior in *The Kitchen* (419) with that of *The Philandering Servant* (419).

Games, too, are links to reality, allegories of ways of winning or losing in the raffle of life, a bittersweet message conveyed relatively painlessly—even amusingly—in scenes of gambling at cards or the gameboard. Painstaking in the remarkable finish of his work, Willem Duyster's *Officers Playing Backgammon* (428) may have been meant as a Vanitas, pipe and gameboard both indicating a waste of precious time. Seriousness, so much in evidence in all the players, suggests higher stakes are involved, theirs that odd combination of intensity and ennui found in the obsessive operators of one-armed bandits.

With his usual wit, Jan Steen shows *A Game of Backgammon* (429), possibly set in a bawdy house, for the gentleman's pipe is at a suggestive angle toward the woman he may be playing with in every sense of the word. This lavishly furnished interior is lined with Spanish gilt-leather wall coverings. The wine cooler on the floor, with ivy leaves around, points out that this chamber is in the realm of Bacchus, presumably for the paid-for pleasures of wine and women. Painted

JACOBUS VREL active second half of 17th century,
probably in Delft and Haarlem
An Old Woman at the Fireplace
(Inv. No. 987) Oil on panel
14 × 12″ (36 × 31 cm)

Above
JEAN-BAPTISTE SIMÉON CHARDIN Paris 1699–1779
The Washerwoman (Inv. No. 1185) Oil on canvas
15 × 17" (37.5 × 42.7 cm)
(Ex coll. Crozat, Paris, 1772)

Right
DAVID TENIERS THE YOUNGER Antwerp 1610–Brussels 1690
Monkeys in a Tavern
(Inv. No. 568) Oil on canvas, transferred from panel
14 × 20" (36 × 50.5 cm)

Overleaf
DAVID TENIERS THE YOUNGER
Monkeys in a Tavern (detail)

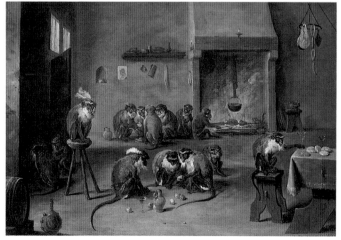

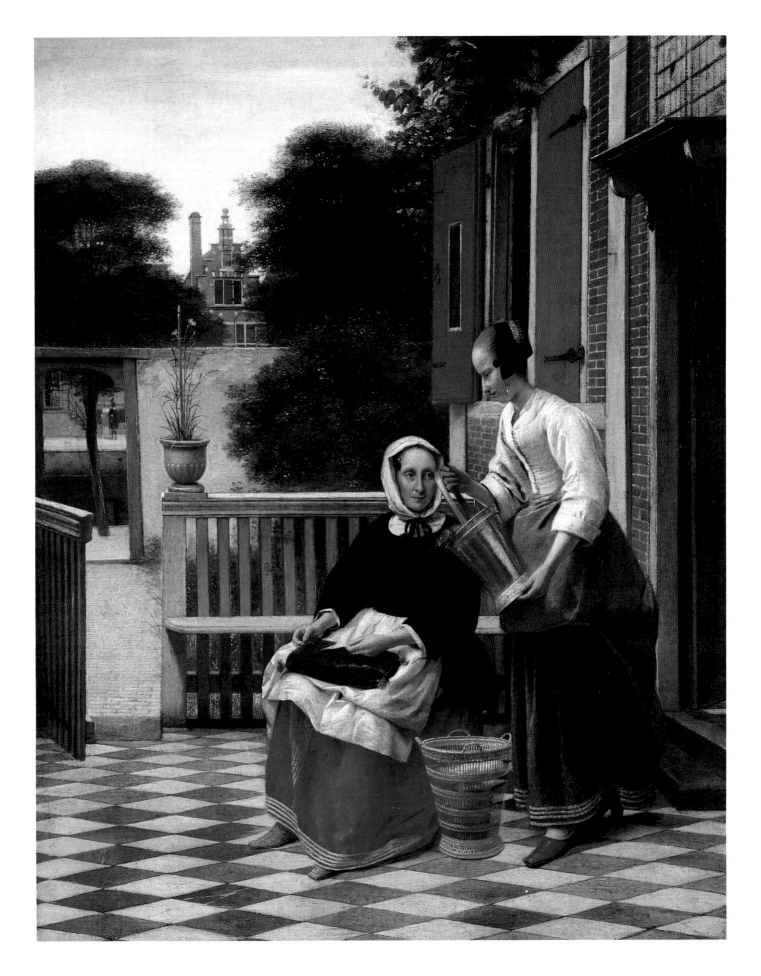

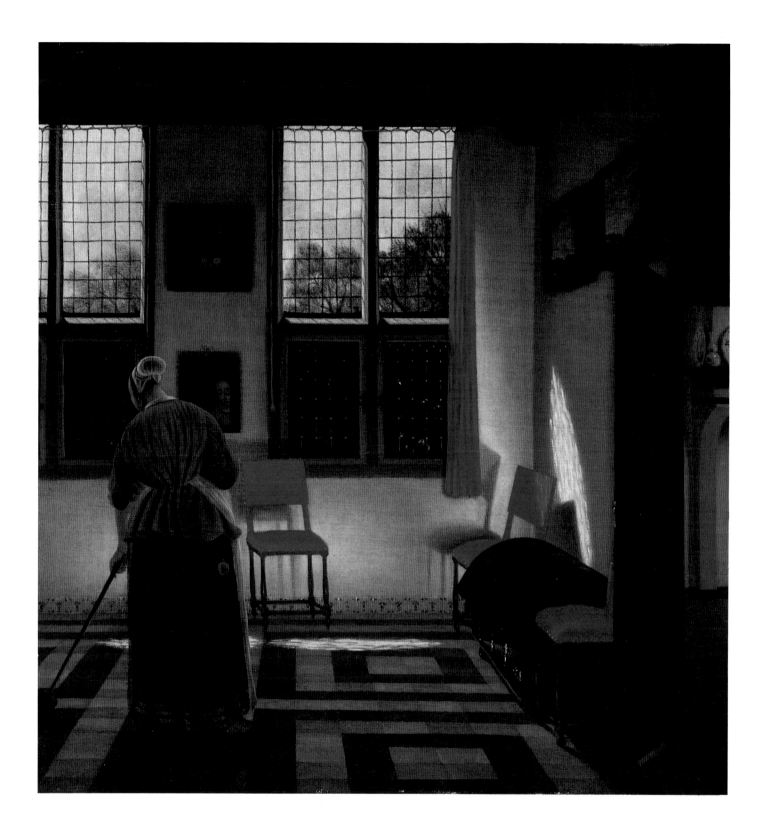

Opposite
PIETER DE HOOCH
Rotterdam 1629–Amsterdam 1684
A Mistress and Her Servant, ca. 1660
(Inv. No. 943) Oil on canvas
21 × 16½″ (53 × 42 cm)

Above
PIETER JANSSENS (ELINGA)
Bruges 1623–Amsterdam ca. 1682
A Dutch Interior
(Inv. No. 1013) Oil on canvas
24 × 23″ (61.5 × 59 cm)
(Ex coll. P.P. Stroganov, St. Petersburg, 1912)

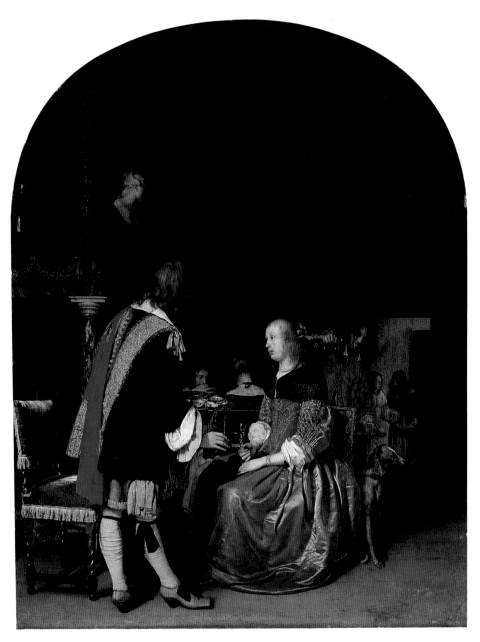

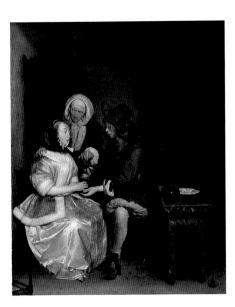

GERARD TER BORCH
Zwolle 1617–Deventer 1681
The Glass of Lemonade
(Inv. No. 881) Oil on canvas, transferred
from panel 26 × 21″ (67 × 54 cm)
(Ex coll. Empress Josephine, Malmaison, 1814)

FRANS VAN MIERIS THE ELDER
Leyden 1635–1681
Refreshment with Oysters, 1659
(Inv. No. 917) Oil on panel
17½ × 13½″ (44.5 × 34.5 cm)
(Ex coll. Brühl, Dresden, 1769)

Opposite
FRANS VAN MIERIS THE ELDER
A Young Woman in the Morning, ca. 1659/60
(Inv. No. 915) Oil on panel
20 × 15½″ (51.5 × 39.5 cm)
(Ex coll. Brühl, Dresden, 1769)

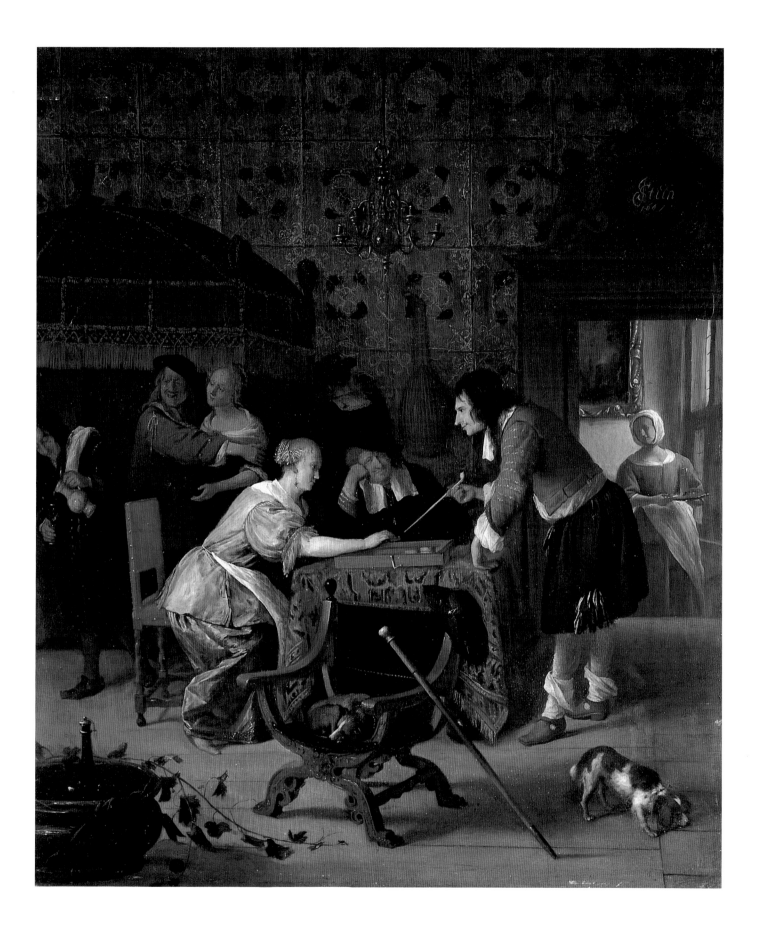

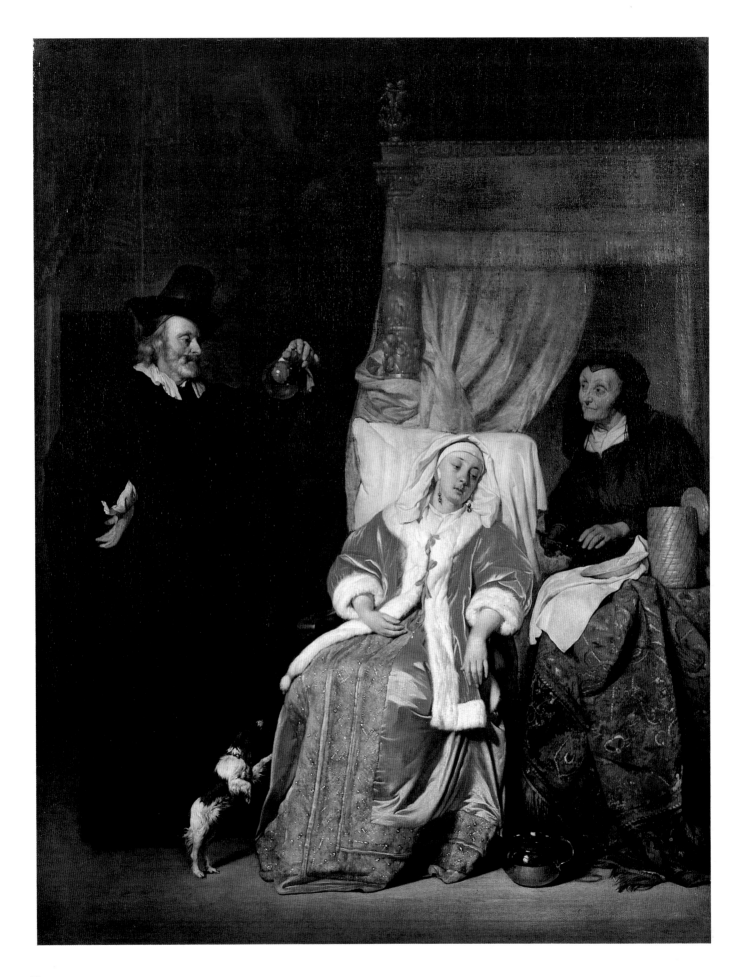

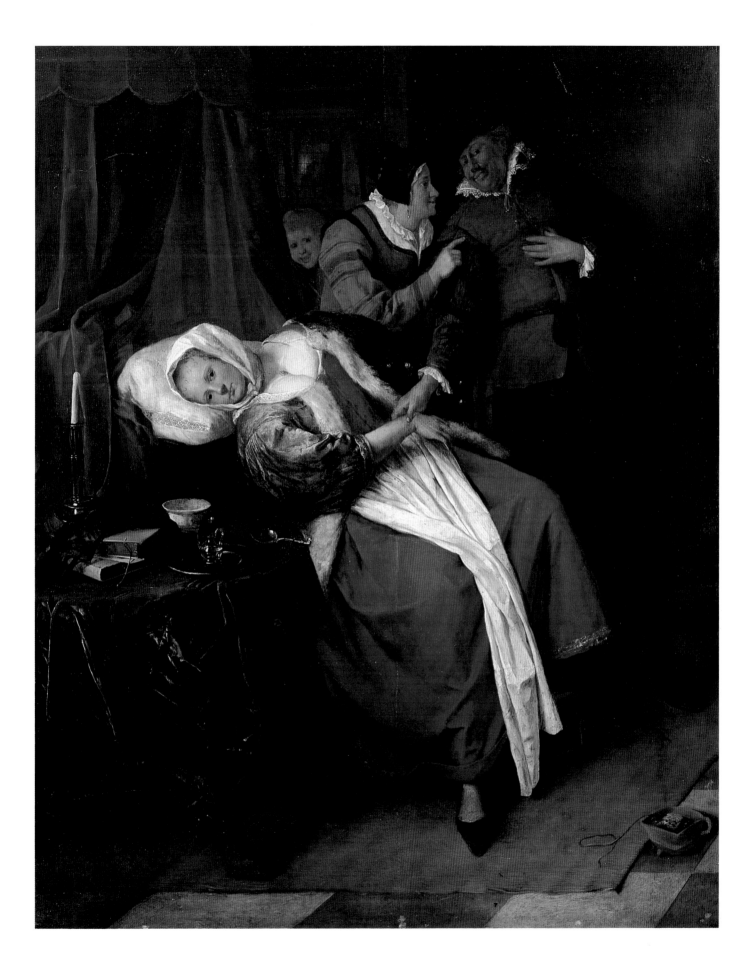

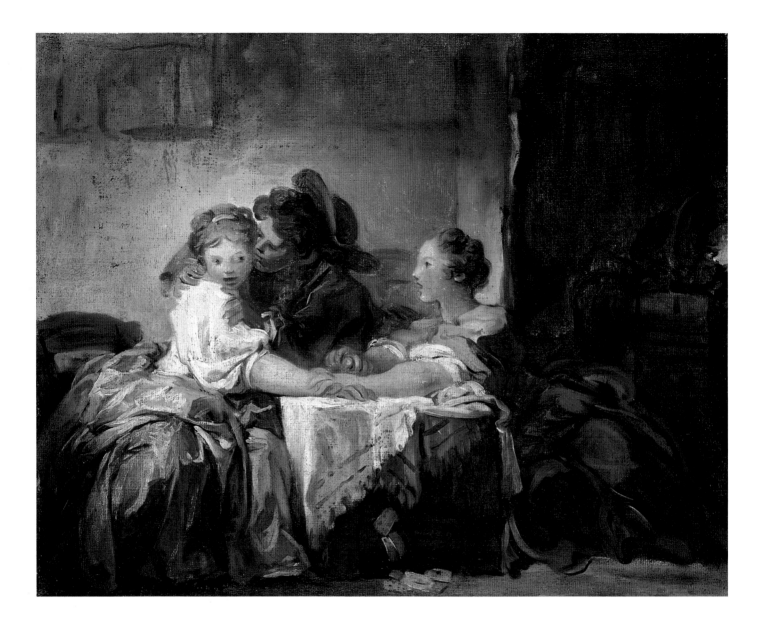

also in Frans van Mieris the Elder's *Refreshment with Oysters* (426). Playing musical instruments, drinking, and eating oysters or other aphrodisiac foods, men and women keep Merry Company in jolly scenes popular among the Dutch and only a little less so in the Catholic countries to the south.

A *Young Woman in the Morning* (427), also by van Mieris, may again show a prostitute. A bed looms large in the background, empty slippers in the foreground (implying sexual abandon), with both the woman and her maid watching a little dog turning a trick, possibly a reference to the woman's profession as well as to her customers: Dogs symbolize obedience, but then there's only the finest of lines between service and obedience.

While there is seldom anything ambiguous as to how near or far, high or low, wide or narrow the interior may be, that's where certainty often ends. Events taking place within four walls—allowing for the one we are without—abound in mystery. Exactly what is that lady

JEAN-HONORÉ FRAGONARD
Grasse 1732–Paris 1806
A Kiss Won
(Inv. No. 5646) Oil on canvas
18½ × 23½" (47 × 60 cm)

Opposite
JEAN-HONORÉ FRAGONARD
The Farmer's Children
(Inv. No. 1179) Oil on canvas
19½ × 24" (50 × 60.5 cm)

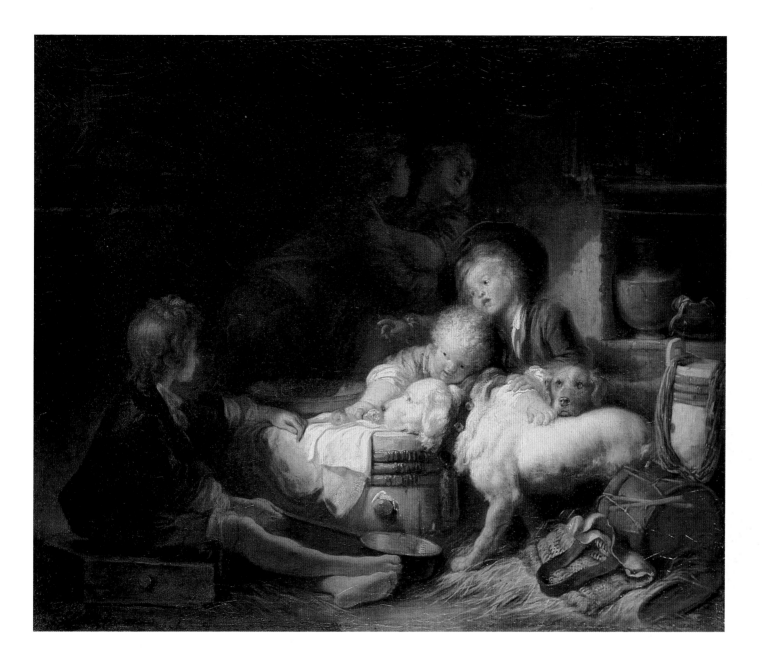

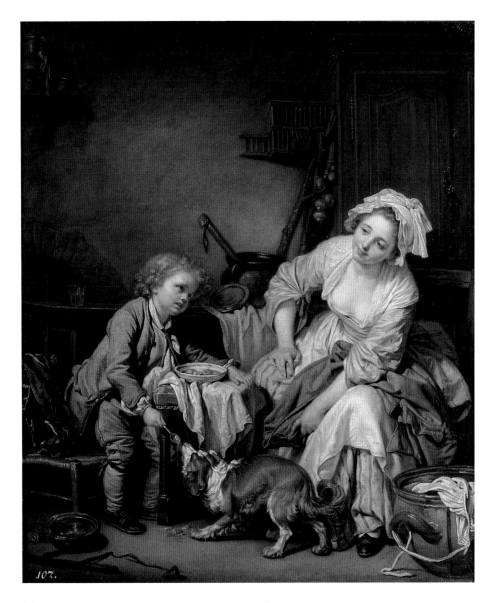

Above
JEAN-BAPTISTE GREUZE
Tournus 1725–Paris 1805
The Spoiled Child, 1765
(Inv. No. 5725) Oil on canvas
26 × 22" (66.5 × 56 cm)

Opposite
JEAN-BAPTISTE SIMÉON CHARDIN
Grace Before a Meal, 1744
(Inv. No. 1193) Oil on canvas
19½ × 15" (49.5 × 38.4 cm)

telling her servant? Who is the visitor? Are those children up to some sort of nastiness? Is there a moral or immoral reading, a double entendre or proverb to explain the caged bird, herring-eater, onion-holder, or a cavalier's suggestive stirring of his beflounced companion's lemonade? (426) Countless cryptic sayings, often vulgar or pithy, close to the anonymous wisdom of street or marketplace, of sewing circle or barnyard may be hidden in Dutch pictures, so much so that far more may be going on than present-day dealers or collectors might care to admit.

A certain exquisite smugness pervades some of those paintings where a *poule de luxe* is about to find out whether she is pregnant or merely dropsical as a doctor examines her urine. Morality, humor, satire, envy, self-righteousness, and even fear war with one another just below the smooth surface of the state of such art, despite the deceptive neutrality of its Vermeer-like, immaculate conception, as in Gabriel Metsu's exquisitely nacreous painting (430). Jan Steen's handling of the same subject (431) is much lighter, more humorous and compassionate, painted with a glancing touch followed by Watteau and Lancret in the next century.

French painters of the Rococo returned to the Dutch masters of the preceding century for suitably picturesque subjects and techniques. Fragonard went back to the free brushwork of Rubens and Rembrandt, knowing the latter's oeuvre particularly well, as he, like the earlier artist, was also active as an

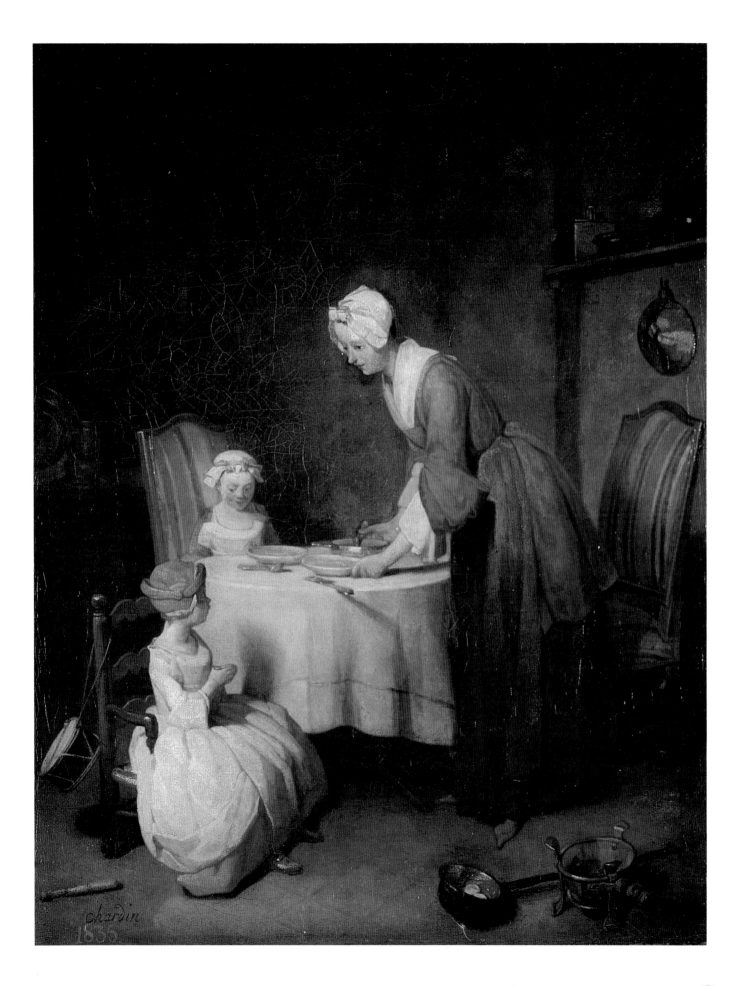

JEAN-BAPTISTE GREUZE
A Visit to the Priest, 1786
(Inv. No. 7521) Oil on canvas
49½ × 63″ (126 × 160.5 cm)
(Ordered from the artist by Grand Prince
Pavel Petrovich, 1780)

etcher. His *A Kiss Won* (432) has a brisk, beautiful freedom all its own: The theme of the game legitimizes the picture's subject—winning at cards lets the youth seize his prize. Amorous high-jinks also animate the background of Fragonard's *The Farmer's Children* (433), whose anecdotal approach already reflects the revival of Murillo's art. Steeped in a rather sugary view of the fertile joys of farm life, this canvas was submitted by Fragonard to the Royal Academy in 1765 at the time of his election.

An equally contrived view of childhood was cooked up by Jean-Baptiste Greuze, placing his *Spoiled Child* (434) in the kitchen, slipping food to a dog. Calculated to please, this canvas is typical of Greuze, ever allowing for a little peekaboo eroticism to enliven his most moralizing subjects. Here a deep décolletage helps "spoil" the purchaser. The painter, much publicized by Diderot, enjoyed the patronage of the greatest families of imperial Russia, both as their portraitist (510, 533) and purveyor of paintings—selling them his own works along with those of his contemporaries—replacing Grimm as agent for Catherine II. Her son, Pavel Petrovich, was among Greuze's patrons, visiting his studio (and that of Houdon) under the pseudonym of the Comte du Nord.

Even the most elaborately conceived of Greuze's narrative compositions may prove to be beautiful, such as the Hermitage's *A Visit to the Priest* (436), for which the French painter has moderated his use of color, producing a cinematic picture of the sort defined and de-

fended by Diderot as "moral painting": "Well! hasn't the brush been consecrated to debauchery and vice for long enough—for too long! Should we not be pleased to see it compete with the drama in an effort to touch us, to instruct us, to correct us and invite us to virtue? Courage, my friend Greuze, paint moral pictures and go on painting them." These lines (translated by Anita Brookner) were penned for the Hermitage's *Paralytic Sustained by His Children*, but could just as well apply to the same museum's *Visit.* Here a priest reproaches a luscious maiden, presumably for "unseemly behaviour," chastising her before her mother, siblings—and dog. Appropriately, Greuze dedicated its reproductive print to priests: "It is to you, preservers of Religion and Morality, spiritual fathers of all citizens, that I owe the idea for this painting. . . ."

NICOLAS LANCRET
The Marriage Contract, ca. 1738
(Inv. No. 1132) Oil on copper
11 × 14" (28 × 36.5 cm)

Among Greuze's few followers was Louis-Léopold Boilly, a fellow member of the Société des Amis des Arts, who continued Greuze's satin surfaces and quality of intimacy, as in his charming *In the Entrance* (438), though here there is a greater sense for the abstract and a certain Neoclassical stiffening, despite the loose ladies' presence. New Empire fashions are present in Boilly's *A Game of Billiards* (439), whose silvery surfaces go back to seventeenth-century little Dutch masters.

Very different from Fragonard's more spontaneous early manner is his sleek, smooth painting of *The Stolen Kiss* (439, 440–41), related in theme but certainly not in style or circumstance to his previous illustration of that theme. A young, confident lover in an affluent setting enters to kiss a surprised young woman. Her outstretched hand holds a fluttering scarf of striped silk gauze—an abstract expression of her mixed emotions. This image is sometimes described as a pendant to Fragonard's still-controversial painting, *The Bolt* (Louvre), where a woman is about to be raped, she and her lover-attacker caught in an intensely balletic pose as he slams a bolt on the bedroom door. Yet a far-likelier companion to the Hermitage's picture is a more polite image, now lost, *The Contract*, reproduced in print form in 1792.

Nicolas Lancret's depiction of that same subject (437) is a reworking based on Jan Steen's models but without their liveliness. This subject shows the *promesse de mariage*, a notarial registration of civil marriage, acceptable to Protestants of the time while Catholics also required a church ceremony.

Parisian nightlife of the Naughty 90s, with its music halls and *café-concerts*, provided new variety and accessibility in a turbulent mix of class and taste. Artists, aware of the suffering and the injustice that went with *Gai Paris* in its most gilded, empire-building age—that of the unfair, if belle, époque—revealed the flip side of what most

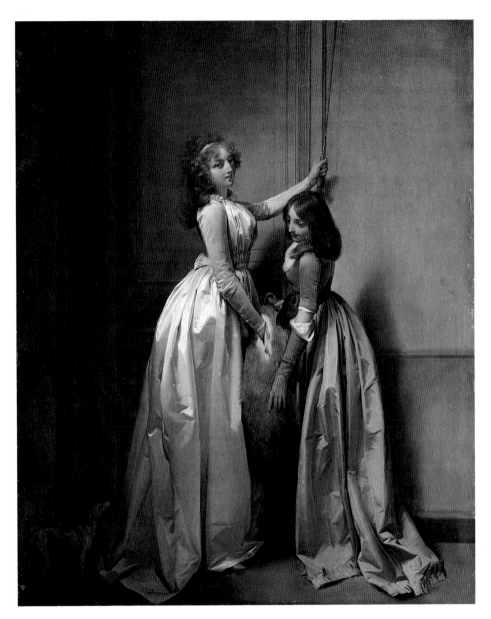

LOUIS LÉOPOLD BOILLY
La Bassée Nord 1761–Paris 1845
In the Entrance, 1796/98
(Inv. No. 6643) Oil on panel
16 × 12" (40 × 31 cm)

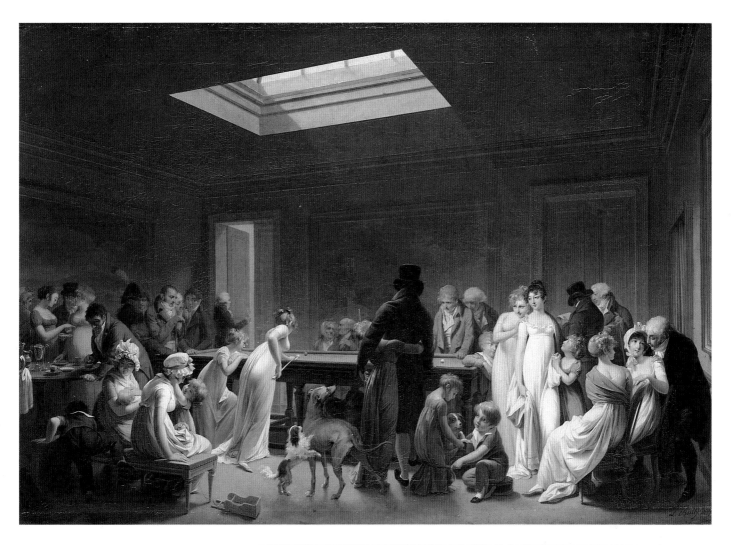

Above
LOUIS LÉOPOLD BOILLY
A Game of Billiards, 1807
(Inv. No. 5666) Oil on canvas
22 × 32″ (56 × 81 cm)

Right
JEAN-HONORÉ FRAGONARD
The Stolen Kiss
(Inv. No. 1300) Oil on canvas
18 × 21½″ (45 × 55 cm)

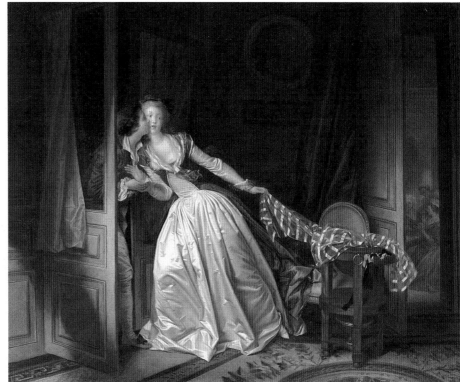

Overleaf
JEAN-HONORÉ FRAGONARD
The Stolen Kiss (detail)

JEAN-LOUIS FORAIN
Reims 1852–Paris 1931
Music Hall, 1890s
(Inv. No. 8996) Oil on canvas
20 × 24″ (50.5 × 61 cm)
(Ex coll. S.I. Shchukin, Moscow)

Opposite
ALFRED HENRY MAURER
New York 1868–1932
In a Café, 1905
(Inv. No. 8919) Oil on cardboard
35½ × 31″ (90 × 79.5 cm)

visitors perceived to be an endless round of entertainment. Like Degas and Toulouse-Lautrec, Jean-Louis Forain showed the life of the *Music Hall* (443), where, safely out of the rain, prostitutes and clients awaited one another.

Five women, eating together in an otherwise almost empty Parisian restaurant, may also be streetwalkers, fortifying themselves before a night's work *In a Café* (442). This canvas is one of the very few surviving early works by Alfred Maurer, who painted in this dazzlingly Impressionistic style before abandoning it for a heavy-handed,

repetitious Expressionism. Like many artists of the later nineteenth century, Maurer adopted the oblique new viewpoints afforded by the camera and the Japanese print.

Music can keep familial discord at bay. The reassuring tedium of practice and the freedom from oneself (and everyone else) so readily, if briefly, afforded by amateur pianism allow for privacy and harmony. Paul Cézanne showed his mother sewing as his sister plays away at a piano version of the overture to *Tannhauser* (445). Similarly, Félix Vallotton paints Mme Vallotton,

FÉLIX VALLOTTON
Lausanne 1865–Neuilly-sur-Seine 1925
Woman at the Piano (Madame Vallotton)
(Inv. No. 4860) Oil on canvas
17 × 22½" (43 × 57 cm)

Opposite
PAUL CÉZANNE
Aix-en-Provence 1839–1906
Young Girl at the Piano
(Overture to Tannhauser), ca. 1868/69
(Inv. No. 9166) Oil on canvas
22½ × 36" (57 × 92 cm)
(Ex coll. I.A. Morozov, Moscow)

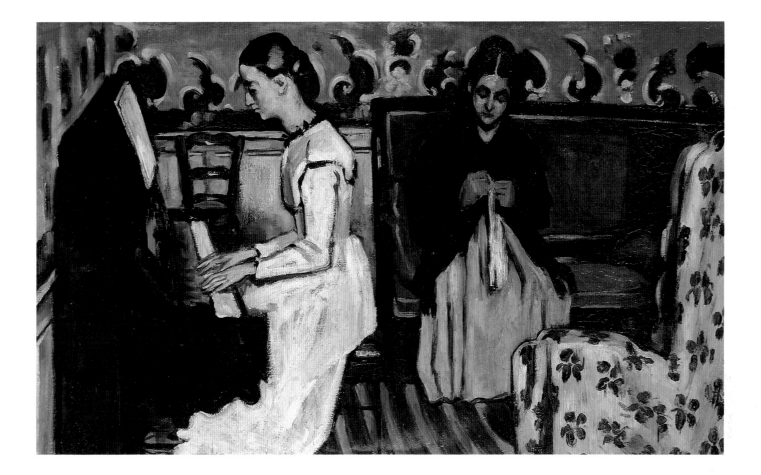

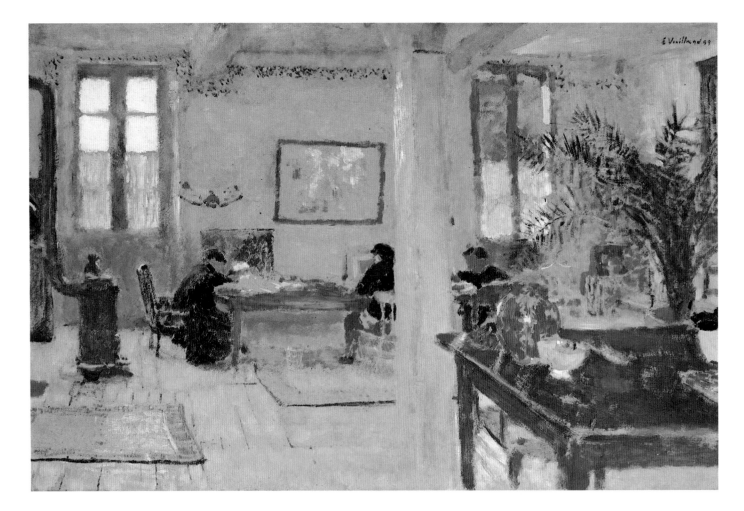

amidst cozy domestic clutter, at the keyboard whose rich harmonies reinforced concord (444).

Some of the most evocative interiors are those by Édouard Vuillard, who pictured them as if the space spoke to him as well as the people (446, 448–49). The ultimate *intimiste*, his unassuming scenes, so many of them set in his mother's Parisian apartment and workroom, have the serenity and completeness of a Japanese screen: tranquil, without a trace of smugness or striving for effect.

Few artists of their time had such a sense for the pleasures of the everyday, for the beauty of the ordinary, as Vuillard and Pierre Bonnard, theirs an exaltation of the discreet charms of lower bourgeois

domesticity. Even when very rich patrons wandered into these artists' pictures, they came out (at least on canvas) with wiser, more reasonable joys and simpler styles of life.

Working in a somewhat primitivistic manner, not far from Puvis de Chavannes, Maurice Denis painted hymns to the joys of the comfortable life, his *Mother and Child* (447) anticipating the colors of Picasso's Blue Period. Virgilio Guidi's little-known *The Visit* (447) is one of the Italian paintings acquired by the Hermitage when Russia was exchanging pictures by her new generation for those by Italians.

Predictably, this century's most daring, wisest interiors were those

painted near its very beginning by Henri Matisse. He knew how that seemingly secure division between interior and exterior was as artificial and meaningless as nations' borders. Wherever we may be, we almost always know there's another world out there, sensing a continuum between within and without.

Matisse's two large canvases, of a couple separated by a window— *The Conversation* (452)—and of a maid setting a table, a garden-filled window to the left—*Harmony in Red* (453)—delineate the fragile, permeable borders between human order and nature, the window in each painting barely able to contain trees' and flowers' growth. Totally absorbed by her task of placing fruit in a compote, the housekeeper

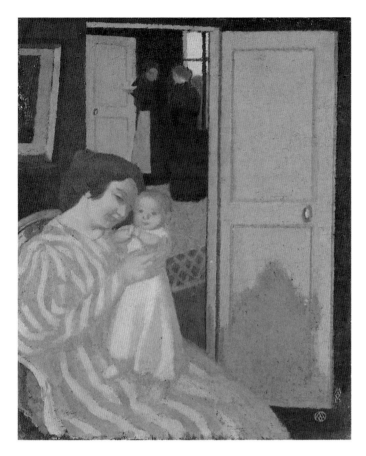

MAURICE DENIS Granville 1870–St-Germain-en-Laye 1943
Mother and Child, 1890s
(Inv. No. 8893) Oil on canvas
18 × 15″ (46.5 × 39 cm)
(Ex coll. I.A. Morozov, Moscow)

VIRGILIO GUIDI Rome 1891–
The Visit, 1928
(Inv. No. 9114) Oil on canvas
57 × 50″ (145 × 127 cm)

Opposite
JEAN ÉDOUARD VUILLARD Cuiseaux 1868–La Baule 1940
In a Room, 1893
(Inv. No. 6538) Oil on cardboard, glued to panel
20½ × 31″ (52 × 79 cm)
(Ex coll. S.I. Shchukin, Moscow)

Overleaf
JEAN ÉDOUARD VUILLARD *In a Room* (detail)

sets a handsome table as if arranging her own still life, assuming some control over fertility, ordering the anarchy of nature.

The Conversation seems an ironic title for a canvas whose couple—the artist and his wife—may have reached a place of stalemate, or at least a polite standoff. Separating them, the window is alive with the lyrical undulation of wrought-iron grillwork seen just before a garden, its blue ovals ready to float into the couple's equally blue room. Three bold statements make this scene so successful: the denial and affirmation of barriers between interior and exterior, between man and woman, between past and present. Writing to Matisse in 1912, Shchukin observed: "I often think of your painting. . . . It reminds me of a Byzantine enamel, so rich and deep in color. It is one of the most beautiful paintings in my memory."

The couple's pose and placement recall figures on Greek funerary reliefs, where the deceased is often seated—always shown alive—opposite a standing deity, guide to the next world. Far taller than her columnlike companion, the woman holds a pose endowed with the splendor of an enthroned archaic goddess. Only in an interior, especially one as ambiguous and complex as this can quite so much be conveyed. For the qualification of relationships, their confines must be quantified. In that most difficult area of "telling it like it is," the "it" has to be shown *where* it is, which is precisely what Matisse, with his usual Classical audacity, has done.

In their living room, the same artist paints his wife and their three children in a rather studiedly "informal" grouping (451). The boys play checkers as their sister sews; their mother takes a mildly supervisory stance, letter or yellow paper-bound book in hand. Here Matisse goes back to a popular eighteenth-century genre known as the Conversation Piece, where the stiff collectivity of the family portrait was to be diminished by a re-creation of some domestic scene. Hostage to their *pater familias*'s daunting creative presence, the Matisse clan doesn't quite convey the blithe charm of Gainsborough's or Hogarth's groups.

Decorative arts help keep them together: The wildly varied patterns of carpet, checkerboard, two divans, wallpaper, tiled mantelpiece (and of its embroidered cloth bearing vases separated by a Matisse statue), assert an individuality all too separate but equal, that quality not yet permissible in wife or children. These are still shown with that static fixity of "knowing their place," kept together by a magic carpet.

Matisse's use of pattern was stimulated by his visit to Munich for a large Islamic exhibition the preceding year. Here the interior is realized in almost mosaic fashion, this painter's vivid, authoritative color code becoming the law for countless twentieth-century artists, whether working on inner, outer, or purely abstract spaces.

HENRI MATISSE
Le Cateau-Cambrésis 1869–Cimiez 1954
Family Portrait, 1911
(Inv. No. 8940) Oil on canvas
56 × 76" (143 × 194 cm)
(Ex coll. S.I. Shchukin, Moscow)

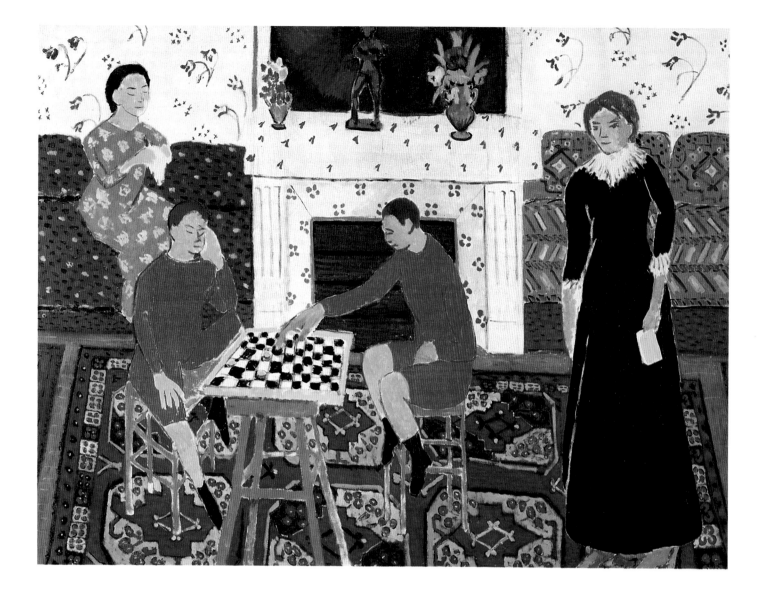

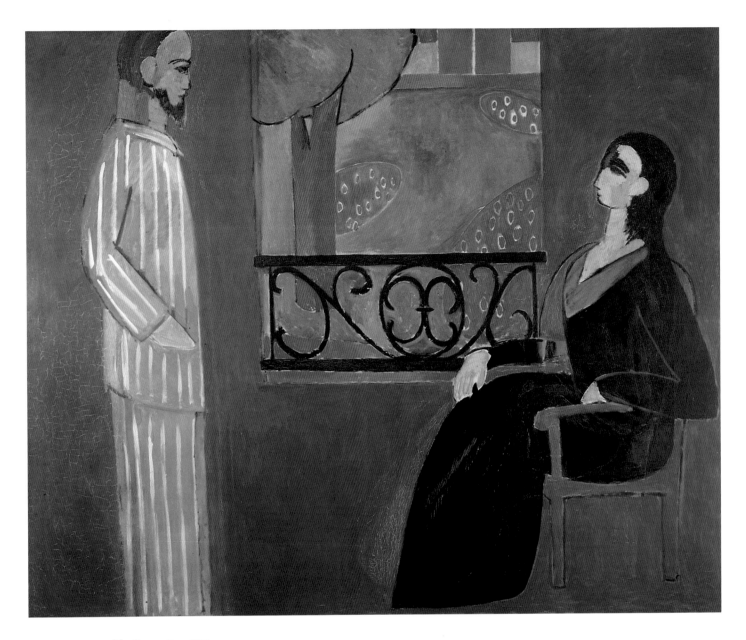

HENRI MATISSE *The Conversation,* 1909
(Inv. No. 6521) Oil on canvas
69½ × 85½" (177 × 217 cm)
(Ex coll. S.I. Shchukin, Moscow)

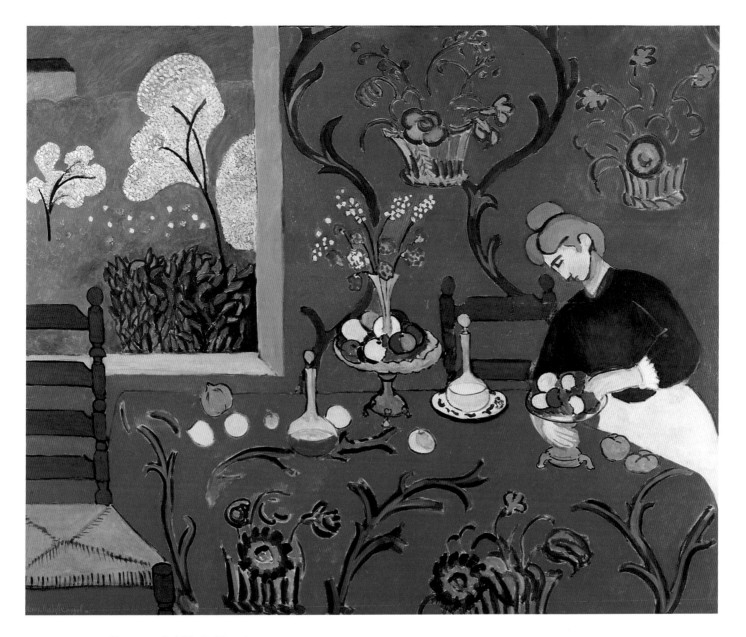

HENRI MATISSE *Harmony in Red (The Red Room)*, 1908
(Inv. No. 9660) Oil on canvas
71 × 86½″ (180 × 220 cm)
(Ex coll. S.I. Shchukin, Moscow)

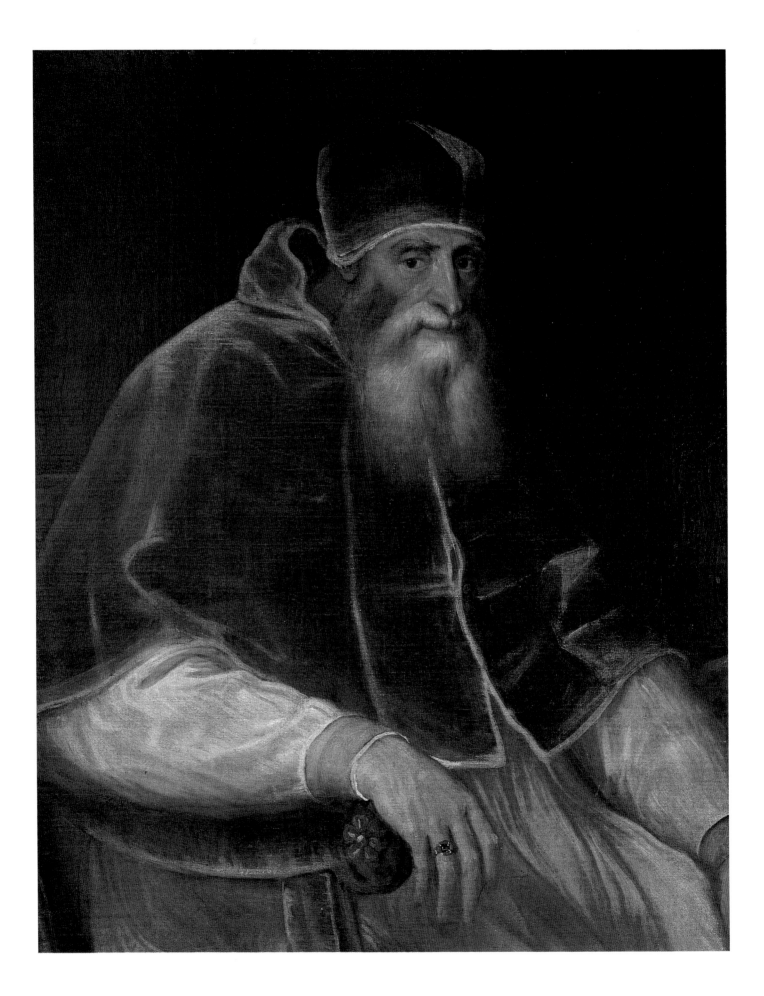

Presenting a life as an individual likeness on a single page—the canvas—portraiture is the art of quintessential biography, limited only by the sitter's wishes and the painter's gifts. When the subject is young, the artist may anticipate the future—the painter as prophet. If the sitter is older, the artist often recalls the past.

These images are monologues: The entire burden of a drama falls upon a single actor, with the painter responsible for all else—writing the script, designing the set, defining the character, choosing the lighting, controling everything but the length of the act, which is eternity. Portraits have to combine a quality of the momentary (if not of spontaneity) with a sense of timelessness, one of the most challenging of painterly achievements.

The face, that battlefield of time etched by its victories and defeats, presents painting's greatest challenge. Since most portraits are paid for by their subjects, the artist is often caught in a double bind. By the time a likeness is affordable, a patron may not care for what they see: an image of a person older if not wiser than they wish to be perceived. What is wanted is an unlikeness, a flattering intimation of Once upon a Time. If never the Fairest One of All, theirs is to be an an image of what might have been, with the addition of a few charmed years.

TITIAN *Pope Paul III*, 1548
(Inv. No. 122) Oil on canvas 38½ × 31″ (98 × 79 cm) (Ex coll. Barbarigo, Venice, 1850)

But portraits address three sitters—just as we have a full face with dissimilar left and right halves (providing the "good" and the less conventionally satisfactory profile)—and it is the trinity of Me, Myself, and I that the painter must convey. The first is the outer person, the second the inner, and the third that ever-shifting, constant compromise between the two that is the "real you." Even if the likeness is acceptable on an official, public level, it will fail if it does not impart an inkling of the invisible, critical mediation between the two.

For most of us, few things are harder than facing ourselves as we are, whether on film or tape. Much effort is spent in seeing ourselves "to suit," readjusting that reflection, reconciling reality and expectation. So portraiture is often the art of reconciling hope and reality, a polite mirror whose surface preserves likeness without stress.

So central is our passion for portraiture to the genesis of art that Alberti made Narcissus the inventor of painting. That youth's fatal infatuation with, and acceptance of, illusion made him the first art lover, perishing in the embrace of his self-image, seen in the water.

Often perilous for painter and sitter alike, portraiture is a critical conjunction of seeing and knowing, recognition shared by artist, patron, and viewer. Some of the best portraits come close to labors of love, in which the artist, like Narcissus, sees what is best in himself or herself reflected in the sitter, while the latter participates in the remaking of his or her own being by a rich process of sympathetic magic, silently sharing, encouraging, shaping the illusionistic regeneration of self so that the result, to steal today's term, becomes the Significant Other.

Posture and gesture can be almost as expressive as physiognomy. Head and neck, back and shoulder, hand and wrist, ankle and foot, each engaged in uniquely eloquent partnership, contribute to an intricately, intimately personal presentation of character and condition. Though the artist must listen to the sitter's chat, the finest images result from the painter's response to the subtle dialogue of body language, in which all these expressive interactions and silent partnerships are asserted.

Hats and shoes, gloves and laces, military orders and fancy furnishings, can all have almost as much to say as a face or hand when it comes to conveying class and character. Ingres drove his sitters mad by endless changes in dress and jewels, sometimes extending the length of time for the execution of a commission by more than a decade, during which fashions changed and waists widened. The portraitist may need to be a dressmaker and tailor, furniture designer and draper, for the wrong dress can ruin the finest of canvases, the too-bulky desk, the best of compositions.

At its richest, the self portrait assumes an allegorical dimension, mirroring the whole creative process, that of painting depicting itself. Working for themselves, by themselves, acting as models and artists, the makers of self-images may exercise unusual freedom, as seen in Samuel van Hoogstraten's portrait of himself drawing a nearby spire in his native Dordrecht as he leans upon a windowsill, his long face catching the light (page 459). Obsessed by the special illusionism of perspective and other trompe l'oeil devices, this unusually talented artist concentrated upon extending the limits of art, that desire felt in this self-image, designed to suggest a sudden encounter.

Among the most remarkable of all self-images is the strikingly modern one by Annibale Carracci (457), included with great audacity as a picture within a picture, still freshly painted, resting on the easel, a palette just below, in the artist's convincingly sloppy studio. By seeing his image in Carracci's time and space, the viewer becomes the artist, assuming his creative identity. A slender statue to the left has been identified as that of Terminus by Mathias Winner—the Roman god standing for the border between life and death, a division transcended by art. Windsor Castle has a sheet with two preparatory sketches for this canvas; in one a horde of dogs and cats stand behind the front legs of the easel, but in the finished work the menagerie has been reduced to one of each.

Anthonis Van Dyck, in the next century, shunned all the attributes of art to present himself as an arche-

ANNIBALE CARRACCI Bologna 1560–Rome 1609
Self Portrait, 1590s
(Inv. No. 77) Oil on panel
17 × 12" (42.5 × 30 cm)
(Ex coll. Crozat, Paris, 1772)

GIUSEPPE MARIA CRESPI Bologna 1665–1747
Self Portrait, ca. 1700 (Inv. No. 189) Oil on canvas
24 × 19½" (60.5 × 50 cm)
(Ex coll. Baudouin, Paris, 1781)

century armor. The Hermitage has an unusually rich collection of works by Feti, an artist of subtle, inventive talents who died at the early age of thirty-five. Rosa shows himself dressed as a contemporary bandit, or *Pasquariello* (484), taking on aspects of the active, violent life so appealing to those locked away in their studios, and particularly suitable to Neapolitan mores.

Titian's portrait of Pope Paul III enthroned, and somewhat resembling a cornered old wolf (454), never went to its sitter, remaining in the artist's house instead, until the latter, with all its contents, including many of the canvases, was sold to the Barbarigo family. The papal sitter actually received somewhat kindlier images, executed largely by Titian's studio, and now in Naples and Venice. The Hermitage's painting, unusually thinly painted and poorly preserved, may also have worked as a preparatory sketch for the superb *Paul III and His Grandsons* (Naples, Museo di Capodimonte), which includes the pope's *nipoti*, Ottavio and Cardinal Alessandro Farnese.

The miracle of Titian's art is that it is never an ikon in the old sense of the word—a static, hieratic, conservative image. Nothing seems more spontaneous or immediate than his brushwork, shimmering, immaterial, so that the form seems to rise, self-defining, from a magical haze. Where Eyckian or Masacciesque early-fifteenth-century portraiture still recalls other media—in the first case, the inspired miniature or waxwork, for the second, ancient marbles reborn—the High Renaissance likenesses from Venice were the pictorial equivalent of breaking the sound barrier, realized with an incomparable speed and freshness that were to reverberate into the present, in portraits by Floris, Hals, Fragonard, Manet, and Renoir.

typal gentleman (476), his languid ivory hands seemingly innocent of oils. Equally elegant, far from the studio's craft, is the introspective self-image of Michael Sweerts (504), one of the founders of Dutch Baroque Academicism, who steeped himself in Catholicism and went on to Indian travels.

Like Carracci, Giuseppe Crespi reveled in art's craft (458). In his self portrait, he holds a brush or drawing instrument in his right hand, wearing the turban that is so often conventional artistic headgear, as he takes a quick look in the mirror to guide his self-imaging.

Two striking Italian examples, each with pronounced, precociously Romantic overtones, are by the seventeenth-century masters Domenico Feti and Salvator Rosa. The first (484) may be a self portrait, for masks were a symbolic attribute of Pictura, the allegorical figure of painting. Of metal, this mask probably originated as part of a suite of early-sixteenth-

Portraiture has always been art's greatest power. Only painters and sculptors can confer immortality quite this readily, their images, if kept intact, surviving the sitters' death or disgrace. When the invention of photography was proclaimed in 1839, a member of the French Academy pronounced: "From today art is dead." If that same prophet of gloom had restricted his statement to "From today portraiture is dead," there would have been far more truth to his bitter prognostication. Artists continued to grow rich through por-

traiture, for only the society portrait can suffice for those who require images of power and prestige. While the Ingreses, Winterhalters, Makarts, and Lenbachs all prospered, portrait painters of the third and fourth ranks almost vanished from the scene. Killed off by Daguerre and Kodak, these artists were forced to pursue that most ignominious of painterly fates, working after, tinting, or retouching the very photographs that had robbed them of their livelihoods.

In antiquity, however, portraiture was fully established as an honorable and remunerative profession. Ancestor worship and the cult of the emperor called for the production of the "speaking likeness," of the most telling, vivacious image, whose arresting verisimilitude justified or inspired faith in the miraculously ongoing powers of the dear or daunting departed. Often these images were stand-ins for the real man or woman, participating in ceremonies in their absence or illness, acting as surrogates-by-illusion.

Portraiture in sculpture and fresco, on canvas and panel, coin and medal, for monuments of victory over enemies or in death, at home and abroad, has always been an art of necessity, central to the structure of power, to the succession of rule, to the order of home, temple and government, making the heir apparent.

Between the fall of Rome and the various sporadic revivals of the portrait genre, the impact of portraiture lessened because successful likeness depends upon a high level of artistic sophistication. Later medieval rulers required statuary and other images on coins and banners, for charters and in devotional contexts; lesser mortals limited their likenesses to the diminutive, kneeling alongside a patron saint or huddled under the Virgin's protective mantle.

Only in the later fourteenth and early fifteenth centuries, at the time of the Early Renaissance, was there a new, less-inhibited concentration on the importance of the individual, one so long diminished by early Christianity's self-effacement and denial, by the Church Fathers' condemnation of vanity and pictorial self-promotion.

Most portraiture was quite literally marginal until well into the fifteenth century, though many of its greatest masters, including Jan van Eyck and Masaccio, showed themselves to be splendidly at home in the genre. Both produced group portraits and individ-

SAMUEL DIRCKSZ. VAN HOOGSTRATEN Dordrecht 1627–1678
Self Portrait (Inv. No. 788) Oil on canvas
40 × 31″ (102 × 79 cm)
(Ex coll. Anichokov, St. Petersburg)

ual likenesses, many of which were set in a liturgical context, perpetuating their subjects in Christian roles.

Pensive portraits of young men, one Venetian (460), the other Umbrian (461), show Late Renaissance portraiture at its very best. The first is by Jacopo Nigreti, known as Palma Vecchio to differentiate him from his less-distinguished grandnephew. Born near Bergamo, Jacopo retained much of the precision and realism of that area, to be tempered by a Giorgionesque lyricism once he began painting in Venice. The Hermitage's portrait is one of Jacopo's finest. With one hand tucked into his mantle, this sitter's pose recalls Roman sculpture. Some of the canvas's qualities are as close to Leonardo as to Giorgione. Palma endows his almost pudgy, shifty-eyed sitter with poetic grace, stressing his wealth by displaying such gentlemanly attributes as his fur-lined garb and prominent gauntlets.

Working in Umbria, Perugino evolved his own prosaic Classicism, a style upon which that of his student, Raphael, was to be founded. His very beautiful portrait of a young man (461), like Palma's, results from taking a none-too-appealing sitter and, by shrewd abstraction or classicization of feature, adding an ideal gloss.

Portraiture really came into its own near the end of the fifteenth century. Then a new self-satisfaction arose with the revival of a phrase from the rediscovered ancient Roman architectural treatise of Vitruvius to the effect that "Man is the measure of all things." Suddenly, no matter who they were, or how they looked, there was a new sense of entitlement to image, of the self's indulgence, the only requirement an obvious one—the money to pay. Far from coincidentally, these were boom years of early capitalist expansion, when the discovery of worlds new to European explorers, to the East and the West, brought riches through trade routes beginning and ending in the development of vast seaports in Antwerp and Lisbon.

Sumptuary rules prohibited people with cash but without class to dress like their "betters"; but money always talks, and it let the newly rich look the way they wanted. Few things conferred greater joy upon the socially aspiring than the commissioning of a portrait that showed them just the way they wished to be seen. More than merely rich, they are painted as entirely at ease with their claims to freshly elevated status.

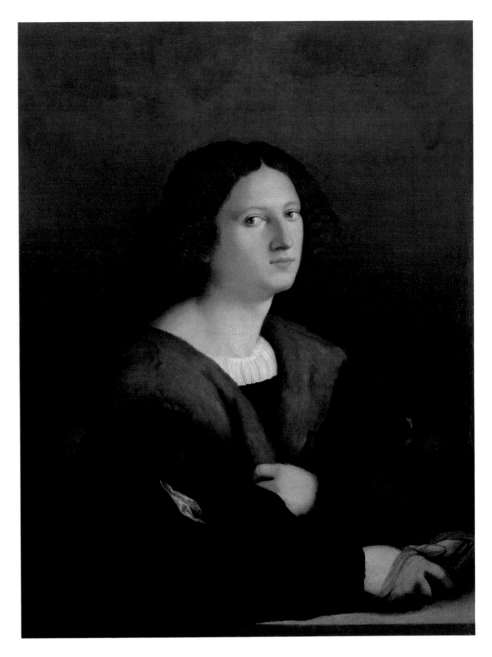

Above
PALMA VECCHIO (JACOPO NIGRETI)
Serina, near Bergamo ca. 1480–Venice 1528
Portrait of a Man, 1512/15
(Inv. No. 258) Oil on canvas
37 × 28″ (93.5 × 72 cm)

Opposite
PERUGINO (PIETRO VANNUCCI)
Città della Pieve ca. 1445/48–Fontignano 1523
Portrait of a Young Man, 1495/1500
(Inv. No. 172) Oil on canvas,
transferred from panel
16 × 10″ (40.5 × 25.5 cm)
(Ex coll. Yu. Lvov, St. Petersburg, 1850)

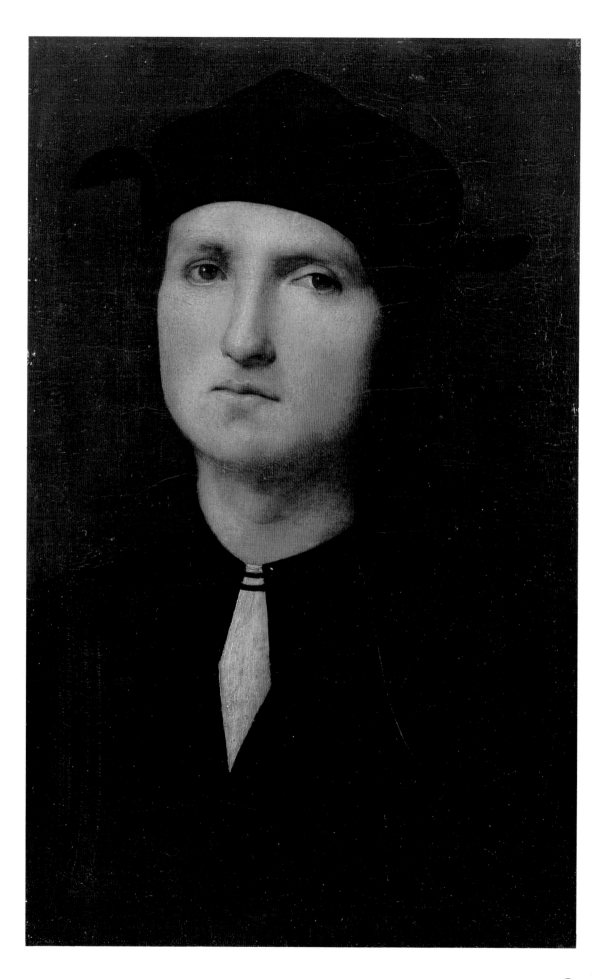

Such images were passports to the upper class, pictorial validation of aspiration, ready for installation by succeeding generations in halls of ancestor portraits. For the successful fabrication of these paintings, the artist needed to be far, far more than a shrewd, adroit limner of likeness. It fell to the portraitist to project ambition without condescension, to clothe the sitter in wealth without conveying the aura of the parvenu, which called upon the portraitist's skills as couturier and interior designer. The most successful portrait painters managed to convey a finely stitched seam of timeless prosperity, their sitters appearing as though to the manner and manor born, even if freshly risen from hovel, brothel, or guardsmen's barracks en route to those best things in life that have never been free.

Almost strangled by her massive gold chains, a wealthy young woman manages to look shrewd yet demure, beringed hands clasped in her lap (462). A Danubian landscape is visible in the distance, yet this painting was probably made when Lucas Cranach the Elder was at the Saxon court. Suitably crimped and sumptuously clad, this heiress' portrait proclaims her eligibility or engagement. Here the emphasis upon smoothness of brow and regularity of feature shows links between North and South, the interest of German-speaking lands in Lombard art, due, in part, to Maximilian's second marriage to an illegitimate Sforza of Milan.

Attributed to Antonio Correggio, a magnificent woman's portrait

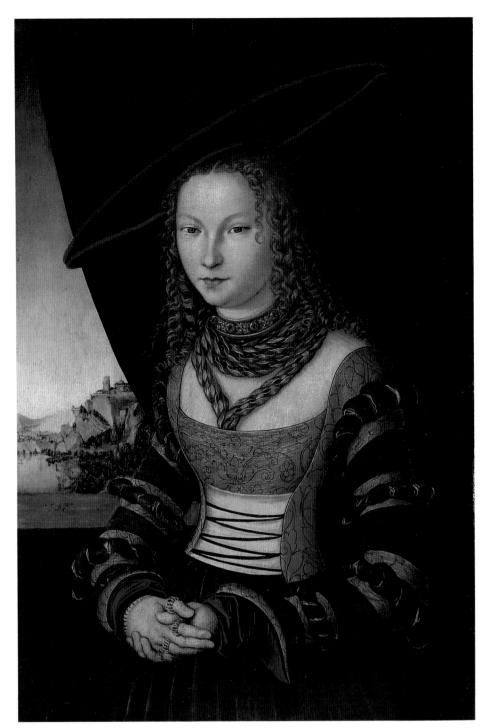

Above
LUCAS CRANACH THE ELDER
Kronach 1472–Weimar 1553
Portrait of a Lady, 1526
(Inv. No. 683) Oil on panel
35 × 23″ (88.5 × 58.6 cm)

Opposite
(Attributed to) **ANTONIO CORREGGIO**
(ANTONIO ALLEGRI)
Correggio, near Parma 1489 (?)–1534
Portrait of a Lady, ca. 1519
(Inv. No. 5555) Oil on canvas
40½ × 34½″ (103 × 87.5 cm)

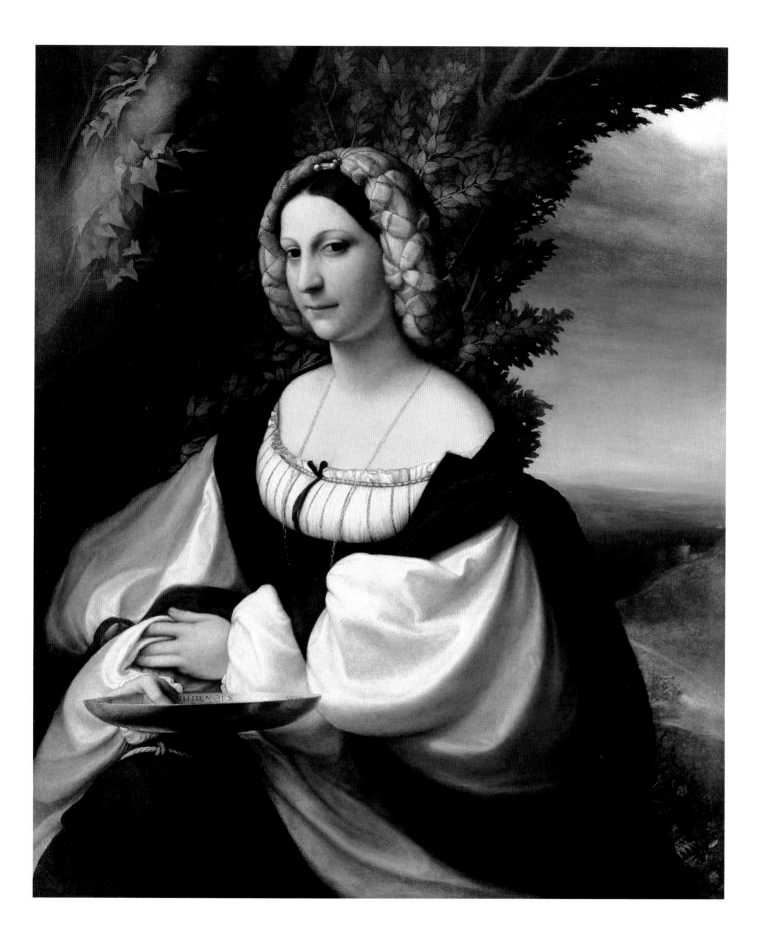

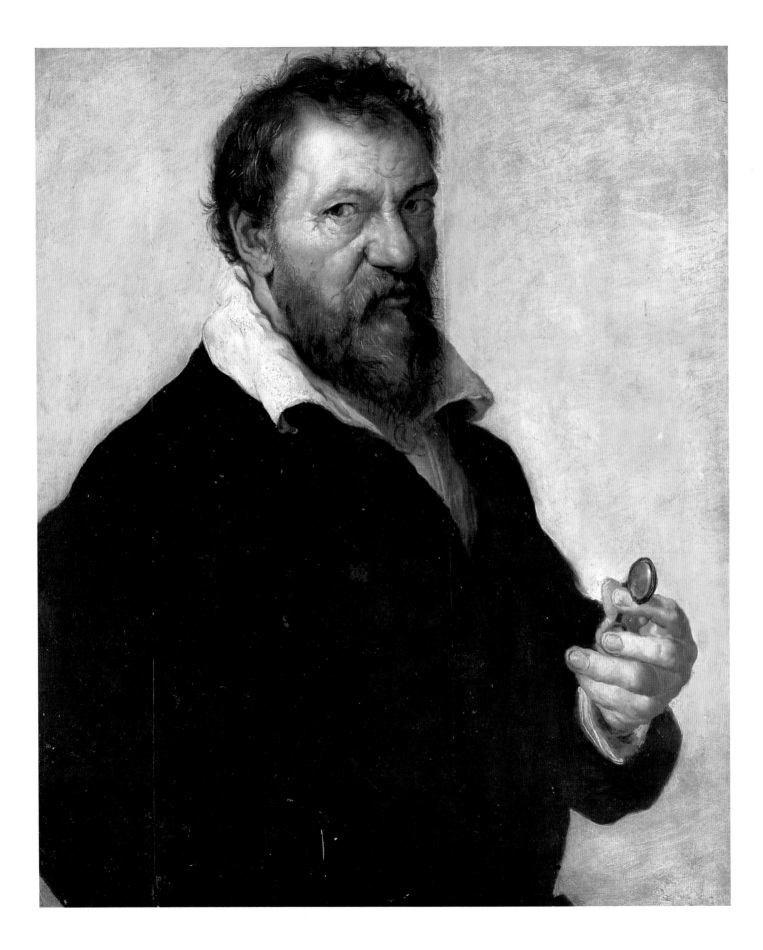

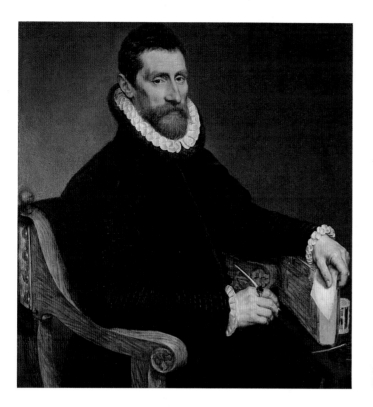

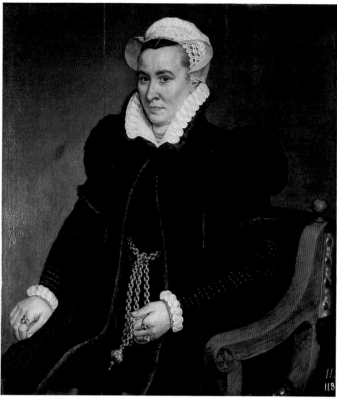

(463) has a breadth and monumentality that seem closer to Sebastiano del Piombo. The sitter holds a patera—an ancient sacrificial vessel—inscribed in Greek, its words taken from the *Odyssey* (1. 4,220): "Helen mixes an opiate that relieves pain, removes anger, and results in oblivion." Cecil Gould suggested that this labels the bowl's contents as nepenthe, an antidote to grief, and that the sitter therefore may be Ginevra Rangone, a Franciscan Tertiary and widow of Giangaleazzo da Correggio.

In that oddly off the shoulder male attire that was seen as good in Venice but bad North of the Alps, a rich young Augsburger (466) posed for Ambrosius Holbein, the son and elder brother of still-better-known painters, the two Hans Holbeins. A plaque proclaims the sitter's age to be twenty in 1518, as he appears proudly beneath a tri-

umphal arch. Though the castle just within the city walls may be sheer fantasy, its architecture a naïve combination of Venetian Gothic and Renaissance motifs, this might just be the sitter's dwelling. Most of Holbein's Italianate decorative motifs had already been worked out in a woodcut alphabet he designed for the Basel humanist printer Johann Froben. This fine portrait is among Ambrosius's final works; he died the following year.

The sort of Venetian glamor that Holbein (and his sitter) strove for is seen in a dashingly Giorgionesque portrait by the little-known Domenico Capriolo (467), an inscription of whose name encircles a goat in a medal at the lower right. (The Italian word for goat, *capra*, is close to the artist's name.) The polar attractions of antiquity and of faith are represented by the statue of Venus and the church view.

Two other Venetian portraits show the sense of clear-eyed objectivity that can pervade this genre. Paolo Veronese, with his characteristically beautiful color (468), modifies a rather cold glance found also in a male portrait by Giovanni Battista Moroni (468).

French sixteenth-century portraiture is represented by four unusually fine works in the Hermitage. The three smaller, more intimate works include an exquisite Corneille de Lyon (470); a man whose image is inscribed *Mr. Le Duc D'alençon* (470), from the same school; and a startling, closely observed youth by Pierre Dumoustier the Elder (473).

The fourth is a self portrait by Lambert Lombard (464). The burly, Falstaffian aspect of this correspondent of the Florentine painter, architect, and art historian Giorgio Vasari, ill accords with preconceptions of just how the official founder of Renaissance instruction in painting in his Liège academy ought to look. Here he works in a proto-Halsian manner, reserving a smooth, more conventional approach for his official commissions. Several versions of this image exist.

Children have always been extremely hard to paint—it is too easy to make them look like midgets, grotesquely overdressed, burdened by parental hopes, prematurely aged by pictorial rigor. Only in fifteenth-century France and Flanders and early-sixteenth-century Venice did the portraiture of the very young become successful.

A Continental painter, possibly

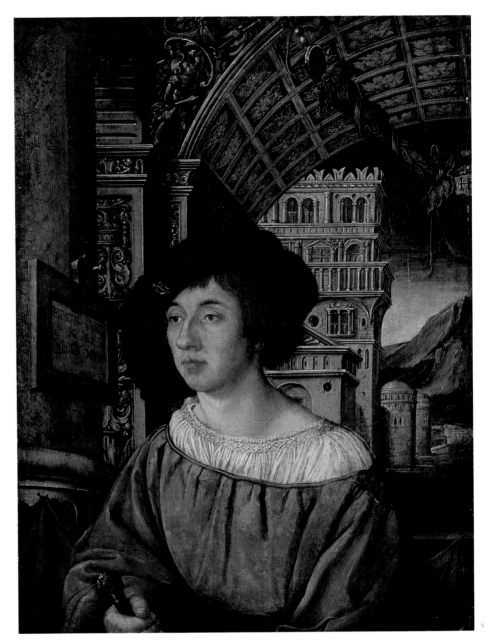

Above
AMBROSIUS HOLBEIN
Augsburg ca. 1494–Basel (?) ca. 1519
Portrait of a Gentleman, 1518
(Inv. No. 685) Oil on panel
17 × 13″ (44 × 32.5 cm)

Opposite
DOMENICO CAPRIOLO
probably Venice 1494–Treviso 1528
Portrait of a Gentleman, 1512
(Inv. No. 21) Oil on canvas
46 × 33½″ (117 × 85 cm)
(Ex coll. Crozat, Paris, 1772)

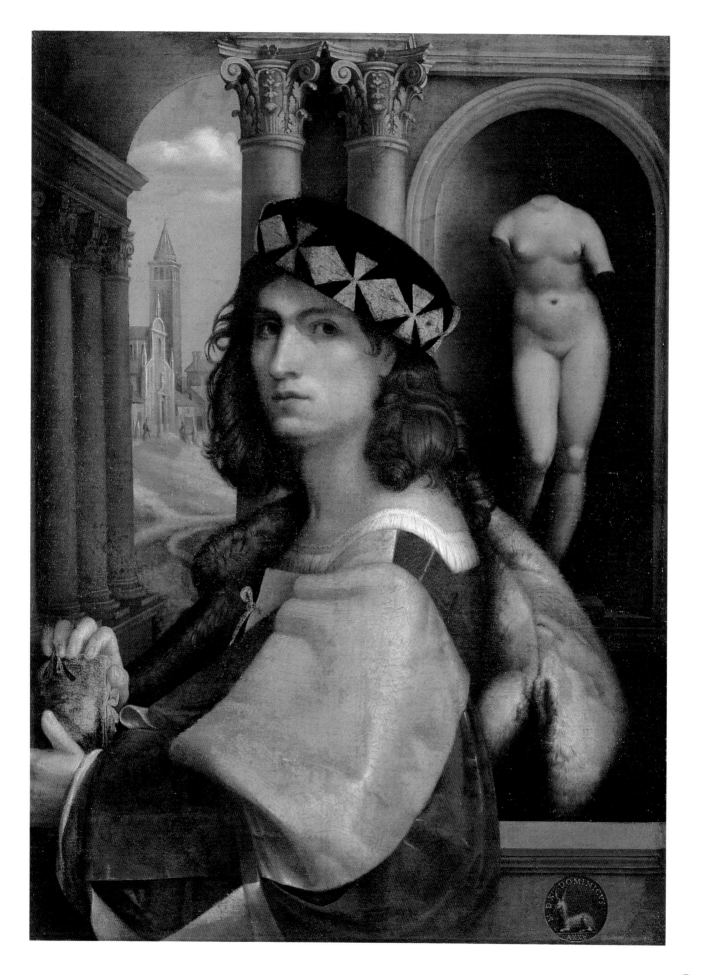

NOSCE TE APHTON

the German Hans Eworth, portrayed poor little Edward VI (471), who succeeded Henry VIII at the age of nine and died at fifteen. Though the pale young king is furnished with a cloth of honor and a column to suggest royal magnificence, Edward's touchingly babyish little hand, innocently close to his codpiece, gives all that royal show away.

By portraying children with servants, several points are made. The approximate age and size of the child are established by proximity to an adult, and parental prosperity is manifested by the assignment of a servant exclusively to the child's care. Following Veronese's formulae for informal poses in Palladian interiors, Pietro Marescalca (472) has the old nurse give her lavishly dressed little charge some cherries, as he looks out at the spectator.

The transition from extremely formal, hierarchical portraiture of the sixteenth century to the new freedom and naturalism of the seventeenth is seen in four court images. The first three, all sixteenth-century works, are by Sofonisba Anguissola (474) and Juan Pantoja de la Cruz (474)—both half-lengths—and by Frans Pourbus II, a full-length portrait of *Margarita of Savoy, Duchess of Mantua* (474). All share a rigid manner, in which the sitters look just as stiff as their very uncomfortable attire. Everything changes with Rubens's fresh portrayal of a *Maid of Honor to the Infanta Isabella* (475), a work completed in the mid-1620s. Much of the Fleming's new lightness and vivacity is due to his return to Northern Italian portraiture of the earlier sixteenth century. Though the maid of honor is burdened by a high,

Above
GIOVANNI BATTISTA MORONI
Bondio ca. 1525–Bergamo 1578
Portrait of a Man
(Inv. No. 171) Oil on canvas
23 × 19½" (57.5 × 50 cm)
(Ex coll. F. Tronchin, Geneva, 1770)

Above, left
PAOLO VERONESE (PAOLO CALIARI)
Verona 1528–Venice 1588
Portrait of a Man
(Inv No 119) Oil on canvas
25 × 20" (63 × 50.5 cm)
(Ex coll. Barbarigo, Venice, 1850)

Opposite
LORENZO LOTTO
Venice 1480–Loreto 1556
Husband and Wife, ca. 1543
(Inv. No. 1447) Oil on canvas
38 × 45½" (96 × 116 cm)

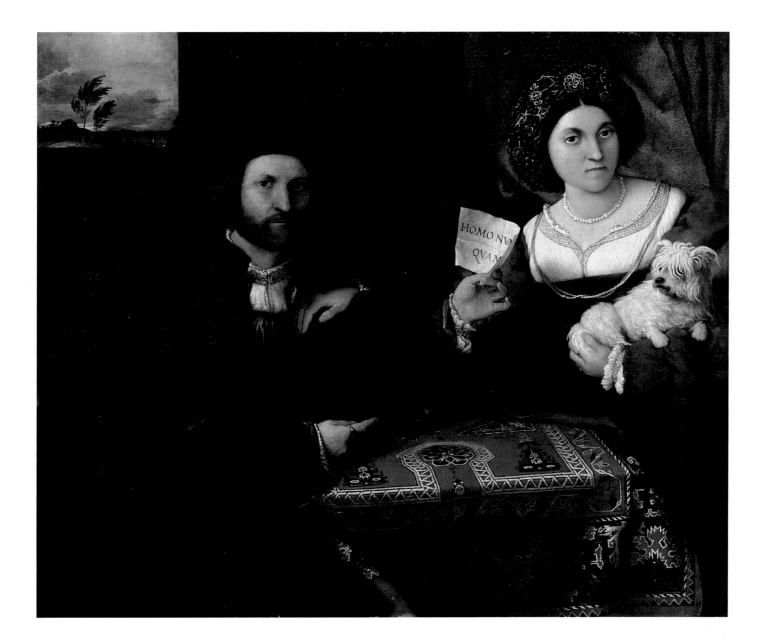

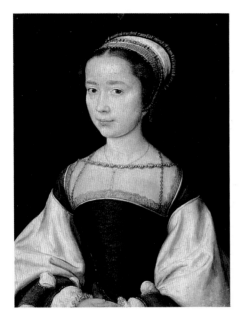

CORNEILLE DE LYON
The Hague ca. 1500/10–Lyon ca. 1574
A Young Lady, 1530s/40s
(Inv. No. 5697) Oil on panel
8 × 6″ (20 × 15.5 cm)

starched, white court collar, she quite literally rises above it, this young woman's humanity neither unstarched nor bleached out of her.

Thrice regal, Anne d'Autriche was the daughter of Philip III of Spain, wife of Louis XIII, and regent for Louis XIV. She is shown as an allegory of royal wisdom by Simon Vouet (477), with Athena's owl and helmet at her feet and the same goddess's girdle encircling her waist, as putti fasten swags of triumphal foliage above. NVLLVM NVMEN ABEST—"No divine spirit is absent"—inscribed at the far right, states that while Athena, and presumably Anne, are the only divinities in symbolic or real view, all the others are present and accounted for, too. Trained in Italy as well as France, Simon Vouet warmed up the formality of French court images with a much-needed tincture of Roman expansiveness, so that even as status-obsessed a portrait as this is not without a sense of flesh and blood.

Images of partners in marriage have a special fascination, whether shown as pendants by Frans Pourbus the Elder (465) still in the veristic, detailed tradition of Hans Holbein or Antonio Moro, or united in a single setting as in Lorenzo Lotto's canvas (469). Monuments to accommodation and tolerance (or their absence), these paintings project an incipient reciprocity and, at certain times, a sense of "Knock wood," or "So far, so good." Both members of Lotto's mature, glumly childless couple have a pet—she, a white dog, a symbol of fidelity, and he, an emblematic

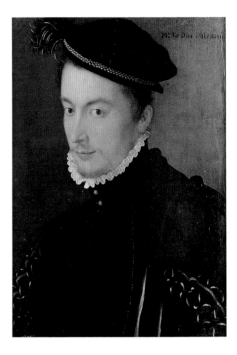

UNKNOWN French, 16th century
An Unknown Man, late 1560s
(Inv. No. 1255) Oil on panel
19 × 12½″ (48.5 × 32 cm)
(Ex coll. Crozat, Paris, 1772)

Opposite
HANS EWORTH (Attributed to)
Antwerp fl. 1540–London after 1574
Edward VI, 1547/53
(Inv. No. 1260) Oil on panel
20 × 14″ (50.5 × 35.6 cm)
(Ex coll. Walpole, Houghton Hall, 1779)

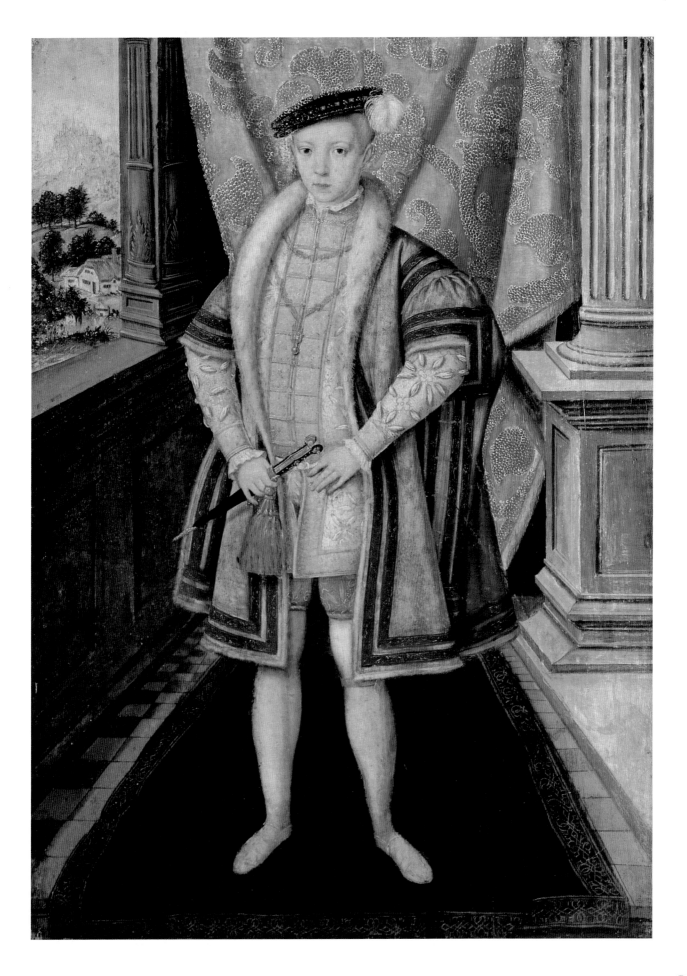

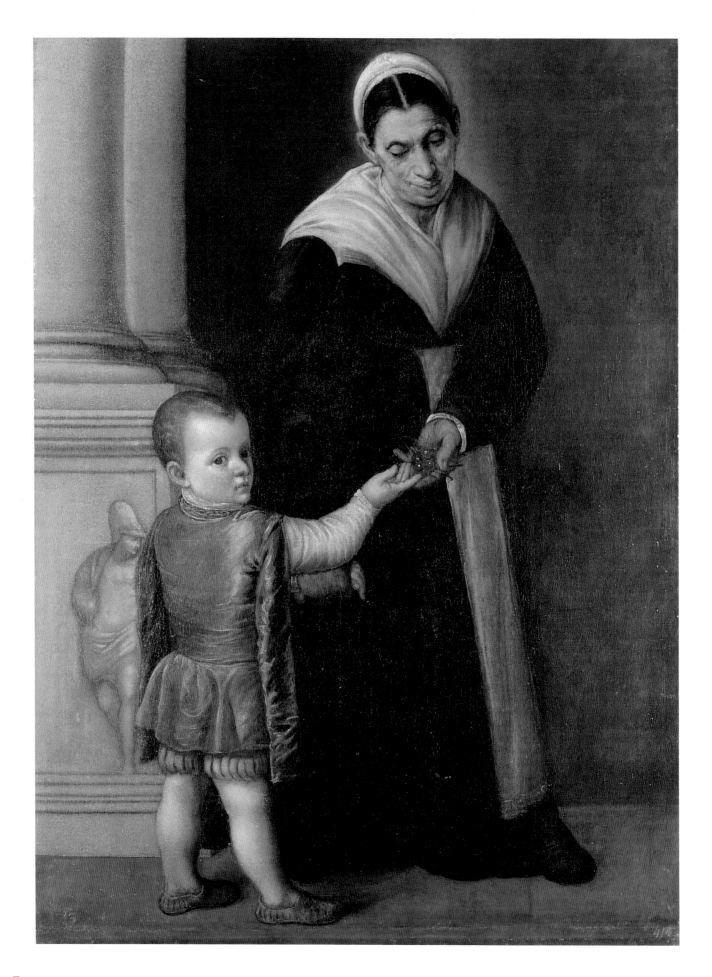

PIERRE DUMOUSTIER THE ELDER
France, ca. 1540–1610
Portrait of a Youth
(Inv. No. 4313) Oil on canvas
12½ × 7½" (32 × 19 cm)
(Ex coll. Cobenzl, Brussels, 1768)

Opposite
PIETRO MARESCALCA (LO SPADA)
Feltre ca. 1503–1584
Child with Nurse
(Inv. No. 182) Oil on canvas
59 × 41" (150 × 105 cm)
(Ex coll. Walpole, Houghton Hall, 1779)

weasel, almost invisible on the carpeted table top. A preparatory drawing in the Rijksmuseum (Amsterdam) has the couple closer together; in the Hermitage's canvas they almost seem to be holding one another at arm's length. She rests her hand on his shoulder, he holds a letter inscribed HOMO NVMQUAM, that enigmatic, possibly Ciceronian motto perhaps contrasting the ways of man and beast, specifically the weasel. A landscape in the upper left, showing paired trees swaying in a storm, may be emblematic of the couple's union through weather fair or foul.

Family portraits tend to be happier than those limited to Him and Her. When they are three or four, or maybe more, these images become celebrations of fertility, triumphs over time into eternity. Such canvases project a happy element of the self-congratulatory, now that the couple is blessed with issue and by the wherewithal to commemorate their abundance. No such timid, genteel belief as that of "too much of a good thing" cramped lives and styles of the Low Countries, as is evident in Bartholomeus van der Helst's pictorial ode to familial prosperity (501) or that of Cornelis de Vos (500).

Jordaens's family portrait (486)—including his self portrait as musician rather than painter, portraits of his parents (an Antwerp linen merchant and wife, Barbara von Wolschaten), his siblings and their progeny—is a celebration of the Good Life. Blessings of love and abundance seem to be showered down by putti overhead, but Julius Held has identified these

UNKNOWN French, second half of 16th century
A Young Man
(Inv. No. 7063) Oil on canvas
16 × 12" (41.5 × 31 cm)

as the souls of Jordaens's three sisters who died in infancy. Fertility is stressed by the servant raising a salver of fruit at the right.

Far more skillful and discerning is an early Van Dyck of an unknown young couple with their baby (487), still dating from his first, Flemish period. Done just before leaving for Italy in 1621, preceding his brief yet splendid Genoese period and his exaltation of the British aristocracy, these direct pictures of Van Dyck's peers, the artist's equals in creative concerns as well as class, share a sympathy seldom encountered in the canvases postdating his knighthood.

The Serenissima invented new approaches to painting, the most important of which convey a feeling of spontaneity and romance, of freedom and immediacy, of fantasy. That now-jaded line, "Free to be you and me," originated, in pictorial terms, in Venetian portraiture, with its uninhibited sense of what came to be known as the picturesque, a new consciousness of, and license to create, poetic fantasy. Now the sitter seems actually to enjoy rather than endure the act of posing; no longer one of rigid isolation, it becomes a generous performance that the viewer is allowed to share. Neither Christian nor Classical in the conventional sense, Venetian portraiture often allows for a fresh quality of self-realization, more nuanced and relaxed, suggesting an intimate dialogue between artist and patron, entered into on terms of equality.

Painter and sitter now seem to invent the latter's presentation as a

Above
JUAN PANTOJA DE LA CRUZ
Madrid 1553–1608
Catalina Micaela of Savoy
(Inv. No. 2594) Oil on canvas
27½ × 19½″ (70 × 50 cm)

Left, top
SOFONISBA ANGUISSOLA
Cremona ca. 1527–Palermo 1623
A Young Lady in Profile
(Inv. No. 36) Oil on canvas
27 × 20½″ (68.5 × 52.5 cm)
(Ex coll. Duchess of St. Leu, Malmaison, 1829)

Left, bottom
FRANS POURBUS THE YOUNGER
Antwerp 1569–Paris 1622
Margarita of Savoy, Duchess of Mantua
(Inv. No. 6957) Oil on canvas
61 × 45″ (155 × 114 cm)

Opposite
PIETER PAUL RUBENS
Siegen (Westphalia) 1577–Antwerp 1640
Maid of Honor to the Infanta Isabella, mid-1620s
(Inv. No. 478) Oil on panel
25 × 19″ (64 × 48 cm)
(Ex coll. Crozat, Paris, 1772)

collaborative, synergistic act, an interaction in which the artist is inspired by the model. Freed from the tight restrictions of earlier tempera techniques, the late-fifteenth-century painter started working in oils, quickly, with the chance to make still speedier changes.

Venetian portraiture never lost its popularity. The newly rich were shown in the Serenissima's ways by Rubens and Van Dyck, painted with a sense of graciousness and freedom that made such images, if not their models, immediately ingratiating. Columns and curtains, handsome courts and flights of stairs, along with thronelike seats and magnificent dogs or horses, all suggested wealth and ease with such ready eloquence that these pictorial devices remained in use until very recently.

It took the two Flemings—Rubens and his equally gifted junior associate Van Dyck—to first show the English as ladies and gentlemen in the grand manner. For this, both painters were duly rewarded, knighted by their grateful Catholic patron, King Charles I. Each artist returned to the by-then romantic styles of sixteenth-century northern Italy, presenting their sitters with a dash and assurance that brought them into the European Common Market of All the Finer Things in Life. No longer merely rich provincial bumpkins, the British were now fitted out in the fruits of the Grand Tour that their Flemish painters had enjoyed at first hand. First Rubens and then Van Dyck worked extensively in Genoa, Mantua, and several other sophisticated patronage centers.

Above
ANTHONIS VAN DYCK Antwerp 1599–
Blackfriar's, near London 1641
Self Portrait, late 1620s/early 1630s
(Inv. No. 548) Oil on canvas
46 × 37″ (116.5 × 93.5)
(Ex coll. Crozat, Paris, 1772)

Opposite
SIMON VOUET Paris 1590–1649
Allegorical Portrait of Anne d'Autriche
(Inv. No. 7523) Oil on canvas
79½ × 68″ (202 × 172 cm)

Page 478
ANTHONIS VAN DYCK
Henry Danvers, Earl of Danby, as a Knight of the Order of the Garter, late 1630s
(Inv. No 545) Oil on canvas
88 × 41″ (223 × 103.6 cm)
(Ex coll. Walpole, Houghton Hall, 1779)

Page 479
ANTHONIS VAN DYCK
Philadelphia and Elizabeth Wharton, late 1630s
(Inv. No. 533) Oil on canvas
64 × 51″ (162 × 130 cm)
(Ex coll. Walpole, Houghton Hall, 1779)

NVLLVM
NVMEN ABEST

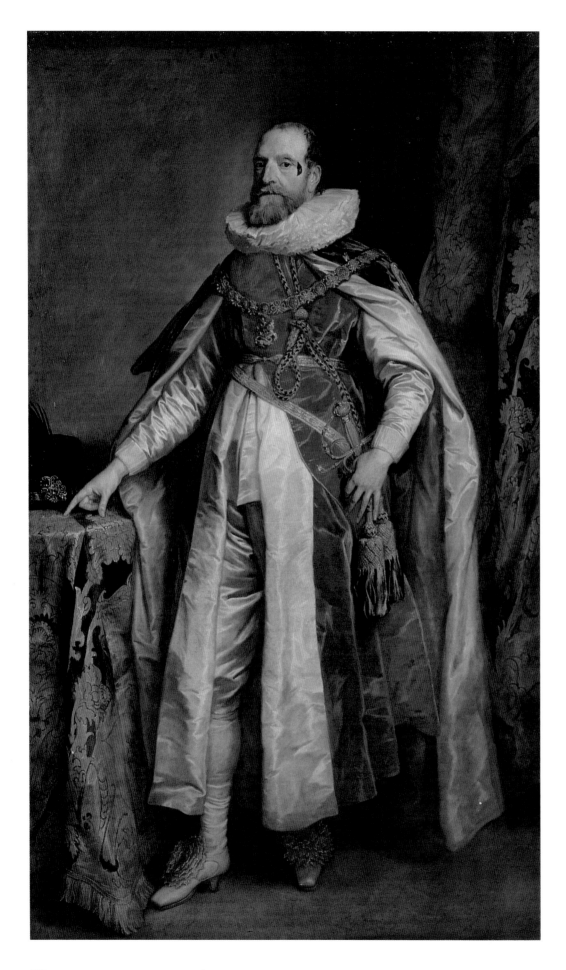

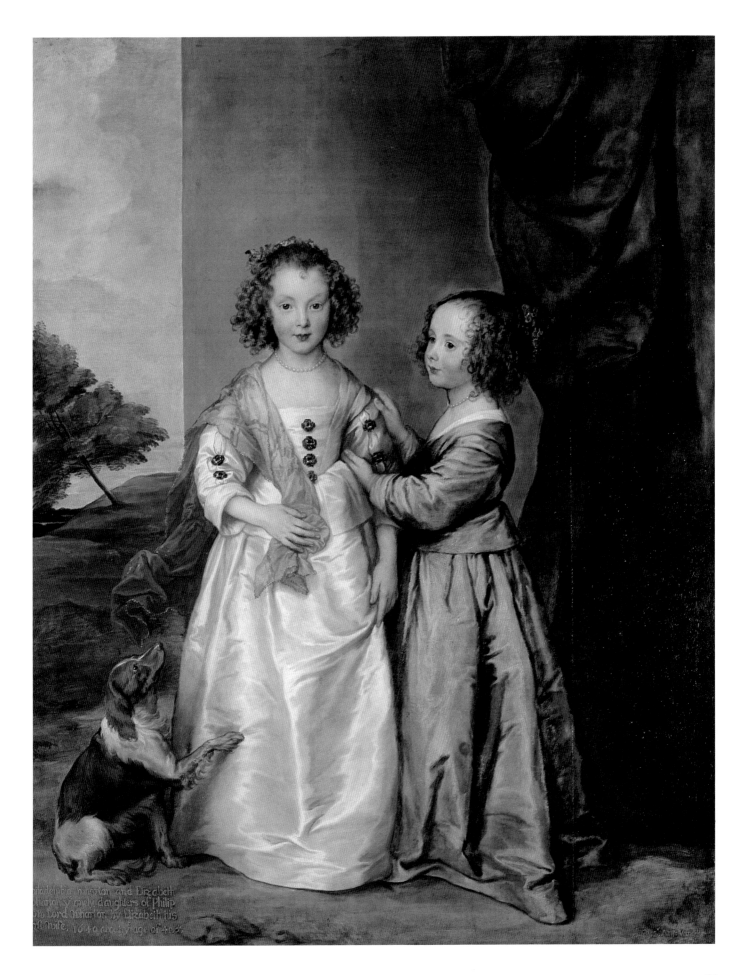

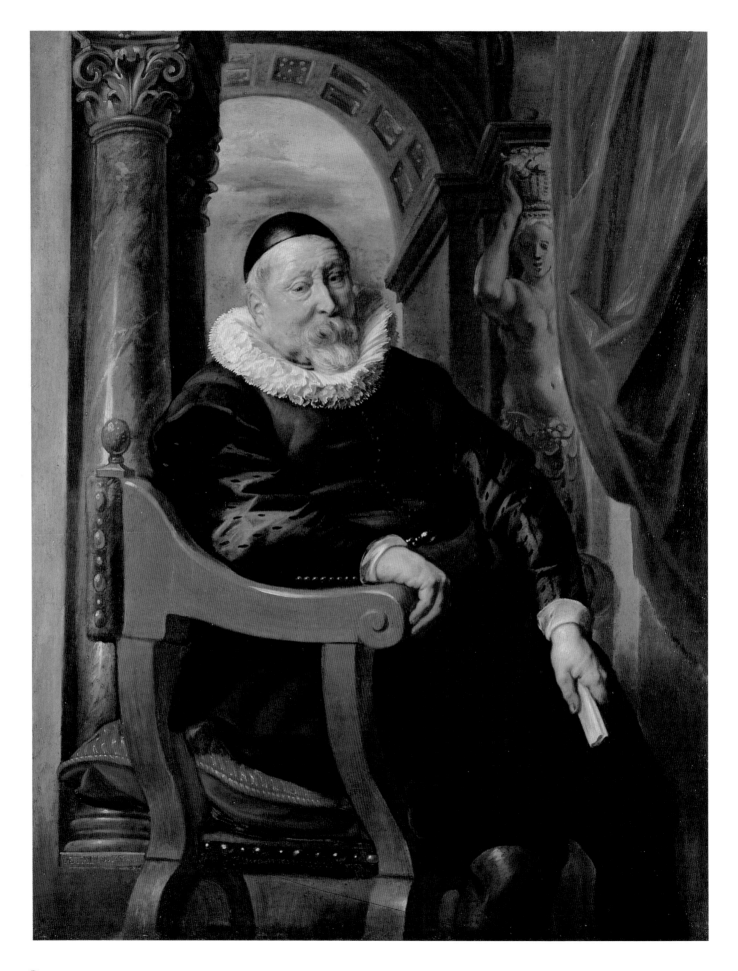

Van Dyck was quite literally a painter's painter: Among his many splendid portraits are those of the leading artists of the Low Countries and England, many commemorated in his etchings as well as oils. Never before had any single artist devoted so much energy to the depiction of his peers, as if by so doing he was elevating Art as well as its practitioners.

Children and parents alike were shown with pale, long faces and pale, long hands, painted with such skill that they provided the pictorial role models for fashionable portraiture for centuries to come. John Singer Sargent's adroit conversion of chorus girls and soap and real estate heiresses into the very grandest of duchesses could only have been effected by having Rubens and Van Dyck at his elbow, guiding his brush.

These Flemish masters, far more than those of Venice, showed how keenly sexuality and aristocracy not only went together, but almost demanded one another—time clearly did not weigh heavily on the hands of handsome ladies-in-waiting, ever ready for the pleasuring. Had seventeenth-century artists required names like those given otherwise unidentified early painters, then Van Dyck might have been called the Master of the Roving Eye. His dashing brush strokes allow for change and age, for shifts in passion, if not loyalty.

The Hermitage's vast collection of the Antwerp artist's works, twenty-five in all, includes splendid religious paintings as well as portraits. Among the latter are eleven bought by Sir Robert Walpole: "twelve

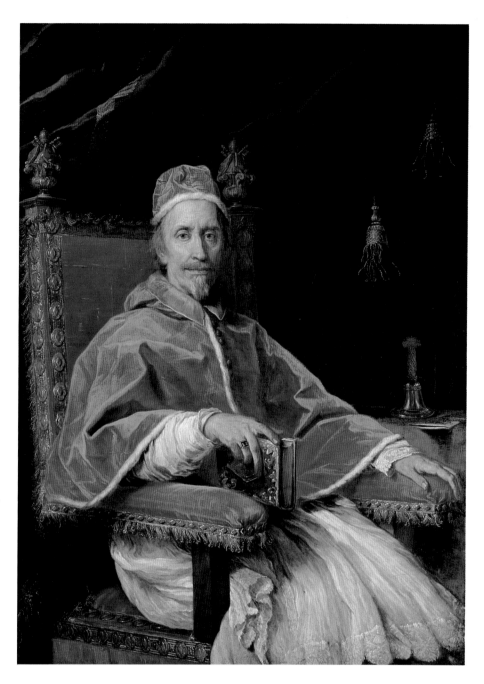

CARLO MARATTA Camerano 1625–Rome 1713
Pope Clement IX
(Inv. No. 42) Oil on canvas
62 × 46½" (158 × 118.5 cm)
(Ex coll. Walpole, Houghton Hall, 1779)

Opposite
JACOB JORDAENS Antwerp 1593–1678
Portrait of an Elderly Gentleman, ca. 1641
(Inv. No. 486) Oil on canvas
60½ × 46½" (154 × 118.5 cm)
(Ex coll. Crozat, Paris, 1772)

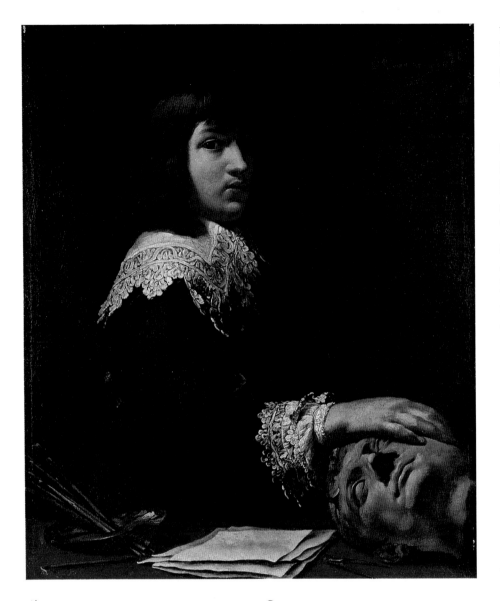

Above
JEAN DARET
Brussels 1613/15–Aix-en-Provence 1668
Self Portrait, 1636 (Inv. No. 5704)
Oil on canvas
31 × 26" (78 × 66 cm)
(Ex coll. Myatlev, St. Petersburg)

Opposite
SIR GODFREY KNELLER
Lübeck 1646/49–London 1723
Grinling Gibbons, before 1690
(Inv. No. 1346) Oil on canvas
49 × 35½" (125 × 90 cm)
(Ex coll. Walpole, Houghton Hall, 1779)

whole lengths of Vandycke and six halflengths" from the ancestors' gallery that Philip, Fourth Lord Wharton, had ordered between 1637 and 1640.

Philadelphia and Elizabeth Wharton (479) shows Van Dyck's scintillating skills as a portrayer of children. Because he worked so fast, they suffered relatively little agony in "holding that pose," indeed, seem actually to have enjoyed the process. Never stiff or self-conscious, his pictures of children display a freshness and immediacy that bring to mind Titian or Renoir.

Considering Van Dyck's enormous output by the time of his early death at forty-two, descriptions of his efficient, immensely speedy portrait production must be reliable. He employed only the briefest, most concentrated of sittings. Van Dyck was a true virtuoso, whose strengths and skills allowed for dazzling rapidity and seemingly effortless execution, typified by his *Anna Dalkeith, Countess of Morton, and Lady Anna Kirk* (501, 502–503), a late work hovering on the brink of stereotype.

A late, unusually analytical portrait of Van Dyck's is that of Henry Danvers, Earl of Danby (478), wearing the knightly attire of the Order of the Garter, an odd, crescent-shaped patch covering an old facial wound won in battle. A scientist, Danvers founded Britain's first botanical garden at Oxford.

Ironically, among the painter's most thoughtful, insightful portraits is that of Sir Thomas Chaloner (495), who proved to be one of the judges who condemned the artist's greatest patron, Charles I, to

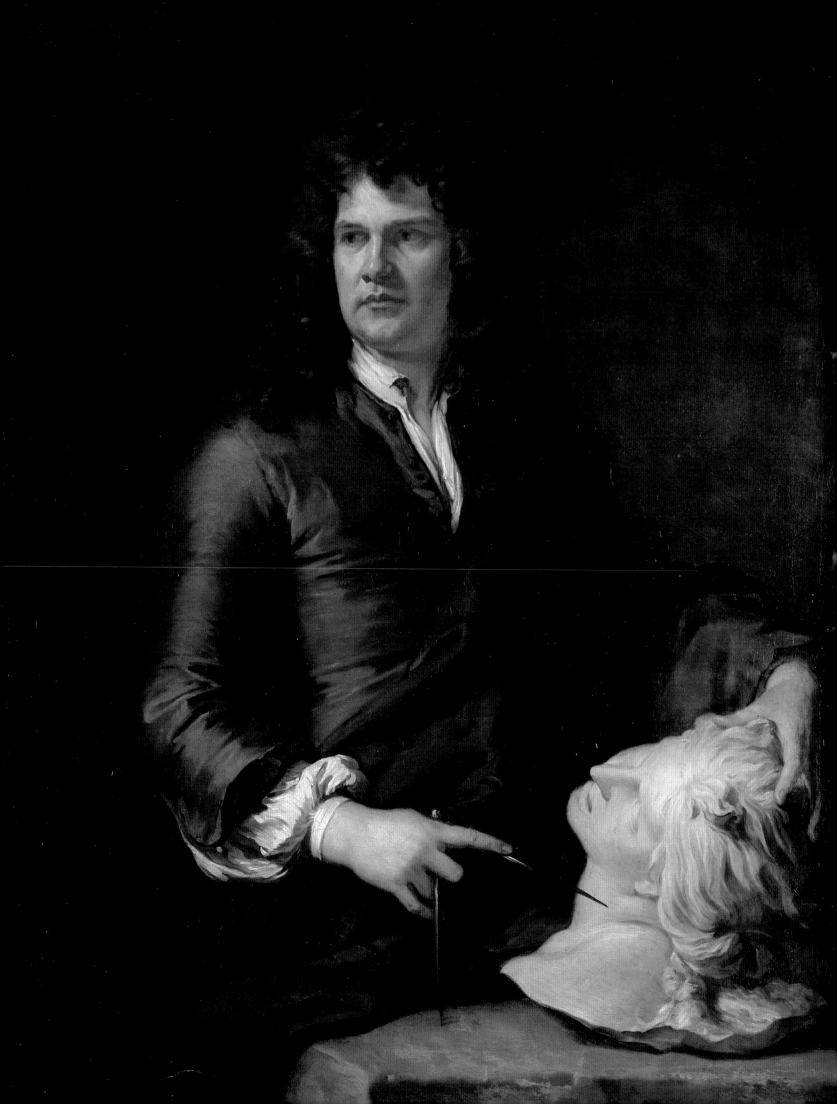

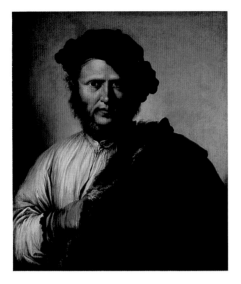

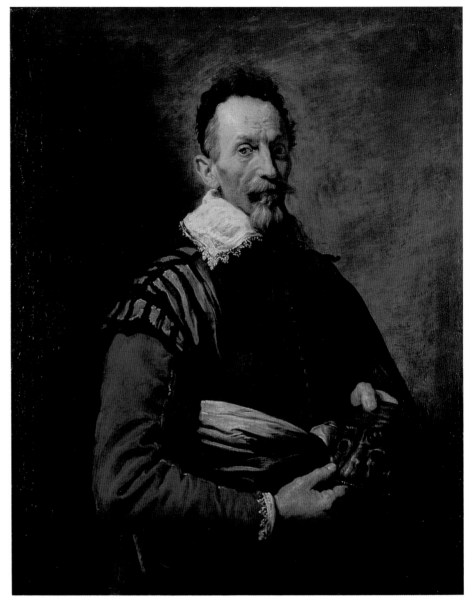

death. Freedom of handling, brevity, and economy of means place this elegantly austere image close to those by Frans Hals.

Jollier and more superficial than Rubens, Jacob Jordaens, though he received commissions as far south as Spain, never reached Rubens's greatness. His is a clever Baroque eclecticism, taking from the best painters around him and producing works distinguished by highly decorative color (480). Carlo Maratta, equally eclectic, drew on Italian sources for his authoritative portraiture (481).

Paintings of sculptors or of painters with sculpture always have a certain element of the *paragone* — of academic comparison — about them, as if the artist were determined to flaunt superiority over the stonecutter's illusionistic skills. With an almost cocky gaze, the young Jean Daret looks out at the spectator (482) as he rests his hand on a Roman imperial bust, possibly a Vitellius. The artist's painting and drawing instruments are in the foreground and he is making it

Above
DOMENICO FETI
Rome ca. 1589–Venice 1623
An "Actor," early 1620s
(Inv. No. 153) Oil on canvas
41½ × 32″ (105.5 × 81 cm)
(Ex coll. Crozat, Paris, 1772)

Above, left
SALVATOR ROSA Arenella 1615–Rome 1673
A Man (Portrait of a Brigand), 1640s
(Inv. No. 1483) Oil on canvas
31 × 25½″ (78 × 64.5 cm)
(Ex coll. Walpole, Houghton Hall, 1779)

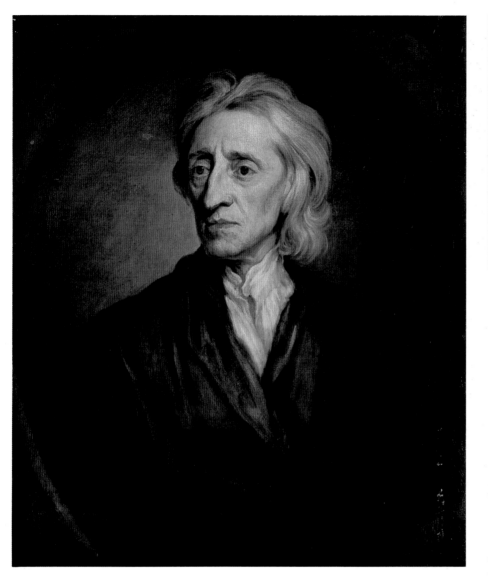

painfully clear to any sculptors who might care to look that he can reproduce their art just as well as his own image—both on a two-dimensional surface.

The same point is made by Sir Godfrey Kneller's *Grinling Gibbons* (483). Here the virtuoso wood-carver prepares to copy a marble head, pointing it off with calipers. Like so many "English" artists, Kneller was of Northern Continental birth, né Gottfried Kniller of Lübeck. His *John Locke* (485) presents the Socratic philosopher's likeness in a forthright manner that even the Puritan's son might have approved of. As a follower of Descartes, Locke might well have been satisfied by this simple, serious image by the same artist who portrayed Sir Isaac Newton.

William Dobson, Van Dyck's most gifted English follower, portrayed Abraham van der Doort (485) with a simplicity akin to Kneller's *Locke,* dispensing with (or incapable of) the flashy, ennobling touch that made Van Dyck such a favorite with the bluebloods or those who aspired to that tincture.

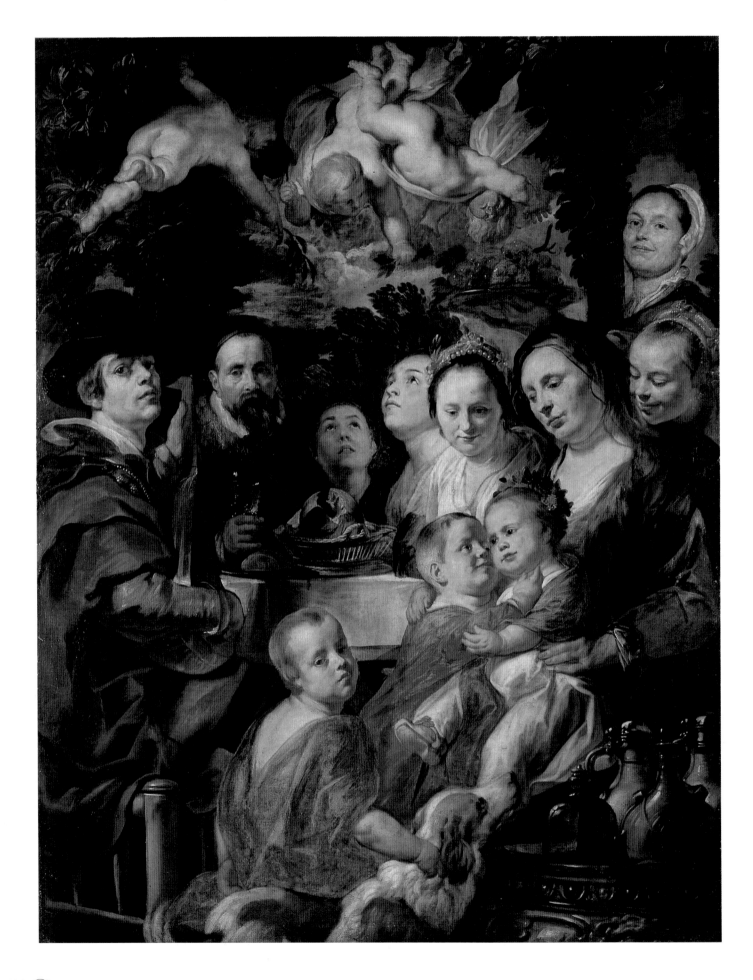

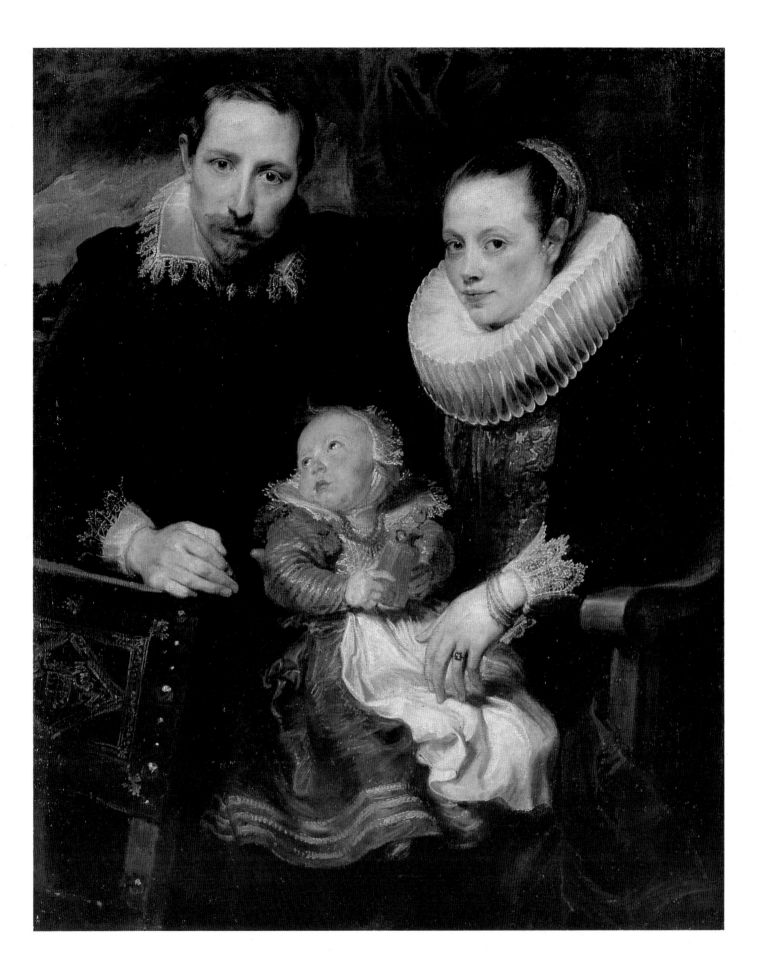

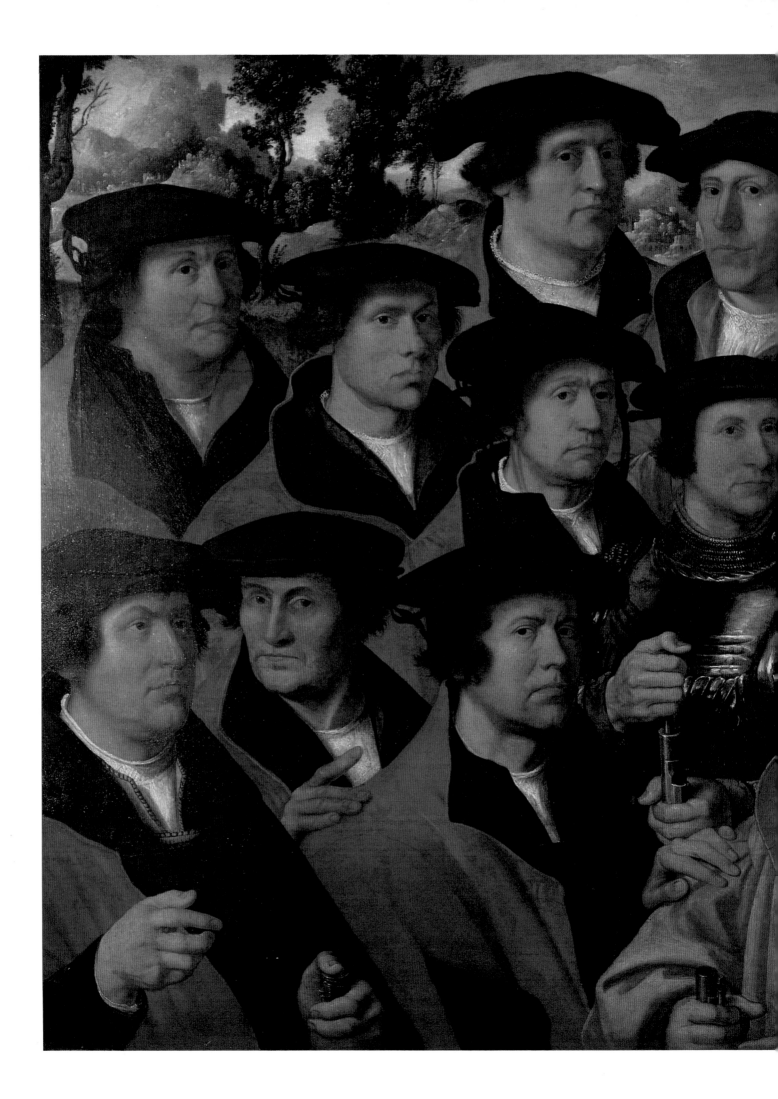

Group portraits were painted before the early sixteenth century, but they were usually cast in the guise of Good Works, tucked away in the backgrounds of saintly deeds or church dedications. Only in the first third of the sixteenth century did that genre come into its own in the Low Countries. Most of the few known practitioners went to Italy to stiffen their spines for the confrontation with so many faces, row upon row, each demanding perpetuation. Sometimes the monotony of these commissions was softened by incorporating a landscape background.

Dirck Barendsz., Jan van Scorel, and Dirck Jacobsz. were pioneers in the exercise of group portraiture, often ordered by men's civic societies to commemorate collective experiences like membership in a society or service organization or pilgrimage. Societies of crossbowmen, or arquebusiers, commissioned many such works, and six of these group portraits by Dirck Jacobsz. survive. The one in the Hermitage (488–89), though not well preserved, makes up for its poor condition by the way in which seventeen heads, rather than vying for equal painter's time, seem perfectly pleased by their pictorial fates, allowed to exhibit whatever they believe to be their better profile even if this means looking in the "wrong" direction.

DIRCK JACOBSZ Antwerp ca. 1497–1567
Group Portrait of the Arquebusiers of Amsterdam, 1532
(Inv. No. 414) Oil on canvas, transferred
from panel
45 × 63" (115 × 160 cm)
(Ex coll. Brühl, Dresden, 1769)

Among France's leading portraitists of the Late Baroque, Nicolas de Largillière benefited from early training in Antwerp, which added a certain warmth and directness to his work, liberating it from the formality of his native Paris. He went on to a brilliant career, ending as Charles Le Brun's successor at court. That such an exalted official position was or would be his is made clear by the magnificent commission of the *Meeting in the Paris Hôtel de Ville to Discuss the Erection of a Monument to Louis XIV* (491). Encompassing portraits of eight lavishly bewigged and gowned officers, Largillière manages to capture them in a reasonable facsimile of dialogue, in chambers, as they debate the merits of ordering a statue by Guérin, whose model appears at the far left. Yes, they chose it.

David Teniers the Younger sets his group portrait outdoors as these men are members of Antwerp's prestigious city council and masters of the Armaments Guild (491, 492–93). They pose proudly before the great Renaissance city hall, among the first such buildings in the North. Crimson sashes cover many well-fed stomachs as the stout councillors stand at attention, while crossbowmen and their band contribute martial music and might to the event. This is a collective portrait of what made a rich harbor city work, of those who ran and defended Antwerp, portrayed without the perceptions of irony and insight that a Rembrandt or Hals would have brought to the scene.

When all is said and done, few images are more satisfying than those of men and women at an age when they know what's what and what *was* what, but without having paid too painful a price for such knowledge and experience, as shown by painters who can communicate Hamlet's two-edged tribute: "What a piece of work is a man, how noble in reason, how infinite in faculties; in form and moving how express and admirable, in action how like an angel. . . ." Significantly, it was in Shakespeare's century that galleries of ancestor portraits came to be de rigueur in England, long after these were commonplace among the Continental aristocracy.

The best portraits suggest a certain magic, as if one might learn from looking, win understanding by viewing. Ironically, these images may actually be of the vain, the foolish, or the evil, exploiting their artist's genius to create the illusion of insight, compassion, or rare wisdom. The Hermitage abounds in dazzling examples of these likenesses—Anthonis Van Dyck's *Sir Thomas Chaloner;* Frans Hals's *Young Man with a Glove* (494; identified by Seymour Slive as a doctor, dating from 1640 or so), and the same painter's unknown male sitter (496).

Though Rembrandt is occasionally Hals's peer as portraitist, as in the *Jan Six* (Collection Jan Six, Amsterdam), the Haarlem artist's canvases often suggest a greater spiritual communion and psychological penetration, an ease and freedom that tend to escape Rembrandt's far more obviously labored likenesses. Where Hals seems to say it all with a selective flurry of swift, deft strokes, Rembrandt

Opposite, top
NICOLAS DE LARGILLIÈRE
Paris 1656–1746
A Meeting in the Paris Hôtel de Ville to Discuss the Erection of a Monument to Louis XIV
(Inv. No. 1269) Oil on canvas
27 × 40" (68 × 101 cm)
(Ex coll. Crozat, Paris, 1772)

Opposite, bottom
DAVID TENIERS THE YOUNGER
Antwerp 1610–Brussels 1690
Members of Antwerp Town Council and Masters of the Armaments Guilds, 1643
(Inv. No. 572) Oil on canvas
53 × 72" (135 × 183 cm)
(Ex coll. Empress Josephine, Malmaison, 1815)

Overleaf
DAVID TENIERS THE YOUNGER
Members of Antwerp Town Council and Masters of the Armaments Guilds (detail)

Page 494
FRANS HALS
Antwerp (?) 1585–Haarlem 1666
A Young Man with a Glove, ca. 1650
(Inv. No. 982) Oil on canvas
31½ × 26" (80 × 66.5 cm)
(Ex coll. J.E. Gotzkowski, Berlin, 1764)

Page 495
ANTHONIS VAN DYCK
Sir Thomas Chaloner, late 1630s
(Inv. No. 551) Oil on canvas
41 × 32" (104 × 81.5 cm)
(Ex coll. Walpole, Houghton Hall, 1779)

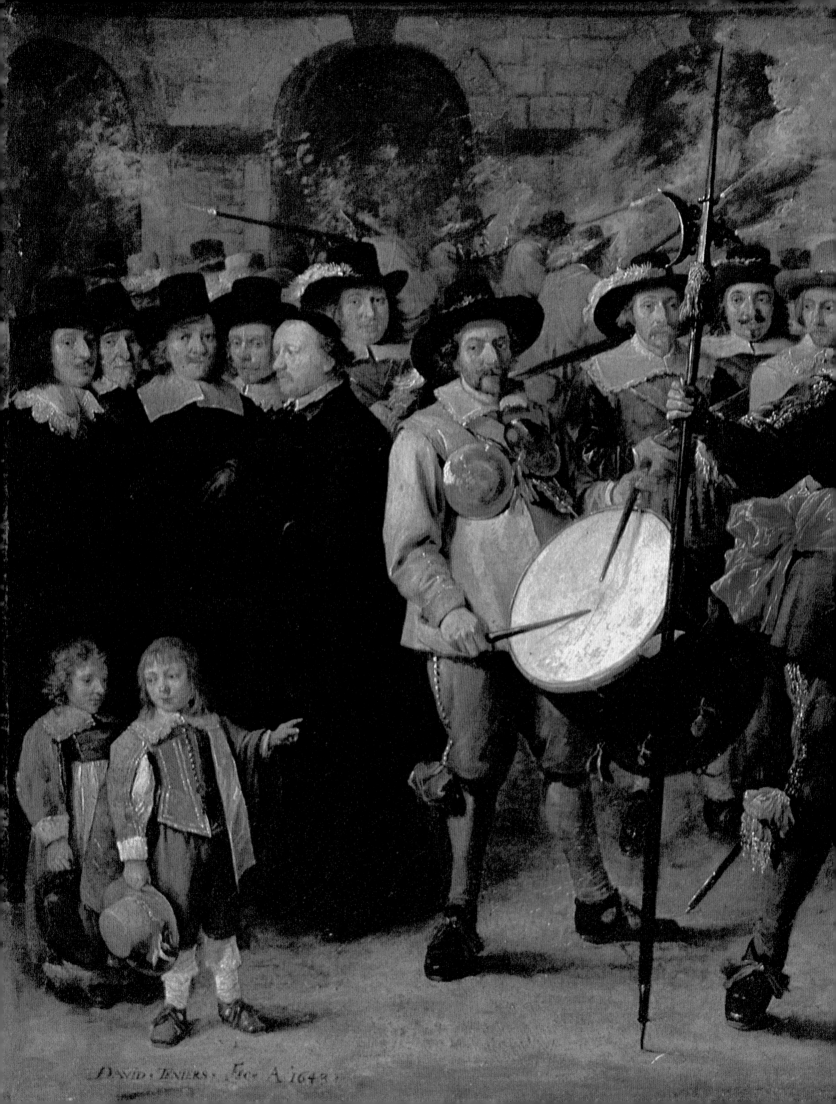

DAVID TENIERS fec A 1643

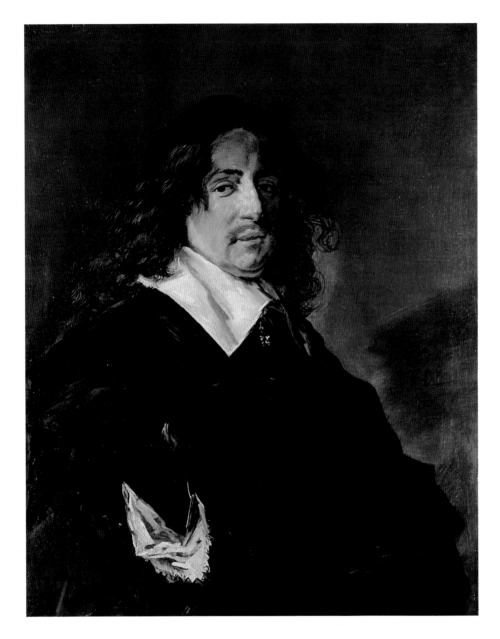

FRANS HALS
Portrait of a Man, before 1660
(Inv. No. 816) Oil on canvas
33 × 26" (84.5 × 67 cm)

thrashes his way through to the truth after many a false start and abortive ending, forced to retrace his steps over and over again.

Rembrandt's *Baartjen Martens Doomer* (498), a portrait of the mother of the painter Lambert Doomer, has a pleasantly matter-of-fact quality—acute, frank, and content, all at the same time. A rich scholar, probably a theologian, looking up from his desk (499), seems also a reflection of Rembrandt's own prosperity in 1631, the year it was painted, thus illustrating Leonardo's motto, "Every artist paints himself." Rembrandt had moved from the university center of Leyden to the Netherlands' commercial hub, Amsterdam. Whether his patron required the lavishly realized book (probably a Bible) or Rembrandt chose to invest vast labor in its rendering, the effect is more of virtuosity than virtue.

The same painter's handsome, possibly Jewish, *Old Man in Red* (498), suggests an apostle or notable figure from the distant past. A slightly self-conscious exercise in the Venetian manner, this was probably painted for Rembrandt's own pleasure and learning. Most arresting of his Hermitage portraits is the late *Jeremias de Dekker* (498), in which the sitter—a poet—seems both robbed and ennobled by the absence of illusion. That this could best be conveyed by illusion is the paradox of art.

The "Little Dutch Masters" are capable of surprisingly moving portraiture; sometimes even Gerard Ter Borch was so, his speciality having been the painting of

quantities of full-length, yet very small scale, likenesses of reasonably prosperous men and women. The Hermitage's Ter Borch, *A Violinist* (497), is an exception, not only for its half-length format but because this is not a miniature monument to class or family. Here is an intimate image of a fellow artist, possibly an impoverished painter stressing his musical side, as did the young Jordaens when he showed himself with a lute.

Adriaen van Ostade, on the other hand, is not known for his portraiture, his specialty having been images of farm life or of low life. His image of an elderly woman (497) prefigures the realism of Greuze or Courbet.

In a melancholic, introspective, unproductive pose Michael Sweerts's painting of a young man (504) is among the Hermitage's most compelling portraits, with much of Poussin's mystery of measure and eloquent, elegant austerity. An invigorating recollection of Caravaggio's vitality and sexuality lends this sophisticated image special force, conveyed without affectation and inscribed *Ratio Quique Reddenda*—"Every man must give an accounting." Discovered by H. I. Raupp to be a Sweerts self portrait, the artist presents himself in the tradition of the Vanitas, linked to the worthlessness of earthly goods conveyed by coins on the desk as well as the Latin motto.

That another great seventeenth-century portrait, the Hermitage's *Man with a Lute* (505), could still remain "nameless" (to reapply the pathos of Bernard Berenson's "home-

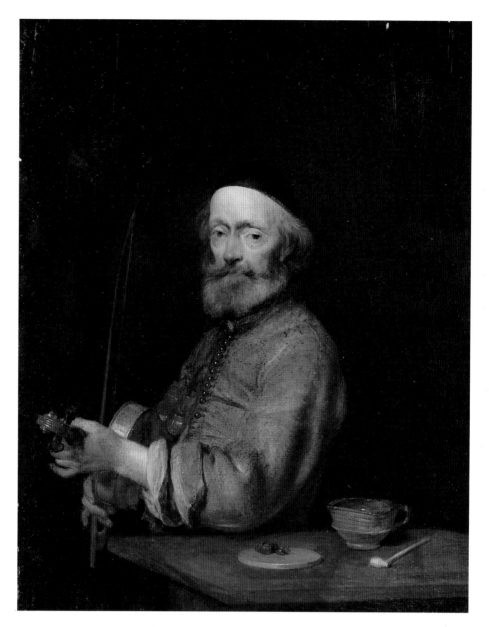

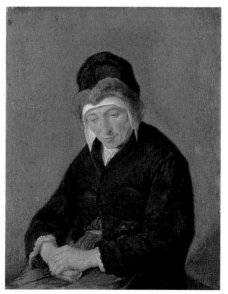

Above
GERARD TER BORCH
Zwolle 1617–Deventer 1681
A Violinist
(Inv. No. 882) Oil on panel
11½ × 9″ (29 × 23.5 cm)
(Ex coll. F. Tronchin, Geneva, 1770)

Left
ADRIAEN VAN OSTADE
Haarlem 1610–1685
An Old Woman, 1646
(Inv. No. 4034) Oil on panel
10 × 8″ (25 × 20 cm)

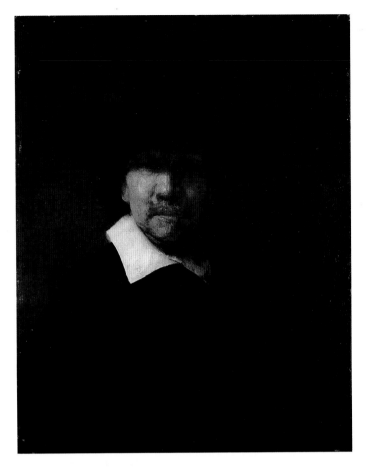

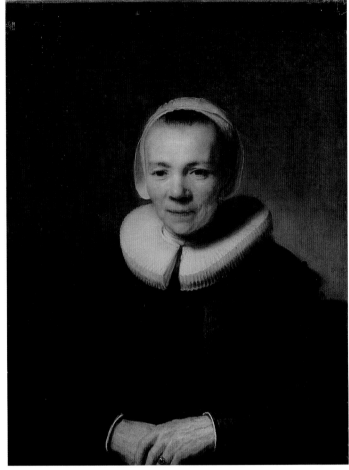

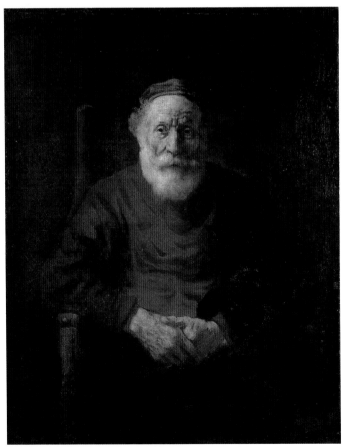

Top, left
REMBRANDT HARMENSZ VAN RIJN Leyden 1606–Amsterdam 1669
Jeremias de Dekker, 1666 (Inv. No. 748) Oil on panel
28 × 22″ (71 × 56 cm)
(Ex coll. Baudouin, Paris 1781)

Top, right
REMBRANDT *Baartjen Martens Doomer,* ca. 1640
(Inv. No. 729) Oil on panel
30 × 22″ (76 × 56 cm)

Left
REMBRANDT *An Old Man in Red,* ca. 1652/54
(Inv. No. 745) Oil on canvas
42½ × 34″ (108 × 86 cm)
(Ex coll. Brühl, Dresden, 1769)

Opposite
REMBRANDT *A Scholar,* 1631
(Inv. No. 744) Oil on canvas
41 × 36″ (104.5 × 92 cm)
(Ex coll. Brühl, Dresden, 1769)

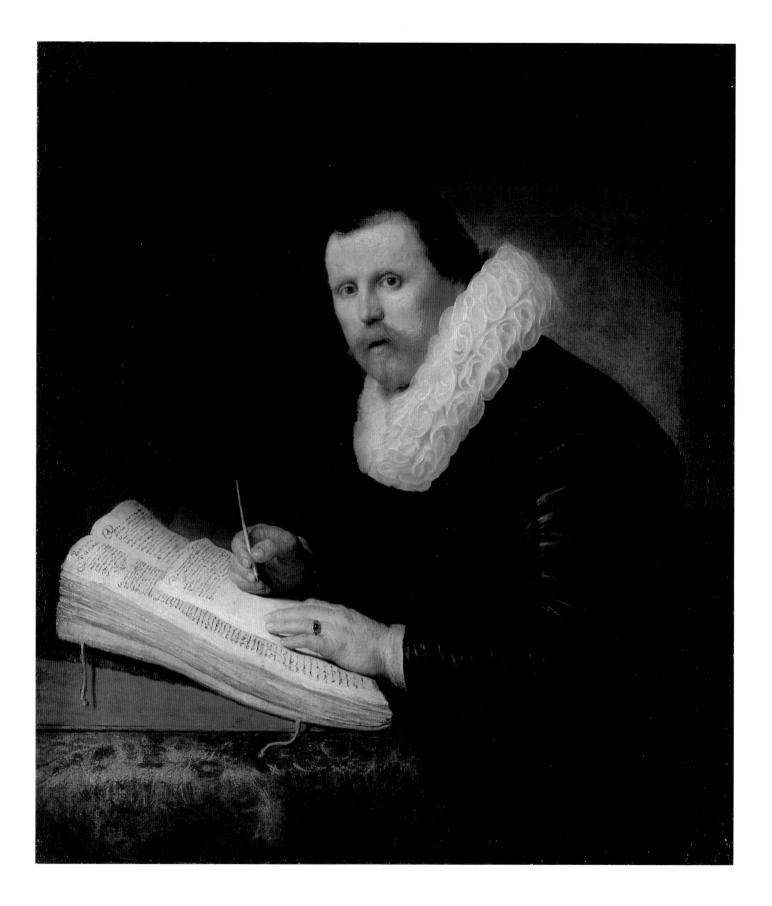

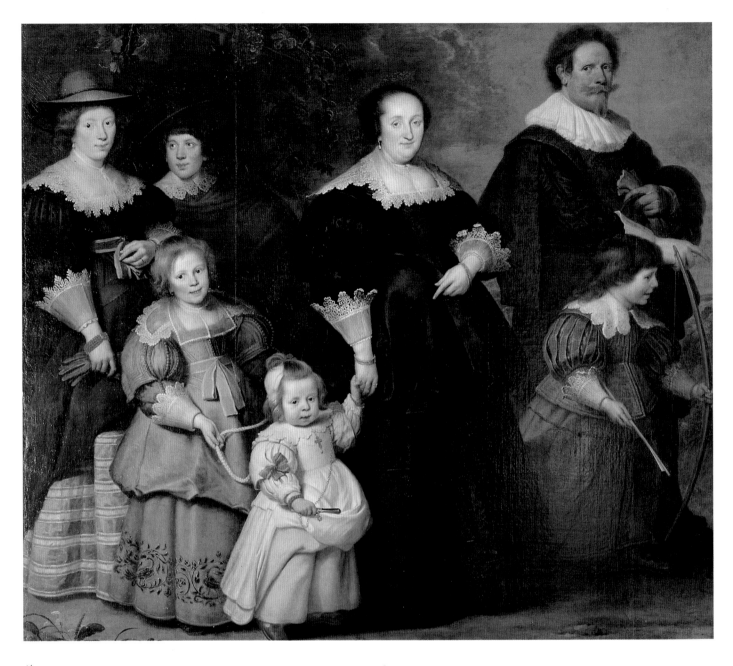

Above
CORNELIS DE VOS Hulst ca. 1584–Antwerp 1651
Family Portrait
(Inv. No. 623) Oil on canvas
73 × 87″ (185.5 × 221 cm)
(Ex coll. G.A. Potemkin, 1792)

Opposite, top
BARTHOLOMEUS VAN DER HELST
Haarlem 1613–Amsterdam 1670
Family Portrait, 1652
(Inv. No. 860) Oil on canvas
74 × 89″ (187.5 × 226.5 cm)

Opposite, bottom
ANTHONIS VAN DYCK
Anna Dalkeith, Countess of Morton, and Lady Anna Kirk, late 1630s
(Inv. No. 540) Oil on canvas
52 × 59″ (131.5 × 150.6 cm)

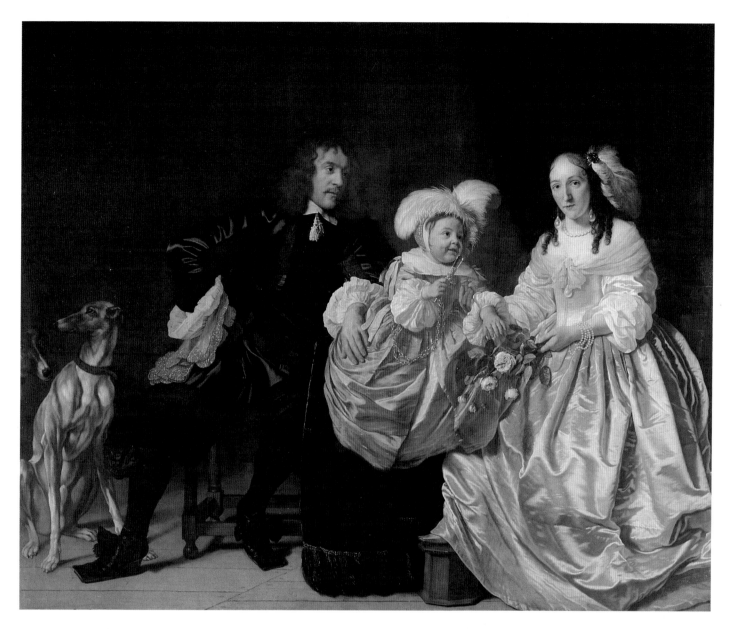

Pages 502–503
ANTHONIS VAN DYCK
Anna Dalkeith, Countess of Morton, and Lady Anna Kirk (detail)

Page 504
MICHAEL SWEERTS Brussels 1624–Goa (India) 1664
Self Portrait (?), 1656
(Inv. No. 3654) Oil on canvas
45 × 36″ (114 × 92 cm)

Page 505
UNKNOWN French, mid-17th century
Lute Player (Inv. No. 1264) Oil on canvas
44 × 35½″ (112 × 90 cm)

less") is one of the mysteries of art history. Defying the attributionists, neither the land of origin of this proud image, nor its scbool or subject have ever been definitively traced. Perhaps such obscurity is due to a crossing over of country or tradition, of an Italian working in the North, or the other way around. Laurence Libin kindly informs me that this is a theorbo or chitarrone, both unusually large lutes used by accompanists, so the sitter is more likely to be that, or a composer for the instrument, as he holds a scroll of music in his other hand. He may be André Campra, a French contemporary of the great composer for the lute, Lully.

Obscure only because his oeuvre is so very small, Jean-Baptiste Santerre, one of the most perceptive portraitists of the time, worked in early-eighteenth-century France. He was close to Watteau in his unsentimental, sensitive presentation of character, often conveyed in terms of the theater. The Hermitage owns three likenesses by this prescient master, two of which are included here (506, 507).

Another fine portrait of the period is one by François de Troy of his wife, Jeanne (509). As the daughter, wife, and sister of painters, Mme. de Troy's deliciously detached, faintly ironic expression may stem from the strain of coping with at least three creative male egos. This affectionate, unusually intimate portrait is clearly one that is far from the flattery demanded of more official—and more officially paid for—images.

Among the Hermitage's finest

likenesses are those by Jean-Baptiste Greuze, a painter too often perceived in terms of cloying sentimentality and tedious eroticism. He was Diderot's favorite painter and remains a portraitist of exquisite penetration, a master of opalescent coloring over a porcelain-like surface. His images of those sympathetic to the arts share an unrivaled fusion of sensitivity and elegance. As Master of the Luminous Gaze, Greuze painted a beauty who suggests Marilyn Monroe cast as the lead in *Iphigenia in Aulis* (508), her sexual luster undimmed in a role of noble, classical sacrifice. Not a true portrait, this canvas was connected by Inna S. Nemilova to the painter's *têtes d'expression* of the late 1770s or early 1780s.

Children come into their own in the eighteenth century, winning

JEAN-BAPTISTE SANTERRE
Magny-en-Vexin 1658–Paris 1717
A Young Woman in a Shawl, 1699
(Inv. No. 1146) Oil on canvas
31½ × 36" (80 × 92 cm)
(Ex coll. Crozat, Paris, 1772)

Opposite
JEAN-BAPTISTE SANTERRE
Two Actresses, 1699
(Inv. No. 1284) Oil on canvas
57½ × 45" (146 × 114 cm)

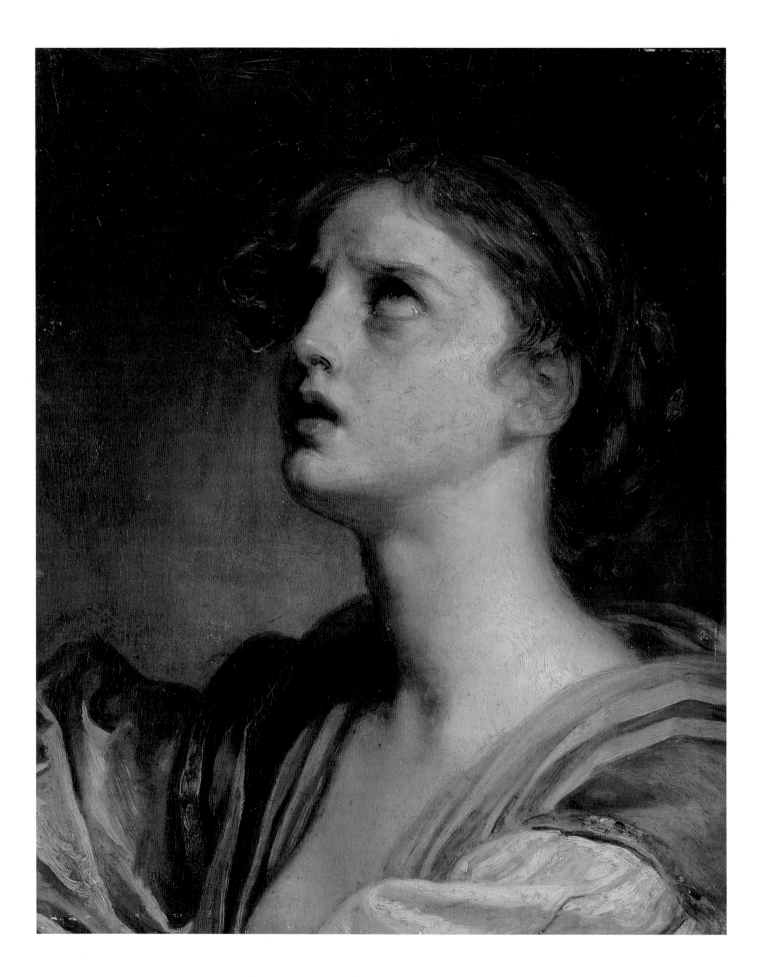

fresh respect through Rousseau's words. Now ignorance becomes innocence, and greed is exalted as "natural." As yet uncorrupted by etiquette or expectation, children were now to be cherished for what they were, not for what they ought to be. Even *Louis, Grand Dauphin de France* (510) by Louis Tocqué manages to look reasonably childlike. Aged ten, he wears the Saint-Esprit and partly military garb in this study for a full-length portrait of 1739 (Louvre).

A sketch by Jean-Baptiste Perronneau (510) is pastel-like in its thin, free brushwork, an ideal way of showing the young—this painting, like its subject, is still "unfinished." The same fresh spirit is felt in *A Young Man in a Hat* (524), by Greuze.

Greuze's *Girl with a Doll* (510) is closer to genre than to genuine portraiture. "A" girl, rather than "the" girl, this is a generalized, sentimentalized image of youth, with its stereotypical image of the Little Woman, in a slighly crass replay of Chardin's real children. Also by Greuze, Count P. A. Stroganov as a Raphaelesque child (510) shows the future hero of the war against Napoleon, painted in Paris in 1778 when the family resided there.

A spooky little overdressed czarlet, the Grand Prince Pavel Petrovich stands in his study (511), painted by the Dane Vigilius Erichsen. Posed like a miniature Apollo Belvedere before a great globe, the message here is that Pavel, only child of Catherine the Great, may well be planning to conquer, as well as learn of, the world behind him.

FRANÇOIS DE TROY Toulouse 1645–Paris 1730
The Artist's Wife, Jeanne, ca. 1704
(Inv. No. 1209) Oil on canvas
40½ × 31″ (103 × 78.5 cm)
(Ex coll. Crozat, Paris, 1772)

Opposite
JEAN-BAPTISTE GREUZE
Tournus, Saône-et-Loire 1725-Paris 1805
Head of a Young Girl, ca. 1777
(Inv. No. 1299) Oil on panel
16 × 13″ (40.5 × 32.5 cm)
(Ex coll. A.I. Somov, St. Petersburg, 1890)

All the lofty effects of Baroque portraiture, especially that of France and Flanders, provided the basis for what was later crassly but accurately referred to as the Society Portrait. This is the sort of image that conveys, overtly and covertly, the fact that the subject is well born and well financed, and certain to be, if not already, well married. There should be a sense of inevitability about all this, as if the sitter just can't help having all those privileges, coming as their due, as much genetically his or hers as the long white fingers and neck that are supposed emblems of enviable status. Few among those most eager for such images actually possessed all the visible requirements, and this created a call for the artist's ingenuity.

One of the major pictorial resources for such pictures is the past, presenting the subject as if he or she were heir to the incalculable benefits of the centuries, showering their collected riches upon the sitter. Just as the Flemish masters returned to the lavish garb of Late-Renaissance Italy, so did the portrait painters of eighteenth-century France and England contrive picturesque attire that was a coy mix of peasant and exotic garb, placing their sitters in what were known as Fancy Pictures.

Some of the most adroit portraitists were always on the move, from court to court, seeking patronage. These artists are also important for the history of art in Russia because they came in contact with significant patronage from that nation. These immensely rich Russians, with that dangerous,

Top
LOUIS TOCQUÉ Paris 1696–1772
Louis, Grand Dauphin de France (1729–1765)
(Inv. No. 1124) Oil on canvas
31½ × 25″ (80 × 64 cm)

Bottom
JEAN-BAPTISTE PERRONNEAU
Paris 1715–Amsterdam 1783
A Boy with a Book, 1740s
(Inv. No. 1270) Oil on canvas
25 × 20½″ (63 × 52 cm)
(Ex coll. A.G. Teplov, St. Petersburg, 1781)

Top
JEAN-BAPTISTE GREUZE
Count P. A. Stroganov as a Child, 1778
(Inv. No. 4063) Oil on canvas
19½ × 16″ (50 × 40 cm)
(Ex coll. Stroganov Palace Museum)

Bottom
JEAN-BAPTISTE GREUZE
A Girl with a Doll
(Inv. No. 3689)
25½ × 21½″ (65 × 55 cm)

Opposite
VIGILIUS ERICHSEN
Copenhagen (?) 1722–1782
Grand Prince Pavel Petrovich in His Study, 1766
(Inv. No. 9909) Oil on canvas
73 × 56″ (186 × 142 cm)

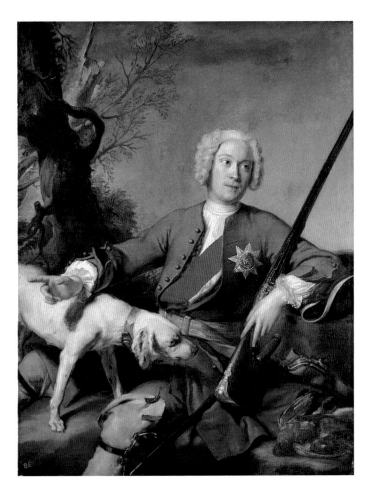

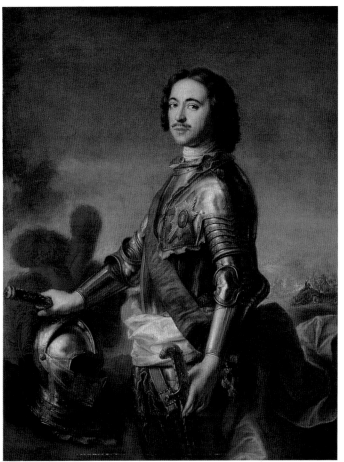

seductive mix of naïveté and great power, were Innocents Abroad, anticipating Henry James's wealthy Americans, not Mark Twain's. They often responded to European art in wise ways, several of them building up fine collections of the "Primitives"—Italian painting before Raphael. (The best of such early pictures in the Hermitage came from their collections, not czarist acquistions.)

Looking every inch the very-well-kept favorite of Catherine that he was, his splendid lynx-lined velvet robe tossed casually over a chair back, Count Z. G. Cherny-shev points to a letter on his *bureau plat* that is presumably in the czarina's hand (512). The Swedish portraitist, Alexander Roslin, places his confident sitter near a bronze

bust of Catherine on the mantle at Chernyshev's side.

Russia's ambassadors were her chief cultural links to the West. Prince Aleksandr Kurakin, who was first stationed in The Hague and then in Paris, was painted by Jean-Marc Nattier in huntsman's garb, with high boots (513)—his Order of Saint Aleksander Nevsky a later addition. There are several versions of the same artist's *Peter the Great* (513) in field marshal's attire. The czar ordered it as a pendant to a portrait of his second wife, *Catherine I* (514), which he much admired.

A full-length likeness of Russia's second and greatest Catherine is by Johann Baptist Lampi the Elder (515). Here an older and wiser czarina points to her emblem, a column, borne by a statuette.

Above
JEAN-MARC NATTIER Paris 1685–1766
Peter I (the Great), 1717
(Inv. No. R.Zh1856) Oil on canvas
56 × 43" (142.5 × 110 cm)
(Ex coll. Winter Palace, 1918)

Above, left
JEAN-MARC NATTIER
A. B. Kurakin, 1728
(Inv. No. 5637) Oil on canvas
51½ × 43" (131 × 109 cm)
(Ex coll. S.V. Panina, St. Petersburg)

Opposite
ALEXANDER ROSLIN Malmö 1718–Paris 1793
Count Z. G. Chernyshev, ca. 1776
(Inv. No. 7624) Oil on canvas
56 × 45½" (142 × 116 cm)
(Ex coll. Chyortkov, St. Petersburg)

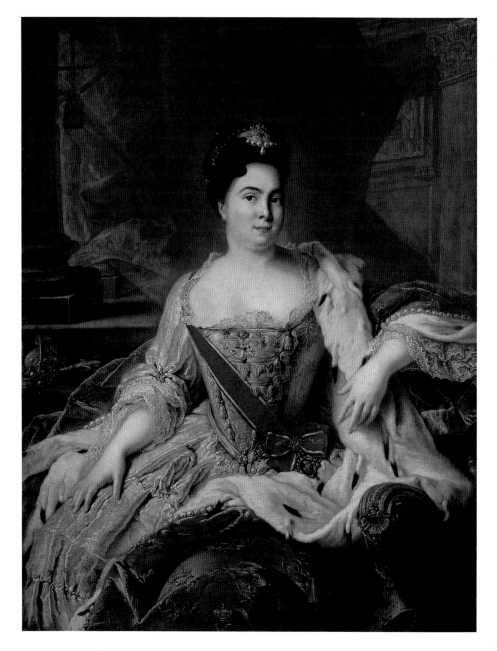

Above
JEAN-MARC NATTIER *Catherine I,* 1717
(Inv. No. R.Zh1857) Oil on canvas
56 × 43" (142.5 × 110 cm)
(Ex coll. Winter Palace, 1918)

Opposite
JOHANN BAPTIST LAMPI THE ELDER
Romeno 1751–Vienna 1830
Catherine II (the Great), 1793
(Inv. No. 2755) Oil on canvas
114 × 82" (290 × 208 cm)
(Ex coll. Winter Palace, 1918)

Though in the French manner of around 1700, a conventional portrait of the *Countess A. A. Chernysheva* (516) is by an Italian painter, Stefano Torelli. Her forthright, appealing expression is in contrast with a rather mincing, affected pose from the court of Louis XIV.

Actors looked like kings and kings looked like actors in much of seventeenth- and eighteenth-century France. For example, in a replica of his signed portrait (New York, Wildenstein), dated 1755, Louis Tocqué portrays the famous French singer, Pierre Jéliotte (517), in a Mozartean pose, plucking Apollo's lyre, which he holds against his embonpoint.

Thomas Gainsborough, a weathy miller's son, had little but contempt for the patrons who lined up at his door for their fashionable portraits. Their high-piled and powdered coiffures made all his women look somewhat alike, but when they were unusually pretty, or ugly, the results were truly noteworthy, as is true for his lovely *Woman in Blue* (518). Her pose is discreetly derived from the *Venus Pudica,* much beloved by Britishers on the Grand Tour, who were most apt to have encountered her on the Capitoline. That great, vertical, artificially whitened blimp of a coiffure, and the beauty of the young sitter's English complexion make this an example of Gainsborough's society portraiture at its prettiest, just the sort that was followed right through this century's Sargent, Zorn, and Boldini.

Pretty portraits are just about the last works to be expected of Goya;

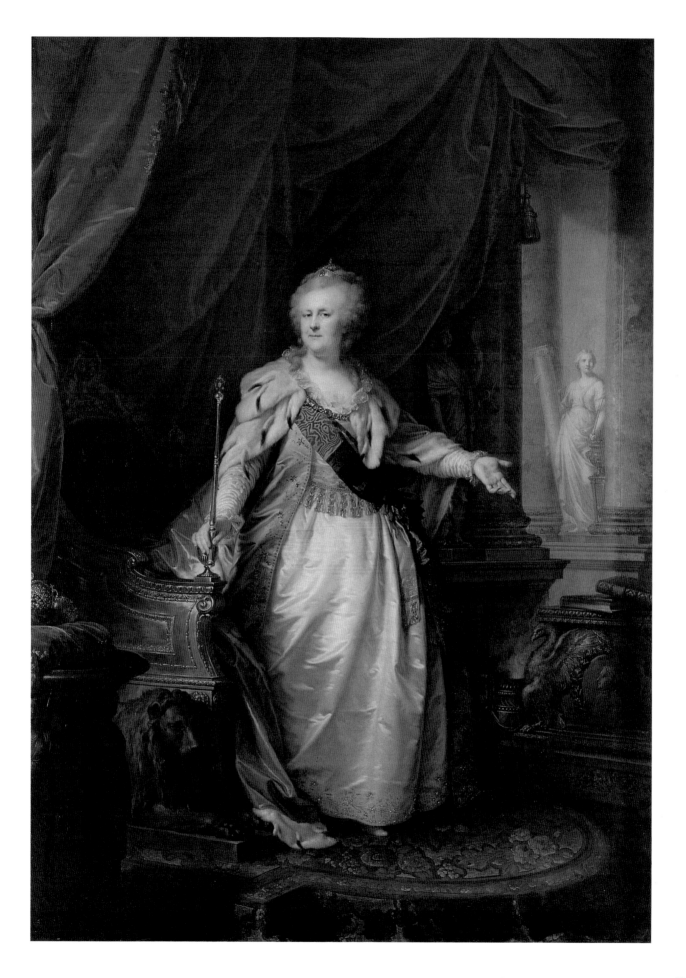

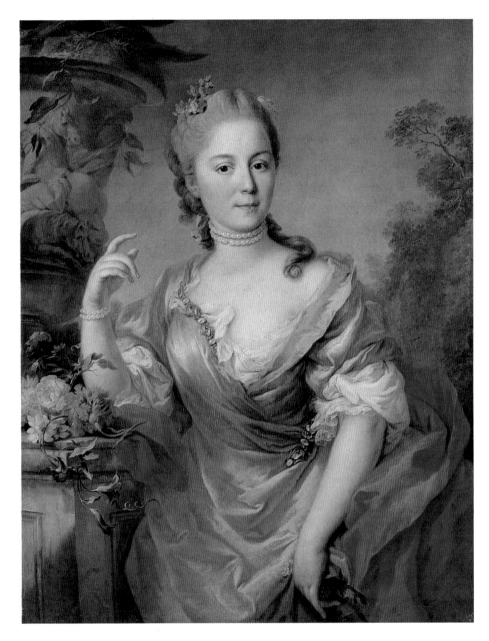

even his beloved Duchess of Alba emerged from his brush looking somewhat like a hard-eyed prostitute. Yet the beautiful actress *Antonía Zarate* (520) must have touched a responsive chord in the deaf, cranky, aging painter.

Louise-Élisabeth Vigée-Lebrun perhaps best exemplifies the painter of the Society Portrait (522, 523). Intelligent, diplomatic, resourceful, and independent, she remains a role model to women who paint, having won wide recognition for her skills and gained admission to academies long closed to her sex. Fleeing the French Revolution, Vigée-Lebrun traveled to Vienna and Saint Petersburg where she painted many of the leading families as she had done in Paris.

Vigée-Lebrun also showed herself in many self portraits (522), fascinating fusions of honesty and convention, of worldliness and of the work-a-day attitude, advertisements for herself, for the skill and industry that made her life so successful and exemplary.

Two lively portraitists, one Italian, Pietro Rotari, the other French, Jean-Louis Voille, also spent time in Russia painting the rich and the noble. Rotari perfected a scintillating surface, showing bright-eyed sitters or models (524). His art is often concerned with varieties of expression, tears and laughter, while that of Voille (524) was far less facile, yet still arresting, with an almost American-primitive, forthright quality to it. Another Parisian artist who was invited to Russia is Louis Tocqué. His *E. A. Golovkina* (524), painted in Saint

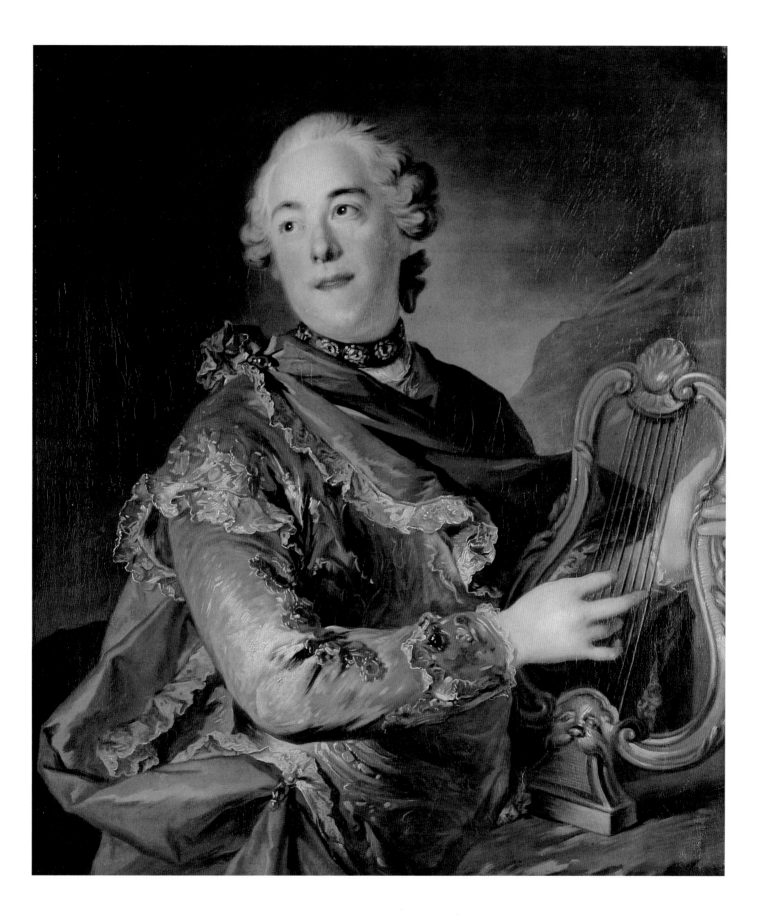

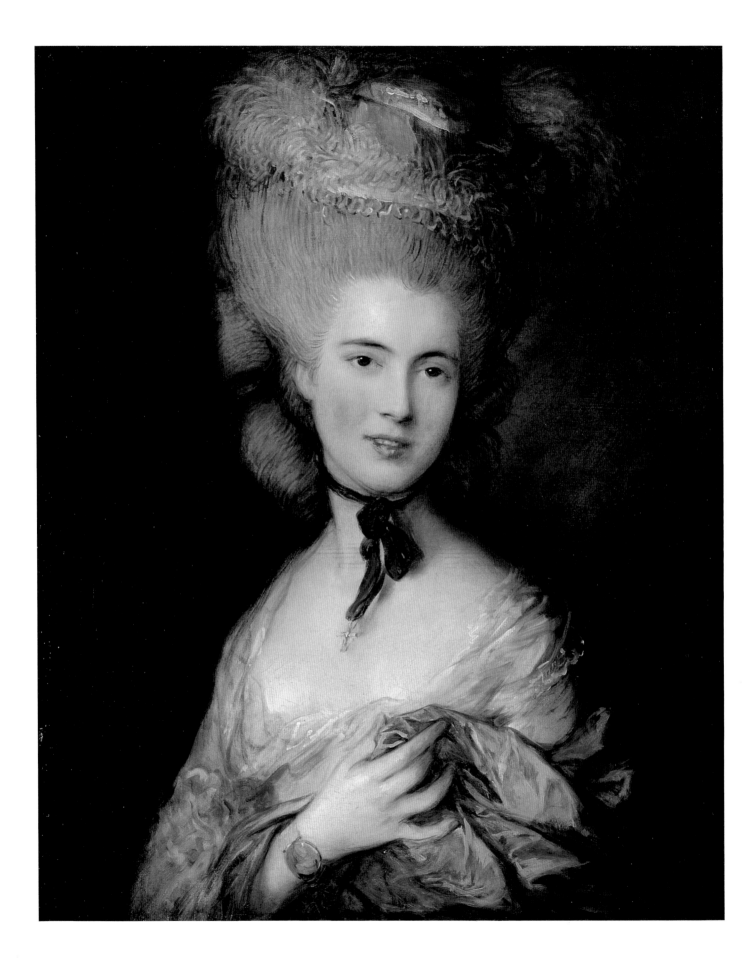

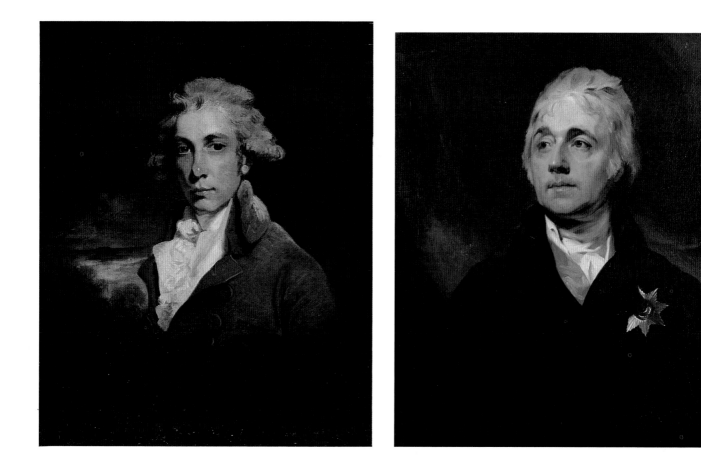

Petersburg in 1757, is typical of his light, perceptive touch.

Biedermeier-period children's portraits, like that by Ferdinand Georg Waldmüller (525), showed how by 1834, in Vienna, the gaiety and whimsy of the Enlightenment was replaced with a proto-Victorian sentimentality, with Big Brother (in pseudo-medieval attire) embracing Little Sister, the latter clearly more than ready to take care of herself.

Two vigorous examples of French portraiture, just on the borderline between the Neoclassical and the Romantic, are by the eccentric, weird painter, Anne-Louis Girodet-Trioson. His self-image (526) has a sculptural, dramatic quality, while the even more compelling, Leonardesque *Woman in a Turban* (527)—who, with her lumi-

nous gaze, was probably called an odalisque—reflects the Napoleonic vogue for the exotic.

History does repeat itself. It took the Russians to beat Hitler in the Second World War, just as they did Napoleon more than a century before, a victory in which their winter played as great a part as their men and women. The Hermitage has a great gallery to commemorate the French invasion and defeat, enjoying a magnificent image of Napoleon at his grandest, in a field marshal's uniform (528), painted by Antoine-Jean Gros, one of the Corsican's favorite painters. Made to look tall and slender, Napoleon rises in flattering three-quarter length, seen from the left (doubtless his "good" side), Byronically bare-headed. His hair is

Above
SIR THOMAS LAWRENCE
Bristol 1769–London 1830
Count S. R. Vorontsov
(Inv. No. 1363)
30 × 25″ (76.5 × 64 cm)

Above, left
JOHN HOPPNER London ca. 1758–1810
Richard Brinsley Sheridan
(Inv. No. 3510) Oil on canvas
30 × 12″ (77 × 30.3 cm)
(Ex coll. A.Z. Khitrovo, St. Petersburg, 1912/16)

Opposite
THOMAS GAINSBOROUGH
Sudbury, Suffolk 1727–London 1788
A Woman in Blue, late 1770s
(Inv. No. 3509) Oil on canvas
30 × 25″ (76 × 64 cm)
(Ex coll. A.Z. Khitrovo, St. Petersburg, 1912/16)

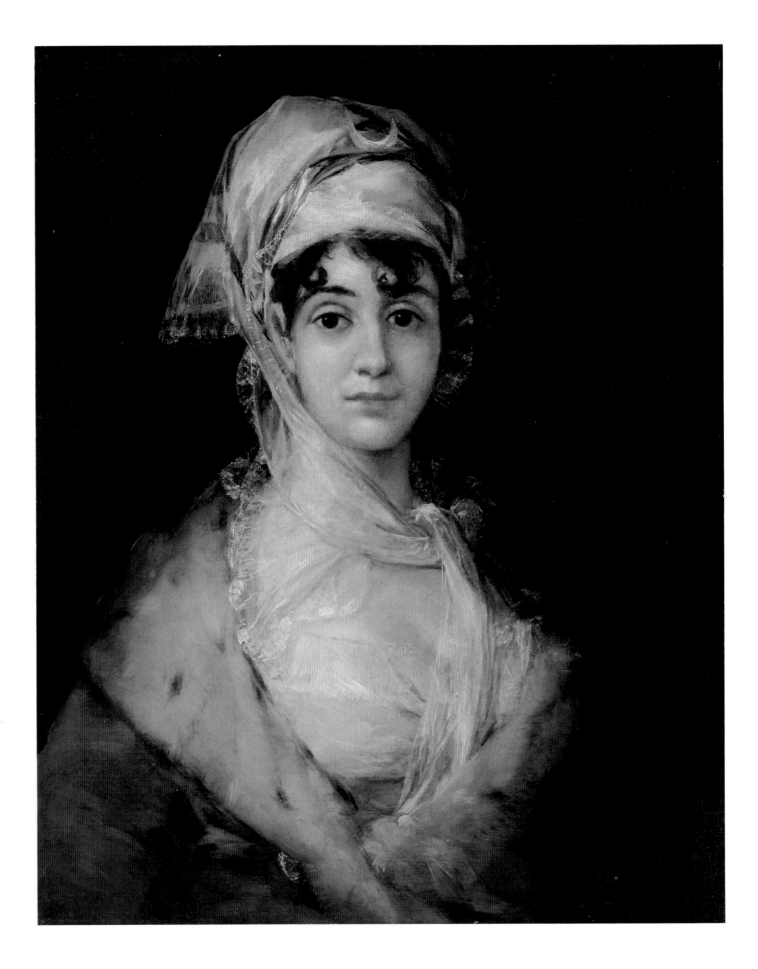

slightly tousled by the breeze in a pose that echoes Alexandrian grandeur: Napoleon is supposedly on the bridge at Arcole where he defeated the Austrians in 1796.

In the Hermitage's gallery of military heroes from the great battle against Napoleon is one of V. G. Madatov (521) by George Dawe, who went to Russia at the invitation of Czar Aleksandr I, and remained there for eight years at the Imperial Academy. Active as a portraitist, he produced about four hundred, many of these for the gallery commemorating the War of 1812. Many of these lively, original portraits came to be well known throughout Europe as they were reproduced in prints by the painter's brother Henry Edward Dawe. All in all, the Hermitage has a surprisingly strong collection of English art of the seventeenth, eighteenth, and nineteenth centuries, including works by John Hoppner (519), Sir Thomas Lawrence (519), George Romney (530), and Joseph Wright of Derby (589), as well as those by Dobson and Gainsborough.

In the nineteenth century some of the most powerful portraits came from a renewed interest in early Northern art and that of mid-sixteenth-century Florence, painting of the so-called Mannerist period. Ingres's likenesses are a shrewd fusion of the hypnotic concentration on physiognomy found in a Jan van Eyck with the sinuous elegance and calculating color of Italian Mannerist art. Of his portraits of men, that of Count Nicolas Dmitrievitch de Guriev (526) is one of the very finest. With the beauty of an ugly

horse, the sitter, who was Russian ambassador to Rome and Naples, presents a quality of justified self-confidence, balanced by a seeming absence of arrogance. Charles Sterling has stressed the deliberately violent color effect — purple, black, and pure white are seen against a background of nocturnal blue, the sky invaded by a menacing storm cloud, adding a tinge of relativism to this uncompromising image.

Later nineteenth-century Paris produced extremely serious portraiture, which was particularly successful when it came to pictures of older, grimmer men, as a very dark palette was then in style, the

Above
GEORGE DAWE London 1781–1829
V. G. Madatov
(Inv. No. 8094)

Opposite
FRANCISCO JOSÉ DE GOYA Y LUCIENTES
Fuendetodos 1746–Bordeaux 1828
Antonia Zarate, ca. 1811
(Inv. No. 10198) Oil on canvas
28 × 23″ (71 × 58 cm)
(Gift of Armand Hammer, 1972)

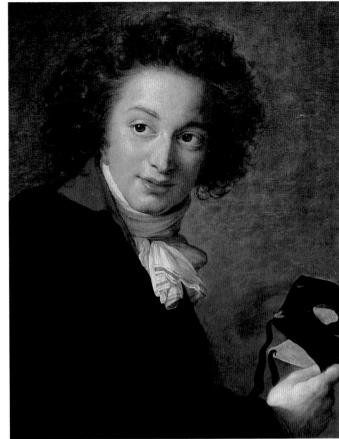

Above, left
LOUISE-ELISABETH VIGÉE-LEBRUN Paris 1755–1842
Countess A. S. Stroganova and Her Son, 1793
(Inv. No. 7587) Oil on canvas
35½ × 29″ (90.5 × 73 cm)
(Ex coll. Stroganov Palace Museum)

Above, right
LOUISE-ELISABETH VIGÉE-LEBRUN
Count G. I. Chernyshev Holding a Mask, 1793
(Inv. No. 7459) Oil on canvas
22 × 17″ (56 × 44 cm)
(Ex coll. Chernysheva-Kruglikova, St. Petersburg)

Left
LOUISE-ELISABETH VIGÉE-LEBRUN
Self Portrait, 1800
(Inv. No. 7586) Oil on canvas
31 × 27″ (78.5 × 68 cm)
(Ex coll. Vigée-Lebrun, St. Petersburg)

Opposite
LOUISE-ELISABETH VIGÉE-LEBRUN
Baron G. A. Stroganov, 1793
(Inv. No. 5658) Oil on canvas
36 × 26″ (92 × 66 cm)
(Ex coll. M.M. Stroganova)

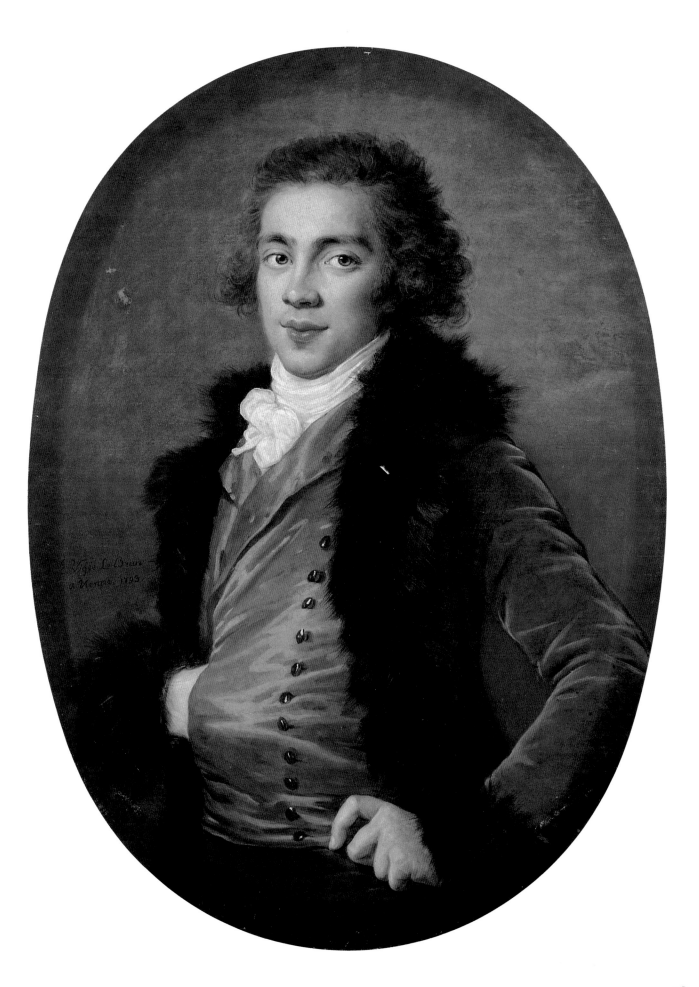

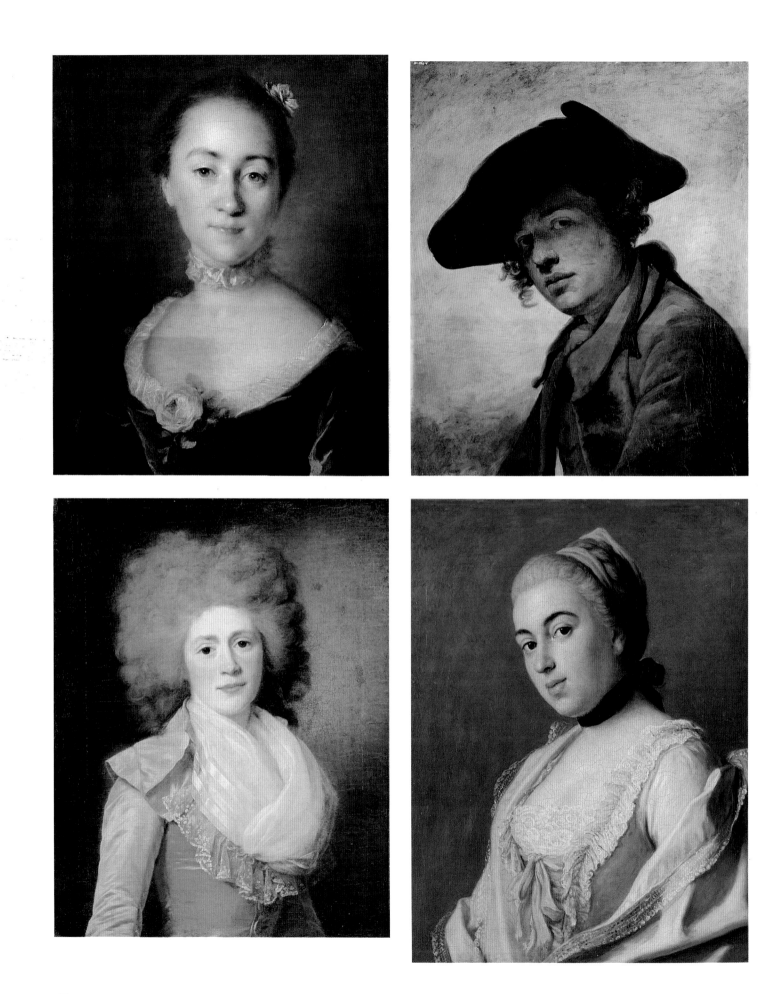

specialty of Léon Bonnat (531), Carolus-Duran (535), and Alexandre Cabanel, seen in the latter's painting of Prince Konstantine Gorchakov of 1868 (531). Their powerful, forbidding images suggest those captured by a camera with a conscience, delineations of rare scruple and scrutiny—looming, compelling, omniscient. These qualities appealed most to those with the least moral doubts, the great magnates and monopolists of the time who flocked to the Parisian masters' studios to have themselves and their families portrayed with such deceptive probity.

Among the Hermitage's surprises is Franz von Lenbach's *Prince Otto von Bismarck* (531). Far from the clichéd image of the Iron Chancellor, this is a conflicted figure, bedeviled by burdens that he can hardly carry. Free brushwork anticipating Kokoschka's contributes to the realization of this complex character. One of the most successful painters of the nineteenth century, Lenbach was a master of portraiture, painting almost a hundred canvases of Bismarck as well as numerous works showing the chancellor's kaiser, Wilhelm.

Two contemporary painters from Austria and Germany display great vigor in their portraits (530). Hans Makart's picture of a handsome woman, painted during the peak of Frans Hals's popularity, was known as that of a woman in a Rembrandt-style hat. In fact, the picture, with its slashing brush strokes is nearer Hals and Rubens than Rembrandt. Anselm Feuerbach's self portrait shows this successful painter, handsome devil

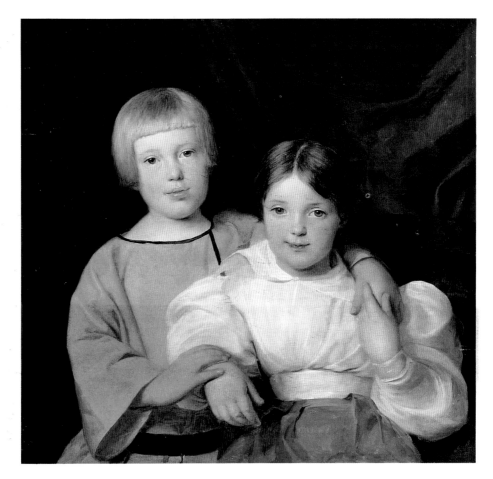

Opposite: Top, left
LOUIS TOCQUÉ
E. A. Golovkina
(Inv. No. 7636) Oil on canvas
19½ × 16″ (50 × 41 cm)
(Ex coll. S.I. Shchukin, Moscow)

Opposite: Top, right
JEAN-BAPTISTE GREUZE
A Young Man in a Hat, 1750s
(Inv. No. 1256) Oil on canvas
24 × 19½″ (61 × 50 cm)
(Ex coll. Crozat, Paris, 1772)

Opposite: Bottom, left
JEAN-LOUIS VOILLE
Paris 1744–(?) after 1803
A Woman in Blue
(Inv. No. 5653) Oil on canvas
29 × 22 ¼″ (73 × 57 cm)
(Ex coll. E.P. and M.S. Oliv, St. Petersburg, 1923)

Opposite: Bottom, right
PIETRO ANTONIO ROTARI
Verona 1707–St. Petersburg 1762
Countess A. M. Vorontsova
(Inv. No. 5430) Oil on canvas
19½ × 18″ (50 × 46.5 cm)
(Ex coll. Myatlev, St. Petersburg, 1923)

Above
FERDINAND GEORG WALDMÜLLER
Vienna 1793-Hinterbrühl 1865
Children, 1834
(Inv. No. 5781) Oil on panel
10 × 12″ (25 × 31 cm)

that he was, in a somewhat swaggering pose. His slightly sinister quality was accentuated by his penchant for striding around Karlsruhe in a red-silk-lined mantle bought in Paris, which gave him the nickname of Fra' Diavolo.

Recalling the pyramidal compositions of the High Renaissance, Franz Xaver Winterhalter's *Empress Maria Aleksandrovna* (532) is an exquisitely formal image, painted by the internationally fashionable German. For all the grandeur of her garb, this remains a private, almost challenging picture, as the empress of Aleksander II, a princess of Hesse, looks out with a slightly hooded, melancholic gaze, posing at a Bavarian watering place in 1857. Rising above and beyond the splendor of her attire, her resigned expression may say: "If you equate my outer riches with inner joys, more the fool you." Winterhalter's greatest skill—beyond the price of the czarina's pearls—was to imply a beauty that might, but probably did not, exist.

Eighteenth-century portraitists also favored white, as seen in the oval by Jens Juel (533). Another oval, this one by Winterhalter (533), painted in Paris in 1858, is more opulent and relaxed; the Ingres-like image shows Sofia Naryshkina, wife of the czar's chamberlain. Though white often conveys a certain virginal luster, this sitter is also in voluptuous furs, her complacent expression very different from the czarina's haunting gaze. An equally insightful likeness is of Countess E. P. Shuvalova, by Greuze (533), which was pendant to that of her husband.

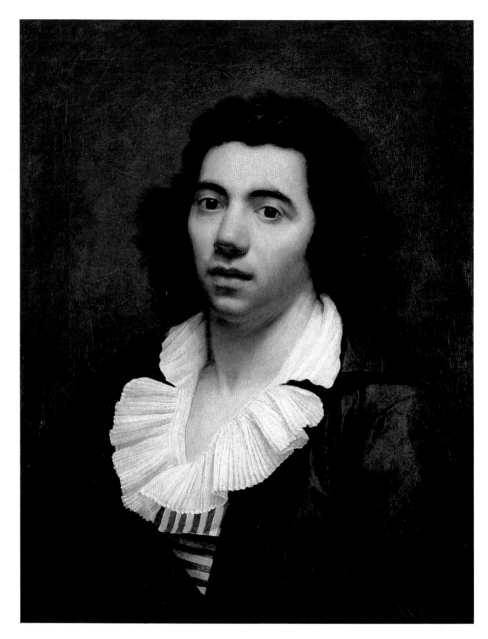

Above
ANNE-LOUIS GIRODET-TRIOSON
(GIRODET DE ROUSSY)
Montargis 1767–Paris 1824
Self Portrait (Inv. No. 5660) Oil on canvas
23 × 18″ (59 × 46 cm)
(Ex coll. K.A. Gorchakov, St. Petersburg)

Opposite
ANNE-LOUIS GIRODET-TRIOSON
A Woman in a Turban
(Inv. No. 8235) Oil on canvas
16 × 13″ (41 × 33.5 cm)

Page 528
BARON ANTOINE-JEAN GROS
Paris 1771–Bas-Meudon 1835
Napoleon Bonaparte on the Bridge at Arcole
(Inv. No. 5669) Oil on canvas
53 × 41″ (134 × 104 cm)
(Ex coll. N.N. Leikhtenbergsky, Leningrad)

Page 529
JEAN-AUGUSTE-DOMINIQUE INGRES
Montauban 1780–Paris 1867
Count N. D. Guriev, 1821
(Inv. No. 5678) Oil on canvas
42 × 34″ (107 × 86 cm)
(Ex coll. A.N. Naryshkina, St. Petersburg, 1922)

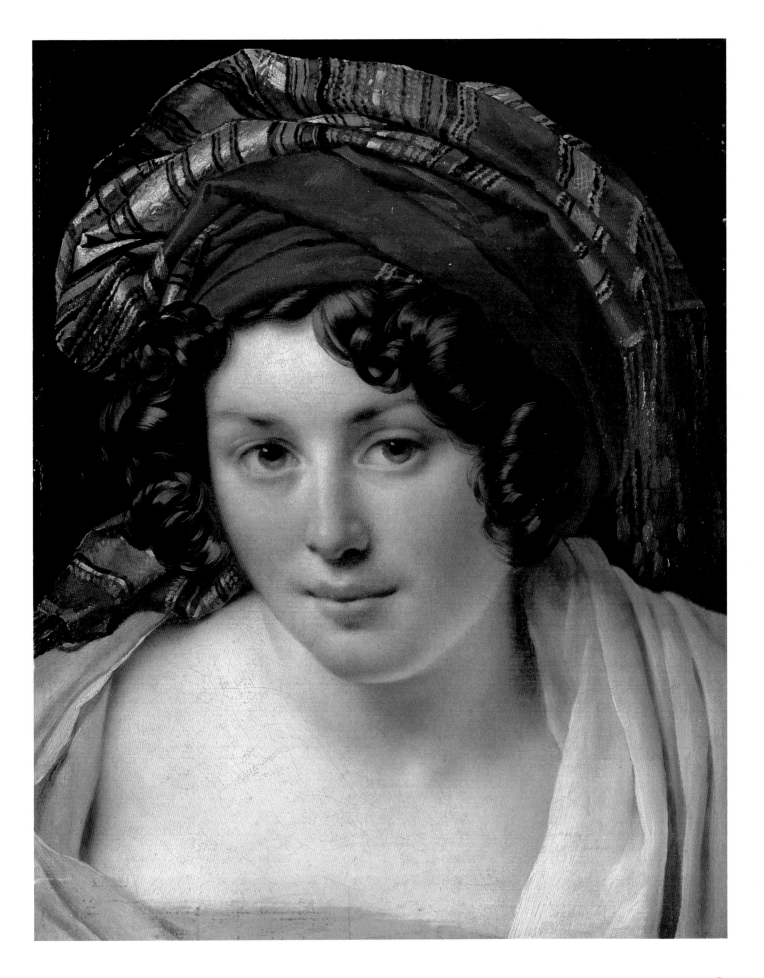

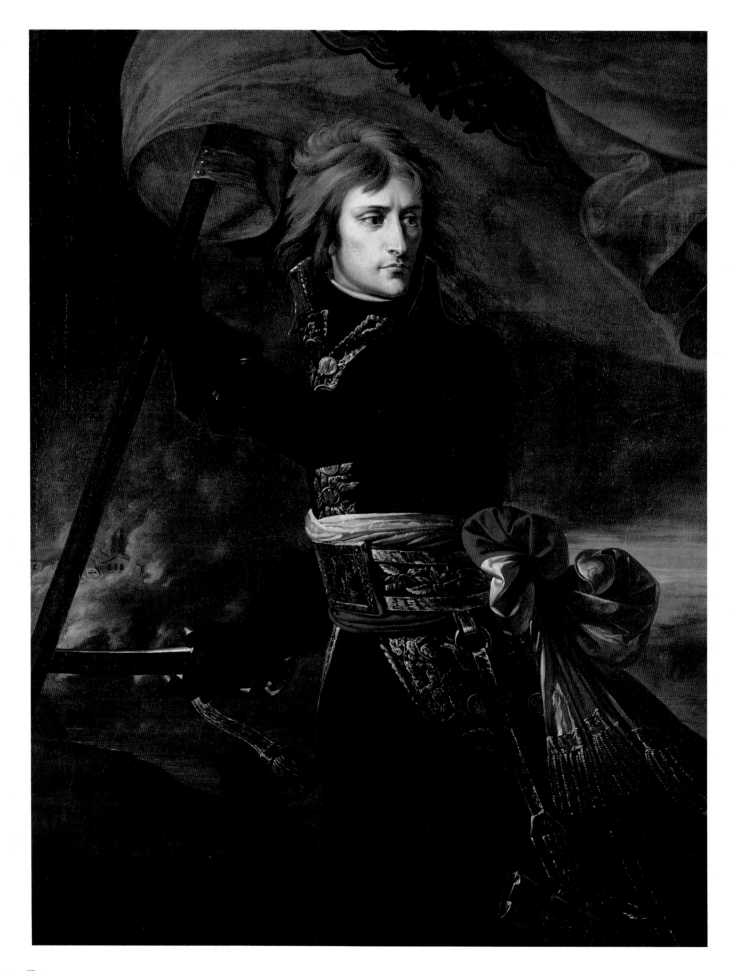

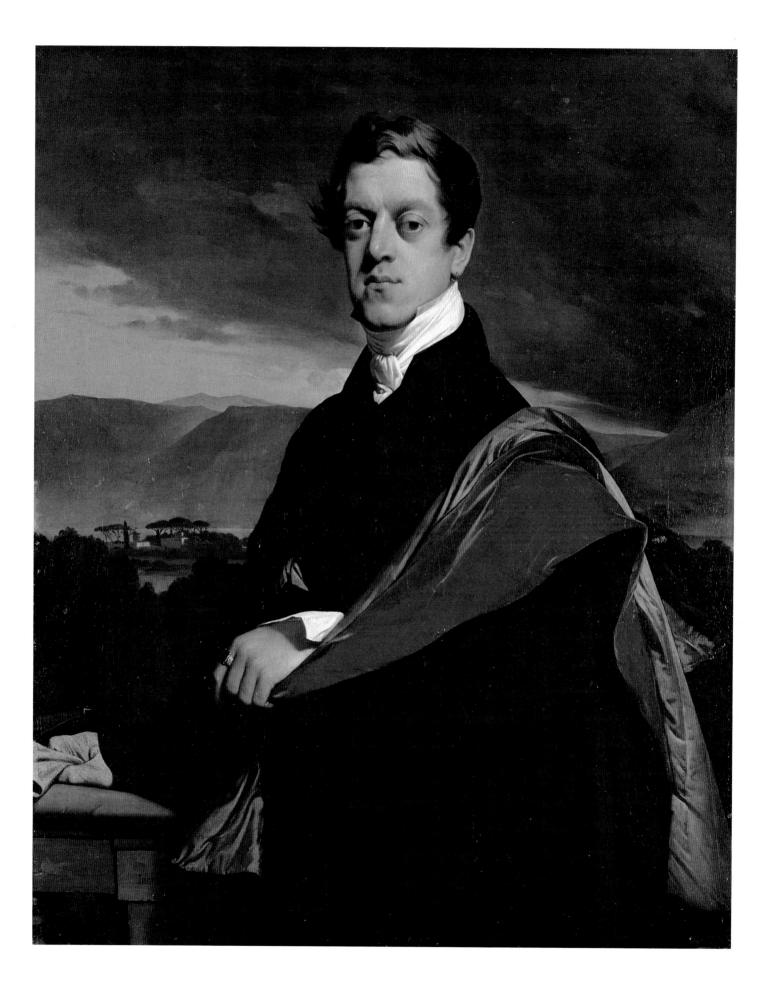

Above
HANS MAKART Salzburg 1840–Vienna 1884
Portrait of a Lady (Inv. No. 6011) Oil on panel
47 × 31½" (120 × 80 cm)

Top, left
ANSELM FEUERBACH Speyer 1829–Venice 1880
Self Portrait (Inv. No. 4307) Oil on canvas
36 × 29" (92 × 73 cm)
(Ex coll. B.A. Dobronitskii, St. Petersburg)

Bottom, left
GEORGE ROMNEY Dalton-in-Furness 1734–Kendal 1802
Mrs. Harriet Greer, 1781
(Inv. No. 3511) Oil on canvas
30 × 25" (76 × 64 cm)
(Ex coll. A.Z. Khitrovo, St. Petersburg, 1912/16)

Above
LÉON BONNAT Bayonne 1833–Monchy-St-Éloi, Oise 1922
Prince V. N. Tenishev, 1896
(Inv. No. 5172) Oil on canvas
47 × 36″ (119.5 × 92 cm)

Top, right
ALEXANDRE CABANEL Montpellier 1823–Paris 1889
Prince K. A. Gorchakov, 1868
(Inv. No. 5093) Oil on canvas
26½ × 22″ (67 × 56 cm)
(Ex coll. Gorchakov, St. Petersburg)

Right
FRANZ VON LENBACH Shrobenhausen 1836–Munich 1904
Prince Otto von Bismarck
(Inv. No. 8389) Oil on panel
31½ × 24½″ (80 × 62 cm)

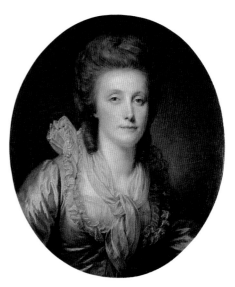

An intimate self-portrait of Horace Vernet *chez soi*, painted in his Roman studio in 1835, was presented to the artist's Russian friend Count Fersen and is so inscribed. Posing against a great blank canvas, for which Vernet probably had a North African or Turkish battle scene in mind, he wears silken Near Eastern slippers and smokes a narghile, or water pipe. His surroundings are punctuated by Turkish armor, a drum, and Smyrnese rug. The popular battle painter takes on some of the exotic, Bohemian garb that would soon become required attire for the truly Artistic.

From the Late Romantic period is an especially sensitive, compelling portrait by Paul Delaroche of the well-known coloratura Henrietta Sontag. Wearing the attire of Donna Anna in Mozart's *Don Giovanni*, the large cross on her breast bespeaking the piety that conflicts with her passion, the singer's is an exquisitely tormented demeanor, her anguished eyes set within the polished surface of a Laurana bust.

Smoky and ephemeral, Eugène Carrière's free modeling suggests a Rodin plaster in its delicate, evanescent chiaroscuro. One of the French painter's finest likenesses is that of a *Lady Leaning Her Elbows on a Table* (536).

Startlingly fresh in its enlightened sense of confrontation is a portrait ascribed to the Swiss painter Giovanni Segantini. Yet this introspective image is rendered in a smoother fashion than that characteristic for him. Here is a woman liberated by her own—and her painter's—

Above
JENS JUEL
Baslev, Fyn Island 1745–Copenhagen 1802
Portrait of a Woman
(Inv. No. 5831) Oil on canvas
25 × 21½″ (64 × 54.5 cm)
(Ex coll. E.P. and M.S. Oliv, St. Petersburg)

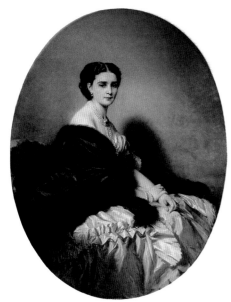

Above, top
JEAN-BAPTISTE GREUZE
Countess E. P. Shuvalova, ca. 1780
(Inv. No. 5726) Oil on canvas
23½ × 19½″ (60 × 50 cm)
(Ex coll. Shuvalov, Leningrad, 1925)

Above, bottom
FRANZ XAVER WINTERHALTER
Menzel-Schwand 1806–
Frankfurt-am-Main 1873
S. P. Naryshkina, 1858
(Inv. No. 5800) Oil on canvas
59 × 45″ (150 × 114 cm)

Opposite
FRANZ XAVER WINTERHALTER
Empress Maria Aleksandrovna, 1857
(Inv. No. 7539) Oil on canvas
47 × 37½″ (120 × 95 cm)
(Ex coll. Winter Palace, 1926)

Page 534
ÉMILE-JEAN-HORACE VERNET
Paris 1789–1863
Self Portrait
(Inv. No. 5679) Oil on canvas
18½ × 15″ (47 × 39 cm)
(Ex coll. Ferzen, St. Petersburg)

Page 535
CHARLES-AUGUSTE-ÉMILE DURAN
(CAROLUS-DURAN)
Lille 1837–Paris 1917
N. M Polovtsova, 1876
(Inv. No. 5175) Oil on canvas
81 × 49″ (206.5 × 124.5 cm)
(Ex coll. A.A. Polovtsov, Leningrad)

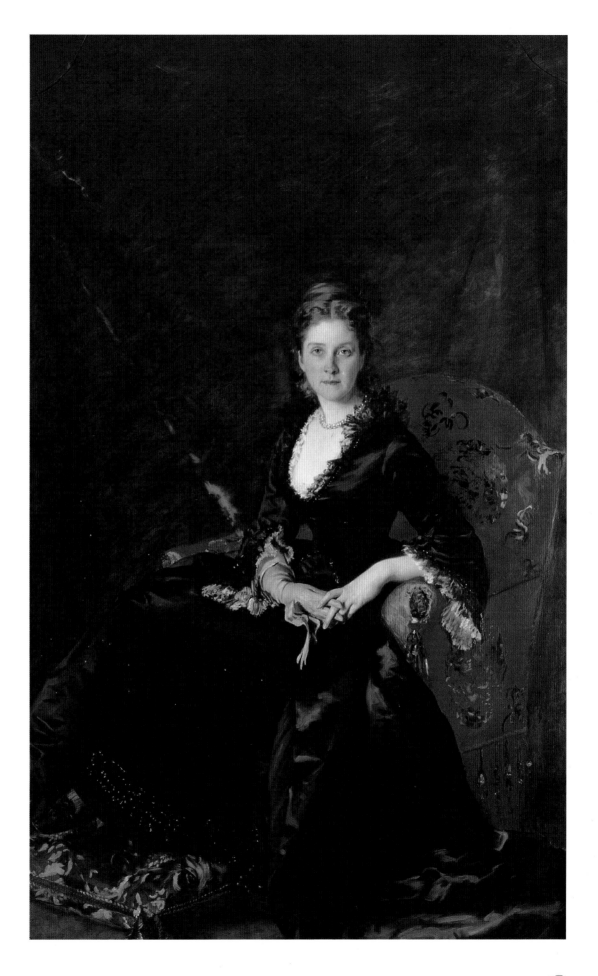

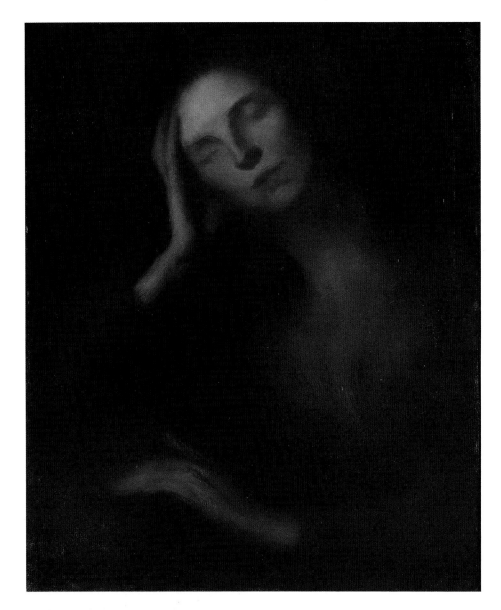

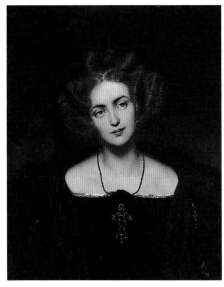

Above
EUGÈNE CARRIÈRE
Gournay, Seine-et-Marne 1849–Paris 1906
Lady Leaning Her Elbows on a Table
(Inv. No. 6565) Oil on canvas
26 × 21" (66 × 54 cm)
(Ex coll. S.I. Shchukin, Moscow)

Left
PAUL DELAROCHE Paris 1797–1856
Henrietta Sontag, 1831
(Inv. No. 7462) Oil on canvas
29 × 23½" (73 × 60 cm)

Opposite
UNKNOWN, late 19th century
Portrait of a Lady
(Inv. No. 8913) Oil on canvas
24½ × 16" (62 × 40 cm)

intelligent communication of self. Caught in a pensive close-up, presented with all the "accidental" cropping of a photograph or a Japanese print, she looks beyond painter and viewer, rendered in an "International Style" of the late nineteenth century shared by such diverse artists as Chase, Whistler, and Eakins, as well as many European painters.

Lighter in effect, with a rich Venetian chromaticism, are Renoir's portraits of the same period, whether of belle époque actresses (539); plump, sweet girls (539); members of the bourgeoisie; or of his own family. Sculptor as well as painter, ever drawn to the reassuring continuity of antiquity and femininity, Renoir worships the twin glories of form and surface, best joined in luminous complexion. His portrait of a girl holding a fan (538) has just that touch of Orientalism so much in vogue in the late nineteenth century.

Cézanne, like Ingres, exasperated his sitters by calling for seemingly endless, motionless posing, but the results often justified that torturous process. His images (540, 541) are Mount Rushmores of classical concern and perpetuation, but unlike those gargantuan likenesses—lifeless though carved from the living rock—Cézanne confers true monumentality upon his patient subjects, won by an awesome fusion of detachment and concentration.

Where he is zealous in avoiding the clichéd concepts of beauty and virtuosity (both probably beyond his peculiarly limited genius) his colors are almost always amazingly

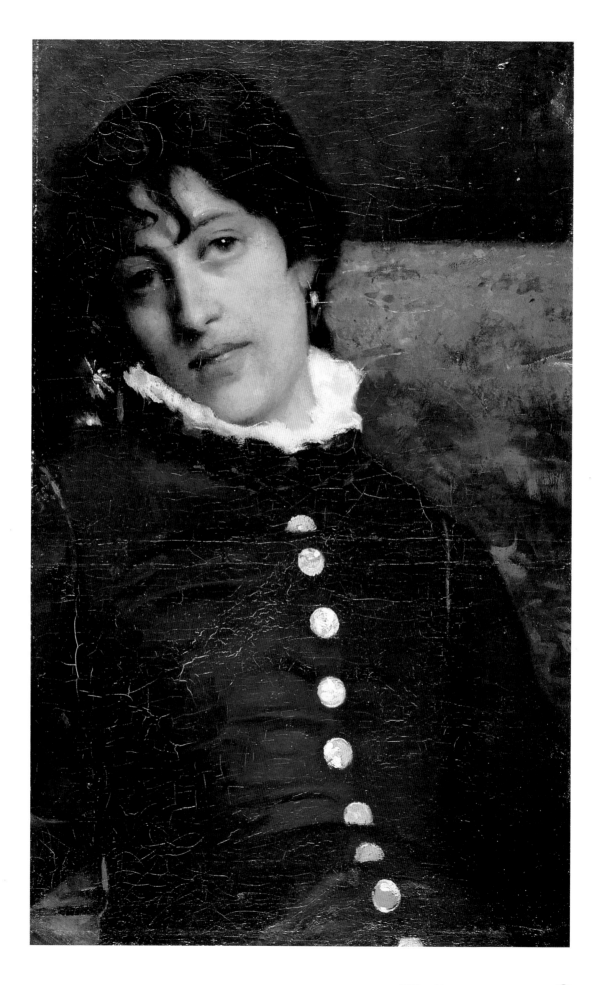

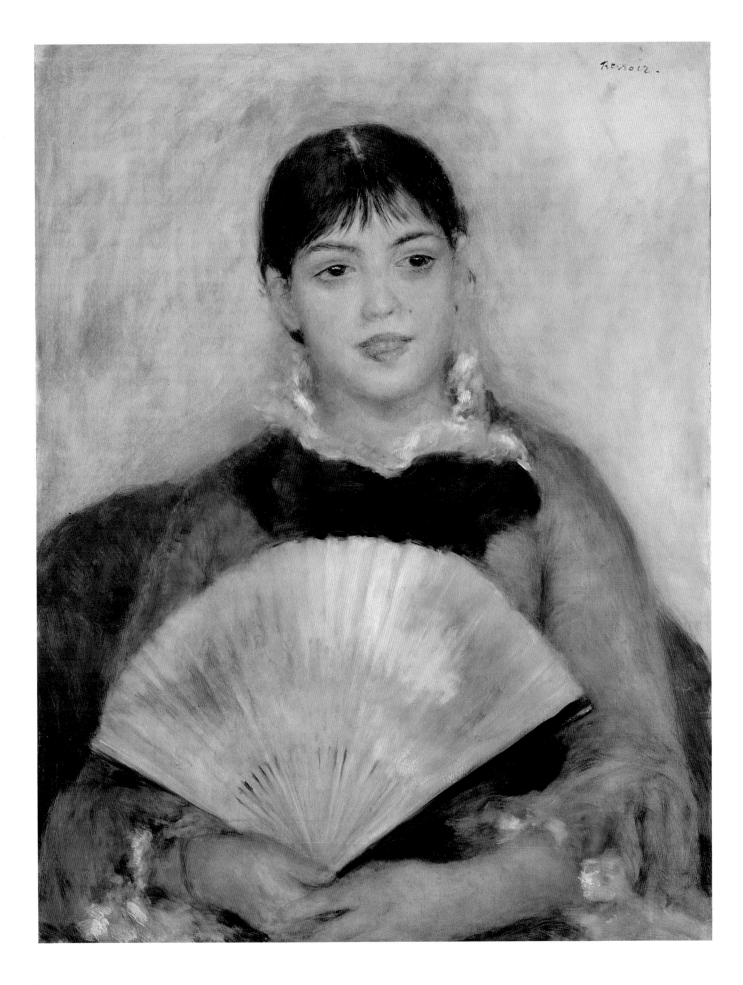

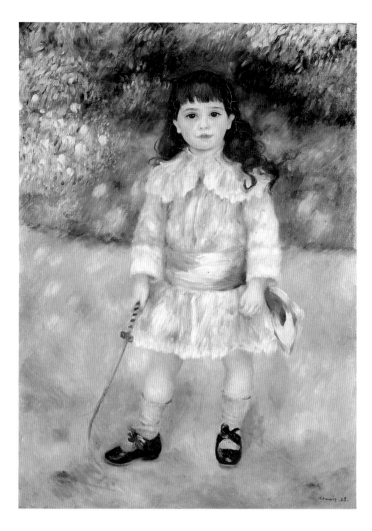

PIERRE-AUGUSTE RENOIR
Child with a Whip, 1885
(Inv. No. 9006) Oil on canvas
41 × 29½" (105 × 75 cm)
(Ex coll. I.A. Morozov, Moscow)

PIERRE-AUGUSTE RENOIR
The Actress Jeanne Samary, 1878
(Inv. No. 9003) Oil on canvas
68 × 40½" (173 × 103 cm)
(Ex coll. I.A. Morozov, Moscow)

Opposite
PIERRE-AUGUSTE RENOIR
Limoges 1841–Cagnes-sur-Mer 1919
Girl with a Fan, 1881
(Inv. No. 6507) Oil on canvas
25½ × 19½" (65 × 50 cm)
(Ex coll. I.A. Morozov, Moscow)

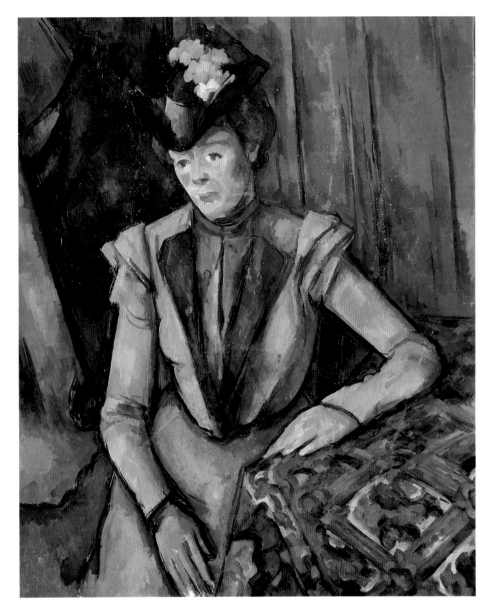

Above
PAUL CÉZANNE
Aix-en-Provence 1839–1906
Woman in Blue (Madame Cézanne), ca. 1899
(Inv. No. 8990) Oil on canvas
35 × 28" (88.5 × 72 cm)
(Ex coll. S.I. Shchukin, Moscow)

Opposite
PAUL CÉZANNE *The Smoker*, ca. 1895
(Inv. No. 6561) Oil on canvas
36 × 28" (91 × 72 cm)
(Ex coll. I.A. Morozov, Moscow)

lovely. Their fresh, prismatic purity and almost decorative quality seem (deceptively) in conflict with his pursuit of pictorial truth.

Even more daring, in terms of color and concept, is Matisse's portraiture. Those in the Hermitage, like Cézanne's, show the artist at his very best: bold, authoritative, analytic—painting in his prime. What makes these still-startling delineations work with such success is the presence of the same element that holds true for Cézanne—a profound, subliminal Classicism. The deepest assimilation of Venetian art supports Matisse, while that of Poussin reinforces Cézanne. Each master reinvented the art of the past, making it his own.

Cézanne wasn't the only taskmaster of early-twentieth-century painters, either. More than a hundred sittings were called for to paint Matisse's wife, Amélie (544), as she posed patiently in their garden at Issy-les-Moulineaux in 1913. In what is the artist's definitive work of that year (and, one is tempted to add, his wife's as well) Mme Matisse wears a slightly bemused expression, and is probably also wearing a creation of her own in honor of her husband's—one of the hats she made to support herself and him as he moved from lawyer to art student. In another exemplary work, this entitled *Young Girl with Tulips* (545), Jeanne Vaderin holds her rounded arms in a fashionable, somewhat self-conscious pose, perhaps placed before two potted plants to stress her youth—she's blooming, they're still in the bud.

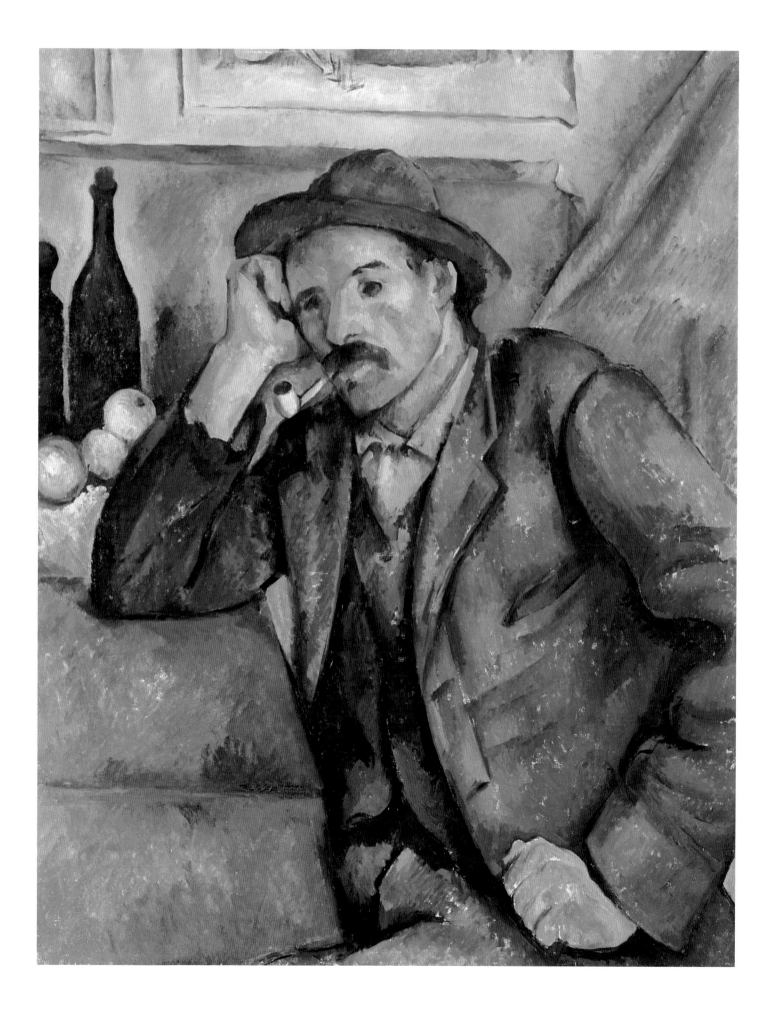

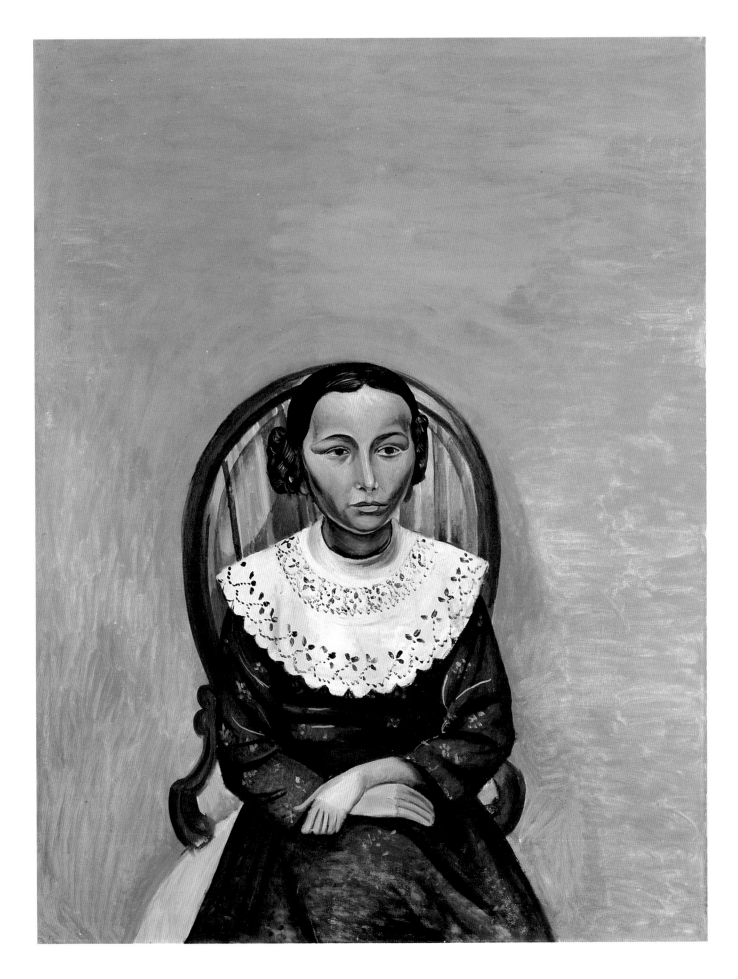

Two portraits by Picasso show the young painter, still close to his Blue Period, working in a rather sentimental, polite Primitivism, dependent upon the shrewd reductions of Puvis de Chavannes (103, 592). One shows the artist's tailor in Barcelona, Soler (543), who accepted this canvas—along with one of his wife (now in Munich)—as payment for Picasso's debts to him. Earlier, Picasso had his friends pose as absinthe drinkers (543) and in other similar, conventionally "depraved" genres. These have a still-adolescent attitudinizing about them, however.

Surprisingly fresh and effective, André Derain's portrait of a young girl against a blue background shows this uneven master at his best, daring in the ratio between the large background area and the small figure seated on a Victorian chair (542). Hers is a remarkably poised expression, rising above the somewhat nunlike costume with its great white eyelet bertha.

Kees van Dongen, known as a sleek café society portraitist before his Art Deco period, worked in a freer, more intriguing style, as seen in this painting of two black entertainers, frequent models of his, who are here presented with an appealing mix of intimacy and professionalism (543).

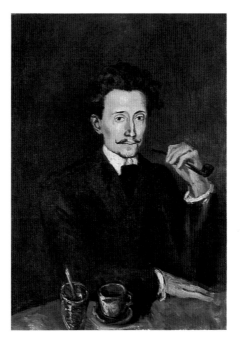

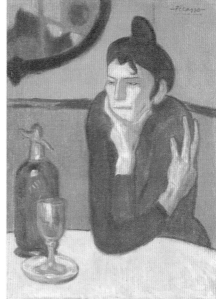

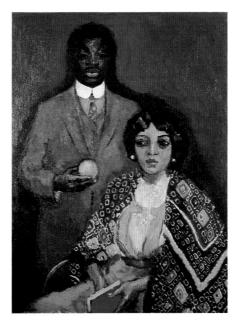

Above
PABLO RUIZ Y PICASSO
Málaga 1881–Mougins 1973
Absinthe Drinker, 1901
(Inv. No. 9045) Oil on canvas
29 × 12" (73 × 54 cm)
(Ex coll. S.I. Shchukin, Moscow)

Above, left
PABLO PICASSO
Portrait of Soler, 1903
(Inv. No. 6528) Oil on canvas
39 × 27½" (100 × 70 cm)
(Ex coll. S.I. Shchukin, Moscow)

Left
KEES VAN DONGEN
Delfshaven 1877–Paris 1968
Lucy and Her Partner, 1911
(Inv. No. 9087) Oil on canvas
51 × 38" (130 × 97 cm)
(Ex coll. Poryvkin, Moscow)

Page 544
HENRI MATISSE
Le Cateau-Cambresis 1869–Cimiez 1954
Portrait of the Artist's Wife, 1913
(Inv. No. 9156) Oil on canvas
57 × 38" (145 × 97 cm)
(Ex coll. S.I. Shchukin, Moscow)

Page 545
HENRI MATISSE
Young Girl with Tulips
(Portrait of Jeanne Vaderin), 1910
(Inv. No. 9056) Oil on canvas
36 × 29" (92 × 73.5 cm)
(Ex coll. S.I. Shchukin, Moscow)

Opposite
ANDRÉ DERAIN Chatou 1880–
Chambourcy 1954
Portrait of a Young Girl in Black, 1914
(Inv. No. 9125) Oil on canvas
45 × 34½" (114.5 × 88 cm)
(Ex coll. S.I. Shchukin, Moscow)

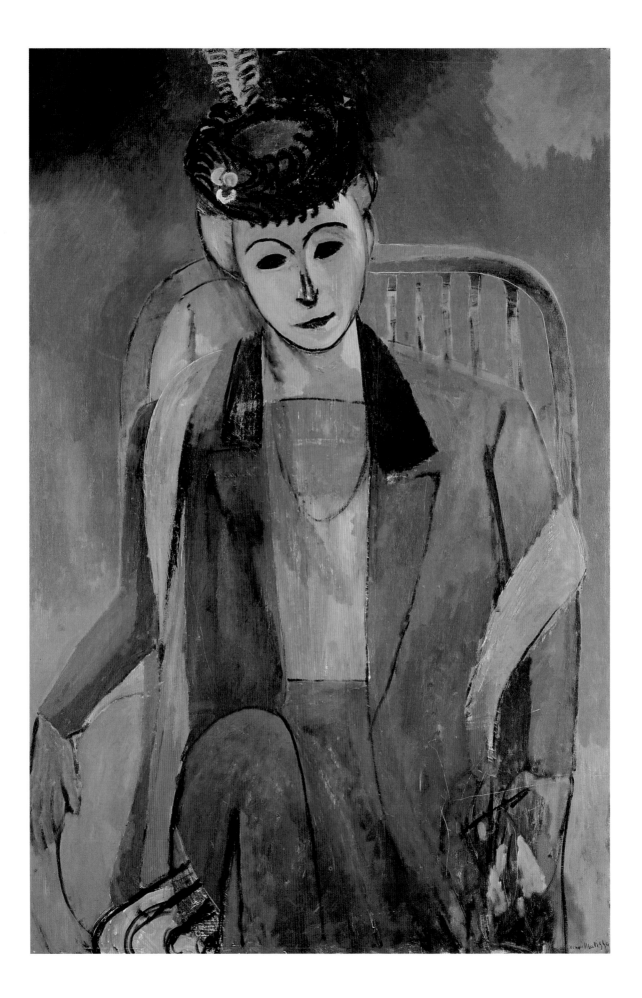

Action Painting: The Art of Genre

D on't just stand [or sit] there — *do something!*" In this command's pictorial consequence lies the difference between most categories of conventional painting and that catchall known as Genre. The latter's "G" could just as well stand for "gerund," because genre is ever the "-ing" image, where something is always happening, often in an everyday, if somewhat contrived, fashion. Because genre suggests doing, such activity converts a picture's content from static to active, enlivening the subject toward engagement, away from the self-absorbed or too obviously posed.

Landscapes leave their original category to become genre when they are so prominently peopled or otherwise animated that nature is crowded into obscurity — reduced to a backdrop. In its official, original French significance, *genre* means no more than "type" or "kind." But the term has long come to take on a more personal dimension in the visual arts, almost the intimate, literary sense of a Galsworthian or Proustian memoir, a vignette by Colette, a Chekhovian or Gogolesque encounter. Moving down the social ladder, genre subjects embrace peasants' days and nights, or the high-jinks of urban low life. Among these are innumerable scenes of domesticity, of bourgeois felicity, dialogues between child and nursemaid, officer and prostitute. These are found in "Within Three Walls" in this book.

JACOB GERRITSZ CUYP Dordrecht 1594–1651/52 *The Grape Grower,* 1628
(Inv. No. 5598) Oil on canvas 44 × 42" (112 × 107 cm)

But those paintings that hover between the personal portrayal and a theatrical setting, as in *The Dancer Camargo* (page 581) by Nicolas Lancret or the theater pieces of the same artist (580); lovers caught in rustic flight by Hubert Robert (585); seas taken over by battling ships (570), or lands occupied by warring armies (572–73)—all these assume an active, engaging sense of scene that places such images beyond nature's autonomy, within the genre of Genre.

This is an art form where the subject matter may indeed matter far more than in "pure" landscape or undiluted still life. Now the painter is active as a playwright and scenographer as well. Having hatched the plot and written the script, the artist's attention is then directed to the actor-models. As if standing behind an old-fashioned view camera, the painter tells the cast (of one or many, many more) just what to do and when to "Hold that pose."

Long out of favor but for the most conservative circles, genre has been dismissed, with most other representational painting, as excessively artificial, anecdotal, and sentimental. Things have changed. Now narrative has become acceptable, and painters are rediscovering for themselves and for their viewers the mysteries of domesticity, the ambiguity and eroticism, the splendors and miseries of the supposedly Everyday. The compelling seduction of the TV screen, with its accessibly small-scale figures, probably helped bring genre back to life. Paul Mellon's incomparably panoramic collection of British art, given to Yale University, literary to the core, has also resuscitated subject matter, restoring the anecdotal, letting narrative come back into its own. A universal revival of Academic art and the new taste for Expressionism, both deeply concerned with narrative and morality, led to a fresh interest in Dutch seventeenth-century art, so much of it on an intimate scale, with intensely bourgeois descriptive values.

Very recent rediscovery by painters of their roles as social critics and students of mores has caused many to move away from the profitable neutrality of the abstract toward such long-forgotten, obscured, or unfavored issues as justice, truth, sexuality, liberty, peace, faith, and many other essential human concerns. As these are slowly returning to the visual sphere, they arouse new curiosity about the social and moral values of the past. Genre, because of its occasional intimacy, its deceptive sense of the ordinary, is one of the subtlest yet most effective ways in which these topics may be served, leaving it to the viewer to draw the inferences, with a gentle nudge or two from the artist.

So genre moves over a broad terrain, from a simple depiction of craft, trade, or profession, of domestic or social activity, into far more complex and challenging areas, where the painter comes to new conclusions from experiencing the particular, sharing or shaping these moral perspectives with the viewer. Such pictorial statements are validated by their visual authenticity, by the depth of the painter's understanding of the trivia that add up to Truth, the little gestures that constitute Love, or those that convey the tragicomedy of Time—all so often tucked within the folds of Genre. This category may mean far more than it shows: The fidelity and dedication of artist to subject bespeaks an intrinsic sense of its worth, compelling the viewer to credit the deceptively casual image with implicit significance, as an unwritten yet constitutional truth to be held self-evident through art.

Genre can impinge upon mystery in those oddly open-ended paintings that are deliberately far from self-explanatory, where a story line is merely suggested, and relationships are ambiguous or conflicted. Some artists furnish deliberately mixed pictorial signals, letting us draw our own conclusions. Watteau and Degas were among the greatest practitioners of this teasing skill, showing but not quite telling, omitting those crucial details that would make it all too obvious. So genre may exert its own mysteries, with the artist not always knowing just how or where his or her picture is going—or went.

Nurture and shelter, among the most basic of concerns, lie close to the bone of survival. That's why farming and hunting, fishing and provisioning are all subjects of pictorial concern. Peasants in the fields provide a calendar manifested by the labors of the months—planting, sowing, and reaping. Farmers, roistering and rewarded for their toil at dances and other festivities, often at carnival time, provide one of the most popular rustic images.

Few visual experiences are more profoundly soul-satisfying than watching others sweat. Self-interest perceives almost any such activity as in our own behalf, part of a pictorially extended community that can be counted upon for the crucial industry that many of us can't, won't, or don't exert. So some or all such sentiments surround a monumental image of the *vigneron* tending his vines by Jacob Cuyp (546). This peasant may be doing double duty, signifying a season—autumn—as much by his aged, mellow presence as by his crop. One of Cuyp's rare large-scale figure pieces, the canvas comes close to a meditation upon the nature of labor.

With his philosopher's head planted upon a peasant's body, the worker in the vineyards provides a living contrast between the contemplative and the active, those halves of the twinned nature of human existence. In the background, men and women tread grapes and roll out barrels; with the cutting of the fruit, the whole process of vintage is presented.

Much the same terrain was covered earlier by Francesco Bassano the Younger's richly toned autumnal landscape (552). This Venetian canvas probably belonged to a cycle of four, one for each season. Such series had been painted and sculpted since Classical antiquity, viewed as scenes of divine providence, as the gods saw to it that each season made way for the next. So people were happy to dine or be buried within walls decorated by the year's four divisions.

While the burly grape-picker shows the beginning of the vintage, the plump, crowned old man in Jacob Jordaens's *The Bean King* (551) depicts its end, that of the consumer, not the laborer. Here the plenitude and fertility that are among Baroque art's best-loved themes are stressed in an idealized depiction of the Feast of the Epiphany as celebrated in a comfortable Flemish household. The joys of maternity and of well-fed (and well-wined) old age are placed in happy polarity. The senior member of the family is crowned as one of the Three Kings, amidst a general climate of benevolence and opulence that Jordaens re-created with habitual skill, reassuring for a Flemish society whose preceding century had been filled with the Spanish terror and iconoclasm.

Familial festivities like Epiphany present occasions for wishful thinking—happy illusions perpetuated by the power of paint. Here's a cheery, lusty old man forever crowned by joy and love. How could sorrow or death ever come to one so well regarded by life and so richly served in art?

Peasant fairs, outdoor festivities like the handsome panorama by Joachim Beuckelaer (553), often include fine folk in fancy dress, possibly the landlords, who join the villagers' celebration, sharing in the harvest frolic so central to their own well-being. In this rustic equivalent to an office party, barriers between classes drop as all share in the fun once the work is done. Often peasant dances—in the Low Countries, *kermesses*—mark religious holidays or spring rites, carnival or harvest. These occasions enjoy a special sense of the here and now, a message of "Eat, drink, and be merry," with an implicit reminder that "Tomorrow we die." Moving to musical measures is so often an allegory of Time, from the Dance of the Hours all the way down to the Minute or Hesitation Waltz. Making for a harmonious passage through life, the dance is central to celebration.

Rustic life is essential, known to be so even by those who can't tell wheat from hay. Seldom if ever a happy one, the peasant's lot, like woman's work, is never ending. One of art's longest-running (and most-profitable) lies, going strong since antiquity, has been that of the simple joys of those condemned to the farmer's harsh fate: Painters' perpetuation of this myth has always found a ready market.

Hans Wertinger's *Village Celebration (The Month of October)* (552, 554–55), with its original painted frame, is still reminiscent of manuscript illumination in its concentration upon detail. Decorative idylls of rustic life, of romantic shepherds and shepherdesses (48, 49), or noble presentations of the stoical, impressive visages of Louis Le Nain's *The Milkmaid's Family* (559), all continue the biblical sense of worth and blessedness of the watchful shepherd; the dutiful farmer, patiently tending field and flock; the sowers and reapers whose good seed, good sense, and good grain bring us the staff of life.

Few later Spanish artists concerned themselves with rusticity—an unusually fine exception is Ignacio de Iriarte (559, 560–61). His long-horned cattle recall those of the Roman campagna. Though called *Fording*, it is not clear whether the man is helping the woman mount, or trying to yank her off, the horse in that Goya-like group at the center.

Italian painters of the Rococo caught on to the popularity of Northern art of the preceding century, reworking its picturesque themes in light-weight fashion. Venetian artists like Francesco Zuccarelli (558) took over many of the Low Countries' rustic motifs to their own advantage. These subjects sold very well in a Serenissima that had lost a lot of its nearby territory, painted illusion almost making up for lost real estate.

Italian artists looked long and hard at prints after the wonderfully animated landscapes by Paulus Potter (558), simplifying and classicizing Netherlandish sources such as this. Nowhere near the Dutch master's equal, Zuccarelli took intricate, consummately skillful views of farm life like Potter's and turned them into pretty scenes far from the latter's keen observations.

That seventeenth-century France should have produced convincing, austere studies of rustic life by the three Le Nain brothers that would, nonetheless, receive official recognition, is one of the most welcome surprises of art and history. Antoine, Louis, and Mathieu Le Nain were born to a moderately prosperous landowner. All painted subtly and skillfully—indeed, their works are hard to tell apart. They also painted collaboratively.

The Le Nains' are the most poetic yet realistic scenes of slender means down on the farm, despite their having come to Paris, where they received important picture orders in the 1620s and 1630s, and Mathieu was appointed *peintre ordinaire* of the city of Paris in 1633. He was given major portrait commissions, including that of Anne d'Autriche (which Louis XIII found to be her finest).

The Hermitage is rich in works by these great painters: One of the finest of Louis Le Nain's pictures is *The Milkmaid's Family* (559). This canvas is so full of varied splendors that it is hard to know where to begin to enumerate them. Is it too obvious to note that he is one of the most observant and respectful painters of children who ever lived? Le Nain leaves them alone, showing them as they are, in what might be called "benign neglect," had that phrase not been poisoned by evil political associations.

A subtle sense of the ritualistic enters his rustic scenes, without a shred of pretension, and a gravity attaches to this peasant family with their donkey and dog, the mother prematurely aged, the children prematurely wise; these qualities fill the viewer with wonder, in both the sense of curiosity and of marveling. It is this stoical farm group, rather than Willy Loman's shabby life and death, that tells the viewer that "Attention must be paid."

Just as daring as the painter's presentation of character is his audacious balance between figure and

JACOB JORDAENS Antwerp 1593–1678
The Bean King, ca. 1638
(Inv. No. 3760) Oil on canvas, transferred to new canvas
62 × 83" (157 × 211 cm)

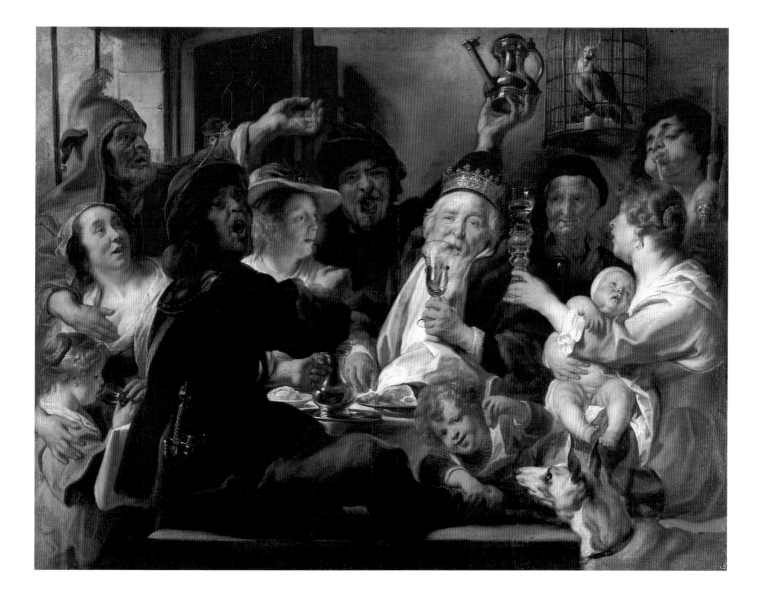

Above
FRANCESCO BASSANO THE YOUNGER
Bassano 1549–Venice 1592
Autumn
(Inv. No. 1598) Oil on canvas
38 × 50″ (96 × 127 cm)
(Ex coll. Crozat, Paris, 1772)

Left
HANS WERTINGER (SOUABE)
Landshut ca. 1465/70–1533
A Village Celebration (The Month of October)
(Inv. No. 5579) Oil on panel
9 × 16″ (22.5 × 40 cm)

JOACHIM BEUCKELAER Antwerp ca. 1533–1573/74
A Village Celebration, 1563
(Inv. No. 450) Oil on canvas, transferred from panel
44 × 64" (112 × 163.5 cm)
(Ex coll. I.S. Semyonov, St. Petersburg, 1893)

Overleaf
HANS WERTINGER *A Village Celebration* (detail)

space, the Yin and Yang between object and void exerting an exquisite pull. Finally, the beauty of the landscape, close to those of Velázquez, Corot, or Degas, is breathtaking for its bold economy and scope. The clouds scud by on a windy day, sudden shafts of light illuminating a white wall, the woman's face, and the side of her milk can—that last as close to Vermeer as any painting in the Hermitage.

Like Zuccarelli, Jean-Baptiste Le Prince painted pastiches borrowing from Jacob van Ruisdael, Hobbema, Ostade, and many others for vignettes of village life (556) that look just a little too good to be true, lacking the realistic bite of his sources, sweetened instead with romantic touches appealing to a later audience. He traveled to the Low Countries and studied the works of Rembrandt and his circle before going on to Saint Petersburg in 1758. There, like Lagrenée and Tocqué, Le Prince received many commissions, including the painting of a ceiling in the Winter Palace (now part of the Hermitage) that recently had been built for Czarina Elizabeth.

Many seventeenth- and eighteenth-century Northern landscapists went to Italy where they reveled in the raffish life and the golden light that ennobled whatever sordid activities might take place below. Subjects like *The Charlatan* (557), painted by Jan Miel, present a quack doctor and his accomplices like figures out of the commedia dell'arte.

The Rider Conversing with a Peasant (557) is by Philips Wouwerman, one of three painter sons of an artist. From Haarlem, Philips worked in France and Italy, much influenced by Pieter van Laer, leader of the early group of Dutch artists active in Rome, where they were known in their own club as the *Bentveughels* (the "bentbirds," after Laer's deformity), called, less flattering still, the *Bamboccio*, or cripples, by the natives who found them an ugly lot. This canvas has a certain sense of drama uncharacteristic of most Dutch genre and reflects Latin influence. The same painter's *Horses Being Watered* (557) is once again close to Italian light, Classical in its treatment of the bathers, showing Wouwerman at his very beautiful best.

Nicholas Berchem's *Italian Landscape with a Bridge* (557) allowed for

JEAN-BAPTISTE LE PRINCE
Metz 1734–St-Denis-du-Port 1781
Playing Ball
(Inv. No. 4654) Oil on canvas
13 × 16″ (33 × 40 cm)

Above
PHILIPS WOUWERMAN Haarlem 1619–1668
A Rider Conversing with a Peasant
(Inv. No. 846) Oil on panel
12½ × 11″ (32 × 28 cm)
(Ex coll. Cobentzl, Brussels, 1768)

Right, top
JAN MIEL Beveren-Waes ca. 1599–Turin 1663
A Charlatan
(Inv. No. 646) Oil on canvas 23½ × 29″ (60 × 74 cm)
(Ex coll. count de Narp, St. Petersburg, 1804)

Right, center
NICOLAES PIETERSZ. BERCHEM Haarlem 1620–Amsterdam 1683
Italian Landscape with a Bridge, 1656
(Inv. No. 1097) Oil on panel 17½ × 24″ (44.5 × 61 cm)
(Ex coll. duc de Choiseul, Paris, 1772)

Right, bottom
PHILIPS WOUWERMAN
Horses Being Watered
(Inv. No. 1006) Oil on panel
12½ × 16″ (32 × 40 cm)

a new prominence of man and beast that removes it from the conventional approach toward the genre. Scenes like this seem like reflections upon shady or sunny doings in golden climes, where pride of place is secondary to who's up to what. Astride his donkey, a peasant snatches a Puccini-like moment for a quick prayer to the statue of the Madonna at the bridge's end before continuing on his way. In picturesque decay, the bridge is a harbinger of the cult of ruins (46, 47) soon to play havoc with past and present in the coming century.

Boucher's brilliant pendants of peasants and travelers fording below a statue of a river god (562) and traversing a wooden bridge with sheep and cattle (563) manage to combine an overtly decorative manner with an elemental message of water, air, and earth. These are pictorial time and motion studies of the very prettiest sort.

Dairymaids go about their daily chores in paintings by J.-B. Camille Corot (564) and Jan Siberechts (565). Clearly the French nineteenth-century master recalled the silvery idylls painted in the Low Countries two centuries earlier before composing his own, far more Classical scene, where Siberechts's deliberately ungainly squatting girl is replaced by a standing maiden of Tanagra-like grace.

In the later nineteenth century, railroads, along with urban and industrial expansion, broke up many vast ranges preserved for the hunt, for that pastime in which one finds "the unspeakable in full pursuit of the uneatable" (to borrow the pithy

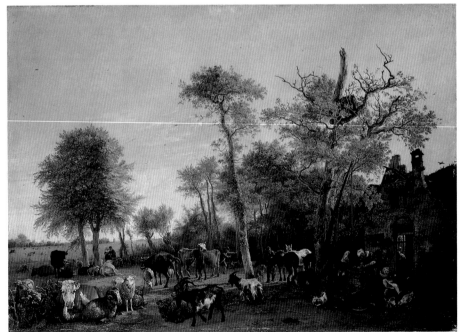

Above, top
FRANCESCO ZUCCARELLI
Pitigliano 1702–Florence 1788
Landscape with a Woman Leading a Cow
(Inv. No. 178) Oil on canvas
23½ × 34½" (60 × 88 cm)

Above, bottom
PAULUS POTTER
Enkhuizen 1625–Amsterdam 1654
A Farm, 1649
(Inv. No. 820) Oil on panel
32 × 45½" (81 × 115.5 cm)
(Ex coll. Empress Josephine, Malmaison, 1814)

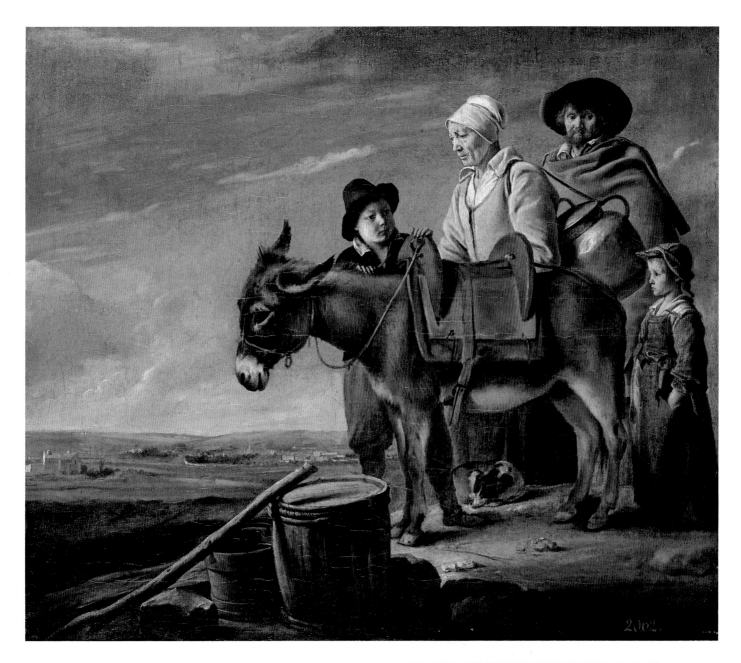

Above
LOUIS LE NAIN Laon 1593 (?)–Paris 1648
The Milkmaid's Family, 1640s
(Inv. No. 1152) Oil on canvas
20 × 23" (51 × 59 cm)

Right
IGNACIO DE IRIARTE
Azcoitia 1621–Seville 1685
Fording
(Inv. No. 310) Oil on canvas
24½ × 33" (62.5 × 83.5 cm)
(Ex coll. Coesvelt, Amsterdam, 1814)

Overleaf
IGNACIO DE IRIARTE *Fording* (detail)

phrase of Oscar Wilde). The chase was among the major prerogatives of the well-born; peasants and small farmers were not allowed to hunt, even on their own lands.

The privileges of the chase, with those of the military life, were among the last and least worthy survivors of the age of chivalry, each redolent with superannuated snobbery. So scenes of warfare and of the hunt—Paul de Vos's vast canvas of dogs in pursuit of bear (567), or Jan Wildens's huntsman returning with dead game (566),

their faithful hounds alone (568, 569) or alongside (566), meant far, far more than what they showed. These pictures represented, in the true sense of the word, the life of the landlord, uniquely entitled to the wildlife on his domain and even to that of others'. Hunting canvases are tributes to social order and stratification, to the hunters' birthright and deathright.

Often very large, with man and beast close to life-size, canvases of the hunt replaced far costlier tapestries of similar subjects that had

long been popular in the late Middle Ages and Renaissance. Like those lavish hangings, these paintings were frequently incorporated into grand architectural settings, seen between columns and above great flights of stairs to remind viewers not only that they were within a place of special authority, but of the ways that power extended above and beyond the lavish confines in which they, and these images, were so fortunate as to find themselves.

Among the most unusual crea-

Opposite
FRANÇOIS BOUCHER Paris 1703–1770
Fording
(Inv. No. 6329) Oil on canvas 23 × 29″ (59 × 73 cm)
(Ex coll. Prince Urusov, 1930)

Above
FRANÇOIS BOUCHER
Bridge Crossing
(Inv. No. 6328) Oil on canvas 23 × 29″ (59 × 73 cm)
(Ex coll. Prince Urusov, 1930)

Page 564
JEAN-BAPTISTE CAMILLE COROT Paris 1796–1875
A Peasant Woman Grazing a Cow at the Edge of a Forest, 1865/70
(Inv. No. 7166) Oil on canvas
19 × 14″ (47.5 × 35 cm)

Page 565
JAN SIBERECHTS Antwerp 1627–London ca. 1703
A Shepherdess, 1666
(Inv. No. 6240) Oil on canvas
41 × 30½″ (103.5 × 77.5 cm)
(Ex coll. S.V. Sheremetyev, St. Petersburg)

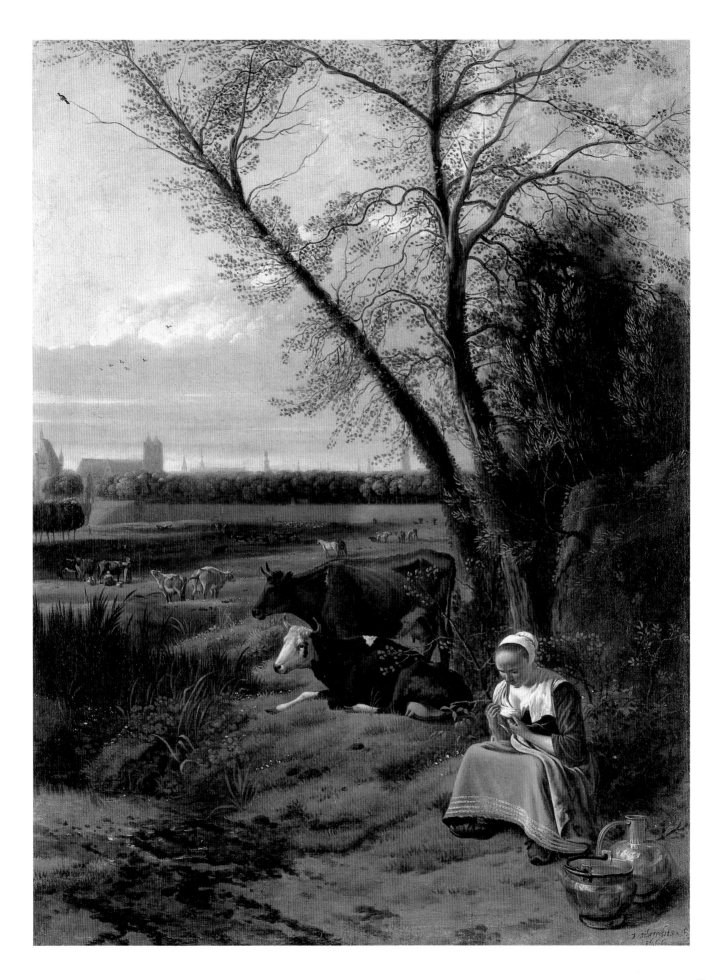

tures painted by Paulus Potter—the Netherlands' greatest animalier—is a Russian wolfhound (567), with the artist's signature written proudly above the entrance to the doghouse. According to Jan Six, this dog was brought back from Moscow in 1648 when Dirk Tulp, the artist's patron (also that of Rembrandt), returned from Russia. Game and other birds, painted with such skill by Melchior de Hondecoeter (569), share very much the same agenda of privilege and exclusion: A château in the background reminds the viewer of just how these fine feathers fit into the great chain of manorial being. Similar pictures include exotic wildlife to suggest the owner's far-flung economic range. Just as Britain's imperial sun was destined "never to set on the Union Jack," so, too, much earlier, did Dutch and Flemish ships reach around Africa to the East Indies, returning with an ornithological paradise all their own.

Making war has always been man's favorite outdoor sport; making love is far more commonplace, cheaper, and allows for less fun and fellowship. Slaughter, singly or collectively, on land or sea, is just fine as long as one wins and, preferably, observes it from a safe distance. Battle scenes, on the high seas or lowlands, have served as grist for the pictorial mill since antiquity, their topicality, patriotism, and excitement guaranteeing an evergreen market, as seen in the brilliant conflict at sea—an early example of the genre—by Andries van Eertvelt (570), and the pan-

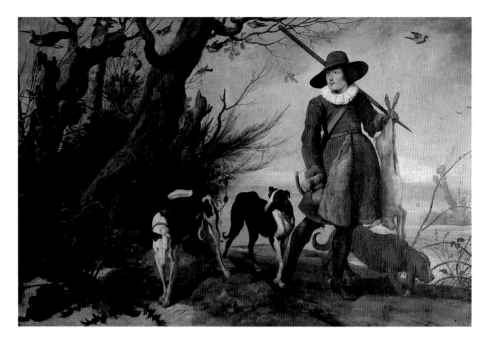

Above, top
JAN WILDENS Antwerp 1584/86–1653
A Hunter with Dogs Against a Landscape, 1625
(Inv. No. 6239) Oil on canvas
78 × 118" (198.7 × 299.5 cm)

Above, bottom
LUDOLF DE JONGH (LIEVE DE JONGH)
Rotterdam 1616–Hillegesberg 1679
Hunters and Dogs, 1665
(Inv. No. 2801) Oil on panel
15½ × 19½" (39.5 × 49.5 cm)
(Ex coll. Semyonov-Tian-Shanskii, 1915)

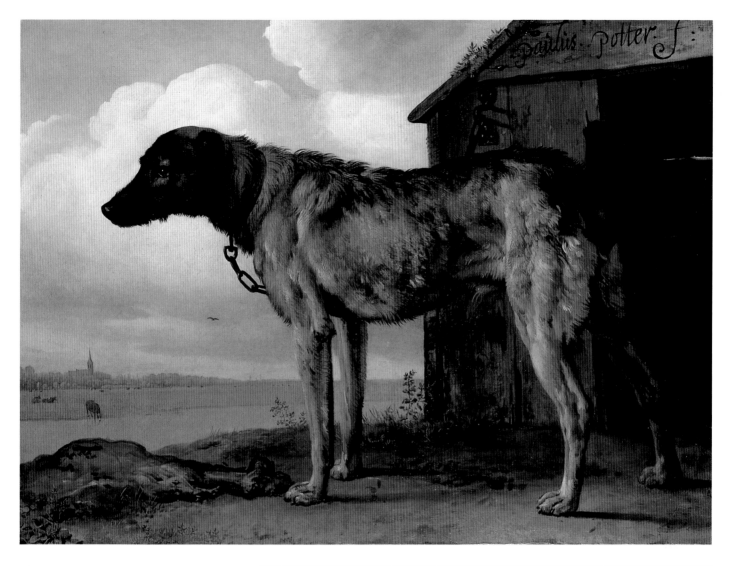

Above
PAULUS POTTER
Watchdog
(Inv. No. 817) Oil on canvas
38 × 52″ (96.5 × 132 cm)
(Ex coll. Empress Josephine, Malmaison, 1814)

Right
PAUL DE VOS
Hulst ca. 1596–Antwerp 1678
Bear Hunt
(Inv. No. 603) Oil on canvas
81 × 136″ (205 × 345 cm)
(Ex coll. Brühl, Dresden, 1769)

oramic skirmish (572–73) by Sebastiaan Vrancx. The first of these might best be viewed as History Painting, since Eertvelt went back in time to reconstruct a naval conflict that took place almost twenty years before he was born.

Early artists often worked as cartographers, a skill that carried over into preparing topographical views, sweeping cosmic vistas that placed the observer in the bird's-eye, if not the catbird's, seat. Painters also functioned as pictorial journalists and military historians, documenting just how, when, and where conflicts had taken place, or were supposed to have done so.

On a far more intimate scale and less sweeping perspective were the vignettes of the day-to-day tedium of the ordinary soldier's life, scenes of the picturesque squalor of encampment, of minor skirmishes rather than major victories, where plunder and rapine were part and parcel of the military calling.

Encampment and bivouac may not seem like pleasant pictorial subjects, but for many purchasers these were nostalgic scenes, recalling the good old days of youthful military adventure, themes treasured for their happy recollections of innocent youthful martial exploits, or unexpected ways to wealth or pleasure. Watteau's pendant *Hardships* and *Recreations of War* (571) pair the mixed blessings of army life. These early works, completed around 1716, were painted on copper, a popular Northern technique in the preceding century. With characteristic honesty, Watteau showed the recreations as those of soldiers in a picnic-like

campsite, while the hardships are suffered by civilians. Though far milder than the antiwar images of the preceding century, as seen in Callot's prints, Watteau may well have recalled them. Another pairing of different aspects of the military experience was painted by a follower of Watteau, Jean-Baptiste Pater, who juxtaposed the military encampment—*étape*—with moving along in the campaign (574).

War has always reveled in macho display—in pageantry, marching bands, and sexy uniforms, all the apparatus and grandeur of a lethal Rose Bowl parade. Just as artists of various sorts and degrees designed the uniforms, armor, orders, banners, buttons, and other decorations, so painters' services were called for to perpetuate the "big picture" in that critical moment of confrontation, followed by victory or defeat.

Little known outside Eastern Europe is an Austrian artist of unusual skill, Peter Fendi, whose animated *Guards on Maneuvers* (575, 576–77) shows a regiment in a suitably sunny, propagandistic moment, taking a break near Saint Petersburg, with Krasnoye Selo in the background. They are seen with knickknack vendors peddling plaster casts, one of them probably a bust of the current czar, Nicholas I.

Belonging to a dynasty of painters, David Teniers the Younger shows a *Guardsroom* (575) as if this were a center for wondrous doings, almost like an alchemist's cave. A pile of trophies or as-yet unused regalia lies in the foreground. Though it is a curtain that supposedly protects the guardsroom, a

Above
ANDRIES VAN EERTVELT Antwerp 1590–1652
The Battle of the Spanish Fleet with Dutch Ships in May 1573
During the Siege of Haarlem
(Inv. No. 6416) Oil on canvas
53 × 65″ (134 × 165.5 cm)
(Ex coll. S.N. Plautin, St. Petersburg)

Opposite, top
JEAN-ANTOINE WATTEAU
Valenciennes 1684–Nogent-sur-Marne 1721
The Recreations of War, ca. 1716
(Inv. No. 1162) Oil on copper
8½ × 13″ (21.5 × 33.5 cm)
(Ex coll. Crozat, Paris, 1772)

Opposite, bottom
JEAN-ANTOINE WATTEAU
The Hardships of War, ca. 1716
(Inv. No. 1159) Oil on copper
8½ × 13″ (21.5 × 33.5 cm)
(Ex coll. Crozat, Paris, 1772)

Overleaf
SEBASTIAAN VRANCX Antwerp 1573–1647
An Assault on a Fortified Camp
(Inv. No. 7164) Oil on canvas
45 × 78″ (115 × 199 cm)

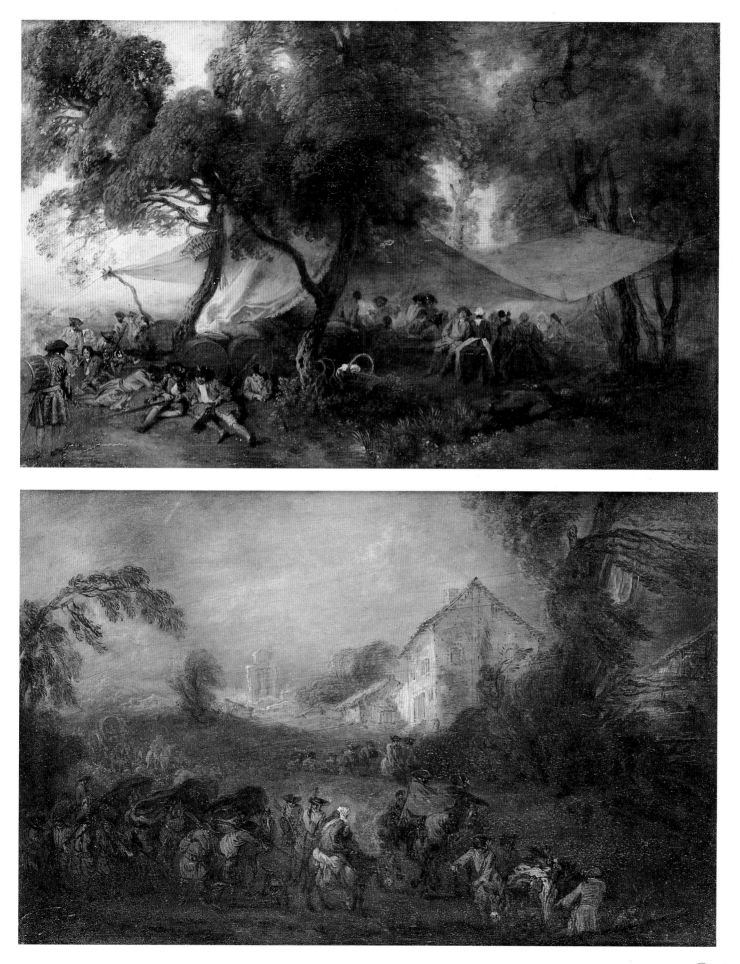

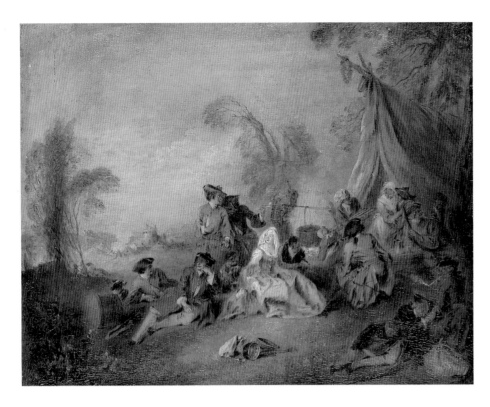

Left, top
JEAN-BAPTISTE PATER
Valenciennes 1695–Paris 1736
Soldiers' Étape
(Inv. No. 1159) Oil on panel
11 × 13″ (28 × 34 cm)

Left, bottom
JEAN-BAPTISTE PATER
Soldiers Setting out from the Étape
(Inv. No. 1143) Oil on panel
11 × 13½″ (28.6 × 34.5 cm)

Opposite, top
PETER FENDI Vienna 1796–1842
Guards on Maneuvers, 1839
(Inv. No. 4753) Oil on canvas
26 × 37½″ (66 × 95 cm)

Opposite, bottom
DAVID TENIERS THE YOUNGER
Antwerp 1610–Brussels 1690
Guardsroom, 1642
(Inv. No. 583) Oil on panel
27 × 40½″ (69 × 103 cm)
(Ex coll. Empress Josephine, Malmaison, 1815)

Overleaf
PETER FENDI
Guards on Maneuvers (detail)

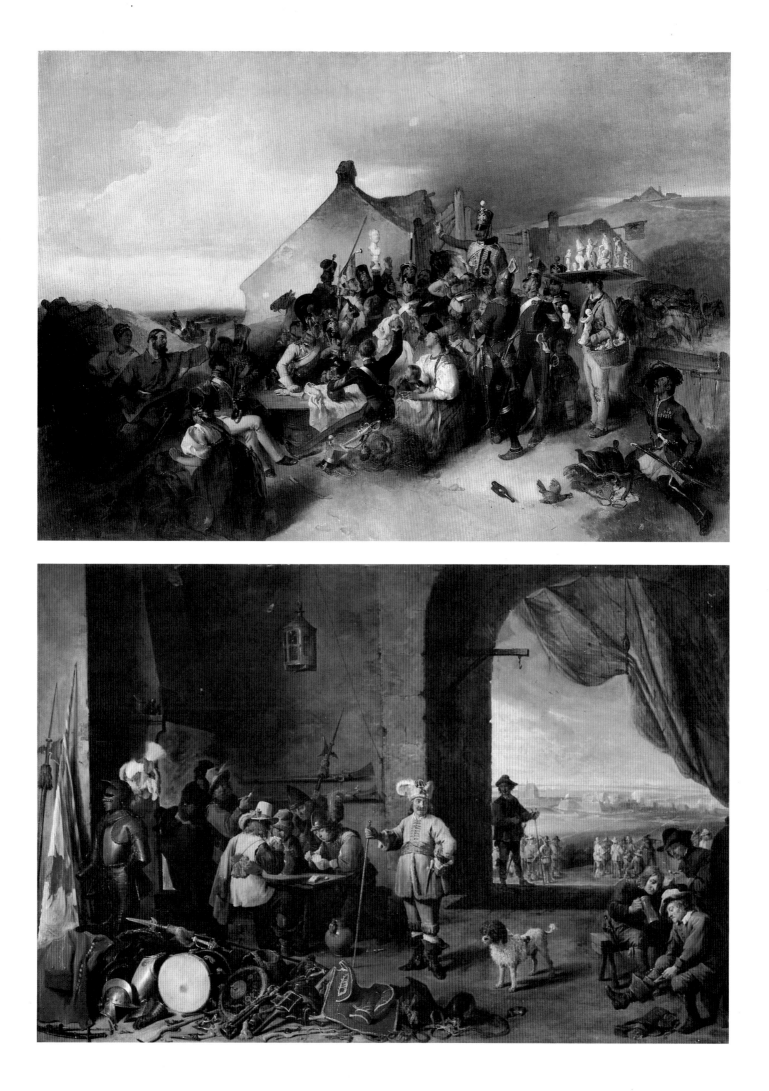

raised hanging at the right also reveals fortifications and a battle.

While images of the vanquished are seldom a major source of commercially successful art, those on the downside of the economic scale, as long as they face adversity with a smile, have long been popular. Happy beggars, tireless street vendors hawking their goods with jolly cries, peddlers who are victims of thieving monkeys, or those who steal and sell babies have all been sought-after genre subjects since at least the fourteenth century.

Whether seen as mythical Good Losers, no trace of rancor in their hunger, or as little proto-Horatio Algers on their way up in the harsh world of economic competition, young beggars seldom did as well in life as in art, where the veil of the picturesque softens anger and muffles need.

Bartolomé Estéban Murillo (followed by a host of imitators) was among the first, along with Caravaggio, to elevate low life into large, expensive canvases. His repulsively, irrepressibly cheery beggar boys (578), and implausibly happy hookers with their "duennas," come from a world of well-washed vice or sweetened squalor for which the next century's *Beggar's Opera* was a much needed corrective. Significantly, the Spaniard's beggar boys were never more popular than in the early nineteenth century, just before social legislation first saw to it that poor children's lives were not to be snuffed out by cleaning chimneys or in other still less savory pursuits.

Watteau's *Savoyard with a Marmot* (579) suggests a very different poverty. On the road, this peddler makes a living by playing the flute and showing off his Alpine pet (a beaver-like creature). Far better dressed than Murillo's beggar, the French boy looks the spectator (and adversity) right in the eye, with a certain bemusement. France tends to respect intelligence, suggested here by the admiring way in which Watteau portrayed his resilient, indomitable model.

Music reached new heights in the eighteenth century on both intimate and official scales—lavish operas and small chamber orchestras were often the center of court activities, with specially devised settings built for their enjoyment. La Camargo danced for Nicolas Lancret's painting (581), her setting fusing art and nature. A painted backdrop is turning into a wood (or the other way around). The intricate artificiality of posture and period, the famous dancer's surprisingly awkward pose and lavishly worked gown all point to the universal theatricality of the times. This began at court, whose endless ceremony made that of Byzantium (or the Caesars) seem like Camp Carefree by comparison.

Lancret's canvas of a scene from Thomas Corneille's tragedy *Le Comte d'Essex* (580) shows either that dashing earl boldly telling England's Elizabeth I of his love for another, or else a courtier bringing news of Essex's beheading to the Virgin Queen. This picture re-creates the way in which plays were staged at the Comédie-Française in the 1720s and 1730s. Here the set

BARTOLOMÉ ESTÉBAN MURILLO
Seville 1618–1682
A Boy with a Dog, 1650s
(Inv. No. 386) Oil on canvas
29 × 24" (74 × 60 cm)
(Ex coll. Count E.F. Choiseul et Amboise, Paris, 1772)

Opposite
JEAN-ANTOINE WATTEAU
The Savoyard with a Marmot, 1716
(Inv. No. 1148) Oil on canvas
16 × 13" (40.5 × 32.5 cm)
(Ex coll. C. Audran, Paris, before 1774)

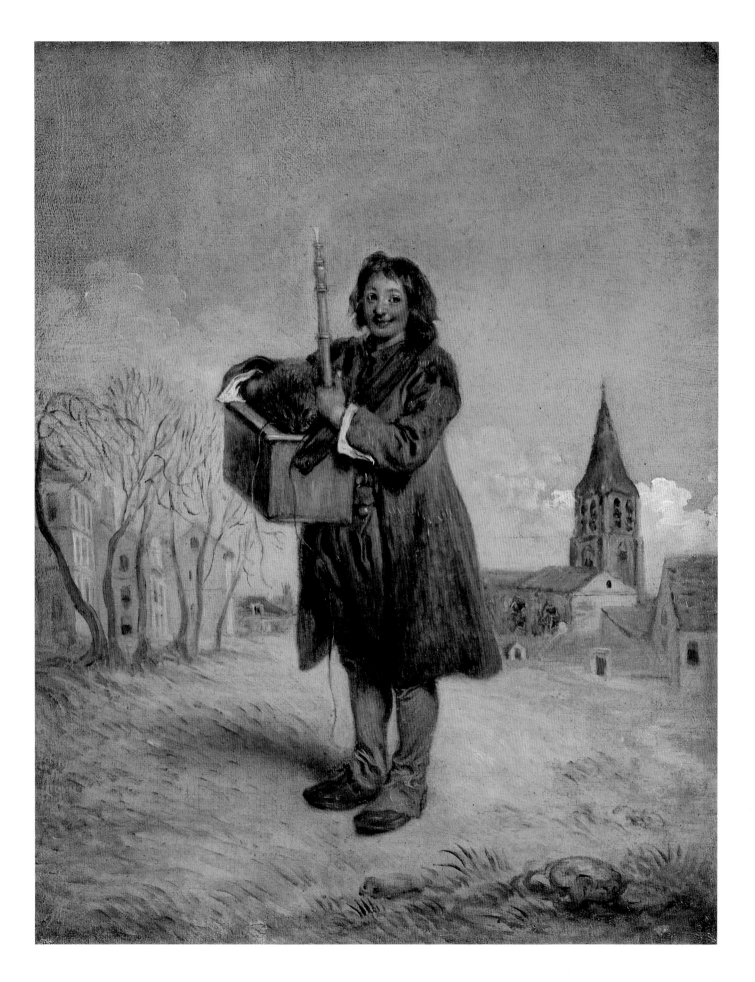

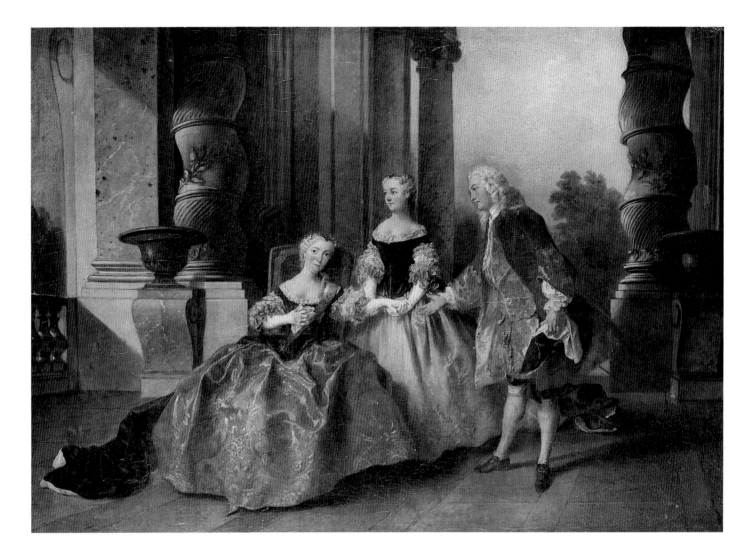

designer followed the magnificent architecture found in Rubens's canvases from the preceding century. But in the age of the Rococo, the doll-like actors are dwarfed by all that splendor in the stone, looking like little more than puppets.

Just exactly what many of Watteau's paintings are all about remains far from obvious. They often owe their titles to those found on slightly later reproductions. Too much may have been made of the artist's legendary melancholy and sensitivity, as Donald Posner has suggested. Certainly Watteau is close to Rubens and Titian in his love for love. So what is best made

of a title like *An Embarrassing Proposal?* Probably very little. Here is a neo-Giorgionesque scene of fresh-faced young people in a plein-air setting (582). Sex is seldom all that far from most people's minds, especially in these party scenes known as *fêtes galantes,* yet it is dubious that among such a polite, attractive group any man should need to make (or the artist wish to perpetuate) a peculiarly crass, unwelcome overture.

Known as *A Capricious Woman* (583), Watteau's exquisite painting shows a very pretty young woman in a romantic, unfashionably dark costume suggesting another time and place, courted by a middle-

NICOLAS LANCRET Paris 1690–1743
A Scene from Corneille's Tragedy
"Le Comte d'Essex," 1734
(Inv. No. 1144) Oil on canvas
16 × 22" (41 × 56 cm)

Opposite
NICOLAS LANCRET
The Dancer Camargo
(Inv. No. 1145) Oil on canvas
18 × 21½" (45 × 55 cm)

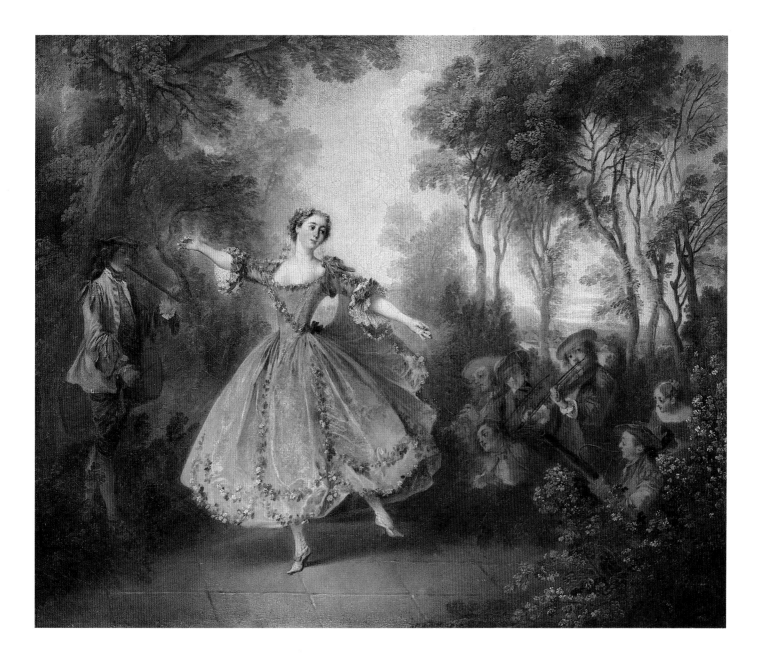

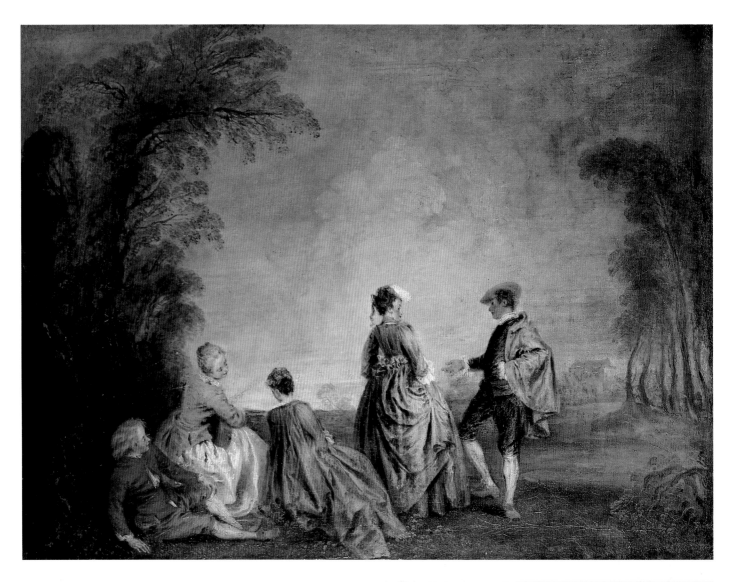

Above
JEAN-ANTOINE WATTEAU *An Embarrassing Proposal,* ca. 1716
(Inv. No. 1150) Oil on canvas 25½ × 33″ (65 × 84.5 cm)
(Ex coll. Brühl, Dresden, 1769)

Right
NICOLAS LANCRET *Garden Party*
(Inv. No. 7497) Oil on canvas
39 × 52″ (99 × 132 cm)

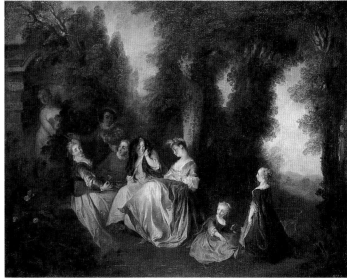

Opposite
JEAN-ANTOINE WATTEAU *A Capricious Woman,* ca. 1718
(Inv. No. 4120) Oil on canvas 16½ × 13″ (42 × 34 cm)
(Ex coll. Walpole, Houghton Hall, 1779)

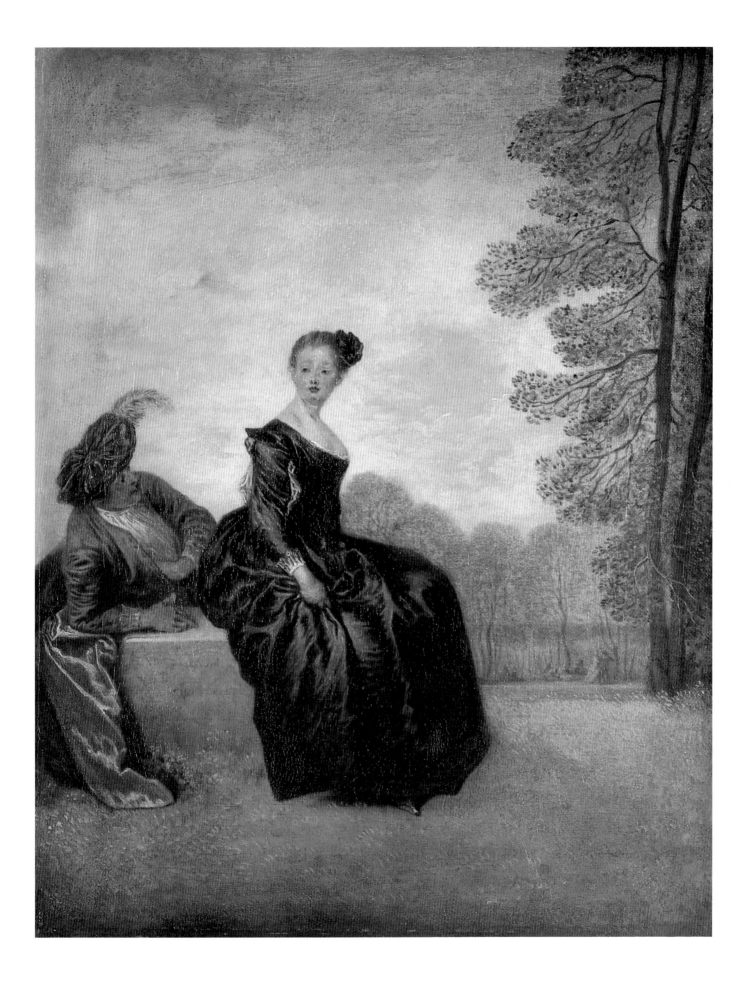

aged man. Neither he nor his declarative gesture—hand upon his breast—impress her. This is another beautiful example of Watteau's bittersweet pleasure in the human comedy with all its foibles and fallacies. Other couples are seen in the background, as if this were a Park of Love, if not an Embarkation for Cythera—the woman waiting for a more appealing partner before leaving for the island of love.

As Nicolas Lancret's *Garden Party* (583) includes figures from the commedia dell'arte, his canvas probably makes a passing, if not central reference to those popular plays. Though the picture suggests specificity, it was primarily meant as a decorative image, to divert the owners and their circle.

Nests, birds, and eggs are all rife with sexual reference, part of that rich language for which, as often, only the French have originated a pithy phrase, the double entendre. So when Hubert Robert, ever the romantic painter, shows a youth climbing a tree in order to be a *Nest Robber* (585), he is referring, quite literally, to love on many levels, satisfying appetites from hors d'oeuvre to dessert.

That canvas's equally beautiful pendant, *Flight* (585), has a young man pursuing a woman, the cascading river crossed by two planks in the foreground a metaphor for the vitality and excitement of sexual pursuit and fulfillment. Here Robert refers to a quotation from Virgil's *Eclogues*, inscribed on the bridge: *Galatea, a playful girl, throws an apple at me. And flees to the willows,*

anxious first to be seen. This makes it clear that this—like most games of love—is one of complicity.

Love's references abound in Lancret's *Spring* (585), where the wreaths of flowers, open-doored cages, bird's nests, and birds on strings all speak to various aspects of the accessibility of desire and its fulfillment. From a series of *The Seasons* designed for the château of La Muette, spring is here tied to play, not to the work of agriculture. Now the world goes around purely for diversion, not providence, this strange perspective in keeping with the increasing French separation of the two, with the upper classes living in their own gilded ghetto, oblivious to the world outside.

Two Peeping Toms in the background mirror the voyeuristic role of anyone viewing Pater's naughty *Women Bathing* (585), a pictorial harem, a garden of earthly feminine delights, that point made clear by the woman with parted legs, her hand dangling between them, who turns up in many of Pater's canvases. Perhaps he had the myth of Diana and Actaeon in mind when he showed these women disturbed at the bath by a poodle—then a hunter's dog.

Hermits were the latest thing in eighteenth-century Europe. Unemployed (or unemployable) elders with suitably flowing white beards agreed to conduct themselves with requisite dignity, living in quasi-monastic retreat on estates to add an essential note of pious contemplation. A steady turnover in hermits took place, as these poor old men tended to drown their sorrows

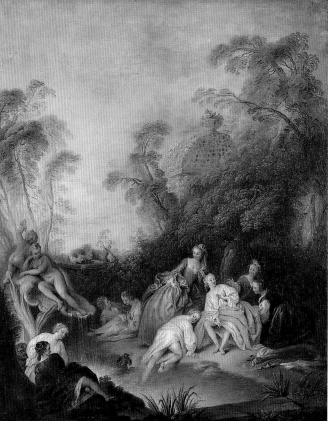

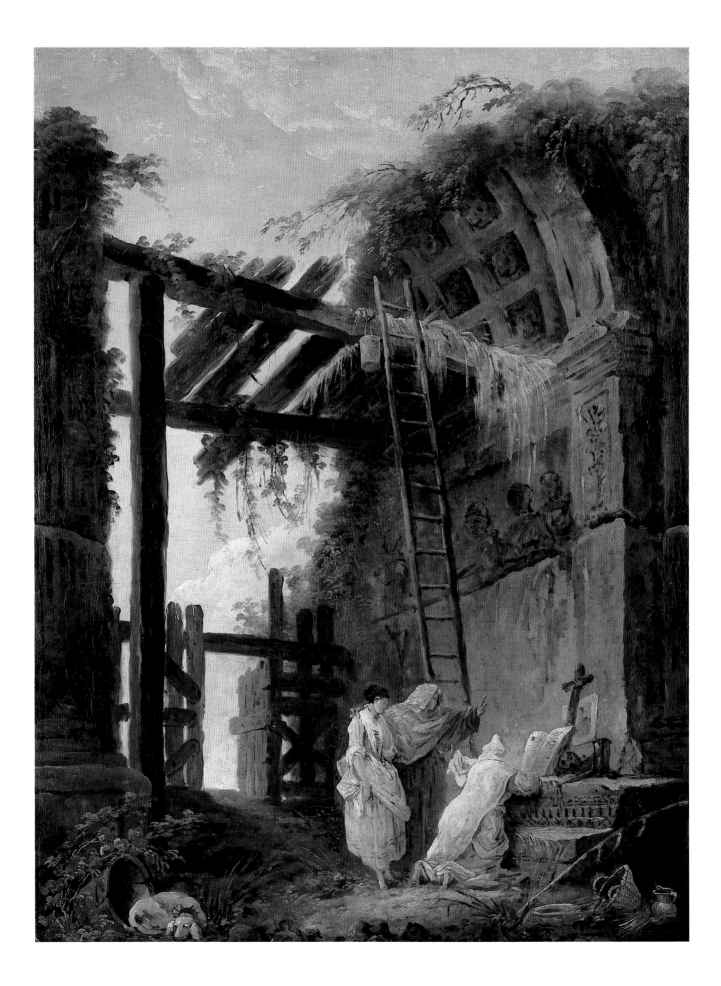

in drink, failing to maintain the appropriate solemnity and isolation morning, noon, and night.

Hubert Robert's subject *At the Hermit's* (586), is taken from La Fontaine's tale *"L'Hermite,"* itself derived from a far older version, *"Le Faiseur des papes, ou l'homme de Dieux."* Inna S. Nemilova noted that Robert drew upon a Fragonard illustration of this subject done in 1785 or earlier and suggests that the artists may have collaborated on that project.

Jean-Baptiste Le Prince traveled extensively to study Russian peasant life, collecting local embroideries and costumes. On his return to Paris in 1763, he fitted these out on mannequins, which created a great stir. Though his oval vignette purports to be a *Scene from Russian Life* (587), it is seen through the eyes of a Boucher pupil. This idyll, for all its accurate costumes and architecture, is essentially a pretty fantasy of *jeunes russes*, suggesting a composition for an oval relief by Clodion.

Bought directly for the Hermitage from the artist, *The Illumination of the Castel Sant'Angelo* (589), by Joseph Wright of Derby, is one of two paintings in the collection by this little-known but very fine English painter. Ever since crusaders brought fireworks back from the Near East, their use for festivities became a minor art form. The British canvas, with its extreme sense of drama and delight in the absolute, reflects recent concern with literature, like Edmund Burke's essay "On the Sublime and Beautiful" (1756), which led viewers and artists alike to seek out touristic and pictorial thrills.

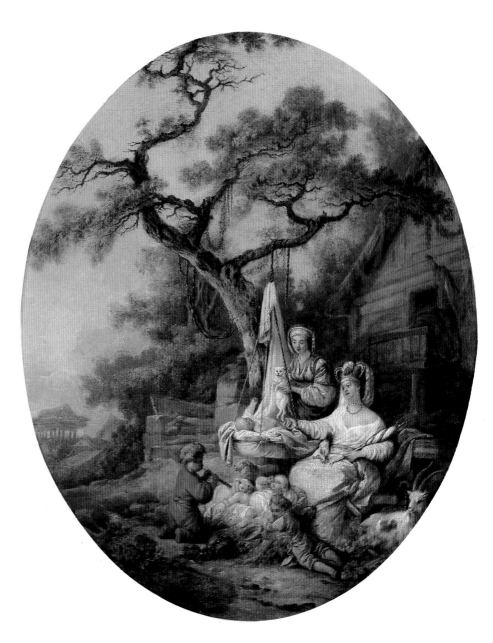

Above
JEAN-BAPTISTE LE PRINCE
A Scene from Russian Life, 1764
(Inv. No. 8408) Oil on canvas
29 × 23½" (73 × 59.5 cm)

Opposite
HUBERT ROBERT *At the Hermit's*
(Inv. No. 8580) Oil on canvas
25 × 19" (64 × 48 cm)

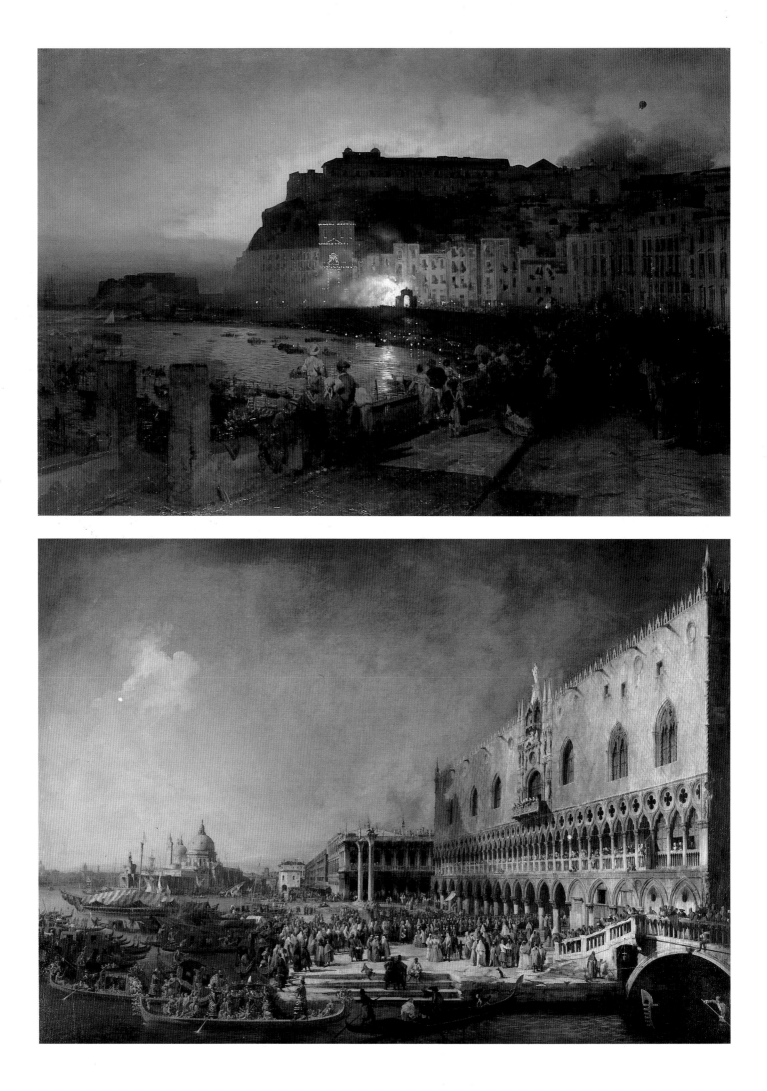

JOSEPH WRIGHT OF DERBY
Derby 1734–1797
Illumination of the Castel Sant'Angelo in Rome, 1778/79
(Inv. No. 1315) Oil on canvas
64 × 84″ (162.5 × 213 cm)
(Ex coll. the artist, 1779)

Opposite, top
OSWALD ACHENBACH Düsseldorf 1827–1905
Fireworks in Naples, 1875
(Inv. No. 7329) Oil on canvas
25½ × 40″ (65 × 101 cm)

Opposite, bottom
ANTONIO CANALETTO (ANTONIO CANALE)
Venice 1697–1768
The Reception of the French Ambassador in Venice, 1740s
(Inv. No. 175) Oil on canvas
71 × 102″ (181 × 259.5 cm)

Overleaf
ANTONIO CANALETTO
The Reception of the French Ambassador in Venice (detail)

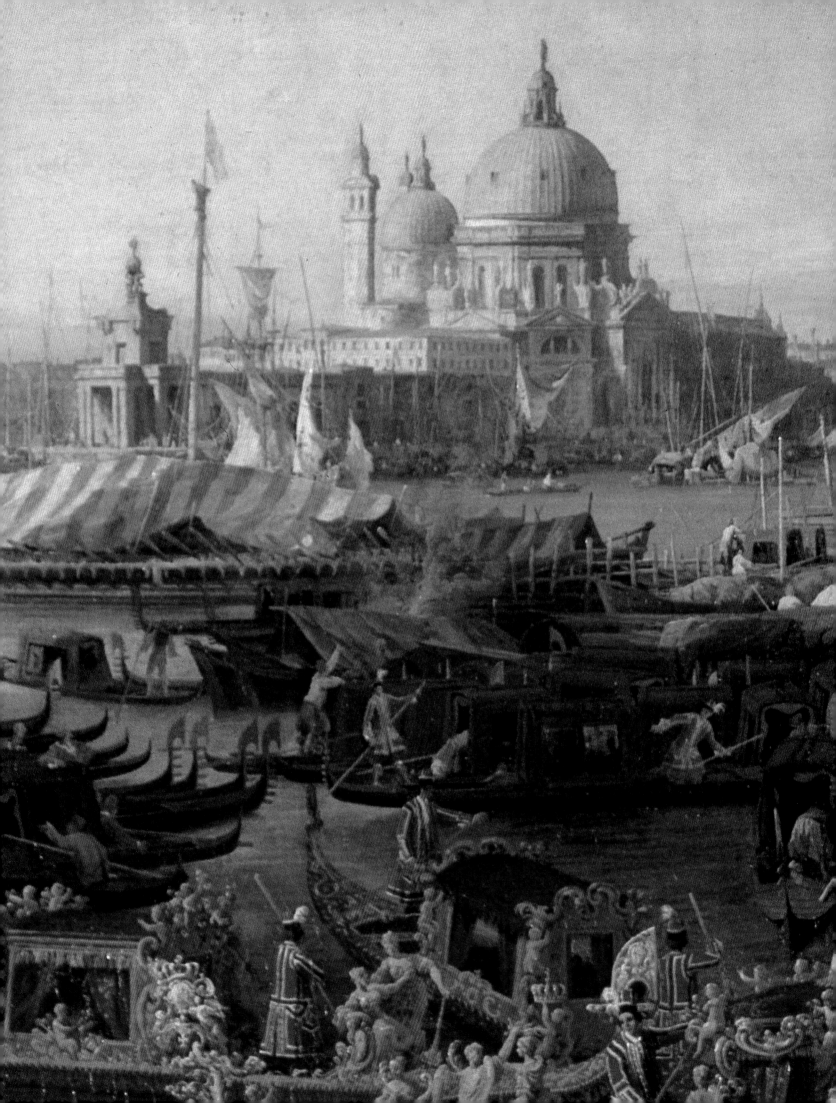

A festival in the via Santa Lucia is lit up by *Fireworks in Naples* (588), painted by Oswald Achenbach. Such canvases as these captured the fly-by-night nature of festivity, selling as costly souvenirs.

Often the sums spent on state occasions represented a significant portion of annual official expenditure, as these receptions had diplomatic or other propagandistic functions. Artists recorded such events not only to paint pretty pictures but also to document the pomp and circumstance designed to dazzle the visiting dignitary, and last, but not least, to show where and how the money went, keeping a pictorial grip on the ephemeral. Antonio Canaletto, with his painstaking eye and hand for detail, was ideally suited to this sort of commemorative, documentary image. In his *Reception of the French Ambassador in Venice* (588, 590–91), magnificent state gondolas lie alongside the Doge's Palace and the Chiesa della Salute is seen in the distance.

Fire seldom fails to excite. The prospect of crackling destruction with the absolute, irrevocable nature of its toll provides a basic source of fascination. It surprises that the great French nineteenth-century painter Pierre-Cécile Puvis de Chavannes should have painted genre subjects, since his fame is based upon classicizing allegories. *Village Firemen* (592, 593) shows how hard it was for Puvis to drop his formal manner: The two women at the left resemble personifications of heroic concepts rather than real people.

Recalling an event from the artist's youth, of a fire that he helped

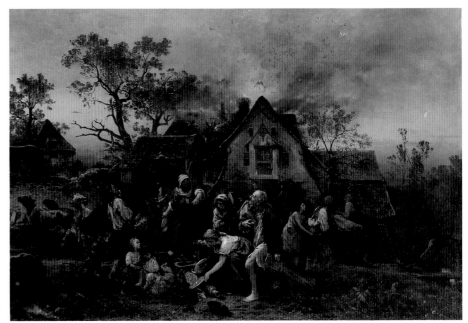

Above, top
PIERRE-CÉCILE PUVIS DE CHAVANNES
Lyon 1824–Paris 1898
Village Firemen, 1857
(Inv. No. 9672) Oil on canvas
70½ × 90" (179 × 228 cm)
(Ex coll. D.P. Botkine, Moscow, 1948)

Above, bottom
LUDWIG KNAUS
Wiesbaden 1829–Berlin 1910
A Farm Fire, 1854
(Inv. No. 4414) Oil on canvas
53 × 76" (135 × 193 cm)

Opposite
PIERRE-CÉCILE PUVIS DE CHAVANNES
Village Firemen (detail)

put out, Ludwig Knaus's *A Farm Fire* (592) looks much more old-fashioned than Puvis's bold sketch, as it is done in a style reminiscent of Greuze's and was actually painted in Paris. The painter's delight in different forms of natural illumination—in addition to the fire's light—adds to his picture's fascination. The Hermitage has a very large collection of nineteenth-century German and Austrian painting, including many canvases by this forgotten artist.

Like the decorative panels and screens that Pierre Bonnard was often fond of painting, his pendant *Morning* (594) and *Evening in Paris* (595) are tapestry-like in their decorative effect. The changing street life of the great Parisian boulevards and parks provides a visual time clock, defining the cycle of the daily in a tone poem to the city of light, an urban song very different from Claude's *Times of Day* (135, 210, and 313), which were conveyed by biblical or Classical subjects.

The very best thing about third-rate artists lies in their occasional capacity to surprise. Louis Valtat's ladies' *Garden Party* (595) may lack the bite of Toulouse-Lautrec or the lyricism of Renoir but it asserts a brisk, light-hearted quality all its own. Here the painter is the proverbial mouse in the corner, the unwatched watcher, making furtive sketches to be worked up in his studio. Her parasol across her knees, a young suburban matron fixes the many pins keeping her hair up. A lady cradles her teacup at the center; in the right foreground, though shown in the sketchiest fashion, the three girls' ennui is palpable. Conveying boredom without being dull is hard to do. Valtat, with the best painters of genre, lets one in on the party without being on the guest list. That's the essence of genre, sharing an event, witnessing an occasion, or, far more interesting, overhearing—in pictorial terms—the exchanges and the loneliness that lie at the heart of social life and life itself.

Above
PIERRE BONNARD
Fontenay-aux-Roses 1867–Le Cannet 1947
Evening in Paris, 1911
(Inv. No. 9105) Oil on canvas
30 × 47½″ (76 × 121 cm)
(Ex coll. I.A. Morozov, Moscow)

Right
LOUIS VALTAT
Dieppe 1869–Choisel 1952
Garden Party, ca. 1898
(Inv. No. 7722) Oil on canvas
25½ × 31½″ (65 × 80 cm)
(Ex coll. I.A. Morozov, Moscow)

Opposite
PIERRE BONNARD
Morning in Paris, 1911
(Inv. No. 9107) Oil on canvas
30 × 48″ (76.5 × 122 cm)
(Ex coll. I.A. Morozov, Moscow)

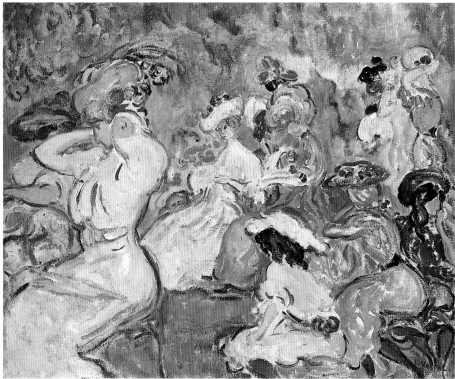

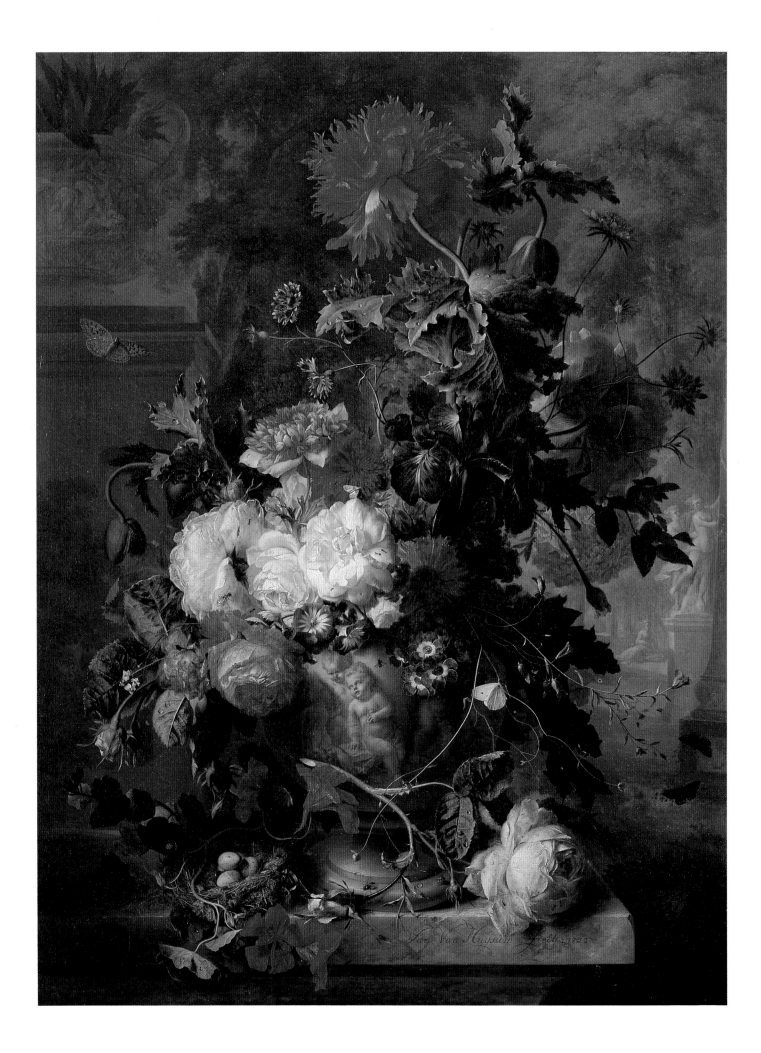

Still life's models, like good servants of yore, "know their place." Inert or inanimate, beyond patience or resignation, ever prepared for the artist's gaze or brush, they can be counted upon to hold their poses or to be moved without protest. Only if the flowers are cut, the hare, bird, or fish dead, must the painter work fast, reminded all too clearly of Hippocrates's Greek motto "Life is short, art is long." If still life's genre has a meaning, that's it—a visual commentary upon the brevity of human existence: The lowliest of bottles or glasses, papers or spoons, can be counted upon to survive us if they escape breakage or recycling.

So, what the French call *nature morte*—"dead nature," their term for still life—so often conveys its essence as no more (or less) than a meditation upon the fragility of life, an art of time and tide, in which most painters come as close to philosophy as they ever can or will.

Death is a fatal democracy, that state when we all look the same (except to the sharp eyes of the coroner or anthropologist), reduced to identical petrified irony. So the skull is an apt reminder of "Here today, gone tomorrow," "Beauty is only skin deep," and other equally painful, if unoriginal, sentiments. Both symbol and reality, our "head bone" is the artist's as well as preacher's delight.

JAN VAN HUIJSUM Amsterdam 1682–1749 *Flowers*, 1722 (Inv. No. 1051)
Oil on canvas, transferrred from panel 31 × 23½ (79 × 60 cm) (Ex coll. Walpole, Houghton Hall, 1779)

Some still lifes present references to unmade sacrifice, pictorial potlatches that defy destruction, conspicuous, yet unconsumed. These gatherings of material value approach the message of the Vanitas, the preacher of Ecclesiastes reminding those who cling to earthly frippery that "All is vanity" in the face of eternity.

"Here today, gone tomorrow": Flowers convey this message in the prettiest fashion, as does fruit, which, if it includes apples, may remind the viewer of the Fall, when death first came to life.

Emblems such as pipe or soap bubble tell of the brevity of life by burning and spiraling away, or bursting. Beginning in the Late Renaissance, thousands of such visual devices, with their mottoes, formed a literature, a pictorial language of their own, Western hieroglyphs conveying almost any message—sour, amorous, or other. Hundreds of emblem books were published, forming a collection all too soon absorbed by poet and painter, Shakespeare among their avid readers and rewriters.

Early still lifes are often no more than assemblages of these emblems, to be deciphered, or read. Snails and lizards, frogs, butterflies, moths or flies, croak and quack their cold-blooded or no-blooded messages of death and decay. The animate join a silent chorus of walnuts and cherries, hazelnuts, currants, and plums, each with its commentary on the human condition.

Early independent still lifes, from the later sixteenth or early seventeenth centuries, keep the quality of catalogues, of scientific examination and enumeration, the artist exploring and describing the separate wonders of each plum or snail. All the physical sciences—from anatomy, zoology, botany, and ornithology to mineralogy, metallurgy, geology, and astronomy—often depended upon the artist's capacity to comprehend and record the structure below the surface, to project a special intelligence. This is still true in medical research, where so many findings defy photography, and call for the understanding artist.

Compellingly simple, *Fruit on a Plate and Shells* (pages 620 and 622–23), by the Dutch seventeenth-century artist Balthasar van der Ast, has just this strong sense of presentation and analysis, a visual register resembling that museological savoring of the rare and different, the freakish and wonderful, that was known in the late Middle Ages as the *Wunderkammer*, or chamber of

natural (and unnatural) wonders, to which Art so often belonged. The exotic seashells in the foreground were reaching prices almost as high as the rare floral species that inspired Tulipmania. Artfully darkened, van der Ast's background allows for a dramatically lit display of the wares in the foreground, that device popular with Caravaggio (415).

Few very early still lifes survive. Seldom truly independent, they were probably painted on furniture such as sacristy or apothecary cupboards to tell priest, pharmacist, or librarian just what was kept behind the door or cover. So, where more recent depictions of books, flowers in vases, shells, and rare minerals or jewels may have either an emblematic, or a purely descriptive or decorative quality, the first were often painted labels, the image prefatory to reality.

Still lifes also exploit nature by breaking away from her limitations. Those ungainly, if massively, imaginary Brueghel bouquets, painted in the sixteenth century, combine flowers and fruits of all four seasons, or else from near and faraway places. Cosmic floral conceits, they express the power of art over time and space, defying the limitation of place or season, illusion the only way to go if you want everything *now*.

So, paradoxically, the still life addresses itself to patience and impatience, to need and fulfillment, to time and its denial. This genre's images are among the easiest ways to an often painful process—thought. Illusion and reality, possession and loss, the meaning of time, art, and nature, such a litany of still life's issues reads like the syllabus for an introductory philosophy course. These pictures can be taken at face value, but they are quick to put down so shallow and inappropriate a reaction—all dressed up and no place to go if the viewer fails to catch the requisite clues, unwilling or unable to let their messages resonate in the mind or go to the heart.

This is a genre that first and foremost declares its independence from the viewer, who, if fooled into accepting illusion for reality, falling for what the French call *trompe-l'oeil* (literally, "fool the eye"), is made to feel simple. Self-possessing and self-referential, still life starts and ends with itself.

Not for the young, still life can bore because it is so

close to the art of contemplation. When Christ dealt with the bickering of Martha and Mary Magdalen as to which of their ways of life was better, the active or the contemplative, he found Mary's intellectuality superior to the houseworkaholic busyness of her sister Martha. Only inquiry and meditation can lead to truth and spiritual values. So painters, showing the siblings' conflict, portrayed Martha's ground-down domesticity by piles of vegetables and meat, stressing the endless lot of womanly labor. Presumably Mary only needed thought for food; in her final hermetic retreat angels took care of her dietary needs. Scenes of the Magdalen's last days, along with those Annunciations where the Virgin Mary reads prophetic books—as shown by Cima da Conegliano (164) and Fra Filippino Lippi (165)—continued the revival of the Classical still life genre, already long popular in fresco decorations like the fourteenth-century papal study in Avignon, whose walls are covered with painted bird cages.

With or without skulls, still life often holds an intrinsic meditation on death that shows life's absence, a pictorial paraphrase of mortality, a totally objective reminder of what's left when life is gone, whether through loss or absence. So what remains to the remains? At their grimmest, skulls and bones; a shade less grim are the dead animals, the hares and rabbits, pheasants and grouse, all slaughtered for human nurture: As they have died so shall you live. This massacre of field and stream is often a sacrifice, to and for class, of food for the very rich. Only they are privileged to banquet upon such aristocratic fare, untouched by peasant hand. Raised by divine Providence in the wilderness of your own waters and woods, these slaughtered trumpeter swan, grouse, and woodcock, fish, bear, and venison, with smaller game, prove you to be lord of the manor, their lost blood validating the exalted quality of your own. Matheus Bloem makes this all too clear in his handsome *Hunting Trophies* (609), strung up against the sumptuously carved limestone walls of a chateau that could only belong to a Very Important Person, like the owner of the one painted by Pieter Gysels (616), the tropical parrot and monkey referring to the lord of the manor's cosmic domain.

Timepieces, always expensive, symbolize their possessor's wealth and prestige. But such flattering symbolism stabs one in the back: The pendulum's sway and the work's tick spring from a mechanical heartbeat that not only outlives your own but almost parodies its inadequacy. Clocks can run forever. Can you?

An early way in which still life came into the picture was through the popular allegory of the Five Senses, their sum total the quality of life. That was the implicit agenda of Caravaggio's *The Lute Player* (415), where the musical papers, instruments for wind and strings, flowers and fruit were a collective, inanimate equivalent to all that the lutanist could provide. A similar sentiment underlies Hendrik van Streek's *Black Servant and a Laid Table* (621). Here the slave is the most valuable "object" in the room, his presence possessing the senses of the olfactory, of sight, and of touch as he grasps a salver and eyes the table. Taste and sound are represented by the food and musical instrument on the table, which is also a Vanitas, the watch, knightly order, and dice all typical of the genre.

For all its possible correspondences with Ecclesiastes's sermon on Vanity, on the futility of treasuring the corruptions of this earth, still life may nonetheless continue that insidious process, perpetuating the glories of the gold- and silversmith's art, the gardener's skills, and the "delirious arts" of interior decoration and fancy table setting.

Sadly, still life, from an Academic viewpoint, was long beneath painters' contempt. Poussin, whose genius would have been ideally suited to the genre, could never have painted one, nor would David, although both their works are full of exquisite still life elements. Most French male artists found its practice the pictorial equivalent to Woman's Work, not because it was never finished, but rather because it was insufficiently "intellectual," ignoble in content. In fact, many of the women belonging to the Parisian artists' guild (they were not admitted to the Academy) painted still lifes, as did their male colleagues, for there was a ready market for these images.

The heart of what ailed still life, for painters on power trips, lay in the nonverbal, "nonsubject," nature of this genre. Still life reiterated what those who strove for Academic grandeur had found to be an irritating reality: the fact that for all the claims to painting being a Liberal Art, it really isn't.

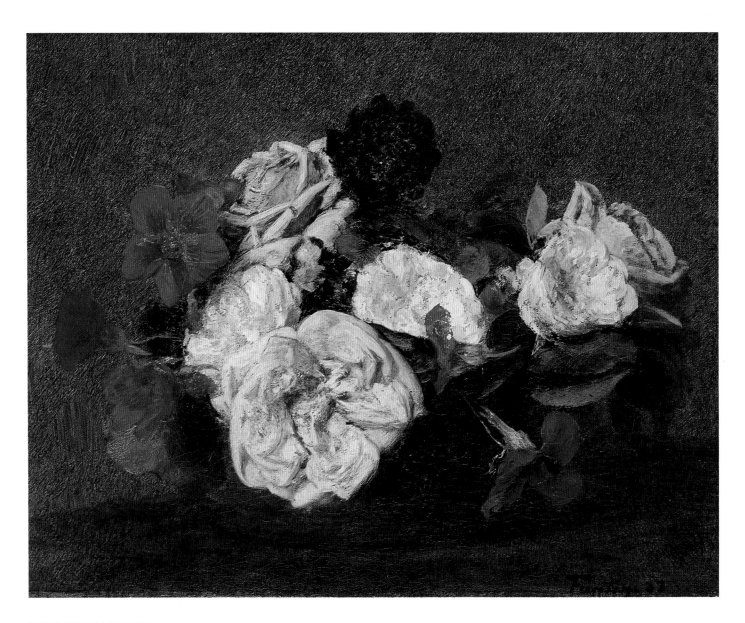

HENRI FANTIN-LATOUR
Grenoble 1836–Buré 1904
Bouquet of Roses and Nasturtiums in a Vase, 1883
(Inv. No. 9675) Oil on canvas
11 × 14″ (28 × 36 cm)
(Ex coll. Count Burlyaev, St. Petersburg, 1950)

Opposite
PAUL CÉZANNE Aix-en-Provence 1839–1906
Bouquet of Flowers in a Vase, 1873/75
(Inv. No. 8954) Oil on canvas
22 × 18″ (56 × 46 cm)
(Ex coll. S.I. Shchukin, Moscow)

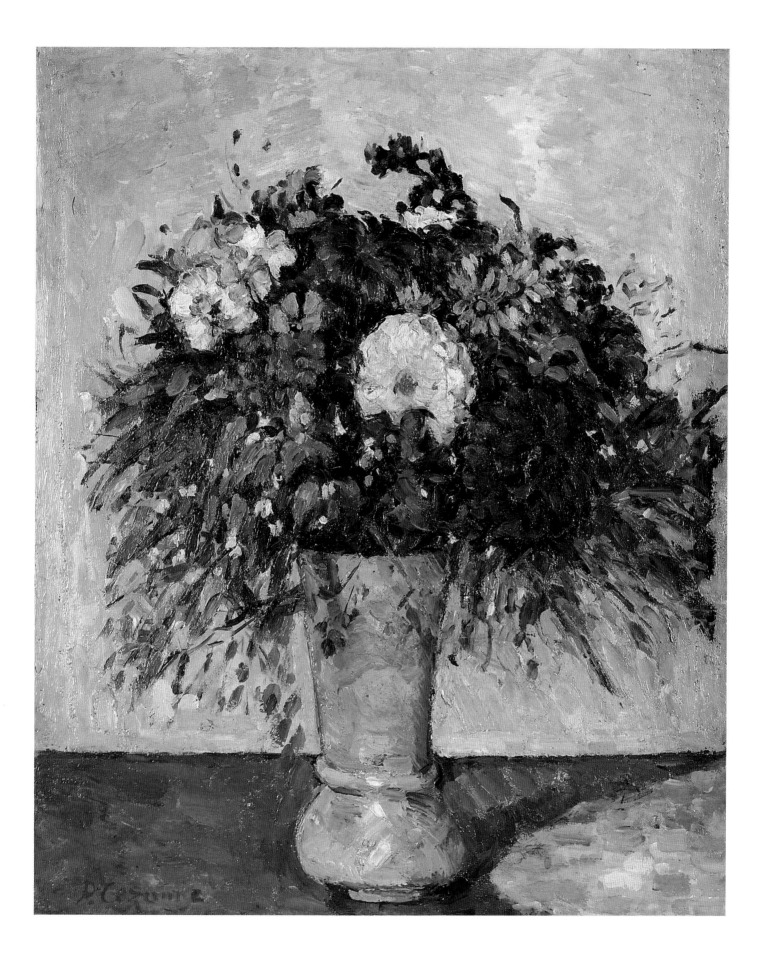

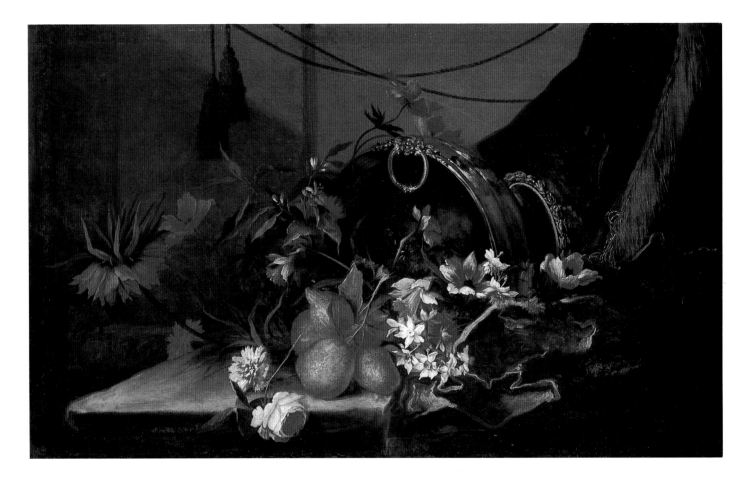

Like it or not (Plato didn't), art is fundamentally imitative, a dirty little truth that Still Life cannot help revealing. Speaking in a low voice, deprived of rhetorical flourish or amorous luster, seldom appealing to faith, knowledge, or patriotism, when still life offers more than meets the eye, the message is unwelcome.

Most images stem from or count upon memory, resonating with that long-ignored, -denied, -maligned capacity's resources. But for the literary or metaphysical arts—those of a Klinger, de Chirico, or Ernst— memory is still in the closet, the Cinderella of the century. No prince or slipper need apply. This deprivation has robbed still life of its due, so much of that genre's powers dependent upon an unstat-

ed "When this you see remember me." Here the "this" is not the obvious "me" of portrait, place, or event, with its often self- (or other-) aggrandizing dimension. Now the "me" is the painter as well as its moral, lurking behind the canvas's images. The fruit and the fish, the bird and bottle, by their existence, underline the artist's life and creative powers. So, when Leonardo wrote, "Every artist paints himself," though his profound observation was more toward portraiture than any other genre, still life, too, takes us to the personal by indirection, so many suggestions of self, of desire, of fear, and of hope concealed within what's scattered on that tabletop. The seeming neutrality of the object, with its spurious sense of objectivity, may also prove the

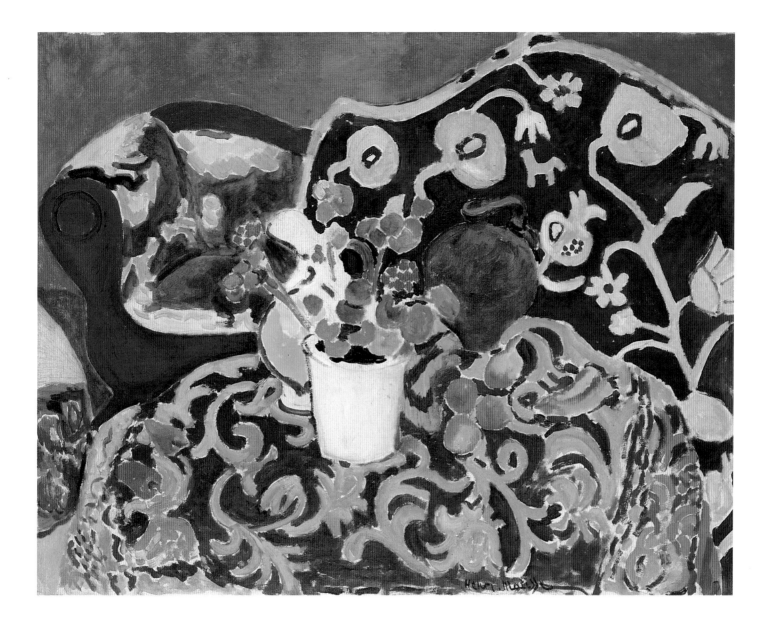

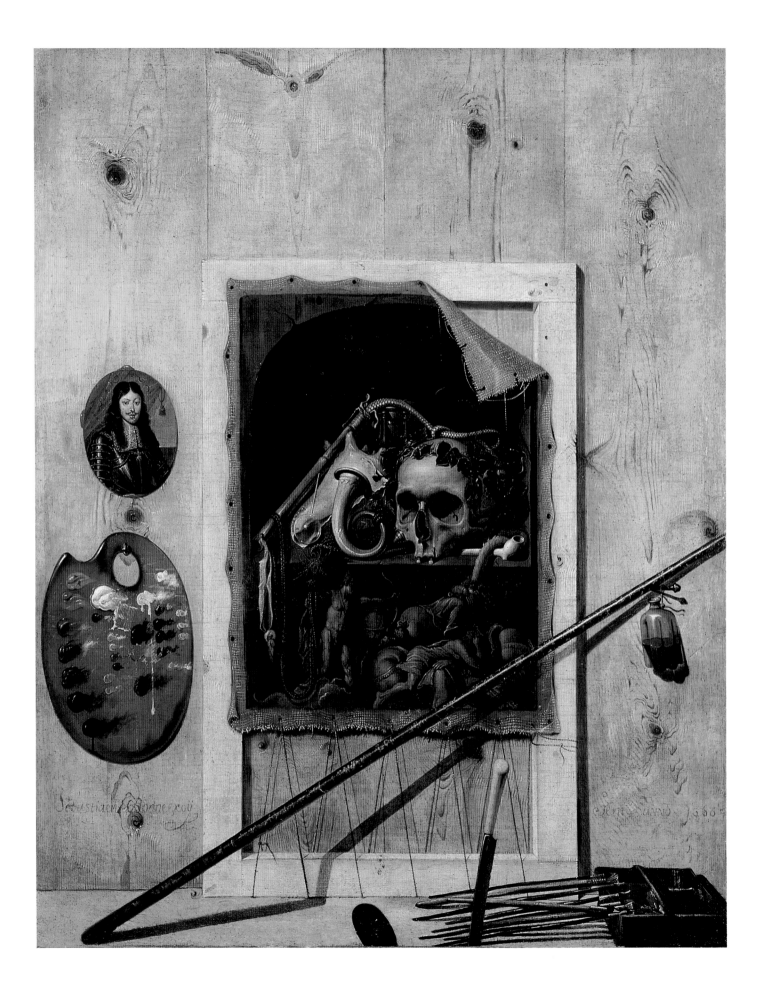

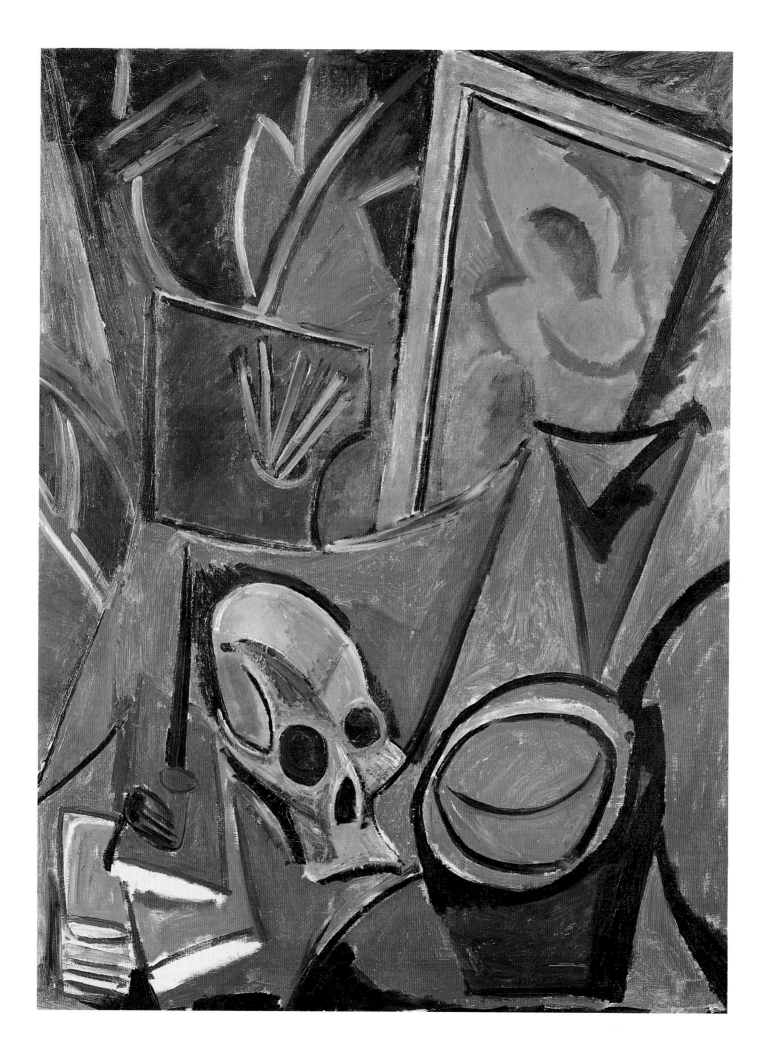

unreflecting mirror of our passions, betraying or affirming the "what" and "who" of the artist's character.

With the changing scale of social and Academic values in the eighteenth century, even leading French artists could afford to succumb to the modest pictorial pleasures of the still life. Chardin, Desportes, and Oudry painted many, these fitting in with a less formal scale and life-style. Where rooms shrank in size, there was a new emphasis upon intimacy, an appreciation for the joys of physical comfort over those of awe-inspiring, if chilly, grandeur. This, after all, was the age when real upholstery was first invented, when the pleasures of eating and seating assumed new prominence in pictures.

Later painters, like Delacroix, Courbet, Manet, and Renoir, painted relatively few still lifes. But, because it was such a welcome change from the usual, that genre gave the artist a special combined pleasure, one of zest and relaxation, almost audible pictorial sighs of relief from the unhappy model, changeable weather, or disgruntled sitter.

For other painters, still life afforded their most lyrical moments, where the anger, the sense of deprivation, and the desire for dominion and destruction that loom so forbiddingly large in much of their oeuvres, suddenly fade into oblivion. This genre allows for a rare purity of reflection, free from the overt reminder of inadequacy or of awe presented by very beautiful people, by extreme youth, or other daunting prospects. All this is

particularly true for Picasso, whose most reflective arts—other than those of his sentimental Blue, Rose, or Oh So Classical phases—are found in his un-peopled paintings.

Flowers have represented almost as many sentiments as there are varieties: columbine was melancholy; the iris and gladiolus (their leaves resembling swords) stood for grief or suffering; the lily, for purity; the daisy, pearllike purity. Violets, peeping shyly out among the leaves and growing close to the earth, meant humility. So florists' old commercial pitch—"Say it with Flowers"—abounded in historical precedents, even if their message wasn't a simple "I love you," but rather an "I love Mary," or, most important of all, "Mary loves me."

In the very grandest of Late Baroque manners, Jan van Huijsum's flower piece (596) is a sumptuous essay in the reciprocal worlds of art and nature. While the lavish bouquet bespeaks a count-not-the-cost economy—which must include an army of overworked gardeners—the handsome cherub-covered bronze vase also refers to a garden of love. That theme is echoed by the presence of statuary after Gianlorenzo Bernini's *Apollo and Daphne,* erected in the park, its narrative a suitable one for an arboreal setting. Van Huijsum may be saying that all art and nature are in flux, their metamorphoses induced by life and love over time. Such a complex subtext is suggested by the prominence of poppies—the flowers of Morpheus, god of dreams—and of moths, which represent the spirit of death. More hopeful symbolism

ANTONÍO DE PEREDA Y SALGADO
Valladolid 1608 (?)–Madrid 1678
Still Life, 1652
(Inv. No. 327) Oil on canvas
31½ × 37" (80 × 94 cm)
(Ex coll. Coesvelt, Amsterdam, 1814)

STILLED LIFE'S SCRUTINY 607

is suggested by the egg-filled nest in the foreground, and by the maiden waiting by the Bernini group. Significantly, the painter places his own name on what will last the longest, the stone ledge, with the implicit hope that his art will triumph over time, following a tradition established three centuries earlier by Jan van Eyck.

Many of the most successful flower painters since the eighteenth century seldom gave a moment's thought to the possibility of deeper meanings to their lovely pictures, nor, for that matter, did their clientele, so interpretation must be limited to the time of the resonating image's origin. What was true for one century may be irrelevant to another, Surrealism's pipes differing in meaning from those on a Baroque panel.

Steadily employed, painting in Paris for his faithful English market, Henri Fantin-Latour produced hundreds of consistently fine flower pieces. These may have benefited from the magnificent floral photography of the period, prepared for artists and decorators. Here a rather tasteless combination of roses and nasturtiums (600) differs distinctly from Fantin's exquisite art, nearer the gaudy colors of Max's floral tribute to his martyr (287).

Few genres are less plausible for Paul Cézanne than flower painting. His *Bouquet* (601) is rendered with all the anxious, alien dexterity of an elephant on a tightrope.

Among the happiest, least still of still lifes ever painted is Matisse's *Seville Still Life II* (603), named after his Spanish residence of 1910–

Above, top
PIETER CLAESZ
Burgsteinfurt 1597/98–Haarlem 1661
Pipes and Brazier, 1636
(Inv. No. 5619) Oil on panel
19 × 25″ (49 × 63.5 cm)
(Ex coll. V.N. Argutinskii-Dolgorukov,
St. Petersburg)

Above, bottom
PIETER CLAESZ
Breakfast with Ham, 1647
(Inv. No. 1046) Oil on panel
16 × 24″ (40 × 61 cm)
(Ex coll. V.P. Kostramitinova,
St. Petersburg, 1895)

1911. Patterned materials realize Matisse's promise of eternal abundance, of life everlasting; pomegranates, symbols of fertility and renewal, adorn the Spanish scarf thrown over the sofa. Another shawl (the painter collected these), used as a tablecloth, is covered with a decorative motif of growing forms; this and the big, ugly, brightly patterned upholstery on the hotel-room sofa, sing songs of endless plenitude, if not of *confort moderne*.

Some seventeenth-century still lifes come close to Matisse's for their daring: Monnoyer's (602), which may have belonged to a series of four, installed over dining room doors, is one. Here, flowers, some of them exotic, are placed with precious purses on a stone ledge as reminders of the transience of natural and commercial splendors, contrasted with stone's immutable character.

Magical realism, the illusionistic triumphs of trompe l'oeil, is found in Sebastiaen Bonnecroy's studio interior (604) where he sets the vanity of art against the eternal verity of death. The artist's youthful self portrait may be the one in armor seen in an oval at the left—one of several pictures within this picture. But Death's image is by far the larger, at stage center, with Bonnecroy's mahlstick laid across the canvas, as if to negate its sting. The artist's signature is woven into the fabric of his canvas, "written" within the grain of the wood, a holy pun on the meaning of Bonnecroy—"good cross," inscribed in nature's matrix, an emblematic self portrait eye-to-eye with Death.

Another Vanitas, Picasso's *Composition with a Skull* (605), also includes the skull and pipe typical for that theme, along with references to the transience of art—the painter's palette and brushes, and a work in progress. Partly inspired by Matisse, this canvas represents the young Catalan at his very best. Only twenty-six, he could paint as audaciously, authoritatively, and inventively as this, proclaiming his virility and indomitability in the very face of death!

A Spanish mid-seventeenth century still life by Antonío de Pereda

MATHEUS BLOEM
active in Amsterdam 1640s
Hunting Trophies
(Inv. No. 1110) Oil on canvas
86½ × 74" (219.5 × 188.5 cm)

Page 610
CHRISTOPH PAUDISS
Hamburg 1618–Freising 1666/67
Still Life, 1660
(Inv. No. 1035) Oil on canvas,
transferred from panel
24½ × 18" (62 × 46.5 cm)

Page 611
JEAN-BAPTISTE OUDRY
Paris 1686–Beauvais 1755
Still Life with Calf's Leg
(Inv. No. 5626) Oil on canvas
38½ × 29" (98 × 74 cm)

y Salgado is one of the Hermitage's most beautiful paintings (607). Pereda's name is written on a sweetmeat box just above some biscuits on a paper, the table covered by a precious crimson cloth, with cheese to the right. A copper chocolate pot with its wooden mixer, and cracked cups and pewter plate are to the left. Local faience and a fancy, silver-mounted cup and glass vessel are found upon an artfully inlaid little cabinet. Many of Pereda's pigments come straight from the Spanish earth, his terrestrial coloring strikingly close to Picasso's of 1906 (632) or that found in a work by the Mexican Diego Rivera (633), recalling those of the Spaniard Juan Gris.

Simple enumeration of qualities and contents, as attempted in the filibuster above, is but one way to avoid answering the question "Why is Pereda's still life so wonderful?" Perhaps the best reply might be the reminder that still life is also known as "painting of the humble truth," and that Pereda's image is surely a transcendent example of that uniquely accessible, immediate art. An alchemical equivalent to that explanation might be that the Spanish artist takes pewter and turns it to platinum's value—without losing the first metal's greater beauty.

A certain complacent materialism pervades much of Dutch art—a smug note perhaps deliberately diminished by those painters who reduced their palette, favoring landscapes and still lifes of welcome

FRANS SNYDERS Antwerp 1579–1657
Fish Stall
(Inv. No. 602) Oil on canvas
81½ × 134" (207 × 341 cm)
(Ex coll. Walpole, Houghton Hall, 1779)

austerity. Jan van Goyen led this movement in landscape, with his monochromatic values (322), and Pieter Claesz. (608), with many other still life painters, followed suit, electing the same approach, to be seen at its peak in the works of Willem Claesz. Heda (627).

Pieter Claesz. sideboards are of relatively slender means, even if including a handsome tumbler or glass of rum to wash down the breakfast ham. These artists, like the enlightened but obscure Christoph Paudiss (610), realized that when it comes to illusion, less can be more. The latter's painting, like Claesz.'s *Pipes and Brazier* (608), is still a Vanitas. Their austere realism, along with the more dramatic illusionism of Matheus Bloem and Paulus van den Bos (620) provided models for German and American

nineteenth-century trompe l'oeil art, as found in works by William Harnett and John Peto.

No matter how brilliantly they may be reproduced, images like Willem Kalf's *Dessert* (619) were not meant to be viewed against sparkling white backgrounds. The Dutch spent lavishly on handsome frames. Kalf's opulent image within would have been treasured in a reliquary-like framing of precious tortoiseshell or ebony, one that would stress the value of the exotic fruit — the orange with its blossom — the Delft charger, Eastern carpet, and extremely costly goldsmith's work, all of these mere reflections of the brilliance of the painter's artistry.

Greed and need are among our most basic drives. Early hunger's memories can never be totally

FRANS SNYDERS
Fruit Stall
(Inv. No. 596) Oil on canvas
81 × 134½" (206 × 342 cm)
(Ex coll. Walpole, Houghton Hall, 1779)

eclipsed, whether for food or love—one and the same in infancy. "The groaning board," a revolting phrase, describes all too well many a Baroque still life, such as Frans Ryckhals's *Fruit and Lobster on a Table* (617), with its tobacco jar, splendid tankard, and silver carafe in the background. Visually, these images of plenitude provide the pictorial promise of food forever in the larder (or refrigerator), a perpetuation of that "too much," which is barely enough. The painting's proud possessor is now secure in the eternal ownership of his or her due, forever theirs in an eternal feast for the eyes.

A whole late-medieval literary genre was spun around abundance: the Land of Cockaigne, where cooked chickens ran about, thoughtfully furnished with knives stuck in their plump, skinned sides, ready for consumption—an ambulant, biodegradable MacDonald's, and free, too. This is where the "big rock candy mountain" of popular song was first found, these images of endless, effortless nurture often painted by Bosch. Whole stalls of fish and fruit, the first teeming with local *fruits de mer*, the second showing an Antwerp housewife giving a peach a severely critical squeeze, were painted by Frans Snyders to assuage a priestly patron's gnawing appetites (612, 613).

Piled up informally, Abraham Mignon's fruits and flowers (617) have much the same sense of heedless abundance as van Huijsum's, including a white hibiscus, that tropical touch added to stress a cosmic profusion. This Baroque quality of an endless outpouring

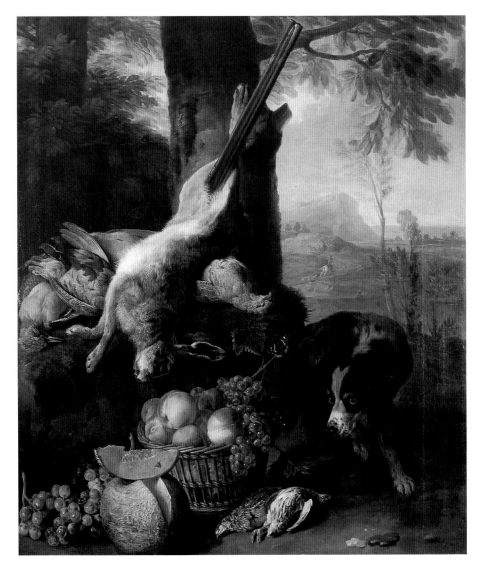

of fertility is also found in Jan de Heem's luscious harvest (615).

Alexandre-François Desportes's autumnal vista (614) includes a gross double entendre: The hare's legs encircle the instrument of his death in a travesty of sexual embrace.

A battered seventeenth-century urn has tumbled from its base in Jean-Baptiste Oudry's uncharacteristically brooding still life (615). Once fashionable, the stone carving has fallen victim to the passage of time. Autumnal fruits in the foreground stress winter's proximity, the year almost spent. Oudry kept

ALEXANDRE-FRANÇOIS DESPORTES
Champigneulles 1661-Paris 1743
Still Life with a Dead Hare and Fruit, 1711
(Inv. No. 2218) Oil on canvas
45 × 39″ (115 × 99 cm)

Above, top
JEAN-BAPTISTE OUDRY
Still Life with Fruit, 1721
(Inv. No. 1121) Oil on canvas
29 × 36" (74 × 92 cm)

Above, bottom
JAN DAVIDSZ. DE HEEM
Utrecht 1606–Antwerp ca. 1684
Fruit and Flowers in a Vase, 1655
(Inv. No. 1107) Oil on canvas
37½ × 49" (95 × 124.5 cm)

this relatively early work in his own collection; their vital, realistic approach presages that of the nineteenth century, when this genre received a major revival with the new doctrine of Realism, the novel belief that "a well-painted turnip is better than a badly painted Madonna."

Another atypical but extremely beautiful Oudry is his *Still Life with Calf's Leg* (611), far from the often crass good cheer or gluttony of rich seventeenth-century works in the same genre yet still close to the earlier monochromatic Dutch masters. This painting has a subtlety that is also very near Chardin's, its richly brushed, monochromatic background found much later in the century, reserved by David for his finest portraits, rather than for that of a quartered veal, its jaunty tail an ironic reminder of all that went when this calf was led to slaughter.

One superb canvas, addressed quite literally to the State of the Art of Still Life, provides all the answers. This is Chardin's *Still Life with the Attributes of the Arts* (624–25), commissioned by Catherine II in 1766 for the conference hall of St. Petersburg's Academy of Fine Arts, part of the Hermitage architectural complex. Catherine, probably trained in the rudiments of the arts, doubtless found Chardin's canvas far too good for mere painters and kept it for herself. The *Attributes* remained in the Hermitage until Nicholas I sold the picture in 1854; a leading light of the gallery, it was repurchased in 1926.

Chardin's most monumental and ambitious painting, it presents pic-

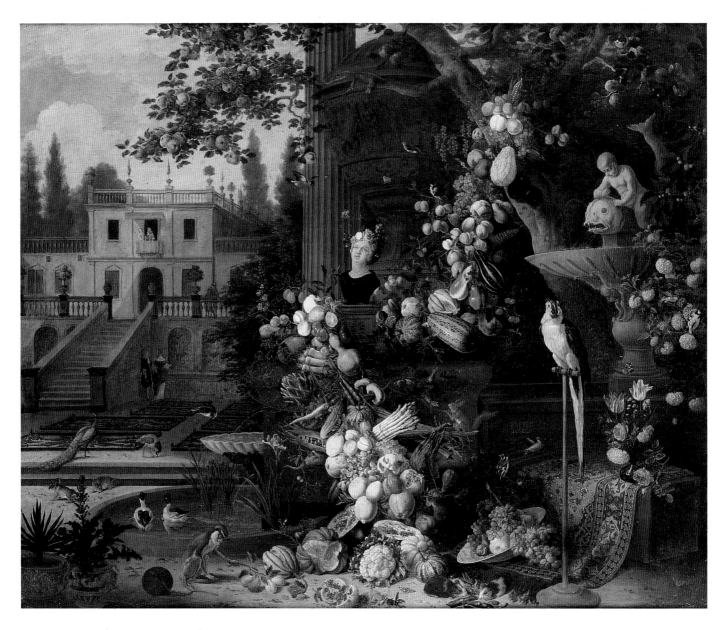

PIETER GYSELS Antwerp 1621–1690/91
Garden
(Inv. No. 662) Oil on copper
20½ × 25½" (52.5 × 64.5 cm)
(Ex coll. Cobentzl, Brussels, 1768)

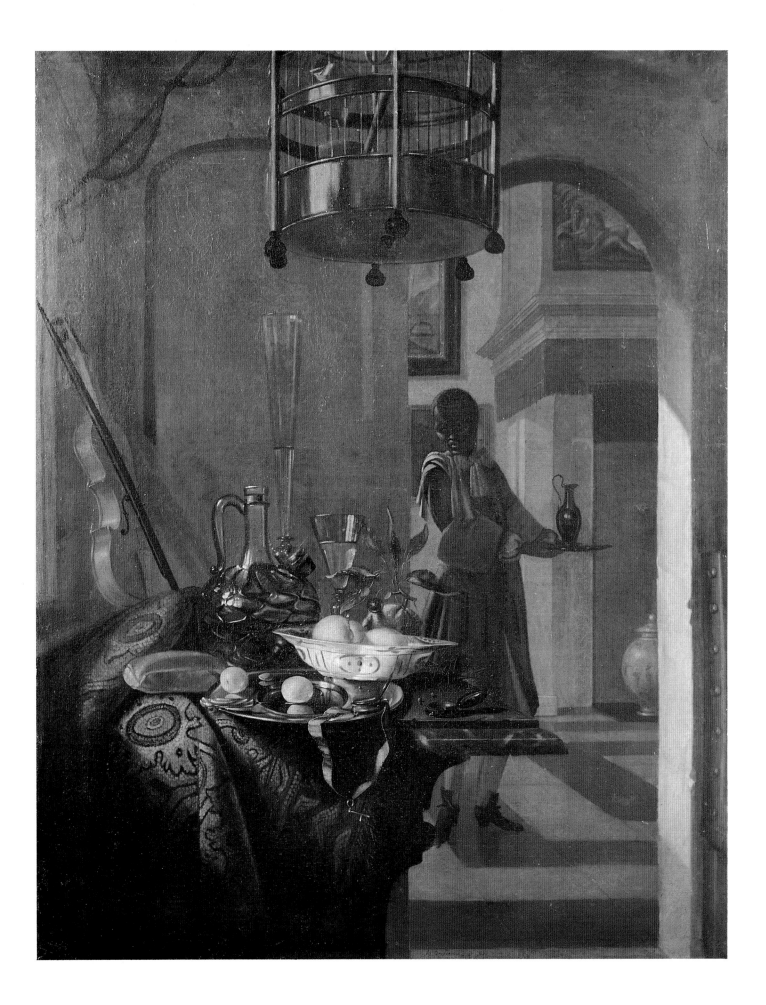

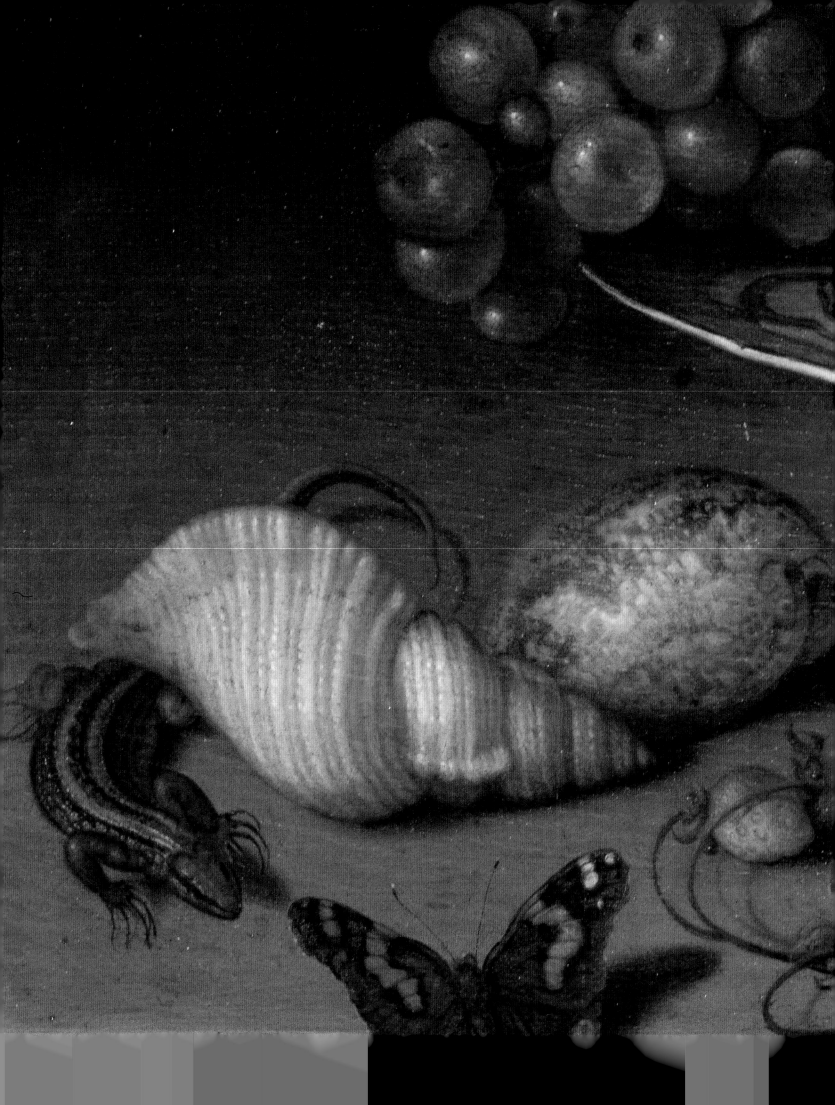

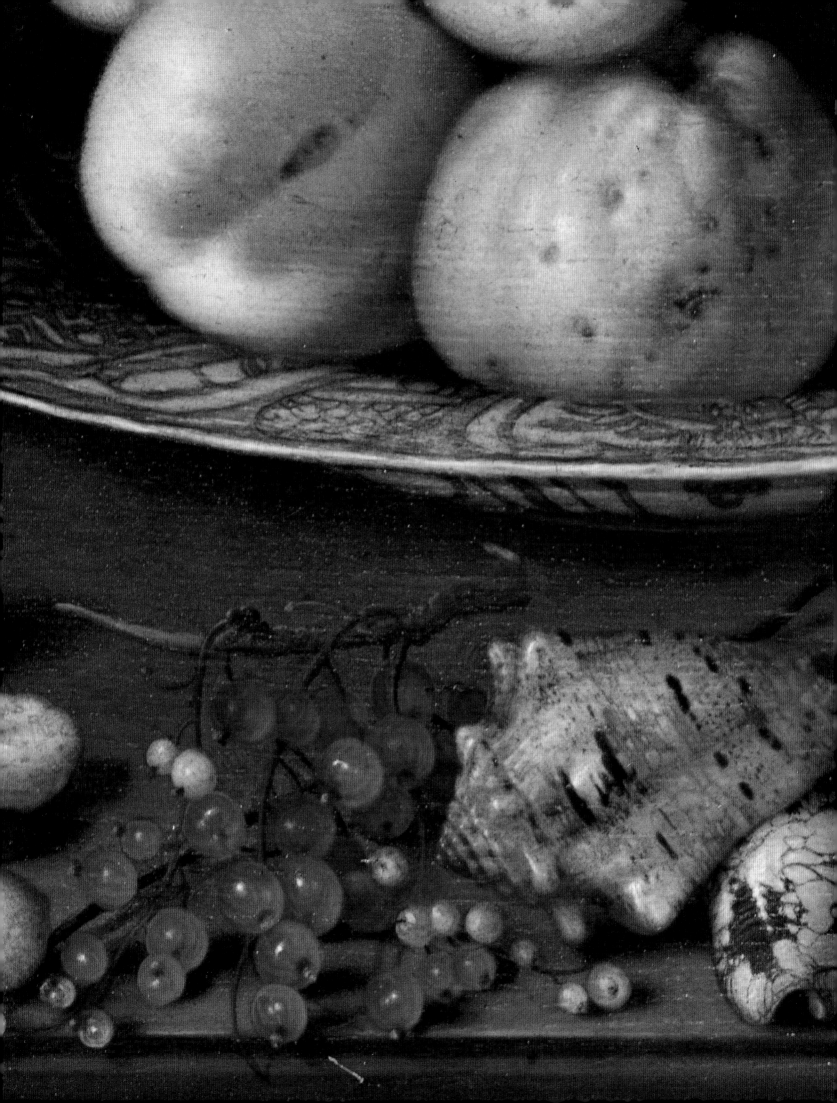

JEAN-BAPTISTE SIMÉON CHARDIN
Paris 1699–1779
Still Life with the Attributes of the Arts, 1766
(Inv. No. 5627) Oil on canvas
44 × 55″ (112 × 140.5 cm)
(Ex coll. St. Petersburg Academy of Arts, 1766)

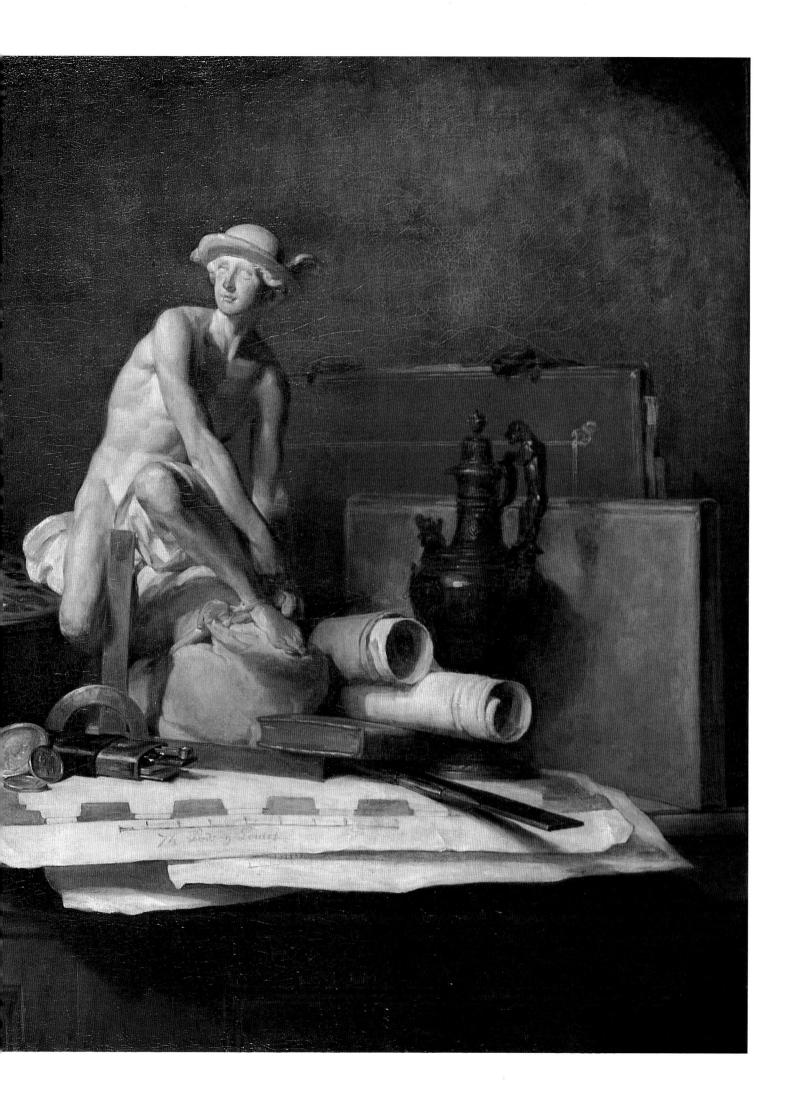

Egyptian quality of finality, a sense of "That's all there is, there ain't no more," to be found in the very best of medieval and Classical art, or that of a Japanese screen or Chinese scroll.

This absolute character puts the Cézanne still life beyond the by-then-hackneyed bounds of the Vanitas. Even if the artist does include clocks and pipes and skulls and flowers, all of these are now obsolete as indices of time and tide: Whatever Cézanne paints is saturated by eternity, as is its witness.

This artist's communication of immutable force—neither *nature* nor *morte*—in his *Still Life with Drapery* is conveyed by composition and color far more than by its commonplace contents: a bogus tapestry curtain, an ugly big pitcher, two clumsy bunched-up cloths (or one long one), two ordinary plates of fruit, with more scattered on the kitchen table, against a dimly figured wall. Most beautiful of all is the unfinished cloth in the right foregound, recalling the Michelangelesque aesthetic of the *nonfinito* and Cézanne's justifiably proud words to the effect that were he to die the next day, all his unfinished works could be seen as complete.

In the spring of 1909 Picasso came ever closer to Cézanne's world—the Provençal painter, having died two years before, was central to the precepts of Cubism. In 1907, the year of his death, Cezanne's letter to Émile Bernard was published: It stated that one was to "Treat nature by the cylinder, the sphere and the cone, everything in proper perspective, so that each side of the

object or plane tends toward a central point." Many of Picasso's paintings of the two years before and two or so after Cézanne's death seem almost like *mementoes* of that master, alive or *mori*.

Unsurprisingly, Cézanne's still lifes, his greatest works, are those of his paintings whose influence is most evident in Picasso's works. The Catalan always helped himself generously to other's achievements, saying that was what they were there for. So Picasso's *Compotier, Fruit, and Glass* (630), from the spring of 1909, is still seen through Cézanne's eyes and in his colors, far less subject to the precepts of conventional Cubism than such works as Picasso's *Nude* (in the Hermitage), from the same year.

Among Picasso's most beautiful early still lifes is an oval canvas, his *Musical Instruments* (635) of 1912. Its

ANDRÉ DERAIN
Chatou 1880–Chambourcy 1954
Still Life, ca. 1912
(Inv. No. 6542) Oil on canvas
39 × 45″ (99 × 115 cm)
(Ex coll. S.I. Shchukin, Moscow)

Opposite
WILLEM CLAESZ. HEDA
Haarlem 1593/94–1680/82
Breakfast with Crab, 1648
(Inv. No. 5606) Oil on canvas
46½ × 46½″ (118 × 118 cm)

decorative shape, most popular in French arts of the seventeenth and eighteenth centuries, has an intrinsic elegance that is continued by the painting's harmonic contents.

Here, once again, is an authoritative, remarkably positive repainting of Baroque still lifes by masters like the Bergamasque Evaristo Baschenis, who found the sonorous implications of stringed instruments the perfect image for his painterly art. Picasso's canvas's outline suggests that it, too, may partake of the musical metaphor, recalling the body of a mandolin, lute, or guitar, here painted for optical playing. Tedious Italian Academic disputes about the *paragone* compared the visual arts to determine which was the best. Son of a drawing professor that he was, Picasso may have been expanding the parameters of such competitions, his art here taking on the quality of music, as if assuming sound through time. This was true, too, for Kandinsky's early *Klänge* (1913), and for so much of the art of the period, which was infatuated by the crossings over of sound and sight engendered by new electronic music, with such instruments as the theremin and the color organ.

Scholars love Picasso's works because they inspire infinite interpretation (and endless articles toward tenure and relative prosperity). The Catalan is the ultimate academic artist, or, better said, the ultimate artist for academics! Could it be that his centrally placed metronome, with its eyelike aperture, is meant to suggest the artist's vision and sexuality, both so closely connected in Picasso's oeuvre?

HENRI MATISSE
Pink Statuette and Jug on a Red Chest, 1910
(Inv. No. 6520) Oil on canvas
35½ × 46" (90 × 117 cm)
(Ex coll. S.I. Shchukin, Moscow)

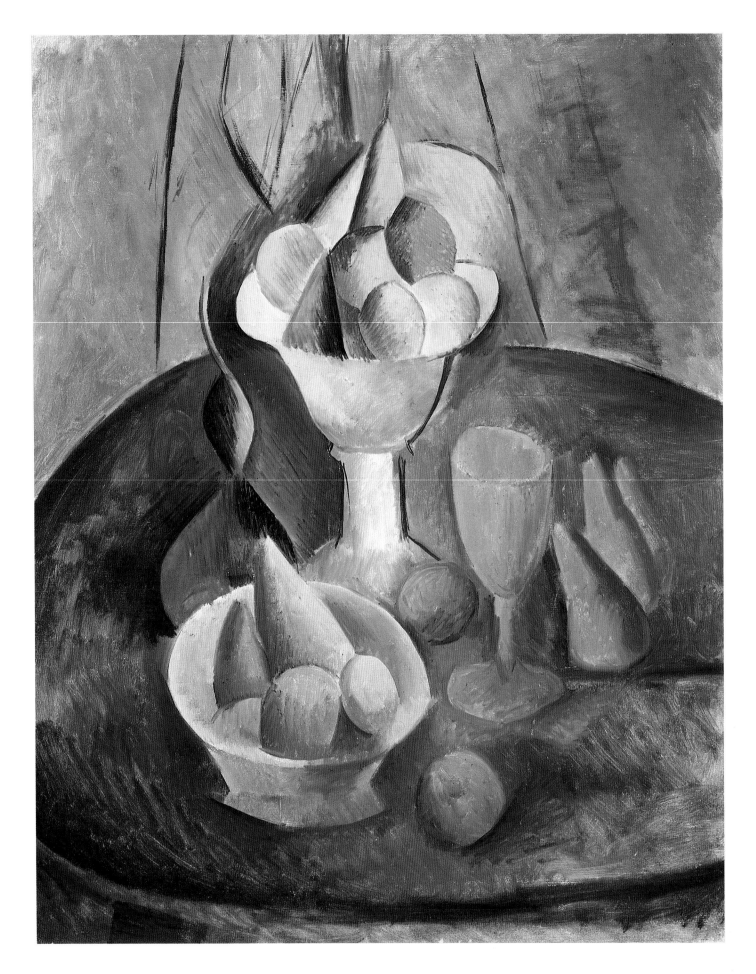

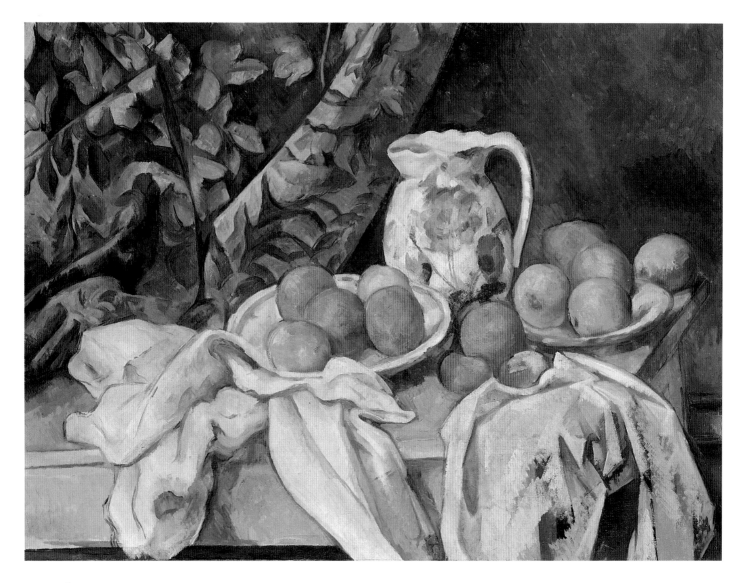

PAUL CÉZANNE
Still Life with Drapery, ca. 1899
(Inv. No. 6514) Oil on canvas
21 × 28″ (53 × 72 cm)
(Ex coll. I.A. Morozov, Moscow)

Opposite
PABLO PICASSO
Compotier, Fruit, and Glass, 1909
(Inv. No. 9160) Oil on canvas
36 × 29″ (92 × 73 cm)

Assembled in 1914, Picasso's handsome *Compotier with Bunch of Grapes and Cut Pear* (637) also revels in an innate Classicism, in the manner of eighteenth-century collages, pasting down varicolored papers, envelopes, playing cards, prints, seals, and other decorative two-dimensional elements. But Picasso's is a more serious exercise, for all its delight in using sawdust and simulating the wooden cornices and faux-marbre effects—the bag and baggage of the commercial *peintre-décorateur*. It's as if Picasso were putting over an elegantly tongue-in-chic takeoff of Pointillisme and the arts of his new friends Juan Gris and Georges Braque (the latter the son of an honest-to-God house-painter).

Violin and Guitar (634) shows Picasso in a far more ambitious, inventive mode and mood. Musical instruments take on an ever-more important role in his art, as he relates their sound to the concept of harmony, a constant in Western thought since antiquity. That the visual, as well as musical, vocabulary of the past is on the painter's mind is indicated by the classicizing cornice. Here the young artist relinquishes the clever effects of earlier collage for far more challenging dimensions of illusionism, dealing with issues of overlay, of serial perception, of transparency. A ghostly easel seems to fight its way into music's realm.

Five years Picasso's junior, Amédée Ozenfant (634) was much drawn to the former's early Cubism, soon reinterpreting it along bland, formulaic lines, his sterile movement given the all-too-appro-

priate name of Purism. A Swiss sense of the pristine pervades Ozenfant's oeuvre, partially inspired by his frequent association with Le Corbusier.

Those medieval manuals guiding readers through their last days and final hours, entitled *The Art of Dying Well*, have many of the same subjects as those of still life and, by extension, to this century's predominant, often deadly, Art of Abstracting Well. All too willingly have artists indulged a quasi-ascetic renunciation of the recognizable goods as the bads of this world. All strip and no tease, this deprivation made the "nonobjective" a new vision, in a devastating bonfire of the pictorial Vanitas. Even though Picasso claimed—correctly, as usual—that there's no such thing as the truly abstract, most recent decades' creative energy eschewed any overt aspect of the imitative. Paradoxically, just as Western culture now returns to the seminal acci-

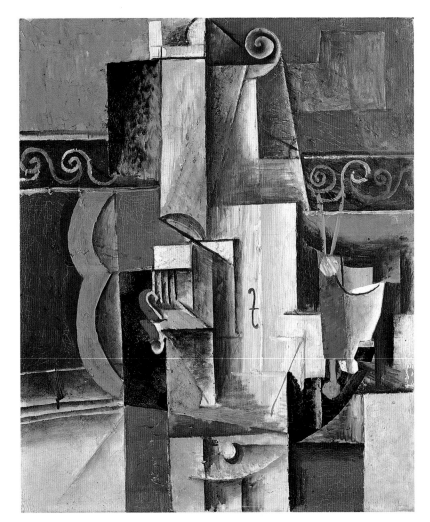

Left, top
PABLO PICASSO
Violin and Guitar, 1913
(Inv. No. 9048) Oil on canvas
25½ × 21″ (65 × 54 cm)
(Ex coll. S.I. Shchukin, Moscow)

Left, bottom
AMEDÉE OZENFANT
Saint-Quentin 1886–Cannes 1966
Still Life, Dishes, 1920
(Inv. No. 9070) Oil on canvas
28 × 23½″ (72 × 60 cm)

Opposite
PABLO PICASSO
Musical Instruments, 1912
(Inv. No. 8939) Oil and plaster on canvas
38½ × 31½″ (98 × 80 cm)
(Ex coll. S.I. Shchukin, Moscow)

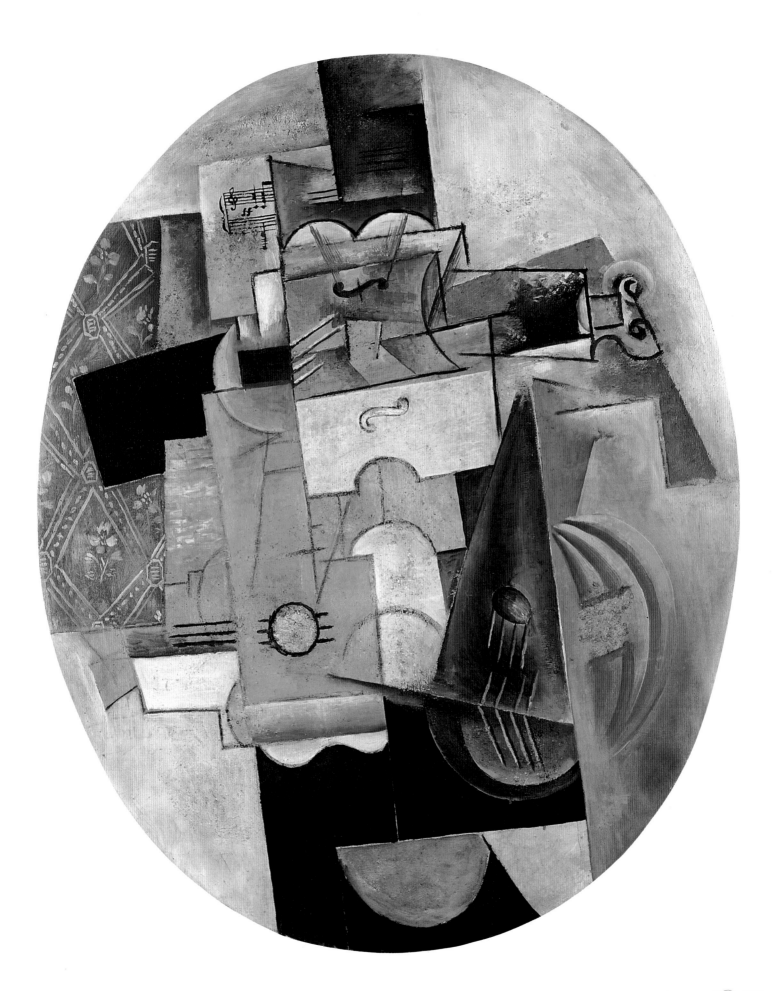

dents and incidents of nature, that of the Russian circle embraces the once despised "decadent Formalism." With the Wall's demise, these extremes may meet, toward a livelier art.

Far the finest of the Hermitage's recent acquisitions is a painting by the father of mystical Modernism, that most spiritual of this century's artists, Vassily Kandinsky. Just as a Russian dog was the first living being to witness the cosmos from outer space, so Kandinsky's canvases, from the earliest decade of this century, were the first to "see" what we "knew" but despaired of representing.

In her splendid "Kandinsky and the Old Russia," Peg Weiss has shown how profoundly the young painter was interested in the ethnological explorations of his vast country. Elected at twenty-three, in 1889, to membership in the Russian Imperial Society of Friends of Natural History, Kandinsky was particularly drawn to descriptions of Altaic shamanistic rituals to sky deities, to their cosmic imagery, inscribed upon circular drumheads. His own early compositions, some coming to him in fevered states of hallucination, include images close to tribal books of divination and to the drumming that brought forth occult revelations. In Kandinsky's early poetry he describes visions

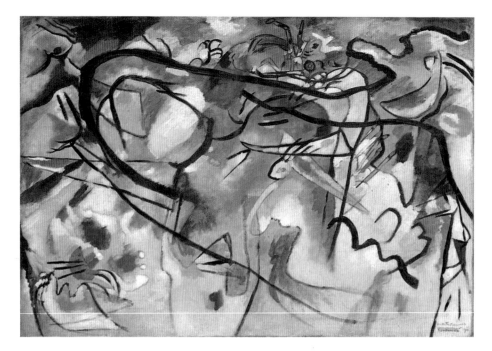

"seen from above," imploring his readers to have them too. For those unable to fly so high, this incomparable painter lets us share his passage and its panorama in *Composition No. 5* (636).

The most ancient of Russian artists, the Altaic shaman, employed a ritual where, upon the arrival of each spirit, a voice would call, "Here am I." All painters, knowing it or not, share a Shamanistic role. Looking through the hundreds of pictures from the Hermitage in this book, we too may "hear" a great visual equivalent to a surging chorus of "Here am I"—a collective pictorial drumbeat, a celebration of the triumph of the spirit through time.

VASSILY KANDINSKY
Composition No. 5, 1911
Oil on canvas
37 × 55" (94.5 × 139 cm)

Opposite
PABLO PICASSO
Compotier with Bunch of Grapes and Cut Pear, 1914
Paper with gouache, tempera, sawdust, and pencil 27 × 21" (68 × 53 cm)

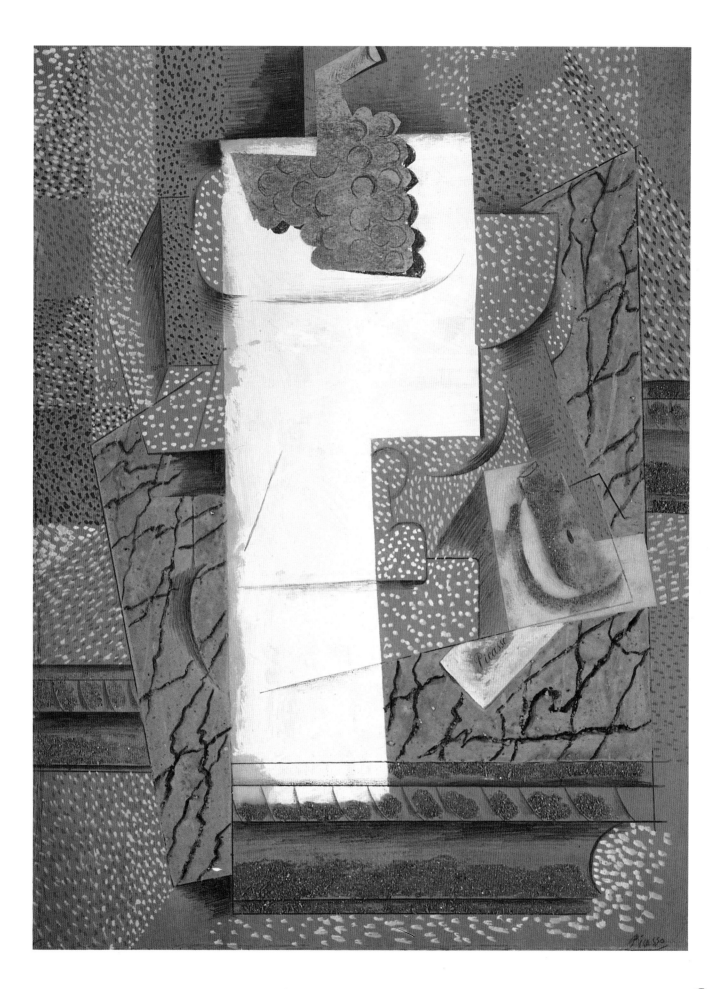

Index to Painters and Titles

Index to Painting Titles

✦✦ ✦✦

Index to Artists by Nationality and Period

Nationalities are listed alphabetically and are broken into subcategories by period, which are listed chronologically. Artists are listed alphabetically under the appropriate period.

Numbers in *italics* refer to pages on which reproductions will be found.

ERRATUM
The caption on page 67 should read:

EDGAR DEGAS
Woman at Her Toilette, 1889
Pastel on paper
23 × 23½" (59 × 60 cm)
(Ex coll. I. Ostrohkhov)

Afterword

Vladimir Visson (who can never be thought of as "the late," his presence still so close to us), his wife, Mirra, and their daughter, Lynn, have given the author and his wife the deepest understanding of the warmth and beauty of Russian hospitality and culture.

Especially helpful in the preparation of this book were the following volumes from the Hermitage's extremely fine, vastly scholarly *Catalogue of Western European Painting* (Giunti): Inna S. Nemilova's *French and German Painting: Eighteenth Century;* Nikolia N. Nikulin's *German and Austrian Painting: Fifteenth to Eighteenth Centuries* and his *German and Austrian Painting: Nineteenth Century;* Boris I. Asvarishch's *German and Austrian Painting: Nineteenth and Twentieth Centuries;* and Valentina N. Berezina's *French Painting: Early and Mid-Nineteenth Century.*

Ursula Lee most kindly lent me her copy of Anna Barskaya's excellent *French Paintings from the Hermitage* (1975). I also used W. F. Levinson-Lessing's *L'Hermitage: Écoles Flamande et Hollandaise* (1962) and very informative French publications on the collection by Germain Bazin (1958) and Charles Sterling (1958).

PAINTINGS IN THE HERMITAGE
was designed by J. C. Suarès and Joseph Rutt.

The text was set in Weiss by
Graphic Arts Composition, Philadelphia, Pennsylvania.

The book was printed and bound by
Arnoldo Mondadori Editore S.p.A.,
Verona, Italy.